ILLUSTRATION INDEX VII
1987–1991

by

Marsha C. Appel

The Scarecrow Press, Inc.
Metuchen, N.J., & London
1993

PREVIOUS VOLUMES:

Illustration Index, by Lucile E. Vance. New York: Scarecrow, 1957. Covers 1950 through June 1956.

Illustration Index, First Supplement, by Lucile E. Vance. New York: Scarecrow, 1961. Covers July 1956 through 1959.

Illustration Index, Second Edition, by Lucile E. Vance and Esther M. Tracey. New York and London: Scarecrow, 1966. Covers 1950 through June 1963.

Illustration Index, Third Edition, by Roger C. Greer. Metuchen, N.J.: Scarecrow, 1973. Covers July 1963 through December 1971.

Illustration Index IV, by Marsha C. Appel. Metuchen, N.J., & London: Scarecrow, 1980. Covers 1972 through 1976.

Illustration Index V, by Marsha C. Appel. Metuchen, N.J., & London: Scarecrow, 1984. Covers 1977 through 1981.

Illustration Index VI, by Marsha C. Appel. Metuchen, N.J., & London: Scarecrow, 1988. Covers 1982 through 1986.

British Library Cataloguing-in-Publication data available

Library of Congress Cataloging-in-Publication Data

Appel, Marsha C., 1953–
 Illustration index VII, 1987–1991 / by Marsha C. Appel.
 p. cm.
 ISBN 0-8108-2659-3 (alk. paper)
 1. Pictures—Indexes. I. Title.
 N7525.A67 1993
 011'.37—dc20 93-5153

Dedicated to my children,
Sam and Jill,
with love

PREFACE

This seventh volume of the *Illustration Index* is entirely new and covers the years 1987–1991. It follow the patterns of scope, style, and arrangement set in volumes four through six. The depth of indexing is attested to by the existence of over 19,000 individual subject headings, encompassing about 28,000 entries.

Though not claiming to be totally comprehensive, the only illustrations methodically excluded are ads. Individual personalities are included, provided that the personality is considered of sufficient historical significance to warrant a separate article in the *World Book Encyclopedia*. The rationale for this criterion is the fact that photos of people enjoying ephemeral fame abound and can easily be located through the periodical indexes.

Each illustration within each journal article is treated separately, rather than indexing a few illustrations from an article to represent its major theme. This system of handling each picture individually allows better access to more obscure subject matter.

There is an extensive system of cross-references. It should be easy for a user unfamiliar with the volume to be steered to the proper entry by following related-term "see also" and primary "see" references. In the interest of easy and multiple access to each citation, there are frequently three or more entries for one illustration, or several cross-references. Entries tend toward the specific. The Hudson, Rio Grande, and Danube rivers can be found under their respective names, but there are "see also" pointers from RIVERS and from the states or countries in which they are located.

Several main listings operate as key locators to identify every example of a given category to be found alphabetically throughout the book. Following are some of the key listings:

Amusements
Animals
Architectural structures
Art forms
Art works (for artists with separate listings)
Arts & crafts
Birds
Blacks in American history
Boats
Fish
Flowering plants
Geological phenomena
Housing
Industries
Military leaders

Minerals
Mountains
National parks
Occupations
Peoples
Plants
Rivers
Rulers and monarchs
Scientists
Sports
Transportation
Trees
Water formations
Weather phenomena
Women
Writers

Publications were selected for their richness of illustration and for the availability of back issues in libraries.

A user desiring anything and everything on a specific country will go to the geographical entry. Here will be found general citations to illustrations of the country, perhaps some photographs of doctors or police officers, maybe a farm or food market. But suppose the user wants pictures of police officers of various nationalities, or would like to see how farmers do their plowing in different parts of the world. The subject breakdowns are geared to yield just this sort of cross-cultural information. There is a major emphasis on historical and sociocultural phenomena, and a quick glance at the entries and cross-references under FESTIVALS or OCCUPA-TIONS will show just how extensive their coverage is. MILITARY COSTUME, for example, is indexed not only by different societies, by also by different centuries as well, introducing a valuable historical perspective.

Marsha C. Appel
Port Washington, New York

USER'S GUIDE

The following is an example of a typical citation under a subject entry:

Nat Geog 180:124–5 (drawing,c,l) Jl '91

Most journal titles are abbreviated; "Nat Geog" refers to *National Geographic*. A complete list of journal abbreviations used follows below in the list of periodicals indexed. The journal designation is followed by the volume number of the publication. After the colon comes inclusive pagination.

Most illustrations in the book are photographs. If the text has identified an illustration as a painting, drawing, lithograph, etc., this additional information will appear as the first item inside the parentheses. If the illustrations are all photographs or a combination of photographs and other pictorial forms, no special notation will be made. There is one exception: if a map accompanies a set of photographs, "map" will appear in the parentheses.

The next item in the sample citation above is a "c," which indicates that the illustration is in color. Lack of a "c" denotes black and white.

Size of illustration is the last item indicated within the parentheses. There will always be a number from 1 to 4 present:

1 Full page or larger
2 1/2 page or larger, but less than full page
3 Larger than 1/4 page, but less than 1/2 page
4 1/4 page or smaller

In the case of numerous illustrations in a single citation, the size of the largest one is indicated.

The date is the final item in the entry, with months in abbreviated form:

Ja	January	Jl	July
F	February	Ag	August
Mr	March	S	September
Ap	April	O	October
My	May	N	November
Je	June	D	December

PERIODICALS INDEXED

Am Heritage	*American Heritage.* vol. 38–42, February 1987–December 1991.
Gourmet	*Gourmet.* vol 47–51, January 1987–December 1991.
Life	*Life.* vol. 10–14, January 1987–December 1991.
Nat Geog	*National Geographic.* vol. 171–180, January 1987–December 1991.
Nat Wildlife	*National Wildlife.* vol. 25–30, February 1987–December 1991.
Natur Hist	*Natural History.* vol. 96–100, January 1987–December 1991.
Smithsonian	*Smithsonian.* vol. 17–22, January 1987–December 1991.
Sports Illus	*Sports Illustrated.* vol 66–75, January 1987–December 1991.
Trav & Leisure	*Travel & Leisure.* vol. 17–21, January 1987–December 1991.
Trav/Holiday	*Travel/Holiday.* vol. 167–176, January 1987–December 1991.

Here are the addresses for each publication in order to inquire about reproduction rights to illustrations cited in this volume. Please note: Most of the publications do not own the illustrations and cannot, therefore, assign rights to them. They will, however, provide referrals to the artist or photographers who do own the rights.

American Heritage
Rights and Permissions Dept.
60 Fifth Avenue
New York, N.Y. 10011

Gourmet
Rights & Permissions Dept.
350 Madison Avenue
New York, N.Y. 10017

Life Picture Service
Room 2858
Time & Life Building
Rockefeller Center
New York, N.Y. 10020

National Geographic
17th & M Streets, N.W.
Washington, D.C. 10036

National Wildlife
National Wildlife Federation
8925 Leesburg Pike
Vienna, Virginia 22102

Natural History
Picture Editor
American Museum of
 Natural History
Central Park West at 79th St.
New York, N.Y. 10024

Smithsonian
Picture Editor
900 Jefferson Drive, S.W.
Washington, D.C. 20568

Sports Illustrated
Picture Syndication Dept.
20th floor
Time & Life Building
Rockefeller Center
New York, N.Y. 10020

Travel & Leisure
Art Assistant–10th floor
1120 Avenue of the
 Americas
New York, N.Y. 10036

Travel/Holiday
Photo Dept.
28 W. 23rd Street
New York, N.Y. 10010

ILLUSTRATION INDEX

—Truck wreckage (British Columbia)
 Nat Geog 180:77 (c,4) N '91
—Uprooted tree blown into car (Michigan)
 Life 13:10 (c,2) Ap '90
—See also
 CRASHES
 DISASTERS
ACCORDION PLAYING
—Cajun accordion (Louisiana)
 Smithsonian 18:124 (c,4) F '88
—Illinois
 Nat Geog 179:54–5 (c,1) My '91
—North Korea
 Life 11:88–9 (c,1) S '88
—On Prague bridge, Czechoslovakia
 Trav&Leisure 21:115 (c,2) Ja '91
—Piano accordion (Louisiana)
 Smithsonian 18:115 (c,4) F '88
—Vietnam
 Life 10:68–9 (c,1) D '87
ACID RAIN
—Balsam fir trees killed by acid rain
 Nat Wildlife 28:34–5 (c,1) F '90
—Forest killed by acid rain (Czechoslova-
 kia)
 Nat Geog 179:46–7 (c,1) Je '91
—Research on acid rain
 Nat Wildlife 25:6–13 (c,1) F '87
ACONCAGUA, ARGENTINA
 Nat Geog 171:456–7 (c,1) Ap '87
 Natur Hist 100:62–3 (c,1) Ap '91
ACROBATIC STUNTS
—Backflip
 Sports Illus 67:64 (c,2) S 28 '87
—Balancing vase on head (China)
 Trav&Leisure 17:82 (4) Ag '87
—Child doing handstand (China)
 Sports Illus 69:38 (c,4) Ag 15 '88
—Crossing stream on high wire (Maine)
 Nat Geog 171:236–7 (c,1) F '87
ACROBATS
—Atop Empire State Building, New York
 City, New York
 Sports Illus 67:28 (4) Jl 27 '87
—Canada
 Life 11:100–1 (c,1) O '88
—China
 Sports Illus 69:59 (c,1) Ag 15 '88
—India
 Life 14:50–1 (1) F '91
—New York circus
 Trav&Leisure 18:NY4 (c,4) N '88
ACROPOLIS, ATHENS, GREECE
 Trav/Holiday 170:54–5 (c,1) S '88
—See also
 PARTHENON
ACTORS
—1939 Hollywood events
 Life 12:102–12 (12) Spring '89

—1939 Hollywood stars
 Life 12:entire issue (c,1) Spring '89
—1940s Hollywood stars exercising
 Life 10:64–6 (1) F '87
—Hollywood stars
 Life 10:entire issue (c,1) Ap '87
 Life 12:entire issue (c,1) Spring '89
—Stars' names in Hollywood sidewalk
 Life 10:107 (c,2) Ap '87
 Trav/Holiday 168:42, 45, 47 (c,3) Ag '87
—See also
 ASTOR, MARY
 ASTAIRE, FRED
 BALL, LUCILLE
 BARRYMORE, ETHEL
 BARRYMORE, JOHN
 BARRYMORE, LIONEL
 BERGMAN, INGRID
 BERNHARDT, SARAH
 BOGART, HUMPHREY
 BOOTH, EDWIN
 BRANDO, MARLON
 CAGNEY, JAMES
 COLBERT, CLAUDETTE
 DAVIS, BETTE
 DEAN, JAMES
 DIETRICH, MARLENE
 DOUGLAS, KIRK
 ENTERTAINERS
 FAIRBANKS, DOUGLAS
 FLYNN, ERROL
 FONDA, HENRY
 GABLE, CLARK
 GARBO, GRETA
 GARLAND, JUDY
 GARRICK, DAVID
 GARSON, GREER
 GILLETTE, WILLIAM HOOKER
 GISH, LILLIAN
 GRABLE, BETTY
 GRANT, CARY
 HARLOW, JEAN
 HEPBURN, KATHARINE
 LANGTRY, LILY
 LOMBARD, CAROLE
 LOREN, SOPHIA
 MARLOWE, JULIA
 MIX, TOM
 MONROE, MARILYN
 MOTION PICTURES
 NEWMAN, PAUL
 OLIVIER, SIR LAURENCE
 PECK, GREGORY
 PICKFORD, MARY
 ROBESON, PAUL
 ROBINSON, EDWARD G.
 ROGERS, GINGER
 STEWART, JAMES
 TAYLOR, ELIZABETH

TEMPLE, SHIRLEY
THEATER
WAYNE, JOHN
WELLES, ORSON
ADAM AND EVE
—15th cent. frescoes (Italy)
 Smithsonian 20:94–5, 97 (painting,c,3) F
 '90
—17th cent. Dutch painting
 Smithsonian 18:127 (c,2) My '87
—Depicted in church tile floor (Capri, Italy)
 Gourmet 50:74 (c,4) Je '90
—Michelangelo's Sistine Chapel fresco
 (Vatican)
 Nat Geog 176:712–13 (c,1) D '89
 Life 14:32–4 (c,1) N '91
ADAMS, ANSEL
—1944 photo of Sierra Nevada
 Life 11:44 (4) Fall '88
—"Clearing Winter Storm" (1944)
 Trav&Leisure 17:107(2) F '87
—Photograph of Canyon de Chelly, Arizona (1947)
 Am Heritage 38:56–7 (1) Ap '87
 Natur Hist 100:66 (4) My '91
—Photograph of redwoods
 Smithsonian 21:42 (2) Ap '90
—Photographs by him
 Natur Hist 100:66–70 (1) My '91
ADAMS, CHARLES FRANCIS
 Smithsonian 21:142 (4) Je '90
ADAMS, HENRY BROOKS
 Smithsonian 21:133, 146 (c,4) Je '90
—Clover Adams
 Smithsonian 21:133 (4) Je '90
—Home (Washington, D.C.)
 Smithsonian 21:134 (4) Je '90
ADAMS, JOHN
 Am Heritage 39:34 (painting,4) N '88
—Caricature
 Smithsonian 21:66–80 (painting,c,1) My
 '90
—Home (Quincy, Massachusetts)
 Life 14:42–3 (c,1) Summer '91
ADAMS, JOHN QUINCY
 Am Heritage 38:107 (painting,4) Ap '87
 Am Heritage 39:39 (2) Mr '88
 Smithsonian 19:135, 138, 160 (painting,c,3) Ap '88
—Caricature
 Smithsonian 21:66–80 (painting,c,1) My
 '90
—Home (Quincy, Massachusetts)
 Life 14:42–3 (c,1) Summer '91
ADAMS, SAMUEL
 Life 14:42 (painting,c,4) Fall '91
ADDAMS, JANE
 Nat Geog 173:33 (4) Ja '88

Am Heritage 40:38 (4) S '89
 Life 13:61 (4) Fall '90
ADDAXES
 Smithsonian 20:112 (c,3) F '90
ADELAIDE, AUSTRALIA
 Gourmet 48:52–7, 128 (map,c,1) Ap '88
—Festival Centre
 Trav&Leisure 17:A30 (c,4) O '87 supp.
ADIRONDACK MOUNTAINS, NEW
 YORK
—Elk Lake
 Trav/Holiday 168:34, 37 (c,3) N '87
—Mt. Marcy
 Nat Geog 171:519 (c,3) Ap '87
ADOBE HOUSES
—Mesa Verde, Colorado
 Am Heritage 38:56 (c,4) Ap '87
ADVERTISING
—1845 plumber's ad (New York)
 Am Heritage 40:114 (4) D '89
—1850s Wells Fargo ad
 Am Heritage 40:81 (c,4) S '89
—1852 ad for *Uncle Tom's Cabin*
 Am Heritage 38:50 (4) D '87
—Late 19th cent. barbed wire ad
 Smithsonian 22:74–5 (c,2) Jl '91
—Late 19th cent. Coca-Cola ad and letterhead
 Nat Geog 175:34 (c,4) Ja '89
—1880s clothing ads
 Am Heritage 39:37–41 (c,3) D '88
—1880s Kodak camera ad
 Smithsonian 19:110 (4) Je '88
—1890s ad for the New York *Sun*
 Am Heritage 40:118 (c,3) D '89
—1890s deceptive angle camera
 Smithsonian 18:116 (drawing,4) O '87
—1899 Uneeda Biscuit ad
 Trav/Holiday 169:34 (c,4) Ja '88
—Early 20th cent. player pianos
 Am Heritage 39:93, 95 (4) My '88
—1911 men's suit ads
 Am Heritage 39:42 (c,4) D '88
—1919 automobile ad
 Am Heritage 39:162 (4) N '88
—1920 Spiegel catalog cover
 Am Heritage 42:126 (c,4) N '91
—1920s Arrow shirt ad
 Am Heritage 39:4 (painting,c,3) D '88
—1920s bathing suit ad
 Am Heritage 39:43 (c,3) D '88
—1920s Marshall Field catalogs
 Smithsonian 22:33 (c,4) Ap '91
—1922 chocolate ad (France)
 Life 12:53 (c,4) Je '89
—1932 toothbrush ad
 Life 11:120 (2) Fall '88
—1935 savings and loan association ad
 Am Heritage 42:66 (4) F '91

—1937 Spam introductory advertisement
Life 10:9 (c,4) N '87
—1941 Coca-Cola weather thermometer
Trav/Holiday 174:83 (c,4) S '90
—1947 Studebaker car ad
Smithsonian 22:50–1 (c,4) D '91
—1949 bra ad
Life 12:92 (c,4) Je '89
—1952 TV commercial for refrigerator
Smithsonian 20:80 (4) Je '89
—1957 Cadillac ad
Smithsonian 21:144 (c,4) N '90
—1957 savings and loan association ad
Am Heritage 42:68 (c,3) F '91
—1988 Olympic sponsorships (Calgary)
Sports Illus 68:68–70, 73 (c,2) F 29 '88
—Atlanta's campaign to host 1996 Olympics
Sports Illus 73:36–7 (c,4) Ag 27 '90
—Billboard art (Los Angeles, California)
Smithsonian 21:98–111 (c,1) S '90
—Cigarette billboard (Los Angeles, California)
Smithsonian 21:100 (c,4) S '90
—Coca-Cola billboard (Guatemala)
Nat Geog 173:770–1 (c,1) Je '88
—Coca-Cola memorabilia
Nat Geog 173:60–1 (c,1) Ja '88
—Coca-Cola sign (Tibet)
Natur Hist 98:47 (c,3) Mr '89
—Michelin man
Trav&Leisure 18:39 (c,4) Mr '88
Am Heritage 40:12 (4) Jl '89 supp.
Smithsonian 21:cov. (stained glass,c,1) N '90
—Old ads and logos
Smithsonian 19:113 (c,2) N '88
—Production of television commercial
Smithsonian 18:134–45 (c,2) O '87
—Babe Ruth in cereal ad
Sports Illus 69:13 (4) D 26 '88
—Santa Claus in 1906 cereal ad
Am Heritage 38:4 (c,3) D '87
—Soft drink billboard (Haiti)
Trav&Leisure 17:12 (c,4) Ja '87
—"Speedy" Alka-Seltzer
Life 12:118 (4) Mr '89
Smithsonian 20:26 (c,4) Ja '90
—See also
BUMPER STICKERS
POSTERS
AEROBIC DANCING
Life 10:53 (c,2) Ag '87
—National Aerobic Championship 1988
(Tennessee)
Sports Illus 68:110, 112 (c,4) My 16 '88
AFGHANISTAN
—Afghan villagers fighting over blankets
Life 12:7 (2) Ap '89

—War with U.S.S.R.
Life 11:100–6 (c,1) F '88
—See also
KHYBER PASS
AFGHANISTAN—COSTUME
—1879
Smithsonian 19:50 (3) D '88
—Guerrilla fighter
Life 10:6–7 (c,1) Je '87
—Khyber Pass area
Smithsonian 19:44–52 (c,3)
D '88
—Soldiers (1931)
Nat Geog 174:300–1 (1) S '88
AFGHANISTAN—HISTORY
—1840s Anglo-Afghan War battle (Kabul)
Smithsonian 19:50 (painting,c,3) D '88
—Nadir Shah
Life 13:44 (c,4) Mr '90
AFGHANISTAN—SOCIAL LIFE AND
CUSTOMS
—Judge arbitrating disagreement
Life 12:122 (c,2) My '89
AFRICA
Nat Geog 177:2–41 (map,c,1) My '90
—African wildlife (Botswana)
Nat Geog 178:cov., 2–63 (c,1) D '90
—African wildlife (Zambia)
Trav/Holiday 171:42–51 (c,1) Ap '89
—Africa's fight against harmful insects
Smithsonian 19:78–89 (c,1) Ag '88
—Great Rift System
Nat Geog 177:2–41 (map,c,1) My '90
—Namib Desert
Natur Hist 97:91 (c,1) Mr '88
—Sahel area
Nat Geog 172:cov., 140–79 (map,c,1) Ag
'87
—See also
AFRICAN TRIBES
KALAHARI DESERT
LAKE TANGANYIKA
NIGER RIVER
NILE RIVER
SAHARA DESERT
STANLEY AND LIVINGSTONE
ZAIRE RIVER
and individual countries
AFRICA—ART
Smithsonian 18:cov., 56–63 (c,1) S '87
Gourmet 50:68 (c,2) Mr '90
—Ancient rock paintings (Algeria)
Nat Geog 172:180–91 (c,1) Ag '87
—Kalabari sculptures (Nigeria)
Smithsonian 19:220 (c,4) D '88
—Recurring themes in African art
Smithsonian 20:252 (c,4) N '89
—West African gold jewelry
Smithsonian 20:180 (c,4) Je '89

—Women's wall paintings (West Africa)
Smithsonian 21:128–35 (c,2) My '90
AFRICAN TRIBES
—Afar people (Djibouti)
Nat Geog 177:24–5, 27 (c,1) My '90
Natur Hist 99:86 (c,4) N '90
—Ariaal people (Kenya)
Natur Hist 98:46–9 (c,1) My '89
—Dogon people (Mali)
Nat Geog 178:100–27 (c,1) O '90
—Herero women (Botswana)
Trav&Leisure 18:121 (c,4) My '88
—Kipsigi man
Natur Hist 98:66 (4) Je '89
—Masai people (Tanzania)
Trav&Leisure 17:cov., 96–7, 106–7 (c,1)
N '87
—Masai village (Kenya)
Life 12:93 (c,2) Ag '89
—Mikea people (Madagascar)
Nat Geog 174:146–7 (c,1) Ag '88
—Ngisonyoka tribe (Kenya)
Natur Hist 96:32–41 (c,1) Ja '87
—Rendille people (Kenya)
Natur Hist 98:40–5 (c,1) My '89
—Surma people (Ethiopia)
Natur Hist 99:86 (c,4) N '90
Nat Geog 179:76–99 (c,1) F '91
—See also
PYGMIES
ZULU PEOPLE
AFRICAN TRIBES—COSTUME
—Children in African attire (New Jersey)
Smithsonian 22:101 (c,2) Je
'91
—Early 20th cent. Mangbetu people
(Zaire)
Natur Hist 99:74 (3) Je '90
AFRICAN TRIBES—HOUSING
—Ndebele house design (South Africa)
Nat Geog 174:346–7 (c,1) S '88
AFRICAN TRIBES—RELICS
—16th cent. Tellem burial caves (Mali)
Nat Geog 178:106–7 (c,1) O '90
—Early 20th cent. Mangbetu artifacts
(Zaire)
Natur Hist 99:72–4 (c,1) Je '90
AFRICAN TRIBES—RITES AND FES-
TIVALS
—Kota coming of age ritual (Congo)
Life 14:46 (c,2) O '91
AGED
—Elderly people exercising in shopping
mall (Illinois)
Life 10:28–9 (c,1) F '87
—Elderly surfers
Life 13:72–7 (c,1) F '90
—Elderly woman (U.S.S.R.)
Trav&Leisure 20:138–9 (c,1) O '90

—Guatemala
Nat Geog 173:803 (c,1) Je '88
—London, England
Nat Geog 180:48–9 (c,2) Jl '91
—Ms. Pennsylvania Senior contest
Life 13:94–102 (c,1) D '90
—Nepal holy man
Trav/Holiday 167:cov. (c,1) My '87
—90-year-old black musician (Texas)
Nat Geog 177:62–3 (c,1) Je '90
—91-year-old mountain climber
Life 11:107 (c,4) Ja '88
—92-year-old woman (Alabama)
Life 11:60 (c,2) N '88
—Old woman (Brazil)
Nat Geog 171:366–7 (c,1) Mr '87
—Old woman doing leg stretch
Life 14:88 (c,2) F '91
—Old woman with cane (Illinois)
Nat Geog 179:66 (c,1) My '91
—100-year-old woman (Ohio)
Nat Geog 177:123 (c,3) Mr '90
—109-year-old woman
Life 12:89–91 (c,1) Ap '89
—114-year-old woman (Florida)
Life 12:61 (c,2) F '89
—120-year-old man (Japan)
Life 10:120 (4) Ja '87
—Senior citizens working with children
(New Jersey)
Life 12:102–6 (c,1) D '89
—World Veterans Championships 1989
(Oregon)
Sports Illus 71:44–7 (c,2) Ag 14 '89
AGRA, INDIA. See TAJ MAHAL
AGUINALDO, EMILIO
Smithsonian 20:150 (4) My '89
AIDS
—AIDS quilt commemorating patients
Life 13:38–9 (c,1) Ja '90
Trav&Leisure 20:203 (c,4) Mr '90
Nat Geog 179:138–9 (c,1) Ja '91
—AIDS sufferers
Life 10:53 (3) N '87
Life 11:42–7 (c,1) Ja '88
Life 12:98–9 (1) Fall '89
Nat Geog 179:136–7 (c,1) Ja '91
—AIDS virus and immune cells
Smithsonian 20:70–1 (c,2) Je '89
—Burned down home of family with AIDS
(Florida)
Life 11:78 (c,3) Ja '88
—Child dying of AIDS (Romania)
Life 14:14–15 (c,1) Ja '91
—Children with AIDS
Life 10:98–100 (1) O '87
Life 13:10–11 (c,1) D '90
—Dying AIDS patient
Life 13:8–9 (1) N '90

SPACECRAFT
AIRPLANES—HUMOR
—Combination air-bus-ship
Trav&Leisure 17:122 (drawing,c,1) D
'87
AIRPORTS
Life 12:132–3 (c,3) Mr '89
—Belize
Trav/Holiday 175:50 (c,1) Je '91
—Edwards Air Force Base, Mojave, California
Life 10:10–1 (c,1) F '87
—Hartsfield Atlanta International, Georgia
Nat Geog 174:10 (c,3) Jl '88
—LaGuardia, New York (1940s)
Am Heritage 38:76 (painting,c,3) D '87
—Lego model of airport (Denmark)
Smithsonian 19:126 (c,3) Je '88
—Los Angeles Airport, California
Life 12:132–3 (c,3) Mr '89
—O'Hare people movers, Chicago, Illinois
Trav&Leisure 17:144 (c,4) D '87
—Remote airstrip (Nepal)
Natur Hist 100:38 (c,4) F '91
—St. Barts airstrip
Trav&Leisure 19:155 (c,4) O '89
—Underground tunnel at O'Hare Airport, Chicago, Illinois
Life 11:7 (c,4) F '88
AIRSHIPS
—1926 dirigible (Norway)
Smithsonian 21:180 (4) O '90
—1937 crash of the Hindenburg (New Jersey)
Life 11:67 (3) N '88
—Blimps
Life 11:64–9 (c,1) N '88
—Dirigible
Nat Geog 178:128–31 (c,1) O '90
—History of the blimp
Life 11:66–9 (c,3) N '88
—Lightning hitting Goodyear blimp
Life 12:7 (c,4) O '89
—See also
ZEPPELIN, FERDINAND VON
ALABAMA
—Bee Branch
Natur Hist 99:80–2 (map,c,1) Mr '90
—Bellingrath Gardens
Trav&Leisure 17:92–9 (c,1) F '87
Trav/Holiday 167:49 (c,1) Mr '87
—Gulf Coast
Trav&Leisure 18:E8–E15 (c,3) N '88
—See also
MOBILE
MONTGOMERY
ALAMO, SAN ANTONIO, TEXAS
Trav&Leisure 19:102 (c,1) Ag '89

Trav/Holiday 176:85 (c,4) Jl '91
ALAND ISLANDS, FINLAND
Nat Geog 175:628–9 (c,1) My '89
ALASKA
Nat Wildlife 28:entire issue (map,c,1) Je '90
—19th cent. Russian outposts in Alaska
Natur Hist 98:46–57 (map,c,1) D '89
—Alaska wildlife
Life 14:78–86 (c,1) Summer '91
—Alsek River area
Natur Hist 97:52–63 (map,c,1) My '88
—Arctic National Wildlife Refuge area
Nat Geog 174:858–67 (map,c,1) D '88
Trav&Leisure 21:67, 70, 75 (map,c,4) F '91
Nat Wildlife 30:38–9, 44–5 (c,1) D '91
—Baranoff Island
Natur Hist 97:50–1 (c,1) Ag '88
—Beaufort Sea
Nat Geog 174:859–61, 865 (map,c,1) D '88
—Cape Romanzof
Life 11:40–1 (c,1) Ap '88
—Cordova
Trav/Holiday 169:54–5 (c,3) Mr '88
—Glacier Bay
Trav&Leisure 17:104–5 (c,1) O '87
—Glaciers
Nat Geog 171:104–19 (map,c,1) Ja '87
Trav/Holiday 169:50–1 (c,1) Mr '88
Smithsonian 19:cov., 96–107 (c,1) Ja '89
Trav/Holiday 172:66 (c,4) Ag '89
Nat Wildlife 28:6–7 (c,1) Je '90
Trav/Holiday 175:67 (c,4) Je '91
Life 14:104 (c,2) Summer '91
—Haines
Trav/Holiday 168:48–53 (c,1) D '87
—Kongakut River
Nat Geog 174:852–3 (c,1) D '88
—Little Diomede Island
Nat Geog 174:476–7 (c,2) O '88
—North-central region
Nat Geog 177:45–69 (map,1) F '90
—Northwest Alaska countryside
Nat Wildlife 28:34–5 (c,1) Ap '90
—Oil exploration sites
Nat Geog 176:254–9 (c,1) Ag '89
—Prince William Sound area
Trav/Holiday 169:50–5 (map,c,1) Mr '88
—Prince William Sound oil spill (1989)
Nat Wildlife 27:4–9, 25–6 (c,1) Je '89
Trav&Leisure 19:48, 53 (map,c,4) Jl '89
Nat Geog 176:260–3 (c,2) Ag '89
Nat Geog 177:2–43 (map,c,1) Ja '90
—Round Island
Nat Wildlife 27:43 (c,1) Je '89
—Ruby
Nat Geog 177:46–7 (1) F '90

—Southeastern Alaska
Trav/Holiday 172:58–66 (map,c,1) Ag
'89
Trav/Holiday 175:62–7, 95 (map,c,1) Je
'91
—Tatshenshini River
Life 14:72–6 (map,c,1) My '91
—Tongass National Forest
Life 10:92–6 (map,c,1) N '87
Sports Illus 68:76–88 (c,1) Mr 14 '88
Natur Hist 97:40–63 (map,c,1) Ag '88
Nat Wildlife 28:8 (c,4) Je '90
—Wrangell area
Trav/Holiday 167:40–5, 75 (map,c,2) Je
'87
—See also
ALASKA PIPELINE
ALASKA RANGE
ANCHORAGE
BERING SEA
DENALI NATIONAL PARK
ESKIMOS
FAIRBANKS
GLACIER BAY NATIONAL PARK
GOLD RUSH
JUNEAU
KATMAI NATIONAL PARK
LAKE CLARK NATIONAL PARK
MOUNT McKINLEY
PRIBILOF ISLANDS
ST. ELIAS RANGE
SITKA
WRANGELL-ST. ELIAS NATIONAL
PARK
YUKON RIVER
ALASKA—MAPS
Natur Hist 96:55 (c,4) Ja '87
—Physical map of Anchorage area
Nat Geog 173:372–3 (c,1) Mr '88
ALASKA PIPELINE, ALASKA
Nat Wildlife 25:6–7 (c,1) Je '87
ALASKA RANGE, ALASKA
Nat Wildlife 28:4–5 (c,1) Je '90
ALBANIA—COSTUME
—Refugees (Italy)
Life 14:12 (c,2) My '91
ALBANY, NEW YORK
—Albany Pine Bush
Natur Hist 97:66–70 (c,1) My '88
ALBATROSSES
Nat Wildlife 25:48 (c,1) Ap '87
Nat Geog 173:143(c,2) Ja '88
Nat Geog 173:412–15, 418–19 (c,1) Mr
'88
Nat Geog 175:344–5, 354–5 (c,1) Mr '89
Natur Hist 98:cov., 26–33 (c,1) Jl '89
Natur Hist 99:62–9 (c,1) Ag '90
Natur Hist 99:6 (c,4) N '90
—Chicks

Nat Geog 173:414–15 (c,1) Mr '88
Nat Geog 175:355, 358 (c,3) Mr '89
—Eggs
Nat Geog 173:143, 151 (c,2) Ja '88
—Mollymawks
Nat Geog 176:525 (c,3) O '89
ALBERTA
—Icefields Parkway
Trav&Leisure 19:187–8 (map,c,4) Je '89
Trav&Leisure 21:260 (c,3) O '91
—Prairie highway
Nat Geog 174:336–7 (c,1) S '88
—See also
BANFF NATIONAL PARK
CALGARY
EDMONTON
JASPER NATIONAL PARK
LAKE LOUISE
ROCKY MOUNTAINS
WATERTON LAKES NATIONAL
PARK
ALBUQUERQUE, NEW MEXICO
—San Felipe de Neri Church
Trav&Leisure 17:E8 (c,4) F '87
ALCATRAZ, CALIFORNIA
Nat Wildlife 25:18–19 (c,1) Ag '87
Trav&Leisure 21:113 (c,4) Mr '91
ALCOHOLISM
—Alcohol abuse counseling (Iceland)
Nat Geog 171:207 (c,4) F '87
—Alcoholic's descent into poverty (1826)
Am Heritage 39:59 (drawing,4) S '88
—William Griffith Wilson
Life 13:66 (4) Fall '90
ALCOTT, LOUISA MAY
Am Heritage 39:108 (4) Ap '88
ALEXANDER III (RUSSIA)
Trav&Leisure 19:192 (painting,c,4) Ap
'89
ALEXANDRIA, VIRGINIA
—Map
Trav&Leisure 18:173 (c,4) O '88
ALGAE
Nat Geog 180:17 (c,1) Jl '91
—Covering glacier
Nat Geog 171:101 (c,2) Ja '87
ALGERIA—ART
—Ancient rock paintings
Nat Geog 172:180–91 (c,1) Ag '87
ALGERIA—COSTUME
—1905 girl wearing coins
Nat Geog 174:322 (4) S '88
ALHAMBRA, GRANADA, SPAIN
Nat Geog 174:100–3 (c,2) Jl '88
Trav&Leisure 19:81 (c,1) Ag '89
ALI, MUHAMMAD
Sports Illus 68:cov., 47–9 (1) Ap 25 '88
Life 11:33 (4) Jl '88
Smithsonian 20:70 (4) Ap '89

Natur Hist 99:44–5, 47 (engraving,1) D
'90
—16th cent. history of La Florida
Nat Geog 173:330–63 (map,c,1) Mr '88
—16th cent. Spanish enslavement of Indians
Smithsonian 22:41 (painting,c,2) D '91
—1505 depiction of New World inhabitants
(Germany)
Am Heritage 42:44 (woodcut,c,4) O '91
—1513 "discovery" of Pacific Ocean by
Balboa
Smithsonian 22:87 (painting,c,4) Ap '91
—1584 landing at Roanoke, Virginia
Am Heritage 38:49–51 (painting,c,1) F
'87
—1586 attack on St. Augustine by Francis
Drake
Nat Geog 173:358–9 (drawing,1) Mr '88
—1793 monument to cross-Canada trip
(British Columbia)
Nat Geog 172:218 (c,4) Ag '87
—Balboa with gifts from Indians
Natur Hist 100:22 (engraving,4) Ap '91
—Champion on Mount Desert Island,
Maine (1604)
Trav/Holiday 171:53 (painting,c,4) F '89
—Columbus Haitian colony site
Nat Geog 172:672–5 (c,1) N '87
—Columbus using lunar eclipse to get aid
from Indians
Natur Hist 96:26 (drawing,4) Ja '87
—Controversial theories of America's discovery
Smithsonian 22:77–85 (painting,c,2) S
'91
—Map of lands discovered by Columbus
Natur Hist 99:46–7 (drawing,2) D '90
Am Heritage 42:42 (4) O '91
Trav/Holiday 176:68–9 (c,1) O '91
—Ocean routes of the explorers
Smithsonian 19:50–1 (map,c,1) F '89
—Pre-Columbus civilizations in the Americas
Nat Geog 180:cov., 4–99 (map,c,1) O '91
—Retracing Coronado's 1540 Southwestern expedition
Smithsonian 20:40–53 (map,c,1) Ja '90
—San Salvador landing spot of Columbus
Trav/Holiday 176:71 (c,4)
O '91
—Scenes from early Virginia history
Am Heritage 38:49–57, 114 (painting,c,1) F '87
—Scenes of Columbus's life and travels
Am Heritage 42:41–55 (painting,c,2) O
'91
Trav/Holiday 176:64–71 (map,c,1) O '91
—Spanish conquistador

Smithsonian 17:98 (painting,c,4) Ja '87
—See also
BALBOA, VASCO NUÑEZ DE
COLUMBUS, CHRISTOPHER
LA SALLE, SIEUR DE
SMITH, JOHN
VESPUCCI, AMERIGO
AMERICAN MUSEUM OF NATURAL
HISTORY, NEW YORK CITY
Trav&Leisure 18:82–91, 128 (c,1) Jl '88
AMIENS, FRANCE
—Cathedral of Notre Dame
Nat Geog 176:108–13 (c,1) Jl '89
AMISH PEOPLE
—Amish farm (1961)
Natur Hist 99:94 (painting,c,2) Ap '90
—Pennsylvania
Gourmet 49:113–16 (c,1) N '89
Trav&Leisure 21:E1–E4 (c,3) Ag '91
AMISH PEOPLE—ART
—Early 20th cent. Amish quilts
Trav&Leisure 20:68, 70 (c,4) Jl '90
AMMAN, JORDAN
Smithsonian 18:109 (c,2) N '87
—Ancient Roman theater
Smithsonian 18:109 (c,2) N '87
AMMUNITION
—Bullet piercing apple
Nat Geog 172:464–5 (c,1) O '87
—Spent ammunition cartridges on street
(Beirut, Lebanon)
Life 10:6–7 (c,1) My '87
AMOS 'N ANDY
Smithsonian 17:76 (4) Mr '87
AMPHIBIANS
—Extinct ichthyostega
Natur Hist 100:22 (drawing,4) Ja '91
—Skeletons used for research
Nat Wildlife 26:4–5 (c,4) Ap
'88
—See also
FROGS
SALAMANDERS
TOADS
TORTOISES
TURTLES
AMSTERDAM, NETHERLANDS
Trav/Holiday 168:50–1 (c,2) Ag '87
Trav&Leisure 19:45, 48 (c,4) Mr '89
Gourmet 49:74–9 (c,1) Ap '89
—Canal map
Trav&Leisure 17:147 (c,4) Jl '87
—Concertgebouw
Trav&Leisure 18:38–9 (c,4) Ap '88
—Jewish Historical Museum
Trav&Leisure 18:39 (c,4) Ap '88
AMUNDSEN, ROALD
Nat Geog 173:43 (3) Ja '88
Smithsonian 21:171, 183 (2) O '90

SHOPPING
SLEEPING
SOAP BOX DERBIES
SPECTATORS
SPORTS
SUNBATHING
SWINGS
TATTOOING
TELEVISION WATCHING
THEATER
TOYS
TREE CLIMBING
ZOOS
Anaheim, California. See DISNEYLAND
ANATOMY
—Artificial body parts
 Life 12:56 (drawing,c,2) F '89
 Nat Geog 176:747, 753–6 (c,1) D '89
—Endocrine system diagram
 Smithsonian 20:62 (c,3) Je '89
—Lymphatic system diagram
 Smithsonian 20:63 (c,3) Je '89
—Medieval anatomical diagram
 Smithsonian 20:69 (c,4) F '90
—Nervous system diagram
 Smithsonian 20:63 (c,3) Je '89
—Man Ray painting of lips
 Smithsonian 19:66–7 (c,2) D '88
—Woman with freckles
 Smithsonian 19:159 (c,3) My '88
—See also
 ANTLERS
 BRAIN
 CELLS
 EARS
 EYES
 FEET
 HANDS
 HEARTS
 SKIN
 SKULLS
 TEETH
 TONGUES
ANCHORAGE, ALASKA
 Nat Geog 173:364–89 (map,c,1) Mr '88
 Trav/Holiday 170:13 (c,4) Jl '88
—1964 Anchorage earthquake
 Life 12:44 (4) F '89
ANCHORS
 Trav&Leisure 19:65 (drawing,c,4) O '89
—Anchor chain
 Smithsonian 22:41 (2) O '91
ANCIENT CIVILIZATIONS
—Ancient civilizations of Iraq
 Nat Geog 179:102–15 (map,c,1) My '91
—Ancient Kushite civilization (Sudan)
 Nat Geog 178:96–125 (map,c,1) N '90
—Ancient Moche civilization (Peru)
 Nat Geog 174:510–55 (c,1) O '88

—Ancient mound-building culture
 Natur Hist 98:74–83 (map,c,1) F '89
—Astronomy activities of ancient Americans
 Nat Geog 177:76–107 (c,1) Mr '90
—Pre-Columbian native Americans
 Nat Geog 180:cov., 4–99 (map,c,1) O '91
—See also
 ARCHAEOLOGICAL SITES
 ASSYRIAN CIVILIZATION
 DRUIDS
 EGYPT, ANCIENT
 ETRUSCAN CIVILIZATION
 GREECE, ANCIENT
 MAN, PREHISTORIC
 PERSIAN EMPIRE
 PHOENICIAN CIVILIZATION
 ROMAN EMPIRE
ANCIENT CIVILIZATIONS—ARCHITECTURE
—5th cent. B.C. Lycian tombs (Turkey)
 Trav/Holiday 174:41 (c,3) Ag '90
—Ancient temple ruins (Malta)
 Nat Geog 175:713 (c,3) Je '89
ANCIENT CIVILIZATIONS—RELICS
—Ancient Carthage
 Natur Hist 96:58–70 (c,1) D '87
—Bactria (Afghanistan)
 Nat Geog 177:50–75 (c,1) Mr '90
—Bronze Age diptych (book)
 Nat Geog 172:730–1 (c,3) D '87
—Bronze Age items found in shipwreck (Turkey)
 Nat Geog 172:cov., 692–733 (c,1) D '87
—Moche people (Peru)
 Nat Geog 177:2–33 (c,1) Je '90
—Prehistoric Clovis spearpoints (Washington)
 Nat Geog 174:501–3 (c,1) O '88
—Sumerian artifacts (Iraq)
 Smithsonian 19:130–41 (c,1) D '88
ANDERSEN, HANS CHRISTIAN
—Birthplace (Odense, Denmark)
 Gourmet 48:56 (c,4) Ag '88
—Items belonging to him
 Gourmet 48:54, 56 (c,4) Ag '88
—Sites related to his life (Denmark)
 Gourmet 48:52–7 (c,1) Ag '88
—Statue (Copenhagen, Denmark)
 Gourmet 48:52 (c,4) Ag '88
ANDERSON, CARL
 Smithsonian 18:104 (4) S '87
ANDERSON, MARIAN
 Life 14:32 (4) F '91
ANDES MOUNTAINS, ARGENTINA
 Natur Hist 100:62–3, 68–9 (c,1) Ap '91
ANDES MOUNTAINS, CHILE
 Nat Geog 174:56–7, 62–3 (c,1) Jl '88
 Nat Geog 179:103–5 (map,c,1) Ja '91

ANDES MOUNTAINS, PERU
Natur Hist 98:66–7 (c,1) F '89
—Quelccaya Ice Cap
Nat Geog 171:102 (c,3) Ja '87
ANDES MOUNTAINS, SOUTH AMER-
ICA
Nat Geog 171:422–59 (map,c,1) Ap '87
Nat Geog 179:76 (c,1) Ap '91
—Andes seen from space
Life 11:190–1 (c,1) N '88
ANEMONES
Life 13:63 (c,2) My '90
ANGEL FALLS, VENEZUELA
Trav/Holiday 170:53 (c,4) N '88
Nat Geog 175:528–9 (c,1) My '89
—Sky diving from Angel Falls
Smithsonian 21:64 (c,2) Ag '90
ANGELFISH
Life 10:46–7 (c,1) Je '87
Natur Hist 96:60–1 (c,1) Jl '87
Nat Geog 173:441 (c,2) Ap '88
Natur Hist 97:46, 48 (c,4) O '88
Smithsonian 21:102–3 (c,4) N '90
Life 14:102 (c,1) Summer '91
Nat Geog 180:139 (c,4) O '91
ANGELS
—Angel Moroni giving gift to Mormon
Smith
Life 14:38 (painting,c,4) Jl '91
—Carved wooden angel (Austria)
Gourmet 48:80 (c,4) D '88
—Carved wooden angel (Norway)
Trav&Leisure 17:92 (c,2) O '87
—Carved wooden angels (Mexico)
Smithsonian 22:126 (c,3) My '91
—Children dressed as angels (Mexico)
Trav&Leisure 21:100 (c,3) Ap '91
Smithsonian 22:127 (c,4) My '91
—Collection of angel figurines
Smithsonian 20:64 (c,2) Mr '90
ANGKOR, CAMBODIA
Natur Hist 99:52–9 (c,1) Ja '90
—Angkor Wat
Smithsonian 21:cov., 36–51 (c,1) My '90
Trav&Leisure 21:24 (drawing,c,4) Mr
'91
—Buddhist shrine
Smithsonian 17:79 (c,1) Ja '87
ANIMAL SACRIFICE
—Dogons killing sheep (Mali)
Nat Geog 178:116–17 (c,1) O '90
—Laotian Hmongs sacrificing cow (Minne-
sota)
Nat Geog 174:605 (c,4) O '88
—Maya jaguar sacrifice
Nat Geog 176:497 (painting,c,4) O '89
—Sacrifice of zebu cattle (Madagascar)
Nat Geog 171:178–9 (c,1) F '87
—Sacrificing chicken (Cameroon)

Nat Geog 172:419 (c,1) S '87
—South Africa
Life 13:25 (c,4) Ap '90
ANIMAL SKINS
—Alligator skins
Nat Geog 178:61 (c,4) O '90
—Drying caribou skin (Canada)
Nat Geog 172:210–11 (c,1) Ag '87
—Jaguar skin
Nat Geog 176:442 (c,4) O '89
—Lynx pelts in warehouse (Quebec)
Nat Geog 172:214 (c,1) Ag '87
—Polar bear skins
Nat Geog 172:215 (c,4) Ag '87
—Skinning zebra (Botswana)
Nat Geog 178:58–9 (c,1) D '90
—Snow leopards
Nat Geog 172:541 (c,4) O '87
ANIMAL TRACKS
—Animal tracks left in snow
Nat Wildlife 27:50–1 (painting,c,4) F '89
Nat Wildlife 28:40 (c,4) D '89
—California desert
Nat Geog 171:50 (c,1) Ja '87
—Cutting horse hoof marks
Sports Illus 74:2–3 (c,1) F 25 '91
—Raccoons
Life 13:65 (c,4) My '90
—Raven tracks
Nat Geog 180:27 (c,3) O '91
—3.5 million-year-old footprints (Laetoli,
Tanzania)
Natur Hist 99:60–3 (c,1) Mr '90
—Wolf prints
Smithsonian 18:107 (c,2) Mr '88
ANIMAL TRAINERS
—1920s carving
Am Heritage 38:45 (c,3) D '87
—Hippo tamer (India)
Life 14:54–5 (1) F '91
ANIMALS
—African wildlife (Botswana)
Nat Geog 178:cov., 2–63 (c,1) D '90
—African wildlife (Zambia)
Trav/Holiday 171:42–51 (c,1) Ap '89
—Alaska
Life 14:78–86 (c,1) Summer '91
—American animal sculptures
Am Heritage 41:6, 66–73 (c,1) My '90
—Animal immobilization rifle
Smithsonian 18:146 (c,4) My '87
—Animal products confiscated by customs
Trav/Holiday 171:52–4, 82 (c,2) Ap '89
—Animal specimens used in scientific study
Nat Wildlife 26:4–13 (c,1) Ap '88
—Animals harmed by plastic debris in
oceans
Smithsonian 18:58–67 (c,1) Mr '88
—Animals' eyes

MASTODONS
SABER-TOOTHED CATS
TRILOBITES
ANIMATION
—Computer animation
Nat Geog 175:728–33 (c,1) Je '89
—"Snow White" (1937)
Life 10:52–6 (c,1) Ap '87
ANNAPOLIS, MARYLAND
Nat Geog 174:162–89 (map,c,1) Ag '88
—Map
Trav&Leisure 18:189 (c,4) Mr '88
—William Paca's home
Nat Geog 178:103 (c,1) D '90
ANNAPURNA MOUNTAIN, NEPAL
Natur Hist 97:26–35 (c,1) Ja '88
Nat Geog 176:390–1 (c,1) S '89
ANNE (GREAT BRITAIN)
Smithsonian 20:156 (painting,c,4) D '89
ANTARCTIC EXPEDITIONS
Nat Geog 171:544–55 (c,1) Ap '87
Nat Geog 178:66–95 (map,c,1) N '90
—1838 discovery of Antarctica
Am Heritage 39:30 (painting,4) Jl '88
—1911 Scott expedition
Nat Geog 171:538–43 (c,1) Ap '87
—1934 Ellsworth expedition
Smithsonian 21:184–8 (c,4) O '90
—See also
AMUNDSEN, ROALD
ANTARCTICA
Nat Geog 171:538–59 (c,1) Ap '87
Trav&Leisure 17:97–105 (map,c,1) Ag '87
Natur Hist 98:28–37 (map,c,1) D '89
Nat Geog 177:2–51 (map,c,1) Ap '90
Nat Geog 178:66–95 (map,c,1) N '90
Nat Wildlife 29:4–11 (map,c,1) Ap '91
Trav&Leisure 21:150–1 (c,1) O '91
—Drake Passage
Nat Geog 175:128–38 (map,c,1) Ja '89
—Effect of ozone hole on Antarctic wildlife
Natur Hist 97:72–80 (c,1) O '88
—Seymour Island fossils
Nat Geog 177:27–9 (c,3) Ap '90
—South Georgia Island
Nat Geog 175:340–75 (map,c,1) Mr '89
—See also
ANTARCTIC EXPEDITIONS
SOUTH POLE
ANTARCTICA—MAPS
—History of ice cap
Nat Geog 171:97 (c,4) Ja '87
ANTEATERS
Nat Geog 176:459 (c,4) O '89
Natur Hist 100:92–3 (c,1) S '91
—See also
ECHIDNAS
ANTELOPES

—Fanciful "jackalopes"
Natur Hist 96:50–5 (c,1) Ag '87
—Impalas
Trav/Holiday 171:44 (c,4) Ap '89
Trav&Leisure 20:104–5, 113 (c,1) S '90
Nat Geog 178:2–4, 26–7, 32–3 (c,1) D '90
—Klipspringers
Nat Wildlife 25:44–5 (c,1) F '87
—Oryxes
Smithsonian 20:33 (c,4) Jl '89
Smithsonian 20:108–9 (c,3) F '90
—Red antelopes
Trav&Leisure 18:114–15 (c,1) My '88
—Sable antelope
Nat Geog 178:62 (c,1) D '90
—See also
ADDAXES
ELANDS
GAZELLES
ROCKY MOUNTAIN GOATS
ANTENNAS
—Goldstone's Mars space antenna, California
Smithsonian 19:cov., 52–3 (c,1) S '88
—Radio antenna (Australia)
Nat Geog 173:628 (c,1) My '88
—Tracking radio-collared mountain lions
Trav&Leisure 21:126–7, 164 (c,1) D '91
ANTHONY, SUSAN B.
Am Heritage 41:40 (4) F '90
—Susan B. Anthony dollar coin (1979)
Sports Illus 71:156 (c,4) N 15 '89
ANTIGUA. See
LEEWARD ISLANDS
ANTIGUA, GUATEMALA
—Convent of Santa Clara
Trav/Holiday 170:64 (c,3) O '88
ANTIQUES
—Antiques fairs (London, England)
Gourmet 49:66–9 (c,1) Je '89
—12-year-old antique collector (Wales)
Life 14:70–4 (c,1) Je '91
ANTLERS
—Caribou
Nat Wildlife 25:2 (c,2) O '87
Nat Geog 174:854–5 (c,1) D '88
Nat Wildlife 27:cov. (c,1) O '89
—Deer
Natur Hist 100:cov., 36–7 (c,1) O '91
—Elk
Smithsonian 20:48 (c,4) S '89
—Moose
Nat Geog 172:266–71, 276 (c,1) Ag '87
Nat Wildlife 28:52 (c,1) Je '90
—Park arch made of elk antlers (Jackson, Wyoming)
Trav&Leisure 19:144–5 (c,1) Mr '89
—Shed elk antlers
Natur Hist 98:40–1 (c,1) Ag '89

—Shown on rabbitlike "jackalopes"
Natur Hist 96:50–5 (c,1) Ag '87
ANTS
Natur Hist 96:62–70 (c,1) Ja '87
Nat Wildlife 25:33 (c,4) O '87
Nat Geog 175:794–5 (c,1) Je '89
Nat Geog 176:416–17 (c,1) S '89
Natur Hist 99:10, 14 (c,3) F '90
Nat Geog 180:60–1 (c,1) S '91
Natur Hist 100:80–1 (c,1) D '91
—Ant farm
Smithsonian 20:83 (c,2) D '89
—Carpenter ants
Nat Wildlife 26:11 (c,4) F '88
Smithsonian 19:118 (sculpture,c,3) D '88
—Honey ants
Natur Hist 100:88–9 (c,1) My '91
—Leaf-cutter ants
Sports Illus 72:95 (c,4) Ap 9 '90
—Pupae
Nat Wildlife 26:11 (c,4) F '88
—Trap-jaw ants
Nat Geog 175:394–400 (c,1) Mr '89
ANTS—HUMOR
—Invasion of the fire ants
Smithsonian 21:cov., 48–57 (paint-
ing,c,1) Jl '90
ANTWERP, BELGIUM
—1906
Smithsonian 21:74 (painting,c,2) O '90
APACHE INDIANS—COSTUME
Life 14:44 (c,3) O '91
—Late 19th cent.
Nat Geog 180:2–3 (1) O '91
APACHE INDIANS—RELICS
—Apache Indians fiddle and bow
Smithsonian 20:52 (c,4) O '89
APACHE INDIANS—RITES AND
FESTIVALS
—Girl's coming of age ceremony
Life 14:44 (c,3) O '91
APALACHICOLA RIVER, FLORIDA
—1948 (Blountstown)
Natur Hist 99:8 (2) D '90
APARTMENT BUILDINGS
—Aerial view of hurricane damage (Char-
leston, S.C.)
Life 13:20 20(c,1) Ja '90
—"Cage apartments" (Hong Kong)
Nat Geog 179:111 (c,4) F '91
—Caracas, Venezuela
Gourmet 50:66 (c,4) F '90
—Hong Kong
Smithsonian 20:42–3 (c,1) Ap '89
—Nice, France
Nat Geog 176:69 (c,3) Jl '89
—Poprad, Czechoslovakia
Nat Geog 171:128–9 (c,1) Ja '87
—Siberia, U.S.S.R.

Nat Geog 177:6–7, 32–3 (c,1) Mr '90
APARTMENT BUILDINGS—CON-
STRUCTION
—Hanoi, Vietnam
Smithsonian 18:68–9 (c,2) Ap '87
APES
—Bush babies
Smithsonian 17:34 (c,4) F '87
Natur Hist 97:79 (c,4) Ap '88
—See also
BABOONS
CHIMPANZEES
GIBBONS
GORILLAS
ORANGUTANS
APHIDS
Nat Geog 176:407–22 (c,1) S '89
APHRODITE
—Ancient sculptures (Turkey)
Smithsonian 19:143, 152 (c,4) Mr '89
APPALACHIAN TRAIL, EASTERN
U.S.
Nat Geog 171:216–43 (map,c,1) F '87
APPLE TREES
Natur Hist 96:24 (c,3) D '87
Gourmet 49:89 (c,1) S '89
APPLES
Gourmet 47:83 (c,4) N '87
—Bullet piercing apple
Nat Geog 172:464–5 (c,1) O '87
—Golden russet variety
Natur Hist 97:104 (painting,c,4) Ap '88
—Gravenstein apples
Gourmet 49:87 (c,4) S '89
—Unusual varieties
Natur Hist 97:86, 88 (painting,c,4) Mr
'88
—Winter banana variety
Natur Hist 97:4 (c,4) Jl '88
Appliances. See
AIR CONDITIONING
FANS
ICEBOXES
LAUNDRY
SEWING MACHINES
STOVES
TOASTERS
VACUUM CLEANERS
APRICOT TREES
Natur Hist 97:76 (c,4) Ja '88
AQUARIUMS
—Monterey Bay Aquarium, California
Nat Geog 177:24–7 (c,1) F '90
AQUEDUCTS
—Ancient Roman (Caesarea)
Nat Geog 171:276 (c,1) F '87
—Arizona
Nat Geog 179:8–9 (c,1) Je '91
—California Aqueduct

Nat Geog 179:56 (c,3) F '91
—Croton Aqueduct, Yonkers, New York
Natur Hist 100:79 (drawing,4) My '91
ARAB COUNTRIES—COSTUME
Life 13:38–46 (c,1) O '90
Nat Geog 180:cov., 2–31, 44–9 (c,1) D
'91
—Men's dishdasha (Oman)
Trav/Holiday 171:79 (c,4) Mr '89
—Persian Gulf nations
Nat Geog 173:654–71 (c,1) My '88
—Women in black (Iraq)
Nat Geog 179:115 (c,2) My '91
Arabian Sea. See
PERSIAN GULF
Arachnids. See
MITES
SCORPIONS
SPIDERS
TARANTULAS
TICKS
ARAL SEA, U.S.S.R.
Nat Geog 177:70–93 (map,c,1) F '90
ARC DE TRIOMPHE, PARIS, FRANCE
Smithsonian 18:85 (2) Ap '87
Nat Geog 176:6–8, 165 (c,1) Jl '89
Life 13:96 (c,2) Ag '90
ARCHAEOLOGICAL SITES
—15th cent. Eskimo site (Barrow, Alaska)
Nat Geog 171:824–36 (c,1) Je '87
—16th cent. St. Catherine's Island, Georgia
Nat Geog 173:350–3 (c,2) Mr '88
—16th cent. Santa Elena site, Florida
Nat Geog 173:340–1 (c,2) Mr '88
—18th cent. Patowmack Canal, Virginia
Nat Geog 171:745–7 (c,2) Je '87
—1911 discovery of Inca's Machu Picchu
ruins, Peru
Am Heritage 38:54–63 (map,c,1) Jl '87
—1922 Andrews Mongolia expedition
Smithsonian 18:94–105 (1) D '87
—America's Stonehenge, New Hampshire
Trav/Holiday 168:28 (c,4) Jl '87
—Anasazi Indian ruins (Chaco, New Mexico)
Natur Hist 96:74–6 (2) Mr '87
Life 14:40–1 (c,1) Summer '91
—Anasazi Indian ruins (Colorado)
Trav&Leisure 21:140–8 (map,c,1) D '91
—Anatolia, Turkey
Smithsonian 21:30–41 (c,1) Ag '90
—Aphrodisias, Turkey
Smithsonian 19:142–55 (c,1) Mr '89
—Bactria, Afghanistan
Nat Geog 177:58–9 (3) Mr '90
—Caesarea, Israel
Nat Geog 171:260–78 (map,c,1) F '87
—Cemetery for 1349 plague victims (London, England)

Life 11:100–1 (c,1) Mr '88
—Columbus Haitian colony site
Nat Geog 172:672–5 (c,1) N '87
—Copán, Honduras
Nat Geog 176:480–505 (map,c,1) O '89
Nat Geog 180:95–105 (c,1) S
'91
—Ephesus, Turkey
Trav&Leisure 17:102–9 (c,1) Mr '87
—Giza, Egypt
Nat Geog 173:512–50 (c,1) Ap '88
—Kebara Cave, Israel
Smithsonian 22:114–26 (c,2) D '91
—Klasies River Mouth, South Africa
Nat Geog 174:460–1 (c,2) O '88
—Kourion, Cyprus
Nat Geog 174:30–53 (c,1) Jl '88
—Lambayeque Valley, Peru
Nat Geog 174:510–55 (map,c,1) O '88
—Louvre, Paris, France
Nat Geog 176:102–7 (c,1) Jl '89
—Mammoth site (South Dakota)
Trav/Holiday 169:80–1 (c,4) F '88
—Maya sites (Belize)
Nat Geog 176:424–505 (map,c,1) O '89
Smithsonian 20:98–113 (c,1) D '89
—Maya sites (Calakmul, Mexico)
Nat Geog 176:428–9, 460 (c,1) O '89
—El Mirador Maya city, Nabke, Guatemala
Nat Geog 172:316–39 (map,c,1) S '87
Natur Hist 100:8–14 (map,c,2) My '91
—Montalto di Catro, Italy
Nat Geog 173:714–15 (c,1) Je '88
—Nippur, Iraq
Nat Geog 179:106–7 (2) My '91
—Pedra Furada, Brazil
Natur Hist 96:8–12 (map,c,4) Ag '87
—Piazza della Signoria, Florence, Italy
Trav&Leisure 19:49 (c,3) Je '89
—Tarquinia, Italy
Nat Geog 173:708–9 (c,3) Je '88
—Thebes, Egypt
Nat Geog 179:6–7, 20–9 (c,1) Ap '91
—Titusville, Florida
Nat Geog 171:406–7 (c,3) Mr '87
—Wood Quey, Dublin, Ireland
Natur Hist 97:92–7 (3) N '88
—Worldwide sites of early man
Nat Geog 174:436–75 (map,c,1) O '88
ARCHAEOLOGISTS
—Giovanni Belzoni
Smithsonian 19:80, 82 (painting,c,4) Je
'88
—Junius Bird
Natur Hist 98:84, 86 (3) F '89
—Carl Humann
Smithsonian 22:79 (drawing,4) O '91
—Henry Mercer

Smithsonian 19:111, 116 (4) O '88
ARCHAEOLOGY
—Air lock technology in archaeological
 digging (Egypt)
 Nat Geog 173:513–33 (c,1) Ap '88
—Digging Indian ruins (Colorado)
 Trav&Leisure 21:cov., 140–7 (c,1) D '91
—Digging for mammoth bones (Colorado)
 Natur Hist 96:10 (3) S '87
—Garbage archaeology (California)
 Natur Hist 99:55 (c,1) My '90
ARCHERY
 Sports Illus 66:40 (c,4) Je 8 '87
 Sports Illus 69:58, 187 (c,2) S 14 '88
 Life 11:10 (c,4) O '88
 Sports Illus 71:24 (c,4) Ag 7 '89
—16th cent. equipment (Turkey)
 Nat Geog 172:587 (c,4) N '87
—Bhutan
 Nat Geog 179:94 (c,3) My '91
—Efe tribe (Zaire)
 Nat Geog 176:671–2 (c,2) N '89
—Hunting with bow and arrows (Suri-
 name)
 Smithsonian 19:96 (c,4) F '89
—Indonesia
 Life 14:32–3 (1) O '91
—Pan American Games 1987 (Indiana)
 Sports Illus 67:2–3, 19 (c,1) Ag 24 '87
ARCHES NATIONAL PARK, UTAH
 Life 14:100–1 (c,1) Summer '91
 Trav&Leisure 21:69 (c,3) Ag '91
ARCHITECTS
—Cass Gilbert
 Nat Geog 175:168 (sculpture,c,4) F '89
—Louis Le Veau (17th cent. France)
 Trav&Leisure 18:30 (painting, 4) My '88
—See also
 BULFINCH, CHARLES
 EIFFEL, GUSTAVE
 GAUDI, ANTONIO
 GROPIUS, WALTER
 L'ENFANT, PIERRE CHARLES
 WHITE, STANFORD
 WRIGHT, FRANK LLOYD
ARCHITECTURAL FEATURES
—Cupola atop 1900 resort (North Carolina)
 Trav/Holiday 172:54 (c,3) N '89
—See also
 BATHROOMS
 BEDROOMS
 CHIMNEYS
 DENS
 DINING ROOMS
 DOORS
 ESCALATORS
 FENCES
 FIREPLACES
 FOUNTAINS

GATES
KITCHENS
LIBRARIES
OUTHOUSES
PARLORS
PORCHES
STAIRCASES
STREET LIGHTS
SWINGS
WALLS
WINDOWS
Architectural Structures. See
 AIRPORTS
 APARTMENT BUILDINGS
 AQUARIUMS
 AQUEDUCTS
 BANKS
 BARBERSHOPS
 BARNS
 BOATHOUSES
 BRIDGES
 BUILDINGS
 CAPITOL BUILDINGS
 CASTLES
 CHATEAUS
 CHURCHES
 CITADELS
 CITY HALLS
 COURTHOUSES
 DAMS
 DOG HOUSES
 DOLL HOUSES
 FACTORIES
 FARMHOUSES
 FIREHOUSES
 FORTRESSES
 FORTS
 GAMBLING CASINOS
 GASOLINE STATIONS
 GAZEBOS
 GOVERNMENT BUILDINGS
 GREAT WALL OF CHINA
 HOSPITALS
 HOTELS
 HOUSES
 HOUSING
 LABORATORIES
 LABYRINTHS
 LIBRARIES
 LIGHTHOUSES
 MILLS
 MONASTERIES
 MOSQUES
 MUSEUMS
 OBSERVATORIES
 OFFICE BUILDINGS
 OUTHOUSES
 PAGODAS
 PALACES

Nat Geog 176:282–4 (c,1) Ag '89
ARCHITECTURE, FRENCH—12TH
 CENT.
—Gothic cathedrals
 Nat Geog 176:108–19 (c,1) Jl '89
ARCHITECTURE, FRENCH—17TH
 CENT.
—Domed structures
 Gourmet 49:52–9, 132 (c,1) Jl
 '89
ARCHITECTURE, FRENCH—20TH
 CENT.
—Modern buildings
 Nat Geog 176:64–5 (c,1) Jl '89
—See-through building (Paris, France)
 Life 12:8 (c,4) Ag '89
ARCHITECTURE, GREEK
—Greek column styles
 Am Heritage 40:113 (drawing, 4) F '89
ARCHITECTURE, JAPANESE
—Design elements
 Smithsonian 21:77 (c,3) Ja '91
—Small Japanese inn
 Trav&Leisure 19:65 (painting,c,4) Ag
 '89
ARCHITECTURE, SPANISH
—Art nouveau buildings (Barcelona,
 Spain)
 Trav/Holiday 169:54–7 (c,1) Je '88
ARCTIC
 Natur Hist 96:cov., 30–9, 50–9 (c,1) Ap
 '87
 Trav&Leisure 18:138–43, 190 (map,c,1)
 O '88
 Nat Geog 178:2–33 (map,c,1) Ag '90
 Nat Wildlife 29:8–9 (map,c,1) Ap '91
 Nat Geog 180:2–31 (map,c,1) Jl '91
—Axel Heiberg Island, Northwest Territo-
 ries
 Natur Hist 100:58–61 (map,c,1) Ja '91
—Effects of permafrost
 Natur Hist 96:30–9 (c,1) Ap '87
—See also
 ELLESMERE ISLAND
 NORTH POLE
 NORTHWEST TERRITORIES
ARCTIC EXPEDITIONS
 Nat Geog 179:124–34 (c,1) Mr '91
—1870s Fort Conger, Ellesmere Island,
 Canada
 Nat Geog 173:764–5 (c,2) Je '88
—1890s Peary expeditions
 Nat Geog 174:394–403 (1) S '88
—1909 Peary expedition to North Pole
 Nat Geog 174:386–413 (1) S '88
—1925 Amundsen-Ellsworth expedition
 Smithsonian 21:171–83 (map,2) O '90
—See also
 HENSON, MATTHEW

NORTH POLE
PEARY, ROBERT E.
ARGENTINA
 Trav/Holiday 167:50–5 (map,c,1) Mr '87
—Patagonia
 Trav&Leisure 21:116–29, 172–8
 (map,c,1) N '91
—See also
 ACONCAGUA
 BUENOS AIRES
 IGUAÇU FALLS
 TIERRA DEL FUEGO
ARGENTINA—COSTUME
 Life 11:78–82 (c,1) Ag '88
—Artist
 Trav/Holiday 167:50 (c,1) Mr '87
—Buenos Aires
 Trav&Leisure 18:132–9, 174–8 (c,1) D
 '88
—Gauchos
 Trav&Leisure 21:116–17, 124–5 (c,1) N
 '91
—Patagonia
 Trav&Leisure 21:116–29 (c,1) N '91
—Tango dancers
 Trav&Leisure 18:132–3 (c,1) D '88
ARGENTINA—POLITICS AND GOV-
 ERNMENT
—Children of junta victims
 Life 11:78–82 (c,1) Ag '88
ARIZONA
—Cathedral Rock
 Trav&Leisure 20:116–17 (c,1) Ja '90
—Desert Vista
 Natur Hist 100:72–5 (map,c,1) F '91
—Glen Canyon Dam area
 Nat Geog 179:20–3 (c,1) Je '91
—Hopi reservation
 Trav/Holiday 170:42–3 (map,c,3) Ag '88
—Kartchner Caverns
 Nat Geog 174:826–7 (c,1) D '88
—Lake Powell
 Trav/Holiday 171:16 (c,4) Mr '89
—Mazatzal Mountains
 Trav&Leisure 20:134–5 (c,1) Ja '90
—Meteor Crater
 Smithsonian 20:93 (c,1) S '89
—Monument Valley
 Natur Hist 99:46–7 (c,1) Je '90
 Nat Geog 180:27–9 (c,1) O '91
—Mt. Graham
 Natur Hist 96:88–90 (map,c,1) Mr '87
 Smithsonian 19:30 (c,4) Je '88
—Paria Canyon
 Life 11:125–7 (c,1) N '88
 Nat Wildlife 27:54–5 (c,1) O '89
—Retracing Coronado's 1540 Southwest-
 ern expedition
 Smithsonian 20:40–53 (map,c,1) Ja '90

—Small arms (Turkey)
Nat Geog 172:585 (c,4) N '87
—Stone Age jade war club (New Zealand)
Nat Geog 172:303 (c,4) S '87
—U.S.-U.S.S.R. arms reduction cartoon
Life 11:128 (4) Ja '88
—World War II artillery emplacement
(Tarawa)
Trav/Holiday 172:70–1 (c,3) S '89
—See also
AMMUNITION
ARCHERY
ARMOR
ATOMIC BOMBS
AXES
BLOWGUNS
BOMBS
CANNONS
CATAPULTS
DAGGERS
DUELS
EXPLOSIONS
GUNS
HUNTING EQUIPMENT
MILITARY COSTUME
MINES, EXPLODING
MISSILES
RIFLES
SLINGSHOTS
SPEARS
SUBMARINES
SWORDS
TANKS, ARMORED
TOOLS
TORPEDOES
ARMSTRONG, LOUIS
Trav&Leisure 19:110 (4) F '89
Life 13:11 (1) Fall '90
Smithsonian 21:73 (4) F '91
Army. See
U.S. ARMY
ARNO, PETER
—Cartoon about Dale Carnegie (1937)
Smithsonian 18:93 (4) O '87
ARNOLD, BENEDICT
Am Heritage 41:60–2 (painting,c,1) S '90
ART EDUCATION
—Drawing class (Bhutan)
Nat Geog 179:89 (c,4) My '91
—Drawing class (Pennsylvania)
Nat Geog 178:110–11 (c,1) D '90
—Student sketching nude model (Illinois)
Smithsonian 19:33 (c,4) Ag '88
Art Forms. See
ANIMATION
CARTOONS
CAVE PAINTINGS
COMIC STRIPS
DESIGN, DECORATIVE

DRAWING
FIGUREHEADS
FRESCOES
GRAFFITI
MOBILES
MOSAICS
MURALS
NEEDLEWORK
PAINTINGS
PHOTOGRAPHY
POSTERS
POTTERY
RESTORATION OF ART WORKS
ROCK CARVINGS
ROCK PAINTINGS
SCULPTURE
SILHOUETTES
SNOW SCULPTURES
STAINED GLASS
TAPESTRIES
TATTOOS
TOTEM POLES
WOOD CARVINGS
Art Galleries. See
MUSEUMS
ART WORKS
—14th–15th cent. Persian art works
Smithsonian 20:180 (c,4) Ap '89
—20th cent. Pop art
Smithsonian 21:cov., 139–49 (c,2) N '90
—Early 20th cent. art works
Smithsonian 18:84–97 (c,1) N '87
—1910 Rookwood tile
Am Heritage 41:35 (c,2) N '90
—1937 Nazi exhibit of "degenerate" mod-
ern art
Smithsonian 22:86–95 (c,1) Jl '91
—Africa
Smithsonian 18:cov., 56–63 (c,1) S '87
—American folk art
Am Heritage 41:77–83 (painting,c,1) Jl
'90
Smithsonian 21:215–16 (c,4) O '90
—Ancient Navajo sand painting (New
Mexico)
Nat Geog 172:605 (c,4) N '87
—Art depicting animals' environmental
problems
Nat Wildlife 29:31–6 (c,3) Je '91
—Art glass (Sweden)
Trav/Holiday 169:44 (c,4) My '88
—Art works by modern women artists
Life 12:64–8 (c,1) Je '89
—Art works created by elephants
Nat Wildlife 25:27–8 (painting,c,1) F '87
—Beaded art works
Smithsonian 21:140 (c,4) Ag '90
—Computer-generated art works
Smithsonian 18:138–42 (c,2) Mr '88

Nat Geog 175:746–51 (c,1) Je '89
Life 12:10 (c,4) Je '89
—Fabergé eggs
Life 12:2 (c,4) Ap '89
Trav&Leisure 19:66–7 (c,3) O '89
Nat Geog 177:82 (c,4) Ja '90
—Famous lost and stolen art works
Smithsonian 18:239–58 (c,2) N '87
—Land sculptures on midwestern farm-
lands
Nat Wildlife 27:30–3 (c,1) Je '89
—Modern works (U.S.S.R.)
Smithsonian 20:130–43 (c,1) '89
—Ornithological art works
Natur Hist 97:32–9 (c,1) Mr '88
—Outdoor wall papered with family photos
(California)
Life 12:7 (c,3) Ag '89
—Sidewalk chalk drawing (Salzburg, Aus-
tria)
Trav&Leisure 17:96 (c,2) Je '87
—Unusual works depicting 20th cent. pres-
idents
Smithsonian 21:cov., 82–9 (c,1) D '90
—Works by David Hockney
Smithsonian 18:63–75 (c,1) F '88
Life 11:53–7 (c,1) F '88
—Works by Jasper Johns
Smithsonian 21:56–68 (c,1) Je '90
—Works by Robert Rauschenberg
Smithsonian 22:54–67 (c,1) My '91
—Works by William Wegman
Smithsonian 22:46–52 (c,3) S '91
—See also
ADAMS, ANSEL
ARNO, PETER
ATGET, EUGENE
AUDUBON, JOHN JAMES
BEERBOHM, SIR MAX
BELLINI, GENTILE
BELLOWS, GEORGE WESLEY
BENTON, THOMAS HART
BERNINI, GIOVANNI LORENZO
BIERSTADT, ALBERT
BINGHAM, GEORGE CALEB
BLAKELOCK, RALPH
BOSCH, HIERONYMUS
BOTTICELLI, SANDRO
BRADY, MATHEW
BRAQUES, GEORGES
BREUGHEL, PIETER THE ELDER
CALDER, ALEXANDER
CARPEAUX, JEAN-BAPTISTE
CARTIER-BRESSON, HENRI
CASSATT, MARY
CATLIN, GEORGE
CEZANNE, PAUL
CHAGALL, MARC
COLE, THOMAS
COURBET, GUSTAVE
CRANACH, LUCAS
CURRIER & IVES
CURRY, JOHN STEUART
DAUMIER, HONORE
DAVID, JACQUES LOUIS
DAVIS, STUART
DEGAS, EDGAR
DE KOONIG, WILLEM
DELACROIX, FERDINAND
DEMUTH, CHARLES
DORE, GUSTAVE
DU BOIS, GUY PENE
DUCHAMP, MARCEL
DUFY, RAOUL
DURER, ALBRECHT
EAKINS, THOMAS
EISENSTADT, ALFRED
EVANS, WALKER
FABERGE, CARL
FEININGER, LYONEL
FRA ANGELICO
FRENCH, DANIEL CHESTER
GAUDI, ANTONIO
GAUGUIN, PAUL
GHIBERTI, LORENZO
GHIRLANDAIO, DOMENICO
GIACOMETTI, ALBERTO
GIORGIONE
GIOTTO
GLACKENS, WILLIAM JAMES
GOYA, FRANCISCO
GRUNEWALK, MATTHIAS
HENRI, ROBERT
HIRSCHFELD, AL
HOGARTH, WILLIAM
HOLBEIN, HANS THE YOUNGER
HOMER, WINSLOW
HOPPER, EDWARD
HOUDON, JEAN ANTOINE
INGRES, JEAN-DOMINIQUE
INNESS, GEORGE
JAMES, WILL
KAHLO, FRIDA
KANDINSKY, VASILY
KLEE, PAUL
KOKOSCHKA, OSKAR
LAFARGE, JOHN
LEAR, EDWARD
LEONARDO DA VINCI
MANET, EDOUARD
MANSHIP, PAUL
MARIN, JOHN
MASACCIO
MATISSE, HENRI
MEMLING, HANS
MICHELANGELO
MIRO, JOAN
MODIGLIANI, AMADEO

—Sculptor's studio (Massachusetts)
Gourmet 49:78–9 (c,1) Je '89
—Sketching nudes (early 20th cent.)
Am Heritage 40:108 (lithograph,4) S '89
—Street artists doing portraits (Moscow,
U.S.S.R.)
Nat Geog 179:19 (c,3) F '91
—Studio (Sweden)
Gourmet 47:59 (c,4) Jl '87
—Henry Tanner
Am Heritage 42:77–83 (4) F '91
—Irving Ramsey Wiles
Am Heritage 39:86 (4) S '88
—Joseph Wright self-portrait
Smithsonian 21:52 (painting,c,4) S '90
—N. C. Wyeth
Nat Geog 180:80 (painting,c,1) Jl '91
—See also
AUDUBON, JOHN JAMES
BENTON, THOMAS HART
BIERSTADT, ALBERT
BLAKELOCK, RALPH
BOSCH, HIERONYMUS
BRAQUES, GEORGES
CARTIER-BRESSON,HENRI
CARTOONISTS
DALI, SALVADOR
DAVIS, STUART
DEGAS, EDGAR
DEMUTH, CHARLES
DU BOIS, PENE
FRENCH, DANIEL CHESTER
GAUGUIN, PAUL
GIACOMETTI, ALBERTO
GOYA, FRANCISCO
JAMES, WILL
KAHLO, FRIDA
KLEE, PAUL
LA FARGE, JOHN
MARIN, JOHN
MATISSE, HENRI
MICHELANGELO
MOORE, HENRY
MORSE, SAMUEL F. B.
O'KEEFFE, GEORGIA
PAINTING
POLLOCK, JACKSON
REMBRANDT
REMINGTON, FREDERIC
RIVERA, DIEGO
RYDER, ALBERT PINKHAM
SCULPTING
SEURAT, GEORGES
SHEELER, CHARLES
SLOAN, JOHN
STIEGLITZ, ALFRED
TITIAN
TRUMBULL, JOHN
TURNER, J. M. W.

WARHOL, ANDY
WEST, BENJAMIN
WRIGHT, FRANK LLOYD
WYETH, ANDREW
ARTS AND CRAFTS
—1787 artifacts of American life
Life 10:28–34 (c,4) Fall '87
—1801 illustrated psalm (Pennsylvania)
Am Heritage 40:29 (c,2) F '89
—Early 20th cent. handicrafts
Am Heritage 38:83–9, 114 (c,3) Jl '87
—American Craft Museum exhibits, New
York City
Trav&Leisure 17:60, 62 (c,4) Ag '87
—American Indian crafts
Smithsonian 18:236 (c,4) O '87
Trav/Holiday 171:20–8 (c,4) Mr '89
—Batik (Jamaica)
Trav/Holiday 167:49–50 (c,4) Ja '87
—Beaded art works
Smithsonian 21:140 (c,4) Ag '90
—Carving ivory (Hong Kong)
Nat Geog 179:33 (c,3) My '91
—Florence craftsmen, Italy
Gourmet 47:51–5 (c,1) Jl '87
—Hong Kong
Gourmet 48:63–7 (c,4) Mr '88
—Insects made from grass (Hong Kong)
Trav/Holiday 167:34–5 (c,3) Mr '87
—Jade carving (China)
Nat Geog 172:287, 292–3 (c,1) S '87
—Jamaica
Trav/Holiday 167:48–51 (c,3) Ja '87
—Massachusetts
Trav/Holiday 167:44–7 (c,2) Ja '87
—Otomí Indians pounding bark into paper
(Mexico)
Natur Hist 100:8 (c,4) Je '91
—Rural Kentucky
Natur Hist 96:50–7 (c,1) Jl '87
—Shaker oval boxes with swallowtail joints
Nat Geog 176:308 (c,1) S '89
—Swedish folk art motifs
Gourmet 47:118 (4) Jl '87
—Woodblock prints (Japan)
Trav&Leisure 17:54, 57–8 (c,4) Ag '87
—See also
BARREL MAKING
BASKET WEAVING
BLACKSMITHS
CARPENTRY
DESIGN, DECORATIVE
GLASSBLOWING
LACE MAKING
METALWORKING
NEEDLEWORK
PAINTING
POTTERY MAKING
QUILTING

RUG MAKING
SCULPTING
SEWING
SILHOUETTES
SPINNING WHEELS
TATTOOING
WEAVING
WOOD CARVING
WOOD WORKING
YARN SPINNING
ARUBA
—Lighthouse
Smithsonian 20:32 (c,4) My '89
—Natural Bridge
Trav/Holiday 168:22 (c,4) D '87
ARUM PLANTS
Natur Hist 97:77 (painting,c,4) S '88
ASBESTOS
—Removing asbestos from office
Nat Geog 171:532 (c,1) Ap '87
—Worker handling asbestos (Germany)
Nat Geog 179:49 (c,4) Je '91
ASCH, SHOLEM
Smithsonian 18:112 (4) Ag '87
ASHEVILLE, NORTH CAROLINA
—Biltmore estate
Trav/Holiday 175:54–61 (c,1) Ap '91
ASIA. See also
BRAHMAPUTRA RIVER
HIMALAYA MOUNTAINS
individual countries
ASIA—MAPS
—Eastern Asia
Trav/Holiday 167:62 (c,4) F '87
ASIAN TRIBES
—1890s Jesup expedition to study Siberian
peoples
Natur Hist 97:60–8 (map,c,4) Mr '88
—Gurung people (Nepal)
Nat Geog 174:cov., 660–71 (c,1) N '88
—Hmong people (Laos)
Nat Geog 171:782, 786–7 (c,1) Je '87
—Laotian Hmong people (U.S.)
Nat Geog 174:586–610 (c,1) O '88
—Sherpa people (Nepal)
Natur Hist 100:40–5 (c,1) F '91
—Uighur camel herder (China)
Life 11:72–3 (c,1) S '88
—Yukaghir people (U.S.S.R.)
Natur Hist 97:68 (4) Mr '88
ASIAN TRIBES—RELICS
—19th cent. Yukagir pictographic love let-
ter (Siberia)
Trav&Leisure 18:128 (c,4) Jl '88
—Chukchi charm string (Siberia)
Smithsonian 19:50 (c,3) O '88
—Koryak people artifacts (Siberia)
Smithsonian 19:45–51 (c,1) O '88
ASIMOV, ISAAC

Trav&Leisure 18:54 (c,4) F '88
ASPARAGUS
Gourmet 48:60–1 (c,1) Ap '88
ASPEN, COLORADO
Trav&Leisure 19:164–73 (c,1) N '89
Life 12:70–2, 77, 80 (c,1) D '89
ASPEN TREES
Trav&Leisure 19:118 (c,4) Mr '89
Trav/Holiday 172:43 (c,1) O '89
Natur Hist 98:14–15 (c,1) D '89
Life 13:47 (c,4) My '90
Trav/Holiday 175:76–7 (c,1) Je '91
—Snow on aspen tree branches
Nat Wildlife 27:58–9 (c,1) D '88
ASSAM, INDIA
Nat Geog 174:698–705 (c,1) N '88
ASSURBANIPAL
—Depicted on frieze
Nat Geog 179:112–13 (c,1) My '91
Assyrian Civilization. See also
ASSURBANIPAL
ASSYRIAN CIVILIZATION—RELICS
—Jewelry
Life 12:6 (c,4) N '89
Nat Geog 179:108–9 (c,2) My '91
ASTAIRE, FRED
Life 11:119 (2) Ja '88
ASTEROIDS
—Depictions of asteroids hitting Earth
Natur Hist 100:46, 53 (painting,c,1) Je '91
—Lakes formed by asteroids (Quebec)
Smithsonian 20:84 (c,4) S '89
Natur Hist 100:50–1 (c,1) Je '91
ASTERS
Nat Wildlife 25:27 (drawing,c,4) Ap '87
Natur Hist 97:58–9 (c,1) O '88
Natur Hist 98:61 (c,4) Jl '89
ASTOR, MARY
Life 11:112–13 (1) Ja '88
ASTROLABES
Gourmet 51:80 (C,4) Ap '91
—11th cent. (Spain)
Nat Geog 174:106 (c,4) Jl '88
ASTRONAUTS
Nat Geog 174:747–55 (c,1) N '88
—Astronaut air pressure training (Ger-
many)
Smithsonian 21:134 (c,3) O '90
—Futuristic space suit
Life 12:90 (c,4) F '89
—Alan Shepard
Am Heritage 42:48, 52–3 (c,4) N '91
—Victims of the shuttle Challenger disaster
(1986)
Life 10:26 (c,4) Mr '87
—Weightlessness training
Nat Geog 175:582–3 (c,1) My '89
—H. G. Wells's depiction of astronauts
(1901)

Am Heritage 40:47 (painting,4) S '89
ASTRONOMY
—Activities of ancient American civilizations
Nat Geog 177:76–107 (c,1) Mr '90
—Discovery of supernova
Nat Geog 173:618–47 (c,1) My '88
—People looking through telescopes
Smithsonian 20:102–11 (c,1) Ap '89
—Sounding rocket boosting X-ray telescope into space
Nat Geog 173:634 (c,1) My '88
—See also
COPERNICUS, NICOLAUS
GALILEO
HERSCHEL, SIR JOHN
LANGLEY, SAMUEL PIERPONT
LOWELL, PERCIVAL
OBSERVATORIES
TELESCOPES
TOMBAUGH, CLYDE
UNIVERSE
ASWAN, EGYPT
Trav&Leisure 17:112–13 (c,1) O '87
ATGET, EUGENE
—1898 photo of organ grinder
Life 11:38 (4) Fall '88
ATHENS, GREECE
Trav/Holiday 170:54–5 (c,1) S '88
Trav&Leisure 20:69 (c,3) Mr '90
—See also
ACROPOLIS
PARTHENON
ATHLETES
—1940s professional women baseball players
Smithsonian 20:88–96 (2) Jl '89
—1984 U.S. Olympic competitors
Life 11:72–84, 89–95 (1) O '88
—1988 winter Olympics competitors
Sports Illus 68:entire issue (c,1) Ja 27 '88
Life 11:76–86 (c,1) F '88
—1988 summer Olympics competitors
Sports Illus 69:entire issue (c,1) S 14 '88
—1988 winning athletes
Sports Illus 69:78–83 (c,3) D 19 '88
—1990 events
Sports Illus 73:47–131 (c,1) D 31 '90
—Black athletes
Sports Illus 75:cov., 38–77 (c,1) Ag 5 '91
Sports Illus 75:40–6 (c,4) Ag 19 '91
—Caricature sculptures of famous athletes
Sports Illus 72:58–70 (c,1) Ja 8 '90
—Organ transplant recipients in races
Nat Geog 180:90–1 (c,1) S '91
—Prominent athletes
Sports Illus 75:82–101 (c,1) D 23 '91
—Sculpture of Olympic sprinter (Vancouver, B.C.)

Trav&Leisure 21:76 (c,3) Ag '91
—Soviet Olympic competitors
Life 11:48–68, 86 (c,2) O '88
—Special Olympic athletes
Sports Illus 70:49–55 (c,4) Mr 27 '89
—Superstitions of athletes
Sports Illus 68:86–94 (painting,c,1) F 8 '88
—Triumphant moments for 1987 sports stars
Life 11:50–4 (c,1) Ja '88
—See also
ALI, MUHAMMAD
BANNISTER, ROGER
BASEBALL PLAYERS
BERRA, YOGI
BODYBUILDERS
BOXERS
BROWN, JIM
BUDGE, DONALD
CHAMBERLAIN, WILT
COBB, TY
CONNOLLY, MAUREEN
DEAN, DIZZY
DEMPSEY, JACK
DIMAGGIO, JOE
DOUBLEDAY, ABNER
DUROCHER, LEO
EDERLE, GERTRUDE
FENCERS
FOOTBALL PLAYERS
GEHRIG, LOU
GIBSON, ALTHEA
GOLFERS
GRANGE, RED
HAGEN, WALTER
HENIE, SONJA
HOGAN, BEN
JACKSON, SHOELESS JOE
JEFFRIES, JAMES
JOHNSON, JACK
JOHNSON, WALTER
JONES, BOBBY
KOUFAX, SANDY
LOMBARDI, VINCE
LOUIS, JOE
MANTLE, MICKEY
MARIS, ROGER
MATHEWSON, CHRISTY
NICKLAUS, JACK
OWENS, JESSE
PAIGE, SATCHEL
PALMER, ARNOLD
ROBINSON, JACKIE
ROCKNE, KNUTE
RUDOLPH, WILMA
RUTH, GEORGE HERMAN (BABE)
SKIERS
SNEAD, SAM

STENGEL, CASEY
SULLIVAN, JOHN L.
SWIMMERS
TENNIS PLAYERS
THORPE, JIM
TILDEN, WILLIAM
TITTLE, Y. A.
TUNNEY, GENE
WILLIAMS, TED
WILLS, HELEN
WRESTLERS
YOUNG, CY
ATHLETES—HUMOR
—Huge fan sculptures of basketball players
 Sports Illus 72:2–3 (c,1) Mr 12 '90
—Life on the sports team bus
 Sports Illus 71:58–68 (drawing,c,1) Jl 3
 '89
ATHLETIC STUNTS
—Bicycling through fire (Australia)
 Life 12:102–3 (c,1) Jl '89
—Bungee jumping off bridge (New Zeal-
 and)
 Sports Illus 70:12 (c,4) Je 5 '89
—Crossing river by pulley (Tibet)
 Nat Geog 174:693 (c,1) N '88
—Disastrous water skiing accident
 Life 13:15 (c,3) Ag '90
—Freestyle skiing
 Life 10:2–3, 97–8 (c,1) D '87
—Hanging from airborne balloon (France)
 Life 11:12 (c,4) S '88
—Jumping from rock into river (Georgia)
 Nat Geog 174:25 (c,1) Jl '88
—Knievel motorcycling over buses (1975)
 Sports Illus 71:4 (4) Ag 7 '89
—Motorcycling over fountain (Nevada)
 Sports Illus 70:26–7 (c,1) Ap 24 '89
 Sports Illus 73:6 (2) N 12 '90
—Riding truck over cars (California)
 Sports Illus 67:56–7 (c,1) S 7 '87
—Swinging from rope into river (Min-
 nesota)
 Sports Illus 71:44–5 (c,2) Ag 7 '89
—See also
 ACROBATIC STUNTS
ATLANTA, GEORGIA
 Nat Geog 174:2–29 (map,c,1) Jl '88
—Carter Presidential Center
 Trav&Leisure 18:E4 (c,2) F '88
—Coca-Cola headquarters
 Trav&Leisure 21:25 (c,4) D '91
—Street map
 Trav/Holiday 174:29 (c,4) O '90
ATLANTIC CITY, NEW JERSEY
 Trav/Holiday 169:52–7 (map,c,1) My '88
—1860s shooting gallery
 Am Heritage 40:113 (1) N '89
—1920 float at first Miss America Pageant

Am Heritage 39:108 (2) Mr '88
—Trump Taj Mahal Hotel
 Trav&Leisure 20:56 (c,4) Ja '90
ATLANTIC OCEAN
—Florida coast
 Nat Geog 179:74–5 (c,1) Je '91
—Long Island coast, New York
 Trav&Leisure 18:97 (c,3) S '88
—New England coast
 Trav&Leisure 19:88–9 (c,1) Je '89
 Trav&Leisure 20:108–9, 113 (c,1) Jl '90
—Routes of early explorers of America
 Smithsonian 19:50–1 (map,c,1) F '89
ATOMIC BOMBS
—1945 test
 Life 12:81 (4) F '89
—Headlines about 1945 bombing of Hiro-
 shima (Washington)
 Natur Hist 99:16 (2) S '90
—Memorial service for atomic bomb vic-
 tims (Hiroshima, Japan)
 Nat Geog 175:436–7 (c,1) Ap '89
—Monument at 1945 first atom bomb site
 (New Mexico)
 Nat Geog 172:613 (c,4) N '87
—Nuclear test site (Nevada)
 Nat Geog 175:408–9 (c,1) Ap '89
—Survivors of 1945 Hiroshima atomic
 bomb explosion, Japan
 Nat Geog 175:406–7, 434–5 (c,1) Ap '89
—Watch stopped during 1945 Hiroshima
 bombing (Japan)
 Nat Geog 177:112 (c,4) Mr '90
AUCKLAND, NEW ZEALAND
 Nat Geog 171:658–61 (c,1) My '87
AUCTIONS
—Aunt Dorothy's auction house (Vienna,
 Austria)
 Smithsonian 21:110–20 (c,2) D '90
—Cattle auction (Florida)
 Trav/Holiday 172:90 (c,3) S '89
—Christie's (New York City, New York)
 Trav&Leisure 17:NY2 (c,3) O '87
—Fishing tackle auction (Maine)
 Sports Illus 69:6 (c,4) S 5 '88
—Horse auctions
 Sports Illus 67:82 (c,4) N 23 '87
 Gourmet 51:53 (c,1) Jl '91
AUDIENCES
—Blacks listening to Malcolm X speech
 (1963)
 Smithsonian 20:74 (4) Ap '89
—Children at 1963 puppet show (Paris,
 France)
 Life 11:10–11 (1) Fall '88
 Life 13:2 (3) S '90
—Children watching show (Washington,
 D.C.)
 Smithsonian 19:20 (c,4) Jl '88

—Concert (Prague, Czechoslovakia)
Trav&Leisure 17:114–15 (c,2) F '87
—Grand Ole Opry, Nashville, Tennessee
Smithsonian 18:92 (c,4) Mr '88
—Rock concert (Poland)
Nat Geog 173:110–11 (c,2) Ja '88
—See also
SPECTATORS
AUDUBON, JOHN JAMES
Nat Wildlife 25:53 (painting,c,4) O '87
—Painting of curlew
Natur Hist 97:6 (c,4) Ap '88
—Painting of eider ducks (1835)
Nat Wildlife 25:52–3 (c,1) O '87
AUKS
Natur Hist 97:35 (etching,4) Mr '88
—Ancient murrelets
Natur Hist 97:26–8 (drawing,2) Jl '88
—Auklets
Nat Wildlife 28:8 (c,4) Je '90
AURORA AUSTRALIS
Nat Geog 177:10 (c,3) Ap '90
AURORA BOREALIS
Natur Hist 96:8 (c,4) S '87
Life 12:7 (c,2) My '89
Natur Hist 98:104–8 (c,3) N '89
Smithsonian 20:40–1 (c,1) Mr '90
Nat Wildlife 28:12–13 (c,1) Je '90
Life 13:16 (c,2) Jl '90
Nat Geog 178:96–7 (c,1) O '90
Nat Geog 180:98–9 (c,1) N '91
AUSTIN, TEXAS
Nat Geog 177:50–71 (c,1) Je '90
—LBJ ranch
Nat Geog 173:496–7 (c,2) Ap '88
AUSTRALIA
Trav&Leisure 17:A1–38 (map,c,1) O '87
supp.
Trav/Holiday 169:40–4 (c,1) Ja '88
Nat Geog 173:entire issue (map,c,1) F
'88
—Aerial view of sheep station
Nat Geog 173:756 (c,1) My '88
—Australian National Maritime Museum
(Sydney)
Smithsonian 22:24 (c,4) My '91
—Australian wildlife
Trav/Holiday 171:60–7 (c,1) Ap '89
—Ayers Rock
Trav&Leisure 17:A38 (c,4) O '87 supp.
Trav&Leisure 18:202 (c,4) Je '88
—Bungle Bungle sandstone range
Nat Geog 179:3–4 (c,1) Ja '91
—Daintree rain forest
Trav&Leisure 20:135–9 (map,c,1) S '90
—Family Islands
Gourmet 4946–51, 162 (map,c,1) Mr '89
—Great Sandy Desert
Nat Geog 179:32–3 (c,1) Ja '91

—Gregory River
Smithsonian 20:140 (c,4) Ja '90
—Hamersley Range National Park
Nat Geog 179:30–1 (c,1) Ja '91
—Kakadu National Park
Trav/Holiday 169:44 (c,3) Ja '88
Nat Geog 173:266–94 (map,c,1) F '88
—Kangaroo Island rocks
Trav/Holiday 168:26 (c,4) S '87
—Kosciusko National Park
Natur Hist 100:33 (c,4) My '91
—Lacepede Islands
Nat Geog 180:116–17 (c,1) D '91
—Lord Howe Island
Nat Geog 180:126–46 (map,c,1) O '91
—Marine life
Nat Geog 171:287–319 (c,1) Mr '87
Nat Geog 179:42–73 (map,c,1) Ja '91
Nat Geog 180:124–46 (c,1) O '91
—Nambung National Park
Trav/Holiday 176:18 (c,4) Jl '91
—Northwest Australia
Nat Geog 179:3–73 (map,c,1) Ja '91
Trav&Leisure 21:80 (c,4) Ja '91
—The Olgas rocks
Nat Geog 173:157–9, 200–1 (c,1) F '88
—Queensland coast
Trav&Leisure 18:146–51 (c,1) D '88
Trav&Leisure 21:154–5 (c,1) O '91
Nat Geog 180:54–5 (c,1) N '91
—Shipwreck Coast
Trav&Leisure 21:174–5, 180–1 (map,c,4)
D '91
—South Australia coast
Nat Geog 171:287, 294–7, 318–19
(map,c,1) Mr '87
—Western Australia scrubland
Nat Geog 180:60–1 (c,1) N '91
—See also
ABORIGINES
ADELAIDE
BRISBANE
CANBERRA
GREAT BARRIER REEF
MELBOURNE
SYDNEY
TASMANIA
AUSTRALIA—COSTUME
Smithsonian 18:137–9 (c,2) Ja '88
Nat Geog 173:entire issue (c,1) F '88
Life 11:39–49 (c,1) F '88
Nat Geog 179:cov., 9–41 (c,1) Ja '91
—1854 wedding picture
Nat Geog 173:241(4) F '88
—1912
Nat Geog 173:240 (3) F '88
—Dockworker (Sydney)
Smithsonian 18:137 (c,2) Ja '88
—Lawn bowlers

—Henry Leland
 Smithsonian 19:128 (4) Jl '88
—Plastic car engine
 Nat Geog 176:768 (c,3) D '89
—Testing car by driving simulation
 Nat Geog 175:726–7 (c,2) Je '89
—See also
 FORD, HENRY
 SLOAN, ALFRED
AUTOMOBILE MECHANICS
 Nat Geog 171:23 (c,3) Ja '87
 Smithsonian 19:156, 160–7 (c,1) N '88
 Nat Geog 175:69 (c,3) Ja '89
—Fixing flat tire in rain
 Gourmet 50:90 (drawing,4) F '90
—Indianapolis 500 pit crew
 Sports Illus 68:28 (c,3) Je 6 '88
—Repairing car (1947)
 Trav/Holiday 175:138 (drawing,4) Mr '91
—Saskatchewan
 Sports Illus 67:54–5 (c,4) Ag 17 '87
—Training class for mechanics (Ohio)
 Smithsonian 19:142 (4) My '88
AUTOMOBILE RACING
 Sports Illus 68:2–3 (c,1) Ap 25 '88
 Sports Illus 70:30–1 (c,2) F 13 '89
 Sports Illus 74:56, 59 (c,3) F 11 '91
 Sports Illus 74:60–1 (c,2) Mr 18 '91
 Sports Illus 75:4–5 (c,1) Jl 15 '91
 Sports Illus 75:64–74 (c,1) S 30 '91
—1902–1905 Florida Speed Carnivals
 (Dayton)
 Am Heritage 38:93–101 (1) N '87
—1905 (France)
 Smithsonian 19:114–15 (2) Je '88
—1908 New York to Paris auto race
 Smithsonian 22:132 (4) S '91
—1955 Mille Miglis (Italy)
 Sports Illus 71:151 (3) N 6 '89
—1957 auto racing car wreckage (Italy)
 Sports Illus 71:152 (4) N 6 '89
—1964 fiery crash at Indianapolis 500
 Am Heritage 40:39 (4) My '89
—1988 Paris-to-Dakar race
 Sports Illus 68:2–3, 20–7 (c,1) F 1 '88
—Auto race crash
 Sports Illus 66:33 (c,4) F 23 '87
 Sports Illus 66:22–7 (c,2) My 18 '87
 Sports Illus 68:48–9 (c,1) F 22 '88
 Sports Illus 70:33, 39 (c,3) Je 5 '89
 Sports Illus 71:2–3 (c,1) Jl 17 '89
 Sports Illus 72:2–3 (c,1) F 26 '90
 Sports Illus 74:54 (c,4) Ap 1 '91
 Sports Illus 75:4–5 (c,1) Jl 15 '91
—Brazil
 Trav/Holiday 171:72–6 (c,1) Mr '89
—Car flipped over
 Sports Illus 67:52–3 (c,1) D 28 '87
 Sports Illus 71:110–11 (c,1) D 25 '89

—Daytona 500 (1987)
 Sports Illus 66:32–3 (c,2) F 23 '87
—Daytona 500 (1988)
 Sports Illus 68:34–6 (c,2) F 8 '88
 Sports Illus 68:48–50 (c,1) F 22 '88
—Daytona 500 (1989)
 Sports Illus 70:46–7 (c,2) F 27 '89
—Daytona 500 (1990)
 Sports Illus 72:24–5 (c,3) F 26 '90
—Daytona 500 (1991)
 Sports Illus 74:28–31 (c,2) F 25 '91
—Detroit Grand Prix 1987
 Sports Illus 66:68–9 (c,2) Je 29 '87
—Detroit Grand Prix 1988
 Sports Illus 68:32–5 (c,3) Je 27 '88
—French Grand Prix 1989
 Sports Illus 71:2–3 (c,1) Jl 17 '89
 Sports Illus 71:110–11 (c,1) D 25 '89
—Indianapolis 500 (1961)
 Sports Illus 75:66 (2) S 30 '91
—Indianapolis 500 (1964)
 Am Heritage 40:39 (4) My '89
 Sports Illus 7567 (4) S 30 '91
—Indianapolis 500 (1965)
 Sports Illus 68:66 (4) My 9 '88
—Indianapolis 500 (1966)
 Sports Illus 68:67 (c,4) My 9 '88
—Indianapolis 500 (1976)
 Sports Illus 68:62 (c,4) My 9 '88
—Indianapolis 500 (1982)
 Sports Illus 69:61 (c,2) N 21 '88
—Indianapolis 500 (1987)
 Sports Illus 66:22–7 (c,2) My 18 '87
 Sports Illus 66:46–8 (c,2) My 25 '87
 Sports Illus 66:2–3, 30–3 (c,1) Je 1 '87
 Sports Illus 68:60 (c,4) My 9 '88
—Indianapolis 500 (1988)
 Sports Illus 68:2–3, 24–9 (c,1) Je 6 '88
—Indianapolis 500 (1989)
 Sports Illus 70:32–4, 39 (c,2) Je 5 '89
 Sports Illus 72:56–7 (c,1) My 14 '90
—Indianapolis 500 (1990)
 Sports Illus 72:34–8 (c,1) Je 4 '90
—Indianapolis 500 (1991)
 Sports Illus 74:25–5 (c,1) Je 3 '91
—Indianapolis 500 history
 Sports Illus 66:55–72 (c,2) My 11 '87
—Le Mans, France
 Sports Illus 75:2–3, 20–1 (c,1) Jl 1 '91
—NASCAR racing
 Sports Illus 67:32–4 (c,2) S 7 '87
 Sports Illus 69:36–7 (c,1) Ag 22 '88
 Sports Illus 71:43–6 (c,3) Jl 3 '89
 Sports Illus 73:26–7 (c,2) Ag 20 '90
 Sports Illus 73:93–4 (c,3) N 26 '90
 Sports Illus 74:35–48 (c,2) F 18 '91
—Phoenix Grand Prix 1989
 Sports Illus 70:28–9 (c,2) Je 12 '89
—Phoenix Grand Prix 1990

Life 11:16 (c,3) N '88
—Wright Brothers' glider in flight
Trav/Holiday 176:86 (4) Jl '91
—See also
AIRPLANE FLYING
AIRPLANE PILOTS
AIRPLANES
AIRPORTS
AIRSHIPS
CRASHES
U.S. AIR FORCE
ZEPPELIN, FERDINAND VON
AVIATION—HUMOR
—Passenger getting royal treatment
Trav/Holiday 174:48–9 (painting,c,2) D
'90
AVOCETS
Nat Wildlife 27:48 (c,4) Ap '89
Natur Hist 98:102–3 (c,1) O '89
AWARDS
—Academy Awards Oscar statue
Life 13:cov., 91 (c,1) Ap '90
—Deaf actress accepting Academy Award
Life 11:30 (c,4) Ja '88
—Manufacturing Oscar statuettes (Illinois)
Life 11:11 (c,4) Ap '88
—See also
MEDALS
TROPHIES

AXES
—Ancient Switzerland
Nat Geog 172:285 (c,4) S '87
AZALEAS
Gourmet 47:69 (c,1) Ap '87
Trav&Leisure 18:145 (painting,c,1) Mr
'88
Gourmet 49:69 (c,4) Ap '89
Trav&Leisure 21:NY6 (c,3) Ap '91
AZTEC CIVILIZATION
—1519 marketplace
Smithsonian 22:180 (painting,c,4) O '91
—Aztec god Quetzalcoatl
Natur Hist 100:16 (painting,c,4) S '91
AZTEC CIVILIZATION—ARCHITEC-
TURE
—Teotihuacan, Mexico
Nat Geog 177:92–3 (c,1) Mr '90
AZTEC CIVILIZATION—RITES AND
FESTIVALS
—Aztec depiction of human sacrifice (Mex-
ico)
Nat Geog 177:96 (c,4) Mr '90
—Depiction of cannibalism
Smithsonian 17:162 (drawing,4) Mr '87
AZTEC CIVILIZATION—SOCIAL
LIFE AND CUSTOMS
—Aztec hip soccer game (Mexico)
Nat Geog 177:96–7 (c,1) Mr '90

- B -

BABCOCK, STEPHEN MOULTON
Am Heritage 41:43 (4) My '90
BABIES
Smithsonian 17:34 (c,4) F '87
Life 10:cov., 30–3, 42 (c,1) Je '87
Life 10:48 (c,2) Ag '87
Life 12:4 (c,4) Ag '89
Life 12:23–4 (c,4) N '89
Life 13:64–7 (c,1) F '90
Life 13:3, 119–26 (c,2) My '90
Life 13:2–3, 28–32 (1) Spring '90
—16th cent. Indian woman with papoose
(West Indies)
Smithsonian 18:94 (painting,c,4) Ja '88
—1787 pewter baby bottle
Life 10:32 (c,4) Fall '87
—1870s Kiowa cradleboard
Smithsonian 18:276 (c,4) N '87
—Early 20th cent. baby shoes
Smithsonian 18:276 (c,4) N '87
—1905
Life 13:28 (4) Spring '90
—1984 photo of fifteen babies
Life 11:73 (c,4) Fall '88

—Adoption process
Life 10:28–34 (c,1) Je '87
—Army mother kissing baby goodbye
Life 14:30–1 (c,1) Ja '91
—Baby dangling from balcony (California)
Life 14:20 (2) Ap '91
—Baby holding adult finger
Nat Wildlife 28:54–5 (c,1) F '90
—Baby's first haircut
Smithsonian 22:115 (c,2) My
'91
—Blackfeet Indian rite of naming child
Life 14:12–13 (c,1) O '91
—Carried in basket (Madeira, Portugal)
Trav&Leisure 17:90 (c,4) D '87
—Carrying baby in front pack (Japan)
Smithsonian 17:45 (c,2) Mr '87
—Carrying toddler on shoulders
Life 10:cov., 17 (c,1) F '87
Sports Illus 66:4 (c,4) Mr 9 '87
—Czechoslovakia
Nat Geog 171:134–5 (c,3) Ja '87
—Eskimo papoose (Canada)
Nat Geog 172:210–11 (c,1) Ag '87

Trav&Leisure 174:70–1 (c,1) N '90
Life 14:108–9 (c,1) Summer '91
BAFFIN ISLAND, NORTHWEST TER-
RITORIES
Trav&Leisure 18:138–43 (c,1) O '88
BAHAMAS
Trav&Leisure 17:cov., 12, 68–77, 114
(map,c,1) Ja '87
Trav/Holiday 168:67–70 (c,1) Ag '87
Trav/Holiday 170:67–74 (c,2) Ag '88
Trav/Holiday 172:79–80 (c,4) Ag '89
—Bimini
Natur Hist 97:52–3 (c,1) Mr
'88
Trav&Leisure 18:109, 114 (c,3) D '88
—Cat Island
Trav&Leisure 18:71–6 (painting,c,3) O
'88
—Eleuthera
Trav&Leisure 20:82–91, 131, 135
(map,c,1) Jl '90
Natur Hist 100:30–1 (c,1) F '91
—Great marine blue hole
Natur Hist 96:42–4 (c,1) Ja '87
—Harbour Island
Trav/Holiday 174:38–45 (map,c,1) D '90
—San Salvador landing spot of Columbus
Trav/Holiday 176:71 (c,4) O '91
BAHAMAS—SOCIAL LIFE AND CUS-
TOMS
—New Year's costumes
Natur Hist 100:22, 26 (c,2) D '91
BAHRAIN
—Ancient burial mounds
Smithsonian 18:134–5 (c,1) My '87
BAKER, JOSEPHINE
Nat Geog 176:174 (3) Jl '89
Am Heritage 40:14 (drawing,4) N '89
BAKERIES
—Bread coming from oven (U.S.S.R.)
Nat Geog 179:11 (c,4) F '91
—Brussels, Belgium
Gourmet 49:78 (c,4) S '89
—China
Trav/Holiday 169:54–5 (c,3) F '88
—France
Gourmet 47:65 (c,1) O '87
Gourmet 49:56–7 (c,1) Mr '89
—Italy
Trav/Holiday 175:52 (c,1) F '91
—New York
Life 12:51 (c,3) O '89
—Old Italian bakery (New York City, New
York)
Am Heritage 40:122–3 (c,1) D '89
—Pastry shop (Budapest, Hungary)
Trav&Leisure 19:33 (c,4) Ag '89
—Pastry shop (Vienna, Austria)
Trav&Leisure 18:130–1 (c,1) N '88

—Warsaw, Poland
Nat Geog 173:100 (c,2) Ja '88
BAKERS
—France
Gourmet 49:57 (c,1) Mr '89
Nat Geog 176:72–3 (c,1) Jl '89
Trav/Holiday 172:44 (c,3) Jl '89
—New York City, New York
Gourmet 50:123 (c,4) O '90
Baking. See
BREAD MAKING
COOKING
BALANCHINE, GEORGE
Life 13:23 (1) Fall '90
BALBOA, VASCO NUÑEZ DE
Am Heritage 39:28 (drawing,4) S '88
Natur Hist 100:22 (engraving,4) Ap '91
Smithsonian 22:87 (painting,c,4) Ap '91
BALDWIN, ABRAHAM
Life 10:58 (drawing,4) Fall '87
BALDWIN, JAMES
Life 11:119 (4) Ja '88
Bali. See
INDONESIA
BALL, LUCILLE
Life 13:110 (c,1) Ja '90
BALLET DANCING
Life 11:128(c,4) Ja '88
Trav&Leisure 18:54 (c,3) My '88
Smithsonian 21:80 (3) F '91
—1916 child in tutu (New York)
Am Heritage 38:108 (2) N '87
—Art works by Degas
Trav/Holiday 167:30 (sculpture,c,4) Ja
'87
Trav&Leisure 17:30 (painting,c,4) Ja '87
Trav&Leisure 17:122 (sculpture,c,4) Je
'87
Gourmet 47:59 (sculpture,c,1) Ag '87
Smithsonian 19:62–3 (c,3) O '88
—Ballerina putting on toe shoes
(U.S.S.R.)
Trav&Leisure 17:96 (c,4) D '87
—Ballerinas
Trav&Leisure 18:39 (c,4) Ja '88
Life 11:76–7 (c,1) Spring '88
Life 13:12–13 (c,2) F '90
—Ballerinas (1936)
Life 13:87 (3) S '90
—Ballerinas (France)
Trav/Holiday 172:65 (c,2) Jl '89
—Ballet class (Leningrad, U.S.S.R.)
Trav&Leisure 19:138, 158 (c,3) F '89
—Close-up of ballerina on toes
Trav&Leisure 17:27 (c,3) S '87
—Girls waiting to audition for role (Flor-
ida)
Life 14:20–1 (1) D '91
—Sumo wrestlers in tutus (Japan)

Sports Illus 74:88 (c,4) Je 24 '91
Life 14:16 (c,2) Ag '91
—Toddlers at ballet recital (Massachusetts)
Life 13:40 (c,3) Spring '90
—U.S.S.R.
Nat Geog 175:cov., 606–7 (c,1) My '89
Trav&Leisure 21:283 (c,3) O '91
—See also
BALANCHINE, GEORGE
BALLOONING
Trav/Holiday 170:78 (c,3) N '88
—1783 (France)
Am Heritage 40:cov., 14 (painting,c,1) Jl
'89 supp.
—1950s female balloonist
Life 13:107–8 (4) N '90
—Albuquerque International Balloon Fi-
esta, New Mexico
Smithsonian 19:100–7 (c,1) O '88
Trav&Leisure 21:195 (c,4) My '91
—California
Am Heritage 38:2A (c,4) S '87
Trav/Holiday 170:30 (c,4) Ag '88
—France
Gourmet 51:127 (c,1) N '91
—New Mexico
Nat Geog 172:620–1 (c,1) N '87
—Switzerland
Trav&Leisure 20:22–3 (c,3) D '90
—Utah
Trav/Holiday 169:cov. (c,1) Je '88
—White-water ballooning (California)
Trav/Holiday 172:28 (c,4) S '89
BALLOONS
Life 13:104–5 (c,1) N '90
Trav/Holiday 175:72–3 (c,1) Je '91
—1870 homemade balloon (Vermont)
Am Heritage 41:120 (3) N '90
—1934 research balloon
Nat Geog 174:306–7 (painting,c,2) S '88
—Betty Boop balloon in parade
Trav/Holiday 172:86 (c,4) N
'89
Nat Geog 178:57 (c,4) S '90
—Macy's Thanksgiving Day Parade, New
York City, New York
Trav/Holiday 172:82–7 (c,1) N '89
—Scientific research balloons (Texas)
Smithsonian 17:82–93 (c,1) Ja '87
BALLOONS, TOY
—Guard blowing up balloon (U.S.S.R.)
Trav&Leisure 20:133 (c,1) O '90
—Launching water balloon from boat (Cal-
ifornia)
Nat Geog 176:188–9 (c,1) Ag '89
BALTIC SEA, EUROPE
Nat Geog 175:602–35 (map,c,1) My '89
BALTIMORE, MARYLAND
—Babe Ruth Birthplace Museum

Trav/Holiday 169:102 (c,4) F '88
—Harbor (1850)
Am Heritage 39:40–1 (painting,c,1) Jl
'88
—Walters Art Gallery
Smithsonian 20:102–13 (c,1) Ag '89
BALZAC, HONORÉ DE
—Bust by Rodin
Gourmet 47:48 (c,4) S '87
Smithsonian 19:30 (c,4) Ag '88
—Caricature
Smithsonian 20:157 (c,3) Ja '90
—Chateau home (Loire Valley, France)
Gourmet 47:50–3 (c,1) S '87
—Home (Passy, Paris, France)
Gourmet 47:49 (c,1) S '87
BAMBOO PLANTS
Trav/Holiday 167:46(c,4) Mr '87
Natur Hist 98:48–57 (c,1) O '89
BANANA INDUSTRY—TRANSPOR-
TATION
—Loading boxes onto barges (Dominica,
West Indies)
Nat Geog 177:115 (c,3) Je '90
BANANAS
—Banana Club museum items (California)
Trav/Holiday 172:26 (c,4) Jl '89
BANCROFT, GEORGE
Smithsonian 21:142 (4) Je '90
BANDELIER NATIONAL MONU-
MENT, NEW MEXICO
Trav/Holiday 168:66 (c,4) S '87
BANDS
—1862 Confederate regiment band
Am Heritage 40:122 (4) S '89
—1923 dance band (Great Britain)
Trav&Leisure 19:97 (4) Ag '89
—1930 jazz band (New York)
Am Heritage 40:126 (3) S '89
—Blues bands (Chicago, Illinois)
Trav/Holiday 170:48–50 (c,4) O '88
—Brass band (Ghana)
Natur Hist 100:40 (c,4) S '91
—Brass bands
Trav&Leisure 19:117 (c,4) F '89
Life 12:54 (c,3) O '89
—Brass oompah band (Berlin, West Ger-
many)
Trav&Leisure 17:92 (c,3) S '87
—Jazz bands
Trav&Leisure 19:108–9 (c,1) F '89
Trav&Leisure 19:E16 (drawing,4) Ap '89
—Mariachi band (Mexico)
Nat Geog 178:138–9 (c,1) D '90
—Mariachi band (Texas)
Trav&Leisure 19:109–11, 114 (c,3) Ag
'89
—Outdoor brass band (Quebec)
Trav&Leisure 19:88 (c,1) Ag '89

BANDS, MARCHING
—Bands around the world
　Natur Hist 100:cov., 38–47 (c,1) S '91
—College band playing at sports events
　Sports Illus 66:58 (c,4) Mr 16 '87
　Sports Illus 73:42–3, 118 (c,1) S 3 '90
—Coronet player in uniform (Bermuda)
　Trav&Leisure 21:128 (c,3) F '91
—Nepal
　Natur Hist 100:cov., 38–9, 42–7 (c,1) S
　'91
—Police band (Grenada)
　Sports Illus 72:114–15 (c,1) F 12 '90
—Reenactment of 1776 Fife and Drum
　Corps (Virginia)
　Trav&Leisure 19:106 (c,4) Jl '89
—Reproduction of 18th cent. marching
　band (Canada)
　Trav&Leisure 17:110–13 (c,1) Je '87
—Tivoli Band, Copenhagen, Denmark
　Gourmet 48:55 (c,2) Ag '88
BANFF NATIONAL PARK, ALBERTA
　Trav&Leisure 18:C20 (c,4) My '88 supp.
　Trav/Holiday 176:46 (c,1) D '91
—Banff Springs Hotel
　Sports Illus 68:314 (4) Ja 27 '88
—See also
　LAKE LOUISE
BANGKOK, THAILAND
　Gourmet 48:86–91, 257, 259 (c,2) N '88
　Trav&Leisure 19:179–80 (c,4) S '89
　Trav/Holiday 176:cov., 48–58 (map,c,1)
　N '91
—Chao Phraya River
　Trav/Holiday 176:48–56 (map,c,1) N '91
—Floating market
　Trav&Leisure 19:180 (c,4) S '89
　Trav/Holiday 172:52–3 (c,1) O '89
　Gourmet 51:80 (c,3) Ja '91
　Trav/Holiday 176:48–9, 55 (c,1) N '91
—Grand Palace
　Trav/Holiday 176:cov., 53 (c,1) N '91
—Railroad station
　Trav/Holiday 168:42–3 (c,1) D '87
—Wat Arun
　Trav/Holiday 176:58 (c,4) N '91
BANGLADESH
—Brahmaputra River scenes
　Nat Geog 174:706–11 (c,1) N '88
—Diking Feni River
　Nat Geog 172:92–101 (c,1) Jl '87
—Flooded homes
　Life 12:88 (c,4) Ja '89
—Rice fields after cyclone
　Life 14:12–13 (c,1) Jl '91
—See also
　BRAHMAPUTRA RIVER
BANGLADESH—COSTUME
　Nat Geog 172:91–101 (c,1) Jl '87

Nat Geog 174:680–1 (2) N '88
—Laborers
　Life 12:64–8 (1) Ag '89
BANK OF ENGLAND, LONDON, EN-
　GLAND
　Gourmet 49:36 (drawing,3) My '89
BANKING
—1853 caricature of banker
　Am Heritage 42:54 (4) F '91
—1873 Crédit Mobilier scandal
　Am Heritage 42:58 (drawing,4) F '91
—1911 cartoon about businessmen doing
　"real" work
　Am Heritage 42:130–1 (1) Ap '91
—1931 cartoon about bank failures
　Am Heritage 38:53 (4) D '87
—1935 savings and loan association ad
　Am Heritage 42:66 (4) F '91
—1957 savings and loan association ad
　Am Heritage 42:68 (c,3) F '91
—History of U.S. bank crises
　Am Heritage 42:50–68 (c,3) F '91
—Run on bank during Panic of 1857
　Am Heritage 38:56 (painting,4) D '87
BANKS
—Early 19th cent. (Connecticut)
　Trav/Holiday 168:62–3 (c,2) O '87
—Late 19th cent. Uncle Sam toy bank
　Am Heritage 42:cov. (c,4) F '91
—1891 teller's window (Texas)
　Am Heritage 41:71 (3) D '90
—1910 (Detroit, Michigan)
　Am Heritage 38:100 (2) Ap '87
—1920s bank lobby (New York City, New
　York)
　Am Heritage 39:94–5 (c,1) N '88
—Bank of England, London, England
　Gourmet 49:36 Trav&Leisure (draw-
　ing,3) My '89
—Bank vault
　Sports Illus 70:78 (c,1) Ap 5 '89
BANNISTER, ROGER
—1954 four-minute mile
　Sports Illus 71:22–3 (1) N 15 '89
BANYAN TREES
　Trav&Leisure 19:172 (c,3) D '89
　Trav&Leisure 21:79 (c,4) Ja '91
BAOBAB TREES
　Nat Geog 171:158–9 (c,1) F '87
　Nat Geog 179:12–13, 25 (c,1) Ja '91
BAPTISMS
—5th cent. mass baptism by St. Patrick
　(Ireland)
　Smithsonian 18:162 (etching,3) Mr '88
—Adult baptisms (South)
　Nat Geog 172:736 (c,3) D '87
　Smithsonian 20:166 (c,4) S '89
—Black adults (Pennsylvania)
　Nat Geog 178:80–1 (1) Ag '90

—Guatemala
Nat Geog 173:791 (c,4) Je '88
—Tahiti
Nat Geog 176:88 (c,3) Jl '89
—U.S.S.R.
Smithsonian 20:142 (c,4) Ap '89
Nat Geog 179:36–7 (c,1) F '91
Life 14:cov., 10–11 (c,1) O '91
—Virginia
Nat Geog 172:353 (c,2) S '87
—Washington, D.C.
Life 14:92 (c,2) O '91
BARBADOS
Trav&Leisure 18:130–41, 152–4
(map,c,1) S '88
Gourmet 50:92–5, 196 (map,c,1) N '90
—Sam Lord's 1820 castle
Trav/Holiday 170:30, 36 (c,4) O '88
BARBAROSSA
Nat Geog 172:594 (painting,c,4) N '87
BARBED WIRE
—1874
Am Heritage 38:10 (4) Jl '87
—1874 barbed wire patent
Am Heritage 41:49 (drawing,4) S '90
—Late 19th cent. barbed wire ad
Smithsonian 22:74–5 (c,2) Jl '91
—Barbed wire border fence (Austria/
Hungary)
Life 13:126–7 (c,1) Ja '90
—Barbed wire border fence (South Africa)
Nat Geog 174:584 (c,4) O '88
—Barbed wire fence
Am Heritage 38:95 (c,4) F '87
—Fence between Hong Kong and China
Nat Geog 179:126–7 (c,1) F '91
—History of western barbed wire
Smithsonian 22:72–83 (c,1) Jl '91
BARBER SHOPS
—Late 19th cent. barbering paraphernalia
Smithsonian 22:114 (c,4) My '91
—1880s
Smithsonian 22:110 (c,1) My '91
—1890s barber pole
Smithsonian 22:111 (c,4) My '91
—Early 20th cent. (Ohio)
Smithsonian 22:112–13 (c,1) My '91
—Early 20th cent. occupational shaving
mugs
Am Heritage 40:36–40 (c,4) Ap '89
Smithsonian 22:113 (c,4) My '91
—1934 (Texas)
Am Heritage 38:44 (4) Jl '87
—Atlanta, Georgia
Nat Geog 174:13 (c,1) Jl '88
—Burma
Trav&Leisure 18:111 (c,4) S '88
—Trendy shop (New York City, New
York)

Nat Geog 178:69 (c,3) S '90
BARBERS
—Pennsylvania
Nat Geog 180:134 (c,1) D '91
—Streetside barbers (China)
Trav&Leisure 17:81 (4) Ag '87
—See also
BEAUTY PARLORS
HAIRDRESSING
HAIRSTYLES
BARCELONA, SPAIN
Gourmet 47:49–53, 124 (c,1) Je '87
Trav/Holiday 169:54–9 (c,1) Je '88
Trav&Leisure 20:136–53 (map,c,1) Je
'90
—Cafe exterior
Trav&Leisure 18:133 (c,1) Ap '88
—Gaudi architecture
Trav&Leisure 17:44–6 (c,4) Ap '87
—Palace of the Counts of Barcelona
Trav&Leisure 18:66 (c,3) Jl '88
—Palau de la Musica interior
Trav&Leisure 19:162–3 (c,1) N '89
—Palau Sant Jordi
Trav&Leisure 21:20 (c,4) Jl '91
—Redoing Barcelona stadium for 1992
Olympics
Trav&Leisure 20:60–1 (c,4) F '90
—Sagrada Familia Church
Trav&Leisure 17:44 (c,4) Ap '87
Gourmet 47:49 (c,1) Je '87
Trav&Leisure 20:137 (c,1) Je
'90
BARGES
Nat Geog 178:64–5 (c,1) N '90
—China
Nat Geog 175:294 (c,1) Mr '89
—Delaware Canal, Pennsylvania
Trav/Holiday 168:56–7 (c,2) N '87
Gourmet 50:84 (c,4) S '90
—Garbage barges (New York)
Nat Wildlife 26:18–19, 23 (c,1) Ag '88
—Grounded in drought (Tennessee)
Nat Geog 178:84–5 (c,2) O '90
—Homeless garbage barge
Life 10:8 (c,4) Ag '87
—Mule-drawn canal barge (Washington,
D.C.)
Trav/Holiday 168:54 (c,4) O '87
—Shipping pottery on river (Great Britain)
Smithsonian 19:130 (c,1) Mr
'89
—Sightseeing by barge (France)
Trav&Leisure 20:51–6 (c,2) Ap '90
—Sightseeing canal barges
Trav&Leisure 18:217–18 (painting,c,4)
Ap '88
BARLEY INDUSTRY
—Barley fields (Scotland)

Gourmet 49:98–9 (c,1) D '89
—Winnowing barley (Tibet)
Nat Geog 172:782–3 (c,1) D '87
BARNACLES
Natur Hist 97:76–7 (c,1) Ag '88
Natur Hist 99:50–1 (c,1) Je '90
BARNS
Smithsonian 20:cov., 30–43 (c,1) Ag '89
—1826 round barn (Massachusetts)
Nat Geog 176:312 (c,4) S '89
Trav&Leisure 21:E2 (c,4) My '91
—1940s farm in winter (Illinois)
Am Heritage 41:cov. (painting,c,1) D '90
—Livestock shelter (India)
Smithsonian 21:130 (c,4) N '90
—Midwest
Nat Geog 171:324–5 (c,1) Mr '87
Smithsonian 20:34–43 (c,1) Ag '89
Gourmet 50:106–7, 110 (c,1) N '90
Smithsonian 22:58 (c,4) Ag '91
—Painted with U.S. patriotic theme (Michigan)
Trav/Holiday 171:16 (c,4) My '89
—Stone barn (Pennsylvania)
Trav&Leisure 17:cov., 64 (c,1) Ag '87
—Vermont
Smithsonian 20:36, 39–42 (c,4) Ag '89
—Virginia
Smithsonian 20:30–3, 36–9 (c,1) Ag '89
—Wyoming
Trav&Leisure 17:122 (c,4) N '87
BARNS—CONSTRUCTION
—Reconstructing 1835 barn (Massachusetts)
Life 12:5 (c,3) N '89
BARNUM, PHINEAS T.
Am Heritage 39:28 (4) F '88
BARRACUDAS
Nat Geog 173:452–3 (c,1) Ap '88
Nat Geog 174:720–1 (c,1) N '88
BARREL MAKING
—19th cent. coopering tools (Pennsylvania)
Smithsonian 19:121 (c,1) O '88
—Cognac barrels (France)
Trav/Holiday 174:71 (c,1) Ag '90
—Making wine casks (Italy)
Trav/Holiday 174:63 (c,4) S '90
BARRELS
—1781 (Great Britain)
Nat Geog 173:816–17 (c,1) Je '88
—Scotch whiskey barrels (Scotland)
Gourmet 49:95–6, 99 (c,4) D '89
BARRYMORE, ETHEL
Am Heritage 41:16 (drawing,4) D '90
BARRYMORE, JOHN
Am Heritage 41:16 (drawing,4) D '90
BARRYMORE, LIONEL
Am Heritage 41:16 (drawing,4) D '90

BARTLETT, JOHN
—Caricature
Smithsonian 22:76 (4) Ag '91
BARTON, CLARA
Nat Geog 173:33 (4) Ja '88
Am Heritage 39:14 (drawing,4) Ap '88
Trav/Holiday 176:76 (drawing,4) Jl '91
BASEBALL
—1787 depiction of baseball game
Sports Illus 67:14 (c,4) O 19 '87
—19th cent. style game (Ohio)
Sports Illus 66:6–8 (c,3) Ap 27 '87
—19th–20th cent. baseball equipment
Sports Illus 70:88–115 (c,1) Je 12 '89
—Baseball Hall of Fame treasures, Cooperstown, New York
Sports Illus 70:88–115 (c,1) Je 12 '89
—Baseball camp (Arizona)
Trav/Holiday 167:48–51 (c,4) My '87
—Baseball memorabilia
Smithsonian 18:cov., 102–13 (c,1) Ap '87
Sports Illus 70:88–115 (c,1) Je 12 '89
Am Heritage 40:116–19, 130 (c,4) S '89
—Baseball player pouring milk on man's head
Sports Illus 67:2–3 (c,1) O 12 '87
—"Bleacher Bums" play
Sports Illus 70:16 (c,4) Je 26 '89
—Baseball's role in American life
Sports Illus 74:52–63 (c,1) Ap 15 '91
Smithsonian 22:98–107 (c,1) Ap '91
—Caribbean Series
Sports Illus 70:16–21 (c,1) F 20 '89
—"Casey at the Bat" and the "Mudville Nine"
Sports Illus 69:cov., 54, 71 (c,1) Jl 18 '88
Sports Illus 69:16 (sculpture, c,4) O 24 '88
—Depicted in paintings
Smithsonian 19:184 (c,4) S '88
—Dominican Republic
Sports Illus 66:132–48 (c,2) F 9 '87
—Japan
Sports Illus 66:74–8 (c,2) Mr 23 '87
Sports Illus 70:76–93 (painting,c,1) My 15 '89
—Japanese players (Kuwait)
Nat Geog 173:660–1 (c,2) My '88
—Kids playing near railroad tracks (Ohio)
Sports Illus 68:2–3 (c,1) My 23 '88
—Native American children (Arizona)
Sports Illus 74:52–3 (c,1) Ap 15 '91
—New York City street game
Sports Illus 74:56 (c,1) Ap 15 '91
—Night game under midnight sun (Alaska)
Nat Geog 177:69 (3) F '90
—Pesäpallo game (Finland)
Sports Illus 75:10–11 (c,3) Jl 15 '91

—Practice with pitching machine
Sports Illus 70:66 (c,4) F 6 '89
Sports Illus 70:58 (c,4) Ap 5 '89
—*Saturday Evening Post* baseball covers
Sports Illus 73:50–5 (c,2) Ag 6 '90
—Stickball playing
Sports Illus 71:152, 154 (c,4) S 11 '89
—U.S.S.R.
Sports Illus 67:44–5 (c,1) D 28 '87
Sports Illus 69:38–44 (c,2) Jl 25 '88

BASEBALL—AMATEUR
—Little League
Sports Illus 68:65–74 (c,1) Je 27 '88
Sports Illus 71:20 (c,2) Jl 24 '89
Sports Illus 71:30 (c,1) D 25 '89
Life 14:92 (c,2) Ap '91
Trav&Leisure 21:86–7 (c,2) Ag '91
Nat Geog 180:142–3 (c,1) D '91
—Little League—Taiwan
Sports Illus 75:60–3 (c,1) Ag 19 '91
—Little League game (1944)
Sports Illus 71:83–4 (3) Ag 28 '89
—Little League World Series 1988 (Pennsylvania)
Sports Illus 69:30–1 (c,3) S 5 '88
—Little League World Series 1989 (Pennsylvania)
Sports Illus 71:32–5 (c,1) S 4 '89
—Little League World Series 1990 (Pennsylvania)
Sports Illus 73:24 (c,4) S 3 '90

BASEBALL—COLLEGE
—College World Series 1988 (Stanford vs. Arizona State)
Sports Illus 68:36–7 (c,2) Je 20 '88
—College World Series 1991
Sports Illus 74:40–3 (c,1) Je 17 '91

BASEBALL—HIGH SCHOOL
—Texas
Sports Illus 68:28–32 (c,1) My 9 '88
Sports Illus 70:cov., 16–21 (c,1) My 8 '89

BASEBALL—HUMOR
—Rotisserie League for baseball fans
Smithsonian 21:100–13 (painting,c,1) Je '90

BASEBALL—PROFESSIONAL
Sports Illus 67:entire issue (c,1) Jl 6 '87
Sports Illus 69:26–36, 41 (c,1) O 17 '88
Sports Illus 70:entire issue (c,1) Ap 5 '89
Sports Illus 72:cov., 26–122 (c,1) Ap 16 '90
Sports Illus 73:2–3, 32–7 (c,1) S 24 '90
Sports Illus 73:14–21 (c,1) O 1 '90
Sports Illus 74:cov., 34–129 (c,1) Ap 15 '91
Sports Illus 75:20–5 (c,1) Ag 5 '91
Sports Illus 75:2–3, 18–23 (c,1) S 30 '91
Sports Illus 75:cov., 34–41 (c,1) O 21 '91

—1925 World Series ticket stub
Am Heritage 40:117 (c,4) S '89
—1940s professional women baseball players
Smithsonian 20:88–96 (2) Jl '89
——1952 Giants winning pennant
Sports Illus 67:48 (4) S 14 '87
Sports Illus 75:68–77 (2) S 16 '91
—1957 headline about Giants moving to San Francisco
Sports Illus 71:56 (4) N 15 '89
—Hank Aaron's 715th home run (1974)
Sports Illus 71:134 (c,4) N 15 '89
—Arguing with umpire
Sports Illus 67:30 (c,4) N 2 '87
Sports Illus 68:22–3 (c,2) My 9 '88
Sports Illus 68:13 (c,4) Je 13 '88
Sports Illus 74:59 (c,4) Je 17 '91
—Batter breaking bat
Sports Illus 71:cov. (c,1) Jl 24 '89
—Batter hit by ball
Sports Illus 69:24 (c,2) S 26 '88
—Batter limbering up
Nat Geog 179:40–1 (c,1) Ap '91
—Bunting
Sports Illus 67:26 (c,2) O 12 '87
Sports Illus 68:30 (c,4) Mr 7 '88
—Catchers
Sports Illus 68:66–7, 109 (c,1) Ap 4 '88
Sports Illus 70:cov., 16–32 (c,1) Ap 5 '89
Sports Illus 75:34–7 (c,1) O 21 '91
—Celebrating
Sports Illus 67:22–3 (c,1) O 5 '87
Sports Illus 71:27 (c,3) N 6 '89
Sports Illus 75:cov. (c,1) N 4 '91
—Clown Prince of Baseball Max Patkin
Sports Illus 68:98–110 (c,1) Je 6 '88
—Collision on baseball field
Sports Illus 67:25 (c,2) S 7 '87
Sports Illus 70:19–21 (c,1) Ap 5 '89
—Error
Sports Illus 68:38 (c,4) Je 27 '88
—Female umpire
Sports Illus 68:cov., 26–7 (c,1) Mr 14 '88
—Fielding
Sports Illus 66:47 (c,3) Je 1 '87
Sports Illus 67:76–9 (c,1) Jl 6 '87
Sports Illus 67:41 (c,2) O 19 '87
Sports Illus 67:52–3 (c,1) O 26 '87
Sports Illus 68:56–67 (c,1) Ap 4 '88
Sports Illus 68:32–3 (c,1) My 23 '88
Sports Illus 69:31–3 (c,2) S 19 '88
Sports Illus 69:74–5 (c,1) D 26 '88
Sports Illus 70:2–3 (c,1) Je 12 '89
Sports Illus 71:24–5 (c,2) Ag 21 '89
Sports Illus 72:34–5, 41 (c,3) My 21 '90
Sports Illus 73:31 (c,2) O 8 '90
Sports Illus 74:50 (c,3) Ap 1 '91
Sports Illus 74:98–9, 111 (c,1) Ap 15 '91

Sports Illus 74:22–3 (c,1) My 6 '91
Sports Illus 74:56 (c,4) Je 17 '91
—Fielding goofs
Sports Illus 68:28–9 (c,3) My 2 '88
—Fighting
Sports Illus 67:14–17 (c,1) Jl 20 '87
Sports Illus 73:12–17 (c,1) Ag 27 '90
Sports Illus 75:23 (c,3) Ag 26 '91
—Hitting
Sports Illus 66:34–5 (c,2) Ja 19 '87
Sports Illus 66:45, 74–5 (c,2) Ap 6 '87
Sports Illus 68:cov. (c,1) Mr 7 '88
Sports Illus 68:46–8 (c,3) Ap 4 '88
Sports Illus 69:24–5 (c,2) Ag 1 '88
Sports Illus 70:2–3 (c,1) My 29 '89
Sports Illus 71:18–23 (c,1) Jl 10 '89
Sports Illus 71:34–9, 45 (c,1) O 16 '89
—Hitting home run
Sports Illus 66:42–3, 50 (c,2) Je 1 '87
Life 10:78–9 (c,1) Ag '87
Sports Illus 67:18–19 (c,1) S 21 '87
Sports Illus 67:31 (c,1) O 19 '87
Sports Illus 67:76–7 (c,1) D 28 '87
Sports Illus 73:68–72 (c,1) S 24 '90
Sports Illus 74:21 (c,1) Je 24 '91
Sports Illus 75:22–3 (c,1) S 23 '91
—Home run ball going over fence
Sports Illus 67:24 (c,2) Ag 17 '87
—Don Larsen pitching perfect game (1956)
Sports Illus 71:12 (3) O 2 '89
Sports Illus 71:84 (4) O 9 '89
—Mascot
Sports Illus 67:36–7 (c,1) Jl 6 '87
—Minor league
Sports Illus 71:32–7 (c,1) Jl 24 '89
Trav/Holiday 174:62–9 (c,1) Jl '90
Sports Illus 73:cov., 6–7, 32–88 (c,1) Jl 23
 '90
Nat Geog 179:cov., 40–73 (c,1) Ap '91
—Missing catch
Sports Illus 72:38 (c,3) Ap 23 '90
—Parachute landing on field of 1986 World
 Series game
Sports Illus 71:132 (c,4) O 9 '89
—Pitching
Sports Illus 66:18 (c,1) Ap 27 '87
Sports Illus 68:74 (c,1) Je 6 '88
Sports Illus 69:44 (c,1) Ag 22 '88
Sports Illus 69:22–5 (c,1) S 26 '88
Sports Illus 70:cov., 19 (c,1) My 1 '89
Sports Illus 73:18–19 (c,1) Ag 13 '90
Life 13:23 (painting,c,4) S '90
Sports Illus 73:20–1, 23 (c,1) S 3 '90
Sports Illus 74:24–7 (c,1) Mr 11 '91
Sports Illus 74:2–3, 125 (c,1) Ap 15 '91
Smithsonian 22:104 (c,2) Ap '91
Sports Illus 74:36–7 (c,1) My 13 '91
Sports Illus 75:cov., 14–15, 35 (c,1) Jl 1
 '91

Sports Illus 75:2–3 (c,1) Jl 8 '91
Sports Illus 75:22–3 (c,1) S 9 '91
—Pitching (1936)
Sports Illus 66:112 (4) Ap 20 '87
—Pitching no-hitter
Life 14:98 (c,4) Ja '91
—Pouring champagne on winners
Sports Illus 66:95 (c,4) Ja 12 '87
—Running
Sports Illus 67:cov. (c,1) O 5 '87
—Senior Pro baseball
Sports Illus 71:28–33 (c,1) N 20 '89
—Sliding
Sports Illus 66:21 (c,2) Ap 27 '87
Sports Illus 67:62–3 (c,1) Jl 6 '87
Sports Illus 67:2–3 (c,1) D 28 '87
Sports Illus 75:18–19 (c,1) S 30 '91
Sports Illus 75:24–5 (c,2) N 4 '91
—Sliding into home plate
Sports Illus 67:22–3 (c,1) Ag 17 '87
Sports Illus 67:31–5 (c,2) N 2 '87
Sports Illus 74:18–19 (c,1) Je 24 '91
—Split-finger pitch
Sports Illus 66:95 (c,4) Ja 12 '87
—Spring training
Sports Illus 68:cov., 30–5 (c,1) Mr 7 '88
Trav/Holiday 171:62–7 (c,1) F '89
Sports Illus 70:58–67 (c,2) Mr 27 '89
Sports Illus 74:2–3, 18–23 (c,1) Mr 4 '91
—Stealing base
Sports Illus 66:37 (c,4) My 25 '87
Sports Illus 71:32–3 (c,2) O 16 '89
Sports Illus 72:28 (c,4) Ap 16 '90
Sports Illus 72:22 (c,3) My 7 '90
Sports Illus 73:25 (c,3) Jl 9 '90
Sports Illus 73:60–6 (c,1) O 1 '90
Sports Illus 73:28 (c,4) O 8 '90
Sports Illus 74:2–3 (c,1) My 6 '91
Sports Illus 75:20–1 (c,1) Ag 26 '91
—Stealing base (1909)
Life 11:118 (4) Fall '88
—Strike zone diagrams
Sports Illus 66:36–46 (c,2) Ap 6 '87
—Tagging runner out
Sports Illus 67:20–1 (c,1) O 12 '87
Sports Illus 67:33 (c,4) O 19 '87
Sports Illus 67:28–9 (c,4) N 2 '87
Sports Illus 67:94–5 (c,1) D 28 '87
Sports Illus 68:40 (c,3) Je 27 '88
Sports Illus 70:21 (c,3) My 1 '89
Sports Illus 72:18–19 (c,1) Ap 30 '90
Sports Illus 72:32 (c,4) Je 11 '90
—Taiwan
Sports Illus 75:65–72 (c,4) Ag 19 '91
—Umpire school (Florida)
Sports Illus 68:12 (c,4) F 22 '88
—Umpires
Sports Illus 67:25, 87–7 (c,4) Jl 6 '87
Sports Illus 67:2–3 (c,1) O 26 '87

—Upended catcher
Sports Illus 75:21 (c,1) O 28 '91
Sports Illus 75:68–9 (c,1) D 30 '91
—Watching 1952 World Series in Chicago
bar
Life 12:66–7 (1) Mr '89
—World Series 1905 (New York Giants vs.
Philadelphia)
Sports Illus 75:47, 50 (c,4) O 7 '91
—World Series 1920 (Cleveland vs.
Brooklyn)
Sports Illus 71:80 (4) O 9 '89
—World Series 1922 (N.Y. Giants vs. N.Y.
Yankees)
Sports Illus 73:56 (4) O 15 '90
—World Series 1932 (N.Y. Yankees vs.
Chicago Cubs)
Sports Illus 71:84 (4) O 9 '89
—World Series 1939 (N.Y. Yankees vs.
Cincinnati)
Sports Illus 71:58 (4) O 9 '89
—World Series 1941 (N.Y. Yankees vs.
Brooklyn Dodgers)
Sports Illus 71:80 (4) O 9 '89
Sports Illus 75:2 (3) O 7 '91
—World Series 1946 (St. Louis vs. Boston)
Sports Illus 73:62 (4) O 15 '90
—World Series 1948 (Cleveland vs. Bos-
ton)
Sports Illus 71:71 (4) O 9 '89
—World Series 1952 (N.Y. Yankees vs.
Brooklyn Dodgers)
Sports Illus 71:66 (4) O 9 '89
Sports Illus 73:64 (4) O 15 '90
—World Series 1954 (New York Giants vs.
Cleveland)
Sports Illus 66:78 (4) Ap 6 '87
Sports Illus 71:42–3 (3) N 15 '89
—World Series 1956 (N.Y. Yankees vs.
Brooklyn Dodgers)
Sports Illus 71:12 (3) O 2 '89
Sports Illus 71:84 (4) O 9 '89
—World Series 1960 (New York vs. Pitts-
burgh)
Sports Illus 68:92 (4) My 23 '88
Sports Illus 69:74 (2) O 10 '88
Sports Illus 71:70–1 (1) N 15 '89
Sports Illus 75:4 (4) O 14 '91
—World Series 1965 (Los Angeles vs. Min-
nesota)
Sports Illus 69:75 (4) O 10 '88
—World Series 1967 (St. Louis vs. Boston)
Sports Illus 75:54, 56 (c,4) O 7 '91
—World Series 1968 (Detroit vs. St. Louis)
Sports Illus 67:94–5 (c,2) D 14 '87
Sports Illus 69:13 (4) O 17 '88
Sports Illus 75:58 (c,4) O 7 '91
—World Series 1969 (New York vs. Balti-
more)

Sports Illus 71:108 (c,4) N 15
'89
—World Series 1971 (Pittsburgh vs. Balti-
more)
Sports Illus 67:62 (c,4) O 12 '87
—World Series 1972 (Oakland vs. Cincin-
nati)
Sports Illus 75:58 (c,3) S 16 '91
—World Series 1973 (Oakland vs. New
York)
Sports Illus 69:71, 80 (c,2) O 10 '88
—World Series 1975 (Cincinnati vs. Bos-
ton)
Sports Illus 67:70 (c,3) O 12 '87
Sports Illus 71:64 (c,4) O 9 '89
—World Series 1978 (N.Y. Yankees vs.
Los Angeles)
Sports Illus 67:67 (c,4) O 12 '87
—World Series 1979 (Pittsburgh vs. Balti-
more)
Sports Illus 69:81 (c,2) O 10 '88
—World Series 1985 (Kansas City vs. St.
Louis)
Sports Illus 71:62 (c,4) O 9 '89
Life 12:145 (c,4) Fall '89
—World Series 1986 (New York Mets vs.
Boston)
Life 10:16–17 (c,1) Ja '87
Sports Illus 66:111–23 (painting,c,1) Ap
6 '87
Sports Illus 67:57 (c,2) O 12 '87
Sports Illus 71:51, 56 (c,4) O 9 '89
—World Series 1987 (Minnesota vs. St.
Louis)
Sports Illus 67:cov., 2–3, 46–53 (c,1) O
26 '87
Sports Illus 67:cov., 26–41 (c,1) N 2 '87
Sports Illus 67:104–9 (c,1) D 28 '87
Life 11:127 (c,4) Ja '88
—World Series 1988 (Dodgers vs.
Oakland)
Sports Illus 69:2–3, 36–46 (c,1) O 24 '88
Sports Illus 69:cov., 32–7 (c,1) O 31 '88
Sports Illus 73:47, 72 (c,4) O 15 '90
—World Series 1989 (Oakland vs. San
Francisco)
Sports Illus 71:2–3, 34–9 (c,1) O 23 '89
Sports Illus 71:22–5 (c,1) O 30 '89
Sports Illus 71:24–7 (c,2) N 6 '89
—World Series 1990 (Cincinnati vs.
Oakland)
Sports Illus 73:cov., 2–3, 18–31 (c,1) O
29 '90
—World Series 1991 (Minnesota vs. At-
lanta)
Sports Illus 75:cov., 20–5 (c,1) O 28 '91
Sports Illus 75:cov., 2–3, 16–27 (c,1) N 4
'91
Sports Illus 75:68–9 (c,1) D 30 '91

—World Series history
 Sports Illus 67:55–70 (c,2) O 12 '87
 Sports Illus 73:47–72 (c,4) O 15 '90
BASEBALL—PROFESSIONAL—HU-
 MOR
—Giving baseball signals
 Sports Illus 74:74–80 (painting,c,1) Ap
 15 '91
BASEBALL BATS
 Sports Illus 66:2–3 (c,1) Ap 27 '87
 Sports Illus 67:41 (c,4) Ag 24 '87
—Aluminum bats
 Sports Illus 71:16–23 (c,1) Jl 24 '89
 Sports Illus 71:112 (c,4) N 15 '89
—Famous bats from baseball history
 Sports Illus 70:90–1, 115 (c,2) Je 12 '89
—Ted Williams's bat (1960)
 Sports Illus 71:68–9 (c,3) N 15 '89
BASEBALL CARDS
 Sports Illus 69:80–2 (c,4) Jl 4 '88
BASEBALL GLOVES
 Sports Illus 70:2–3, 16–17 (c,1) Ap 5 '89
 Sports Illus 72:2–3, 67–82 (drawing,c,1)
 My 7 '90
—1950
 Sports Illus 72:37 (c,4) Ap 16 '90
—Adored baseball glove up on pedestal
 Sports Illus 72:2–3 (painting,c,1) My 7
 '90
—Gloves of famous players
 Sports Illus 70:92–3 (c,1) Je 12 '89
—Making baseball gloves
 Sports Illus 74:82–4 (c,4) Je 24 '91
—Repairing gloves
 Sports Illus 66:148, 152 (c,4) Ap 6 '87
BASEBALL PLAYERS
—19th cent.
 Natur Hist 98:20 (4) N '89
—1915
 Sports Illus 71:54 (4) O 9 '89
—1928
 Trav&Leisure 20:106 (4) O '90
—1950s
 Sports Illus 66:82–9 (c,2) Je 1 '87
 Sports Illus 72:cov., 26 (c,1) Ap 16 '90
 Smithsonian 22:117–21 (3) Jl '91
—Claymation figures of baseball players
 Sports Illus 70:42–50 (c,1) Ap 5 '89
—Luke Easter
 Smithsonian 22:117–27 (c,3) Jl '91
—History of baseball uniforms
 Sports Illus 70:108–18 (c,1) Ap 5 '89
—Little League (1950)
 Life 12:10 (3) Je '89
—See also
 BERRA, YOGI
 COBB, TY
 DEAN, DIZZY
 DIMAGGIO, JOE

DOUBLEDAY, ABNER
DUROCHER, LEO
GEHRIG, LOU
JACKSON, SHOELESS JOE
JOHNSON, WALTER
KOUFAX, SANDY
MARIS, ROGER
MANTLE, MICKEY
MATHEWSON, CHRISTY
ROBINSON, JACKIE
RUTH, GEORGE HERMAN (BABE)
PAIGE, SATCHEL
STENGEL, CASEY
WILLIAMS, TED
YOUNG, CY
BASEBALL TEAMS
—1883
 Sports Illus 73:79 (2) Jl 23 '90
—1911 college team
 Sports Illus 74:86 (3) Mr 18 '91
—1920
 Sports Illus 74:56 (4) My 6 '91
—1920s Yankees
 Sports Illus 73:134 (4) S 3 '90
—1923
 Sports Illus 75:100 (4) O 21 '91
—1940
 Sports Illus 74:54–5 (1) My 6 '91
—1964
 Sports Illus 71:76–7 (c,1) S 25 '89
—Bahamas
 Trav&Leisure 17:77 (c,4) Ja '87
BASEBALLS
—Doubleday Ball
 Sports Illus 70:100–1 (c,1) Je 12 '89
—Man holding seven baseballs in one hand
 Sports Illus 70:55 (c,4) My 29 '89
BASEL, SWITZERLAND
—Stylized depiction
 Gourmet 50:53 (drawing,c,2) Ja '90
—Town hall
 Gourmet 47:78 (c,4) D '87
BASKET WEAVING
—1830s style (Massachusetts)
 Trav/Holiday 168:63 (c,4) O '87
—Hopi Indians (Arizona)
 Trav/Holiday 170:40–1 (c,2) Ag '88
—South Carolina
 Nat Geog 172:754–5 (c,1) D '87
BASKETBALL
—1960 Olympics (Rome)
 Sports Illus 69:71–4 (3) Ag 29 '88
—1988 Olympics (Seoul)
 Sports Illus 69:91–7 (c,2) O 10 '88
—Ball stuck in playground net (Maryland)
 Life 14:88 (c,2) Ag '91
—Basketball camp
 Sports Illus 75:50–1 (c,2) Jl 15 '91
—Basketball inventor James Naismith

Sports Illus 70:28–9 (c,1) Je 26 '89
—Coaches
Sports Illus 69:105, 110 (c,1) N 7 '88
—Dunking
Sports Illus 68:37 (c,2) Ja 11 '88
Sports Illus 71:55 (c,1) N 6 '89
Sports Illus 72:33 (c,1) F 12 '90
Sports Illus 73:84–5 (c,1) D 31 '90
Sports Illus 74:2–3 (c,1) F 18 '91
Sports Illus 74:28–9, 32 (c,1) Mr 11 '91
Sports Illus 74:2–3 (c,1) Je 3 '91
—Fighting
Sports Illus 68:72–3, 76 (c,2) F 8 '88
—History
Sports Illus 75:104–20 (c,1) D 2 '91
—Jump Ball
Sports Illus 68:18–19 (c,1) Je 20 '88
—NBA Playoffs 1987 (Lakers vs. Celtics)
Sports Illus 66:cov., 18–23 (c,1) Je 15 '87
Sports Illus 66:cov., 2–3, 14–21 (c,1) Je 22 '87
Sports Illus 75:22 (c,4) N 18 '91
—NBA Playoffs 1988 (Pistons vs. Lakers)
Sports Illus 68:18–23 (c,1) Je 13 '88
Sports Illus 68:13–23 (c,1) Je 20 '88
Sports Illus 68:cov., 2–3, 22–31 (c,1) Je 27 '88
Sports Illus 69:58–9, 62 (c,2) Jl 4 '88
—NBA Playoffs 1989 (Pistons vs. Lakers)
Sports Illus 70:cov., 2–3, 24–31 (c,1) Je 5 '89
Sports Illus 70:30–1, 37–8 (c,2) Je 12 '89
Sports Illus 70:22–5 (c,2) Je 19 '89
Sports Illus 70:28–30 (c,1) Je 26 '89
—NBA Playoffs 1990 (Pistons vs. Trailblazers)
Sports Illus 72:26–8, 33 (c,1) Je 18 '90
Sports Illus 72:2–3, 32–4 (c,1) Je 25 '90
—NBA Playoffs 1991 (Bulls vs. Lakers)
Sports Illus 74:cov., 18–23 (c,1) Je 10 '91
Sports Illus 74:cov., 2–3, 28–33 (c,1) Je 17 '91
Sports Illus 74:38–49 (c,1) Je 24 '91
Sports Illus 75:54, 60–1, 90–1 (c,1) D 30 '91
—Shooting
Sports Illus 68:33 (c,1) Je 6 '88
Sports Illus 74:cov. (c,1) Mr 11 '91
—Strategy planned on magnetic board
Sports Illus 68:2–3 (c,1) My 30 '88
BASKETBALL—PROFESSIONAL—HUMOR
Sports Illus 67:66–9 (drawing,c,1) N 9 '87
Sports Illus 70:96–102 (drawing,c,1) Mr 20 '89
BASKETBALL COURTS
Sports Illus 66:40–1 (c,2) Ja 5 '87
BASKETBALL PLAYERS
Sports Illus 70:2–3 (c,1) Mr 6 '89

—Print of basketball player's hand on placemat (Indiana)
Sports Illus 68:6–7 (c,1) Mr 21 '88
—7'7" basketball player
Sports Illus 71:186 (c,4) N 15 '89
—See also
CHAMBERLAIN, WILT
BASKETBALL TEAMS
—1948 professional team
Sports Illus 71:132 (4) N 6 '89
—1960 U.S. Olympic team
Sports Illus 69:71 (4) Ag 29 '88
BASKETBALLS
Sports Illus 66:36–45 (drawing,c,1) Mr 2 '87
Sports Illus 72:98 (c,3) Mr 19 '90
—Aerial view of ball in hoop
Sports Illus 66:32–3 (c,2) Mr 9 '87
Sports Illus 67:52–3 (c,1) N 9 '87
Sports Illus 68:28–9 (c,2) Mr 21 '88
Sports Illus 68:30 (c,3) Ap 4 '88
—Twirling on finger
Sports Illus 66:69 (c,4) Je 22 '87
BASKETS
—Africa
Trav/Holiday 167:16 (c,2) Ja '87
—Botswana
Nat Geog 178:48–9 (c,2) D '90
—Venezuela
Gourmet 50:64 (c,4) F '90
BASS (FISH)
Nat Wildlife 27:56 (c,3) D '88
—Rockfish
Natur Hist 97:72–3 (painting,c,2) N '88
Nat Geog 177:33–5 (c,1) F '90
BASSETT, RICHARD
Life 10:55 (painting,4) Fall '87
BATH, ENGLAND
Natur Hist 97:37 (c,4) Ap '88
—Museum of English Folk Art
Gourmet 50:68 (c,3) Jl '90
—Pulteney Bridge
Gourmet 50:90 (c,3) My '90
BATH, MAINE
Am Heritage 42:28 (c,4) S '91
BATHING
—At Czech spas
Nat Geog 171:125, 146 (c,1) Ja '87
—Athlete in whirlpool
Sports Illus 67:86–7 (c,1) S 9 '87
—Bathing an elephant (India)
Nat Geog 179:16–17 (c,2) My '91
—Bathing baby in street (Hanoi, Vietnam)
Nat Geog 176:586–7 (c,1) N '89
—Bathing children in tub (Alaska)
Nat Geog 177:48–9 (1) F '90
—Bathing in Narmada River, India
Smithsonian 21:119 (c,2) N '90
—Children at beach (Pitcairn Island)

Smithsonian 18:102 (c,2) F '88
—Children in fire hydrant fountain (New York)
Life 14:51 (2) Fall '91
—Children in river (Brazil)
Nat Geog 174:810–11 (c,1) D '88
—Children playing in ocean (Papua New Guinea)
Trav&Leisure 17:78 (c,3) Mr '87
—Children under sprinkler
Nat Wildlife 29:24 (c,4) Je '91
Trav/Holiday 175:78 (c,4) Je '91
—Ganges River, Benares, India
Trav&Leisure 19:90, 124 (c,1) Jl '89
Life 13:59 (c,4) D '90
—Geothermal pond (Iceland)
Nat Geog 171:184–5 (c,1) F '87
—Hot peat bath (West Germany)
Nat Geog 171:420 (c,4) Mr '87
—Hot springs (Antarctica)
Nat Geog 177:24–5 (c,1) Ap '90
—Hot springs (Japan)
Nat Geog 175:427 (c,4) Ap '89
Nat Geog 176:642–3 (c,1) N '89
Trav/Holiday 172:78 (c,2) D '89
—Hot springs (Yellowstone, Wyoming)
Trav&Leisure 19:112–13 (c,1) Mr '89
—Hot tubs in cable car (Japan)
Trav/Holiday 172:80 (c,4) D '89
—In hot tub (California)
Trav/Holiday 169:74 (c,4) Ja '88
—In irrigation tank (Arizona)
Smithsonian 20:46 (c,4) Ja '90
—In luxurious hotel bathtub (Hong Kong)
Trav&Leisure 18:112–13 (c,1) Ja '88
—In outdoor tub (Australia)
Nat Geog 179:25 (c,1) Ja '91
—In street (Romania)
Life 13:86 (c,4) Ap '90
—Jacuzzi at spa (California)
Trav&Leisure 18:141 (c,1) Mr '88
—Man in bubble bath
Life 13:52–3 (c,1) S '90
Sports Illus 73:2–3 (c,1) D 10 '90
—Matis Indians showering (Brazil)
Natur Hist 99:60 (c,4) Ag '90
—Men in steam bath (London, England)
Nat Geog 180:42–3 (c,1) Jl '91
—Mud bath
Life 10:26–7 (c,1) F '87
Nat Geog 177:121 (c,4) Mr '90
—Navy recruits in cold shower (California)
Life 14:14–15 (1) F '91
—Nude children at beach (Bahamas)
Trav&Leisure 20:82–3, 155 (c,1) Jl '90
—Playing in fire hydrant water (Washington, D.C.)
Life 13:71 (1) Spring '90

—Pouring water jug on self (Oman)
Nat Geog 176:244–5 (c,1) Ag '89
—Sand bathing (Japan)
Trav/Holiday 172:74–9 (c,1) D '89
—Thermal baths (Budapest, Hungary)
Nat Geog 174:928 (c,2) D '88
—Thermal spa (Römerbad, Austria)
Gourmet 48:84 (c,4) D '88
—Under waterfall (Florida)
Trav&Leisure 17:109 (c,1) D '87
—Woman in bathtub (France)
Sports Illus 69:80–1 (c,2) S 14 '88
—See also
BATHS
BATHTUBS
BEACHES, BATHING
SAUNAS
SWIMMING
SWIMMING POOLS
BATHING—HUMOR
—History of bathing
Smithsonian 21:126–35 (painting,c,1) F '91
BATHING SUITS
Life 10:77–80 (c,1) F '87
Sports Illus 66:cov., 2–4, 98–131 (c,1) F 9 '87
Sports Illus 68:cov., 78–111 (c,1) F 15 '88
Sports Illus 70:entire issue (c,1) F 10 '89
Sports Illus 72:cov., 98–133 (c,1) F 12 '90
Sports Illus 74:cov., 90–130 (c,1) F 11 '91
—1908
Smithsonian 19:81 (painting,c,3) Ap '88
—1917
Am Heritage 41:59 (1) Jl '90
—1920s bathing suit ad
Am Heritage 39:43 (c,3) D '88
—1922
Am Heritage 41:120 (3) My '90
—1940
Life 13:85 (2) Jl '90
—1953 (Yugoslavia)
Life 11:70–1 (1) Mr '88
—Bathing cap
Sports Illus 69:48–9 (c,1) Jl 18 '88
—Child wearing bathing cap (U.S.S.R.)
Trav/Holiday 174:49 (c,3) Ag '90
—History
Sports Illus 70:20–34 (c,2) F 10 '89
Am Heritage 41:cov., 59–67 (c,1) Jl '90
—U.S.S.R.
Life 11:13 (c,2) N '88
Nat Geog 177:30–1 (c,1) Mr '90
BATHROOMS
—1787 commode cabinet
Life 10:30 (c,4) Fall '87
—19th cent. chamber pots
Am Heritage 39:50 (drawing,4) S '88

Sports Illus 66:2–3 (c,1) My 18 '87
—Martinique
Trav/Holiday 175:50–1 (c,1) Ja '91
—Maui, Hawaii
Trav/Holiday 170:64 (c,3) S '88
—Nude beach (Australia)
Nat Geog 173:210–11 (c,1) F '88
—Picnic on beach
Gourmet 49:cov. (c,1) Jl '89
—Positano, Italy
Trav&Leisure 18:64–5 (c,1) Ag '88
—Rhodes, Greece
Trav/Holiday 170:57 (c,2) S '88
—Rio de Janeiro, Brazil
Trav/Holiday 167:43 (c,1) F '87
Trav&Leisure 17:LA4 (c,4) N '87 supp.
—St. Barts
Trav/Holiday 172:56–7 (c,2) D '89
Trav&Leisure 20:120–1 (c,1) D '90
—St. Lucia
Trav/Holiday 171:61 (c,2) F '89
—St. Martin
Trav/Holiday 167:42 (c,4) F '87
—St. Tropez, France
Trav&Leisure 18:108–9, 114–17 (c,1) Je
'88
Gourmet 51:75 (c,3) Je '91
—Sardinia, Italy
Trav&Leisure 18:138–9 (c,1) Ap '88
—Sydney, Australia
Smithsonian 18:139 (c,2) Ja '88
—Virginia Beach, Virginia
Nat Geog 178:88–9 (c,2) O '90
—Waikiki, Honolulu, Hawaii
Trav&Leisure 19:80, 84–5 (c,1) Ja '89
Trav/Holiday 173:42–3 (c,1) Mr '90
Trav/Holiday 174:78–9 (c,1) O '90
—See also
BATHING SUITS
LIFEGUARDS
RESORTS
BEAGLES
Smithsonian 18:115, 117 (c,1) Je '87
Life 12:102–3 (c,1) S '89
—Beagling (Virginia)
Sports Illus 74:8 (c,4) Ja 14 '91
BEARDS
—Fluffy white beard (Romania)
Nat Geog 179:30 (c,4) Mr '91
—Macau
Trav&Leisure 18:104–5 (c,1) Ja '88
BEARS
Trav/Holiday 169:62–3 (c,2) F '88
Nat Geog 180:99 (c,1) D '91
—Bear on utility pole
Life 12:111–12 (c,1) O '89
—Bear shopping in supermarket
Life 13:104 (2) Jl '90
—Black bears

Nat Wildlife 26:60 (c,1) Ap '88
Nat Wildlife 26:55 (c,1) O '88
Nat Wildlife 27:2 (c,2) Ag '89
Smithsonian 20:49 (c,1) S '89
Natur Hist 98:60–5 (c,1) S '89
Nat Wildlife 28:4–11 (c,1) Ap '90
Nat Geog 177:90 (c,4) Je '90
—Brown
Nat Wildlife 25:60 (c,1) Ap '87
Smithsonian 20:56–65 (c,1) Ap '89
Life 14:4–5, 84 (c,1) Summer '91
Nat Wildlife 30:40–1 (c,1) D '91
—Brown bear fighting with gulls over fish
Nat Wildlife 28:10–11 (c,1) Je '90
—Brown bears catching salmon
Nat Wildlife 26:50 (c,4) D '87
Natur Hist 98:112–13 (c,1) O '89
Trav/Holiday 174:59 (c,2) Jl '90
Nat Wildlife 29:10–11 (c,1) F '91
—Circus bears walking upright
Natur Hist 99:64–5 (1) Mr '90
—Gypsy with dancing bear (Bulgaria)
Nat Geog 176:344 (c,2) S '89
—In movie "The Bear" (1989)
Life 12:89–91 (c,1) Spring '89
—Silhouette of black bear
Natur Hist 99:80–1 (c,1) Jl '90
—Sloth bears
Smithsonian 22:129 (c,4) Ag '91
—Spectacled bear
Nat Wildlife 29:15 (c,4) F '91
—See also
GRIZZLY BEARS
POLAR BEARS
BEARS—HUMOR
—Bears drunk on fermented corn
Nat Wildlife 26:28 (painting,c,2) Ap '88
BEATLES
Trav&Leisure 21:19 (4) d '91
—See also
LENNON, JOHN
BEAUFORT, SOUTH CAROLINA
Trav/Holiday 175:58–65 (map,c,1) My
'91
BEAUMONT, WILLIAM
—Home (Lebanon, Connecticut)
Am Heritage 40:90–1 (c,1) Ap '89
BEAUTY CONTESTS
—1920 float at first Miss America Pageant
(New Jersey)
Am Heritage 39:108 (2) Mr '88
—Indiana
Sports Illus 75:31 (c,3) S 9 '91
—"Little Miss Italia" contest (Utica, New
York)
Nat Geog 178:55 (c,3) N '90
—Miss Texas competition
Life 13:56–7 (c,1) S '90
—Miss Waxachie, Texas

Life 12:100–1 (c,1) F '89
—Ms. Pennsylvania Senior contest
Life 13:94–104 (c,1) D '90
—South Africa
Nat Geog 174:574–5 (c,1) O '88
BEAUTY PARLORS
—Hair dryer (Louisiana)
Life 12:86 (c,2) O '89
—Shanghai, China
Trav&Leisure 17:80–1 (1) Ag '87
—See also
BARBER SHOPS
HAIRDRESSING
HAIRSTYLES
BEAUVOIR, SIMONE DE
Life 10:120 (4) Ja '87
BEAVERS
Nat Wildlife 29:34–7 (c,1) Ap '91
—1777 depiction of Canadian beaver hunt-
ing (Great Britain)
Nat Geog 172:209 (engraving,c,1) Ag '87
BEDFORD, GUNNING
Smithsonian 18:35 (drawing,4) Jl '87
Life 10:55 (painting,c,4) Fall '87
BEDOUINS (DUBAI)
—Watching World Cup soccer on tel-
evision
Life 13:92–3 (c,1) Ag '90
BEDOUINS (EGYPT)—COSTUME
Natur Hist 96:24–33 (c,1) Jl '87
BEDOUINS (JORDAN)—COSTUME
Trav/Holiday 172:46–7 (c,2) O '89
BEDOUINS (SAUDI ARABIA)—COS-
TUME
Nat Geog 172:423–4, 436–7 (c,1) O '87
BEDROOMS
—1870 cadet's room (West Point, New
York)
Am Heritage 39:50 (4) Ap '88
—Antebellum bedroom (West Virginia)
Trav/Holiday 170:20 (c,4) Jl '88
—Honoré de Balzac's château bedroom
(France)
Gourmet 47:53 (c,1) S '87
—Boys studying at desks (Japan)
Smithsonian 17:50–1 (c,2) Mr '87
—College basketball player (Indiana)
Sports Illus 66:2–3 (c,1) Ap 13 '87
—11-year-old girl's room (Missouri)
Life 12:49 (c,3) N '89
—French villa
Smithsonian 17:50 (c,1) Ja '87
—Gaddafi's bombed out bedroom (Libya)
Life 10:12 (c,4) N '87
—Victor Hugo's chamber (Guernsey)
Smithsonian 18:82 (c,4) Ap '87
—Prep school dorm room (Virginia)
Sports Illus 66:81 (c,4) F 16 '87
—Priest's bedroom (Illinois)

Life 14:56 (c,2) Ag '91
—Teenagers' rooms
Life 11:106 (c,3) S '88
Sports Illus 69:67 (c,3) O 10 '88
Sports Illus 71:2–3 (c,1) D 25 '89
BEDS
—18th cent. bed of Marie Antoinette (Ver-
sailles, France)
Nat Geog 176:36–7 (c,2) Jl '89
—Early 19th cent. four-poster (South Car-
olina)
Am Heritage 41:35 (c,1) S '90
—Early 20th cent. Ellis Island cots, New
York
Life 13:30–1 (c,2) S '90
—British canopied bed (British Columbia)
Trav/Holiday 168:69 (c,4) N '87
—Canopied four-poster
Trav&Leisure 17:104 (c,4) D '87
Trav/Holiday 170:46 (c,3) N '88
—Covered with mosquito netting (Carib-
bean)
Trav&Leisure 19:174–5 (c,1) O '89
—Cupboard bed (Sweden)
Gourmet 47:59 (c,4) Jl '87
—Elegant hotel (Washington, D.C.)
Trav&Leisure 17:120–1 (c,1) My '87
—Four-poster (Great Britain)
Trav&Leisure 18:124 (c,4) Ap '88
Trav&Leisure 20:25 (c,4) D '90
—Ho Chi Minh's deathbed (Hanoi, Viet-
nam)
Nat Geog 176:575 (c,4) N '89
—Abraham Lincoln's bed (Springfield, Illi-
nois)
Am Heritage 40:79 (c,3) Ap '89
—96″ long bed
Sports Illus 67:16 (c,4) D 7 '87
—Summer camp bunks
Smithsonian 21:88, 94 (c,4) Ag '90
Life 14:52–3 (c,2) Jl '91
—Woman making her bed (Maine)
Nat Geog 177:98–9 (c,2) F '90
—See also
HAMMOCKS
BEECH TREES
—Coigue
Natur Hist 96:42–7 (c,1) S '87
BEEKEEPING
Smithsonian 18:62–74 (c,1) Jl '87
BEER INDUSTRY
—Beer companies sponsoring sports
Sports Illus 69:2–3, 68–82 (c,1) Ag 8 '88
—Brewery exterior (Great Britain)
Trav&Leisure 19:122 (c,3) My '89
—Matis Indians making corn beer (Brazil)
Natur Hist 99:54–5 (c,1) Ag '90
BEERBOHM, MAX
—Sketch of Swinburne and Gosse

Smithsonian 19:158 (drawing,c,4) Je '88
BEES
Smithsonian 18:62–74 (c,1) Jl '87
Nat Geog 178:85 (c,4) Jl '90
Natur Hist 99:54–5 (c,1) D '90
—Bee dancing to communicate food locations
Nat Geog 177:134–40 (c,1) Ja '90
—Bees preserved in amber
Natur Hist 97:86 (c,4) S '88
—Comb
Natur Hist 99:52–3 (c,1) D '90
—Covering man in bee bearding contest (New Jersey)
Nat Wildlife 25:12–13 (c,1) Ag '87
—Desert bees
Natur Hist 98:68–74 (c,1) Mr '89
—Harvesting honey from honeybees (Nepal)
Nat Geog 174:cov., 660–71 (c,1) N '88
Natur Hist 99:56–7 (c,1) D '90
—Killer bees
Smithsonian 22:116–18, 122, 126 (painting,c,1) S '91
—Numbered honeybees
Natur Hist 99:120–1 (c,1) Ap '90
—Robot bee used to study bee communications
Nat Geog 177:134–40 (c,1) Ja '90
—See also
BUMBLEBEES
BEETLES
Nat Wildlife 26:58 (c,4) D '87
Natur Hist 97:90–3 (c,1) Mr '88
Nat Wildlife 26:7 (c,4) Ap '88
Nat Geog 175:791, 795 (c,4) Je '89
Natur Hist 99:44–6 (c,1) F '90
Smithsonian 21:218 (c,4) Ap '90
Natur Hist 99:89–93 (c,1) Ap '90
Life 13:66 (c,4) My '90
Natur Hist 100:38–45 (c,1) My '91
—Bombardier beetle
Nat Wildlife 28:44–5 (c,1) Ag '90
—Burying beetles
Natur Hist 98:32–7 (c,1) Je '89
—Fossil beetle fragments
Natur Hist 99:14 (c,3) Ja '90
—Live beetles worn as jewelry (Mexico)
Smithsonian 18:116 (c,4) Je '87
—Painting by Dürer
Natur Hist 98:82 (c,3) S '89
—Palmetto beetle
Nat Wildlife 28:50–1 (c,1) Ag '90
—Tree damage caused by bark beetles
Natur Hist 98:56–7 (c,1) Ja '89
—See also
FIREFLIES
LADYBUGS
WEEVILS

BEGGARS
—New York City, New York
Life 11:76–83 (1) N '88
BEGONIAS
Nat Geog 176:56–7 (c,1) Jl '89
BEIJING, CHINA
—Railroad station
Nat Geog 173:310 (c,4) Mr '88
BEIRUT, LEBANON
—Clearing debris from street
Life 14:16 (c,2) F '91
—Spent ammunition cartridges on street
Life 10:6–7 (c,1) My '87
BELAU ISLANDS
Trav/Holiday 168:60–5 (map,c,1) D '87
Trav/Holiday 172:66–7 (c,1) S '89
BELÉM, BRAZIL
Trav/Holiday 168:61–3 (c,2) Jl '87
—Ver-o-Pêso
Nat Geog 171:378–9 (c,1) Mr '87
BELGIUM
—Bouillon Castle
Nat Geog 176:332–3 (c,1) S '89
—Country inn
Gourmet 50:90–3 (c,1) Je '90
—Tournai
Trav/Holiday 173:41 (c,3) Ap '90
—See also
ANTWERP
BRUGES
BRUSSELS
GHENT
YPRES
BELGIUM—COSTUME
—Mardi Gras Gilles (Binche)
Trav/Holiday 172:44 (c,4) D '89
BELIZE
Trav&Leisure 21:82 (c,4) Ja '91
Smithsonian 22:86–100 (c,1) N '91
—Glover Reef
Nat Geog 176:432–3 (c,1) O '89
—Sites associated with the Maya
Nat Geog 176:424–505 (map,c,1) O '89
Smithsonian 20:98–113 (c,1) D '89
Trav/Holiday 175:52 (c,4) Je '91
—Stylized depiction of Belize
Trav&Leisure 18:88 (drawing,c,3) Mr '88
BELIZE—MAPS
Trav&Leisure 18:92 (c,4) Mr '88
Trav&Leisure 21:78 (c,4) S '91
BELIZE CITY, BELIZE
Trav/Holiday 175:50–1, 55 (map,c,1) Je '91
BELL, ALEXANDER GRAHAM
Nat Geog 173:10–11, 38, 43 (4) Ja '88
Am Heritage 39:46 (4) Mr '88
Nat Geog 174:287, 358–85 (1) S '88
—Bell's 1876 patent for the telephone

Am Heritage 41:46, 52 (c,4) S '90
—Home (Nova Scotia)
　Nat Geog 174:380–1 (c,1) S '88
—Inventions by him
　Nat Geog 174:368–79 (c,1) S '88
—Scenes from his life
　Nat Geog 174:358–85 (c,1) S '88
BELLBIRDS
　Natur Hist 96:54–60 (c,1) Je '87
BELLINI, GENTILE
—"Madonna and Child"
　Trav&Leisure 18:28 (painting,c,2) Jl '88
BELLOW, SAUL
　Trav/Holiday 174:39 (c,4) Jl '90
BELLOWS, GEORGE WESLEY
—"Dempsey and Firpo" (1924)
　Am Heritage 40:110 (painting,c,4) S '89
BELLS
—771 A.D. huge bronze bell (Korea)
　Trav/Holiday 167:26 (c,4) Ja '87
—11th cent. bell tower (Collioure, France)
　Trav/Holiday 173:85 (c,4) Ja '90
—1940s ship's bell
　Smithsonian 22:20 (c,4) N '91
—Apartment doorbells (Italy)
　Trav/Holiday 175:54 (c,4) F '91
—Bell foundry (France)
　Gourmet 47:66 (c,4) My '87
—Bell tower (Andalusia, Spain)
　Trav&Leisure 19:cov. (c,1) Ag '89
—Farm dinner bell (Kansas)
　Nat Geog 179:101 (c,3) Mr '91
—See also
　LIBERTY BELL
BELUGAS
　Life 10:6 (c,4) Ag '87
　Nat Geog 174:904–7 (c,1) D '88
　Nat Geog 175:595 (c,3) My '89
　Nat Geog 180:24 (c,3) Jl '91
BENTON, THOMAS HART
　Trav&Leisure 17:101 (c,2) Jl '87
　Am Heritage 40:12 (drawing,4) Jl '89
—"July Hay" (1943)
　Trav&Leisure 17:100 (painting,c,2) Jl
　'87
—Paintings by him
　Smithsonian 20:cov., 82–101 (c,1) Ap '89
—Self-portraits
　Smithsonian 20:82, 100 (painting,c,2) Ap
　'89
BERGEN, NORWAY
　Trav&Leisure 18:94–5 (c,1) Je '88
BERGMAN, INGRID
　Smithsonian 20:70 (4) Ap '89
　Life 12:40–1 (1) Spring '89
　Am Heritage 42:94 (drawing,c,1) D '91
BERING SEA
—Bering Strait
　Nat Geog 174:476–7 (c,2) O '88

BERING SEA—MAPS
　Natur Hist 97:10 (c,3) Ja '88
BERLIN, IRVING
　Life 13:112 (1) Ja '90
　Life 13:110 (1) Fall '90
BERLIN, GERMANY
　Trav&Leisure 17:90–9, 152–4, 160–3
　(map,c,1) S '87
　Trav&Leisure 19:79–88 (c,3) F '89
　Trav/Holiday 174:66–73 (map,c,1) S '90
—Brandenburg Gate
　Life 13:8–9 (c,1) D '90
—Charlottenburg Castle courtyard
　Trav&Leisure 17:90–1, 156 (c,1) S '87
—Gestapo building
　Nat Geog 180:34–5 (c,1) S '91
—Night scene
　Nat Geog 180:13 (c,4) S '91
—Old Reichstag building
　Trav&Leisure 17:95 (c,4) S '87
—Pergamon Museum
　Smithsonian 22:76–90 (c,1) O '91
—Spandau prison
　Life 10:42 (c,2) O '87
BERLIN WALL, GERMANY
　Sports Illus 69:12–13 (c,2) S 14 '88
　Sports Illus 71:19–20 (c,2) N 27 '89
　Nat Geog 177:106–15 (c,1) Ap '90
　Trav/Holiday 174:70–1 (c,1) S '90
—1961
　Life 13:121–4 (2) Ja '90
—Covered with graffiti
　Trav&Leisure 17:98–9 (c,1) S '87
—Destroying symbolic Berlin Wall at rock
　concert
　Trav&Leisure 21:112–13 (c,1) Ja '91
—Dismantling border fence (1991)
　Nat Geog 180:11 (c,3) S '91
—East Berliners destroying Berlin Wall
　(1989)
　Life 13:8–9, 132–3 (c,1) Ja '90
　Nat Geog 177:108–15 (c,1) Ap '90
　Smithsonian 21:83 (c,4) Mr '91
—Sections of dismantled wall
　Life 14:118–19 (c,1) Ja '91
　Nat Geog 179:12–13 (c,1) Mr '91
—Soldier letting child through barbed wire
　(1961)
　Nat Geog 177:118 (4) Ap '90
BERBER PEOPLE
—Morocco
　Trav&Leisure 17:92–3 (c,3) Mr '87
BERMUDA
　Trav/Holiday 171:9–10 (c,3) F '89
　Gourmet 50:80–5, 176–8 (map,c,1) Mr
　'90
　Trav&Leisure 21:120–35, 138(map,c,1)
　F '91
　Trav/Holiday 176:80–5 (map,c,1) S '91

—Natural Arches
Trav&Leisure 21:120–1 (c,1) F '91
—Warwick Long Bay rocks
Trav&Leisure 19:28 (c,4) F '89
—See also
HAMILTON
BERMUDA—ARCHITECTURE
—Mid 17th cent. house
Am Heritage 40:28 (c,4) N '89
BERMUDA—COSTUME
Trav&Leisure 19:28, 39 (c,4) F '89
Trav&Leisure 21:122–31 (c,1) F '91
BERMUDA—HOUSING
—Brightly painted houses
Trav&Leisure 21:130–1 (c,2) F '91
BERMUDA—MAPS
Trav&Leisure 19:63 (c,2) Ap '89
BERN, SWITZERLAND
—Railroad station
Trav&Leisure 20:188 (c,4) S '90
BERNHARDT, SARAH
Life 11:57 (4) Fall '88
Nat Geog 176:167 (4) Jl '89
Am Heritage 40:53–65 (1) Jl '89
—Posters promoting her 1905–1911 U.S.
tours
Am Heritage 40:56, 60, 65, 114 (c,4) Jl
'89
BERNINI, GIOVANNI LORENZO
—Statue of Prosperine
Smithsonian 19:22 (c,3) Ap '88
BERNSTEIN, LEONARD
Life 11:40–4 (c,1) S '88
Trav&Leisure 20:87 (4) Ag '90
Life 13:10 (1) Fall '90
Life 14:102–3 (c,4) Ja '91
Smithsonian 21:73 (4) F '91
BERRA, YOGI
Sports Illus 67:10 (c,4) D 21 '87
Sports Illus 69:6 (4) O 3 '88
Life 13:83 (c,4) My '90
Smithsonian 22:70 (4) Ag '91
BERRIES
—Wild berries
Nat Wildlife 26:52–9 (c,1) O '88
—See also
BLUEBERRIES
CRANBERRIES
MULBERRIES
RASPBERRIES
STRAWBERRIES
BEVERLY HILLS, CALIFORNIA
Trav&Leisure 18:cov., 103–13, 174
(map,c,1) My '88
—Beverly Hills sign
Trav/Holiday 168:20 (c,4) D '87
Trav&Leisure 18:110 (c,4) My '88
—Humorous view of poolside lifestyle
Trav&Leisure 17:54 (drawing,c,4) Ja '87

—Rodeo Drive
Trav&Leisure 21:16 (c,2) Ja '91
BHUTAN
Nat Geog 179:78–101 (map,c,1) My '91
—Building a road
Life 11:86–95 (c,1) Mr '88
—See also
HIMALAYA MOUNTAINS
THIMPHU
BHUTAN—COSTUME
Life 11:86–95 (c,1) Mr '88
Nat Geog 179:80–99 (c,1) My '91
—King Jigme Singye Wangchuck
Nat Geog 179:80–1 (c,1) My '91
BIBLES
—Late 18th cent. (Great Britain)
Smithsonian 18:97 (c,4) F '88
—1801 illustrated psalm (Pennsylvania)
Am Heritage 40:29 (c,2) F '89
—1836 Bible
Life 14:60–1 (c,4) Summer '91
—Algonquin translation of Bible (1685)
Am Heritage 41:62 (4) N '90
—Bible scenes on Sistine Chapel frescoes,
Vatican
Nat Geog 176:688–713 (c,1) D '89
—Bible used for 1789 Washington in-
auguration
Life 12:8 (c,3) F '89
—Creation sculpture by Hart (Washington,
D.C.)
Smithsonian 21:116–17 (c,1) Je '90
—Founding site of the Gideon Association
(Wisconsin)
Am Heritage 42:105 (c,4) Ap '91
—Garden of Eden
Smithsonian 18:127–34 (map,c,1) My '87
—Gideon Bible
Am Heritage 42:104 (4) Ap '91
—Hand-held electronic Bible
Life 12:12 (c,4) D '89
—Simon the Tanner's house, Jaffa, Israel
Trav&Leisure 21:91 (c,2) Jl '91
—Wildlife reserve of Bible animals (Israel)
Smithsonian 20:106–15 (c,2) F '90
—See also
ADAM AND EVE
ANGELS
CHRISTIANITY
DEAD SEA SCROLLS
JESUS CHRIST
JUDAISM
NOAH'S ARK
SAINTS
BICYCLE INDUSTRY
—Bicycle plant (Vietnam)
Nat Geog 176:584–5 (c,1) N '89
BICYCLE RACES
Sports Illus 66:58 (c,2) Je 29 '87

Sports Illus 69:20 (c,4) S 14 '88
Sports Illus 71:24 (c,3) Ag 7 '89
—1988 Olympics (Seoul)
Sports Illus 69:85 (c,4) O 3 '88
Sports Illus 69:123 (c,3) O 10 '88
—High-wheel bicycles (Scotland)
Life 13:2–3 (c,1) Ag '90
—Indiana
Smithsonian 18:75 (c,3) Je '87
—Racers covered with mud (Switzerland)
Sports Illus 69:103 (c,1) D 26 '88
—World Mountain Bike Championships
1990 (Colorado)
Sports Illus 73:38–9 (c,2) S 24 '90
—Wyoming
Sports Illus 71:53–9 (c,2) Jl 17 '89
BICYCLE TOURS
—Tour de France
Gourmet 49:72 (painting,c,2) Jl '89
—Tour de France 1987
Sports Illus 67:54–5 (c,4) Jl 20 '87
Sports Illus 67:2–3, 22–3 (c,1) Ag 3 '87
Sports Illus 67:74–5 (c,1) D 28 '87
—Tour de France 1988
Nat Geog 176:132–7 (c,1) Jl '89
—Tour de France 1989
Sports Illus 71:210–11 (c,1) N 15 '89
Sports Illus 71:54–72 (c,1) D 25 '89
—Tour de France 1990
Sports Illus 73:cov., 16–21 (c,1) Jl 30 '90
—Tour de France 1991
Sports Illus 75:2–3, 26–31 (c,1) Ag 5 '91
—Tour de Trump 1989
Sports Illus 70:32–9 (map,c,1) My 22 '89
Sports Illus 71:cov., 12–17 (c,1) Jl 31 '89
—Tour de Trump 1990
Sports Illus 72:2–3, 42–7 (c,1) My 21 '90
—Tour du Pont 1991
Sports Illus 74:42, 45 (c,3) My 27 '91
BICYCLES
—1900 oak bicycle
Life 12:70 (c,4) Jl '89
—1911 tricycle
Life 14:72 (4) Jl '91
—Postman's bicycle
Gourmet 51:98 (drawing,4) Jl '91
—Tricycle decorated for Independence
Day (California)
Nat Geog 173:79 (c,2) Ja '88
BICYCLING
—19th cent. woman on bicycle
Sports Illus 66:30 (4) F 9 '87
—1940 (California)
Life 13:86–7 (1) Jl '90
—Along old railroad bridge (Iowa)
Nat Wildlife 26:40–1 (c,1) Ag '88
—Alsace, France
Gourmet 50:79–80 (c,1) Ap '90
—Bicycling through fire (Australia)

Life 12:102–3 (c,1) Jl '89
—Biking along old rail corridors
Smithsonian 21:132–6 (c,3) Ap '90
—Blind cyclist
Sports Illus 70:82 (c,3) Mr 6 '89
—Carrying bicycles on bike (China)
Sports Illus 69:38 (c,4) Ag 15 '88
—Child learning to ride
Life 11:98 (3) F '88
—China
Trav&Leisure 18:107 (c,4) Ja '88
Trav/Holiday 171:40–4 (c,1) My '89
—Dog riding in basket (New Jersey)
Trav/Holiday 169:54 (c,4) My '88
—Family bicycling (Alaska)
Nat Geog 173:380 (c,3) Mr '88
—Fat Tire Bike Week (Colorado)
Trav/Holiday 171:18 (c,4) Ja '89
—Father and daughter on minibike (Wash-
ington)
Nat Geog 176:813 (c,1) D '89
—Hawaii
Trav/Holiday 170:65 (c,3) S '88
—Hotel room service by bicycle (Cali-
fornia)
Trav&Leisure 18:140–1 (c,1) D '88
—Man on unicycle (Nova Scotia)
Trav&Leisure 20:90 (c,4) Ap '90
—Massachusetts
Trav&Leisure 19:97 (c,3) Je '89
Smithsonian 20:81 (c,1) Ag '89
Trav&Leisure 20:NY1 (c,3) Ag '90
—Netherlands
Trav/Holiday 168:53 (c,4) Ag '87
—New York City, New York
Life 10:44–5 (c,1) Ap '87
—Northern California
Trav&Leisure 21:122–40 (c,1) Mr '91
—On ice (Northwest Territories)
Trav&Leisure 18:138–9 (c,1) O '88
—Panda on bicycle (China)
Trav&Leisure 17:82–3 (4) Ag '87
Trav/Holiday 173:98 (c,4) Ja '90
—Pulling children in cart
Sports Illus 68:60 (c,4) My 30 '88
Trav&Leisure 21:126–7 (1) Je '91
—Toddlers in bicycle seats
Sports Illus 66:44 (c,4) My 25 '87
—Tourists (France)
Trav&Leisure 18:144–50, 158 (c,1) O
'88
—Unicycle (California)
Sports Illus 67:63 (c,3) S 7 '87
Smithsonian 18:113 (c,1) S '87
—Utah
Life 10:48 (c,2) F '87
Trav/Holiday 169:49–51 (c,1) Je '88
—Vietnam
Nat Geog 176:558–60, 603 (c,1) N '89

BIDDLE, NICHOLAS
Am Heritage 41:82 (painting,c,4) N '90
—Home (Pennsylvania)
Am Heritage 41:80–7 (c,1) N '90
BIERSTADT, ALBERT
Smithsonian 21:88 (4) F '91
—Malkasten home, Irvington-on-Hudson,
New York
Smithsonian 21:89 (engraving,4) F '91
—Painting of sequoias (1870s)
Life 10:59 (c,4) O '87
—Paintings by him
Am Heritage 40:96–7 (c,1) D '89
Smithsonian 21:86–97 (c,1) F '91
—"Sunrise, Yosemite Valley" (1860s)
Smithsonian 21:38–9 (painting,c,2) Ap
'90
BIG BEN CLOCK TOWER, LONDON,
ENGLAND
Life 13:4–5 (c,1) Ap '90
BIG BEND NATIONAL PARK, TEXAS
Life 14:50–5 (c,1) Summer '91
Trav&Leisure 21:122–32 (map,c,1) S '91
BILLIARD PLAYING
Sports Illus 68:84 (c,2) F 22 '88
Smithsonian 20:158–69 (c,1) N '89
—1880s pool table (California)
Am Heritage 41:74 (c,4) Ap '90
—1959
Sports Illus 71:64 (3) N 15 '89
—Brazil
Nat Geog 174:786 (c,4) D '88
—Chile
Nat Geog 174:66–7 (c,1) Jl '88
—Cue stick construction
Smithsonian 20:160–1 (c,4) N '89
—Family at garage pool table
Nat Geog 179:22–3 (c,1) Ja '91
—Father teaching toddler
Sports Illus 66:33 (c,4) Ja 26 '87
—Missouri pool hall (1983)
Nat Geog 175:206–7 (1) F '89
—Nuns playing snooker (Great Britain)
Life 12:8 (4) O '89
—Snooker (Scotland)
Sports Illus 73:6–8 (c,3) O 29 '90
—Snooker table
Gourmet 50:70 (painting,c,2) My '90
—Tibet
Nat Geog 174:691 (c,3) N '88
BILLY THE KID
Am Heritage 41:14 (drawing,4) Ap '90
Smithsonian 21:137–48 (c,3) F '91
Am Heritage 42:65 (4) Ap '91
—Sites associated with Billy the Kid (New
Mexico)
Am Heritage 42:65–78 (map,c,4) Ap '91
—Tombstone (New Mexico)
Am Heritage 42:78 (c,4) Ap '91

BINGHAM, GEORGE CALEB
—"Jolly Boatmen in Port" (1857)
Natur Hist 96:38–9 (painting,c,1) My '87
Trav/Holiday 173:97 (painting,c,4) F '90
Smithsonian 20:54–5 (painting,c,1) Mr
'90
—Paintings by him
Smithsonian 20:42–55 (c,3) Mr '90
—Self-portrait
Smithsonian 20:44 (painting,c,4) Mr '90
BINOCULARS
—Coin-operated viewers (Vermont)
Trav/Holiday 174:46–7 (c,2) Jl '90
—Man peering at birds through binoculars
Trav&Leisure 20:88 (painting,c,3) Mr
'90
—Sports fan looking through binoculars
Sports Illus 69:70–1 (c,2) N 14 '88
—Tern watching bird watcher (Manitoba)
Life 13:128 (c,2) Je '90
BIOLOGY
—Biological biomechanics
Smithsonian 20:98–105 (c,1) Jl '89
—See also
ANATOMY
CELLS
EVOLUTION
GENETICS
REPRODUCTION
BIRCH TREES
Life 14:85 (c,1) F '91
BIRD CAGES
—19th cent.
Smithsonian 22:136 (c,4) D '91
—Hong Kong
Trav&Leisure 18:128 (c,4) Ja '88
Gourmet 49:56 (painting,c,2) Ap '89
—Mexico
Nat Geog 176:442 (c,4) O '89
BIRD FEEDERS
Nat Wildlife 29:44 (c,2) F '91
Smithsonian 22:146–7 (c,3) N '91
BIRD HOUSES
—Antebellum bird mansion (Georgia)
Trav/Holiday 169:71 (c,4) Je '88
—Bluebird nesting boxes (Montana)
Nat Wildlife 26:34–5 (c,2) Je '88
—Kestrel nest box
Nat Wildlife 29:18, 22 (c,4) Ag '91
—Purple martin homes
Nat Wildlife 28:20–4 (c,2) Ag '90
—Quebec
Trav&Leisure 19:121 (c,4) Ag '89
BIRD NESTS
Nat Wildlife 25:42–9 (c,1) Ap '87
—Bird next in traffic light
Natur Hist 96:108–9 (c,1) N '87
Nat Wildlife 28:2 (c,2) Ag '90
—Bush tit nest

—State birds
 Smithsonian 18:210 (painting,c,4) F '88
—Stealing birds' eggs from nests (Great
 Britain)
 Smithsonian 22:50–63 (c,1) Ap '91
—U.S. postage stamps featuring birds
 Smithsonian 18:210 (c,4) F '88
—See also
 ALBATROSSES
 AUKS
 AVOCETS
 BELLBIRDS
 BIRD NESTS
 BIRDS OF PARADISE
 BITTERNS
 BLACKBIRDS
 BLUE JAYS
 BLUEBIRDS
 BOOBY BIRDS
 BOWERBIRDS
 BULLFINCHES
 BUNTINGS
 CANADA GEESE
 CARACARAS
 CARDINALS
 CHATS
 CHICKADEES
 CHICKENS
 CHICKS
 COCKATOOS
 CONDORS
 CORMORANTS
 COWBIRDS
 CRANES
 CROWS
 CUCKOOS
 CURLEWS
 DODO BIRDS
 DOVES
 DUCKS
 EAGLES
 EGRETS
 FALCONS
 FEATHERS
 FINCHES
 FLAMINGOS
 FLICKERS
 FRIGATE BIRDS
 GANNETS
 GEESE
 GOLDFINCHES
 GOSHAWKS
 GREBES
 GROUSE
 GUILLEMOTS
 GULLS
 HARRIERS
 HAWKS
 HERONS
 HOATZINS
 HUMMINGBIRDS
 IBISES
 JACANAS
 JAYS
 JUNCOS
 KESTRELS
 KINGFISHERS
 KITES
 KITTIWAKES
 LOONS
 MACAWS
 MAGPIES
 MALLARDS
 MARTINS
 MOAS
 MOCKINGBIRDS
 MUD HENS
 MURRES
 ORIOLES
 OSPREYS
 OSTRICHES
 OWLS
 OYSTER CATCHERS
 PARAKEETS
 PARROTS
 PEACOCKS
 PELICANS
 PENGUINS
 PETRELS
 PHEASANTS
 PIGEONS
 PLOVERS
 PRAIRIE CHICKENS
 PTARMIGANS
 PUFFINS
 QUAIL
 QUETZALS
 RAILS
 RAVENS
 REDSTARTS
 REDWINGED BLACKBIRDS
 RHEAS
 ROAD RUNNERS
 ROBINS
 ROOSTERS
 RUFFS
 SANDERLINGS
 SANDPIPERS
 SAPSUCKERS
 SHEARWATERS
 SHRIKES
 SKIMMERS
 SKUAS
 SNIPES
 SPARROWS
 SPOONBILLS
 STARLINGS
 STORKS

SWALLOWS
SWANS
TANAGERS
TERNS
THRUSHES
TITMICE
TOUCANS
TURKEYS
VIREOS
VULTURES
WARBLERS
WAXWINGS
WHOOPING CRANES
WOOD DUCKS
WOODCOCKS
WOODPECKERS
WRENS
YELLOWTHROATS
BIRD—HUMOR
—Birds carrying other birds during migration
Nat Wildlife 25:38–40 (drawing,c,1) O '87
—Mythical versions of common birds
Natur Hist 99:70–5 (painting,c,4) Ap '90
—Starlings' rowdy behavior
Nat Wildlife 28:24–7 (painting,c,1) Ap '90
Smithsonian 21:76–83 (painting,c,1) S '90
—Woodpeckers attacking utility poles
Nat Wildlife 27:22 (painting,c,2) F '89
BIRDS, ENDANGERED
—Guam Micronesian kingfishers
Nat Wildlife 26:12–13 (painting,c,1) Ag '88
—Guam rails
Smithsonian 22:113, 119 (c,3) Ag '91
—See also
CONDORS
WHOOPING CRANES
BIRDS, EXTINCT
—Last dusky seaside sparrow
Life 11:105 (c,4) Ja '88
—'O'o-'a'a bird
Nat Geog 175:697 (c,4) Je '89
—Pterosaurs
Natur Hist 97:cov., 58–65 (painting,c,1) D '88
—Species wiped out by snakes (Guam)
Nat Wildlife 26:14–15 (painting,c,4) Ag '88
—See also
DODO BIRDS
MOAS
BIRDS OF PARADISE
Natur Hist 100:30 (c,2) Je '91
BIRDS-OF-PARADISE FLOWERS
Natur Hist 97:76 (painting,c,4) S '88

BIRTHDAY PARTIES
—Boys at party (1963)
Life 14:87 (c,4) Je '91
—Breaking piñata (Nicaragua)
Life 10:134 (4) D '87
—Circus theme child's party
Life 11:cov., 90–5 (c,1) Ag '88
—John F. Kennedy's 45th birthday party (1962)
Life 10:66–70 (1) Je '87
—Mickey Mouse's 60th birthday party
Trav/Holiday 170:10 (c,4) S '88
—One-year-old eating cake
Life 13:126 (c,3) My '90
—Royal child blowing out candles (Great Britain)
Life 13:54–5 (c,1) O '90
BISMARCK, OTTO VON
Smithsonian 21:88 (4) Mr '91
BISON
Nat Wildlife 26:5 (c,1) D '87
Life 11:67 (c,3) Ag '88
Nat Geog 175:cov. (c,1) F '89
Sports Illus 70:48–50 (c,2) Mr 13 '89
Smithsonian 20:42 (c,4) S '89
Natur Hist 99:62–3 (c,2) Je '90
Nat Geog 179:106 (c,3) Mr '91
Trav&Leisure 21:84–6 (c,1) Ap '91
Nat Geog 180:14–16, 24–6 (c,1) O '91
—Extinct bison species
Life 12:64–5 (painting,c,4) Ap '89
Natur Hist 99:38–41 (c,1) Jl '90
—Huge concrete statue (North Dakota)
Nat Geog 171:326 (c,4) Mr '87
BITTERNS
—Least bittern chicks
Nat Wildlife 29:2 (c,2) Ap '91
BLACK, HUGO
Life 14:63 (4) Fall '91
BLACK AMERICANS
Life 11:entire issue (c,1) Spring '88
—1900 family portrait (Georgia)
Am Heritage 40:118 (3) Ap '89
—1930s (Harlem, New York)
Smithsonian 21:160 (4) F '91
—1930s (Mississippi)
Life 12:58–64 (1) N '89
—1940 Johnson paintings of black life
Smithsonian 22:142 (c,4) S '91
—1940s U.S. Air Force pilot
Smithsonian 21:20 (4) Mr '91
—Black athletes
Sports Illus 75:cov., 38–77 (c,1) Ag 5 '91
Sports Illus 75:40–6 (c,4) Ag 19 '91
—Black dreadlocks (Pennsylvania)
Nat Geog 178:87 (4) Ag '90
—Black pride graffiti (Atlanta, Georgia)
Nat Geog 174:14–15 (c,1) Jl '88

—Blacks listening to Malcolm X speech
(1963)
Smithsonian 20:74 (4) Ap '89
—Bluesman Robert Johnson
Am Heritage 42:50, 56 (1) Jl '91
—Clara McBride (Mother) Hale
Nat Geog 176:218 (2) Ag '89
—Inventions by black Americans (1948–
1923)
Smithsonian 20:212 (c,4) S '89
—Life in Harlem, New York City, New
York
Nat Geog 177:cov., 52–75 (c,1) My '90
—Lifestyle of middle-class blacks (Geor-
gia)
Life 11:46–50 (c,1) Spring '88
——90-year-old black musician (Texas)
Nat Geog 177:62–3 (c,1) Je '90
—Philadelphia, Pennsylvania
Nat Geog 178:66–90 (1) Ag '90
—Prominent black women
Life 11:54–63 (1) Spring '88
Nat Geog 176:206–25 (1) Ag '89
—Prominent blacks in the arts
Life 11:72–7 (c,1) Spring '88
—Sea Island lifestyle, South Carolina/
Georgia
Natur Hist 96:68 (2) S '87
Nat Geog 172:734–63 (c,1) D '87
Life 11:110–11 (c,1) Spring '88
BLACK-EYED SUSANS
Nat Wildlife 25:26 (drawing,c,4) Ap '87
Nat Wildlife 28:57 (c,4) Ap '90
BLACK FOREST, WEST GERMANY
Gourmet 47:48–9, 52–3 (c,1) F '87
Trav/Holiday 167:28 (c,4) My '87
Trav/Holiday 169:27 (c,4) Mr '88
—Effects of air pollution
Nat Geog 171:506–7 (c,1) Ap '87
BLACK HISTORY
—1863 Emancipation Proclamation
Life 11:6–7 (c,1) Spring '88
—1865 sculpture of freed female slave
(Georgia)
Am Heritage 42:4 (c,2) Jl '91
—Late 19th cent. personalities
Nat Geog 173:18–19 (c,1) Ja '88
—1890 blacks (Virginia)
Am Heritage 38:42–3 (1) My '87
—1915 black cavalry "Buffalo Soldiers"
Smithsonian 20:62–3 (2) Ag '89
—Mum Bett
Am Heritage 41:51, 55 (painting,c,4) Mr
'90
—Black Americans of the Old West
Smithsonian 20:58–69 (c,1) Ag '89
—Black Civil War soldiers
Am Heritage 39:65–73, 114 (c,3) F '88
Am Heritage 39:8 (lithograph,4) Ap '88

Smithsonian 2146–61 (c,1) O '90
—"Black Like Me" story by John Howard
Griffins (1959)
Am Heritage 40:44–55 (1) F '89
—Black migration north (1915–1940)
Smithsonian 18:72–83 (c,1) My '87
—Black Power salute at 1968 Olympics
Sports Illus 71:106 (c,4) N 15 '89
Sports Illus 75:60–1, 77 (1) Ag 5 '91
Sports Illus 75:60–1 (1) Ag 12 '91
—Depicted in Jacob Lawrence paintings
Smithsonian 18:56–67 (c,2) Je '87
—Flag of black Civil War regiment
Am Heritage 39:114 (c,4) F '88
—History of Black Seminoles
Smithsonian 22:90–101 (c,1) Ag '91
—See also
ABOLITIONISTS
BLACK AMERICANS
BLACKS IN AMERICAN HISTORY
CIVIL RIGHTS
CIVIL RIGHTS MARCHES
CIVIL WAR
KU KLUX KLAN
LYNCHINGS
SLAVERY
BLACKBEARD
—Death of Blackbeard (1718)
Am Heritage 38:54 (painting,c,4) F '87
BLACKBIRDS
Nat Wildlife 27:47 (c,2) Je '89
BLACKBOARDS
—1960s
Smithsonian 18:104 (4) S '87
BLACKFEET INDIANS—COSTUME
Smithsonian 20:176, 178 (c,4) N '89
BLACKFEET INDIANS—RITES AND
FESTIVALS
—Blackfeet Indian rite of naming child
Life 14:12–13 (c,1) O '91
Blacks in American History. See
ALI, MUHAMMAD
ANDERSON, MARIAN
ARMSTRONG, LOUIS
BALDWIN, JAMES
BROWN, JIM
CARVER, GEORGE WASHINGTON
CHAMBERLAIN, WILT
DAVIS, MILES
DAVIS, SAMMY, JR.
DOUGLASS, FREDERICK
DU BOIS, W. E. B.
DUNBAR, PAUL LAURENCE
ELLINGTON, DUKE
FITZGERALD, ELLA
GARVEY, MARCUS
GIBSON, ALTHEA
GILLESPIE, JOHN BIRKS (DIZZY)
HOLIDAY, BILLIE

HUGHES, LANGSTON
JOHNSON, JACK
KING, MARTIN LUTHER, JR.
LOUIS, JOE
MALCOLM X
MONK, THELONIOUS
OWENS, JESSE
PAIGE, SATCHEL
PARKER, CHARLIE
PARKS, ROSA
PRICE, LEONTYNE
ROBESON, PAUL
ROBINSON, JACKIE
TRUTH, SOJOURNER
TUBMAN, HARRIET
WASHINGTON, BOOKER T.
BLACKSMITHS
—18th cent. (Great Britain)
 Smithsonian 21:54 (painting,c,4) S '90
—Late 19th cent. (Vermont)
 Am Heritage 41:116–17 (1) N '90
—1934 (Texas)
 Am Heritage 38:44 (4) Jl '87
—1976 blacksmith shoeing horse (Missouri)
 Nat Geog 175:198–9 (1) F '89
—Antique blacksmith's tools
 Smithsonian 21:59 (c,4) F '91
—Shoeing buffalo (India)
 Nat Geog 177:130–1 (c,1) My '90
—Shoeing horse (Italy)
 Trav/Holiday 173:73 (c,4) F '90
BLADDERWORT PLANTS
 Nat Geog 171:413 (c,1) Mr '87
 Natur Hist 99:79–80 (c,3) F '90
BLAIR, JOHN
 Life 10:56 (painting,c,4) Fall '87
BLAKELOCK, RALPH
 Smithsonian 18:82 (4) D '87
—Paintings by him
 Smithsonian 18:80–91 (c,1) D '87
BLANKETS
—Mid 19th cent. Navajo blanket
 Am Heritage 40:25 (c,2) Jl '89
—Phosphorescent comforter
 Life 11:16 (c,4) N '88
BLIGH, WILLIAM
—1789 "Mutiny on the Bounty"
 Smithsonian 18:92–8 (painting,c,1) F '88
BLIMPS. See
 AIRSHIPS
BLINDNESS
—1865 typewriter for the blind
 Smithsonian 21:60 (c,4) D '90
—1909 blind man following guide (New Mexico)
 Smithsonian 21:127 (1) My '90
—Blind child touching Liberty Bell
 Life 13:8 (c,3) Ap '90

—Blind children (Bhutan)
 Nat Geog 179:88 (c,2) My '91
—Blind children (Malawi)
 Nat Geog 176:389 (c,4) S '89
—Blind cyclist
 Sports Illus 70:82 (c,3) Mr 6 '89
—Blind girl playing hopscotch (Ohio)
 Life 12:7 (3) D '89
—Blind man with guide dog
 Life 11:73–80 (c,3) Jl '88
—Deaf and blind children
 Life 13:88–98 (1) O '90
—Reading Braille
 Smithsonian 19:166 (c,4) My '88
—See also
 KELLER, HELEN
BLIZZARDS
 Nat Wildlife 28:50–1 (painting,c,1) O '90
—1888 (Nebraska)
 Smithsonian 18:72–3 (4) Mr '88
—1888 (New York City)
 Smithsonian 18:70–81 (c,1) Mr '88
 Am Heritage 39:34 (4) Mr '88
 Life 11:40 (1) Mr '88
—Disastrous 1931 blizzard (Colorado)
 Am Heritage 39:81–94 (drawing,2) F '88
BLOODROOT PLANTS
 Life 13:66 (c,4) My '90
BLOOMER, AMELIA
 Am Heritage 38:58 (drawing,4) D '87
BLOUNT, WILLIAM
 Life 10:56 (painting,c,4) Fall '87
BLOWGUNS
—Iban blowguns (Borneo)
 Trav/Holiday 172:74–5 (c,3) S '89
BLUE JAYS
 Nat Wildlife 26:42–4 (c,1) D '87
 Nat Wildlife 28:8–9 (c,1) Ag '90
 Nat Wildlife 29:cov. (c,1) D '90
BLUEBELL PLANTS
 Natur Hist 99:84 (c,4) N '90
BLUEBERRIES
 Natur Hist 96:56–9 (c,1) Ag '87
 Natur Hist 97:49 (c,1) Ag '88
BLUEBIRDS
—Fledgling bluebird taking first flight
 Nat Wildlife 28:9 (c,4) Ag '90
BLUEBONNETS (FLOWERS)
 Smithsonian 18:36 (c,1) Ap '87
 Nat Wildlife 25:25 (drawing,c,4) Ap '87
 Life 14:51 (c,4) Summer '91
BLUEFISH
 Nat Wildlife 25:22–4 (c,1) Je '87
BLY, NELLIE
 Nat Geog 173:32 (4) Ja '88
BO TREES
 Smithsonian 18:184 (c,1) F '88
BOA CONSTRICTORS
 Sports Illus 66:182 (c,3) F 9 '87

—*A Connecticut Yankee in King Arthur's Court* (1889)
 Am Heritage 40:97–104 (drawing,4) N '89
—"Cyrano de Bergerac" illustration
 Nat Geog 176:167 (4) Jl '89
—D'Artignon, of *The Three Musketeers*
 Gourmet 48:80 (sculpture,c,4) My '88
—Dr. Seuss book illustrations
 Life 12:105–7 (c,4) Jl '89
—Dolls based on Maurice Sendak's "Wild Things"
 Life 11:50–1 (c,1) Ag '88
—Hardy Boys book illustrations
 Smithsonian 22:54, 56, 58 (c,4) O '91
—Hawaiian sites from *From Here to Eternity*
 Trav/Holiday 173:cov., 42–51 (c,1) Mr '90
—Illuminated pages (Italy)
 Gourmet 47:56 (c,4) F '87
—Illustrations from *Peter Rabbit* stories
 Gourmet 48:62–5, 96 (c,4) Je '88
 Smithsonian 19:80–91 (c,2) Ja '89
—Illustration from Poe's "The Pit and the Pendulum"
 Smithsonian 19:76 (drawing,4) Mr '89
—Joyce's *Ulysses* page proof
 Smithsonian 20:132 (3) Mr '90
—Law office bookshelves
 Sports Illus 67:96–7 (c,1) N 18 '87
—"Little Red Riding Hood"
 Nat Wildlife 25:4 (drawing,4) Ag '87
—Manuscript of *A la Recherche du Temps Perdu* by Proust
 Smithsonian 21:119 (c,4) S '90
—Nazis collecting books for burning (1933)
 Smithsonian 22:94 (4) Jl '91
—Old books on bookshelves
 Trav/Holiday 169:76 (drawing,4) F '88
 Gourmet 50:79 (c,4) F '90
 Trav/Holiday 175:64 (2) Ja '91
—Persian book illustrations (14th–16th cents.)
 Smithsonian 19:122–7 (c,2) Ja '89
—Plague scene from the *Decameron*
 Smithsonian 20:73 (painting,c,4) F '90
—Pop-up books
 Smithsonian 18:208 (c,4) D '87
—Restoring 16th cent. bookbinding (Washington, D.C.)
 Nat Geog 171:250–1 (c,2) F '87
—Scenes from Hugo's *Les Miserables*
 Smithsonian 18:74–7 (c,3) Ap '87
—Shakespeare's Falstaff
 Smithsonian 18:173 (drawing,4) S '87
—Shakespeare's Puck
 Natur Hist 100:4 (drawing,c,4) O '91
—Stack of books

 Trav&Leisure 20:212 (drawing,4) O '90
—Edward Stratemeyer's series for adolescents
 Smithsonian 22:51–61 (c,1) O '91
—Tom Sawyer's fence (Hannibal, Missouri)
 Trav/Holiday 176:50 (4) Jl '91
—Tom Swift book illustrations
 Smithsonian 22:52, 57 (c,4) O '91
—*Treasure Island* illustrations
 Life 10:35 (c,4) Mr '87
 Am Heritage 38:108, 111 (painting,c,4) My '87
 Nat Geog 180:83 (painting,c,2) Jl '91
—*Wind in the Willows* illustrations
 Smithsonian 20:114–15 (c,4) Ja '90
—Yiddish books
 Smithsonian 21:60, 62–6 (c,4) Ja '91
—See also
 BIBLES
 HOLMES, SHERLOCK
 LIBRARIES
 PRINTING INDUSTRY
 READING
 WRITERS
BOONE, DANIEL
 Am Heritage 41:98 (painting,c,3) F '90
 Smithsonian 20:46–7 (painting,c,1) Mr '90
 Am Heritage 41:73 (painting,c,4) N '90
BOOTH, EDWIN
 Am Heritage 40:36 (4) N '89
BOOTH, JOHN WILKES
 Am Heritage 40:36 (4) N '89
 Am Heritage 42:115 (drawing, 1) F '91
—Derringer used to shoot Lincoln
 Life 14:60–1 (c,3) Summer '91
BORDERS
—Cutting barbed wire at Austria/Hungary border
 Nat Geog 177:125 (c,2) Ap '90
—Fence between Hong Kong and China
 Nat Geog 179:126–7 (c,1) F '91
—Maine-Quebec border
 Nat Geog 177:96–9, 118 (c,1) F '90
—See also
 BERLIN WALL
 CUSTOMS OFFICIALS
BORIS III (BULGARIA)
 Life 13:38 (4) Mr '90
BORNEO
 Trav/Holiday 172:72–9 (c,1) S '89
BORNEO—COSTUME
 Trav/Holiday 172:72–9 (c,1) S '89
—Dayak woman with stretched earlobes
 Nat Geog 175:105 (c,4) Ja '89
BOSCH, HIERONYMUS
—Paintings by him
 Smithsonian 18:cov., 40–55 (c,1) Mr '88

——Self-portrait
 Smithsonian 18:52 (drawing,c,4) Mr '88
BOSTON, MASSACHUSETTS
 Am Heritage 40:54–65 (map,c,1) Ap '89
 Nat Geog 177:78–9, 94–5 (map,c,1) Je
 '90
—18th cent. Federal style homes
 Am Heritage 40:68–74 (c,1) My '89
—19th cent. scenes
 Am Heritage 40:54, 60, 65 (c,4) Ap '89
—1899 street scene
 Am Heritage 39:106 (2) Mr '88
—Arnold Arboretum
 Trav&Leisure 18:NY2 (c,4) My '88
—Back Bay Fens
 Nat Geog 177:94–5 (map,c,1) Je '90
—Beacon Hill
 Am Heritage 40:55 (c,1) Ap '89
 Trav/Holiday 173:26 (map,c,4) Je '90
—Boston Athenaeum (1876)
 Am Heritage 41:84–5 (painting,c,1) D
 '90
—Boston Harbor (1870s)
 Am Heritage 42:76 (3) Jl '91
—John F. Kennedy Library
 Life 11:64–9 (c,1) D '88
—North End sights
 Gourmet 48:72 (drawing,c,2) Ap '88
 Trav&Leisure 21:78–83, 106 (map,c,1)
 Ag '91
—Old State House
 Am Heritage 40:65 (c,4) Ap '89
 Smithsonian 21:34 (c,3) Ja '91
—Quincy Market
 Trav/Holiday 167:70 (c,3) My '87
—Sculpture in subway stations
 Smithsonian 18:114–27 (c,1) Ap '87
—State Street traffic
 Smithsonian 21:34 (c,3) Ja '91
—Street scene
 Am Heritage 39:107 (c,2) Mr '88
—Wind damage to Hancock Tower win-
 dows
 Smithsonian 19:122 (c,4) My '88
BOSTON MARATHON
 Sports Illus 66:94–106 (painting,c,1) Ap
 20 '87
—1986
 Trav/Holiday 169:90 (c,4) Mr '88
—1987
 Sports Illus 66:34–5 (c,2) Ap 27 '87
—1988
 Sports Illus 68:98, 100 (c,3) Ap 25 '88
—1990
 Sports Illus 72:48–9 (c,2) Ap 23 '90
—1991
 Sports Illus 74:77 (c,4) Ap 22 '91
BOSTON TEA PARTY (1783)
—Humorous depiction

 Smithsonian 21:68 (painting,c,4) My '90
BOSWELL, JAMES
 Smithsonian 18:254 (painting,c,4) N '87
BOTSWANA
 Nat Geog 178:2–97 (map,c,1) D '90
—Okavango River and Delta
 Trav&Leisure 18:114–21 (map,c,1) My
 '88
 Nat Geog 178:38–69 (map,c,1) D '90
—See also
 KALAHARI DESERT
BOTSWANA—COSTUME
 Nat Geog 178:38–97 (c,1) D '90
—Herero women
 Trav&Leisure 18:121 (c,4) My '88
BOTSWANA—POLITICS AND GOV-
 ERNMENT
—Parliament meeting
 Nat Geog 178:80 (c,4) D '90
BOTTICELLI, SANDRO
—"Birth of Venus"
 Trav&Leisure 17:94 (painting,c,4) Ap
 '87
 Trav&Leisure 19:65 (painting,c,4) O '89
BOTTLES
—1781 (Great Britain)
 Nat Geog 173:818 (c,3) Je '88
—1787 pewter baby bottle
 Life 10:32 (c,4) Fall '87
—Home canning jars
 Gourmet 47:84–5 (c,2) D '87
 Gourmet 48:86–7 (c,1) O '88
—Old-fashioned milk bottles
 Life 12:52–3 (c,3) O '89
—Perfume bottles (France)
 Trav&Leisure 20:66 (c,4) Ap '90
 Smithsonian 22:61 (c,1) Je '91
—Perfume bottles through history
 Smithsonian 22:58–9 (c,4) Je '91
—Recyclable plastic bottles
 Natur Hist 99:83 (c,2) My '90
—See also
 WINE
BOUGAINVILLEA PLANTS
 Gourmet 48:85 (c,4) O '88
 Trav&Leisure 20:125 (c,4) Ap '90
BOWERBIRDS
 Nat Geog 173:285 (c,4) F '88
 Nat Wildlife 27:48–9 (c,1) Je '89
BOWLING
 Sports Illus 66:26–7 (c,4) My 4 '87
 Sports Illus 67:46 (c,3) S 28 '87
 Sports Illus 68:50–9 (c,2) Ja 25 '88
 Sports Illus 69:42 (c,4) Jl 18 '88
 Sports Illus 70:92 (c,4) My 1 '89
—19th cent. home alley (Connecticut)
 Am Heritage 40:147 (c,3) N '89
—1988 Olympics (Seoul)
 Sports Illus 69:20 (c,4) S 26 '88

Sports Illus 72:2–3, 20–1 (c,1) Ja 29 '90
—Foreman-Frazier fight (1973)
 Sports Illus 71:64–5 (c,2) Jl 17 '89
 Sports Illus 71:126 (c,4) N 15 '89
—Graziano-Zale fight (1947)
 Sports Illus 72:15 (4) Je 4 '90
 Life 14:108 (4) Ja '91
—Hearns-Leonard fight (1981)
 Sports Illus 70:50 (c,4) Je 5 '89
—History of boxing
 Am Heritage 42:cov., 69–79 (c,1) O '91
—Holyfield-Cooper fight (1991)
 Sports Illus 75:2–3, 40–1 (c,1) D 2 '91
—Holyfield-Douglas fight (1990)
 Sports Illus 73:76–80 (c,1) N 5 '90
 Life 14:8–9 (c,1) Ja '91
—Holyfield-Foreman fight (1991)
 Sports Illus 74:cov., 22–7 (c,1) Ap 29 '91
—Japan
 Sports Illus 68:20–3 (c,1) Mr 28 '88
—Johnson-Jeffries fight (1910)
 Am Heritage 42:70–1 (c,4) O '91
—Knocked out boxer
 Sports Illus 71:2–3 (c,1) Jl 24 '89
—Landing punch
 Sports Illus 71:90–1 (c,1) D 25 '89
—Leonard-Hagler fight (1987)
 Sports Illus 66:cov., 18–25 (c,1) Ap 13
 '87
 Sports Illus 66:50–3 (c,2) Ap 20 '87
 Life 11:50 (c,4) Ja '88
—Leonard-Hearns fight (1989)
 Sports Illus 70:cov., 18–21 (c,1) Je 19 '89
—Leonard-Lalonde fight (1988)
 Sports Illus 69:36–7 (c,2) N 21 '88
—Liston-Patterson fight (1962)
 Sports Illus 71:83 (4) N 15 '89
 Sports Illus 74:66–76 (c,1) F 4 '91
—Louis-Schmeling fight (1938)
 Am Heritage 39:36 (4) My '88
 Smithsonian 19:170–4 (2) N '88
 Am Heritage 39:6 (4) D '88
—Louis-Walcott fight (1947)
 Am Heritage 42:77 (1) O '91
—Marciano-Charles fight (1954)
 Sports Illus 71:25 (2) N 15 '89
—Patterson-Moore fight (1956)
 Am Heritage 42:110 (2) S '91
—Referees
 Sports Illus 74:46–7 (c,2) Mr 4 '91
 Sports Illus 74:21 (c,2) Mr 25 '91
—Removing warming wrap
 Sports Illus 71:2–3 (c,1) D 18 '89
—Robinson-Basilio fight (1958)
 Sports Illus 71:60–1 (c,1) N 15 '89
—Spinks-Ali fight (1978)
 Sports Illus 71:152 (c,3) N 15 '89
—Spinks-Cooney fight (1987)
 Sports Illus 66:22–3 (c,2) Je 22 '87

—Spinks-Holmes fight (1985)
 Sports Illus 68:67–8 (c,3) Je 20 '88
—Sullivan-Kilrain fight (1889)
 Am Heritage 40:30 (4) Jl '89
 Sports Illus 71:70–2 (4) Jl 3 '89
—Tunney-Dempsey fight (1927)
 Sports Illus 67:10 (4) S 28 '87
—Tyson-Holmes fight (1988)
 Sports Illus 68:cov., 12–15 (c,1) F 1 '88
—Tyson-Ruddock fight (1991)
 Sports Illus 74:cov., 18–23 (c,1) Mr 25 '91
—Tyson-Smith fight (1987)
 Sports Illus 66:20–1 (c,4) Mr 16 '87
—Tyson-Spinks fight (1988)
 Sports Illus 69:cov., 18–25 (c,1) Jl 4 '88
—Tyson-Thomas fight (1987)
 Sports Illus 66:2–3, 26–7 (c,1) Je 8 '87
—Tyson-Tillman fight (1990)
 Sports Illus 72:38–42 (c,1) Je 25 '90
—Tyson-Tucker fight (1987)
 Sports Illus 67:cov., 20–3 (c,1) Ag 10 '87
—Willard-Johnson fight (1915)
 Am Heritage 41:43 (4) Ap '90
BOY SCOUTS
 Life 11:50–1 (c,1) N '88
—Eagle Scouts (Minnesota)
 Nat Geog 174:610 (c,2) O '88
—Great Britain
 Life 13:13 (2) S '90
BRADY, MATHEW
—Photo of General Sherman
 Am Heritage 38:144 (4) My '87
 Am Heritage 42:78 (4) Jl '91
—Photo of Abraham Lincoln
 Life 11:48 (4) Fall '88
—Portrait of Mary Lincoln
 Am Heritage 38:34 (4) S '87
BRAHMANS
 Trav/Holiday 169:44 (c,3) F '88
BRAHMAPUTRA RIVER, ASIA
 Nat Geog 174:672–711 (map,c,1) N '88
BRAIN
—Brain cell
 Smithsonian 20:64 (c,4) Je '89
—Development of brain in human embryo
 Life 13:46 (c,2) Ag '90
—Diagram of autistic brain
 Life 11:63 (4) Ag '88
BRANDEIS, LOUIS
 Am Heritage 42:98–9 (4) O '91
 Life 14:61 (4) Fall '91
BRANDO, MARLON
 Am Heritage 39:53 (4) D '88
 Life 13:64 (1) Fall '90
—In "On the Waterfront" (1954)
 Trav&Leisure 18:126–7 (1) Je '88
 Life 14:70–1 (1) F '91
BRAQUES, GEORGES
 Smithsonian 19:98 (4) Jl '88

Smithsonian 21:72 (painting,c,4) O '90
—Paintings by him
Smithsonian 19:96–107 (c,1) Jl '88
BRASÍLIA, BRAZIL
–National Congress building
Nat Geog 171:364–5 (c,1) Mr '87
BRATISLAVA, CZECHOSLOVAKIA
Gourmet 50:82 (c,2) My '90
BRAZIL
Nat Geog 171:348–85 (map,c,1) Mr '87
—Amazon area
Trav/Holiday 168:60–5 (c,2) Jl '87
Trav/Holiday 173:70–7 (map,c,1) Mr '90
—Bahia
Trav&Leisure 17:LA8 (c,4) N '87 supp.
—Eirunepé
Smithsonian 20:cov., 58–75 (map,c,1) N
'89
—Gardens of Roberto Burle Marx
Smithsonian 21:96–107 (c,1) Jl '90
—Pantanal flood plain
Trav&Leisure 21:86–92 (map,c,3) D '91
—Paranaguá to Curitiba train
Trav&Leisure 20:82–3 (c,1) Ag '90
—Pedra Furada rock-shelter
Natur Hist 96:8–12 (map,c,4) Ag '87
—Rain forests
Smithsonian 19:106–16 (c,1) Ap '88
Nat Geog 174:772–817 (map,c,1) D '88
Smithsonian 20:cov., 58–75 (c,1) N '89
Life 13:8–9 (c,1) Jl '90
Trav&Leisure 20:188 (c,3) Mr '90
Nat Geog 180:105–5 (c,1) D '91
—Recife
Trav&Leisure 17:74–6 (c,4) D '87
—Rondônia
Nat Geog 174:772–817 (map,c,1) D '88
—Rubber industry
Smithsonian 20:cov., 58–67 (c,1) N '89
—Santos harbor
Trav/Holiday 173:71 (c,3) Ja '90
—See also
AMAZON RIVER
BELÉM
BRASÍLIA
IGUAÇU FALLS
MANAUS
RIO DE JANEIRO
RIO NEGRO
SALVADOR
SÃO PAULO
BRAZIL—ARCHITECTURE
—17th cent. Baroque church (Recife)
Trav&Leisure 17:74 (c,4) D '87
BRAZIL—ART
—Ancient Pedra Furada rock art
Natur Hist 96:8–10 (c,4) Ag '87
BRAZIL—COSTUME
Nat Geog 171:348–85 (c,1) Mr '87

Nat Geog 174:934–7 (c,1) D '88
Smithsonian 20:cov., 58–75 (c,1) N '89
—Kanamari Indians
Smithsonian 20:70, 74 (c,4) N '89
—Matis Indians
Natur Hist 99:52–61 (c,1) Ag '90
—Miners
Natur Hist 11:148–9 (1) Fall '88
—Rondônia settlers
Nat Geog 174:772–99 (c,1) D '88
—Street vendor (Belém)
Natur Hist 96:86–7 (2) S '87
—Urueu-Wau-Wau Indians
Nat Geog 174:800–17 (c,1) D '88
BRAZIL—HISTORY
—1888 Day of the Golden Law (Rio de
Janeiro)
Trav&Leisure 21:184–5 (2) O '91
—See also
PEDRO II
BRAZIL—HOUSING
—House on stilts
Smithsonian 20:68 (c,4) N '89
—Matis Indians long house
Natur Hist 99:59 (c,4) Ag '90
BRAZIL—RITES AND FESTIVALS
—Carnival
Nat Geog 171:356–7 (c,1) Mr '87
BRAZIL, ANCIENT
—Ancient mound-building culture
Natur Hist 98:74–83 (map,c,1) F '89
BREAD
Gourmet 50:120–3 (c,1) O '90
—Challah
Gourmet 48:80–1, 164 (c,1) S '88
—French breads
Gourmet 49:145–6 (drawing,4) Mr '89
—Simit bread (Turkey)
Gourmet 48:93 (c,4) D '88
BREAD MAKING
—Baking biscuits (Maryland)
Trav/Holiday 172:45 (c,4) Ag '89
—Baking bread in hot ground (Iceland)
Nat Geog 171:191 (c,4) F '87
—Baking bread in peat (Ireland)
Nat Geog 171:416 (c,4) Mr '87
—Braiding challah
Gourmet 48:164 (drawing,4) S '88
—Cooking tortillas (Costa Rica)
Smithsonian 17:59 (c,4) Mr '87
—Estonia
Life 10:140 (c,4) N '87
—Kneading dough (Egypt)
Natur Hist 96:28–9 (c,1) Jl '87
Smithsonian 19:98 (4) Jl '88
BREARLEY, DAVID
Life 10:52 (painting,4) Fall '87
BRENNAN, WILLIAM
Life 14:64 (4) Fall '91

BREUGHEL, PIETER THE ELDER
—16th cent. "Triumph of Death" depicting
 plague
 Nat Geog 173:680–1 (painting,c,1) My
 '88
 Smithsonian 20:66–7 (painting,c,1) F '90
BRICE, FANNY
 Smithsonian 17:75 (4) Mr '87
BRIDGES
—14th cent. bridge (Assos, Turkey)
 Trav/Holiday 173:83 (c,1) Ap '90
—19th cent. railroad bridge (New York)
 Am Heritage 40:108–9 (2) D '89
—1893 wrecked covered bridge (Vermont)
 Am Heritage 41:122–3 (1) N '90
—1940 collapse of Tacoma Narrows
 Bridge, Washington
 Smithsonian 19:120 (4) My '88
—1983 collapse of Mianus River Bridge,
 Connecticut
 Life 12:138 (c,4) Fall '89
 Nat Geog 176:777 (2) D '89
—Ambassador Bridge, Detroit, Michigan/
 Ontario
 Smithsonian 18:127 (c,2) S '87
—Bamboo and wood bridge (Nepal)
 Natur Hist 97:29 (c,4) Ja '88
—Bratislava, Czechoslovakia
 Gourmet 50:82 (c,2) My '90
—Bridge on the River Kwai, Thailand
 Trav/Holiday 174:37 (c,3) N '90
—Bridges across the Harlem River, New
 York
 Am Heritage 38:102–3 (c,2) Ap '87
—Budapest, Hungary
 Gourmet 48:70 (c,3) O '88
 Trav/Holiday 171:84–5 (c,1) Mr '89
 Trav&Leisure 20:107 (c,3) Ja '90
—Bungy jumping off bridge (New Zeal-
 and)
 Sports Illus 70:12 (c,4) Je 5 '89
—Cane and wire bridge (India)
 Nat Geog 174:672–3 (c,1) N '88
—Canton park, China
 Gourmet 47:56–7 (c,1) My '87
—Chicago River, Chicago, Illinois
 Trav&Leisure 20:180 (c,4) O '90
—Cleveland, Ohio
 Trav/Holiday 176:79 (c,4) O '91
—Covered bridge (Indiana)
 Gourmet 50:105 (c,2) D '90
—Covered bridge (Vermont)
 Trav/Holiday 167:65 (c,3) My '87
 Trav&Leisure 20:E1 (c,3) N '90
—Covered bridge Kapellbrucke (Lucerne,
 Switzerland)
 Gourmet 51:66 (c,3) F '91
—Covered bridges (Oregon)
 Trav/Holiday 167:71–2 (map,c,4) Ja '87

—Crossing river by pulley (Tibet)
 Nat Geog 174:693 (c,1) N '88
—Damaged by 1989 San Francisco earth-
 quake, California
 Sports Illus 71:23, 26 (c,4) O 30 '89
—Dublin, Ireland
 Trav&Leisure 21:202–3 (c,1) O '91
—Florida Keys, Florida
 Am Heritage 42:26 (c,4) Ap '91
 Trav&Leisure 21:264 (c,3) O '91
—Hanging grass bridge (Peru)
 Nat Geog 171:470–1 (c,1) Ap '87
—Hood River, Oregon
 Smithsonian 20:56–7 (c,1) O '89
—Maryland
 Am Heritage 40:95–7, 105 (c,1) Ap '89
 Sports Illus 71:2–3 (c,1) Jl 3 '89
—Mostar, Yugoslavia
 Nat Geog 172:592–3 (c,1) N '87
—Natural Bridge, Aruba, Netherlands An-
 tilles
 Trav/Holiday 168:22 (c,4) D '87
—Netherlands
 Gourmet 49:76 (c,2) Ap '89
 Gourmet 50:74 (c,2) Ap '90
 Trav&Leisure 21:112–15 (c,1) Ap '91
—New River, West Virginia
 Trav/Holiday 169:72 (c,2) F '88
—Newport, Rhode Island
 Trav&Leisure 17:E2 (c,3) Ag '87
—Ponte 25 de Abril, Lisbon, Portugal
 Trav&Leisure 19:105 (c,4) S '89
—Ponte Vecchio, Florence, Italy
 Trav&Leisure 17:105–5 (c,1) Ap '87
—Pulteney Bridge, Bath, England
 Gourmet 50:90 (c,3) My '90
—Railroad bridge (West Virginia)
 Nat Geog 171:226–7 (c,1) F '87
—Red River bridge damaged in Vietnam
 War (Hanoi)
 Nat Geog 176:575 (c,4) N '89
—Rope bridge (Sri Lanka)
 Trav&Leisure 21:148–9 (c,1) My '90
—Seven-arched bridge (Ferndale, Califor-
 nia)
 Am Heritage 39:4 (c,2) F '88
—Tampa, Florida
 Am Heritage 40:114–15 (c,3) My '89
—Tower Bridge, London, England
 Gourmet 51:156 (drawing,4) Ja '91
 Nat Geog 180:38 (c,4) Jl '91
—Union Railway Bridge, Glasgow, Scot-
 land
 Smithsonian 20:135 (c,1) O '89
—Venice, Italy
 Trav&Leisure 18:94–5 (c,1) F '88
 Trav/Holiday 170:32–3 (c,2) D '88
 Trav&Leisure 19:88 (c,4) Ap '89
 Trav/Holiday 172:43 (c,1) D '89

—Vermont/New Hampshire
Smithsonian 21:84–5 (c,1) Ap '90
—Vicksburg, Mississippi
Trav/Holiday 171:68–9 (c,2) Ja '89
—Vine footbridge (Kashmir)
Nat Geog 172:538–9 (c,2) O '87
—See also
BROOKLYN BRIDGE
GOLDEN GATE BRIDGE
SAN FRANCISCO-OAKLAND BAY
BRIDGE
BRIDGES—CONSTRUCTION
—Brooklyn Bridge, New York (1870s)
Am Heritage 42:46–51 (c,4) Ap '91
BRIEFCASES
—British prime minister's briefcase
Life 12:28 (c,4) O '89
BRINKLEY, DAVID
Smithsonian 20:86–7 (3) Je '89
BRISBANE, AUSTRALIA
Trav/Holiday 169:42–3 (c,3) Ja '88
BRISTLECONE PINE TREES
Smithsonian 18:68 (c,1) N '87
Nat Geog 175:72–4 (c,1) Ja '89
—Pine cone
Natur Hist 97:16 (c,4) F '88
BRITISH COLUMBIA
Sports Illus 74:84–96 (c,1) Ja 14 '91
Nat Geog 180:68–99 (map,c,1) N '91
—Alaska Highway
Nat Geog 180:68–99 (map,c,1) N '91
—Bugaboo Mountains avalanche site
Sports Illus 74:13 (c,4) Mr 25 '91
—Canyon
Trav&Leisure 17:40 (c,4) Mr '87
—Coast Mountains
Trav&Leisure 21:108–9 (c,1) Ja '91
—Gulf Islands
Trav/Holiday 170:60–5 (c,1) Ag '88
—Icefields Parkway
Trav&Leisure 19:187–8 (map,c,4) Je
'89
Trav&Leisure 21:260 (c,3) O '91
—Sidney Spit
Natur Hist 100:74–6 (map,c,1) Ja '91
—Whistler ski resort
Trav&Leisure 21:106–9, 141 (map,c,1)
Ja '91
—See also
QUEEN CHARLOTTE ISLANDS
ROCKY MOUNTAINS
VANCOUVER
VICTORIA
BRITISH MUSEUM, LONDON, EN-
GLAND
—Reading room
Trav&Leisure 19:215 (c,4) D '89
BROCCOLI
Life 14:61 (c,2) Ja '91

BRONX, NEW YORK CITY, NEW
YORK
—1748 Van Cortlandt house
Am Heritage 42:98–9 (c,2) My '91
—Bridges across the Harlem River
Am Heritage 38:102–3 (c,2) Ap '87
—Bronx Zoo's African Market
Trav&Leisure 20:NY8 (c,3) O '90
—New York Botanical Garden
Trav&Leisure 21:NY6 (c,3) Ap '91
BROOKLYN, NEW YORK CITY, NEW
YORK
Smithsonian 19:120–5 (c,2) D '88
—1652 Pieter Claesen Wyckoff house
Am Heritage 42:96–7 (c,4) My '91
—Brighton Beach area
Trav&Leisure 21:NY2 (painting,c,3) My
'91
—Brooklyn Botanic Garden
Trav&Leisure 19:NY1–4 (c,4) S '89
—Brooklyn Heights
Trav&Leisure 18:NY10, NY12 (c,3) Ap
'88
—Ebbets Field
Sports Illus 68:90 (4) Ap 11 '88
Sports Illus 72:32 (diagram,4) Ap 16 '90
—Jamaica Bay area
Smithsonian 21:110–17 (c,1) Jl '90
—Street scene during policeman's funeral
Life 12:58 (c,2) Ja '89
—See also
BROOKLYN BRIDGE
CONEY ISLAND
BROOKLYN BRIDGE, NEW YORK
CITY, NEW YORK
—Aerial view of bridge approaches
Trav&Leisure 18:93 (c,4) Je '88
—Construction (1870s)
Am Heritage 42:46–51 (c,4) Ap '91
—Hockney collage (1982)
Life 11:68 (c,2) Fall '88
—See also
ROEBLING, JOHN A.
ROEBLING, WASHINGTON A.
BROOMS
—Handmade (Ohio)
Gourmet 47:83 (c,4) N '87
—Egypt
Natur Hist 97:66–7 (c,2) D '88
BROWN, JIM
Sports Illus 71:88, 96–7, 110 (c,1) N 15
'89
BROWN, JOHN
—Harpers Ferry site of Brown's 1859 raid,
West Virginia
Am Heritage 39:30 (c,4) N '88
BRUGES, BELGIUM
Trav&Leisure 18:72–81, 125 (c,1) Jl '88
Trav/Holiday 171:cov., 64–71 (c,1) Mr '89

—Procession of the Holy Blood
Trav/Holiday 171:64–71 (c,3) Mr '89
BRUSHES
—16th cent. porcelain brush (China)
Trav&Leisure 18:56–7 (c,4) F '88
BRUSSELS, BELGIUM
Gourmet 49:72–9, 124 (map,c,1) S '89
—Grand-Place
Gourmet 49:74–5, 79 (c,1) S '89
Trav&Leisure 20:57 (c,4) Mr '90
—Shopping arcade
Natur Hist 99:69 (2) Ja '90
BRYAN, WILLIAM JENNINGS
Natur Hist 96:20 (3) N '87
Am Heritage 39:32 (4) Ap '88
BRYCE CANYON NATIONAL PARK,
UTAH
Trav/Holiday 170:38–9 (c,1) Jl '88
Life 14:101 (c,4) Summer '91
BUBONIC PLAGUE
—14th cent. Bubonic Plague (Europe)
Smithsonian 20:66–79 (painting,c,1) F
'90
—1656 plague scene (Naples, Italy)
Smithsonian 20:70–1 (painting,c,2) F '90
—Breughel's 16th cent. depiction of plague
Nat Geog 173:680–1 (painting,c,1) My
'88
—Cemetery for 1349 plague victims (London, England)
Life 11:100–1 (c,1) Mr '88
—History of plagues
Nat Geog 173:673, 676–87 (map,c,1) My
'88
BUCHANAN, JAMES
Life 10:&) (painting,c,4) Ag '87
BUCHAREST, ROMANIA
Trav/Holiday 167:62–3 (c,3) Ap '87
Trav/Holiday 169:68–71 (c,1) Mr '88
—Ceauşescu's palace
Nat Geog 179:4–5 (c,1) Mr '91
BUCK, PEARL S.
Am Heritage 39:40 (4) N '88
BUCKWHEAT
Natur Hist 97:27 (c,1) My '88
Natur Hist 97:19 (c,4) D '88
BUDAPEST, HUNGARY
Nat Geog 172:586 (c,2) N '87
Gourmet 48:cov., 66–73 (c,1) O '88
Trav/Holiday 171:82–7 (map,c,1) Mr '89
Trav&Leisure 19:83–6 (c,4) O '89
Trav&Leisure 20:106–13 (c,1) Ja '90
Trav/Holiday 173:11 (painting,c,3) Je '90
Smithsonian 21:43 (c,1) Jl '90
Trav&Leisure 21:116–17 (c,2) Ja '91
—1860s
Trav&Leisure 21:185 (4) O '91
—Millennium Monument
Gourmet 50:78 (c,2) My '90

—See also
DANUBE RIVER
BUDDHA
—Huge bronze sculpture (Hong Kong)
Life 12:52 (c,2) S '89
Life 13:10–11 (c,1) My '90
—Kamakura, Japan
Trav/Holiday 167:70 (sculpture,c,4) F
'87
—Statue of Shweyattaw Buddha (Burma)
Trav&Leisure 18:113 (c,1) S '88
—Thailand
Nat Geog 172:800 (sculpture,c,1) D '87
Smithsonian 21:124 (c,4) Mr '91
BUDDHISM—COSTUME
—15th cent. painting of 6th cent. zen Buddhist (Japan)
Smithsonian 19:75 (painting,c,3) N '88
—16th cent. zen patriarch (Japan)
Smithsonian 19:75 (painting,c,3) N '88
—Buddhist nuns (Tibet)
Natur Hist 98:40–3, 46–7 (c,1) Mr '89
—Chief priest of Zen Buddhism (Japan)
Life 14:11 (c,2) D '91
—Child priest in training (Tibet)
Life 14:16 (c,1) N '91
—Dalai Lama (Tibet)
Nat Geog 172:767 (4) D '87
Life 11:21, 24 (c,3) Je '88
Smithsonian 22:92 (c,4) Je '91
—Monk (Vietnam)
Nat Geog 176:594 (c,1) N '89
—Monks (Burma)
Trav&Leisure 18:107 (c,4) S '88
Life 13:56–7 (c,1) D '90
Life 14:26 (c,2) O '91
—Monks (Sri Lanka)
Nat Geog 180:38–9 (c,1) D '91
—Monks (Thailand)
Nat Geog 172:800 (c,1) D '87
Trav&Leisure 19:180 (c,4) S '89
Trav&Leisure 20:140–1, 148 (c,1) F '90
Natur Hist 99:44–5 (c,1) Je '90
Trav/Holiday 176:51, 56 (c,2) N '91
—Sakugen Shuryo (Japan)
Smithsonian 19:78 (painting,c,3) N '88
—Tibetan monks (India)
Life 13:62 (c,4) D '90
BUDDHISM—HISTORY
—1963 Buddhist monk setting himself on
fire (Vietnam)
Nat Geog 176:601 (4) N '89
BUDDHISM—RITES AND FESTIVALS
—Bathing in waterfall (Japan)
Life 13:71 (c,3) D '90
—Feast of the Lanterns (South Korea)
Nat Geog 174:240–1 (c,1) Ag '88
Trav&Leisure 18:108 (c,2) Ag '88
—Pi mai celebrations (Laos)

BULLFROGS
 Nat Geog 178:6–7 (c,1) D '90
—Eating each other
 Nat Wildlife 29:14–15 (c,1) Je '91
BUMBLEBEES
 Nat Wildlife 25:2 (c,2) Ag '87
 Natur Hist 99:52–9 (c,1) Jl '90
BUMPER STICKERS
—Bumper stickers promoting wool (New
 Zealand)
 Nat Geog 173:564 (c,4) My '88
BUNCHBERRIES
 Nat Geog 174:849 (c,4) D '88
 Nat Wildlife 27:56 (c,4) O '89
 Life 14:81 (c,1) F '91
 Nat Wildlife 29:48 (c,2) Ag '91
BUNKER HILL, BATTLE OF
—Depicted in women's wig
 Smithsonian 22:124 (etching,c,2) O '91
BUNTINGS
 Nat Wildlife 29:60 (c,1) Ap '91
BURMA
 Trav&Leisure 18:106–13, 142–6
 (map,c,1) S '88
—Huge gilded boulder
 Life 13:56–7 (c,1) D '90
BURMA—COSTUME
 Trav&Leisure 18:106–13, 142–6 (c,1) S
 '88
—Miners
 Nat Geog 180:104–5 (c,1) O '91
BURNS, GEORGE
 Life 14:80–1 (1) S '91
BURROUGHS, JOHN
 Natur Hist 100:67 (4) F '91
BURTON, SIR RICHARD FRANCIS
 Smithsonian 18:250 (4) N '87
 Smithsonian 20:127–44 (c,3) F '90
 Trav/Holiday 175:111 (painting,c,4) Mr
 '91
—Depicted in film
 Trav/Holiday 173:93 (c,4) F '90
BUSES
—Afghanistan
 Smithsonian 19:48–9 (c,3) D '88
—Bus terminal (Great Falls, Montana)
 Smithsonian 19:121 (c,1) N '88
—Commuters boarding minibuses (Kam-
 pala, Uganda)
 Nat Geog 173:478–9 (c,1) Ap '88
—Decorated bus (Pakistan)
 Smithsonian 20:122 (c,4) Mr '90
—Double-decker buses (London, En-
 gland)
 Trav&Leisure 18:38–9 (c,4) Mr '88
—Hong Kong
 Trav/Holiday 172:50–1 (c,1) S '89
 Trav/Holiday 176:50, 58 (c,4) O '91
—Life on the sports team bus

 Sports Illus 71:58–68 (drawing,c,1) Jl 3
 '89
—Painted buses (Panama)
 Natur Hist 97:44–9 (c,1) Ap '88
—School bus (Alaska)
 Trav&Leisure 18:96–7 (c,1) Ap '88
—Shakespeare tour bus (Stratford, En-
 gland)
 Smithsonian 18:170 (c,4) S '87
—Sightseeing bus on safari (Kenya)
 Trav/Holiday 176:15 (c,3) S '91
—Tourist courtesy shuttle bus (Monaco)
 Gourmet 48:71 (c,1) My '88
BUSH, GEORGE
 Life 11:136–9 (c,1) My '88
 Life 11:96 (c,3) Ag '88
 Life 11:14–15 (c,1) D '88
 Life 12:36 (c,2) My '89
 Life 14:45, 82 (c,4) Mr '91
—1940s
 Life 12:70–5 (1) S '89
—1945 wedding
 Life 12:74 (4) S '89
—1988 presidential campaign shown as
 cowboy shootout
 Smithsonian 19:160 (painting,c,2) O '88
—Birthplace (Milton, Massachusetts)
 Life 11:8 (c,4) Ag '88
 Life 11:46 (c,4) N '88
—Barbara Bush
 Life 12:cov., 34 (c,1) My '89
 Life 13:16 (c,2) Je '90
 Life 14:51 (c,4) Ja '91
—Bush engaged in sports activities
 Sports Illus 69:2–3, 140–60 (c,1) D 26 '88
 Life 12:20–1 (c,1) Ja '89
 Life 13:24 (c,3) Ja '90
 Trav/Holiday 173:66 (c,3) F '90
 Sports Illus 73:9 (c,4) O 15 '90
 Life 14:115 (c,1) Ja '91
 Sports Illus 75:32–8 (c,1) Ag 19 '91
—Bush family
 Life 12:36–42 (c,1) Mr '89
—Bush family residences (1924–1988)
 Life 11:46–7 (c,4) N '88
—Caricature
 Nat Wildlife 29:14–17 (drawing,c,1) D
 '90
 Life 14:23 (drawing,4) My '91
BUSINESSMEN
—16th cent. memorial to wool merchant
 (Great Britain)
 Nat Geog 173:573 (c,4) My '88
—Late 19th cent. Chicago millionaires
 Am Heritage 38:35–44 (c,1) N '87
—1911 cartoon about businessmen doing
 "real" work
 Am Heritage 42:130–1 (1) Ap '91
—Edward L. Bernays

Life 13:52 (4) Fall '90
—Businessman waiting for train (New York)
Sports Illus 71:109 (c,1) N 20 '89
—Enzo Ferrari
Sports Illus 71:117 (4) O 23 '89
—James Fisk, Jr.
Am Heritage 42:20 (drawing,4) F '91
—Joyce C. Hall
Life 13:55 (4) Fall '90
—Japanese businesswoman
Nat Geog 177:60–1 (c,2) Ap '90
—Ray Kroc
Life 13:55 (4) Fall '90
—Life of businesswoman (New Jersey)
Life 13:54–62 (1) Ag '90
—John H. Patterson
Smithsonian 20:151, 157, 166 (4) Je '89
—Henry Phipps, Jr.
Am Heritage 38:102 (4) N '87
—Jacob Schiff
Am Heritage 40:86 (4) Jl '89
—South Korea
Nat Geog 174:238–9 (c,1) Ag '88
—Leland Stanford
Am Heritage 41:74 (painting,c,4) N '90
—Charles Lewis Tiffany
Smithsonian 18:56 (painting,c,4) D '87
—William Wrigley, Jr.
Smithsonian 22:159 (4) O '91
—See also
ARMOUR, PHILIP DANFORTH
BIDDLE, NICHOLAS
CARNEGIE, ANDREW
CARNEGIE, DALE
DU PONT, PIERRE S.
FIELD, MARSHALL
FORD, HENRY
GETTY, J. PAUL
GOULD, JAY
GREEN, "HETTY" HENRIETTA
HEARST, WILLIAM RANDOLPH
HUGHES, HOWARD
LAW, JOHN
LUCE, HENRY
McCORMICK, CYRUS
MEETINGS
MORGAN, JOHN PIERPONT
OFFICES
PALEY, WILLIAM
PALMER, POTTER
PULLMAN, GEORGE
ROCKEFELLER, JOHN D.
SCHWAB, CHARLES
SLOAN, ALFRED
STANFORD, LELAND
STRAUS, NATHAN
VANDERBILT, CORNELIUS
WATSON, THOMAS J., JR.

BUTCHERS
—Butcher carrying newly slaughtered pig (Hong Kong)
Nat Geog 179:116–17 (c,1) F '91
—Butchering elephant meat (South Africa)
Nat Geog 179:46–7 (c,1) My '91
—Egypt
Life 13:40–1 (c,1) O '90
—Great Britain
Trav&Leisure 19:122 (c,3) My '89
Trav&Leisure 21:80 (c,4) Jl '91
—Livestock processing (Botswana)
Nat Geog 178:84 (c,4) D '90
—Plant slaughterman (Australia)
Nat Geog 173:220–1 (c,1) F '88
—Training class (Ohio)
Smithsonian 19:135 (4) My '88
BUTLER, PIERCE
Life 10:58 (drawing,4) Fall '87
BUTLERS
Smithsonian 18:111–21 (c,2) Mr '88
BUTTERFISH
Nat Geog 177:17 (c,3) F '90
BUTTERFLIES
Nat Wildlife 26:12–13 (c,1) Ap '88
Nat Wildlife 26:4–11 (c,1) Ag '88
Natur Hist 97:58–63 (c,1) O '88
Nat Wildlife 27:9, 24 (c,1) Ap '89
Natur Hist 98:24–8 (c,3) My '89
Nat Wildlife 27:52 (c,1) Je '89
Nat Wildlife 29:cov., 4–9 (c,1) Ag '91
—Alphabet designs on butterfly wings
Nat Wildlife 26:12–13 (c,4) F '88
Sports Illus 71:160–2 (c,4) D 25 '89
—Butterfly World, Florida
Trav/Holiday 172:N4–8 (c,1) S '89
—Karner blue butterflies
Natur Hist 97:64–5, 71 (c,1) My '88
—Monarchs
Life 10:21, 25 (c,4) My '87
Nat Wildlife 25:52 (c,1) Ag '87
Trav/Holiday 168:96 (c,4) N '87
Nat Wildlife 26:2 (c,2) D '87
Nat Wildlife 26:7 (c,1) Ag '88
Natur Hist 99:68 (painting,c,4) F '90
Nat Geog 179:72–3 (c,1) Je '91
Nat Wildlife 29:6–7 (c,1) Ag '91
—Swallowtail
Smithsonian 21:218 (c,4) Ap '90
Trav/Holiday 175:117 (c,4) My '91
Nat Wildlife 29:33 (painting,c,4) Je '91
BUTTONS
—1638 (Far East)
Nat Geog 178:50 (c,3) S '90
—1781 British military uniform buttons
Nat Geog 173:813 (c,3) Je '88
—1956 "I Like Ike" button
Sports Illus 71:50 (c,4) N 15 '89

—1960 Kennedy and Nixon campaign but-
tons
Life 11:51 (4) S '88
—1968 Peace button
Sports Illus 71:106 (c,4) N 15 '89
—1972 "Reelect Nixon" button
Sports Illus 71:123 (c,4) N 15 '89
—1984 Mondale button
Sports Illus 71:178 (c,4) N 15 '89
—Peter the Great's 17th cent. coat buttons

(U.S.S.R.)
Nat Geog 177:89 (c,4) Ja '90
BYRD, RICHARD E.
Smithsonian 21:178 (4) O '90
BYRON, LORD
Sports Illus 66:90–2 (painting,4) My 25 '87
Smithsonian 18:251 (painting,c,4) N '87
BYZANTINE EMPIRE
—Emperor Alexius Comnenus (Turkey)
Nat Geog 176:349 (painting,c,4) S '89

- C -

CABINS
—Campers' lean-to shelter (Maine)
Nat Geog 171:218–19 (c,1) F '87
—Replica of Thoreau's cabin (Concord,
Massachusetts)
Am Heritage 39:68–9 (c,2) Jl '88
—See also
LOG CABINS
CABLE CARS (GONDOLAS)
—Ohio State Fair ride
Sports Illus 67:43 (c,2) S 7 '87
Cable cars (streetcars). See
TROLLEY CARS
CACTUS
Trav&Leisure 17:104 (c,4) Ja '87
Natur Hist 97:43 (c,4) O '88
Nat Geog 174:822 (c,4) D '88
Gourmet 49:45, 102 (c,1) Ja '89
Life 12:86 (c,2) Jl '89
Trav/Holiday 173:67 (c,4) Ja '90
Natur Hist 99:20 (c,4) Je '90
—Barrel cactus
Trav&Leisure 17:E4 (c,4) O '87
Trav/Holiday 174:54 (c,1) Jl '90
—Cactus flowers
Nat Wildlife 27:46–51 (c,1) Ag '89
Gourmet 51:86 (c,4) Mr '91
Nat Geog 179:130–40 (c,1) Je '91
—Cholla cactus
Trav&Leisure 19:216 (c,4) N '89
—Hedgehog cactus
Natur Hist 98:88–9 (c,3) Mr '89
Natur Hist 98:68 (c,2) S '89
—Saguaro
Trav&Leisure 17:96–7, 104 (c,1) Ja '87
Trav&Leisure 17:191 (c,4) D '87
Nat Wildlife 27:15 (c,2) Ap '89
Natur Hist 99:88–9 (c,1) Ap '90
Natur Hist 100:72–3 (c,1) F '91
Trav&Leisure 21:60, 62 (c,4) Je '91
Sports Illus 75:65 (c,2) S 2 '91
—See also
PRICKLY PEARS

CAESAR, JULIUS
Smithsonian 18:148 (sculpture,4) Mr '88
CAESAR, SID
—Poster of him
Trav/Holiday 167:10 (4) Ja '87
Cafes. See
COFFEEHOUSES
RESTAURANTS
CAGNEY, JAMES
Life 10:18 (4) Ap '87
CAIRO, EGYPT
—Khan el-Khalili
Trav&Leisure 21:94–100 (c,2) D '91
—Step pyramid
Trav&Leisure 21:74 (c,3) Jl '91
CALCUTTA, INDIA
Trav&Leisure 20:67 (c,2) Ap '90
Smithsonian 22:32–5 (c,1) Jl '91
—Mother Teresa's Missionaries of Charity
Home
Life 11:28–32 (c,2) Ap '88
CALDER, ALEXANDER
—Cheshire cat sculpture (1967)
Am Heritage 41:72 (c,1) My '90
—"Cheval Rouge" sculpture
Trav&Leisure 20:E1 (c,2) S '90
—Fountain designed by him (Philadelphia,
Pennsylvania)
Trav/Holiday 167:53 (c,1) Ap '87
—Mobile (France)
Trav&Leisure 18:109 (c,1) Jl '88
CALENDARS
—Ancient calendars (Latin America)
Smithsonian 21:41 (c,4) F '91
Natur Hist 100:28 (c,4) Ap '91
—Inca knotted string calendar (Peru)
Nat Geog 177:91 (c,4) Mr '90
CALGARY, ALBERTA
Sports Illus 66:72–84 (map,c,1) Mr 9 '87
Trav/Holiday 168:22 (c,4) Ag '87
Gourmet 48:52–7, 120 (map,c,1) Ja '88
Sports Illus 68:22–3 (painting,c,1) Ja 27
'88

—1870s
Sports Illus 68:30 (painting,c,3) Ja 27 '88
—Night fireworks scene
Sports Illus 68:82–2 (c,1) F 29 '88
—See also
OLYMPICS—1988 WINTER (CAL-
GARY)
CALIFORNIA
—Anza-Borrego Desert
Nat Geog 176:198–9 (c,1) Ag '89
—Arcata
Smithsonian 21:174–80 (c,1) Ap '90
—Big Sur
Trav&Leisure 17:118–33 (c,1) S '87
—Bodie
Am Heritage 41:cov., 70–7 (c,1) Ap '90
Am Heritage 41:15 (c,4) D '90
—Calaveras Big Trees State Park, Califor-
nia
Gourmet 48:79 (c,1) N '88
—California desert highway
Smithsonian 18:66–7 (collage,c,1) F '88
Trav&Leisure 18:58 (c,2) F '88
—Carlsbad spa
Trav&Leisure 18:136–41 (c,1) Mr '88
—Central Valley
Nat Geog 179:48–73 (map,c,1) F '91
Nat Wildlife 29:7 (map,c,2) Je '91
—Coachella Valley
Nat Geog 174:836 (map,c,3) D '88
Trav&Leisure 20:118–19 (map,c,1) S '90
—Coast Ranges
Life 10:35 (c,4) Jl '87
—Coastline
Nat Geog 177:38–9 (c,1) F '90
Trav&Leisure 20:134–5 (c,1) Ap '90
Nat Geog 180:34–5 (c,1) O '91
—Del Mar
Trav&Leisure 20:E20 (c,3) S '90
—Desert areas
Nat Geog 171:42–77 (map,c,1) Ja '87
—Ferndale's seven-arched bridge
Am Heritage 39:4 (c,2) F '88
—Gold Rush region
Gourmet 48:72–9, 211, 214 (map,c,1) N
'88
—Hearst Castle, San Simeon
Trav&Leisure 17:132–3 (c,2) S '87
—Humboldt Coast
Natur Hist 99:95 (c,1) My '90
—Imperial Valley Sand Dunes
Nat Geog 171:44–5 (c,1) Ja '87
—Irwindale during 1987 earthquake
Life 10:38–9 (c,1) N '87
—Kelso Dunes
Smithsonian 21:37 (c,3) S '90
—La Jolla
Trav&Leisure 19:120–30 (c,1) Ja '89
—Laguna Beach

Trav&Leisure 20:84–92 (map,c,4) N '90
—Monterey Bay
Nat Geog 177:2–43 (map,c,1) F '90
—Mt. Diablo State Park
Nat Wildlife 27:8–9 (c,1) D '88
—Mount Tamalpais State Park
Trav&Leisure 21:108–9 (c,1) Mr '91
—Napa and Sonoma
Gourmet 47:26 (painting,c,2) Je '87
Gourmet 48:44, 92 (painting,c,2) Mr '88
Trav&Leisure 18:156–70 (map,c,1) D '88
Gourmet 49:86–91, 170 (map,c,1) S '89
Trav&Leisure 21:122–40 (map,c,1) Mr
'91
—Northern California
Trav&Leisure 21:81–186 (map,c,1) Mr
'91
—Ojai
Trav/Holiday 174:48–52 (map,c,1) Jl '90
—Palm Springs
Trav&Leisure 17:106–7 (c,3) D '87
Trav&Leisure 19:110–17 (c,1) Je '89
—Point Reyes National Seashore
Gourmet 49:100–7 (c,1) D '89
—Rancho Mirage
Nat Geog 171:72–3 (c,1) Ja '87
—Russian River
Trav&Leisure 18:161 (c,2) D '88
Trav&Leisure 21:82–3, 129 (c,1) Mr '91
—San Ysidro
Trav&Leisure 20:122–3 (c,1) Je '90
—Santa Cruz Island
Nat Geog 174:834–5 (c,1) D '88
Trav&Leisure 19:E20 (c,3) O '89
—Southern California outdoor sports and
activities
Sports Illus 67:cov., 2–3, 50–72 (c,1) S 7
'87
—Tahoe
Trav/Holiday 171:88–95 (map,c,1) Mr
'89
—See also
ALCATRAZ
BEVERLY HILLS
CARMEL
CATALINA ISLAND
DEATH VALLEY
DEVILS POSTPILE NAT'L MONU-
MENT
DISNEYLAND
FARALLON ISLANDS
GLENDALE
GOLDEN GATE BRIDGE
HOLLYWOOD
JOSHUA TREE NAT'L MONUMENT
KINGS CANYON NATIONAL PARK
LAKE TAHOE
LOS ANGELES
MONTEREY

—1890s Blair camera
Nat Geog 175:243 (c,4) F '89
—Early 20th cent.
Am Heritage 39:112 (4) F '88
Am Heritage 39:cov. (1) Mr '88
—Early 20th cent. Brownie cameras
Smithsonian 19:115–17 (c,1) Je '88
—1908 collapsible bellows-camera
Am Heritage 39:4 (c,2) Mr '88
—1908 Powers Cameragraph projector
Trav&Leisure 19:NY2 (c,4) Mr '89
—1925 Leica A
Life 11:96 (c,4) Fall '88
—1939 movie cameras
Life 12:32–47 (1) Spring '89
—1940s press photographer's camera
Life 11:96 (c,4) Fall '88
—1942 xerography patent
Am Heritage 41:58 (drawing,4) S '90
—1948 Hasselblad 1600F
Life 11:96–7 (c,4) Fall '88
—1950s television cameras
Smithsonian 20:74–5, 88 (2) Je '89
—1959 Nikon F
Life 11:97 (c,4) Fall '88
—1963 Instamatic
Sports Illus 71:87 (4) N 15 '89
—Camera on tripod
Nat Wildlife 26:2 (c,2) Ap '88
—Early Kodak camera
Life 11:13 (4) Jl '88
—Spy cameras
Smithsonian 18:cov., 118–19 (c,1) O '87
—Still video cameras
Life 11:105–6 (c,2) Fall '88
—Television broadcasting technology
Life 12:93–8 (c,1) Mr '89
—Underwater cameras
Trav&Leisure 20:143–4 (c,4) Jl '90
—Unusual cameras
Smithsonian 18:cov., 108–19 (c,1) O
'87
—See also
EASTMAN, GEORGE
LAND, EDWIN
MOTION PICTURE PHOTOGRA-
PHY
PHOTOGRAPHY
CAMEROON
—1986 Lake Nyos gas burst
Natur Hist 96:44–9 (map,c,1) Ag '87
Nat Geog 172:404–19 (map,c,1) S '87
CAMEROON—HOUSING
—Huts
Natur Hist 96:48–9 (c,1) Ag '87
CAMEROON—RITES AND FESTI-
VALS
—Funeral rites for 1986 gas burst victims
Nat Geog 172:416–17 (c,1) S '87

CAMPFIRES
Nat Wildlife 25:20–1 (c,1) F '87
Nat Geog 174:206–7 (c,1) Ag '88
Trav&Leisure 21:126 (c,1) D '91
—Cowboys at campfire (Nevada)
Nat Geog 175:76 (c,4) Ja '89
—Migrant workers at campfire (Washing-
ton)
Nat Geog 176:804–5 (c,1) D '89
—Roasting marshmallows (Ohio)
Smithsonian 18:55 (c,1) O '87
—Warming hands over campfire (India)
Life 12:115 (c,4) D '89
CAMPING
—1920s (Yosemite, California)
Life 14:32 (2) Summer '91
—Baseball camp (Arizona)
Trav/Holiday 167:48–51 (c,4) My '87
—Camp for children with cancer (Connect-
icut)
Life 11:cov., 24–30 (c,1) S '88
—Campers fetching water from creek
(Idaho)
Gourmet 48:64 (c,4) Jl '88
—Campground at Lake Powell, Arizona
Nat Geog 179:20–1 (c,1) Je '91
—Canadian RVs camping in parking lot
(Washington)
Nat Geog 177:114–15 (c,1) F '90
—Children at summer camp
Smithsonian 21:86–97 (c,1) Ag '90
Life 14:7, 52–6 2(c,1) Jl '91
Sports Illus 75:52–63 (c,1) Jl 8 '91
—Children at summer camp (1930s)
Smithsonian 21:91 (3) Ag '90
—Europe
Trav/Holiday 171:52–9 (c,1) My '89
—Fishing camps (Alaska)
Natur Hist 97:54, 58–9 (c,1) My '88
—Girl Scouts at camp (Ohio)
Smithsonian 18:48–9, 52–5 (c,1) O
'87
—Lean-to shelter (Maine)
Nat Geog 171:218–19 (c,1) F '87
—Northwest Territories
Trav&Leisure 18:140–1 (c,1) O '88
—RVs at campsite (Arizona)
Life 14:88 (c,2) Summer '91
—Tanzania
Trav&Leisure 17:108, 173 (c,4) N '87
—U.S. citizens camping in Siberia
Life 12:16–19 (c,3) Jl '89
—See also
CAMPFIRES
HIKING
TENTS
CANADA
Trav&Leisure 18:C1–C32 (c,1) My '88
supp.

Trav&Leisure 19:1–41 (map,c,1) Ap '89
supp.
Trav&Leisure 21:1–18 (map,c,1) Ap '91
supp.
—Beaufort Sea
Nat Geog 178:12 (c,1) Ag '90
—Far northern islands
Nat Geog 175:584–601 (map,c,1) My '89
—Northwest Passage, Arctic region
Nat Geog 178:2–3 (map,c,1) Ag '90
—Sights along cross-country train trip
Sports Illus 68:298–318 (c,1) Ja 27 '88
—See also
ALBERTA
ARCTIC
BRITISH COLUMBIA
MANITOBA
NEW BRUNSWICK
NORTHWEST TERRITORIES
NOVA SCOTIA
ONTARIO
QUEBEC
ROCKY MOUNTAINS
ST. LAWRENCE RIVER
SASKATCHEWAN
YUKON
CANADA—COSTUME
—Montreal
Nat Geog 179:60–85 (c,1) Mr '91
—Reproduction of 18th cent. marching
band
Trav&Leisure 17:110–13 (c,1) Je '87
CANADA—HISTORY
—1497 voyage of John Cabot to New-
foundland
Smithsonian 19:48 (painting,c,4) F '89
—Late 18th cent. Acadian deportation
from Nova Scotia
Nat Geog 178:45 (map,c,2) O '90
—1793 monument to cross-Canada trip
(British Columbia)
Nat Geog 172:218 (c,4) Ag '87
—Benedict Arnold's march on Quebec
(1775)
Smithsonian 18:cov., 40–9 (painting,c,1)
D '87
—History of Canadian fur trading industry
Nat Geog 172:192–229 (c,1) Ag '87
—History of railroad construction
Sports Illus 68:302, 310, 316 (4) Ja 27 '88
—Newfoundlanders' role in World War I
Smithsonian 18:196–234 (c,1) N '87
—Royal Canadian Mounted Police history
Smithsonian 19:78–91 (c,1) F '89
—World War I recruitment poster (Can-
ada)
Smithsonian 18:206 (c,4) N '87
—See also
FRENCH AND INDIAN WAR

MACKENZIE, ALEXANDER
CANADA—MAPS
Trav&Leisure 18:C4 (c,3) My '88 supp.
—Arctic islands
Nat Geog 173:756 (c,1) Je '88
—U.S.-Canadian border
Nat Geog 177:106–7, 123 (c,1) F '90
CANADA—RITES AND FESTIVALS
—Canada Day carnival (Windsor, Ontario)
Nat Geog 177:102–3 (c,1) F '90
—Trappers' Festival (Manitoba)
Nat Geog 172:221 (c,2) Ag '87
—Yukon Sourdough Rendezvous (White-
horse)
Trav/Holiday 170:41–3 (c,3) D '88
CANADA—SOCIAL LIFE AND CUS-
TOMS
—Battle over bilingualism
Trav&Leisure 20:184 (drawing,c,3) My
'90
—Canadians wintering in Hollywood, Flor-
ida
Nat Geog 177:116–17 (c,1) F '90
CANADA GEESE
Life 11:192 (c,2) D '88
Nat Wildlife 27:13, 34–5 (c,2) D '88
CANALS
—18th cent. Potomac Canal, Southeast
Nat Geog 171:cov., 716–53 (map,c,1) Je
'87
—Amsterdam, Netherlands
Trav&Leisure 19:45 (c,4) Mr '89
Gourmet 49:77 (c,2) Ap '89
—Annecy, France
Gourmet 47:64 (c,4) My '87
—Bruges, Belgium
Trav&Leisure 18:72–3 (c,1) Jl '88
Trav/Holiday 171:68–9 (c,1) Mr '89
—Burgundy, France
Trav/Holiday 169:60–1 (c,2) Mr '88
—C&O, Washington, D.C.
Trav/Holiday 168:54 (c,4) O '87
—Delaware Canal, Pennsylvania
Trav/Holiday 168:56–7 (c,2) N '87
—Haarlem, Netherlands
Gourmet 50:74 (c,2) Ap '90
—Hamburg, West Germany
Trav&Leisure 18:132 (c,2) Je '88
—Jiangsu Province, China
Nat Geog 175:285, 294 (c,1) Mr '89
—Kerala, India
Nat Geog 173:610–11 (c,1) My '88
—Main-Danube Canal
Smithsonian 21:34 (c,4) Jl 90
—Maya canals (Mexico)
Natur Hist 100:13 (c,4) F '91
—Mexico
Nat Geog 179:35 (c,1) Je '91
—Rideau, Ottawa, Ontario

Trav/Holiday 169:60 (c,4) Ja '88
—Romania
Smithsonian 21:38–9 (c,3) Jl '90
—Sightseeing canal barges
Trav&Leisure 18:217–18 (painting,c,4)
Ap '88
—Strasbourg, France
Trav/Holiday 171:48–9 (c,1) Ja '89
—Venice, Italy
Trav&Leisure 17:102–3 (c,1) O '87
Trav&Leisure 18:91, 94–5, 98–9 (c,1) F
'88
Trav&Leisure 18:92 (c,4) Je '88
Trav/Holiday 173:76–7, 80–1 (c,1) My
'90
—Welland locks, Great Lakes
Nat Geog 172:21 (c,1) Jl '87
—See also
ALL-AMERICAN CANAL
ERIE CANAL
PANAMA CANAL
SUEZ CANAL
CANALS—CONSTRUCTION
—Panama Canal (1910)
Natur Hist 100:6 (painting,c,4) Jl '91
CANARY ISLANDS, SPAIN
—Seen from space
Life 11:193 (c,3) N '88
CANBERRA, AUSTRALIA
Trav/Holiday 169:56–9 (c,1) Ap '88
CANCER
—Camp for children with cancer (Connect-
icut)
Life 11:cov., 24–30 (c,1) S '88
—Cancer support group
Life 11:74–8 (c,1) Mr '88
—Lip cancer on fish
Nat Geog 172:27 (c,3) Jl '87
—Lung cancer patient (Bulgaria)
Nat Geog 179:52–3 (c,1) Je '91
—Radiation treatment for cancer
Nat Geog 175:402–3, 411 (c,1) Ap '89
—Skin cancer research (Australia)
Nat Geog 173:189 (c,4) F '88
—Tumor removed from ear (California)
Nat Geog 178:88 (c,4) O '90
CANDLES
—18th cent. candlesticks (Great Britain)
Am Heritage 40:115 (c,4) F '89
CANNONS
Trav/Holiday 173:121 (painting,c,4) Ap
'90
—1627 bronze cannon (Austria)
Nat Geog 175:459 (c,3) Ap '89
—18th cent. (Fort Niagara, New York)
Am Heritage 39:92 (c,4) Mr '88
—1749 (Virgin Islands)
Am Heritage 39:72 (c,3) S '88
—Early 19th cent. (Haiti)

Smithsonian 18:162–3 (c,2) O '87
—1905 Fabergé jade sculpture (U.S.S.R.)
Nat Geog 172:306–7 (c,1) S '87
—Civil War cannons
Trav&Leisure 17:E2 (c,4) Ap '87
Life 11:58 (c,1) Ag '88
Am Heritage 41:106–7 (c,2) Mr '90
—Covered with snow (New York)
Sports Illus 66:30–1 (c,2) Ja 19 '87
—Revolutionary War cannon (Virginia)
Am Heritage 40:30 (c,4) S '89
CANOEING
—Late 19th cent. Indians in canoes
Am Heritage 38:106 (painting,c,2) My
'87
Am Heritage 40:103 (painting,c,2) D '89
—1820s (Manitoba)
Nat Geog 172:226–7 (painting,c,2) Ag
'87
—1869 (Minnesota)
Smithsonian 19:80–1 (painting,c,3) Jl
'88
—Dugout canoe (Peru)
Natur Hist 96:58–9 (c,1) O '87
—Dugout canoe race (Senegal)
Trav/Holiday 173:54 (c,3) Ja '90
—Haida Indians (British Columbia)
Nat Geog 172:111 (c,4) Jl '87
—Minnesota
Smithsonian 19:78–92 (c,1) Jl '88
—Outrigger canoe race (Hawaii)
Sports Illus 69:5–6 (c,3) D 12 '88
—Papua New Guinea
Trav&Leisure 17:98–9 (c,1) D '87
—Racing canoe (Tonga)
Sports Illus 67:10 (c,4) Ag 24 '87
—Sunset over canoe on lake (Wyoming)
Trav/Holiday 170:37 (c,4) Jl '88
—Tennessee
Trav&Leisure 167:14 (c,4) My '87
—White water canoeing (Virginia)
Sports Illus 70:56, 58, 65 (c,2) Je 19 '89
CANOES
—1912 dugout canoe (Korea)
Natur Hist 97:92–3 (4) Ap '88
—Construction of birchbark canoes (On-
tario)
Nat Geog 172:219 (c,1) Ag '87
—Longboats (Borneo)
Trav/Holiday 172:74–5 (c,4) S '89
—Motorized dugout canoe (Brazil)
Smithsonian 20:62 (c,4) N '89
—Outrigger canoes (Pacific Islands)
Trav&Leisure 18:128–9 (c,1) F '88
CANS
—Collection of beverage cans (Tennessee)
Smithsonian 20:65 (c,2) Mr '90
—Crushing beer can
Trav&Leisure 20:130 (c,4) S '90

CARACARAS (BIRDS)
 Nat Geog 173:421–2 (c,2) Mr '88
CARACAS, VENEZUELA
 Gourmet 50:62–7 (c,1) F '90
CARAVANS
—1922 (Mongolia)
 Smithsonian 18:102–3 (3) D '87
CARD PLAYING
—1760s Chippendale card table
 Am Heritage 42:35 (c,2) F '91
—1780s card counter poker chips
 Life 10:33 (c,4) Fall '87
—19th cent. device to alter cards
 Smithsonian 21:58 (c,4) F '91
—Civil War soldiers
 Am Heritage 41:98 (2) S '90
—Ely Culbertson playing bridge (1935)
 Am Heritage 41:87 (painting,c,4) D '90
—In restaurant (France)
 Trav/Holiday 173:82–3 (c,2) Ja '90
—Old men in bar (Spain)
 Nat Geog 179:132–3 (c,1) Ap '91
—Playing poker in bar
 Sports Illus 67:107 (c,3) S 9 '87
—Zaire
 Nat Geog 180:20–1 (c,1) N '91
CARDIFF GIANT
 Natur Hist 98:14–16 (3) N '89
CARDINAL FLOWERS
 Natur Hist 100:80 (c,3) Mr '91
CARDINALS
 Nat Wildlife 27:21 (c,1) D '88
 Nat Wildlife 29:59 (c,1) O '91
CARDOZO, BENJAMIN
 Life 14:32 (4) Fall '91
CARDS
—19th cent. tarot card
 Life 12:53 (c,4) Je '89
—"Smart cards"
 Am Heritage 40:24 (c,4) Jl '89 supp.
—Telephone "smart card" (France)
 Nat Geog 176:96 (c,4) Jl '89
CARIBBEAN SEA
—Great marine blue hole (Bahamas)
 Natur Hist 96:42–4 (c,1) Ja '87
—Marine life
 Trav/Holiday 169:cov., 8, 52–7 (c,1) Ja
 '88
 Natur Hist 97:46–55 (c,1) O '88
—View from Antigua
 Gourmet 51:87 (c,1) Ja '91
—See also
 WEST INDIES
CARIBBEAN SEA—MAPS
 Nat Geog 178:124–5 (c,1) Jl '90
CARIBOU
 Nat Wildlife 25:4–5, 10–11 (c,1) Je '87
 Nat Wildlife 25:2, 56–7 (c,1) O '87
 Trav&Leisure 18:172 (c,4) Ap '88

Nat Geog 173:754–5 (c,1) Je '88
Nat Geog 174:846–57 (c,1) D '88
Nat Wildlife 27:23 (c,4) Ag '89
Nat Wildlife 27:cov. (c,1) O '89
Nat Wildlife 28:34–5 (c,1) Ap '90
Nat Wildlife 28:2–3, 8–9 (c,1) Je '90
Life 13:24 (c,3) D '90
Nat Wildlife 29:8–9 (c,1) Ap '91
Smithsonian 22:98–107 (c,1) My '91
Life 14:80–3 (c,1) Summer '91
Nat Wildlife 30:44–5 (c,1) D '91
—Attacked by bear
 Natur Hist 96:54 (c,4) Ja '87
Caricatures. See
 CARTOONS
CARLSBAD CAVERNS NATIONAL
 PARK, NEW MEXICO
 Life 14:103 (c,1) Summer '91
CARMEL, CALIFORNIA
 Trav&Leisure 17:134–7, 166–8 (c,3) S '87
CARNEGIE, ANDREW
 Nat Geog 173:24 (3) Ja '88
 Trav&Leisure 20:85 (4) Ag '90
 Life 13:96 (4) Fall '90
 Smithsonian 21:76 (4) F '91
—Cartoon of Andrew Carnegie giving
 money to schools
 Am Heritage 40:38 (drawing,4) My '89
CARNEGIE, DALE
 Smithsonian 18:82–90 (c,2) O '87
—1937 cartoon by Peter Arno
 Smithsonian 18:93 (4) O '87
Carnivals. See
 FESTIVALS
CAROL II (ROMANIA)
 Life 13:35 (4) Mr '90
Caroline Islands. See
 BELAU ISLANDS
CARPEAUX, JEAN-BAPTISTE
—"La Danse" (1869)
 Smithsonian 17:90 (sculpture, c,4) Mr '87
CARPENTRY
—Making cedar shingles (New Brunswick)
 Trav/Holiday 171:47 (c,4) F '89
CARRIAGES AND CARTS
—19th cent. lacquer wedding carriage (Ja-
 pan)
 Smithsonian 19:212 (c,4) O '88
—High-wheeled carts (Sicily, Italy)
 Trav/Holiday 173:74 (c,2) F '90
CARRIAGES AND CARTS—HORSE-
 DRAWN
 Trav/Holiday 170:48–9 (c,2) S '88
—16th–18th cent. Russian royal carriages
 Nat Geog 177:92 (c,3) Ja '90
—19th cent. (Great Britain)
 Smithsonian 21:88 (painting,c,4) O '90
—19th cent.-style wagon (New Brunswick)
 Trav&Leisure 20:E10 (c,3) S '90

—1890s (Chicago, Illinois)
Am Heritage 38:112 (2) S '87
—1930s (Arkansas)
Smithsonian 22:104–5 (painting,c,1) Jl
'91
—1934 (Milan, Italy)
Life 13:85 (2) S '90
—Bahamas
Trav/Holiday 168:70 (c,4) Ag '87
—Cape May, New Jersey
Am Heritage 40:6a (c,4) S '89
—Coach Museum, Lisbon, Portugal
Trav&Leisure 19:104–5 (c,1) S '89
—Combined driving competition (New Jersey)
Sports Illus 69:110–12 (c,2) D 5 '88
—Delaware
Trav&Leisure 17:65 (c,3) Ag '87
Gourmet 50:97 (c,4) My '90
—Elegant coach (Great Britain)
Gourmet 49:108 (c,4) O '89
—Grindelwald, Switzerland
Trav/Holiday 168:39 (c,3) O '87
—Louisiana plantation
Trav&Leisure 19:100–1 (c,1) F '89
—Mackinac Island, Michigan
Gourmet 49:72 (c,4) Je '89
—New York City, New York
Trav&Leisure 18:100–1 (c,1) Mr '88
—Philadelphia, Pennsylvania
Trav/Holiday 167:46, 51 (c,3) Ap '87
—Pinehurst, North Carolina
Trav/Holiday 172:52–3 (c,2) N '89
—Texas
Trav/Holiday 170:46 (c,4) D '88
—Yugoslavia
Trav&Leisure 21:190 (c,4) Ap '91
CARROLL, CHARLES
—Home (Annapolis, Maryland)
Nat Geog 174:167 (c,1) Ag '88
CARROLL, DANIEL
Life 10:55 (painting,c,4) Fall '87
CARROLL, LEWIS
Nat Geog 179:101, 116 (2) Je '91
—Illustrations from *Alice in Wonderland*
Nat Geog 179:104–15, 118, 126–7 (c,1) Je
'91
—Illustrations from his books
Nat Geog 179:104–20, 126–7 (c,1) Je '91
—Alice Liddell, of "Alice in Wonderland"
Life 11:40 (4) Fall '88
Nat Geog 176:540 (2) O '89
Nat Geog 179:100, 102, 128 (4) Je '91
—Sites relating to his life
Nat Geog 179:100–29 (c,1) Je '91
CARSON, KIT
Nat Geog 179:116–17 (c,3) Mr '91
CARSON, RACHEL
Am Heritage 38:51 (4) D '87

Life 13:19 (4) Fall '90
CARTAGENA, COLOMBIA
Nat Geog 175:495–509 (map,c,1) Ap
'89
—San Felipe fort
Am Heritage 39:83 (c,4) Mr '88
Nat Geog 175:498–9 (c,1) Ap '89
CARTER, JIMMY
Life 10:74 (c,4) Ag '87
Life 10:26–7 (c,1) O '87
Life 11:176 (c,4) My '88
Trav/Holiday 173:65 (c,4) F '90
—Carter as a child
Life 11:11–6 (4) My '88
—Carter Presidential Center, Atlanta,
Georgia
Trav&Leisure 18:E4 (c,2) F '88
—Carter at baseball game
Sports Illus 75:2–3 (c,1) O 21 '91
—Cartoons about Jimmy Carter
Am Heritage 42:46, 49 (2) Jl '91
CARTHAGE
—Artifacts from ancient Carthage
Natur Hist 96:58–70 (c,1) D '87
CARTIER-BRESSON, HENRI
Life 10:124–30 (1) D '87
—"Alicante, Spain" (1933)
Trav&Leisure 18:36–7 (3) Ja '88
—Art works by him
Life 10:127 (c,2) D '87
—Photo of Henri Matisse
Trav&Leisure 19:46 (4) N '89
—Photo of outdoor steps (1932)
Life 11:43 (4) Fall '88
CARTOONISTS
—Clare Briggs
Am Heritage 39:79 (4) My '88
—Al Capp self-portrait
Smithsonian 18:190 (drawing,4) N '87
—Cartoonist's studio (California)
Life 12:104–5 (c,1) Jl '89
—"Mark Trail's" artists
Nat Wildlife 26:15 (c,4) F '88
—H. T. Webster
Am Heritage 42:100 (4) S '91
—Chic Young self-portrait
Smithsonian 18:190 (drawing,4) N '87
—See also
ARNO, PETER
DISNEY, WALT
HIRSCHFELD, AL
CARTOONS
—1754 Franklin "Join or die" cartoon
against French
Am Heritage 38:14 (4) My '87
Am Heritage 38:53 (4) D '87
—1891 cartoon about snapshot photography
Smithsonian 19:106 (c,2) Je '88

—1900 cartoon of Carry Nation smashing
saloon
Smithsonian 20:148 (drawing,4) Ap '89
—1907 cartoon warning against fast food
restaurants
Am Heritage 39:70 (4) Ap '88
—1910s cartoons about U.S. income tax
Am Heritage 40:101, 104–5 (2) Mr '89
—1911 cartoon about businessmen doing
"real" work
Am Heritage 42:130–1 (1) Ap '91
—1912 anti-capitalism cartoon
Am Heritage 38:47 (4) N '87
—1927 cartoon about Lindbergh
Smithsonian 18:214 (4) O '87
—1931 cartoon about bank failures
Am Heritage 38:53 (4) D '87
—1935 cartoon about progressive education
Am Heritage 41:76 (4) F '90
—1936 U.S. isolationist cartoon
Am Heritage 38:53 (4) D '87
—1955 cartoon about U.S. involvement in
Vietnam
Am Heritage 38:53 (4) D '87
—Betty Boop balloon in parade
Trav/Holiday 172:86 (c,4) N '89
Nat Geog 178:57 (c,4) S '90
—Bugs Bunny
Nat Geog 100:8 (drawing,c,4) O '91
—Caricature of Ulysses S. Grant
Am Heritage 39:cov. (c,4) Jl '88
—Caricature of John Kennedy
Am Heritage 39:cov. (c,1) Jl '88
—Caricature of Richard Nixon
Am Heritage 39:114 (c,1) Jl '88
—Caricature of Franklin Roosevelt
Am Heritage 39:cov. (c,1) F '88
—Caricature of Theodore Roosevelt
Am Heritage 39:114 (c,1) Jl '88
—Cartoon about antismoking regulations
Life 11:29 (4) Ja '88
—Cartoon about endangered wetlands
Nat Wildlife 26:38 (c,4) Je '88
—Cartoon of Andrew Carnegie giving
money to schools
Am Heritage 40:38 (drawing,4) My '89
—Cartoon of George Eastman as amateur
photographer
Smithsonian 19:109 (4) Je '88
—Cartoon spoofing life in the South
Smithsonian 20:180 (c,2) S '89
—Cartoons about 1929 stock market crash
and Depression
Am Heritage 39:105–9 (3) Jl '88
—Cartoons about 1988 drought
Natur Hist 98:70–1 (4) Ja '89
—Cartoons by Gary Larson
Smithsonian 18:168 (drawing,4) Ap '87
Natur Hist 98:78–9 (4) My '89

Natur Hist 100:54, 68 (4) Jl '91
—Cartoons about *National Geographic*
Nat Geog 174:254–7 (c,2) S '88
—Cartoons by H. T. Webster
Am Heritage 42:101–7 (1) S '91
—College football players' illegal activities
Sports Illus 70:2–3 (c,1) F 27 '89
—Diseases awaiting Panama Canal build-
ers (1904)
Natur Hist 98:18 (painting,c,4) O '89
—Editorial cartoons about 1980s America
Life 12:89, 91 (4) Fall '89
—Flintstones' store, Bedrock City, Flag-
staff, Arizona
Smithsonian 19:112 (c,3) N '88
—Winsor McCay cartoon
Smithsonian 18:264 (4) N '87
—Museum of Cartoon Art, Rye Brook,
New York
Trav/Holiday 169:26–8 (c,3) Ja '88
—Scrooge McDuck
Life 10:90 (c,4) Fall '87
—"The Simpsons"
Life 14:39 (c,4) Ja '91
—"The Three Little Pigs"
Nat Wildlife 25:10 (c,4) Ag '87
—Wildlife cartoons about Christmas
Nat Wildlife 27:18–19 (drawing,c,2) D '88
—See also
ANIMATION
CARTOONISTS
CHARACTER SYMBOLS
COMIC STRIPS
MICKEY MOUSE
POLITICAL CARTOONS
CARUSO, ENRICO
—Caricature
Am Heritage 41:57 (c,2) F '90
—In "Aïda"
Trav&Leisure 19:45 (4) My '89
—Self-portrait of Caruso eating (1906)
Am Heritage 40:129 (drawing,4) D '89
CARVER, GEORGE WASHINGTON
Natur Hist 99:84 (4) Mr '90
CASCADE RANGE, OREGON
Trav/Holiday 171:63–5 (c,1) My '89
CASCADE RANGE, NORTHWEST.
See also
MOUNT HOOD
MOUNT RAINIER
MOUNT ST. HELENS
CASH REGISTERS
—19th cent.
Smithsonian 20:150–7 (2) Je '89
CASPER, WYOMING
Sports Illus 71:53 (c,2) Jl 17 '89
CASSATT, MARY
—"Portrait of Mrs. Robert Simpson Cas-
satt" (1889)

Am Heritage 39:50 (painting,c,1) My '88
—"Young Woman in Black"
Smithsonian 18:168 (painting,c,4) Ja '88
CASTLE, VERNON AND IRENE
Smithsonian 19:84 (4) Mr '89
CASTLES
—12th cent. castle (Paris, France)
Nat Geog 176:103–7 (c,1) Jl '89
—Bellver Castle, Majorca, Spain
Trav&Leisure 18:142–3 (c,1) My '88
—Blarney Castle, Ireland
Trav/Holiday 169:126 (4) Mr '88
—Bodrum, Turkey
Nat Geog 172:576–7 (c,1) N '87
Trav&Leisure 20:106–7 (c,1) Je '90
—Bojnice, Czechoslovakia
Nat Geog 171:125 (c,1) Ja '87
—Bouillon, Belgium
Nat Geog 176:332–3 (c,1) S '89
—Brittany, France
Nat Geog 176:80 (c,4) Jl '89
—Brodick Castle, Scotland
Gourmet 49:82–3, 124 (c,1) My '89
—Burghotel Sababurg, West Germany
Gourmet 49:53 (c,2) Mr '89
—Burgundy, France
Trav&Leisure 19:94 (c,3) D '89
—Caernarvon, Wales
Trav&Leisure 17:106–7 (c,1) Jl '87
Natur Hist 97:38 (c,4) Ap '88
—Casbahs (Morocco)
Trav&Leisure 17:91, 94–5 (c,1) Mr '87
—Charlottenburg, Berlin, West Germany
Trav&Leisure 17:90–1, 156 (c,1) S '87
—Clytha Castle, Wales
Gourmet 51:109 (c,2) D '91
—Cochem, West Germany
Trav/Holiday 168:72 (c,1) Jl '87
—Dunrobin, Scotland
Trav&Leisure 17:67 (painting,c,4) My
'87
—Edinburgh Castle, Scotland
Natur Hist 97:42 (c,4) Ap '88
—Egeskov Castle, Funen, Denmark
Gourmet 48:57 (c,2) Ag '88
—Entrance hall (Meersburg, West Ger-
many)
Gourmet 49:62 (c,1) Je '89
—Falkland, Scotland
Trav/Holiday 167:54 (c,1) Ap '87
—Gillette Castle, East Haddam, Con-
necticut
Trav/Holiday 169:28, 30 (c,4) Ap '88
—Güssing, Austria
Gourmet 47:48–9 (c,1) Jl '87
—Hearst Castle, San Simeon, California
Trav&Leisure 17:132–3 (c,2) S '87
—Heidelberg, West Germany
Gourmet 47:49, 53 (c,1) Ja '87

—Kelso, Scotland
Gourmet 48:48–51 (c,1) Ag '88
—Kenilworth castle ruins, England
Trav&Leisure 19:134–5 (c,1) My '89
—Leed's, Kent, England
Natur Hist 97:33 (c,4) Ap '88
—Linderhof Castle, West Germany
Gourmet 50:51 (c,1) Ag '90
—Lyndhurst Castle, New York
Am Heritage 40:146–7 (c,4) N '89
Nat Geog 178:84–5 (c,1) S '90
—Mainau, West Germany
Gourmet 49:138 (drawing,4) Je '89
—McIntosh, Kingston, Ontario
Trav/Holiday 167:22 (4) Ja '87
—Neuschwanstein, West Germany
Trav&Leisure 17:145 (c,2) F '87
—Olesko, Ukraine, U.S.S.R.
Nat Geog 171:596–7 (c,1) My '87
—Osaka, Japan
Trav/Holiday 167:64–5 (c,1) Ap '87
—St. Andrews, Scotland
Trav/Holiday 167:57 (c,2) Ap '87
—São Jorge Castle, Lisbon, Portugal
Trav&Leisure 19:106–7 (c,1) S '89
—Winter carnival ice palaces
Smithsonian 17:62–9 (c,1) Ja '87
—Yalta, U.S.S.R.
Nat Geog 171:626–7 (c,1) My '87
—See also
CHATEAUS
PALACES
WINDSOR CASTLE
CASTRO, FIDEL
Sports Illus 66:50 (c,4) F 9 '87
Sports Illus 66:2–3 (c,1) Je 29 '87
Life 10:8 (c,3) Ag '87
Nat Geog 180:96 (c,4) Ag '91
Am Heritage 42:88, 90 (c,3) N '91
CATALINA ISLAND, CALIFORNIA
Smithsonian 22:153–67 (c,1) O '91
CATAPULTS
—Replica of 13th cent. catapult (France)
Smithsonian 22:46–7 (c,2) My '91
CATERPILLARS
Nat Geog 174:844–5 (c,1) D '88
Nat Geog 176:418–19 (c,1) S '89
Natur Hist 99:49 (c,1) F '90
Natur Hist 100:40–1, 44–5 (c,1) Je '91
Nat Geog 180:96 (c,3) D '91
—Arctic woolly bears
Natur Hist 97:36–41 (c,1) Ja '88
—Caterpillars camouflaged among
flowers
Nat Wildlife 28:46–7 (c,1) Ag '90
CATFISH
Nat Geog 180:128–9 (c,1) O '91
—Pet fish
Smithsonian 20:98–100 (c,4) My '89

CATHER, WILLA
 Smithsonian 18:146 (4) Je '87
 Am Heritage 41:81–2 (4) Ap '90
—Home (Red Cloud, Nebraska)
 Am Heritage 41:84–5 (c,1) Ap '90
CATHERINE II, THE GREAT
 (U.S.S.R.)
 Nat Geog 177:92 (painting,c,4) Ja '90
 Trav/Holiday 175:103 (painting,c,3) Ap
 '91
Catholic Church. See
 CHRISTIANITY
CATLIN, GEORGE
—1834 Choctaw Indians ball game
 Am Heritage 41:116 (painting,c,4) My
 '90
—"Buffalo Hunt under the Wolf-skin
 Mask"
 Nat Wildlife 25:7 (painting,c,4) Ag '87
—"Death of La Salle"
 Am Heritage 38:108 (painting,4) F '87
—Yellow Stone steamboat (1839)
 Am Heritage 38:121, 126 (painting,c,4)
 My '87
CATS
 Life 10:72 (3) My '87
 Life 10:96 (2) S '87
 Natur Hist 98:40–7 (c,1) Jl '89
 Natur Hist 98:4 (c,4) S '89
—Abyssinian kittens
 Smithsonian 19:40 (c,4) F '89
—Caracal
 Smithsonian 20:109 (c,4) F '90
—Cat catching rats (1868 engraving)
 Natur Hist 100:18 (3) Je '91
—Cat falling
 Natur Hist 98:21 (c,2) Ag '89
 Natur Hist 98:6 (c,3) O '89
—Cheshire cat sculpture by Calder (1967)
 Am Heritage 41:72 (c,1) My '90
—Jaguarundis
 Nat Geog 176:459 (c,4) O '89
 Sports Illus 72:90 (c,2) Ap 9 '90
 Life 14:22 (c,3) N '91
—Kitten
 Life 10:88 (c,2) Mr '87
—Room full of cats
 Life 12:122–3 (c,1) Je '89
—Sitting on parked motorbike (Italy)
 Gourmet 50:88 (c,4) My '90
—See also
 BOBCATS
 CHEETAHS
 JAGUARS
 LEOPARDS
 LIONS
 LYNXES
 MARGAYS
 MOUNTAIN LIONS

 PANTHERS
 SABER-TOOTHED CATS
 SERVALS
 TIGERS
 WILDCATS
CATSKILL MOUNTAINS, NEW YORK
 Life 10:56–9 (c,1) O '87
CATTAILS
 Natur Hist 98:75 (c,4) Je '89
 Nat Wildlife 29:10 (c,2) D '90
CATTLE
 Am Heritage 40:44–5 (c,1) Ap '89
 Nat Wildlife 29:44 (c,4) D '90
—1886 painting by Charles M. Russell
 Smithsonian 18:74 (c,4) Mr '88
—Bull
 Smithsonian 21:80 (c,4) Ap '90
 Trav&Leisure 20:E8 (c,3) Jl '90
—Calf
 Sports Illus 71:114–15 (c,1) O 9 '89
—Calves dead from heat (North Dakota)
 Life 11:33 (c,3) S '88
—Cows
 Life 10:58–9 (c,1) S '87
 Nat Geog 173:68–9 (c,1) Ja '88
 Gourmet 49:48 (c,4) Ag '89
 Gourmet 49:91 (c,1) S '89
 Natur Hist 98:8 (c,4) S '89
 Trav&Leisure 20:131 (c,4) Mr '90
 Trav/Holiday 173:56–7 (c,1) Je '90
 Nat Geog 179:30–1 (c,1) F '91
—Dead from toxic gas burst (Cameroon)
 Natur Hist 96:48–9 (c,1) Ag '87
 Nat Geog 172:412–13 (c,1) S '87
—Sacred cow (India)
 Trav&Leisure 20:246 (c,4) O '90
—Washing steer (Nebraska)
 Smithsonian 21:42 (c,4) N '90
—Woman embracing cow
 Nat Wildlife 27:4 (c,1) Ag '89
—See also
 BISON
 BRAHMANS
 BUFFALOES
 DAIRYING
 MUSK OXEN
 OXEN
 RANCHING
 WATER BUFFALOES
 YAKS
CATTON, BRUCE
 Am Heritage 39:6 (4) Mr '88
CAVE EXPLORATION
—1925 ordeal of Floyd Collins (Kentucky)
 Smithsonian 21:137–50 (c,3) My '90
—Great Expectations Cave, Wyoming
 Sports Illus 68:80–93 (c,1) My 2 '88
—New Mexico
 Smithsonian 19:52–64 (c,2) N '88

—Estonia
Life 10:142–3 (c,1) N '87
—"Hermitage" graveyard, Nashville, Tennessee
Trav/Holiday 175:62–3 (1) Ja '91
—Highgate, London, England
Trav&Leisure 17:86 (painting,c,2) Je '87
Gourmet 49:30, 32 (painting,c,3) Ag '89
—Iran
Life 11:31 (c,3) O '88
—Japanese oyster divers (Australia)
Nat Geog 180:118–19 (c,2) D '91
—Jewish (West Germany)
Life 10:128 (c,4) N '87
Nat Geog 176:337 (c,1) S '89
—Johnstown, Pennsylvania
Smithsonian 20:61 (c,2) My '89
—Lebanon, Connecticut
Am Heritage 40:90 (c,4) Ap '89
—Lithuania
Nat Geog 178:34–5 (c,1) N '90
—Looted ancient Indian graves (Kentucky)
Nat Geog 175:376–93 (c,1) Mr '89
—Mausoleum (California)
Sports Illus 70:96–7 (c,2) Ap 3 '89
—Nevis
Trav&Leisure 19:166 (c,2) O '89
—New Orleans, Louisiana
Am Heritage 39:92 (c,3) Ap '88
—Old Jewish Cemetery, Prague, Czechoslovakia
Trav&Leisure 17:112 (c,4) F '87
Trav/Holiday 170:28 (c,3) Jl '88
Trav/Holiday 173:48 (c,3) My '90
—Père Lachaise, Paris, France
Gourmet 47:28, 32 (painting,c,2) Jl '87
—Puerto Rico
Sports Illus 67:61 (c,3) N 23 '87
—Rhode Island
Sports Illus 66:62 (c,2) Je 1 '87
—Site of old Jewish cemetery (Lithuania)
Smithsonian 21:71 (c,2) Ja '91
—South Korea
Life 10:22–3 (c,1) S '87
—U.S. World War II soldiers (Africa)
Am Heritage 41:109 (4) D '91
—See also
ARLINGTON NATIONAL CEMETERY
TOMBS
TOMBSTONES
CENSORSHIP
—Censored tabloids (Saudi Arabia)
Nat Geog 172:447 (c,4) O '87
CENSUS
—1890 census fight between Minneapolis and St. Paul
Am Heritage 41:106–9 (2) Jl '90

—History of the U.S. Census
Am Heritage 40:1–23 (c,1) N '89 supp.
—Taking census of the homeless (Washington, D.C.)
Life 14:70 (c,3) Ja '91
CENTIPEDES
Nat Geog 175:793 (c,2) Je '89
CENTRAL AMERICA
—Cocos Island
Trav/Holiday 172:88–90 (c,1) N '89
CENTRAL AMERICA—MAPS
—Regions associated with the Maya
Nat Geog 176:424, 437 (c,1) O '89
CENTRAL PARK, NEW YORK CITY, NEW YORK
Trav&Leisure 18:98–109 (map,c,1) Mr '88
Trav/Holiday 170:48–51 (c,2) S '88
Gourmet 49:48 (painting,c,2) Je '89
—Central Park Zoo
Trav&Leisure 19:NY2–4 (c,3) F '89
Trav/Holiday 171:73–5 (c,4) My '89
CÉZANNE, PAUL
—"Baigneurs"
Smithsonian 17:93 (painting,c,3) Mr '87
—"On the Banks of the Pond" (1870s)
Smithsonian 22:44–5 (painting,c,2) Ag '91
—"The Water Can" (1880)
Smithsonian 17:57 (painting,c,4) Ja '87
CHAGALL, MARC
—"Green Violinist"
Trav&Leisure 17:38 (painting,c,4) N '87
—Painting of the Eiffel Tower (1911)
Smithsonian 22:47 (c,3) Ag '91
—"Purim" (1910s)
Smithsonian 22:91 (painting,c,3) Jl '91
—Stained glass window (New York)
Trav&Leisure 17:NY2 (c,4) S '87
CHAIRS
—18th cent. ladder-back chair (Connecticut)
Am Heritage 40:85 (c,4) Ap '89
—1730 (Great Britain)
Am Heritage 40:115 (c,4) F '89
—Late 18th cent. side chair (Rhode Island)
Am Heritage 40:73 (c,3) My '89
—1790s pine armchair (Pennsylvania)
Am Heritage 41:86 (c,4) N '90
—19th cent. bentwood rocker (Austria)
Smithsonian 22:137 (c,4) D '91
—19th cent. piano stool (Italy)
Gourmet 47:65 (c,1) S '87
—1824 side chair (Maryland)
Am Heritage 40:48 (c,4) Jl '89
—1855 Belter chair (New York)
Am Heritage 40:25 (c,1) Mr '89
—Early 20th cent. Frank Lloyd Wright designs

Am Heritage 38:83 (c,3) Jl '87
Trav&Leisure 17:46 (c,4) D '87
Smithsonian 19:130 (c,4) Ag '88
Am Heritage 42:68 (c,4) Jl '91
—1907 art nouveau chair (Austria)
Trav&Leisure 19:88 (4) Mr '89
—1909 Greene and Greene armchair
Am Heritage 41:35 (c,1) Ap '90
—Chair with western motif (Wyoming)
Am Heritage 42:114 (c,4) Jl '91
—Four-rocker chair (Kentucky
Natur Hist 96:57 (c,2) Jl '87
—Larger straw chair
Trav/Holiday 175:37 (c,4) F '91
—Lawn chairs (Hyde Park, London, England)
Trav&Leisure 20:169 (c,1) N '90
—Rocking chairs
Nat Geog 173:74–5 (c,1) Ja '88
Life 11:3 (c,2) Ag '88
Trav/Holiday 174:89 (drawing,4) Ag '90
—28-foot high chair in lake (Switzerland)
Life 12:12 (c,4) Jl '89
—Wooden chair with umbrella attached
Trav/Holiday 174:81 (c,2) Ag '90
—See also
THRONES
CHAMBERLAIN, NEVILLE
Smithsonian 19:162, 178–92 (2) O '88
CHAMBERLAIN, WILT
Sports Illus 68:85–90 (c,3) Ap 18 '88
Sports Illus 71:47 (4) N 15 '89
Sports Illus 72:58 (sculpture,c,1) Ja 8 '90
CHAMELEONS
Natur Hist 96:92–3 (c,1) Ja '87
Nat Geog 171:152–3 (c,1) F '87
Life 11:8 (c,4) F '88
Nat Geog 174:766 (drawing,2) N '88
Nat Wildlife 27:54 (c,3) Ap '89
Smithsonian 21:cov., 44–53 (c,1) Je '90
Nat Geog 178:5 (c,4) D '90
Nat Wildlife 29:6–7 (c,1) F '91
CHAMPLAIN, SAMUEL DE
—1615 attack on Iroquois (New York)
Nat Geog 172:372–3 (engraving,2) S '87
—Champlain on Mount Desert Island,
Maine (1604)
Trav/Holiday 171:53 (painting,c,4) F '89
CHANDELIERS
—1890s wrought iron chandelier (North
Carolina)
Trav/Holiday 175:59 (c,1) Ap '91
—1940 western motif Molesworth chandelier (Wyoming)
Am Heritage 42:31 (c,2) Jl '91
—Kremlin, Moscow, U.S.S.R.
Life 10:33 (c,1) O '87
—Lisbon palace, Portugal
Gourmet 48:66 (c,2) Ap '88

—Riyadh palace, Saudi Arabia
Life 11:92 (c,1) Ap '88
CHAPLIN, CHARLIE
Am Heritage 38:7 2(3) F '87
Life 12:106 (4) Ap '89
—"The Great Dictator" (1940)
Am Heritage 41:42 (4) S '90
—People dressed as "The Little Tramp"
Life 12:106–7 (1) Ap '89
CHARACTER SYMBOLS
—Alf
Trav&Leisure 20:130 (c,4) S '90
—"Big Boy" hamburger symbol
Am Heritage 39:75 (c,3) Ap '88
—James Bond movies artifacts
Life 10:114–15 (c,1) Ap '87
—"E.T." (1982)
Sports Illus 71:168 (c,4) N 15 '89
—Father Time
Gourmet 48:44 (drawing,c,2) D '88
—McGruff, the Crime Dog
Smithsonian 19:121–31 (c,2) Ap '88
—Michelin man
Trav&Leisure 18:39 (c,4) Mr '88
Am Heritage 40:12 (4) Jl '90 supp.
Smithsonian 21:cov. (stained glass,c,1) N
'90
—People dressed as "The Little Tramp"
Life 12:106–7 (1) Ap '89
—Popeye characters
Trav/Holiday 169:26 (c,3) Ja '88
Life 11:25 (c,2) F '88
Trav&Leisure 19:107 (drawing,c,3) N
'89
—"The Simpsons"
Life 14:39 (c,4) Ja '91
—"Snow White" (1937)
Life 10:52–6 (c,1) Ap '87
Life 11:107 (c,4) Ja '88
—"Speedy" Alka-Seltzer
Life 12:118 (4) Mr '89
Smithsonian 20:26 (c,4) Ja '90
—Spuds Mackenzie
Life 11:104 (c,3) Ja '88
—Teenage Mutant Ninja Turtles playing
chess
Sports Illus 73:89 (c,4) D 24 '90
—See also
BATMAN
COMIC STRIPS
HOLMES, SHERLOCK
MICKEY MOUSE
PUPPETS
SUPERMAN
TARZAN
CHARLES V (SPAIN)
Nat Geog 172:562 (painting,c,4) N '87
CHARLESTON, SOUTH CAROLINA
Trav&Leisure 18:40–2 (c,4) F '88

Gourmet 49:68–73, 144 (c,1) Ap '89
—1989 damage from Hurricane Hugo
Sports Illus 71:8–10 (c,3) O 23 '89
Trav&Leisure 20:79 (c,4) Ja '90
Life 13:20 (c,1) Ja '90
—Charleston gardens
Trav/Holiday 167:44–5 (c,1) Mr '87
Trav/Holiday 174:66–7 (c,1) N '90
—The Citadel
Trav&Leisure 18:42 (c,4) F '88
—East Battery area (1831)
Am Heritage 38:62 (painting,c,4) Ap '87
—Historic district
Am Heritage 38:62–9 (c,1) Ap '87
CHARLOTTE, NORTH CAROLINA
Sports Illus 75:72 (c,4) O 28 '91
CHARLOTTE AMALIE, ST. THOMAS,
 VIRGIN ISLANDS
—Harbor
Trav/Holiday 169:48–9 (c,2) Ap '88
CHARLOTTESVILLE, VIRGINIA
Gourmet 47:66–71, 98 (c,1) Ap '87
—University of Virginia
Trav&Leisure 19:128–9 (c,1) S '89
Am Heritage 41:106 (drawing,3) S '90
—See also
 JEFFERSON, THOMAS
CHÂTEAUS
—Aigle, Switzerland
Gourmet 49:53 (c,1) Ag '89
—Chambord, France
Smithsonian 18:142 (c,4) S '87
Nat Geog 176:58–9 (c,1) Jl '89
—Château de Montfort, Dordogne, France
Nat Geog 176:68 (c,3) Jl '89
—Château du Feÿ, Burgundy, France
Trav/Holiday 167:58–9 (c,2) F '87
Gourmet 51:124–5 (c,1) N '91
—Chenonceau, France
Trav&Leisure 18:146–7 (c,2) O '88
—Dumas' Château de Monte-Cristo, Paris,
 France
Gourmet 48:78–81, 146 (c,1) My '88
—Languedoc, France
Trav/Holiday 175:105 (c,2) Mr '91
—Loire Valley, France
Gourmet 47:72–3 (c,4) Ap '87
Gourmet 47:50–3 (c,3) S '87
Trav&Leisure 18:144–7, 154–6 (c,1) O
 '88
Trav&Leisure 18:208 (c,4) D '88
Nat Geog 176:60–1 (c,1) Jl '89
Trav&Leisure 21:135–7, 142–5 (map,c,1)
 Je '91
—Montesquieu's La Brède home (Bor-
 deaux, France)
Smithsonian 20:188 (4) S '89
—Montgeoffroy château, France
Gourmet 49:50–1, 94 (c,1) Jl '89

—Vaux-le-Vicomte, France
Trav&Leisure 18:28 (c,3) My '88
CHATS (BIRDS)
Nat Wildlife 26:52 (c,1) Je '88
CHATTANOOGA, TENNESSEE
Sports Illus 72:26–7 (c,1) Ap 30 '90
—Map of Civil War battle (1863)
Am Heritage 41:86–7 (c,1) Mr '90
CHEERLEADERS
—Cheerleader training
Sports Illus 75:38–46 (c,1) D 30 '91
—College
Sports Illus 67:63 (c,4) D 21 '87
Sports Illus 68:30 (c,4) Mr 21 '88
Sports Illus 69:2–3 (c,1) D 12 '88
Life 12:114–16 (c,1) O '89
Sports Illus 75:38–46 (c,1) D 30 '91
—Septuagenarian cheerleaders (Arizona)
Life 13:14 (c,3) N '90
CHEESE
—Cheese wheels (Great Britain)
Gourmet 47:65 (c,1) Ap '87
—French cheeses
Trav&Leisure 17:30 (c,4) S '87
Gourmet 49:154 (c,4) Jl '89
—Italian cheeses
Gourmet 47:74–7 (c,1) O '87
Trav/Holiday 172:63, 66–7 (c,3) N '89
—Netherlands
Gourmet 50:76 (c,4) Ap '90
—Vermont colby cheese
Gourmet 50:64 (c,4) Ja '90
CHEESE INDUSTRY
—Cheese factory (1906)
Natur Hist 96:80 (4) Jl '87
—France
Nat Geog 176:73–4 (c,2) Jl '89
—Parma, Italy
Gourmet 47:74–9 (c,1) O '87
CHEETAHS
Trav&Leisure 17:100–1 (c,1) N '87
Natur Hist 96:42–3 (c,1) D '87
Trav&Leisure 18:114 (c,4) My '88
Natur Hist 98:cov., 50–9 (c,1) Je '89
Trav&Leisure 98:62–5 (c,1) N '89
Nat Wildlife 28:39 (c,4) O '90
Nat Wildlife 29:12–13 (c,1) F '91
CHEFS
Gourmet 47:84 (drawing,4) Mr '87
—Aboard cruise ship
Trav&Leisure 17:115 (c,2) O '87
—Austria
Gourmet 51:117 (c,4) O '91
—California
Gourmet 51:38, 57 (c,3) N '91
—Chicago, Illinois
Trav&Leisure 20:173 (c,2) O '90
—Auguste Escoffier
Gourmet 49:124 (2) O '89

CHICAGO, ILLINOIS
Nat Wildlife 27:10–11 (c,1) D '88
Nat Geog 175:160–1, 174–85 (c,1) F '89
Trav&Leisure 20:164–80 (map,c,1) O '90
Trav/Holiday 174:26 (map,c,4) N '90
Nat Geog 179:52–3, 61 (c,1) My '91
—Late 19th cent. Chicago millionaires
Am Heritage 38:35–44 (c,1) N '87
—1880s Tacoma Building
Nat Geog 173:16 (drawing,4) Ja '88
—1893 Columbian Exposition
Am Heritage 38:36 (painting,c,2) N '87
Am Heritage 39:79 (painting,c,1) D '88
—1898 map of business district
Am Heritage 38:40 (c,2) N '87
—Aerial view
Trav/Holiday 169:28 (c,4) Mr '88
Nat Geog 175:174 (c,1) F '89
—Art Institute of Chicago
Smithsonian 19:28–37 (c,1) Ag '88
—Chicago Auditorium Building
Am Heritage 40:42 (4) D '89
—Chicago River
Trav&Leisure 20:180 (c,4) O '90
Nat Geog 179:52–3 (c,1) My '91
—Chicago Tribune tower
Am Heritage 40:147 (c,4) N '89
—Daily News building (1929 and today)
Am Heritage 38:118–19 (c,2) My '87
—Grand Central Station
Am Heritage 41:93 (4) Jl '90
—Lake Michigan flood damage
Nat Geog 172:2–7 (c,1) Jl '87
—Map of ethnic neighborhoods
Nat Geog 179:57 (c,1) My '91
—Newberry Library
Smithsonian 18:125–35 (c,1) Mr '88
—Palmer mansion
Am Heritage 38:44–5 (1) N '87
—Scenes of Chicago life
Nat Geog 179:51–77 (c,1) My '91
—Studying wind patterns on a model of
Chicago
Smithsonian 19:129 (c,2) My '88
—Terra Museum
Trav&Leisure 17:152 (c,4) D '87
—Water Tower
Trav/Holiday 167:10 (c,4) Je '87
Am Heritage 38:28 (c,4) N '87
—Wigwam convention center (1860)
Am Heritage 39:112 (4) N '88
—Wrigley Building
Trav/Holiday 167:12 (c,4) Je '87
—See also
CHINATOWN
FIELD, MARSHALL
LAKE MICHIGAN
PALMER, POTTER
SEARS TOWER

CHICKADEES
Natur Hist 97:60–1 (c,1) Ag '88
Nat Wildlife 29:41–4 (c,1) F '91
CHICKENS
Smithsonian 19:113–24 (drawing,c,2) Ag
'88
Life 12:2–3 (c,1) Ap '89
Gourmet 49:202 (drawing,4) S '89
Nat Wildlife 29:46 (c,4) D '90
—Chicken with red contact lenses
Life 11:17 (c,2) D '88
—Jungle fowl
Nat Wildlife 27:44–5 (c,1) Je '89
—See also
ROOSTERS
CHICKS
Nat Wildlife 25:42–9 (c,1) Ap '87
—Albatrosses
Nat Geog 173:414–15 (c,1) Mr '88
Nat Geog 175:355, 358 (c,3) Mr '89
—Cattle egrets
Smithsonian 18:69 (c,1) My '87
—Condors
Sports Illus 66:66 (c,4) Mr 23 '87
Sports Illus 69:83–4 (c,4) O 31 '88
Life 12:60 (c,4) Ja '89
—Cuckoos
Natur Hist 98:50–4 (c,1) Ap '89
—Eaglets
Life 11:52–5 (c,1) My '88
Nat Wildlife 27:39 (c,4) O '89
—Flickers
Nat Wildlife 25:48 (c,4) Ap '87
Nat Wildlife 26:8 (c,4) F '88
—Goshawks
Nat Wildlife 29:25 (c,1) Ap '91
—Gulls
Smithsonian 20:84–5 (c,2) O '89
—Hoatzin chicks
Natur Hist 100:50–1 (c,1) Ag '91
—Kestrel chicks
Smithsonian 21:91, 100 (c,4) Ap '90
Nat Wildlife 29:23 (c,1) Ag '91
—Kites
Natur Hist 97:cov., 47–8 (c,1) Ja '88
Smithsonian 19:57, 59 (c,4) Jl '88
—Least bittern chicks
Nat Wildlife 29:2 (c,2) Ap '91
—Mockingbirds
Natur Hist 98:12–13 (c,3) Je '89
—Ostrich chicks
Nat Geog 178:66 (c,4) D '90
—Peregrine falcons
Life 12:68 (c,4) Ap '89
Smithsonian 21:94, 96 (c,4) Ap '90
Nat Geog 179:109–11 (c,1) Ap '91
—Petrel
Natur Hist 98:52 (c,3) Mr '89
—Ptarmigans

Natur Hist 96:64 (c,3) F '87
—Roadrunner mother feeding chicks
Nat Wildlife 27:16 (c,2) Ap '89
—Sanderlings
Natur Hist 96:84–5 (c,1) D '87
—Spoonbills
Nat Geog 171:283 (c,4) F '87
—Tern
Natur Hist 98:10 (c,3) D '89
—Warbler feeding chicks
Natur Hist 98:58–9 (c,1) My '89
CHILDBIRTH
Life 14:28–38 (1) Ap '91
—Doctor delivering twins (West Virginia)
Smithsonian 20:54 (4) S '89
—Doctor holding newborn
Life 14:49 (1) Fall '91
—Guanaco being born
Nat Geog 179:108 (c,2) Ja '91
CHILDREN
Life 13:entire issue (c,1) Spring '90
—1870s victim of child abuse (New York)
Am Heritage 41:85–91 (1) Jl '90
—1880s orphans praying (New York)
Life 13:80–1 (1) Spring '90
—1899 children at zoo (Washington, D.C.)
Smithsonian 20:28–9 (4) Jl '89
—1905 children's playhouse (Vermont)
Am Heritage 41:114 (4) N '90
—1940 school recess playtime (North Dakota)
Am Heritage 40:106–7 (1) F '89
—1948 child war victims (Italy)
Life 11:129 (3) Fall '88
—1950 children's TV show premiums
Smithsonian 20:83–4 (c,4) Je '89
—1990 children's fads
Life 14:93 (c,2) Ja '91
—Abandoned children (Brazil)
Nat Geog 171:363 (c,2) Mr '87
—Blowing soap bubbles
Smithsonian 19:138–43 (c,1) S '88
Trav&Leisure 20:216–17 (c,3) S '90
—Bolivia
Nat Geog 171:444–5, 451 (c,1) Ap '87
—Boys running home from school (Wisconsin)
Smithsonian 21:141 (c,1) Ap '90
—Brazil
Nat Geog 174:810–11 (c,1) D '88
Natur Hist 99:58–9 (c,1) Ag '90
—George Bush's grandchildren
Life 12:36–42 (c,1) Mr '89
—Camp for children with cancer (Connecticut)
Life 11:cov., 24–30 (c,1) S '88
—Child dying of AIDS (Romania)
Life 14:14–15 (c,1) Ja '91
—Child hanging from monkey bars

Sports Illus 74:46–7 (c,1) Je 10 '91
—Child in inflated tube in ocean (Florida)
Trav&Leisure 19:176 (c,1) D '89
—Child playing in snow
Nat Wildlife 27:6 (c,4) D '88
—Child swinging from tree (Pitcairn Island)
Natur Hist 96:cov. (c,1) My '87
—Child with first lost baby tooth
Life 13:36–7 (c,1) Spring '90
—Children at play (1880–1988)
Life 13:66–72 (1) Spring '90
—Children at summer camp
Smithsonian 21:86–97 (c,1) Ag '90
Life 14:7, 52–62 (c,1) Jl '91
—Children at summer camp (1930s)
Smithsonian 21:91 (3) Ag '90
—Children eating candy apples (Quebec)
Trav&Leisure 19:89 (c,4) Ag '89
—Children playing in ocean (Papua New Guinea)
Trav&Leisure 17:78 (c,3) Mr '87
—Children playing in rural Connecticut snow (1880s)
Am Heritage 40:96–7 (1) Jl '89
—Children playing in toy store (Massachusetts)
Smithsonian 20:80–1 (c,1) D '89
—Children riding on luggage cart (Illinois)
Nat Geog 175:183 (c,2) F '89
—Children studying paintings at museum (Illinois)
Smithsonian 19:32–3, 37 (c,2) Ag '88
—Children under sprinkler
Nat Wildlife 29:24 (c,4) Je '91
Trav/Holiday 175:78 (c,4) Je '91
—Children watching show (Washington, D.C.)
Smithsonian 19:20 (c,4) Jl '88
—Children's dance class (New York)
Smithsonian 20:84–95 (1) Mr '90
—Children's drawings of TV characters
Life 12:76–81 (c,1) Mr '89
—Children's lunchboxes (1950s–1970s)
Life 12:116–19 (c,4) Mr '89
—Collecting spent ammunition cartridges (Lebanon)
Life 10:6–7 (c,1) My '87
—Dancing in ballroom competition
Smithsonian 19:96 (c,2) Mr '89
—French children watching puppet show (1963)
Life 11:10–11 (1) Fall '88
—Girl doing handstand (Chile)
Nat Geog 174:76–7 (c,1) Jl '88
—Homeless children (Sudan)
Life 11:72–8 (1) Je '88
—Locating abducted child
Life 14:34–43 (2) Je '91

—Playing badminton (Laos)
Nat Geog 171:784 (c,3) Je '87
—Playing in box of colorful balls
Sports Illus 74:74 (c,3) Ap 29 '91
—Playing in park (Missouri)
Nat Geog 175:201 (3) F '89
—Playing with tire (India)
Nat Geog 174:704 (c,4) N '88
—Poor family (Ohio)
Life 12:56–66 (1) S '89
—Senior citizens working with children
(New Jersey)
Life 12:102–6 (c,1) D '89
—Sick children cheered by clowns
Life 13:76–85 (c,1) Ag '90
—Spelling bees (1925–1989)
Life 13:52–3 (c,2) Spring '90
—Three-year-old coal peddler (El Salvador)
Life 12:28–9 (c,1) F '89
—Tibetan nomads
Nat Geog 172:764–5, 776–7, 781 (c,1) D '87
—Toddlers bundled in baskets (China)
Trav&Leisure 18:183 (c,4) N '88
—Winning Little League team 1989
Sports Illus 71:32–3 (c,1) S 4 '89
—Worldwide early childhood rituals
Life 14:10–26, 92 (c,1) O '91
—See also
BABIES
CHILDBIRTH
DAY CARE CENTERS
FAMILIES
FAMILY LIFE
PLAYGROUNDS
TOYS
YOUTH
CHILDREN—ART
—International Museum of Children's Art,
Oslo, Norway
Smithsonian 21:148–57 (c,2) O '90
CHILDREN—COSTUME
—Mid 19th cent. (Massachusetts)
Nat Geog 174:362–3 (2) S '88
Am Heritage 40:94 (painting,c,2) D '89
—1900 school children (Utah)
Am Heritage 38:40–1 (1) My '87
—Early 20th cent. wealthy children (New
York)
Am Heritage 38:102–9 (1) N '87
—1910 girl in kimono (Japan)
Nat Geog 174:325 (c,2) S '88
—1912 schoolgirls (Oregon)
Am Heritage 40:136 (4) D '89
—1922 urban black children (Virginia)
Smithsonian 18:81 (2) My '87
—Children all dressed up (Georgia)
Nat Geog 174:27 (c,4) Jl '88

—Children in butterfly costumes (California)
Life 10:27 (c,4) My '87
—Children in traditional finery (India)
Trav&Leisure 20:150–1 (c,1) D '90
—Children in traditional dress (Raiatea,
Polynesia)
Trav&Leisure 18:125 (c,1) F '88
—China
Trav&Leisure 17:89 (c,4) D '87
—Indonesia
Trav&Leisure 20:122–3, 127 (c,1) Ja '90
—Italian boys (Naples)
Trav&Leisure 18:96–7 (c,1) Je '88
—Kindergarten graduation (California)
Nat Geog 171:59 (c,4) Ja '87
—Local children after Battle of Gettysburg
(1863)
Am Heritage 40:97–8, 100–1, 106–7
(painting,c,1) My '89
—Malawi
Nat Geog 176:373, 381–9 (c,1) S '89
—Mexico
Sports Illus 68:6 (c,4) F 22 '88
Trav&Leisure 18:86 (c,4) S '88
—New Zealand
Nat Geog 171:661, 673 (c,3) My '87
—School children
Life 13:102–7 (c,2) Spring '90
Nat Geog 180:110–11 (c,2) N '91
—School children (Japan)
Smithsonian 17:cov., 44–53 (c,1) Mr '87
Nat Geog 177:72–3, 78–9 (c,1) Ap '90
—School children (Nigeria)
Nat Geog 179:102–3 (c,1) Ap '91
—School children (Oman)
Trav/Holiday 171:81 (c,3) Mr '89
—South Korea
Trav&Leisure 18:104–5 (c,1) Ag '88
—Traditional attire (Netherlands)
Trav/Holiday 169:16 (4) Ja '88
—U.S.S.R.
Nat Geog 17:594 (c,1) My '87
Trav&Leisure 19:132 (c,3) F '89
CHILE
Nat Geog 174:54–85 (map,c,1) Jl '88
—Andes region
Nat Geog 171:422–3, 432–3, 455–9
(map,c,1) Ap '87
—Aucanquilcha volcano
Nat Geog 171:454–5 (c,1) Ap '87
—Las Campanas Observatory
Smithsonian 19:50–1, 54 (c,2) Ap '88
—Forests
Natur Hist 96:42–7 (c,1) S '87
—Osorno volcano
Natur Hist 96:42–3 (c,1) S '87
—See also
ANDES MOUNTAINS

Nat Wildlife 29:12–13 (c,1) D '90
CHOATE, RUFUS
Am Heritage 39:46 (1) D '88
CHOCTAW INDIANS (SOUTH)
—1834 ball game
Am Heritage 41:116 (painting,c,4) My
'90
CHOU EN-LAI
Life 12:110 (c,4) Mr '89
CHRISTIANITY. See also
AMISH PEOPLE
CHURCH SERVICES
CHURCHES
CONVENTS
GREEK ORTHODOX CHURCH
JESUS CHRIST
MENNONITES
MONASTERIES
MORMONS
RUSSIAN ORTHODOX CHURCH
SHAKERS
VATICAN CITY
CHRISTIANITY—ART
—6th cent. church mosaics (Ravena, Italy)
Smithsonian 20:cov., 54–65 (c,1) Ja '90
—13th cent. church sculptures (Reims,
France)
Nat Geog 176:114 (c,3) Jl '89
—17th–18th cent. miniature crèches
(Naples, Italy)
Smithsonian 22:cov., 100–5 (c,1) D '91
—Bellini's "Madonna and Child"
Trav&Leisure 18:28 (painting,c,2) Jl '88
—Italian Renaissance works
Smithsonian 22:59, 62–4 (painting,c,3) Jl
'91
—Sacred frescoes (Turkey)
Nat Geog 176:330–1 (c,1) S '89
—Statue of Virgin Mary (Yugoslavia)
Life 14:cov., 28 (c,1) Jl '91
CHRISTIANITY—COSTUME
—1934 clerics (Italy)
Life 13:86–7 (1) S '90
—Archbishop (Washington)
Life 10:160 (2) N '87
—Archbishop of Canterbury, England
Life 14:60 (c,3) D '91
—Benedictine monks
Smithsonian 20:70–1 (3) Ap '89
—Bishop of Bruges, Belgium
Trav/Holiday 171:64 (c,3) Mr '89
—Bishops (Washington, D.C.)
Smithsonian 21:119 (c,3) Je '90
—Clergymen (Italy)
Gourmet 49:74 (c,3) My '89
—Female Episcopal bishop (Massachu-
setts)
Life 13:23 (c,3) Ja '90
—Franciscan nuns (Yugoslavia)

Nat Geog 178:114–15 (c,1) Ag '90
—Lutheran reverend
Life 14:61 (c,3) D '91
—Medieval monk
Smithsonian 19:168 (painting,c,4) F '89
—Monk (Albania)
Nat Geog 176:342 (c,1) S '89
—Monks (Italy)
Trav&Leisure 17:94 (c,3) Ap '87
—Nun (Brazil)
Nat Geog 171:366–7 (c,1) Mr '87
—Nuns
Life 11:96 (c,3) Ag '88
Nat Wildlife 29:43 (c,1) D '90
—Nuns (France)
Life 10:88 (2) Ag '87
—Nuns playing snooker (Great Britain)
Life 12:8 (4) O '89
—Priest (Illinois)
Life 14:47–56 (c,1) Ag '91
—Priest (India)
Nat Geog 173:606 (c,3) My '88
—Priest (Italy)
Trav&Leisure 17:106 (c,3) Ap '87
—See also
KNIGHTS OF ST. JOHN
POPES
CHRISTIANITY—HISTORY
—5th cent. mass baptism by St. Patrick
(Ireland)
Smithsonian 18:162 (etching,3) Mr '88
—13th cent. Albigensian Crusade
Smithsonian 22:40–51 (c,1) My '91
—1594 parish registers (Florida)
Nat Geog 173:357 (c,4) Mr '88
—1597 crucifixion (Japan)
Nat Geog 178:16 (painting,c,4) S '90
—Life of Father Berra (California)
Life 10:69–71 (c,3) S '87
—Location of Garden of Eden
Smithsonian 18:128, 132–3 (map,c,2) My
'87
—Moorish occupation and Christian recon-
quest of Spain
Nat Geog 174:86–119 (map,c,1) Jl '88
—See also
JESUS CHRIST
JUSTINIAN
KNIGHTS OF ST. JOHN
LUTHER, MARTIN
POPES
SAINTS
WHITEFIELD, GEORGE
CHRISTIANITY—RITES AND FESTI-
VALS
—16th cent. Corpus Christi procession
(Florida)
Nat Geog 173:342–3 (painting,c,1) Mr
'88

—1888 Penitente sect crucifixion (New Mexico)
Smithsonian 21:118–19 (2) My '90
—All Saints' Day horseback fest (Guatemala)
Nat Geog 176:476–7 (c,1) O '89
—Annual religious festival (Portugal)
Natur Hist 96:60–1 (c,1) F '87
—"Danger of the Holy Innocents" ritual (Spain)
Life 14:20 (2) O '91
—Evangelist carrying wooden cross across America
Nat Geog 173:70–1 (c,1) Ja '88
—Evangelist laying hands on believer
Sports Illus 67:94 (c,4) N 23 '87
—Faith healing (Massachusetts)
Life 11:150 (c,3) Fall '88
—Fiesta de Santa Fe, New Mexico
Nat Geog 172:619 (c,3) N '87
—Fiestas de Octubre (Guadalajara, Mexico)
Trav/Holiday 171:50–6 (c,1) Je '89
—Good Friday (Guatemala)
Nat Geog 173:cov., 799 (c,1) Je '88
Nat Geog 176:425–6 (c,1) O '89
Life 13:52 (c,3) D '90
—Good Friday (Haiti)
Nat Geog 172:668–9 (c,1) N '87
—Healing rites (Yugoslavia)
Life 14:33, 35 (c,2) Jl '91
—Holy Week observances (Spain)
Nat Geog 174:89 (c,2) Jl '88
Nat Geog 170:128–9 (c,1) Ap '91
—Hot candle wax on hands (Peru)
Nat Geog 171:438 (c,4) Ap '87
—Laying on of hands (Latvia)
Nat Geog 178:33 (c,1) N '90
—Lighting candles for All Saints' Day (Yugoslavia)
Nat Geog 178:116 (c,4) Ag '90
—Passing boy through split sapling (Italy)
Life 14:30–1 (1) O '91
—Pilgrimage to shrine (Peru)
Nat Geog 171:428–9 (c,1) Ap '87
Natur Hist 96:42–53 (c,1) Je '87
—Pilgrims at shrine of Marianzell, Austria
Nat Geog 176:326–7 (c,2) S '89
—Pope ordaining bishops (Vatican)
Life 13:10 (c,3) Mr '90
—Priest hearing confession (Mexico)
Sports Illus 67:88 (c,4) D 21 '87
—Procession of the Holy Blood (Bruges, Belgium)
Trav/Holiday 171:64–71 (c,3) Mr '89
—Religious processions (Chile)
Nat Geog 174:63, 84 (c,3) Jl '88
—Religious processions (Malta)
Nat Geog 175:703, 710 (c,1) Je '89

—See also
BAPTISMS
CHRISTMAS
CHURCH SERVICES
COMMUNION
EASTER
PRAYING
CHRISTIANITY—SHRINES AND SYMBOLS
—9th cent. *Book of Kells* (Ireland)
Trav&Leisure 17:34 (c,4) N '87
—Catherine's wheel (Philippines)
Nat Geog 178:10–11 (c,1) S '90
—Early Christian ring (Cyprus)
Nat Geog 174:30 (c,4) Jl '88
—"Ghent Altarpiece" by Van Eyck
Trav&Leisure 17:51 (painting,c,4) Jl '87
—Incense censers (Guatemala)
Nat Geog 173:774–5 (c,1) Je '88
—Lady of Porta Vaga palanguin (Philippines)
Nat Geog 178:2–4, 10–11 (c,1) S '90
—Medjugorje, Yugoslavia
Life 14:cov., 28–36 (c,1) Jl '91
—Shroud of Turin
Life 11:12 (c,4) S '88
—Talisman of Charlemagne
Nat Geog 180:120 (c,1) O '91
—Three Wise Men
Nat Wildlife 26:18 (painting,c,2) D '87
Life 10:123 (drawing,4) D '87
Smithsonian 20:60–1 (mosaic,c,1) Ja '90
Nat Wildlife 30:34–5 (painting,c,1) D '91
—Wall shrine (Majorca, Spain)
Trav&Leisure 18:141 (c,4) My '88
—See also
ANGELS
BIBLES
CHRISTMAS TREES
CRUCIFIXES
DEVILS
JESUS CHRIST
SAINTS
SANTA CLAUS
CHRISTIE, AGATHA
Smithsonian 21:86–95 (1) S '90
CHRISTMAS
—Early 19th cent. carol songsheets
Natur Hist 99:60–1, 64 (c,1) D '90
—1906 carol singers (Great Britain)
Natur Hist 99:58–9 (1) D '90
—1920s Christmas shoppers
Am Heritage 39:cov. (painting,c,2) D '88
—Appenzell festivities, Switzerland
Trav/Holiday 172:39 (painting,c,2) D '89
—Christmas centerpiece
Gourmet 50:cov. (c,1) D '90
—Christmas levee bonfires (Louisiana)
Smithsonian 20:146–51 (c,1) D '89

—Christmas lights (Sedona, Arizona)
 Trav&Leisure 20:118–19 (c,1) Ja '90
—Christmas lights on outhouse (Alaska)
 Life 14:134 (c,2) D '91
—Christmas market (Stuttgart, West Germany)
 Trav/Holiday 172:cov. (c,1) D '89
—Christmas pageant (Washington, D.C.)
 Gourmet 51:105 (c,1) D '91
—Christmas shopping at mall (California)
 Life 14:122–30 (c,1) D '91
—Christmas traditions (Nantucket, Massachusetts)
 Gourmet 47:66–71 (c,1) D '87
—Christmas wreaths
 Gourmet 47:66–71 (c,4) D '87
 Gourmet 48:98–9 (c,2) D '88
 Trav&Leisure 19:114 (c,4) Jl '89
 Gourmet 51:102–3 (c,1) D '91
—Crèches
 Gourmet 49:158 (drawing,4) D '89
—Decorations (Frankfurt, West Germany)
 Trav/Holiday 172:36–7 (c,1) D '89
—Feast of Santa Lucia (Sweden)
 Trav/Holiday 172:40 (c,2) D '89
—Live Nativity scene (Arles, France)
 Trav/Holiday 172:38 (c,4) D '89
—Living crèche (Séguret, Provence, France)
 Gourmet 49:109 (c,4) D '89
—Medieval-style festival (British Columbia)
 Trav/Holiday 168:66–9 (c,1) N '87
—Outdoor Christmas lanterns (Santa Fe, New Mexico)
 Am Heritage 39:24 (c,4) D '88
 Trav/Holiday 174:60–2, 65 (c,1) D '90
—Reenactment of 18th cent. Christmas (Williamsburg, Va.)
 Trav&Leisure 19:100–14 (c,1) Jl '89
—San Antonio decorations, Texas
 Am Heritage 40:2a (c,4) S '89
—Santa ornament (Hong Kong)
 Trav&Leisure 20:75 (c,4) D '90
—Singing carols at pub (Great Britain)
 Natur Hist 99:62–3, 65 (c,1) D '90
—Table set for Christmas dinner
 Gourmet 49:161 (c,1) D '89
—Torchlight procession (Italy)
 Life 11:56 (c,3) Ap '88
—Ukrainian Christmas egg
 Trav&Leisure 20:78 (c,4) D '90
—U.S. Supreme Court Justices singing carols
 Life 10:106–7 (c,3) Fall '87
—Wildlife cartoons about Christmas
 Nat Wildlife 27:18–19 (drawing,c,2) D '88
—See also

CHRISTMAS TREES
MISTLETOE
SANTA CLAUS
CHRISTMAS ISLAND
 Nat Geog 172:822–31 (map,c,1) D '87
CHRISTMAS TREES
 Nat Geog 171:620–1 (c,1) My '87
 Nat Wildlife 28:4–13 (c,1) D '89
 Gourmet 51:100–1 (c,1) D '91
—Bringing Christmas tree home
 Nat Wildlife 28:7, 10–11 (c,2) D '89
—Decorated with origami animals
 Natur Hist 97:74 (c,4) D '88
—General Noriega's tree (Panama)
 Life 13:10 (c,3) F '90
—Old-fashioned parlor at Christmas (New York)
 Am Heritage 41:6 (c,2) D '90
—Rockefeller Center Christmas tree, New York City
 Nat Wildlife 28:13 (c,2) D '89
—Sleigh carrying Christmas tree home (New England)
 Nat Wildlife 27:4–5 (c,1) D '88
—Switzerland
 Gourmet 47:79–81 (c,1) D '87
CHRISTOPHE, HENRI (HAITI)
 Smithsonian 18:160–73 (c,1) O '87
CHRYSANTHEMUMS
 Trav&Leisure 17:96–7 (c,1) F '87
—Made of pearls
 Natur Hist 97:cov. (c,1) Mr '88
CHUBS (FISH)
 Nat Geog 174:839 (c,4) D '88
CHUCKWALLAS
 Smithsonian 18:83 (c,4) Ag '87
CHURCH SERVICES
—1569 (Florida)
 Nat Geog 173:347 (painting,c,2) Mr '88
—Baptist services
 Nat Geog 172:352 (c,4) S '87
 Life 11:38–9 (c,1) Spring '88
—Czechoslovakia
 Nat Geog 171:137 (c,1) Ja '87
—Deacons singing hymns (South Africa)
 Nat Geog 174:560–1 (c,1) O '88
—Easter mass (Ukraine, U.S.S.R.)
 Life 11:110–11 (c,1) Jl '88
—Hawaii
 Trav/Holiday 169:52–3 (c,2) Ap '88
—Jewish service (Kiev, U.S.S.R.)
 Nat Geog 171:614 (c,4) My '87
—Mariachi mass (Texas)
 Trav&Leisure 19:109 (c,3) Ag '89
—Mass (Lebanon)
 Life 14:12–13 (c,1) N '91
—U.S.S.R.
 Trav/Holiday 176:47, 55 (c,1) S '91
—See also

Trav&Leisure 17:91 (c,1) D '87
Trav&Leisure 20:158 (c,2) O '90
—Puebla, Mexico
Trav/Holiday 167:23 (c,4) Ap '87
—Recife, Brazil
Trav&Leisure 17:74 (c,4) D '87
—Red Cloud, Nebraska
Am Heritage 41:88–9 (c,1) Ap '90
—Russian Orthodox (Alaska)
Trav&Leisure 20:168–9 (c,1) Mr '90
—Sagrada Familia, Barcelona, Spain
Trav&Leisure 17:44 (c,4) Ap '87
Gourmet 47:49 (c,1) Je '87
Trav&Leisure 20:137 (c,1) Je '90
—St. Basil's Cathedral, Moscow, U.S.S.R.
Trav/Holiday 168:60–3 (c,1) Ag '87
Life 11:89 (2) Ja '88
Trav/Holiday 176:49–53 (c,1) S '91
—St. Jakobikirche altar, Hamburg, Germany
Gourmet 50:108 (c,4) O '90
—St.-Just Cathedral, Narbonne, France
Gourmet 47:61 (c,1) O '87
—St. Louis Cathedral, New Orleans, Louisiana
Trav&Leisure 19:13 (c,4) F '89
—St. Michael's, Charleston, South Carolina
Gourmet 49:68–9 (c,1) Ap '89
—St. Nicholas Church, Leipzig, East Germany
Trav/Holiday 173:94–5 (c,3) Ja '90
—St. Patrick's Cathedral, Dublin, Ireland
Trav/Holiday 169:44 (c,4) Je '88
—St. Paul's facade, Macau
Trav&Leisure 18:102–3 (c,1) Ja '88
—St. Stephen's Cathedral, Vienna, Austria
Gourmet 50:67 (c,2) Ja '90
—St. Vincent Street Church, Glasgow, Scotland
Trav/Holiday 174:48 (c,4) N '90
—Sainte-Chapelle, Paris, France
Nat Geog 176:116–17 (c,1) Jl '89
—Salisbury Cathedral, England
Trav&Leisure 20:161 (c,3) Ap '90
—San Miguel, Mexico
Trav&Leisure 19:127 (c,1) N '89
—San Pedro Claver, Cartagena, Colombia
Nat Geog 175:495, 501 (c,1) Ap '89
—Santa Prisca, Cuernavaca, Mexico
Gourmet 49:65 (c,1) F '89
—Santiago de Compostela cathedral, Spain
Trav&Leisure 20:144, 148–9 (c,1) Mr '90
—Sarchi, Costa Rica
Gourmet 50:108 (c,2) D '90
—Small chapel (Ephesus, Turkey)
Trav&Leisure 17:107 (c,2) Mr '87
—South Dakota
Life 13:48–9 (c,1) D '90

—Spain
Gourmet 47:76–7 (c,1) N '87
Gourmet 51:68–9, 75 (c,1) Mr '91
—Tahiti
Life 11:50 (c,4) Jl '88
—Taos, New Mexico
Trav/Holiday 171:cov., 30–1 (c,1) Je '89
Smithsonian 20:148 (c,3) N '89
—Tepoztlán church interior, Mexico
Trav/Holiday 174:50–1 (c,1) O '90
—Texas
Gourmet 47:43 (c,1) O '87
Nat Geog 173:492 (c,1) Ap '88
—Trastevere, Italy
Gourmet 50:85 (c,4) My '90
—Trinity Church, New York City, New York
Am Heritage 38:54 (painting,4) N '87
—Unalaska, Alaska
Am Heritage 41:95 (4) Jl '90
—Vence's Matisse Chapel, France
Trav&Leisure 19:56, 61 (c,3) Jl '89
—Vermont
Trav/Holiday 167:76 (c,4) My '87
Trav/Holiday 174:41–2 (c,1) Jl '90
—Washington National Cathedral, Washington, D.C.
Smithsonian 21:14 (4) Ag '90
Smithsonian 21:116–29 (c,1) Je '90
Trav&Leisure 21:E12 (c,3) My '91
—Wells Cathedral, England
Trav&Leisure 19:143 (c,2) My '89
—West Indies
Trav/Holiday 171:58–9 (c,4) F '89
Trav&Leisure 19:166 (c,2) O '89
Trav/Holiday 172:57 (c,4) D '89
Trav&Leisure 175:52 (c,2) Ja '91
—Williamstown, Massachusetts
Gourmet 47:56 (c,1) Ag '87
—Winchester Cathedral, Winchester, England
Trav&Leisure 20:121, 124 (c,4) O '90
—York Minster, England
Trav&Leisure 19:45 (c,4) F '89
—See also
MISSIONS
MONASTERIES
MOSQUES
NOTRE DAME
ST. PAUL'S CATHEDRAL
ST. PETER'S BASILICA
ST. SOPHIA CATHEDRAL
TEMPLES
WESTMINSTER ABBEY
CHURCHILL, WINSTON
Smithsonian 17:53–4 (4) Ja '87
Am Heritage 38:cov., 65–87 (1) F '87
Smithsonian 21:129 (4) Jl '90
Smithsonian 22:134 (4) My '91

Nat Geog 180:77 (2) Jl '91
Am Heritage 42:72 (4) D '91
—Blenheim birthplace, Oxfordshire, England
Am Heritage 42:46–7 (painting,c,1) S '91
—Chartwell home (Kent, England)
Am Heritage 38:66, 78 (3) F '87
—Parents
Am Heritage 38:6 (2) F '87
Am Heritage 38:6 (4) Jl '87
—Playing golf
Sports Illus 67:6 (4) O 26 '87
CICADAS
Nat Geog 174:764 (drawing,4) D '88
Smithsonian 19:118 (sculpture,c,3) D '88
CIGAR MAKING
—Hand rolling cigars (Cuba)
Nat Geog 180:115 (c,4) Ag '91
CIGAR SMOKING
Nat Geog 172:612 (c,2) N '87
Sports Illus 67:cov. (c,1) D 7 '87
Sports Illus 69:72–3 (c,1) S 26 '88
Life 14:78–9, 84–5 (1) S '91
—Fidel Castro with cigar
Life 10:8 (c,3) Ag '87
—Dutch laborer (Indonesia)
Nat Geog 176:228–9 (c,1) Ag '89
—Yukon
Nat Geog 180:84–5 (c,1) N '91
CIGARETTE INDUSTRY
—Cigarette billboard (Los Angeles, California)
Smithsonian 21:100 (c,4) S '90
—Hand rolling clove cigarettes (Indonesia)
Nat Geog 175:117 (c,2) Ja '89
CIGARETTE SMOKING
Nat Geog 171:530 (c,4) Ap '87
—19th cent. anti-smoking efforts
Smithsonian 20:107–17 (c,2) Jl '89
—1880s boy smoking
Am Heritage 39:71 (painting,c,1) D '88
—Cartoon about anti-smoking regulations
Life 11:29 (4) Ja '88
—Lighting cigarette (1966)
Am Heritage 40:42 (3) F '89
—Smoker on airplane
Trav/Holiday 172:14 (painting,c,4) N '89
—Van Gogh's "Skull with a Burning Cigarette"
Smithsonian 20:18 (painting,c,4) S '89
CINCINNATI, OHIO
Trav/Holiday 169:58–63 (map,c,2) My '88
—Ohio River scene in winter (1857)
Am Heritage 40:98–9 (painting,c,1) D '89
—Union Terminal
Am Heritage 42:6 (c,2) Ap '91
Trav/Holiday 176:85 (c,4) D '91

CIRCUS ACTS
Life 11:98–102 (c,1) O '88
—Carvings of 1920s circus acts
Am Heritage 38:42–7, 114 (c,1) D '87
—Circus bears walking upright
Natur Hist 99:64–5 (1) Mr '90
—Contortionists (Canada)
Life 11:101 (c,4) O '88
Nat Geog 179:76–7 (c,1) Mr '91
—Fire-breathing act at Moslem festival (India)
Natur Hist 99:56 (c,4) S '90
—Fire eater (Florida)
Trav/Holiday 167:39 (c,4) Ja '87
—Fire eater (France)
Trav/Holiday 172:72 (c,4) Jl '89
—Fire eater (Senegal)
Trav/Holiday 173:54 (c,4) Ja '90
—Fire walking (Fiji)
Gourmet 51:96 (c,4) O '91
—India
Life 14:48–56 (1) F '91
—Jumbo the Elephant (1880s)
Natur Hist 100:22–7 (2) Mr '91
—Man on unicycle (Nova Scotia)
Trav&Leisure 20:90 (c,4) Ap '90
—Tightrope walkers (Canada)
Life 11:98–9 (c,1) O '88
—Trained panda (China)
Trav/Holiday 173:98 (c,4) Ja '90
—See also
ACROBATIC STUNTS
ACROBATS
ANIMAL TRAINERS
ATHLETIC STUNTS
BARNUM, PHINEAS T.
CLOWNS
JUGGLERS
MAGIC ACTS
RINGLING, JOHN
THUMB, TOM
CIRCUSES
—1890 Seurat painting (France)
Trav&Leisure 21:27 (painting,c,4) Ap '91
Smithsonian 22:111 (painting,c,2) O '91
—1944 fire at circus (Hartford, Connecticut)
Life 14:56–7, 64 (1) N '91
—Big Apple Circus (New York)
Trav&Leisure 18:NY1, NY4 (c,2) N '88
—India
Life 14:48–56 (1) F '91
—Tent mud shows
Natur Hist 97:38–45 (1) Jl '88
CITADELS
—Bam, Iran
Life 11:70 (c,3) S '88
—Haiti's Citadelle
Smithsonian 18:160 (c,1) O '87

Nat Geog 172:666 (c,1) N '87
—Quebec City, Quebec (1722)
　Am Heritage 39:80 (engraving,2)
CITY HALLS
—Basel, Switzerland
　Gourmet 47:78 (c,4) D '87
—Houston, Texas
　Gourmet 47:71 (c,1) O '87
—Interior (San Francisco, California)
　Sports Illus 67:32 (c,3) Jl 27 '87
—Lindau, West Germany
　Trav&Leisure 19:163 (c,2) Ap '89
　Gourmet 49:63 (c,2) Je '89
—Menton, France
　Gourmet 48:59 (c,1) Ja '88
—Milwaukee, Wisconsin
　Trav/Holiday 168:25 (c,4) D '87
—New York City, New York
　Trav&Leisure 17:NY2 (drawing,c,4) F
　'87
—Old City Hall, Grand Rapids, Michigan
　Am Heritage 41:93 (4) Jl '90
—Oradea, Romania
　Trav/Holiday 167:60–1 (c,1) Ap '87
—Oslo, Norway
　Trav/Holiday 167:64 (c,4) Je '87
—Philadelphia, Pennsylvania
　Trav&Leisure 19:42 (c,3) F '89
—Rathaus, Vienna, Austria
　Trav&Leisure 18:120–1 (c,1) N '88
—Sonoma, California
　Gourmet 47:26 (painting,c,2) Je '87
—Tokyo, Japan
　Trav&Leisure 21:21 (c,4) Ag '91
CIVETS
　Nat Geog 174:144 (c,4) Ag '88
CIVIL RIGHTS
—1863 Emancipation Proclamation
　Life 11:6–7 (c,1) Spring '88
—1954 Brown vs. Topeka Board of Educa-
　tion
　Life 10:87 (4) Fall '87
—1954 Supreme Court integration decision
　headline
　Nat Geog 175:206 (4) F '89
—1954 newly integrated classroom (Vir-
　ginia)
　Am Heritage 42:34 (4) Ap '91
—1955 schoolchildren in segregated lines
　(Arkansas)
　Life 13:39 (4) Ap '90
—1957 desegregation of high school (Little
　Rock, Arkansas)
　Life 11:12–13 (1) Spring '88
—1958 arrest of Martin Luther King, Jr.
　(Alabama)
　Life 11:26–7 (1) Spring '88
—1960 lunch counter sit-in (Nashville,
　Tennessee)

Life 11:14–15 (1) Spring '88
—1961 firebombing of freedom rider bus
　(Alabama)
　Life 11:16–17 (1) Spring '88
—1963 black victim of bombing
　Life 11:18–19 (1) Spring '88
—1963 policeman with protestor (Al-
　abama)
　Am Heritage 40:125 (4) S '89
—1964 Rockwell paintings on civil rights
　themes
　Smithsonian 20:125 (c,3) Ap '89
　Life 12:10 (c,4) Ag '89
—1965 Watts riots, Los Angeles, California
　Life 11:22–3 (c,1) Spring '88
　Am Heritage 41:39 (4) Jl '90
—1976 anti-busing riot (Boston, Mas-
　sachusetts)
　Life 10:12–13 (1) Fall '87
—Anti-black demonstrators (Georgia)
　Life 11:76–7 (c,1) Ja '88
—Black Power salute at 1968 Olympics
　(Mexico City)
　Sports Illus 71:106 (c,4) N 15 '89
　Sports Illus 75:60–1, 77 (1) Ag 5 '91
　Sports Illus 75:60–1 (1) Ag 12 '91
—H. Rap Brown
　Sports Illus 75:60 (1) Ag 12 '91
—Stokely Carmichael
　Sports Illus 75:61 (1) Ag 12 '91
—Civil rights memorial (Montgomery, Al-
　abama)
　Smithsonian 22:cov., 32, 43 (c,1) S '91
—Cross burning (Minnesota)
　Life 14:88–9 (c,2) Fall '91
—Angela Davis
　Nat Geog 176:214 (2) Ag '89
—History of the civil rights movement
　Life 11:entire issue (c,1) Spring '88
—Martyrs of the civil rights movement
　(1955–1966)
　Smithsonian 22:34 (4) S '91
—James Meredith integrating U. of Missis-
　sippi (1962)
　Smithsonian 20:114 (4) Ap '89
—Prominent women in the American civil
　rights movement
　Life 11:54–63 (1) Spring '88
—Harry Truman's role in the civil rights
　movement
　Am Heritage 42:55–68 (3) N '91
—See also
　BLACK HISTORY
　GARVEY, MARCUS
　KING, MARTIN LUTHER, JR.
　MALCOLM X
　PARKS, ROSA
　list under BLACKS IN AMERICAN
　HISTORY

—Stockpile of Union materiel
Am Heritage 39:99 (3) Jl '88
—Tree stump severed by Civil War bullets
(1864)
Smithsonian 20:24 (c,4) My '89
—Union battle flags
Am Heritage 41:41–9 (c,2) Mr '90
—Union Civil War regalia
Am Heritage 39:73 (painting,c,2) D '88
—Union Civil War soldiers playing cards
Am Heritage 41:98 (2) S '90
—Union soldiers
Am Heritage 41:112 (3) F '90
Am Heritage 41:13 (4) Ap '90
—See also
ABOLITIONISTS
BRADY, MATHEW
CATTON, BRUCE
GRANT, ULYSSES S.
HOOD, JOHN BELL
HOOKER, JOSEPH
JACKSON, STONEWALL
JOHNSTON, JOSEPH E.
LEE, ROBERT E.
LINCOLN, ABRAHAM
McCLELLAN, GEORGE BRINTON
MEADE, GEORGE
MOSBY, JOHN SINGLETON
MONITOR AND MERRIMACK
ROSENCRANS, WILLIAM STARKE
SHERMAN, WILLIAM TECUMSEH
SLAVERY
STANTON, EDWIN M.
THOMAS, GEORGE HENRY
Civilizations. See
ANCIENT CIVILIZATIONS
list under PEOPLE AND CIVILIZA-
TIONS
CLASSROOMS
—1895 (Nebraska)
Am Heritage 41:66–7 (1) F '90
—1900 (Utah)
Am Heritage 38:40–1 (1) My '87
—1901 (New York)
Life 13:57 (4) Spring '90
—1920 (Bruges, Belgium)
Trav&Leisure 18:80–1 (c,1) Jl '88
—Bolivia
Nat Geog 171:444–5 (c,1) Ap '87
—Daufuskie Island, South Carolina
Nat Geog 172:746–7 (c,1) D '87
—Elementary school classes
Life 13:32–3 (c,1) Ap '90
Life 14:22–39 (c,1) S '91
Life 14:48–53 (c,1) N '91
—Grammar school (Great Britain)
Trav&Leisure 19:129 (c,4) My '89
—High school (New Hampshire)
Life 10:56–7 (c,1) Ja '87

—India
Life 12:116 (c,4) D '89
—Junior high school classroom (Washing-
ton, D.C.)
Nat Geog 173:329C–D (c,2) Mr '88
—Kindergarten class (Japan)
Nat Geog 177:72–3, 78–9 (c,1) Ap '90
—Laos
Nat Geog 171:792–3 (c,1) Je '87
—One-room schoolhouse (North Dakota)
Nat Geog 171:334–5 (c,1) Mr '87
—Uganda
Nat Geog 173:484 (c,3) Ap '88
—See also
BLACKBOARDS
TEACHERS
CLAUDEL, PAUL
Smithsonian 20:154 (4) Ja '90
CLAUDIUS
Smithsonian 18:154 (sculpture,4) Mr '88
CLAY, HENRY
Am Heritage 42:40 (painting,4) S '91
Clemens, Samuel. See
TWAIN, MARK
CLEVELAND, GROVER
Am Heritage 38:32 (4) D '87
Nat Geog 173:35 (4) Ja '88
—Cartoons about his illegitimate son
Life 10:75 (4) Ag '87
Smithsonian 19:154 (painting,c,4) O '88
CLEVELAND, OHIO
Trav&Leisure 19:113, 116 (c,4) Ap '89
Trav/Holiday 172:54–5 (c,3) Ag '89
Sports Illus 73:118–19 (painting,c,1) D
31 '90
Trav/Holiday 176:72–9 (map,c,1) O '91
—Shopping arcade
Am Heritage 38:90–1 (c,2) Jl '87
CLIFFS
Natur Hist 99:34–5 (c,1) F '90
—13th cent. Pueblo cliff dwelling (Ar-
izona)
Nat Geog 180:85 (c,2) O '91
—Australia
Nat Geog 171:295 (c,3) Mr '87
Trav&Leisure 173:275 (c,2) F '88
Trav&Leisure 21:59 (c,1) Ag '91
—Auto on edge of Yosemite cliff (1923)
Nat Geog 174:308 (3) S '88
—Chalk cliffs (Eastbourne, England)
Nat Geog 179:124–5 (c,1) Je '91
—Corsica, France
Gourmet 51:74–5 (c,1) S '91
—Dorset coast, England
Trav/Holiday 173:57 (c,1) Ap '90
—Granite cliffs (North Devon, England)
Trav&Leisure 21:210 (c,4) My '91
—Himalayas, Nepal
Natur Hist 99:50 (c,1) D '90

Life 12:92 (c,4) Je '89
—1965 miniskirt
 Sports Illus 71:89 (c,4) N 15 '89
—Baby dresses (Spain)
 Gourmet 50:87 (c,1) Je '90
—Bola ties
 Trav&Leisure 21:88 (c,4) My '91
—Djellabas (Morocco)
 Life 12:47 (c,4) S '89
—Dress made of garbage bags (Great Britain)
 Life 11:13 (c,4) Jl '88
—Felt kepenek (Turkey)
 Nat Geog 173:584–5 (c,1) My '88
—Fire-resistant suits
 Nat Geog 173:564–5 (c,1) My '88
 Nat Geog 176:773 (c,4) D '89
—Hawaiian aloha shirt
 Trav&Leisure 21:53, 56 (c,4) S '91
—Hawaiian chief's cloak
 Nat Geog 175:696 (c,2) Je '89
—History of the bra
 Life 12:cov., 88–98 (c,1) Je '89
—Kimonos (Japan)
 Trav&Leisure 17:64–6 (c,3) D '87
 Trav&Leisure 20:103 (c,1) Ag '90
—Levi Strauss emblem
 Am Heritage 38:108 (4) D '87
—Man in pajamas (Washington, D.C.)
 Life 10:28–9 (1) Ag '87
—Man removing vest from under jacket (1940)
 Life 13:90 (4) Jl '90
—Man with his pants down
 Life 14:91 (c,3) Ja '91
—Men's dishdasha (Oman)
 Trav/Holiday 171:79 (c,4) Mr '89
—Men's formal attire (New Mexico)
 Nat Geog 172:627 (c,3) N '87
—Protective suit against pesticide exposure
 Nat Wildlife 26:30–1 (c,1) Je '88
—Protective suits for toxic waste cleanup
 Nat Geog 171:639 (c,3) My '87
 Nat Wildlife 26:20 (c,4) Ag '88
 Life 12:18–20 (c,1) Mr '89
 Nat Geog 175:430 (c,1) Ap '89
 Life 12:6 (c,4) N '89
 Nat Wildlife 28:36–7 (c,1) F '90
—Radiation suits
 Life 11:9 (c,2) Je '88
—Saris (India)
 Trav&Leisure 19:91–5 (c,1) Jl '89
—Survival suit
 Smithsonian 19:110 (c,2) D '88
—Traditional Sulu sarong (Fiji)
 Trav&Leisure 21:107 (c,1) F '91
—Wool clothing (Peru)
 Nat Geog 173:586–7 (c,2) My '88
—See also

BATHING SUITS
BUTTONS
CHILDREN—COSTUME
COATS
EYEGLASSES
FOOTWEAR
GLOVES
GOGGLES
HATS
HEADGEAR
LIFE JACKETS
MASKS
MILITARY COSTUME
PURSES
RAINWEAR
SNOWSHOES
SPORTSWEAR
U.S.—COSTUME
individual countries—COSTUME
list under OCCUPATIONS
CLOTHING—HUMOR
—History of the necktie
 Smithsonian 20:122–33 (painting,c,1) My '89
CLOUDS
—Cloud of volcanic ash (Alaska)
 Nat Wildlife 30:55 (c,2) D '91
—Clouds reflected in puddle (Colorado)
 Smithsonian 21:38 (c,4) S '90
—Monsoon clouds (India)
 Nat Geog 173:594–5 (c,1) My '88
—Monteverde cloud forest, Costa Rica
 Trav/Holiday 169:40–1 (c,1) F '88
—Mountain gorge (Nepal)
 Natur Hist 97:30–1, 35 (c,1) Ja '88
—Over Colorado countryside
 Nat Geog 180:32–3 (c,1) O '91
—Seen from space (1984)
 Life 11:8–9, 73 (c,1) Fall '88
—Storm clouds
 Am Heritage 38:52 (2) Ap '87
 Nat Geog 178:38–9 (c,1) S '90
 Nat Geog 179:28–9 (c,1) Ja '91
 Smithsonian 21:46–7 (1) Mr '91
—Sunset clouds (New Mexico)
 Nat Wildlife 27:56 (c,3) F '89
 Life 14:84 (c,4) F '91
CLOVER
 Nat Wildlife 28:18 (c,1) Ap '90
CLOWNS
 Life 10:44–5 (c,1) D '87
 Trav/Holiday 169:53 (c,1) Je '88
 Trav/Holiday 176:86 (c,4) Jl '91
—Canada
 Life 11:102 (c,2) O '88
—Clown Prince of Baseball Max Patkin
 Sports Illus 68:98–110 (c,1) Je 6 '88
—In parade (Kentucky)
 Trav/Holiday 169:67 (c,2) Mr '88

—Emmett Kelly
 Smithsonian 22:161 (4) My '91
—Mardi Gras (Cologne, West Germany)
 Trav/Holiday 172:45 (c,2) D '89
—Sick children cheered by clowns
 Life 13:76–85 (c,1) Ag '90
CLUBS
—1897 ladies' reading club (Illinois)
 Am Heritage 39:7 (4) F '88
—Early 20th cent. country clubs
 Am Heritage 41:75–83 (2) S '90
—Académie Française
 Smithsonian 20:144–57 (c,3) Ja '90
—Pledging allegiance to flag at club meet-
 ing (Wyoming)
 Nat Geog 173:54–5 (c,1) Ja '88
—Wilderness Scouts (Georgia)
 Sports Illus 70:46–9 (c,4) F 6 '89
—See also
 BOY SCOUTS
 GIRL SCOUTS
 KU KLUX KLAN
 NATIONAL GEOGRAPHIC SOCI-
 ETY
 NIGHT CLUBS
CLYMER, GEORGE
 Life 10:52 (painting,c,4) Fall '87
COAL INDUSTRY
—Carrying coal in wagon (Poland)
 Nat Geog 173:104–5 (c,1) Ja '88
COAL MINING
—Coal miners on strike (Siberia,
 U.S.S.R.)
 Nat Geog 177:29 (c,4) Mr '90
—Poland
 Nat Geog 179:42–3 (c,1) Je '91
—Watering down coal dust (Ontario)
 Nat Geog 172:25 (c,3) Jl '87
—West Virginia
 Nat Geog 180:78–9 (c,2) Ag '91
Coast Guard. See
 U.S. COAST GUARD
COATS
—1861 women's cloaks
 Am Heritage 39:40 (painting,c,3) D '88
—Burberry (Great Britain)
 Trav&Leisure 19:95–6 (c,4) O '89
—Fur coats
 Life 10:2–3 (c,1) O '87
—Fur coats (Italy)
 Trav&Leisure 17:81, 84 (c,4) Ja '87
—Loden coats (Austria)
 Trav&Leisure 18:71–2 (c,4) Mr '88
—Made out of teddy bears
 Life 11:7 (c,4) O '88
—Old buffalo coat
 Smithsonian 20:60 (c,4) Ag '89
—Safari jacket
 Trav&Leisure 19:174 (c,4) Je '89

Coats of arms. See
 SEALS AND EMBLEMS
COBB, TY
 Sports Illus 70:20 (4) Je 12 '89
 Sports Illus 72:8 (4) My 14 '90
—Stealing third base (1909)
 Life 11:118 (4) Fall '88
COCKATOOS
 Trav/Holiday 171:65 (c,4) Ap '89
 Life 12:106 (c,3) S '89
 Sports Illus 71:123 (c,1) N 6 '89
 Natur Hist 100:44–51 (c,1) N '91
COCKER SPANIELS
 Life 11:140 (2) O '88
COCKROACHES
 Smithsonian 18:112 (c,4) Je '87
 Natur Hist 96:28–32 (c,3) N '87
COCONUT INDUSTRY—HARVEST-
 ING
—Monkeys picking coconuts (Malaysia)
 Smithsonian 19:110–19 (c,1) Ja '89
COCONUT PALM TREES
 Trav&Leisure 17:79, 86 (c,1) Mr '87
 Smithsonian 19:111, 116–19 (c,1) Ja '89
 Gourmet 49:39 (c,1) Ja '89
 Natur Hist 98:82 (c,4) O '89
COCOONS
—Fleas
 Nat Geog 173:691 (c,4) My '88
—Moths
 Nat Geog 173:557 (c,4) My '88
COCTEAU, JEAN
 Nat Geog 176:170 (3) Jl '89
 Smithsonian 20:146 (4) Ja '90
CODES AND CIPHERS
—1910s cipher machine
 Smithsonian 18:136 (4) Je '87
—Code used in Jefferson and Madison let-
 ters
 Nat Geog 172:360 (c,2) S '87
—Cryptologists William and Elizabeth
 Friedman
 Smithsonian 18:128–44 (2) Je '87
—German Enigma encoding machine
 Smithsonian 21:22 (c,4) My '90
CODFISH
 Nat Geog 173:166–7 (c,1) F '88
 Trav&Leisure 18:114–15 (c,1) O '88
 Nat Geog 179:65 (c,4) Ja '91
 Nat Geog 180:16 (c,3) Jl '91
CODY, WILLIAM (BUFFALO BILL)
 Trav&Leisure 17:E22 (4) Je '87
 Nat Geog 173:22 (3) Ja '88
 Am Heritage 39:49 (3) D '88
 Smithsonian 21:138 (4) S '90
 Am Heritage 42:85 (4) Ap '91
 Trav/Holiday 176:85 (painting,c,3) Jl '91
COELACANTHS (FISH)
 Nat Geog 173:824–37 (c,1) Je '88

—Fossil coelacanth fish
Nat Geog 173:832 (c,4) Je '88
COELENTERATES
—Hydroids
Natur Hist 99:50–3 (c,1) Je '90
—Porpita Porpita
Natur Hist 98:80–1 (c,1) Ag '89
—See also
CORALS
JELLYFISH
PORTUGUESE MAN-OF-WAR
SEA ANEMONES
COFFEE INDUSTRY
—Drying beans (Guatemala)
Nat Geog 173:792 (c,3) Je '88
COFFEE INDUSTRY—HARVESTING
—Costa Rica
Gourmet 50:111 (c,1) D '90
COFFEEHOUSES
—Cambodia
Trav&Leisure 21:121 (c,1) Je '91
—Vienna, Austria
Trav&Leisure 18:34, 36 (c,4) F '88
Trav&Leisure 20:218 (c,4) N '90
Gourmet 51:85 (c,1) Ja '91
COFFINS
Life 10:10–11 (1) Jl '87
—Aboriginal coffin (Australia)
Nat Geog 179:34 (c,4) Ja '91
—Coffin shaped like onion (Ghana)
Life 11:9 (c,4) Je '88
—Remains of U.S. soldiers in Vietnam
(1988)
Nat Geog 176:576–7 (c,1) N '89
—U.S.S.R.
Life 12:39 (c,1) F '89
COINS
—5th cent. B.C. (Kos, Greece)
Natur Hist 97:10 (c,4) Ag '88
—5th cent. Roman coin depicting emperor
Valens
Nat Geog 174:53 (c,4) Jl '88
—17th cent. Spanish pieces of eight
Smithsonian 17:99 (painting,c,4) Ja '87
—1670s (Sweden)
Nat Geog 175:448 (c,2) Ap '89
—1780s
Nat Geog 171:730 (c,4) Je '87
Life 10:30 (c,4) Fall '87
Am Heritage 38:4, 122 (c,1) N '87
—1804 (Mexico)
Nat Geog 178:32 (c,4) S '90
—1864 two-cent piece (U.S.)
Am Heritage 40:31 (4) Ap '89
—1959 Lincoln penny
Sports Illus 71:64 (c,4) N 15 '89
—Ancient Etruscan coin (Italy)
Nat Geog 173:730 (c,4) Je '88
—Ancient Greek Athena decadrachm

Sports Illus 74:89 (c,4) My 13 '91
—Ancient Parthian Empire (Iran)
Nat Geog 177:60 (c,4) Mr '90
—Ancient Roman
Nat Geog 171:266 (c,4) F '87
—Susan B. Anthony dollar coin (1979)
Sports Illus 71:156 (c,4) N 15 '89
—U.S. quarter
Smithsonian 17:24 (c,4) Ja '87
Trav&Leisure 17:36 (c,4) Ag '87
—See also
CURRENCY
COLBERT, CLAUDETTE
Life 10:91 (4) Ap '87
Trav&Leisure 19:226 (4) N '89
COLD
—Research on human response to cold
Smithsonian 19:100–10 (c,1) D '88
Nat Wildlife 29:11 (c,4) D '90
COLE, THOMAS
—"Oxbow" (1836)
Smithsonian 21:36–7 (painting,c,2) Ap
'90
COLETTE
Nat Geog 176:168–9 (1) Jl '89
Life 14:114 (4) N '91
COLLEGE LIFE
—1890 Yale freshmen (Connecticut)
Am Heritage 42:92 (4) Ap '91
—California
Smithsonian 18:100–13 (c,1) S '87
—College football festivities
Sports Illus 71:98–112 (c,2) O 23 '89
—Dorm rooms
Sports Illus 69:80 (c,3) S 5 '88
Sports Illus 75:53, 63, 66 (c,2) O 14 '91
—Harvard student swallowing goldfish
(1939)
Am Heritage 40:33 (4) Mr '89
—Heidelberg, West Germany
Gourmet 47:48–51 (c,1) Ja '87
—Nude students covered with paint
(France)
Nat Geog 176:84–5 (c,1) Jl '89
—Oxford, England
Trav&Leisure 19:112–13, 167 (c,1) My
'89
—Pinups on dorm walls
Sports Illus 70:222–8 (c,3) F 10 '89
—Brooke Shields' Princeton transcript
Life 10:25 (c,2) Ag '87
—Students walking on campus (North Car-
olina)
Sports Illus 66:32–3 (c,2) Mr 2 '87
COLLEGES AND UNIVERSITIES
—1970 shootings at Kent State, Ohio
Life 13:137–41 (1) My '90
Sports Illus 72:4 (4) My 14 '90
—Caltech, Pasadena, California

Smithsonian 18:100–13 (c,1) S '87
—The Citadel, Charleston, South Carolina
 Sports Illus 67:45 (c,3) Ag 31 '87
 Trav&Leisure 18:42 (c,4) F '88
—Classes by television (Saudi Arabia)
 Nat Geog 172:446–7 (c,1) O '87
—Georgetown University, Washington,
 D.C.
 Trav/Holiday 168:53 (c,2) O '87
—Liberty University, Lynchburg, Virginia
 Sports Illus 71:84–5 (c,2) N 13 '89
—M.I.T., Cambridge, Massachusetts
 Gourmet 49:94 (c,4) S '89
—Trinity College, Dublin, Ireland
 Trav&Leisure 18:113 (4) Ap '88
 Trav/Holiday 169:44–5 (c,2) Je '88
—Villanova, Pennsylvania
 Sports Illus 66:52 (c,4) Mr 16 '87
—University of Virginia, Charlottesville,
 Virginia
 Gourmet 47:68, 71 (c,1) Ap '87
 Trav&Leisure 19:128–9 (c,1) S '89
 Am Heritage 41:106 (drawing,3) S '90
—See also
 COLLEGE LIFE
 COMMENCEMENT
 HARVARD UNIVERSITY
 OXFORD UNIVERSITY
 PRINCETON UNIVERSITY
 STANFORD UNIVERSITY
 YALE UNIVERSITY
COLLIES
—Lassie
 Life 12:2–3 (1) Mr '89
COLOGNE, GERMANY
—Water tower turned hotel
 Trav&Leisure 21:83 (c,4) Ja '91
COLOMBIA
—Coca farming
 Nat Geog 175:18–19 (c,1) Ja '89
—Guatavita lagoon
 Life 10:32–3 (c,1) Mr '87
—See also
 CARTAGENA
COLOMBIA—COSTUME
—1985 victim of volcano
 Life 12:122–3 (c,1) Fall '89
—Cartagena
 Nat Geog 175:495–509 (c,1) Ap '89
COLOMBIA—HISTORY
—Cartagena historical sites
 Nat Geog 175:495–509 (map,c,1) Ap
 '89
—Defense of Cartagena (1586–1741)
 Nat Geog 175:502–3 (map,c,1) Ap '89
COLOMBIA—SOCIAL LIFE AND CUS-
 TOMS
—Kogi people chewing coca leaves
 Nat Geog 175:12–13 (c,1) Ja '89

COLOR
—Bright colors of coral reef fish
 Smithsonian 21:98–103 (c,2) N '90
—Swirling different paint colors together
 Smithsonian 18:122–3 (c,4) D '87
COLORADO
—1890s Leadville ice palaces
 Smithsonian 17:65 (c,4) Ja '87
 Nat Geog 175:232 (3) F '89
—Anasazi Indian ruins
 Trav&Leisure 21:140–8 (map,c,1) D '91
—Chimney Rock
 Nat Geog 175:246 (c,4) F '89
—Countryside
 Natur Hist 99:41 (c,4) Je '90
 Life 13:68–9 (c,1) S '90
—Crested Butte
 Trav&Leisure 20:200 (c,3) D '90
—Grand Mesa
 Natur Hist 96:14–16 (map,c,1) My '87
—Indian Peaks Wilderness
 Trav/Holiday 171:46–51 (map,c,1) My
 '89
—Little Dry Creek Park, Englewood
 Nat Geog 177:84–5 (c,2) Je '90
—San Juan Mountains
 Nat Geog 175:216–17 (c,1) F '89
—Slumgullion Slide, Gunnison National
 Forest
 Natur Hist 98:34–7 (map,c,1) Ap '89
—Stonewall Valley
 Nat Geog 179:112–13 (c,1) Mr '91
—Summer scenes
 Trav/Holiday 175:72–80 (map,c,1) Je '91
—Telluride
 Gourmet 47:54–7 (c,1) Ja '87
 Trav&Leisure 18:cov., 132–9, 212–15
 (map,c,1) N '88
 Trav/Holiday 175:74–5 (c,1) Je '91
—Vail
 Sports Illus 70:70–82 (c,1) Ja 30 '89
—Wilson Peak
 Smithsonian 21:37 (c,4) S '90
—See also
 ASPEN
 DENVER
 GARDEN OF THE GODS
 GREAT SAND DUNES NATIONAL
 MONUMENT
 MESA VERDE NATIONAL PARK
 MOUNT EVANS
 MOUNT OF THE HOLY CROSS
 PIKES PEAK
 RIO GRANDE RIVER
 ROCKY MOUNTAIN NATIONAL
 PARK
 ROCKY MOUNTAINS
COLORADO—MAPS
—1926 road map

Smithsonian 18:183 (c,4) N '87
—"Lois Lane"
Life 11:13 (c,4) My '88
—"Mark Trail"
Nat Wildlife 26:14–17 (c,4) F '88
—Museum of Cartoon Art, Rye Brook,
New York
Trav/Holiday 169:26–8 (c,3) Ja '88
—"Pogo"
Trav&Leisure 19:241 (c,4) O '89
—"Prince Valiant"
Smithsonian 18:183 (c,3) N '87
—"Secret Agency X-9" (1934)
Smithsonian 18:192 (4) N '87
—"Terry and the Pirates"
Smithsonian 18:183 (c,4) N '87
—War comics
Smithsonian 21:138–9 (c,2) N '90
—See also
BATMAN
CARTOONISTS
CHARACTER SYMBOLS
SUPERMAN
COMMENCEMENT
—Cadets throwing caps in air (West Point,
New York)
Am Heritage 39:52 (c,4) Ap '88
—College graduates celebrating (Great
Britain)
Nat Geog 179:118 (c,4) Je '91
—Graduates forming circle (Connecticut)
Life 14:50 (2) O '91
COMMENCEMENT—COSTUME
—College graduation
Life 10:24 (c,2) Ag '87
—Kindergarten graduation (California)
Nat Geog 171:59 (c,4) Ja '87
COMMUNICATIONS
—Sending messages with signal mirror
Nat Wildlife 25:22 (c,4) F '87
COMMUNION
—Dominica, Windward Islands
Nat Geog 177:112 (c,1) Je '90
—Eskimo girl (Alaska)
Life 13:39 (1) Spring '90
—Mexico
Nat Geog 176:446–7 (c,3) O '89
Life 14:40–1 (1) O '91
—Pope giving communion to Lech Walesa
(Poland)
Life 12:42 (c,4) D '89
COMMUNISM
—Shanghai site of 1921 Chinese Com-
munist Congress
Trav&Leisure 17:87 (4) Ag '87
—See also
CHOU EN-LAI
ENGELS, FRIEDRICH
GOLDMAN, EMMA

HO CHI MINH
LENIN, NIKOLAI
MARX, KARL
McCARTHY, JOSEPH
STALIN, JOSEF
COMMUTERS
—Businessman waiting for train (New
York)
Sports Illus 71:109 (c,1) N 20 '89
—Commuters boarding minibuses (Kam-
pala, Uganda)
Nat Geog 173:478–9 (c,1) Ap '88
—Grand Central Terminal, New York
City, New York
Nat Geog 177:108–9 (c,1) Mr '90
—Rush hour on bridge (California)
Nat Geog 178:68–9 (c,1) O '90
—Sleeping commuter on Chicago "el", Illi-
nois
Nat Geog 179:52–3 (c,1) My '91
—Subway commuter dreaming of vacation
Trav/Holiday 173:14 (painting,c,4) Je '90
—Van-pooling commuters (Ontario)
Nat Geog 177:104–5 (c,1) F '90
COMPASSES
—Mid 19th cent. (Massachusetts)
Am Heritage 39:66–7 (c,1) Jl '88
COMPOSERS
—Composer at work at piano
Life 11:40–1 (c,1) S '88
Life 12:170–1 (c,1) Mr '89
—Studying score (Poland)
Nat Geog 173:102–3 (c,1) Ja '88
—See also
BACH, JOHANN SEBASTIAN
BERLIN, IRVING
BERNSTEIN, LEONARD
DONIZETTI, GAETANO
FOSTER, STEPHEN
HERBERT, VICTOR
HONEGGER, ARTHUR
IVES, CHARLES
MOZART, WOLFGANG AMADEUS
MUSICAL INSTRUMENTS
MUSICIANS
PUCCINI, GIACOMO
RODGERS, RICHARD
SMETANA, BEDRICH
STRAUSS, JOHANN
THOMSON, VIRGIL
VERDI, GIUSEPPE
COMPUTERS
—Caricature of life in the Information Age
Smithsonian 21:22 (sculpture,c,4) Jl '90
—Computer-generated art works
Smithsonian 18:138–42 (c,2) Mr '88
Nat Geog 175:746–51 (c,1) Je '89
Life 12:10 (c,4) Je '89
—Computer graphics applications

Nat Geog 175:718–51 (c,1) Je '89
—Computer simulation of driving tanker
 Life 12:8 (c,4) Je '89
—Hotline link between Moscow and Wash-
 ington
 Life 11:9 (c,4) S '88
—Medical imaging technologies
 Nat Geog 171:2–41 (c,1) Ja '87
—Sitting at terminal
 Trav/Holiday 167:38 (c,4) Ap '87
 Smithsonian 19:140 (3) My '88
 Smithsonian 22:70 (c,4) N '91
—U.S. air defense Q-7 computer
 Trav&Leisure 17:E14 (4) Ap '87
—Using electronic yellow pages (France)
 Nat Geog 176:96 (c,4) Jl '89
—Video simulation of artificial envi-
 ronments
 Smithsonian 21:36–45 (c,1) Ja '91
COMPUTERS—HUMOR
—Electronic bulletin boards
 Smithsonian 19:82–93 (painting,c,1) S '88
Conan-Doyle, Sir Arthur. See
 HOLMES, SHERLOCK
CONCENTRATION CAMPS
—1940s footwear taken from Auschwitz
 victims (Poland)
 Nat Geog 173:90 (c,1) Ja '88
—1940s murals painted by Auschwitz in-
 mates, Poland
 Life 12:79–82 (c,2) S '89
—1945 concentration camp corpses (Buch-
 enwald)
 Life 11:48 (3) Fall '88
—1945 crucifix carved by Auschwitz victim
 (Poland)
 Nat Geog 173:91 (c,4) Ja '88
—Auschwitz Museum, Poland
 Nat Geog 173:90–1 (c,1) Ja '88
—Dachau, Germany
 Nat Geog 180:35 (c,4) S '91
CONCERTS
—1969 Woodstock music festival, New
 York
 Life 12:cov., 20–45 (c,1) Ag '89
—American pop star (U.S.S.R.)
 Life 10:38–9 (c,1) O '87
—Classical music (New York City, New
 York)
 Smithsonian 21:68–9 (c,1) F '91
—Destroying symbolic Berlin Wall at rock
 concert
 Trav&Leisure 21:112–13 (c,1) Ja '91
—Eastbourne bandstand, England
 Nat Geog 179:122–3 (c,1) Je '91
—Grand Ole Opry, Nashville, Tennessee
 Trav/Holiday 170:58–9, 61 (c,1) O '88
—Jazz band (New Orleans, Louisiana)
 Trav&Leisure 19:108–9 (c,1) F '89

—Outdoor big band concert (Vermont)
 Trav/Holiday 168:14 (c,4) Ag '87
—Rock concert (New York)
 Life 14:69 (c,4) Ja '91
—Rock concert (U.S.S.R.)
 Nat Geog 175:608 (c,4) My '89
—Singer in high school gym (Pennsylvania)
 Life 11:132 (c,3) My '88
—See also
 AUDIENCES
 BANDS
 CONDUCTORS, MUSIC
 MUSICIANS
CONCORD, MASSACHUSETTS
—1841
 Am Heritage 39:73 (drawing,4) Jl '88
—Minute Man statue
 Trav&Leisure 20:209 (c,4) S '90
—Walden Pond
 Sports Illus 67:6 (c,4) O 19 '87
 Trav&Leisure 19:19 (c,4) Jl '89
CONDORS
 Sports Illus 66:62–6 (c,3) Mr 23 '87
 Life 11:104 (c,4) Ja '88
 Life 12:65 (c,4) Ap '89
 Nat Geog 175:665 (c,2) Je '89
 Nat Wildlife 29:15 (c,4) F '91
 Trav&Leisure 21:73 (c,4) O '91
—Baby condor being born
 Life 13:15 (3) Je '90
—Chicks
 Sports Illus 66:66 (c,4) Mr 23 '87
 Sports Illus 69:83–4 (c,4) O 31 '88
 Life 12:60 (c,4) Ja '89
CONDUCTORS, MUSIC
 Smithsonian 18:78 (c,4) Je '87
 Life 10:8–9 (c,1) Jl '87
—Choir conductor (Louisiana)
 Trav&Leisure 19:110–11 (c,1) F '89
—High school band (California)
 Sports Illus 66:50 (c,3) Je 15 '87
—See also
 BERNSTEIN, LEONARD
 STOKOWSKI, LEOPOLD
Conductors, railroad. See
 RAILROAD CONDUCTORS
CONEY ISLAND, BROOKLYN, NEW
 YORK
—1884 Coney Island roller coaster ride
 Smithsonian 20:86 (drawing,c,4) Ag '89
—1940s
 Life 11:84–8 (2) Ag '88
—History of Nathan's Famous hot dogs
 Trav&Leisure 21:41, 44–5 (3) Jl '91
—Locomotive pulling hotel away from
 ocean (1888)
 Am Heritage 39:31 (drawing,4) Ap '88
CONIES
—Rock hyrax

—Cooking stew outdoors for 300 people
(South Carolina)
Nat Geog 172:752–3 (c,1) D '87
—Cooking with leftovers
Gourmet 50:64 (painting,c,4) Ap '90
—Cook-off contests
Smithsonian 19:124–35 (c,1) S '88
—Elephant (Zaire)
Nat Geog 176:676–7 (c,2) N '89
—Frying donuts
Gourmet 51:77 (c,1) F '91
—Grinding barley (Tibet)
Nat Geog 175:764–5 (c,1) Je '89
—In earth oven (Papua New Guinea)
Trav&Leisure 17:85 (c,1) Mr '87
—Kebabs (India)
Gourmet 47:69 (c,4) S '87
—Making pastries (France)
Gourmet 49:102–5 (c,1) N '89
—Making pastries (Italy)
Gourmet 51:134–5 (c,1) N '91
—Making yak cheese (Bhutan)
Nat Geog 179:96–7 (c,1) My '91
—Nepal
Nat Geog 171:531 (c,4) Ap '87
Nat Geog 176:400–1 (c,2) S '89
—On camping stove (Antarctica)
Nat Geog 178:76 (c,3) N '90
—Open hearth restaurant grill (California)
Gourmet 48:36 (painting,c,3) My '88
—Paella (Puerto Rico)
Trav/Holiday 168:13 (c,4) S '87
—Pillsbury Bake-off (1949)
Life 12:140–1 (4) D '89
—Pounding corn husks (North Carolina)
Nat Geog 174:599 (c,4) O '88
—Preparing crab (U.S.S.R.)
Smithsonian 22:34–5 (c,4) Ag '91
—Preparing pizza dough
Sports Illus 70:46 (c,4) Ja 16 '89
Trav/Holiday 174:54 (c,4) S '90
—Preparing Puerto Rican meat fritters
Natur Hist 97:32 (c,3) S '88
—Preparing salad
Life 10:38 (2) F '87
Gourmet 49:38 (c,4) Ja '89
—Preparing sushi (Hawaii)
Trav&Leisure 21:24 (c,4) Ap '91
—Pueblo Indian milling corn (New Mex-
ico)
Sports Illus 68:149 (c,4) F 15 '88
—Putting goose in pot (Maryland)
Sports Illus 69:130 (c,4) D 19 '88
—Restaurant kitchen
Gourmet 47:86 (drawing,4) Ja '87
Gourmet 48:104 (drawing,3) O '88
Gourmet 49:20, 28 (painting,3) Ja '89
Gourmet 49:28 (drawing,4) Mr '89
Nat Geog 176:75–7 (c,1) Jl '89

Gourmet 49:36, 38 (painting,c,2) Ag '89
Trav&Leisure 20:E10 (c,3) N '90
Trav&Leisure 21:135–40 (c,2) My '91
Gourmet 51:30, 117 (painting,c,3) Ag '91
Gourmet 51:38 (c,3) N '91
—Roasting hot dogs over Olympic flame
(Calgary, Alberta)
Sports Illus 68:74–5 (c,1) F 29 '88
—Roasting pig (Spain)
Nat Geog 174:115 (c,3) Jl '88
—Shredding coconut (Fiji)
Trav/Holiday 171:47 (c,4) Ja '89
—Stuffing blood sausages (Spain)
Nat Geog 179:119 (c,1) Ap '91
—Ukrainians making varenyky (Chicago,
Illinois)
Nat Geog 179:75 (c,3) My '91
—Woman at stove
Gourmet 50:48 (drawing,c,4) Ja '90
—See also
BREAD MAKING
CHEFS
DINNERS AND DINING
FOOD PROCESSING
RESTAURANTS
COOKING EDUCATION
—Julia Child demonstrating cooking tech-
niques
Life 12:95–100 (c,2) D '89
—France
Trav/Holiday 167:56–9 (c,1) F '87
Gourmet 49:105 (c,3) N '89
Gourmet 51:126 (c,3) N '91
—Italy
Gourmet 47:74 (c,4) My '87
Trav&Leisure 20:97 (c,3) F '90
—Mexico
Trav/Holiday 169:22 (c,4) Ap '88
—Thailand
Gourmet 48:93 (c,3) N '88
COOKING UTENSILS
—Copper pans (France)
Gourmet 49:51 (c,1) Jl '89
COOLIDGE, CALVIN
Nat Geog 173:39 (4) Ja '88
Life 13:70 (4) Fall '90
—Home (Plymouth, Vermont)
Trav/Holiday 167:64 (c,3) My '87
COOPERSTOWN, NEW YORK
Gourmet 49:102–7 (c,1) O '89
—Baseball Hall of Fame exhibits
Trav/Holiday 171:76–81 (c,4) F '89
Trav&Leisure 19:E8–12 (c,4) My '89
Sports Illus 70:88–115 (c,1) Je 12 '89
Gourmet 49:103–4 (c,1) O '89
COPENHAGEN, DENMARK
Trav&Leisure 20:70 (painting,c,4) Ap
'90
Trav/Holiday 176:72–3 (map,c,3) S '91

—Our Savior's church
Trav/Holiday 176:14 (c,4) N '91
—Tivoli amusement park
Trav&Leisure 21:49, 52 (c,4) Ap '91
COPERNICUS, NICOLAUS
Smithsonian 22:40 (painting,c,4) D '91
COPPER
—Four-ton hunk of copper
Smithsonian 22:64–5 (c,3) S '91
COPPERHEAD SNAKES
Nat Wildlife 26:22–3 (c,1) O '88
Nat Wildlife 29:54 (c,4) O '91
CORAL REEFS
Life 10:46–7 (c,1) Je '87
—Belize
Nat Wildlife 26:45 (c,2) Ag '88
—Florida
Nat Geog 178:114–32 (c,1) Jl '90
—See also
GREAT BARRIER REEF
CORALS
Nat Geog 173:437–48 (c,1) Ap '88
Trav&Leisure 18:116 (c,4) O '88
Natur Hist 97:46–7 (c,1) O '88
Trav/Holiday 171:44 (c,4) Ja '89
Nat Geog 176:522–3 (c,1) O '89
Sports Illus 72:144–6 (c,3) F 12 '90
Natur Hist 99:cov., 46–54 (c,1) Ap '90
Nat Geog 178:15, 20–1 (c,1) O '90
Nat Geog 179:58–9 (c,1) Ja '91
Nat Wildlife 29:2 (c,2) F '91
Trav/Holiday 175:49 (c,4) My '91
Nat Wildlife 29:46–7 (c,1) Je '91
—Coral fossils
Natur Hist 96:40–1 (c,3) N '87
—Dying corals
Nat Geog 178:118–31 (c,1) Jl '90
—See also
LIMESTONE
SEA FANS
COREOPSIS
Nat Geog 173:494–5 (c,1) Ap '88
Trav&Leisure 19: E20 (c,3) O '89
CORMORANTS
Life 12:10 (c,4) My '89
Smithsonian 22:cov., 44–55 (c,1) Jl '91
CORN INDUSTRY
—Corn hanging to dry (Italy)
Gourmet 40:105 (C,1) N '90
—Drying corn (South America)
Nat Geog 179:87 (c,3) Ap '91
—Drying corn on ground (Portugal)
Natur Hist 96:56–7 (c,1) F '87
CORN INDUSTRY—HARVESTING
—Pennsylvania
Gourmet 49:113 (c,1) N '89
Trav&Leisure 21:E2 (c,4) Ag '91
CORNFIELDS
—Aerial view (China)

Nat Geog 175:308–9 (c,1) Mr '89
—Midwest
Life 11:2–3 (c,1) S '88
Nat Wildlife 28:22–3 (c,1) Ap '90
Smithsonian 21:120, 126 (c,4) Ap '90
—Mexico
Nat Geog 178:130–1 (c,1) D '90
—North Carolina
Nat Geog 174:598–9 (c,1) O '88
CORNWALLIS, CHARLES
Nat Geog 173:806 (painting,4) Je '88
CORONADO, FRANCISCO VASQUEZ
DE
—Retracing Coronado's 1540 Southwest-
ern expedition
Smithsonian 20:40–53 (map,c,1) Ja '90
CORPUS CHRISTI, TEXAS
—Store scenes (1934)
Am Heritage 38:42–7 (1) Jl '87
CORSICA, FRANCE
Gourmet 51:74–9, 150 (map,c,1) S '91
COSMETICS
—Efe tribe face paint (Zaire)
Nat Geog 176:684 (c,4) N '89
—Multicolor fingernails
Life 12:34–5 (c,1) Ja '89
—Polishing toenails
Trav&Leisure 17:144 (c,3) N '87
—Women putting on make-up
Sports Illus 68:122 (c,4) Ja 27 '88
Sports Illus 71:2–3 (c,1) N 27 '89
COSTA RICA
Smithsonian 17:58–66 (c,2) Mr '87
Trav/Holiday 169:40–5 (map,c,1) F '88
Trav&Leisure 18:130–7, 178–82
(map,c,1) O '88
Gourmet 50:108–11, 176 (map,c,1) D '90
—Cocos "Treasure" Island
Life 10:35 (4) Mr '87
—Monteverde cloud forest
Natur Hist 97:6 (c,4) S '88
Trav&Leisure 18:49, 128–31 (c,1) O '88
Sports Illus 72:84–90, 95–8 (c,1) Ap 9 '90
—Poás Volcano National Park
Trav&Leisure 18:134–5 (c,1) O '88
—Rain forests
Trav&Leisure 20:129 (c,4) S '90
Nat Geog 180:78–107 (c,1) D '91
—Tortuga Island
Gourmet 50:109–110 (c,1) D '90
COSTA RICA—COSTUME
—Men at bar
Trav&Leisure 18:133 (c,1) O '88
COSTA RICA—MAPS
—National parks
Trav&Leisure 21:68 (c,4) Mr '91
Costume. See
CHILDREN—COSTUME
CLOTHING

COMMENCEMENT—COSTUME
MASKS, CEREMONIAL
MASQUERADE COSTUME
MILITARY COSTUME
THEATER—COSTUME
U.S.—COSTUME
individual countries—COSTUME
specific religions—COSTUME
list under OCCUPATIONS
list under PEOPLE
COTOPAXI VOLCANO, ECUADOR
 Nat Geog 171:424–5 (c,1) Ap '87
 Smithsonian 20:94–5 (painting,c,1) O '89
COTTAGES
—1846 summer cottage (Connecticut)
 Am Heritage 40:4, 140–5 (c,1) N '89
—1879 Victorian cottage (Chautauqua,
 New York)
 Am Heritage 42:32 (c,4) Jl '91
—Cottage Orné, Tipperary, Ireland
 Gourmet 50:100 (c,4) S '90
—Dorset, England
 Trav/Holiday 173:54 (c,1) Ap '90
—Anne Hathaway's cottage (Shottery, En-
 gland)
 Trav&Leisure 19:131 (c,2) My '89
—Seaside, Florida
 Trav&Leisure 18:110, 115 (c,1) Mr '88
—Suffolk, England
 Gourmet 47:57 (c,1) Je '87
—Zimbabwe
 Trav/Holiday 176:39 (c,3) N '91
COTTON INDUSTRY
—Convicts working in cotton field (Missis-
 sippi)
 Nat Geog 175:330–1 (c,1) Mr '89
—Cotton plant
 Nat Geog 179:29 (c,1) Je '91
COTTON INDUSTRY—HARVESTING
—California
 Nat Geog 179:58–9 (c,1) F '91
—Loading bales onto truck (Mississippi)
 Nat Geog 175:314–15 (c,1) Mr '89
—U.S.S.R.
 Nat Geog 177:81–3 (c,1) F '90
COTTONWOOD TREES
 Life 13:49 (c,3) My '90
Cougars. See
 MOUNTAIN LIONS
Counseling. See
 THERAPY
COURBET, GUSTAVE
—"L'Atelier du peintre" (1855)
 Smithsonian 17:93 (painting,c,3) Mr '87
COURTHOUSES
—Caracas, Venezuela
 Gourmet 50:63 (c,4) F '90
—New Castle, Delaware
 Am Heritage 41:36 (c,4) S '90

—Philipsburg, St. Maarten, West Indies
 Gourmet 47:42 (c,4) Ja '87
COURTROOMS
—1899 (Rennes, France)
 Smithsonian 20:124 (4) Ag '89
—1917 (Virginia)
 Am Heritage 38:34–5 (1) My '87
—1948 (Indiana)
 Life 14:20–1 (1) Fall '91
—1965 divorce hearing (China)
 Life 11:72 (3) Mr '88
—China
 Sports Illus 73:23 (drawing,c,1) Jl 30 '90
—Humorous scene of wine bottle in wit-
 ness stand
 Gourmet 48:40 (painting,c,3) S '88
—Little girl in witness chair (Florida)
 Life 12:18 (4) O '89
—Mock trials
 Sports Illus 75:32–3 (p,c,1) Jl 15 '91
—Trial (Romania)
 Life 14:120–1 (c,1) Ja '91
COUSTEAU, JACQUES-YVES
 Nat Geog 174:315 (4) S '88
COVERED WAGONS
 Trav&Leisure 20:109 (c,3) Mr '90
—19th cent.
 Nat Geog 179:1–2, 123 (engraving,3) Mr
 '91
—1889 (Oklahoma)
 Smithsonian 20:192–4 (2) N '89
—Frontier wagon train
 Am Heritage 38:74–5 (painting,c,2) D
 '87
—Gypsy tourist wagon (Switzerland)
 Trav/Holiday 167:54 (c,3) My '87
—Gypsy wagons (Great Britain)
 Natur Hist 97:54–7 (c,1) F '88
COWBIRDS
 Natur Hist 98:94–5 (c,2) O '89
COWBOYS
 Am Heritage 38:37–40 (painting,c,1) D
 '87
 Trav&Leisure 19:186 (painting,c,2) Mr
 '89
 Nat Geog 179:114–15 (c,1) Mr '91
—1910 (Montana)
 Smithsonian 21:56–7 (2) N '90
—Black Americans of the Old West
 Smithsonian 20:58–69 (c,1) Ag '89
—Depicted by Will James
 Smithsonian 18:168–79 (c,1) F '88
—Depicted in Remington art works
 Trav&Leisure 18:38 (sculpture,c,2) Mr
 '88
 Nat Geog 174:203–31 (c,1) Ag '88
—France
 Gourmet 49:48–9 (c,2) Jl '89
—Gauchos (Argentina)

Trav&Leisure 21:116–17, 124–5 (c,1) N
 '91
—U.S.S.R.
Nat Geog 171:608–9 (c,1) My '87
—See also
 MIX, TOM
 RANCHING
 RODEOS
 WESTERN FRONTIER LIFE
COWRIES
 Nat Wildlife 25:54–5 (c,1) F '87
Cows. See
 CATTLE
COYOTES
 Nat Wildlife 25:48–9 (c,1) F '87
 Smithsonian 18:103 (c,4) Mr '88
 Nat Wildlife 26:59 (c,1) O '88
 Nat Wildlife 27:6–7 (c,1) F '89
 Nat Wildlife 27:cov., 34–8 (c,1) Ap '89
 Nat Wildlifc 28:39 (c,4) D '89
 Nat Wildlife 28:36–7 (c,1) O '90
 Smithsonian 21:68–79 (c,1) Mr '91
 Natur Hist 100:60–3 (c,1) Je '91
 Natur Hist 100:54–5 (c,1) D '91
COYPUS (RODENTS)
 Nat Wildlife 27:42–4 (c,1) D '88
CRAB INDUSTRY
—Maryland
 Trav/Holiday 172:cov., 40–51 (c,1) Ag
 '89
CRABS
 Nat Geog 172:822–31 (c,1) D '87
 Natur Hist 97:84–5 (c,1) My '88
 Natur Hist 99:64–5 (painting,c,1) F '90
 Nat Geog 179:62–3 (c,1) Ja '91
 Natur Hist 100:76 (c,4) Ja '91
 Nat Wildlife 29:53 (c,1) O '91
—Annapolis Crab Feast, Maryland
 Nat Geog 174:174–5 (c,1) Ag '88
—Blue crab shedding shell
 Nat Geog 174:173 (c,4) Ag '88
—Dungeness crabs
 Gourmet 48:41, 104 (c,4) Ag '88
—Otter eating snow crab
 Natur Hist 96:80–1 (c,1) My '87
—Spider crab
 Smithsonian 19:20 (c,4) Ap '88
 Natur Hist 97:54 (c,4) O '88
 Nat Geog 178:16–17 (c,1) O '90
—See also
 HERMIT CRABS
CRANACH, LUCAS
—"Adam and Eve"
 Gourmet 47:52 (painting,c,4) Ja '87
CRANBERRY INDUSTRY
—Cranberry bog (Oregon)
 Nat Geog 179:83 (c,4) Ap '91
CRANBERRY INDUSTRY—HAR-
 VESTING

—Massachusetts
 Nat Geog 171:403 (c,2) Mr '87
CRANE, STEPHEN
 Am Heritage 42:108 (4) My '91
CRANES
 Nat Geog 174:682 (c,4) N '88
 Natur Hist 99:41 (c,4) N '90
 Nat Geog 178:42 (c,4) D '90
—Sandhill
 Nat Wildlife 25:cov. (c,1) Ap '87
 Life 10:52 (c,3) Jl '87
 Trav&Leisure 21:78 (c,4) O '91
 Life 14:94 (c,4) Fall '91
—See also
 WHOOPING CRANES
CRASHES
—1957 auto racing car wreckage (Italy)
 Sports Illus 71:152 (4) N 6 '89
—1987 plane crash wreckage (Michigan)
 Sports Illus 67:32 (c,3) N 23 '87
 Life 11:66–72 (c,3) Ap '88
—1989 plane crash wreckage and survivors
 (Iowa)
 Life 12:cov., 28–39 (c,1) S '89
—Auto race crash
 Sports Illus 66:22–7 (c,2) My 18 '87
 Sports Illus 68:48–9 (c,1) F 22 '88
 Sports Illus 70:33, 39 (c,3) Je 5 '89
 Sports Illus 71:2–3 (c,1) Jl 17 '89
 Sports Illus 72:2–3 (c,1) F 26 '90
 Sports Illus 74:54 (c,4) Ap 1 '91
 Sports Illus 75:4–5 (c,1) Jl 15 '91
—Collision of planes in air show (West
 Germany)
 Life 12:120–1 (c,1) Ja '89
—Crashed biplane (New Mexico)
 Smithsonian 17:137 (c,4) Mr '87
—F4 jet crashing into concrete block
 Life 13:8 (c,3) Mr '90
—Fiery crash at Indianapolis 500 (1964)
 Am Heritage 40:39 (4) My '89
—Rescuing plane crash survivor (Mon-
 tana)
 Nat Geog 171:810–11 (c,2) Je '87
—Satellite rescue network for crash victims
 Smithsonian 17:136–46 (c,1) Mr '87
—Smashed up racing car
 Sports Illus 68:80 (c,3) Ap 18 '88
 Sports Illus 68:61 (4) My 16 '88
—Train crash wreckage (Maryland)
 Life 10:10–11 (c,1) Mr '87
 Life 11:29 (c,4) Ja '88
 Life 12:145 (c,4) Fall '89
—See also
 ACCIDENTS
 DISASTERS
 SHIPWRECKS
CRATER LAKE, OREGON
 Life 14:107 (c,4) Summer '91

CRAWFISH
Trav&Leisure 18:E10 (drawing,3) Ja '88
Gourmet 50:87, 89, 160 (c,2) Mr '90
Smithsonian 22:117 (c,4) O '91
—Rock lobsters
Nat Geog 176:518 (c,2) O '89
CRAYONS
Life 14:62–3 (c,4) Ja '91
CREDIT CARDS
—History of credit cards
Am Heritage 42:125–32 (c,2) N '91
CREEK INDIANS
—1813 Creek Indian defense (Tennessee)
Am Heritage 39:34 (drawing,4) N '88
CREEKS
—Indian Creek, Missouri
Natur Hist 97:20–2 (map,c,1) Ag '88
—Workman Creek, Arizona
Natur Hist 98:86–8 (map,c,1) Mr '89
CRICKET PLAYING
—Australia
Smithsonian 18:139 (c,4) Ja '88
—Dominica, Windward Islands
Nat Geog 177:111 (c,3) Je '90
—Great Britain
Gourmet 47:56–7 (c,2) S '87
Trav&Leisure 19:143 (c,4) My '89
—Singapore
Trav&Leisure 19:64 (c,3) S '89
CRICKETS
Smithsonian 19:118–19 (sculpture,c,3) D
'88
Natur Hist 98:22 (c,4) Jl '89
Natur Hist 100:66–73 (c,1) S '91
CRIME AND CRIMINALS
—17th cent. self-defense diagrams (Nether-
lands)
Sports Illus 71:5–6 (4) S 11 '89
—1780s Old Bailey records (Great Britain)
Nat Geog 173:234–5 (c,1) F '88
—19th cent. thugs strangling victim (India)
Smithsonian 18:47 (painting,c,4) Ja '88
—1870s victim of child abuse (New York)
Am Heritage 41:85–91 (1) Jl '90
—Early 20th cent. gangsters (New York)
Sports Illus 69:81 (4) Ag 22 '88
—1906 frontier outlaw
Am Heritage 38:37 (painting,c,3) D '87
—1925 pilloried murderers (China)
Nat Geog 174:298–9 (2) S '88
—"Birdman of Alcatraz" Robert Stroud
Am Heritage 39:43 (4) N '88
—Butch Cassidy
Am Heritage 40:48 (4) Ap '89
—Henri Charriere (Papillon)
Smithsonian 19:94 (4) Ag '88
—Child watching arrest of his parents
(Tennessee)
Life 13:8–9 (1) Ag '90

—Confiscated elephant tusks (Kenya)
Nat Geog 179:8–9 (c,1) My '91
—Eskimo sculpture depicting violent
crimes (Northwest Territories)
Natur Hist 99:cov., 32–41 (c,1) Ja '90
—Examining counterfeit dollars
Smithsonian 20:40–1 (c,4) My '89
—Famous lost and stolen art works
Smithsonian 18:239–58 (c,2) N '87
—Lynette "Squeaky" Fromme
Life 10:56 (4) Mr '87
—Gunshot victim on New York City sub-
way
Life 13:14–15 (1) S '90
—Informer strangled by drug traffickers
(Peru)
Nat Geog 175:22–3 (c,2) Ja '89
—Jail record and fingerprints (Florida)
Sports Illus 66:28 (c,3) Ja 5 '87
—Martin Luther King's assassin James
Earl Ray
Life 11:6 (4) Mr '88
—Louis Lepke
Am Heritage 40:33 (4) Jl '89
—Charles Manson
Life 10:54–6 (c,1) Mr '87
—McGruff, the Crime Dog
Smithsonian 19:121–31 (c,2) Ap '88
—Men in handcuffs (Oklahoma)
Sports Illus 70:cov. F 27 '89
—Motel site of 1968 King assassination
(Tennessee)
Life 11:8 (c,4) Ap '88
—Murder site (Montana)
Life 11:177–86 (c,3) N '88
—Outlaw Ned Christie
Smithsonian 20:120 (3) Ap '89
—Paranoid woman on street
Trav&Leisure 20:57 (painting,c,3) Je
'90
—Pope John Paul II assassination attempt
(1981)
Life 12:160 (c,2) Fall '89
—Jack Ruby shooting Lee Harvey Oswald
(1964)
Life 12:106–7 (2) Mr '89
—Shoplifting
Life 11:32–8 (c,1) Ag '88
—Smuggling cocaine (Florida)
Nat Geog 175:6–7, 26–33 (c,1) Ja '89
—Stealing birds' eggs from nests (Great
Britain)
Smithsonian 22:50–63 (c,1) Ap '91
—World War II deserter Eddie Slovick
Am Heritage 98:97–103 (4) S '87
—See also
BILLY THE KID
BLACKBEARD
BOOTH, JOHN WILKES

CAPITAL PUNISHMENT
CAPONE, AL
CONVICTS
DRUG ABUSE
JAMES, JESSE
JUSTICE, ADMINISTRATION OF
LYNCHINGS
POLICE WORK
PROSTITUTION
PRISONS
PUNISHMENT
SPIES
TERRORISM
CRIMEAN WAR
—British soldiers (1855)
 Life 11:82 (2) Fall '88
—Crimean War photography van
 Smithsonian 19:109 (4) Je '88
Crinoids. See
 SEA LILIES
CROCODILES
 Nat Geog 173:282–3, 287 (c,2) F '88
 Nat Geog 178:30, 41 (c,4) D '90
 Life 14:36 (c,3) My '91
—Measuring crocodile jaw
 Smithsonian 20:138 (c,4) Ja '90
—Newborn crocodile
 Nat Geog 178:67 (c,4) D '90
CROCUSES
 Trav&Leisure 17:104 (c,4) S '87
 Smithsonian 19:104–9 (c,1) Ag '88
 Gourmet 50:124–5, 162 (c,4) O '90
CRONKITE, WALTER
 Smithsonian 20:75, 78 (2) Je '89
CROQUET PLAYING
 Sports Illus 66:86 (c,4) My 25 '87
 Trav&Leisure 18:NY2 (c,3) F '88
 Sports Illus 71:11–12 (c,3) Ag 14 '89
 Gourmet 49:260 (painting,c,4) O '89
 Trav&Leisure 20:125 (c,1) Mr '90
 Gourmet 50:98 (c,4) Ap '90
—Giant motorized croquet match (Nevada)
 Sports Illus 68:88–9 (c,4) Ap 11 '88
—Mallets
 Gourmet 51:91 (c,4) My '91
CROSBY, BING
 Life 13:42 (4) Fall '90
CROSS COUNTRY
 Sports Illus 67:103 (c,2) O 26 '87
 Sports Illus 67:42–3 (c,3) D 7 '87
 Sports Illus 69:90, 93 (c,4) D 5 '88
—AAU meet (1936)
 Sports Illus 69:6 (4) D 12 '88
—TAC National Championships (New York)
 Sports Illus 73:99–100 (c,3) D 3 '90
Cross-country skiing. See
 SKIING—CROSS-COUNTRY

CROW INDIANS (MONTANA)
 Life 11:64–9 (c,1) Ag '88
CROW INDIANS (MONTANA)—COSTUME
 Trav&Leisure 19:cov., 126–33, 182–4 (c,1) Mr '89
CROW INDIANS (MONTANA)—RITES AND FESTIVALS
—Crow Fair
 Trav&Leisure 19:cov., 126–33, 182–4 (c,1) Mr '89
 Trav/Holiday 173:80–1 (c,2) Ap '90
—Ritual of the sweat lodge
 Life 11:67 (c,4) Ag '88
CROW INDIANS (MONTANA)—SOCIAL LIFE AND CUSTOMS
—High school basketball
 Sports Illus 74:64–73 (3) F 18 '91
CROWDS
—Aboard riverboat (Zaire)
 Nat Geog 180:2–9, 12–13, 24–5 (c,1) N '91
—Crowd listening to the Pope
 Nat Geog 173:86–8 (c,1) Ja '88
 Life 12:34–5, 40 (c,1) D '89
—Crowded elevator (1945)
 Smithsonian 20:220 (4) N '89
—Impressionistic photo of crowd
 Life 12:84 (c,4) F '89
—Indonesia
 Nat Geog 175:98–9 (c,1) Ja '89
—Istanbul's Grand Bazaar, Turkey
 Trav&Leisure 20:142–3 (c,1) Ja '90
—Labor Day boaters in Copper Canyon, Arizona/California
 Nat Geog 179:6–7 (c,1) Je '91
—New York concert-goers on ticket line (1936)
 Trav&Leisure 20:86 (4) Ag '90
—New York City street scene
 Smithsonian 19:119 (c,2) F '89
—Political demonstration (Czechoslovakia)
 Nat Geog 177:124–5 (c,1) Ap '90
—Political rally (Romania)
 Life 13:6–7 (c,1) Jl '90
—Prague, Czechoslovakia
 Life 13:26–7, 33 (1) F '90
 Trav/Holiday 173:cov. (c,1) My '90
—Seoul market, South Korea
 Smithsonian 19:48 (c,4) Ag '88
—Times Square, New York City (1921)
 Am Heritage 42:72–3 (1) O '91
—Tokyo railroad station, Japan
 Trav&Leisure 19:124 (c,4) O '89
—World Series victory celebration (Cincinnati, Ohio)
 Sports Illus 73:2–3 (c,1) O 29 '90
CROWNS
—6th cent. (Korea)

Am Heritage 42:80 (c,2) N '91
CUBA—SOCIAL LIFE AND CUSTOMS
—Sports in Cuba
Sports Illus 75:60–70 (c,1) Jl 29 '91
CUCKOOS
Natur Hist 98:50–4 (c,1) Ap '89
CUERNAVACA, MEXICO
Gourmet 49:64–9 (map,c,1) F '89
CUMBERLAND RIVER, TENNESSEE
Trav/Holiday 167:14 (c,4) My '87
CURIE, MARIE
Smithsonian 19:220 (painting,c,4) N '88
CURLEWS
Natur Hist 97:6 (painting,c,4) Ap '88
CURLING
Sports Illus 68:292–3, 297 (c,3) Ja 27 '88
—Alberta
Sports Illus 68:16 (c,4) F 29 '88
CURRENCY
—1780s
Nat Geog 171:730 (c,4) Je '87
—1837 phony bank note
Am Heritage 38:139 (4) My '87
—Mid 19th cent. bank notes
Am Heritage 40:50 (c,4) Jl '89
Am Heritage 41:44 (4) Jl '90
—1860s U.S. bills
Am Heritage 41:46–50 (c,4) Jl '90
—1880 twenty-dollar bill
Am Heritage 41:51 (c,4) Jl '90
—1882 gold certificate
Am Heritage 41:52, 54 (4) Jl '90
—1900 interior of safe
Am Heritage 42:6 (painting,c,2) F '91
—1918 $1000 bill
Am Heritage 41:56 (4) Jl '90
—Foreign notes
Trav&Leisure 18:162 (c,2) S '88
—Money pouring over athlete
Sports Illus 71:56–7 (c,1) N 6 '89
—Printing U.S. currency
Trav&Leisure 18:118 (c,1) S '88
Smithsonian 20:36–44 (c,1) My '89
—Ruined U.S. bills needing replacement
Smithsonian 20:36–7, 44 (c,1) My '89
—Rwanda
Trav&Leisure 18:112 (c,4) O '88
—Ten pound note (Great Britain)
Gourmet 49:36 (c,3) My '89
—U.S. dollar bill
Life 11:83, 88 (2) Ap '88
—See also
COINS
CURRENCY—HUMOR
—1973 cartoon about devaluation of U.S. dollar
Am Heritage 42:39 (4) Jl '91
—Exchanging money abroad

Trav/Holiday 172:58–63 (painting,c,1) D '89
CURRIER AND IVES
—19th cent. stylized depiction of the South
Am Heritage 40:150 (engraving,4) N '89
—1864 print of locomotives
Am Heritage 39:21 (c,3) D '88
CURRY, JOHN STEUART
—John Brown mural (Topeka, Kansas)
Trav/Holiday 169:29 (c,4) Mr '88
CURTAINS
—White lace curtains (South Carolina)
Trav/Holiday 175:60 (c,1) My '91
CURTISS, GLENN
—Glenn Curtiss's 1926 Opa-Locka city hall (Florida)
Am Heritage 39:4 (c,2) My '88
CUSCUS
Trav&Leisure 17:86 (c,4) Mr '87
CUSTER, GEORGE ARMSTRONG
Trav/Holiday 173:76 (4) Ap '90
—Battle of Little Big Horn (1876)
Trav&Leisure 18:E6 (painting,c,3) Ap '88
Natur Hist 99:90 (painting,c,4) N '90
CUSTOMS OFFICIALS
—Animal products confiscated by customs
Trav/Holiday 171:52–4, 82 (c,2) Ap '89
—Seizing contraband foods at airports
Smithsonian 18:106–17 (c,1) Je '87
CUTTLEFISH
Nat Geog 171:306–7 (c,1) Mr '87
CYCLONES
—Seen from space
Life 13:12 (c,2) Ap '90
CYCLONES—DAMAGE
—Rice fields after cyclone (Bangladesh)
Life 14:12–13 (c,1) Jl '91
CYPRESS TREES
Natur Hist 96:68–70 (c,1) Ag '87
Trav&Leisure 18:52 (c,3) Je '88
Gourmet 50:86 (c,2) Mr '90
Life 13:42–3 (c,1) My '90
Nat Geog 178:110–11 (c,1) Jl '90
Trav/Holiday 174:60–1 (c,1) Jl '90
—See also
JUNIPER TREES
CYPRUS
Trav&Leisure 19:207–11 (c,4) Ap '89
—Ancient Kourion
Nat Geog 174:30–53 (map,c,1) Jl '88
CZECHOSLOVAKIA
—Rural Slovakia
Nat Geog 171:120–46 (map,c,1) Ja '87
—Tatra Mountains
Nat Geog 171:120–1, 128–9 (c,1) Ja '87
—Tatransky National Park
Natur Hist 99:60 (c,1) Je '90
—See also

- D -

—Ashanti (Nevis)
Gourmet 49:63 (c,4) Mr '89
—Cambodia
Natur Hist 98:cov., 3, 55–63 (c,1) Ap '89
—Child ballroom dancers (Australia)
Nat Geog 173:222–3 (c,1) F '88
—Fiji
Trav/Holiday 171:41, 45 (c,3) Ja '89
—Indonesia
Trav/Holiday 175:41 (c,1) Ap '91
Trav&Leisure 21:284 (c,3) O '91
—Malawi
Nat Geog 177:40 (c,1) My '90
—Paris showgirls (France)
Trav/Holiday 172:61 (c,1) Jl '89
—Rockettes (New York)
Trav&Leisure 18:148–54 (c,1) N '88
—Thailand
Gourmet 51:81 (c,1) Ja '91
—Tribal dancers applying makeup (Senegal)
Trav/Holiday 173:52–3 (c,1) Ja '90
—See also
ASTAIRE, FRED
CASTLE, VERNON AND IRENE
GRAHAM, MARTHA
DANCES
—1820s Christmas ball (Manitoba)
Nat Geog 172:217 (engraving,3) Ag '87
—1859 ball (Washington, D.C.)
Smithsonian 17:80–1 (drawing,c,2) F '87
—1895 country club ball (New York)
Am Heritage 41:75 (drawing,4) S '90
—1945 ROTC ball
Life 13:96–100 (1) Mr '90
—Ball (Vienna, Austria)
Trav&Leisure 17:45 (c,4) O '87
Trav&Leisure 18:124–5 (c,1) N '88
Gourmet 50:66 (c,2) Ja '90
—Debutante balls (Southern U.S.)
Nat Geog 174:26–7 (c,1) Jl '88
Life 14:48 (2) O '91
—High school prom (Kentucky)
Life 14:47 (3) O '91
—New Year's Eve ball (West Germany)
Gourmet 49:42 (c,3) Ja '89
DANCING
—20th cent. dance artifacts (Illinois)
Smithsonian 18:132 (c,4) Mr '88
—Early 20th cent. ballroom dancing
Smithsonian 19:cov. (painting,c,1) Mr '89
Smithsonian 22:154 (2) O '91
—1934 dance marathon
Smithsonian 19:89 (4) Mr '89
—Ballroom dancing
Smithsonian 19:cov., 84–96 (c,1) Mr '89
—Ballroom dancing championships
Smithsonian 19:85–7 (c,2) Mr '89
—Barong dance (Denjalan, Indonesia)

Trav/Holiday 170:62–3, 67 (c,1) Jl '88
—Cajun dancing (Louisiana)
Smithsonian 18:120 (c,3) F '88
Nat Geog 178:50–1 (c,3) O '90
—Chorus line (Berlin, West Germany)
Trav&Leisure 17:160 (c,4) S '87
—Cuba
Nat Geog 180:94–5 (c,1) Ag '91
—"Dirty dancing" fad
Life 11:132–3 (c,1) Ja '88
—Dogon stilt dancing (Mali)
Nat Geog 178:120–3 (c,1) O '90
—Firewalking dance (Indonesia)
Trav&Leisure 20:191 (c,4) F '90
—Flamenco (Spain)
Nat Geog 174:110 (c,4) Jl '88
—French can-can (1901)
Smithsonian 22:46 (painting,c,2) Ag '91
—Harvest festival (Czechoslovakia)
Nat Geog 171:126 (c,4) Ja '87
—Hula (Hawaii)
Trav/Holiday 169:22 (c,4) Je '88
Nat Geog 179:78–9 (c,1) Ja '91
—Lambada (Brazil)
Trav&Leisure 19:51 (c,2) Ja '89
—Latin dances (California)
Life 11:106–8 (c,1) Je '88
—Mexican dance (New Mexico)
Nat Geog 179:122–3 (c,1) Mr '91
—Ritual dances of Tewa Pueblos (New Mexico)
Nat Geog 180:97–9 (c,1) O '91
—Short woman dancing with tall man (Utah)
Life 13:12 (3) Je '90
—Square dancing
Nat Geog 171:55 (c,4) Ja '87
Life 12:69 (c,4) D '89
—Street fair (Pennsylvania)
Nat Geog 178:71 (1) Ag '90
—Tango (Argentina)
Trav&Leisure 18:132–3 (c,1) D '88
—Tennis players in victory conga line (France)
Sports Illus 75:70 (c,3) D 9 '91
—Traditional (Bali, Indonesia)
Trav&Leisure 17:cov., 70–3 (c,1) Jl '87
Trav/Holiday 175:41, 44–5 (c,1) Ap '91
Gourmet 51:68–9 (c,1) Ap '91
—Traditional (Cambodia)
Natur Hist 98:55–63 (c,1) Ap '89
—Traditional Mexican dancers
Trav/Holiday 170:90–1 (c,3) S '88
Trav/Holiday 171:54 (c,4) Je '89
—Urueu-Wau-Wau Indians' victory dance (Brazil)
Nat Geog 174:802–3 (c,1) D '88
—Waitresses dancing on diner counter (Ohio)

Trav/Holiday 172:52–3 (c,1) Ag '89
—Whirling Dervishes (Turkey)
Natur Hist 96:94 (c,4) F '87
Nat Geog 172:564–5 (c,1) N '87
Nat Geog 180:31 (c,1) D '91
—Youngsters waltzing (Virginia)
Nat Geog 172:351 (c,3) S '87
—See also
AEROBIC DANCING
BALANCHINE, GEORGE
BALLET DANCING
FOLK DANCING
DANCING—EDUCATION
—Aerobics class (Saudi Arabia)
Nat Geog 172:443 (c,3) O '87
—Ballet class (Florida)
Life 13:62–3 (c,1) O '90
—Ballet class (Leningrad, U.S.S.R.)
Trav&Leisure 19:138, 158 (c,3) F '89
—Cambodia
Natur Hist 98:60–1 (c,1) Ap '89
—Children's dance class (New York)
Smithsonian 20:84–95 (1) Mr '90
DANCING, CONTEMPORARY
—Dancing to "house music"
Life 12:96–8 (c,1) F '89
—Missouri teenagers dancing (1953)
Nat Geog 175:207 (4) F '89
—Night club (Paris, France)
Nat Geog 176:62–3 (c,1) Jl '89
Trav/Holiday 172:64 (c,2) Jl '89
—Party (New Zealand)
Nat Geog 171:665 (c,3) My '87
DANCING, MODERN
Life 10:104–8 (c,1) N '87
Smithsonian 19:cov., 28–39 (c,1) Jl '88
Trav/Holiday 173:21 (c,4) Ja '90
Life 13:12 (3) D '90
Life 14:3, 36–9 (2) Ag '91
—Australia
Life 11:42–3 (c,1) F '88
—Broadway show rehearsal
Life 12:122–3, 128 (c,1) Mr '89
—Leap in air
Life 10:14 (4) My '87
Nat Geog 179:98–9 (c,1) Ja '91
—Tribute to basketball star in dance
Life 12:12 (c,3) D '89
DANDELIONS
Nat Wildlife 26:39–41 (c,1) Ap '88
Nat Wildlife 27:2 (c,2) Ag '89
—Eating dandelion salad and wine
Nat Wildlife 26:38 (c,1) Ap '88
DANUBE RIVER, EUROPE
Gourmet 50:78–83, 192 (map,c,1) My '90
Smithsonian 21:32–43 (map,c,1) Jl '90
DANUBE RIVER, HUNGARY
—Budapest
Gourmet 48:66–7, 70–1 (c,1) O '88

Trav/Holiday 171:84–5 (c,1) Mr '89
Trav&Leisure 20:107 (c,3) Ja '90
Smithsonian 21:43 (c,1) Jl '90
Trav&Leisure 21:116–17 (c,2) Ja '91
DANUBE RIVER, WEST GERMANY
—Passau
Gourmet 50:79 (c,1) My '90
DARROW, CLARENCE
Life 13:86–7 (1) Fall '90
DAUMIER, HONORÉ
—Cartoon about the Academie Francaise
Smithsonian 20:151 (4) Ja '90
—"First Class Carriage"
Smithsonian 20:107 (painting,c,4) Ag '89
DAVID, JACQUES LOUIS
—Painting of the 1789 French Tennis Court
Oath
Am Heritage 40:41 (c,3) Jl '89
—Portrait of Antoine Lavoisier
Am Heritage 40:4 (painting,c,3) Jl '89 supp.
DAVIS, BETTE
Smithsonian 17:77 (4) Mr '87
Life 12:11, 34–5, 103–4, 115 (c,1) Spring '89
Trav&Leisure 19:228 (4) N '89
Life 13:108 (1) Ja '90
DAVIS, MILES
Smithsonian 20:178 (4) O '89
Trav&Leisure 20:88 (4) Ag '90
DAVIS, SAMMY, JR.
Life 14:101 (4) Ja '91
DAVIS, STUART
—Paintings by him
Smithsonian 22:60–9 (c,2) D '91
—Self-portrait (1912)
Smithsonian 22:60 (painting,c,2) D '91
DAWN
—West Virginia countryside
Natur Hist 99:20–1 (c,1) O '90
DAWSON, YUKON
Trav/Holiday 176:40–1 (c,3) Jl '91
—1900
Trav/Holiday 176:40 (4) Jl '91
DAY CARE CENTERS
Life 12:102–6 (c,1) D '89
Life 14:82–3 (1) Jl '91
—Babies in cribs (Czechoslovakia)
Nat Geog 171:134 (c,4) Ja '87
—Children on day care cots (Cuba)
Nat Geog 180:104–5 (c,1) Ag '91
—Day care around the world
Life 11:150–9 (c,1) N '88
DAYTON, JONATHAN
Life 10:52 (painting,4) Fall '87
DAYTON, OHIO
—1913 flood
Smithsonian 20:164 (4) Je '89

DEAD SEA, ISRAEL
Trav/Holiday 170:70 (c,3) S '88
DEAD SEA SCROLLS
Life 11:50 (4) Fall '88
DEAN, DIZZY
Sports Illus 67:49 (4) S 14 '87
DEAN, JAMES
Sports Illus 71:48 (4) N 15 '89
DEATH
—15th cent. "dance of death"
Smithsonian 22:33 (painting,c,4) D '91
—19th cent. depictions of death
Natur Hist 99:74–82 (1) O '90
—1945 concentration camp corpses (Buch-
enwald)
Life 11:48 (3) Fall '88
—1984 child victim of toxic gas leak (India)
Life 11:16–17 (c,1) Fall '88
—AIDS victim dying
Life 13:8–9 (1) N '90
—Athlete in coffin
Sports Illus 70:68–9 (c,1) F 20 '89
—Body carried on bicycle (Uganda)
Nat Geog 173:490–1 (c,1) Ap '88
—Calves dead from heat (North Dakota)
Life 11:33 (c,3) S '88
—Crushed earthquake victim (Iran)
Life 13:12–13 (c,1) Ag '90
—Dead Civil War soldiers on battlefield
Life 10:6–7 (1) Fall '87
Life 14:26–7 (1) F '91
—Dead Mafia victim (Sicily, Italy)
Life 11:147 (2) Fall '88
—Dead Yugoslavian soldier
Life 14:10–11 (c,1) S '91
—Earthquake victims (Armenia)
Life 12:34–7 (c,1) F '89
—Informer strangled by drug traffickers
(Peru)
Nat Geog 175:22–3 (c,2) Ja '89
—Kurdish baby (Iraq)
Life 14:16 (c,1) Je '91
—Shooting victim under sheet (California)
Sports Illus 68:38 (2) Mr 28 '88
—Victim of English Channel ferry disaster
Life 10:4–5 (c,1) My '87
—See also
CEMETERIES
COFFINS
CRIME AND CRIMINALS
FUNERAL RITES AND CEREMO-
NIES
MUMMIES
TOMBS
TOMBSTONES
DEATH MASKS
—Jean Paul Marat
Nat Geog 176:41 (c,4) Jl '89
—Isaac Newton's death mask

Nat Geog 175:574 (c,4) My '89
DEATH VALLEY, CALIFORNIA
Nat Geog 171:42–3, 77 (c,1) Ja '87
Trav/Holiday 167:8, 10 (c,4) Mr '87
DEBS, EUGENE V.
Life 13:47 (4) Fall '90
Life 14:61 (4) Fall '91
DEER
Natur Hist 100:cov., 34–41 (c,1) O '91
—Black-tailed deer
Natur Hist 97:52–5 (c,1) Ag '88
Nat Wildlife 28:52 (c,1) Ag '90
—Bucks fighting
Natur Hist 100:36–7 (c,2) O '91
—Chital deer
Natur Hist 97:74 (c,4) Jl '88
—Key deer
Nat Wildlife 25:42–5 (c,1) O '87
—Red deer stags
Natur Hist 97:72–3 (c,2) Ag '88
Natur Hist 98:12 (c,3) D '89
—White-tailed deer
Nat Wildlife 25:36–9 (painting,c,1) Ag
'87
Nat Wildlife 27:6 (c,4) D '88
Nat Wildlife 29:16–21 (c,1) O '91
—See also
CARIBOU
ELKS
MOOSE
MULE DEER
MUSK DEER
REINDEER
DEGAS, EDGAR
—Ballerina art works
Trav/Holiday 167:30 (sculpture,c,4) Ja '87
Trav&Leisure 17:30 (painting,c,4) Ja '87
Trav&Leisure 17:122 (sculpture,c,4) Je
'87
Gourmet 47:59 (sculpture,c,1) Ag '87
—"Orchestra of the Opera" (1870)
Life 12:135 (painting,c,4) Ja '89
—Paintings by him
Smithsonian 19:58–69 (c,1) O '88
—Self-portrait
Smithsonian 19:60 (painting,c,4) O '88
—"A Visit to the Museum" (1885)
Smithsonian 22:50 (painting,c,4) Ag '91
DE GAULLE, CHARLES
Smithsonian 17:188 (painting,c,4) Mr '87
Am Heritage 39:110 (4) My '88
DEITIES
—Aztec god Quetzalcoatl
Natur Hist 100:16 (painting,c,4) S '91
—Clay images of goddess Kali (India)
Smithsonian 22:32–3 (c,1) Jl '91
—Egyptian goddess Sakhmet
Trav&Leisure 17:51 (sculpture,c,4) D
'87

Smithsonian 19:87 (sculpture,c,3) Je '88
—Maya sun god
　Trav/Holiday 175:49 (sculpture,c,1) Je '91
—Shinje, Buddhist lord of death
　Nat Geog 174:689 (painting,c,1) N '88
—See also
　BUDDHA
　GOD
　JESUS CHRIST
　MYTHOLOGY
　specific religions
DE KOONING, WILLEM
—"Lisbeth's Painting" (1926)
　Smithsonian 18:95 (c,4) N '87
DELACROIX, EUGÈNE
—"Chasse aux lions"
　Smithsonian 17:92 (painting,c,3) Mr '87
DELAWARE
—Brandywine region
　Trav&Leisure 17:cov., 64–75, 109–13
　　(map,c,1) Ag '87
—Du Pont's Winterthur estate
　Trav&Leisure 17:65–9 (c,1) Ag '87
—New Castle courthouse
　Am Heritage 41:36 (c,4) S '90
—See also
　DOVER
　RODNEY, CAESAR
　WILMINGTON
DELAWARE—MAPS
—1638 map of Fort Christina, New Sweden
　Am Heritage 39:32 (4) My '88
DELAWARE INDIANS—COSTUME
—Delaware Indians moccasin
　Smithsonian 20:50–1 (c,4) O '89
DELAWARE RIVER, NEW JERSEY
　Trav/Holiday 172:N4–5 (c,1) O '89
DELHI, INDIA
　Gourmet 47:67–71 (c,1) S '87
—Red Fort
　Gourmet 47:70 (c,4) S '87
Demolition. See
　BUILDINGS—DEMOLITION
DEMONSTRATIONS
—1976 anti busing riot (Boston, Mas-
　sachusetts)
　Life 10:12–13 (1) Fall '87
—1989 eastern European political demon-
　strations
　Life 13:128–9 (c,3) Ja '90
—1989 student revolt (China)
　Life 12:2–3, 38–46 (c,1) Jl '89
　Life 12:5, 32–3 (c,1) Fall '89
　Trav&Leisure 20:140–1 (c,1) Ja '90
　Life 13:52–8 (c,1) Ja '90
　Trav/Holiday 175:59 (collage,c,4) F '91
　Nat Geog 180:112–15 (c,1) Jl '91
—1991 anti Gulf War protest (Washington)
　Life 14:8–9 (c,1) Mr '91

Life 14:10–11 (c,1) Fall '91
—Anti logging protests
　Nat Geog 173:133 (c,3) S '90
　Sports Illus 74:57 (c,4) My 27 '91
—Anti nuclear demonstration (Yugo-
　slavia)
　Nat Geog 178:120–1 (c,1) Ag '90
—Anti nuclear protesters (Nevada)
　Life 11:9 (c,2) Je '88
—Anti nuclear (New Zealand)
　Nat Geog 171:678 (c,4) My '87
—Anti nuclear march across America
　Life 10:90–5 (c,1) Ja '87
—Anti pollution protest (Arizona)
　Nat Geog 171:503 (c,4) Ap '87
—Anti proposed toxic waste site (New Jer-
　sey)
　Nat Wildlife 26:24–5 (c,1) Ap '88
—Anti Soviet (Estonia)
　Nat Geog 175:632–3 (c,1) My '89
—Army man confronting demonstrator
　(U.S.S.R.)
　Nat Geog 179:3–4 (c,1) F '91
—Canadians protesting U.S. trade agree-
　ment
　Nat Geog 177:112 (c,3) F '90
—Great Louisiana Toxics March (1988)
　Nat Wildlife 28:14–15 (c,2) F '90
—Hunger strikers (Lithuania)
　Nat Geog 178:8–9 (c,1) N '90
—Neo-Nazi rally (Munich, Germany)
　Nat Geog 180:38–9 (c,1) S '91
—Peace vigil (Iceland)
　Nat Geog 171:187 (c,4) F '87
—Political (Czechoslovakia)
　Nat Geog 177:124–5 (c,1) Ap '90
—Political (East Berlin, Germany)
　Nat Geog 177:127 (c,1) Ap '90
—Political (Pakistan)
　Life 10:124–5 (c,1) Ja '87
—Political (Philippines)
　Trav/Holiday 171:20 (c,4) F '89
—Political demonstration (U.S.S.R.)
　Life 14:122–3 (c,1) Ja '91
—Pro environment activists
　Smithsonian 21:185–204 (c,1) Ap '90
—Right-to-lifers demonstration (Washing-
　ton, D.C.)
　Life 10:14–15 (c,1) Fall '87
—Student protest (Chile)
　Nat Geog 174:68–9 (c,1) Jl '88
—Student protest (South Korea)
　Sports Illus 69:26–7, 33 (c,1) Jl 4 '88
—Tear gas victim (Chile)
　Nat Geog 174:70–1 (c,1) Jl '88
—See also
　RIOTS
DEMOSTHENES
　Smithsonian 18:124 (drawing,c,3) O '87

DESIGN, DECORATIVE
—Early 20th cent. art nouveau items (Vienna, Austria)
　Trav&Leisure 19:87–90 (c,2) Mr '89
—Aerial views of Kenyan countryside
　Life 12:90–5 (c,1) Ag '89
—Alphabet designs on butterfly wings
　Nat Wildlife 26:12–13 (c,4) F '88
　Sports Illus 71:160–2 (c,4) D 25 '89
—Art deco buildings (Miami, Florida)
　Trav&Leisure 19:119 (c,1) S '89
—Art deco elevator doors (New York City, New York)
　Gourmet 51:90–3, 143 (c,1) S '91
—Art deco hotel (Marrakesh, Morocco)
　Trav&Leisure 18:140–7 (c,1) N '88
—Art nouveau buildings (Barcelona, Spain)
　Trav/Holiday 169:54–7 (c,1) Je '88
—Art nouveau style furniture (France)
　Smithsonian 18:90 (c,4) N '87
—Artistic natural designs in ice
　Nat Geog 171:80–1 (c,1) Ja '87
—Bright colors of coral reef fish
　Smithsonian 21:98–103 (c,2) N '90
—Checkerboard pattern in sand garden (Japan)
　Nat Geog 176:649 (c,4) N '89
—Design motifs of India
　Trav&Leisure 21:108 (painting,c,3) N '91
—Designing perfume bottles (France)
　Smithsonian 22:61 (c,1) Je '91
—Japanese style and aesthetics (Kyoto)
　Smithsonian 21:74–9 (c,1) Ja '91
—Land patterns seen from the air (China)
　Nat Geog 175:278–311 (c,1) Mr '89
—Mexican design motif
　Trav&Leisure 20:78 (c,2) Ap '90
—Moorish design (Spain and Morocco)
　Nat Geog 174:100–3 (c,2) Jl '88
—Motifs evocative of the Caribbean
　Gourmet 48:58 (painting,c,2) N '88
—Ndebele house design (South Africa)
　Nat Geog 174:346–7 (c,1) S '88
—Occurrence of spirals in nature
　Nat Wildlife 27:52–9 (c,1) Ap '89
—Painted finishes on furnishings
　Gourmet 47:76–9 (c,1) My '87
—Shaker oval boxes with swallowtail joints
　Nat Geog 176:308 (c,1) S '89
—Surma tribe painted bodies (Ethiopia)
　Nat Geog 179:76–99 (c,1) F '91
—Swirling different paint colors together
　Smithsonian 18:122–3 (c,4) D '87
—Textile motifs (Zaire)
　Smithsonian 19:172 (c,4) Je '88
—Visual patterns in chaotic behavior
　Smithsonian 18:122–35 (c,1) D '87

DESKS
—18th cent. chestnut desk (Massachusetts)
　Nat Geog 177:139 (c,4) F '90
—19th cent. Shaker sewing desk
　Am Heritage 38:102 (c,4) My '87
—Early 20th cent. school desk (Missouri)
　Trav/Holiday 176:56–7 (1) Jl '91
—1902
　Am Heritage 38:84–5 (c,3) Jl '87
—FDR's presidential desk
　Smithsonian 20:59 (c,3) D '89
—Governor's desk (Albany, New York)
　Am Heritage 41:61 (c,3) D '90
—Patrick Henry's writing desk
　Life 10:70 (c,2) Fall '87
—John F. Kennedy's desk (Massachusetts)
　Life 11:66–7 (c,1) D '88
—Roll-top (Bolivia)
　Nat Geog 171:448 (c,4) Ap '87
DE SOTO, HERNANDO
　Am Heritage 40:34 (drawing,4) My '89
DETROIT, MICHIGAN
　Am Heritage 38:101 (c,2) Ap '87
　Nat Geog 177:102–5 (c,1) F '90
　Trav/Holiday 174:22 (map,c,4) Ag '90
　Life 14:58–9 (c,3) Je '91
—1910 downtown street scene
　Am Heritage 38:100 (2) Ap '87
—Ambassador Bridge
　Smithsonian 18:127 (c,2) S '87
—See also
　DETROIT RIVER
DETROIT RIVER, MICHIGAN/ONTARIO
　Smithsonian 18:127 (c,2) S '87
　Nat Geog 177:102–3 (c,1) F '90
DEVILS
—Boys dressed as Satan (Mexico)
　Smithsonian 22:124–5 (c,2) My '91
—Devil depicted in art works
　Life 12:49–56 (c,2) Je '89
DEVILS POSTPILE NATIONAL MONUMENT, CALIFORNIA
　Nat Geog 175:491 (c,3) Ap '89
DE VOTO, BERNARD
　Smithsonian 21:211 (4) Ap '90
DEWEY, GEORGE
　Am Heritage 39:51 (2) D '88
DIAMOND INDUSTRY
—Cutting 531 carat finished diamond
　Smithsonian 19:72–83 (c,1) My '88
—Diamond cutting (Australia)
　Nat Geog 173:192–3 (c,1) F '88
DIAMOND MINES
—Australia
　Nat Geog 179:26 (c,4) Ja '91
DIAMOND MINING
—Botswana
　Nat Geog 178:76–7 (c,1) D '90

DIAMONDS
—128.5 carat diamond
 Am Heritage 38:90 (c,4) S '87
—407 carat finished diamond
 Smithsonian 19:83 (c,1) My '88
—890 carat rough diamond
 Smithsonian 19:72 (c,4) My '88
DICKENS, CHARLES
—Caricatures
 Sports Illus 68:184, 186 (drawing,c,4) F
 15 '88
DICKINSON, JOHN
 Am Heritage 38:48 (painting,c,4) My '87
 Life 10:55 (painting,c,4) Fall '87
DIETRICH, MARLENE
 Life 12:109 (3) Spring '89
DIKES
—Huang Ho River, China
 Natur Hist 100:32–5 (c,1) Ag '91
DIKES—CONSTRUCTION
—17th cent. dike building (China)
 Natur Hist 100:34–5 (painting,c,1) Ag
 '91
DIMAGGIO, JOE
 Sports Illus 67:76 (painting,c,4) S 14 '87
 Smithsonian 19:184 (painting,c,4) S '88
 Sports Illus 69:16 (c,4) N 21 '88
 Sports Illus 71:23 (4) Jl 24 '89
 Life 12:94–102 (c,1) O '89
—1954 marriage to Marilyn Monroe
 Sports Illus 71:32 (4) N 15 '89
—Caricature sculpture of him
 Sports Illus 72:58– (c,2) Ja 8 '90
—Plaque at Hall of Fame, Cooperstown,
 New York
 Trav/Holiday 171:80 (c,4) F '89
DINING ROOMS
—Late 18th cent. (Massachusetts)
 Am Heritage 40:73 (c,4) My '89
—Aboard cruise ship
 Trav/Holiday 167:53 (c,3) Ja '87
—Elegant hotel (Washington, D.C.)
 Trav&Leisure 17:115 (c,2) My '87
—Elegant table setting (Connecticut)
 Gourmet 47:92–3 (c,1) F '87
—Early 20th cent. dining hall (Ellis Island,
 New York)
 Smithsonian 21:94 (3) Je '90
 Trav&Leisure 20:76, 80 (3) S '90
—Japanese (Florida)
 Trav&Leisure 18:E20 (c,3) F '88
—Loire Valley château, France
 Gourmet 47:73 (c,4) Ap '87
—Franklin Roosevelt's home (Hyde Park,
 New York)
 Am Heritage 38:45 (c,2) Ap '87
DINNERS AND DINING
—15th cent. banquet (France)
 Smithsonian 22:32 (painting,c,4) D '91

—Mid 19th cent. Thanksgiving dinner
 Am Heritage 40:34 (engraving,4) N '89
—1894 poor people saying grace
 Am Heritage 42:76–7 (painting,c,1) F '91
—Early 20th cent. Chinese restaurant
 (New York)
 Am Heritage 38:105 (4) D '87
—1929 dinner party
 Am Heritage 39:69, 71 (painting,c,3) S
 '88
—Aboard ship (1882)
 Am Heritage 40:100–1 (painting,c,1) D
 '89
—Banquet without chairs (U.S.S.R.)
 Nat Geog 177:100–1 (c,1) Ja '90
—Breakfast on urban rooftop
 Gourmet 50:98 (drawing,4) S '90
—Breakfast table at small inn (California)
 Trav/Holiday 173:12, 14 (c,4) Ja '90
—Child eating pizza (Italy)
 Trav&Leisure 20:130–1 (c,1) F '90
—Children eating candy apples (Quebec)
 Trav&Leisure 19:89 (c,4) Ag '89
—Children eating school lunches
 Life 13:106–7 (c,1) Spring '90
—Chinese restaurant (California)
 Life 10:34–5 (1) F '87
 Gourmet 47:32 (painting,c,2) Je '87
—Clambake (Massachusetts)
 Trav&Leisure 19:96 (c,3) Je '89
—Crabhouse dining (Maryland)
 Nat Geog 174:174–5 (c,1) Ag '88
 Trav&Leisure 18:58 (c,4) Ag '88
 Trav/Holiday 172:43 (c,4) Ag '89
—Cutting meat from spit at restaurants
 (Brazil)
 Trav&Leisure 18:35 (c,4) O '88
—Dim sum meal (China)
 Gourmet 47:62 (c,4) My '87
—Eating at deli (Maryland)
 Nat Geog 174:188–9 (c,1) Ag '88
—Eating at hero stand (New York)
 Sports Illus 70:49 (c,2) My 15 '89
—Eating dandelion salad and wine
 Nat Wildlife 26:38 (c,1) Ap '88
—Eating at restaurant counters
 Gourmet 51:100–5 (c,2) O '91
—Eating fast food in car (North Carolina)
 Nat Geog 174:939 (c,1) D '88
—Eating fried eels (Virginia)
 Nat Wildlife 28:22–3 (c,2) O '90
—Eating pizza
 Sports Illus 66:80 (c,4) Je 1 '87
 Sports Illus 69:68 (c,3) D 12 '88
 Sports Illus 72:55 (c,3) Ap 9 '90
—Family breakfast
 Sports Illus 67:28–9 (c,1) Jl 6 '87
—Family dinner (Pennsylvania)
 Nat Geog 178:78–9 (1) Ag '90

—1866 sketch of cholera contagion (Great Britain)
Nat Geog 179:117 (2) Ja '91
—1904 cartoon about diseases awaiting canal builders
Nat Geog 98:18 (painting,c,4) O '89
—Africa's fight against harmful insects
Smithsonian 19:78–89 (c,1) Ag '88
—Autism
Life 10:84–9 (1) S '87
—Austistic brain
Life 11:63 (diagram,4) Ag '88
—Child with muscular dystrophy
Nat Geog 180:76–7 (c,2) S '91
—Children with chicken pox
Life 13:10 (c,3) Mr '90
—Children with intestinal parasites (Brazil)
Natur Hist 99:58–9 (c,1) Ag '90
—Comatose hospital patients
Life 12:80–7 (c,1) Ag '89
—Fish munching on skin with psoriasis (Turkey)
Life 11:18 (c,4) D '88
—Goiters (Kashmir)
Nat Geog 172:536 (c,4) O '87
—Headaches
Smithsonian 18:175–90 (c,3) D '87
—History of plagues
Nat Geog 173:673, 676–87 (map,c,1) My '88
—Lyme disease research
Natur Hist 98:8 (drawing,c,3) Jl '89
Nat Geog 179:114–15, 122–5 (c,1) Ja '91
—Lyme disease victim
Nat Geog 179:122 (c,2) Ja '91
—Man with Lou Gehrig's disease
Nat Geog 175:574–5 (c,2) My '89
—Mosquito-borne diseases
Natur Hist 100:64–5 (map,c,4) Jl '91
—Parkinson's disease victims
Life 12:76–82 (c,1) My '89
—Radon gas danger
Nat Geog 175:424–5 (map,c,1) Ap '89
—Salt mine cure for asthma (Romania)
Life 12:8 (c,4) F '89
—Sick children cheered by clowns
Life 13:76–85 (c,1) Ag '90
—Sickle cell anemia
Natur Hist 98:10–14 (map,c,4) F '89
—Teen with progeria (premature aging)
Life 12:74–8 (c,1) O '89
—Tourette's syndrome
Life 11:94–102 (c,1) S '88
—Tuberculosis (early 20th cent.)
Am Heritage 38:38 (2) F '87
—Tuberculosis (Haiti)
Life 10:63 (c,2) Ag '87
—X-ray of enlarged heart (Bolivia)

Nat Geog 171:446 (c,3) Ap '87
—See also
 AIDS
 ALCOHOLISM
 BUBONIC PLAGUE
 CANCER
 DRUG ABUSE
 INFLUENZA
 LEUKEMIA
 MALARIA
 MALNUTRITION
 MEDICINE—PRACTICE
 MENTAL ILLNESS
 VACCINATIONS
 VIRUSES
 YELLOW FEVER
DISEASES—HUMOR
—Sneezing
 Nat Wildlife 29:38–9 (painting,c,1) Ap '91
DISNEY, WALT
 Life 13:26 (c,1) Fall '90
DISNEYLAND, ANAHEIM, CALIFORNIA
 Am Heritage 38:22 (c,4) F '87
 Sports Illus 67:72 (c,4) S 7 '87
DIVING
 Sports Illus 66:18 (c,4) Mr 23 '87
 Sports Illus 66:40 (c,2) Ap 27 '87
 Sports Illus 70:68, 71 (c,3) My 15 '89
—1904 Olympics (St. Louis)
 Am Heritage 39:44 (2) My '88
—1952 Olympics (Helsinki)
 Sports Illus 69:47 (4) Ag 1 '88
—1988 Olympic trials
 Sports Illus 69:2–3, 28–33 (c,1) Ag 29 '88
—1988 Olympics (Seoul)
 Sports Illus 69:58–60, 65 (c,1) O 3 '88
 Sports Illus 69:63 (c,3) O 10 '88
 Life 12:156 (c,1) Ja '89
—Back dive
 Sports Illus 74:34–5 (c,2) Ja 14 '91
—Banging head on diving board at 1988 Olympics (Seoul)
 Sports Illus 69:86–7 (c,1) D 26 '88
 Sports Illus 71:204 (c,4) N 15 '89
—China
 Sports Illus 69:78–81 (c,1) Ag 15 '88
—Competition
 Sports Illus 68:40, 45 (c,3) My 23 '88
 Sports Illus 69:85–7 (c,1) S 14 '88
—Diver depicted on ancient Roman tomb (Paestum, Italy)
 Trav&Leisure 18:80 (c,3) Ag '88
—Into hotel pool (California)
 Trav&Leisure 19:cov. (c,1) Ja '89
—Off rocks (Mexico)
 Trav&Leisure 17:84–5, 180 (c,1) S '87
—Pan American Games 1987 (Indiana)

—Casa de Campo resorts
Trav&Leisure 18:64, 142 (c,3) Ja '88
DONIZETTI, GAETANO
—His piano (Italy)
Gourmet 47:65 (c,1) S '87
DONKEYS
Trav&Leisure 20:110 (c,4) Je '90
—Kiangs
Nat Geog 174:682–3 (c,1) N '88
—Somali wild ass
Smithsonian 18:142 (c,4) My '87
—See also
ONAGERS
DOORMEN
—Chicago, Illinois
Nat Geog 179:77 (c,3) My '91
—London hotel, England
Trav&Leisure 19:92–3 (c,1) Ag '89
DOORS
—18th cent. facades (Charleston, South
Carolina)
Gourmet 49:71 (c,4) Ap '89
—Mid 18th cent. Georgian style
Am Heritage 40:116–17 (c,2) F '89
—Early 19th cent. fanlights (Charleston,
South Carolina)
Am Heritage 38:68 (c,4) Ap '87
—Apartment doorbells (Italy)
Trav/Holiday 175:54 (c,4) F '91
—Art deco elevator doors (New York City,
New York)
Gourmet 51:90–3, 143 (c,1) S '91
—Decorated door (France)
Gourmet 47:62 (c,4) O '87
—Doorway (Switzerland)
Smithsonian 20:81 (c,1) Mr '90
—London pub, England
Gourmet 47:53, 57 (c,1) Mr '87
—Ornate wooden doors (Kenya)
Trav/Holiday 170:50 (c,4) Ag '88
—Palace door (Fez, Morocco)
Gourmet 50:80 (c,4) S '90
—Tunisia
Gourmet 50:46 (c,3) Ag '90
—Wooden door knockers (Japan)
Smithsonian 21:76 (c,4) Ja '91
DORÉ, GUSTAVE
—1868 engraving of cat catching rats
Natur Hist 100:18 (3) Je '91
DOUBLEDAY, ABNER
Natur Hist 98:18 (4) N '89
DOUGLAS, KIRK
Life 10:64–5 (c,1) Ap '87
DOUGLASS, FREDERICK
Nat Geog 173:19 (3) Ja '88
Smithsonian 20:118 (4) Ap '89
Smithsonian 21:51 (4) O '90
Am Heritage 42:14 (drawing,4) F '91
—Depicted in Jacob Lawrence paintings

Smithsonian 18:58–9 (c,4) Je '87
DOVER, DELAWARE
—Liberty Bell
Trav/Holiday 170:10 (c,4) D '88
—Old mansion
Trav/Holiday 170:10 (c,4) D '88
DOVES
Nat Wildlife 29:18–20 (painting,c,1) D
'90
Natur Hist 100:18 (drawing,4) Ap '91
DOYLE, SIR ARTHUR CONAN
—Grave (Minstead, England)
Trav&Leisure 20:160 (c,4) Ap '90
DRAGONFLIES
Nat Wildlife 26:51 (c,1) D '87
Smithsonian 19:118–19 (sculpture,c,3) D
'88
Natur Hist 98:80–1 (c,1) My '89
Nat Geog 178:78 (c,4) Jl '90
Nat Wildlife 29:2 (c,2) D '90
Nat Wildlife 29:14–17 (c,1) Ap '91
Smithsonian 22:118 (c,4) O '91
DRAGONS
—Chinese New Year's dragon
Gourmet 51:74 (drawing,3) F '91
DRAKE, SIR FRANCIS
Smithsonian 18:90 (painting,c,4) Ja '88
—1586 attack on St. Augustine by Francis
Drake
Nat Geog 173:358–9 (drawing,1) Mr '88
DRAWING
—Sidewalk chalk drawing (Italy)
Trav/Holiday 168:53 (c,4) S '87
DREISER, THEODORE
Smithsonian 18:182 (4) My '87
DREYFUS, ALFRED
Smithsonian 20:115–18, 124–8 (c,4) Ag
'89
—Cartoon of convict Dreyfus
Smithsonian 19:94 (4) Ag '88
—"Dreyfus Affair" events
Smithsonian 20:114–29 (c,2) Ag '89
DRINKING CUSTOMS
—1813 U.S. saloon scene
Am Heritage 39:4 (painting,c,2) S '88
—Afternoon tea (Great Britain)
Trav/Holiday 170:42–6 (c,2) Jl '88
—Afternoon tea at hotel
Gourmet 47:93–7, 268 (c,1) N '87
Trav&Leisure 20:171 (c,2) O '90
—Afternoon tea setting (Alberta)
Gourmet 48:57 (c,4) Ja '88
—Athlete drinking from bottle
Sports Illus 71:2–3 (c,1) S 18 '89
—Bears drunk on fermented corn
Nat Wildlife 26:28 (painting,c,2) Ap '88
—Beer drinking contest (Alaska)
Nat Geog 173:370 (c,3) Mr '88
—Beer garden (West Germany)

Trav&Leisure 19:100–1 (c,1) Ag '89
—British pubs
Trav&Leisure 19:136–7, 182 (1) My '89
Trav&Leisure 20:89 (c,3) Mr '90
Nat Geog 180:45 (c,3) Jl '91
—Businessmen having drinks (Japan)
Nat Geog 177:66 (c,3) Ap '90
—Christmas punch
Gourmet 47:cov. (c,1) D '87
—Clinking glasses in toast (Latvia)
Smithsonian 21:64 (c,3) Ja '91
—Decanting wine (Italy)
Trav&Leisure 21:108 (c,4) Jl '91
—Dousing golfer with champagne
Sports Illus 68:54 (c,4) Mr 28 '88
—Hotel bar (San Francisco, California)
Trav&Leisure 20:158–9 (c,1) Mr '90
—Hotel lobby coffee service (Oman)
Trav/Holiday 171:77 (c,2) Mr '89
—Irish pub (Dublin)
Trav/Holiday 169:43 (c,4) Je '88
—Morning coffee service (Indiana)
Gourmet 50:105 (c,4) D '90
—Pouring wine into glass slipper
Gourmet 49:52 (painting,c,2) My '89
—Sipping communal drink (Vietnam)
Natur Hist 100:62 (c,3) N '91
—Tea (Morocco)
Trav&Leisure 18:97 (c,1) Jl '88
Trav&Leisure 18:145 (c,2) N '88
—Tea at hotel (Hong Kong)
Trav/Holiday 176:53 (c,2) O '91
—Tea ceremony (Taiwan)
Gourmet 49:82 (c,4) Ap '89
—Tea tray (Virginia)
Trav&Leisure 20:142–3 (c,1) My '90
—Toasting with wine glasses
Trav/Holiday 168:9 (c,4) Jl '87
—Wine tasting
Trav/Holiday 168:48 (c,4) Jl '87
Trav/Holiday 172:88 (c,4) S '89
—Wine tasting (Australia)
Nat Geog 173:185 (c,3) F '88
—Wine tasting (France)
Trav/Holiday 169:61 (c,4) Mr '88
—Wine tasting (Italy)
Trav/Holiday 169:65 (c,1) F '88
Gourmet 48:28 (painting,c,3) My '88
—See also
ALCOHOLISM
COFFEEHOUSES
TAVERNS
WINE
DRINKING CUSTOMS—HUMOR
—Beer drinkers (Great Britain)
Gourmet 48:38 (drawing,c,2) F '88
DROUGHT
—1930s Dust Bowl scenes (Oklahoma)
Smithsonian 20:cov., 44–57 (1) Je '89

—Impact of drought on golf course (Minnesota)
Natur Hist 98:62 (c,2) Ja '89
—Impact of drought on U.S. farmlands
Life 11:2–3, 32–6 (c,2) S '88
—Impact of drought on wildlife
Sports Illus 69:64–72 (c,1) S 12 '88
—Mississippi River, Tennessee
Nat Geog 178:84–5 (c,2) O '90
—Oklahoma countryside
Smithsonian 20:56–7 (c,1) Je '89
—Parched land
Sports Illus 69:64–5 (c,1) S 12 '88
—Parched land (Spain)
Nat Geog 179:123 (c,1) Ap '91
—Sahel area, Africa
Nat Geog 172:cov., 140–79 (map,c,1) Ag '87
—Summer of 1988 drought scenes (U.S.)
Natur Hist 98:42–71 (c,1) Ja '89
Life 12:12–13 (c,1) Ja '89
DRUG ABUSE
—19th cent. opium den (China)
Smithsonian 20:48 (drawing,4) Ap '89
—Ancient coca paraphernalia (Colombia)
Nat Geog 175:11 (c,4) Ja '89
—Cocaine industry
Nat Geog 175:2–47 (c,1) Ja '89
—Drug culture in New York City, New York
Life 11:92–100 (1) Jl '88
Nat Geog 175:40–1 (c,2) Ja '89
—Drug culture in North Philadelphia, Pennsylvania
Life 13:30–41 (1) Je '90
—Drug rehabilitation therapy for teens (Massachusetts)
Nat Geog 175:48–51 (c,1) Ja '89
—Inhaling heroin (Nepal)
Nat Geog 172:63 (c,4) Jl '87
—Kogi people chewing coca leaves (Columbia)
Nat Geog 175:12–13 (c,1) Ja '89
—Mexican illegal drug industry
Life 11:80–4 (c,1) Mr '88
—Opium and hashish store (Pakistan)
Smithsonian 19:47 (c,4) D '88
—Rastafarian girls smoking marijuana (Jamaica)
Life 14:34–5 (c,1) O '91
—Rehabilitation center (Italy)
Life 11:52–6 (c,1) Ap '88
—Scenes from the war on drugs
Life 12:18–24 (c,1) S '89
—Sniffing glue (Botswana)
Nat Geog 178:89 (c,4) D '90
—Young crack addict
Life 12:54–7 (1) Ja '89

DRUG INDUSTRY
—Drying bear gallbladders used to treat ailments
Nat Geog 180:118–19 (c,3) S '91
—Synthetic insulin production (Indiana)
Nat Geog 172:252 (c,4) Ag '87
DRUGS
—Cocaine
Nat Geog 175:2–3, 18, 36–8 (c,1) Ja '89
—Dragon bones used in medicine (China)
Natur Hist 99:60–7 (c,1) S '90
—History of penicillin discovery
Smithsonian 21:173–87 (4) N '90
—Medicinal plants (Suriname)
Smithsonian 19:94–101 (c,1) F '89
—See also
PHARMACIES
DRUIDS
Smithsonian 18:146–66 (c,2) Mr '88
—61 A.D. Roman attack on Druids (Wales)
Smithsonian 18:152 (engraving,4) Mr '88
—Druids collecting mistletoe
Life 13:28 (engraving,4) My '90
—Modern summer solstice ritual at Stone-henge, England
Smithsonian 18:166 (c,4) Mr '88
DRUM PLAYING
—1988 Olympics opening ceremony (Se-oul, South Korea)
Sports Illus 69:2–3 (c,1) S 26 '88
—At baseball stadium
Sports Illus 75:42–3 (c,2) O 7 '91
DRUMS
—1824
Am Heritage 40:50–1 (c,1) Jl '89
DUBAI
Nat Geog 173:666–7 (c,1) My '88
—Golf course
Life 13:42–3 (c,1) O '90
DUBAI—SOCIAL LIFE AND CUS-TOMS
—Camel racing
Life 12:79–80 (c,1) Ap '89
DUBLIN, IRELAND
Trav&Leisure 18:104–13, 161–4 (map,1) Ap '88
Trav/Holiday 169:42–7 (c,1) Je '88
—Bridge
Trav&Leisure 21:202–3 (c,1) O '91
—Shelbourne Hotel
Trav&Leisure 20:56–7 (c,2) My '90
—Trinity College
Trav&Leisure 18:113 (4) Ap '88
Trav/Holiday 169:44–5 (c,2) Je '88
—Wood Quay Viking ruins
Natur Hist 97:92–7 (3) N '88
DU BOIS, GUY PÈNE
Am Heritage 40:82 (4) F '89

—Paintings by him
Am Heritage 40:72–81 (c,1) F '89
—Portrait of Juliana Force (1921)
Am Heritage 40:112 (painting, c,1) S '89
DU BOIS, W. E. B.
Life 13:75 (4) Fall '90
DUBUQUE, IOWA
—Riverboat Museum
Trav/Holiday 169:32 (4) Ja '88
DUCHAMP, MARCEL
—Art works by him
Smithsonian 21:142, 147 (c,4) N '90
—"Nude Descending a Staircase" (1913)
Am Heritage 39:32 (painting,4) F '88
DUCKS
Nat Geog 172:24 (c,3) Jl '87
Nat Wildlife 25:50–1 (c,1) Ag '87
Life 10:58–9 (c,1) D '87
Nat Wildlife 27:4–13 (painting,c,1) O '89
—Duck decoys (Louisiana)
Nat Geog 178:56 (c,4) O '90
—Dragon Boat Race duck catching (Leshan, China)
Nat Geog 173:318–19 (c,1) Mr '88
—See also
CANVASBACKS
EIDER DUCKS
GADWALLS
GEESE
MALLARDS
PINTAIL DUCKS
SWANS
TEALS
WOOD DUCKS
DUELS
Am Heritage 42:102 (drawing,1) O '91
—Early 20th cent. (France)
Nat Geog 176:173 (2) Jl '89
DUFY, RAOUL
—"Boats at L'Estaque" (1908)
Smithsonian 21:77 (painting,c,2) O '90
DUGONGS
Nat Geog 179:48 (c,4) Ja '91
DULLES, JOHN FOSTER
Smithsonian 22:161 (4) My '91
DUMAS, ALEXANDRE PÈRE
—Caricature
Smithsonian 20:157 (c,3) Ja '90
—D'Artignon, of *The Three Musketeers*
Gourmet 48:80 (sculpture,c,4) My '88
—Dumas' Chateau de Monte-Cristo, Paris, France
Gourmet 48:78–81, 146 (c,1) My '88
DUNBAR, PAUL LAURENCE
Smithsonian 20:59 (4) Ag '89
DU PONT, PIERRE S.
Am Heritage 41:58 (4) Ap '90

DURANTE, JIMMY
 Life 10:69 (2) Je '87
DÜRER, ALBRECHT
—"Adoration of the Magi" (1504)
 Natur Hist 96:4 (painting,c,4) S
 '87
—Animal and plant paintings by him
 Natur Hist 98:76–82 (c,3) S '89
—Diagram of rhinoceros (1515)

Trav&Leisure 19:116 (4) Ja '89
DUROCHER, LEO
 Sports Illus 68:25 (4) My 9 '88
 Sports Illus 75:31 (4) O 21 '91
DÜSSELDORF, WEST GERMANY
—Outdoor cafe
 Trav&Leisure 19:217 (c,3) N '89
DYLAN, BOB
 Life 13:14 (1) Fall '90

- E -

EAGLES
 Nat Geog 173:283 (c,4) F '88
 Nat Geog 178:14–15 (c,1) D '90
—1855 wooden bald eagle as U.S. symbol
 Am Heritage 38:98–100 (c,1) F '87
—Bald
 Nat Wildlife 25:45 (c,1) Ap '87
 Trav&Leisure 167:41 (c,1) Je '87
 Am Heritage 39:55, 114 (painting,c,1)
 Mr '88
 Life 11:52–6 (c,1) My '88
 Natur Hist 97:cov. (c,1) Ag '88
 Nat Wildlife 26:cov., 34–41 (c,1) O '88
 Nat Wildlife 27:8–9 (c,1) F '89
 Nat Wildlife 28:2–3 (c,2) F '90
 Nat Wildlife 28:cov. (painting,c,1) O '90
 Life 14:81 (c,4) Summer '91
 Nat Wildlife 29:37 (painting,c,1) Je '91
 Natur Hist 100:56–7 (c,2) D '91
—Golden
 Natur Hist 96:67 (c,3) F '87
 Nat Wildlife 25:46–7 (c,1) Ag '87
 Nat Geog 174:841 (c,4) D '88
 Nat Wildlife 27:34–41 (c,1) O '89
 Smithsonian 21:101 (c,1) Ap '90
EAKINS, THOMAS
 Am Heritage 42:57, 64 (4) S '91
 Smithsonian 22:54 (4) N '91
—1884 multiple exposure of broad jump
 Nat Geog 176:546–7 (1) O '89
—1900 portrait of Louis Kenton
 Am Heritage 38:94 (painting,c,4) D '87
—Family
 Am Heritage 42:64, 68 (c,4) S '91
 Smithsonian 22:66 (painting,c,4) N '91
—"The Gross Clinic" (1875)
 Am Heritage 42:59, 62 (painting,c,1) S
 '91
 Smithsonian 22:58 (painting,c,2) N '91
—"Home Ranch" (1888)
 Am Heritage 38:38 (painting,c,3) D '87
—Painting of Frank Hamilton Cushing
 (1895)
 Am Heritage 41:104 (c,4) F '90

—Paintings by him
 Nat Wildlife 25:54–5 (c,1) O '87
 Am Heritage 42:6, 58–69 (c,1) S '91
 Smithsonian 22:52–67 (c,1) N '91
—Portrait of Henry Tanner (1900)
 Am Heritage 42:77 (painting,c,4) F '91
EARHART, AMELIA
 Am Heritage 38:109 (4) Jl '87
 Am Heritage 40:132 (4) D '89
 Am Heritage 42:70–5 (4) F '91
EARP, WYATT
 Smithsonian 20:118 (4) Ap '89
 Trav/Holiday 176:82 (4) Jl '91
EARS
—Dayak woman with stretched earlobes
 (Borneo)
 Nat Geog 175:105 (c,4) Ja '89
EARTH
—1983 space shuttle photo of Himalayas
 Nat Geog 174:658–9 (c,1) N '88
—1988 events affecting the planet
 Life 12:8–18 (c,1) Ja '89
—Ancient K-T boundary layer (Spain)
 Nat Geog 175:682–5 (c,1) Je '89
—Chart of species extinction
 Nat Geog 175:666–71 (c,4) Je '89
—Computer images of exploding globe
 Nat Geog 175:732–3 (c,2) Je '89
—Evidence of meteorite impact on earth
 Smithsonian 20:80–93 (map,c,1) S '89
—Research on earth's ozone layer
 Smithsonian 18:142–55 (c,2) F '88
—Researching effects of cataclysms on spe-
 cies extinction
 Nat Geog 175:662–99 (c,1) Je '89
—Seen from space
 Nat Geog 173:329B (c,4) Mr '88
 Life 11:8–9, 73 (c,1) Fall '88
 Life 11:cov., 189–98 (c,1) N '88
 Nat Geog 174:768–8 (c,1) D '88
 Smithsonian 19:70–1, 74–5 (c,1) D '88
 Life 12:30–1 (c,1) My '89
 Nat Geog 178:127–9 (c,1) N '90
—Voyager I shots of Earth and moon

Nat Geog 178:53 (c,4) Ag '90
—See also
GEOLOGICAL PHENOMENA
WEATHER PHENOMENA
individual countries
EARTH—MAPS
—Holograph of earth
Nat Geog 174:cov. (c,1) D '88
—Map of earth's ozone hole
Nat Wildlife 28:42 (c,4) F '90
Nat Geog 177:42 (c,3) Ap '90
—Plate tectonic continent theory
Natur Hist 96:38–9 (c,4) N '87
—Varieties of world map projections
Nat Geog 174:910–13 (c,4) D '88
—See also
GLOBES
MAPS
EARTHQUAKES
Life 12:40–9 (c,1) F '89
—136 A.D. Chinese earthquake alarm
Life 12:48 (c,4) F '89
—1989 landslide on California highway
Nat Geog 177:78–80 (c,1) My '90
—Aerial photo of 1987 California quake
Life 10:38–9 (c,1) N '87
—Earthquake ride at amusement park
(California)
Life 12:10 (c,3) My '89
—How earthquakes work
Life 12:44–5, 48–9 (drawing,c,4) F '89
—Fukui, Japan (1948)
Life 12:45 (4) F '89
—Japanese earthquake legend
Life 12:49 (painting,c,4) F '89
—Making buildings earthquake-proof
Nat Geog 177:100–1 (drawing,c,1) My
'90
—See also
RICHTER, CHARLES
EARTHQUAKES—DAMAGE
Life 12:40–5 (c,1) F '89
—1906 San Francisco earthquake
Life 12:44 (4) F '89
Nat Geog 177:92–5 (1) My '90
—1964 Anchorage earthquake, Alaska
Life 12:44 (4) F '89
—1989 San Francisco earthquake
Sports Illus 71:6–7, 22–9 (c,1) O 30 '89
Sports Illus 71:213 (c,4) N 15 '89
Life 1326–32 (c,1) Ja '90
Nat Geog 177:76–91, 96–105 (c,1) My '90
—Armenia (1988)
Life 12:34–41 (c,1) F '89
—Crushed earthquake victim (Iran)
Life 13:12–13 (c,1) Ag '90
—Kourion, Cyprus (365 A.D.)
Nat Geog 174:30–53 (map,c,1) Jl '88
—Yungay, Peru (1970)

Nat Geog 171:436–7 (c,2) Ap '87
EASTER
—Decorated Easter statue of Christ (Chile)
Nat Geog 174:58–9 (c,1) Jl '88
—Easter egg hunt (Texas)
Nat Geog 173:492 (c,1) Ap '88
—Easter eggs
Gourmet 48:74, 164 (painting,c,2) Ap
'88
—Easter eggs (Greece)
Trav/Holiday 175:74 (c,2) Mr '91
—Easter mass (Ukraine, U.S.S.R.)
Life 11:110–11 (c,1) Jl '88
—Easter procession (Guatemala)
Nat Geog 173:774–5 (c,1) Je '88
—Easter procession "Correr a Cristo"
(Chile)
Natur Hist 96:44–53 (c,1) My '87
—Greece
Trav/Holiday 175:72–9 (c,1) Mr '91
—Russian Easter foods
Gourmet 49:98–9 (c,1) Ap '89
—Ukrainian Easter breakfast (Illinois)
Nat Geog 179:63 (c,3) My '91
EASTER ISLAND—ART
—Maori stone sculptures
Trav/Holiday 167:62 (c,4) Ja '87
Trav&Leisure 21:178–9 (c,1) O '91
EASTERN U.S.
—Scenes along Appalachian Trail
Nat Geog 171:216–43 (map,c,1) F '87
—See also
APPALACHIAN TRAIL
CHESAPEAKE BAY
EASTMAN, GEORGE
Nat Geog 173:10 (4) Ja '88
Smithsonian 19:107 (4) Je '88
Life 13:96 (4) Fall '90
—Cartoon of George Eastman as amateur
photographer
Smithsonian 19:109 (4) Je '88
ECHIDNAS
Nat Geog 173:173 (c,4) F '88
Natur Hist 100:37 (c,1) My '91
Echinoderms. See
SAND DOLLARS
SEA CUCUMBERS
SEA LILIES
SEA URCHINS
STARFISH
ECLIPSES
—1504 lunar eclipse helping Columbus
with Indians
Natur Hist 96:26 (drawing,4) Ja '87
—1854 daguerreotype of eclipse
Life 11:123 (4) Fall '88
—Lunar eclipse
Nat Wildlife 30:58 (c,3) D '91
—Solar eclipse

Natur Hist 100:76, 82–3 (painting,c,4) Jl
'91
Life 14:8–9 (c,1) S '91
ECUADOR
—Rain forests
Smithsonian 22:36–49 (c,1) Je '91
—Rio Napo
Trav&Leisure 20:186 (c,3) Mr '90
—Sangay volcano
Nat Geog 171:434–5 (c,1) Ap '87
—See also
EL MISTI
GALÁPAGOS ISLANDS
ECUADOR—COSTUME
—Jivaro Indian headdress
Smithsonian 20:44–5 (c,2) O '89
ECUADOR—HOUSING
Trav&Leisure 21:20 (c,4) Mr '91
ECUADOR—RITES AND FESTIVALS
—Infant's funeral
Life 14:74–5 (c,1) O '91
EDDY, MARY BAKER
Am Heritage 42:43 (4) F '91
EDERLE, GERTRUDE
Sports Illus 69:46 (4) Ag 1 '88
EDGERTON, HAROLD
Nat Geog 172:464, 466 (c,4) O '87
Life 11:100 (c,2) Fall '88
EDINBURGH, SCOTLAND
Trav&Leisure 19:cov., 68–75, 137 (c,1)
Jl '89
—Edinburgh Castle
Natur Hist 97:42 (c,4) Ap '88
Trav&Leisure 19:cov., 72–4 (c,1) Jl '89
—Royal High School
Nat Geog 174:360 (c,4) S '88
EDISON, THOMAS ALVA
Nat Geog 173:10 (3) Ja '88
Smithsonian 20:115 (4) Jl '89
Am Heritage 41:cov. (4) S '90
Life 13:97 (1) Fall '90
—1880 patent for light bulb
Am Heritage 41:54 (drawing,4) S '90
—Edison's first phonograph
Am Heritage 40:10 (4) N '89
—Edison's laboratory (Ft. Myers, Florida)
Trav&Leisure 19:177 (c,4) D '89
—Edison's laboratory (New Jersey)
Life 14:46 (c,4) Summer '91
—Home (West Orange, New Jersey)
Trav/Holiday 168:32 (drawing,4) Ag '87
EDMONTON, ALBERTA
Nat Geog 172:229 (c,1) Ag '87
EDUCATION
—1935 cartoon about progressive ed-
ucation
Am Heritage 41:76 (4) F '90
—Air traffic controller school
Smithsonian 20:122–31 (c,1) Ja '90

—Astrology class (Bhutan)
Nat Geog 179:99 (c,3) My '91
—Excellent teachers at work
Life 13:60–70 (c,1) O '90
—First-graders studying gerbil (Virginia)
Life 13:69 (c,2) O '90
—Hebrew class (Moscow, U.S.S.R.)
Nat Geog 179:23 (c,3) F '91
—History of American education system
Am Heritage 41:cov., 66–81 (c,1) F '90
—Sailing class (Maryland)
Trav/Holiday 172:86 (c,2) Ag '89
—School for butlers (Great Britain)
Smithsonian 18:111–21 (c,2) Mr '88
—School programs encouraging creativity
(Indiana)
Life 13:56–61 (c,1) Spring '90
—Sex education class
Life 12:27 (3) Jl '89
—Teaching fly fishing (Northeast)
Sports Illus 70:101–3 (c,2) My 22 '89
Trav&Leisure 19:E28 (c,4) D '89
—Vocational high school program (Ohio)
Smithsonian 19:132–43 (1) My '88
—See also
ART EDUCATION
BLACKBOARDS
CLASSROOMS
COLLEGES AND UNIVERSITIES
COOKING EDUCATION
DANCING—EDUCATION
GOLF—EDUCATION
MANN, HORACE
MEDICAL EDUCATION
MILITARY TRAINING
MUSIC EDUCATION
SCHOLARS
SCHOOLS
SCIENCE EDUCATION
SWIMMING EDUCATION
TEACHERS
THEATER—EDUCATION
WASHINGTON, BOOKER T.
EDUCATION—HUMOR
—1960s "New Math"
Am Heritage 41:77–83 (painting,c,1) D
'90
EDWARD VII (GREAT BRITAIN)
Life 10:36 (4) S '87
EDWARD VIII (GREAT BRITAIN)
Life 10:37 (4) S '87
EELS
Life 10:50 (c,4) Je '87
Nat Geog 173:454 (c,4) Ap '88
Trav&Leisure 18:13, 117 (c,4) O '88
Nat Wildlife 28:18–23 (c,1) O '90
Nat Geog 178:26–7 (c,1) O '90
—Moray eels
Life 10:48–9 (c,2) Je '87

Life 13:40–1 (c,1) O '90
—Camel driver
Life 12:52–3 (c,1) Mr '89
EGYPT—HISTORY
—Ancient Kushite rule over Egypt
Nat Geog 178:104–5 (painting,c,1) N '90
—Hosni Mubarak
Life 14:70 (c,4) Mr '91
—Time line of ancient Egypt
Nat Geog 173:542 (c,3) Ap '88
EGYPT—MAPS
Nat Geog 178:102 (c,1) N '90
EGYPT—RITES AND FESTIVALS
—Circumcision of girl
Life 14:36 (c,2) O '91
EGYPT, ANCIENT
—Ancient sites along the Nile
Trav&Leisure 19:cov., 138–56 (map,c,1)
S '89
—Diagram of necropolis complex (Giza)
Nat Geog 173:520–1 (c,1) Ap '88
—Ramses II killing prisoners
Nat Geog 179:5 (painting,c,2) Ap '91
—Time line of ancient Egypt
Nat Geog 173:542 (c,3) Ap '88
—See also
KHUFU (CHEOPS)
MUMMIES
NEFERTITI
RAMSES II
TUTANKHAMUN
EGYPT, ANCIENT—ARCHITECTURE
—Luxor
Trav&Leisure 21:51–3 (c,4) Ag '91
—See also
PYRAMIDS
TEMPLES—ANCIENT
EGYPT, ANCIENT—ART
—Nefertiti's tomb paintings (Luxor)
Life 11:143–7 (c,2) D '88
Nat Geog 179:24–5 (c,2) Ap '91
—Tomb carving
Smithsonian 22:126 (c,4) O '91
—Tomb paintings (Thebes)
Nat Geog 173:544–7 (c,2) Ap '88
EGYPT, ANCIENT—HUMOR
—Taxation system in ancient Egypt
Smithsonian 19:122–7 (painting,c,1) Mr
'89
EGYPT, ANCIENT—MAPS
Nat Geog 173:543 (c,3) Ap '88
—Empire of Ramses II
Nat Geog 179:11 (c,1) Ap '91
EGYPT, ANCIENT—RELICS
Smithsonian 20:160 (c,4) F '90
—3500 B.C. Naqada vase
Nat Geog 173:536 (c,4) Ap '88
—14th cent. B.C. earthenware statues of
servants

Smithsonian 19:84 (c,4) Je '88
—Ancient Egyptian funeral boats
Nat Geog 173:522–47 (c,1) Ap '88
—Ancient Egyptian tombs (Saqqara)
Nat Geog 179:14–15 (c,1) Ap '91
—Ancient Egyptian wooden coffin mask
Smithsonian 21:109 (c,1) Ag '90
—Artifacts from King Tut's tomb
Nat Geog 173:540–1 (c,1) Ap '88
—Ramses II tomb sculptures (Abu Simbel)
Smithsonian 19:85 (painting,c,3) Je '88
Nat Geog 179:6–7, 9 (c,1) Ap '91
—Relief carving (Abu Simbel)
Nat Geog 178:123 (c,2) N '90
EGYPT, ANCIENT—RITES AND FES-
TIVALS
—Festival of Opet (Thebes)
Nat Geog 179:20–3 (painting,c,1) Ap '91
Egypt, ancient—sculpture. See
SCULPTURE—ANCIENT
SPHINX
EIDER DUCKS
Nat Wildlife 29:9 (c,4) Ap '91
Nat Geog 180:26–7 (c,1) Jl '91
—Audubon painting (1835)
Nat Wildlife 25:42–3 (c,1) O '87
EIFFEL, GUSTAVE
Trav&Leisure 19:147, 153 (4) Ap '89
EIFFEL TOWER, PARIS, FRANCE
Trav&Leisure 18:E1 (c,4) Mr '88 supp.
Trav&Leisure 19:cov. (c,1) F '89 supp.
Trav&Leisure 19:146–53, 188 (c,1) Ap
'89
Life 12:58–9 (c,1) Ap '89
Nat Geog 176:cov., 9–11, 160–1 (c,1) Jl
'89
Trav/Holiday 172:cov., 62 (c,1) Jl '89
—1911
Smithsonian 22:47 (painting,c,3) Ag '91
—Construction of tower (1889)
Life 12:59 (4) Ap '89
Am Heritage 40:22 (4) Jl '89 supp.
—Tower restaurant relocated to New Or-
leans, Louisiana
Trav&Leisure 18:NY8 (c,3) Mr '88
EINSTEIN, ALBERT
Life 13:25 (1) Fall '90
EISENHOWER, DWIGHT DAVID
Smithsonian 17:188 (c,4) Mr '87
Nat Geog 174:313 (4) S '88
Life 11:58 (4) S '88
Smithsonian 20:62 (4) O '89
Sports Illus 71:130 (4) N 6 '89
Trav/Holiday 173:67 (4) F '90
Am Heritage 41:30 (4) Ap '90
Life 13:118–19 (c,4) Je '90
Life 13:69 (4) Fall '90
Trav/Holiday 174:70–4 (1) O '90
Life 14:80 (4) Ag '91

Smithsonian 22:102 (4) S '91
Am Heritage 42:107 (4) D '91
—Mamie Eisenhower
Life 13:120 (4) Je '90
—Home (Abilene, Kansas)
Trav/Holiday 174:75–6 (c,3) O '90
—On covers of *Life* magazine
Life 13:118 (c,4) Je '90
EISENSTAEDT, ALFRED
Life 11:3 (4) Ag '88
Life 13:92–3 (3) S '90
—Photo of Martha's Vineyard, Massachusetts
Life 11:2–3 (c,1) Ag '88
—Photos by him
Life 13:2–3, 84–93 (1) S '90
EL MISTI VOLCANO, PERU
Nat Geog 171:442–3 (c,1) Ap '87
EL PASO, TEXAS
—Homes with no water supply
Life 10:152–6 (1) N '87
EL SALVADOR—COSTUME
—Three-year-old coal peddler
Life 12:28–9 (c,1) F '89
EL SALVADOR—POLITICS AND
GOVERNMENT
—Burying dead guerrilla
Life 12:94 (c,4) My '89
ELANDS
Trav/Holiday 171:68, 71 (c,1) Ap '89
ELECTIONS
—1814–1815 elections (Pennsylvania)
Am Heritage 38:cov., 146 (painting,c,1)
My '87
Am Heritage 40:73 (painting,c,1) N '89
—Mid 19th cent. Election Day scene (Midwest)
Smithsonian 20:43 (painting,c,3) Mr '90
—Haiti
Life 11:18–19 (c,1) Ja '88
Life 12:96 (c,3) Ja '89
—Putting vote in ballot box (South Korea)
Nat Geog 174:248–9 (c,2) Ag '88
—Putting votes in ballot box (1877)
Am Heritage 41:18 (drawing,4) Jl '90
—Romania
Life 14:124 (c,2) Ja '91
—See also
POLITICAL CAMPAIGNS
WOMEN'S SUFFRAGE MOVEMENT
ELECTRICITY
—1965 blackout (New York City, New
York)
Smithsonian 17:39 (c,2) F '87
—Bringing electricity to Soviet city Baku
(1920s)
Am Heritage 39:62 (3) D '88
—Lineman
Smithsonian 17:cov., 48 (c,1) F '87

—Los Angeles electrical utility system,
California
Smithsonian 17:cov., 40–9 (c,2) F '87
—Restoring power after blackout
Smithsonian 17:cov., 48 (c,1) F '87
—Superconductivity research
Life 10:38–41 (c,1) S '87
—U.S. electric energy sources
Nat Geog 180:60–89 (c,1) Ag '91
—Utility wires (California)
Nat Geog 180:60–1 (c,1) Ag '91
—See also
EDISON, THOMAS ALVA
LIGHTING
TESLA, NIKOLA
ELECTRONICS
—1950 transistor patent
Am Heritage 41:59 (drawing,4) S '90
—1950s dictaphones
Am Heritage 40:47 (3) F '89
—1980s consumer products
Life 12:49 (c,4) Fall '89
—Beeper system for finding lost mountain
climbers
Sports Illus 66:74 (c,4) Mr 2 '87
—Credit-card size translators
Trav&Leisure 20:61 (c,4) Mr '90
—Electronic surveillance of shoplifters
Life 11:32–8 (c,1) Ag '88
—Hand-held electronic Bible
Life 12:12 (c,4) D '89
—Inventors of the transistor (1948)
Am Heritage 38:60 (c,4) D '87
—Microchip wafer
Nat Geog 174:237 (c,4) Ag '88
—People overcome by technology
Smithsonian 22:64–75 (drawing,c,1) O
'91
—Satellite rescue network for crash victims
Smithsonian 17:136–46 (c,1) Mr '87
—Satellite videoconference
Smithsonian 19:76 (c,4) D '88
—Silicon micromotors
Smithsonian 21:84–96 (c,1) N '90
—Surveillance equipment
Life 10:12 (c,4) Ag '87
—TV sports viewing in the year 2001
Sports Illus 75:cov., 40–7 (c,1) Jl 22 '91
—See also
ANTENNAS
COMPUTERS
ELECTRICITY
LASERS
MICROPHONES
PHONOGRAPHS
RADAR
RADIOS
RECORDING STUDIOS
ROBOTS

Nat Wildlife 26:9 (c,4) D '87
Natur Hist 98:42–3 (c,1) Ag '89
ELLESMERE ISLAND, NORTHWEST
 TERRITORIES
Natur Hist 97:40 (c,4) Ja '88
Nat Geog 173:750–67 (map,c,1) Je '88
ELLINGTON, DUKE
Am Heritage 39:52 (1) D '88
ELLSWORTH, LINCOLN
Smithsonian 21:171–88 (2) O '90
ELLSWORTH, OLIVER
Life 10:51 (painting,c,4) Fall '87
ELM TREES
Am Heritage 38:10 (4) D '87
Nat Geog 179:104–5 (c,1) Mr '91
EMERALD INDUSTRY
—Colombia
Nat Geog 178:44–51 (c,1) Jl '90
—Zambia
Nat Geog 178:42–3, 60–1 (c,1) Jl '90
EMERALDS
Nat Geog 178:38–69 (c,1) Jl '90
EMERSON, RALPH WALDO
Am Heritage 38:107 (4) Jl '87
Emotions. See
 CRYING
 GRIEF
 KISSING
 ROMANCE
 SADNESS
 TERROR
EMPIRE STATE BUILDING, NEW
 YORK CITY, NEW YORK
Nat Geog 175:150–1 (2) F '89
Trav&Leisure 20:58 (drawing,c,4) My
 '90
—Construction (1931)
Nat Geog 175:151 (4) F '89
ENERGY
—Fermenting sugar cane for fuel (Brazil)
Nat Geog 171:376 (c,4) Mr '87
—Generating energy by burning garbage
 (Connecticut)
Nat Geog 180:82–3 (c,2) Ag '91
—Tapping magma inside earth (California)
Life 12:8 (c,3) N '89
—U.S. electric energy sources
Nat Geog 180:60–89 (c,1) Ag '91
—Uses of geothermal energy (Iceland)
Nat Geog 171:190–1 (c,1) F '87
—Wind turbines (California)
Nat Geog 171:48–9 (c,1) Ja '87
Natur Hist 99:92–3 (c,1) My '90
Nat Geog 180:80–1 (c,1) Ag '91
—See also
 ALASKA PIPELINE
 ELECTRICITY
 GAS, NATURAL
 GASOLINE STATIONS

NUCLEAR ENERGY
NUCLEAR POWER PLANTS
OIL INDUSTRY
POWER PLANTS
SOLAR ENERGY
WIND
WINDMILLS
ENERGY SHORTAGE
—1973 cartoon about empty gas tanker
Am Heritage 42:40 (2) Jl '91
—1976 cartoon about OPEC consuming
 American lifestyle
Am Heritage 42:112 (3) My '91
—Home energy conservation measures
Nat Wildlife 27:46–7 (painting,c,1) D '88
Nat Wildlife 27:18–23 (c,3) Je '89
ENGELS, FRIEDRICH
Trav&Leisure 17:94 (c,1) D '87
England. See
 GREAT BRITAIN
ENGLISH CHANNEL
—Construction of English Channel Tunnel
Trav&Leisure 19:54 (c,2) Je '89
Nat Geog 176:100–1 (map,c,4) Jl '89
Life 13:27–39 (1) N '90
ENTERTAINERS
—1930s radio stars
Smithsonian 17:70–8 (2) Mr '87
—Comedy club (Florida)
Trav/Holiday 167:56 (c,2) Mr '87
—Flea circus (West Germany)
Nat Geog 173:692–3 (c,1) My '88
—Lariat rope tricks (British Columbia)
Smithsonian 20:102–3 (c,1) Ap '89
—Modern performance artist
Trav/Holiday 173:20 (c,4) Ja '90
—Performance artist Rachel Rosenthal
Life 11:66–7 (c,1) S '88
—Performance in park (St. Lucia)
Trav/Holiday 171:59 (c,4) F '89
—Street performer (Boston, Massachu-
 setts)
Trav&Leisure 20:219 (c,3) Mr '90
—Street performers (San Diego, Cali-
 fornia)
Trav/Holiday 169:10 (c,4) Ja '88
—Ed Sullivan
Am Heritage 39:10 (4) My '88
—See also
 ACTORS
 ALLEN, FRED
 AMOS 'N ANDY
 BANDS
 BRICE, FANNY
 BURNS, GEORGE
 CAESAR, SID
 CHAPLIN, CHARLIE
 CIRCUS ACTS
 CLOWNS

CONCERTS
DANCERS
DURANTE, JIMMY
FIELDS, W. C.
JUGGLERS
KEATON, BUSTER
LAUREL AND HARDY
LEWIS, JERRY
LLOYD, HAROLD
MAGICIANS
MARX BROTHERS
MUSICIANS
OAKLEY, ANNIE
ROGERS, WILL
SINGERS
THEATER
ENVELOPES
—1850s illustrated envelopes
Am Heritage 39:66–7 (c,3) Mr '88
ENVIRONMENT
Smithsonian 21:entire issue (c,1) Ap '90
—1988 events affecting the planet
Life 12:8–18 (c,1) Ja '89
—Art depicting animals' environmental
problems
Nat Wildlife 29:32–6 (c,3) Je '91
—Cartoon about endangered wetlands
Nat Wildlife 26:38 (c,4) Je '88
—Earth Day 1970
Nat Wildlife 28:4 (c,4) F '90
—Effect of ozone hole on Antarctic wildlife
Natur Hist 97:72–80 (c,1) O '88
—Effects of Kuwait's burning oil fields
Nat Geog 180:cov., 2–33 (map,c,1) Ag
'91
—Environmental problems
Nat Wildlife 27:33–40 (painting,c,2) F
'89
Nat Wildlife 28:entire issue (c,1) F '90
—"Greenpeace" ship
Trav/Holiday 176:79 (c,4) O '91
—Signs of world warming
Nat Geog 178:66–99 (c,1) O '90
—U.S. trash disposal problem
Life 11:158–6 2(c,1) D '88
—See also
DEMONSTRATIONS
OIL SPILLS
OZONE
POLLUTION
list under NATURALISTS
ENVIRONMENTALISTS
—Activities of environmentalists
Nat Wildlife 26:30–7 (c,1) Je '88
Smithsonian 21:185–204 (c,1) Ap '90
—Anna Bostford Comstock
Nat Wildlife 26:51 (painting,c,1) O '88
—Environmental activists blocking logging
road

Sports Illus 74:57 (c,4) My 27 '91
—Lighthawk environmental flying service
Smithsonian 22:86–100 (c,1) N '91
—"Mark Trail" comics
Nat Wildlife 26:14–17 (c,4) F '88
—See also
CARSON, RACHEL
DE VOTO, BERNARD
MUIR, JOHN
list under NATURALISTS
EPHESUS, TURKEY
—Ancient ruins
Trav&Leisure 17:102–9 (c,1) Mr '87
EQUESTRIAN EVENTS
Sports Illus 69:88, 116 (c,4) S 14 '88
—1988 Olympics (Seoul)
Sports Illus 69:86–8 (c,2) O 3 '88
—Carolinas
Gourmet 51:84–7 (c,1) Ap '91
—Horsemen's Sunday (London, England)
Gourmet 51:32, 36 (painting,c,2) F '91
—Pan American Games 1991 (Havana,
Cuba)
Sports Illus 75:2–3 (c,1) Ag 19 '91
—Royal Windsor Horse Show, England
Gourmet 47:63 (c,4) Ap '87
ERIE CANAL, NEW YORK
Nat Geog 178:38–65 (map,c,1) N '90
—1838 scene at Lockport
Nat Geog 178:44 (engraving,4) N '90
ERMINE
Natur Hist 97:cov., 54–65 (c,1) Je '88
Natur Hist 97:4 (c,3) S '88
ESCALATORS
—1903 store escalator (Boston, Mas-
sachusetts)
Smithsonian 20:218 (4) N '89
—Baseball stadium
Sports Illus 67:34 (c,2) Jl 6 '87
—Man carrying large dog on escalator
Life 10:124 (2) O '87
—Subway station (Seoul, South Korea)
Life 10:25 (c,4) S '87
ESKIMOS (ALASKA)—COSTUME
—15th cent. costume and lifestyle (Barrow)
Nat Geog 171:824–36 (c,1) Je '87
—Modern dress
Life 10:17–18 (c,4) F '87
ESKIMOS (ALASKA)—HOUSING
—Stilt-supported Eskimo homes (1928)
Natur Hist 98:58 (4) Jl '89
ESKIMOS (ALASKA)—RELICS
Smithsonian 19:46–55 (c,1) O '88
—15th cent. artifacts
Nat Geog 171:828–36 (c,2) Je '87
—Late 19th cent. Eskimo mask
Natur Hist 98:74 (c,4) D '89
—1880 ivory drill bow
Nat Geog 174:506–7 (c,3) O '88

—Ancient Eskimo ivory walrus pup
 Natur Hist 96:36 (c,4) O '87
ESKIMOS (CANADA)
 Nat Geog 178:2–3, 15, 24–32 (c,1) Ag '90
—Traveling by snowmobile
 Nat Geog 172:198–9 (c,1) Ag '87
ESKIMOS (CANADA)—ART
—Eskimo sculpture depicting violent
 crimes (Northwest Terr.)
 Natur Hist 99:cov., 32–41 (c,1) Ja '90
ESKIMOS (CANADA)—COSTUME
 Nat Geog 173:762–3 (c,3) Je '88
Eskimos (Canada)—Housing. See
 IGLOOS
ESKIMOS (CANADA)—SOCIAL LIFE
 AND CUSTOMS
—Eskimo sculpture depicting violent
 crimes (Northwest Terr.)
 Natur Hist 99:cov., 32–41 (c,1) Ja '90
ESKIMOS (GREENLAND)
—Hunting narwhals
 Life 12:140–5 (1) Mr '89
ESKIMOS (GREENLAND)—COS-
 TUME
—Late 19th cent.
 Nat Geog 174:398 (3) S '88
ESKIMOS (U.S.S.R.)
—Sea hunting
 Natur Hist 100:30–7 (c,1) Ja '91
Espionage. See
 SPIES
ESTONIA
 Nat Geog 178:3–37 (map,c,1) N '90
—Convent (Kohtla-Järve)
 Life 10:134–43 (c,1) N '87
—Kunda
 Nat Geog 178:29 (c,1) N '90
ESTONIA—COSTUME
 Nat Geog 178:3, 16, 19, 29–31 (c,2) N '90
ESTONIA—POLITICS AND GOVERN-
 MENT
—Anti Soviet demonstration
 Nat Geog 175:632–3 (c,1) My '89
ETHIOPIA
 Nat Geog 177:2–3, 16–17, 22–3 (c,1) My
 '90
 Nat Geog 179:80–1 (c,1) F '91
—Danakil Depression
 Nat Geog 177:22–3 (c,1) My '90
ETHIOPIA—COSTUME
—Shepherds
 Nat Geog 177:2–3 (c,1) My '90
—Starving people (1985)
 Life 12:24–5 (1) Fall '89
—Surma people
 Natur Hist 99:86 (c,4) N '90
 Nat Geog 179:76–99 (c,1) F '91
ETHIOPIA—RITES AND FESTIVALS
—Surma stick-fighting ritual

 Nat Geog 179:92–5 (c,1) F '91
ETRUSCAN CIVILIZATION
 Nat Geog 173:696–743 (map,c,1) Je '88
ETRUSCAN CIVILIZATION—ARCHI-
 TECTURE
—4th cent. B.C. Etruscan city gate
 (Volterra, Italy)
 Nat Geog 173:703 (c,4) Je '88
ETRUSCAN CIVILIZATION—ART
—Tomb paintings (Tarquinia, Italy)
 Nat Geog 173:696–7, 700–5, 722–3 (c,1)
 Je '88
ETRUSCAN CIVILIZATION—RELICS
 Nat Geog 173:696–745 (c,1) Je '88
—Gold jewelry
 Nat Geog 173:716–17 (c,4) Je '88
EUCALYPTUS TREES
 Trav&Leisure 17:92–3 (c,1) D '87
 Nat Geog 173:173 (c,4) F '88
 Natur Hist 99:40–1 (c,1) Ag '90
EUROPE
 Trav&Leisure 18:E1–E30 (c,4) Mr '88
 supp.
 Trav&Leisure 19:1–33 (c,4) Mr '89 supp.
 Trav&Leisure 20:E1–E26 (c,1) Mr '90
 supp.
 Trav&Leisure 21:1–18 (c,1) Mr '91 supp.
 Trav/Holiday 175:87–104 (c,1) Mr '91
—15th cent. life in Europe
 Smithsonian 22:28–41 (painting,c,2) D
 '91
—Baltic nations
 Nat Geog 178:cov., 3–37 (map,c,1) N '90
—Europe's great railroad stations
 Trav&Leisure 17:110–17 (c,1) S '87
—European national parks
 Natur Hist 99:54–70 (map,c,1) Je '90
—Political scenes in Eastern Europe
 Trav&Leisure 21:110–28 (map,c,1) Ja
 '91
—Pollution in Eastern Europe
 Nat Geog 179:36–69 (map,c,1) Je '91
—See also
 ALPS
 BALTIC SEA
 DANUBE RIVER
 LAKE CONSTANCE
 individual countries
Europe—History. See
 CRUSADES
 MIDDLE AGES
 WORLD WAR I
 WORLD WAR II
EUROPE—MAPS
—Eastern Europe
 Nat Geog 177:120–3 (c,1) Ap '90
EVANS, WALKER
—Photo of Alabama general store (1936)
 Life 11:41 (4) Fall '88

EVARTS, WILLIAM
 Smithsonian 21:142 (4) Je '90
EVERGLADES NATIONAL PARK,
 FLORIDA
 Trav&Leisure 19:148–53, 188 (map,c,1)
 D '89
 Nat Geog 178:108–13 (c,1) Jl '90
 Trav&Leisure 174:60–1 (c,1) Jl '90
 Life 14:70–1, 76 (c,1) Summer '91
 Trav&Leisure 176:54–65 (c,1) D '91
EVERGREEN TREES
 Natur Hist 96:46–7 (c,1) S '87
EVOLUTION
—Chart of species extinction
 Nat Geog 175:666–71 (c,4) Je '89
—Evolution of arthropods
 Natur Hist 97:14–25 (c,4) Ap '88
—Evolution of the horse
 Natur Hist 96:18–22 (drawing,3) Ap '87
—Evolutionary path of whales
 Nat Geog 174:883–5 (painting,c,1) D '88
—William Patten's 1925 evolution chart
 Natur Hist 97:19 (3) My '88
—Stages of elephant evolution
 Nat Geog 179:21–3 (painting,c,1) My '91
—See also
 MAN, PREHISTORIC
EXERCISE EQUIPMENT
 Sports Illus 67:50 (c,4) D 14 '87
—1910 Zander equipment (Virginia)
 Sports Illus 68:88 (c,4) Je 13 '88
—Aboard cruise ship
 Trav/Holiday 168:99 (c,4) O '87
—Cybex machine
 Sports Illus 69:44 (c,4) Jl 11 '88
—Exercise bicycle
 Sports Illus 68:254 (c,4) Ja 27 '88
—Hydraulic fitness machine
 Sports Illus 68:138 (c,4) F 15 '88
—Indoor rowing championships
 Sports Illus 66:108–10 (c,4) Ap 20 '87
—Rowing machine
 Life 10:61 (c,2) Mr '87
—Stair climber
 Sports Illus 75:28–9 (c,1) S 2 '91
—Strengthening arms
 Sports Illus 67:28–9 (c,1) Ag 24 '87
EXERCISING
—Early 20th cent. factory workers ex-
 ercising (Ohio)
 Smithsonian 20:160, 162 (4) Je '89
—American fitness activities
 Life 10:22–73 (c,1) F '87
—"Jazzercise" class (California)
 Nat Geog 176:190–1 (c,1) Ag '89
—Lana Turner on rowing machine
 Life 10:65 (4) F '87
—See also
 AEROBIC DANCING

CALISTHENICS
EXPLORATION
 Nat Geog 174:entire issue (map,c,1) N
 '88
—14th cent. travels of Ibn Battuta (Middle
 East)
 Nat Geog 180:2–49 (map,c,1) D '91
—1519–1521 world voyage of Magellan
 Smithsonian 22:84–95 (map,c,3) Ap '91
—1922 Andrews Mongolia expedition
 Smithsonian 18:94–105 (1) D '87
—See also
 AMERICA—DISCOVERY AND EX-
 PLORATION
 ANTARCTIC EXPEDITIONS
 ARCTIC EXPEDITIONS
EXPLORERS
—Late 19th cent. explorers
 Nat Geog 173:14–15 (c,1) Ja '88
—Alexandra David-Neel
 Trav&Leisure 18:222 (painting,c,2) N
 '88
—Monument to the Discoverers (Lisbon,
 Portugal)
 Trav&Leisure 19:103 (c,2) S '89
—See also
 AMUNDSEN, ROALD
 BALBOA, VASCO NÚÑEZ DE
 BURTON, SIR RICHARD FRANCIS
 BYRD, RICHARD E.
 CHAMPLAIN, SAMUEL DE
 COLUMBUS, CHRISTOPHER
 COOK, JAMES
 CORONADO, FRANCISCO
 VASQUEZ DE
 COUSTEAU, JACQUES-YVES
 DE SOTO, HERNANDO
 DRAKE, SIR FRANCIS
 ELLSWORTH, LINCOLN
 HALLIBURTON, RICHARD
 HENSON, MATTHEW
 LA SALLE, SIEUR DE
 MACKENZIE, ALEXANDER
 MAGELLAN, FERDINAND
 PEARY, ROBERT E.
 POLO, MARCO
 STANLEY AND LIVINGSTONE
 VESPUCCI, AMERIGO
EXPLOSIONS
—Car bomb explosion
 Life 12:130–1 (c,1) Mr '89
—Demolition of missile silo (Arkansas)
 Life 10:28–9 (c,1) N '87
—World War I phosphorus bomb ex-
 ploding
 Am Heritage 41:79 (4) My '90
EYEGLASSES
—1787
 Life 10:29 (c,4) Fall '87

—1940s baseball player's sunglasses
Sports Illus 70:104 (c,4) Je 12 '89
—Basketball fans with black-frame glasses
Sports Illus 72:78–81 (c,2) Mr 19 '90
—Futuristic liquid screen glasses
Life 12:cov. (c,1) F '89
—Sunglasses
Trav&Leisure 19:45 (c,3) Jl '89
Trav/Holiday 173:81 (c,3) Je '90
—See also
GOGGLES
EYES
—Animals' eyes
Nat Wildlife 29:48–55 (c,1) O '91

—Checking boxer's eyes during fight
Sports Illus 72:2–3 (c,1) Ja 29 '90
—Chicken with red contact lenses
Life 11:17 (c,2) D '88
—Development of eyes in human embryo
Life 13:42 (c,2) Ag '90
—Fish eyes
Smithsonian 18:172–7 (c,1) N '87
—Octopus eye
Nat Geog 178:32 (c,4) O '90
—Retina
Life 12:78 (c,3) F '89
—See also
BLINDNESS

- F -

FABERGÉ, CARL
—Fabergé eggs
Life 12:2 (c,4) Ap '89
Trav&Leisure 19:66–7 (c,3) O '89
Nat Geog 177:82 (c,4) Ja '90
—Jade cannon (U.S.S.R.)
Nat Geog 172:306–7 (c,1) S '87
FACTORIES
Nat Wildlife 25:8–9 (painting,c,2) F '87
Smithsonian 21:48, 55 (c,4) Ap '90
—1930s auto plant (Michigan)
Am Heritage 38:86–9 (painting,c,1) N '87
—Brick factory (China)
Nat Geog 175:290 (c,1) Mr '89
—Chemical plant (New Jersey)
Natur Hist 99:50–1 (c,3) My '90
—Nickel smelter (Ontario)
Nat Geog 177:120 (c,4) F '90
—Soda ash (California)
Nat Geog 171:70 (c,3) Ja '87
—Steel plant (Michigan)
Nat Geog 172:22–3 (c,1) Jl '87
—Steel plant (Ontario)
Nat Geog 172:24 (c,3) Jl '87
—Steel plant (Yugoslavia)
Nat Geog 178:118–19 (c,1) Ag '90
—See also
CHIMNEYS
MANUFACTURING
MILLS
POWER PLANTS
SAWMILLS
FACTORY WORKERS
—Early 20th cent. (Ohio)
Smithsonian 20:154–62 (4) Je '89
—Early 20th cent. child laborers (New England)
Am Heritage 39:49 (4) Mr '88

Life 14:28–9 (1) Fall '91
—1930s auto workers (U.S.S.R.)
Am Heritage 39:60 (4) D '88
—At lunch (Germany)
Nat Geog 180:29 (c,2) S '91
—Automobile plant (Ukraine, U.S.S.R.)
Life 11:124–7 (1) My '88
—Fish cannery (U.S.S.R.)
Nat Geog 178:14–15 (c,1) Jl '90
—Fish processing plant (Iceland)
Nat Geog 171:210–11 (c,1) F '87
—Nuclear workers in radiation detector (Chernobyl, U.S.S.R.)
Nat Geog 175:416 (c,3) Ap '89
—Romania
Nat Geog 179:66 (c,1) Je '91
—Steel factory (Ukraine, U.S.S.R.)
Life 11:2–3, 120–3 (1) My '88
—Steel worker (South Africa)
Nat Geog 174:556–7 (c,1) O '88
—Steel mill (Pennsylvania)
Nat Geog 180:136–7 (c,1) D '91
—Steel workers (Poland)
Nat Geog 173:109 (c,1) Ja '88
—Vietnam
Smithsonian 18:66 (c,3) Ap '87
FADS
—1968 Peace button
Sports Illus 71:106 (c,4) N 15 '89
—1980s fads
Life 12:49, 63–6 (c,4) Fall '89
—1986 fads
Life 10:104–14 (c,1) Ja '87
—1987 fads
Life 11:132–3 (c,1) Ja '88
—1990 fads
Life 14:93–6 (c,2) Ja '91
—"Dirty dancing" fad
Life 11:132–3 (c,1) Ja '88

—Harvard student swallowing goldfish
(1939)
Am Heritage 40:33 (4) Mr '89
—Man streaking (1974)
Trav&Leisure 21:31 (4) O '91
—Quartz crystals
Smithsonian 19:82–101 (c,1) N '88
—Rubik's Cube
Life 12:63 (c,4) Fall '89
—Yellow "On Board" car window signs
Life 10:104–5 (c,1) Ja '87
FAIRBANKS, DOUGLAS
Life 12:59–60 (4) Spring '89
—Pickfair home, California
Life 12:59–60 (4) Spring '89
FAIRBANKS, ALASKA
Nat Wildlife 29:4–5 (c,1) D '90
FAIRS
—1893 Columbian Exposition, Chicago, Il-
linois
Am Heritage 38:36 (painting, c,2) N '87
Am Heritage 39:79 (painting, c,1) D '88
—1900 International Exhibition, Paris,
France
Nat Geog 176:160–1 (1) Jl '89
—1904 St. Louis World's Fair program
Am Heritage 39:114 (c,4) My '88
—1939 Golden Gate Int'l Expo, San Fran-
cisco, California
Am Heritage 40:42–53, 122 (c,1) My '89
—1939 World's Fair (New York City, New
York)
Am Heritage 38:111 (4) F '87
Am Heritage 40:116 (4) My '89
—County fair
Trav/Holiday 174:85 (painting, c,4) Jl '90
—Gondola ride at Ohio State Fair
Sports Illus 67:43 (c,2) S 7 '87
—Iowa State Fair
Trav&Leisure 20:E8–10 (c,3) Jl '90
—Open-air art fair (Moscow, U.S.S.R.)
Smithsonian 20:130–1 (c,1) D '89
—People falling from elevated canal ride
(Japan)
Life 13:6–7 (c,1) Je '90
—School science fair projects
Smithsonian 21:62–73 (c,1) S '90
—Sporting goods trade show
Sports Illus 70:36–40 (c,4) F 20 '89
—Test of muscle strength
Life 10:62 (3) N '87
FAISAL I (IRAQ)
Smithsonian 22:148 (4) My '91
FALCONS
Smithsonian 19:148 (painting,c,4) My '88
Life 14:38 (c,3) Summer '91
—Gyrfalcons
Smithsonian 17:137 (painting,c,4) Ja '87
Natur Hist 97:32 (lithograph,c,1) Mr '88

Natur Hist 98:38–9, 42–3 (c,1) Je '89
—Male falcon copulating with hat
Smithsonian 21:92 (c,4) Ap '90
—Peregrine
Natur Hist 97:33 (woodcut,4) Mr '88
Trav/Holiday 170:cov. (c,1) Ag '88
Nat Geog 174:841 (c,4) D '88
Nat Wildlife 27:10–13 (c,1) Je '89
Smithsonian 21:89–96 (c,2) Ap '90
Nat Geog 179:106–15 (map,c,1) Ap '91
—Peregrine chicks
Life 12:68 (c,4) Ap '89
Smithsonian 21:94, 96 (c,4) Ap '90
Nat Geog 179:109–11 (c,1) Ap '91
—Prairie
Nat Geog 174:840 (c,3) D '88
—See also
HAWKS
FALKLAND ISLANDS
Nat Geog 173:390–422 (map,c,1) Mr '88
Natur Hist 98:32–3 (c,1) Jl '89
FAMILIES
Sports Illus 69:70–1 (c,2) Jl 11 '88
—Family hugging at reunion (Indiana)
Life 13:58–9, 64 (c,1) S '90
—Locating abducted child
Life 14:34–43 (2) Je '91
—Parents with infant
Sports Illus 68:62 (c,3) My 16 '88
Life 12:60–1 (c,1) Je '89
Sports Illus 72:36–7 (c,2) Ja 8 '90
Life 14:cov., 36–7 (c,1) Ap '91
—Seven generations of one family together
Life 12:90–1 (c,1) Ap '89
FAMILY LIFE
—1888 living room scene (Mississippi)
Am Heritage 40:106–7 (1) D '89
—1940 family in loving room (Illinois)
Am Heritage 40:17 (3) N '89 supp.
—Battered abused women
Life 11:120–31 (1) O '88
—Caring for sick child (Massachusetts)
Life 14:58–67 (1) Ag '91
—Departing soldier hugging child (Vir-
ginia)
Life 14:21 (c,2) Mr '91
—Family bicycling
Sports Illus 74:59 (c,2) My 20 '91
—Family in park (France)
Life 13:83 (c,4) Jl '90
—Family living room activities (Illinois)
Nat Geog 175:185 (c,2) F '89
—Family reunion meal (Yugoslavia)
Gourmet 50:52 (painting,c,2) Ap '90
—Family walking dog
Sports Illus 68:40 (c,4) Ja 25 '88
—Fathers with babies
Sports Illus 68:74 (c,3) Ap 25 '88
Sports Illus 70:66 (c,4) Ap 5 '89

—Fathers with children
 Life 11:29–30 (4) Je '88
 Nat Geog 179:70–1 (c,1) My '91
—Father and son roughhousing outdoors
 (New York)
 Life 11:74–5 (c,1) F '88
—"International" family living on farm
 (Oregon)
 Life 14:76–87 (1) D '91
—Japan
 Nat Geog 177:68–73, 82–3 (c,1) Ap '90
—Life of working mother (Missouri)
 Life 12:100–8 (1) My '89
—Lifestyle of family with fourteen children
 (N.J.)
 Life 14:78–89 (1) My '91
—Mother hugging child
 Life 13:16 (c,3) F '90
 Life 13:34 (c,3) Ap '90
 Life 13:59 (1) Ag '90
—Mothers helping children with
 schoolwork (Japan)
 Smithsonian 17:44–53 (c,1) Mr '87
—North Carolina
 Nat Geog 174:938–41 (c,1) D '88
—Parents on bed with children
 Life 11:64–5 (c,1) Ap '88
 Life 12:104–5 (1) Fall '89
 Life 13:70 (c,1) F '90
—Parents pulling children on sled (Colo-
 rado)
 Life 12:72–3 (c,1) Ap '89
—Playing airplane with baby on legs
 Sports Illus 72:2–3 (c,1) My 14 '90
—Poor family (Ohio)
 Life 12:56–66 (1) S '89
—Teenagers with babies (New Mexico)
 Life 14:78–89 (1) Jl '91
—See also
 BABIES
 CHILDREN
 LIFESTYLES
FANS
—19th cent. theatrical fan (Japan)
 Smithsonian 19:70–1 (c,4) N '88
—Early 20th cent. bamboo fan (Korea)
 Natur Hist 97:72 (c,4) My '88
—Stadium ventilator
 Sports Illus 67:2–3 (c,1) O 26 '87
Fans, sports. See
 SPECTATORS
FARALLON ISLANDS, CALIFORNIA
—Southeast Farallon Island
 Natur Hist 97:6 (c,3) Je '88
FARGO, NORTH DAKOTA
—Aerial view
 Nat Geog 171:332 (c,1) Mr '87
FARM LIFE
—1939 (Indiana)

Life 12:117 (4) N '89
—Arkansas
 Sports Illus 71:112–18 (c,1) O 9 '89
—Feeding cows (Italy)
 Gourmet 47:74 (c,3) O '87
—"International" family living on farm
 (Oregon)
 Life 14:76–87 (1) D '91
—Lugging empty milk cans (Missouri;
 1971)
 Nat Geog 175:190–1 (1) F '89
—Milking cows
 Life 11:16–17 (c,1) Ja '88
 Nat Geog 175:60–1 (c,2) Ja '89
 Sports Illus 71:86 (c,4) Ag 21 '89
—Milking cows (Egypt)
 Natur Hist 96:28 (c,4) Jl '87
—Recreation of 19th cent. farm (Iowa)
 Trav/Holiday 171:96–9 (c,3) Mr '89
FARM MACHINERY
—1794 cotton gin patent by Eli Whitney
 Am Heritage 41:48 (4) S '90
—Manure spreader
 Smithsonian 21:117 (c,4) Ap '90
—Mowing large field (Pennsylvania)
 Life 13:112 (c,3) N '90
—Prehistoric bone sickle (Israel)
 Nat Geog 174:463 (c,4) O '88
—Wildflower vacuum seed retriever
 Nat Geog 173:498–9 (c,1) Ap '88
—See also
 McCORMICK, CYRUS
 TRACTORS
FARM WORKERS
—1798 slave women farming (Virginia)
 Nat Geog 172:354 (painting,c,4) S '87
 Smithsonian 18:84 (painting,c,4) S '87
—1930s (South)
 Smithsonian 18:80 (4) My '87
 Smithsonian 20:50 (3) Je '89
—California
 Nat Geog 179:50–67 (c,1) F '91
—China
 Trav&Leisure 18:106–7 (c,1) Ja '88
—Costa Rica
 Gourmet 50:111 (c,1) D '90
—Cuba
 Life 11:40–7 (1) Ag '88
—Egypt
 Trav&Leisure 19:147 (c,1) S '89
—France
 Trav&Leisure 20:100–1 (c,1) Ja '90
—Guatemala
 Nat Geog 176:430–1 (c,1) O '89
—Italy
 Trav/Holiday 172:67 (c,4) N '89
—Lifestyle of migrant farm worker family
 (Florida)
 Life 11:126–32 (1) D '88

Trav/Holiday 171:50–6 (c,1) Je '89
—Harvest celebration (Mexico)
Natur Hist 100:40–1 (2) S '91
—Huge heads for Mardi Gras floats (New Orleans, La.)
Life 13:2–3 (c,1) Mr '90
—Ice Lantern Festival (Harbin, China)
Nat Geog 173:308–9 (c,1) Mr '88
—Kentucky Derby festivities
Trav/Holiday 169:62–7 (c,1) Mr '88
—Louisiana rice festival
Gourmet 48:100 (painting,c,2) O '88
—Lumberjack World Championships
Sports Illus 67:2–3, 54–9 (c,1) Ag 10 '87
—Mardi Gras (Cologne, West Germany)
Trav/Holiday 172:45 (c,2) D '89
—Mardi Gras (Mamou, Louisiana)
Nat Geog 178:52–3 (c,1) O '90
—Mardi Gras Gilles (Binche, Belgium)
Trav/Holiday 172:44 (c,4) D '89
—Oktoberfest (Munich, Germany)
Nat Geog 180:8–9, 16–17 (c,1) S '91
—Palio (Siena, Italy)
Trav&Leisure 17:126–31 (c,1) Ap '87
Sports Illus 67:42–9 (c,1) Ag 10 '87
—Pooram festival (Trichur, India)
Nat Geog 173:602–3 (c,1) My '88
—Riverfest (Cincinnati, Ohio)
Trav/Holiday 169:58–9 (c,2) My '88
—Song and Dance Festival (Estonia)
Nat Geog 178:30–1 (c,1) N '90
—Spring Nyepi festival (Bali, Indonesia)
Trav&Leisure 17:80 (c,3) Jl '87
—Statue of Liberty centennial celebration, New York
Life 10:8–9, 24, 47–50 (c,1) Ja '87
—Trappers' Festival (Manitoba)
Nat Geog 172:221 (c,2) Ag '87
—U.S. flag painted on face for Mardi Gras (Louisiana)
Nat Geog 173:44–5 (c,1) Ja '88
—Winter carnival (Sapporo, Japan)
Smithsonian 17:69 (c,1) Ja '87
—Winter carnival ice palaces
Smithsonian 17:62–9 (c,1) Ja '87
—Yukon Sourdough Rendezvous (Whitehorse)
Trav/Holiday 170:41–3 (c,3) D '88
—See also
BEAUTY CONTESTS
BIRTHDAY PARTIES
DANCES
FAIRS
FIREWORKS
HOLIDAYS
MARRIAGE RITES AND CUSTOMS
PARADES
PARTIES
RACES

RELIGIOUS RITES AND FESTIVALS
SPORTS
specific countries—RITES AND FESTIVALS
specific religions—RITES AND FESTIVALS
FEW, WILLIAM
Life 10:58 (painting,c,4) Fall '87
FEZ, MOROCCO
Gourmet 50:76–8, 168 (c,1) S '90
FIELD, MARSHALL
Am Heritage 38:42 (4) N '87
FIELDS
—Arizona meadow
Natur Hist 96:88–9 (c,1) Mr '87
—Field of flowers (California)
Nat Geog 171:46–7 (c,1) Ja '87
—Newly mown field of grass (Italy)
Gourmet 50:102 (c,2) N '90
—Field of wildflowers (Italy)
Gourmet 48:51 (c,1) Je '88
—Great Basin meadows, Nevada
Natur Hist 97:60–1, 65 (c,1) O '88
—Sonoma, California
Trav&Leisure 18:156–7, 160 (c,1) D '88
—See also
CORNFIELDS
GRASSLANDS
WHEAT FIELDS
FIELDS, W. C.
Smithsonian 20:117 (3) Jl '89
FIG TREES
Nat Geog 180:102 (c,4) D '91
FIGHTING
—1595 diagram of lance attack and defense (Netherlands)
Smithsonian 18:130 (painting,c,4) Mr '88
—19th cent. hands of eye gouger
Am Heritage 39:55 (drawing,4) S '88
—1841 frontier brawl
Am Heritage 39:112 (woodcut,3) Jl '88
—Bull elephants sparring
Nat Geog 179:18–20, 34–5 (c,1) My '91
—Caribou bulls sparring
Smithsonian 22:107 (c,2) My '91
—Deer bucks fighting
Natur Hist 100:36–7 (c,2) O '91
—Rugby player being punched (Great Britain)
Sports Illus 71:98 (c,2) D 25 '89
—Street brawl victims
Sports Illus 69:28 (c,2) S 5 '88
—Surma stick-fighting ritual (Ethiopia)
Nat Geog 179:92–5 (c,1) F '91
FIGHTING FISH
Sports Illus 68:132 (c,3) F 15 '88
FIGUREHEADS
—German ship

Gourmet 50:104 (c,4) O '90
—Norwegian ship
Trav&Leisure 17:89 (c,4) O '87
—Texas ship
Trav&Leisure 18:248 (c,4) D '88
FIJI
Trav/Holiday 171:40–7 (map,c,1) Ja
'89
Trav&Leisure 21:104–13, 146, 158
(map,c,1) F '91
Gourmet 51:94–9, 148 (map,c,1) O '91
Trav/Holiday 176:22 (c,4) D '91
FIJI—COSTUME
Trav&Leisure 21:104–13 (c,1) F '91
—Dancers
Trav/Holiday 171:41, 45 (c,3) Ja '89
—Traditional Sulu sarong
Trav&Leisure 21:107 (c,1) F '91
FIJI—HOUSING
—Thatched huts
Trav/Holiday 171:116–17 (c,2) Ja '89
FILES
—Boxes of documents used in court
cases
Life 14:22–3 (c,1) Fall '91
FILING CABINETS
—Early 20th cent.
Smithsonian 21:91 (c,4) Je '90
FINCHES
Nat Geog 173:140–2 (c,1) Ja '88
Nat Wildlife 27:24–5 (c,1) D '88
Nat Wildlife 28:4–5 (c,1) Ag '90
Natur Hist 100:14, 16 (c,4) Ja '91
—See also
BULLFINCHES
BUNTINGS
CARDINALS
GOLDFINCHES
JUNCOS
FINLAND
—Langinkoski
Trav&Leisure 19:192–4 (c,3) Ap '89
—Turku
Trav&Leisure 17:158–60 (c,4) Je '87
—See also
ALAND ISLANDS
HELSINKI
FINLAND—SOCIAL LIFE AND CUS-
TOMS
—Pesäpallo game
Sports Illus 75:10–11 (c,3) Jl 15 '91
FIR TREES
—Balsam fir trees killed by acid rain
Nat Wildlife 28:34–5 (c,1) F '90
FIRE FIGHTERS
—19th cent. fireman's coat (Japan)
Smithsonian 17:115 (c,4) Mr '87
—New Jersey
Life 10:121 (c,2) Fall '87

FIRE FIGHTING
—At Yellowstone National Park, Wy-
oming
Nat Geog 175:262–3 (c,1) F '89
—Australia farmhouse
Natur Hist 100:82 (painting,4) Ap '91
—House on fire (Virginia)
Life 11:12–13 (c,1) Fall '88
—Kuwait
Nat Geog 180:cov., 17, 30–1 (c,2) Ag '91
—Ohio
Life 13:17 (c,2) D '90
—Rescuing man from burning building
(New York)
Life 14:14 (1) Jl '91
—Training (Ohio)
Smithsonian 19:133–4 (3) My '88
FIRE HYDRANTS
—1918 (Massachusetts)
Smithsonian 19:145 (3) Ja '89
FIREFLIES
—Tobacco plant growing with firefly gene
Smithsonian 18:126 (c,4) Ag '87
FIREHOUSES
—Amador City, California
Gourmet 48:78 (c,4) N '88
—Mississippi
Trav&Leisure 21:88–9 (c,1) Ag '91
FIREPLACES
Trav/Holiday 174:94 (painting,c,4) N '90
—1683 home (Massachusetts)
Am Heritage 42:135 (c,4) N '91
—Four-sided fireplace (Kentucky)
Natur Hist 96:50–1 (c,1) Jl '87
—Lincoln's home (Springfield, Illinois)
Trav/Holiday 167:49 (c,2) F '87
—Resort lodge
Gourmet 50:216 (drawing,4) D '90
Trav&Leisure 20:148–9 (c,1) D '90
FIRES
—1853 fire on gunpowder ship (San Fran-
cisco, California)
Am Heritage 41:86–7 (painting,c,1) D
'90
—1865 fire at the Smithsonian, Wash-
ington, D.C.
Smithsonian 18:24 (drawing,4) D '87
—1937 crash of the Hindenburg (New Jer-
sey)
Life 11:67 (3) N '88
—1944 fire at circus (Hartford, Con-
necticut)
Life 14:56–7, 64 (1) N '91
—1965 Watts riots, Los Angeles, California
Life 11:22–3 (c,1) Spring '88
—1989 fires caused by earthquake (San
Francisco, Calif.)
Nat Geog 177:84–5 (c,1) My '90
—Bicycling through fire (Australia)

Life 12:102–3 (c,1) Jl '89
—Bonfire at festival (Iceland)
Nat Geog 171:202–3 (c,2) F '87
—Burning illegally-obtained elephant
tusks (Kenya)
Life 12:2–3 (c,1) S '89
—Burning the American flag (South Ko-
rea)
Sports Illus 69:45 (c,4) S 26 '88
—Christmas levee bonfires (Louisiana)
Smithsonian 20:146–51 (c,1) D '89
—Dani tribesmen starting grass fire (Indo-
nesia)
Nat Geog 175:122 (c,4) Ja '89
—Everglades National Park, Florida
Nat Geog 178:112–13 (c,2) Jl '90
—Fiery crash at Indianapolis 500 (1964)
Am Heritage 40:39 (4) My '89
—Fire-resistant suits
Nat Geog 173:564–5 (c,1) My '88
Nat Geog 176:773 (c,4) D '89
—Fire-vaulting on Good Friday (Gua-
temala)
Life 13:52 (c,3) D '90
—Forest fires
Life 11:110 (c,4) Ja '88
Natur Hist 97:66–7 (c,1) My '88
Natur Hist 98:50 (c,2) Ja '89
—Grass fire (Botswana)
Natur Hist 99:6 (c,3) Ap '90
Nat Geog 178:44 (c,1) D '90
—IRA firebombing British vehicle (1981)
Life 12:96–7 (c,1) My '89
—Laser beams piercing flame
Smithsonian 18:70–7 (c,1) O '87
—Office building fire (Los Angeles, Cali-
fornia)
Life 11:7 (c,2) Jl '88
Nat Geog 175:152 (c,1) F '89
—Oil tanker on fire (Italy)
Life 14:10–11 (c,1) Jl '91
—Pleasure boats on fire
Sports Illus 67:2–3 (c,1) S 28 '87
Life 10:140 (c,2) D '87
—Post-fire forest growth and wildlife
Nat Wildlife 27:36–7 (painting,c,1) Ag
'89
—Rain forest burning down (Honduras)
Nat Geog 176:438–9 (c,1) O '89
—Rain forest fires (Brazil)
Smithsonian 19:107 (c,3) Ap '88
Life 13:8–9 (c,1) Jl '90
—Research on the composition of fire
Smithsonian 18:70–9 (c,1) O '87
—Ruins of Ceausescu's palace, Romania
Life 13:6–7 (c,1) F '90
—Tanker on fire (Mideast)
Nat Geog 173:649–50 (c,1) My '88
—Tire junkyard on fire (Colorado)

Life 11:13 (c,3) Jl '88
—Woman hit by firebomb (South Korea)
Life 12:98 (c,1) Ja '89
—Yellowstone National Park, Wyoming
Life 11:208–12 (c,1) N '88
Life 12:10–11 (c,1) Ja '89
Natur Hist 98:52–5 (c,1) Ja '89
Nat Geog 175:cov., 252–73 (c,1) F '89
Trav&Leisure 19:125 (c,4) Mr '89
Natur Hist 98:34–51 (c,1) Ag '89
Smithsonian 20:36 (c,3) S '89
Life 12:30–1 (c,1) Fall '89
—See also
CAMPFIRES
FIRE FIGHTING
SMOKE
FIRES—DAMAGE
—1912 remains of ice warehouse (New Jer-
sey)
Nat Geog 171:93 (3) Ja '87
—Burned down home of family with AIDS
(Florida)
Life 11:78 (c,3) Ja '88
—Fire damage in London subway station,
England
Life 11:128 (c,4) Ja '88
—Grafting skin for child burn victim
(Georgia)
Nat Geog 180:80–1 (c,2) S '91
FIRETRUCKS
—Driving old firetruck
Smithsonian 20:60 (c,2) Mr '90
FIREWORKS
Trav/Holiday 169:11 (c,4) Ja '88
—18th cent. (Italy)
Smithsonian 21:59 (painting,c,2) S '90
—1990 New Year's freedom celebration at
Berlin Wall
Life 14:6–7 (c,1) Ja '91
—At baseball stadium
Nat Geog 179:78–9 (c,1) Mr '91
Nat Geog 179:62–3 (c,1) Ap '91
—Australian bicentennial
Trav&Leisure 17:cov. (c,1) O '87 supp.
Life 12:29 (c,4) Ja '89
—Calgary, Alberta
Sports Illus 68:82–3 (c,1) F 29 '88
Sports Illus 68:2–3 (c,1) Mr 7 '88
—Celebrating bicentennial of French Rev-
olution
Nat Geog 176:cov. (c,1) Jl '89
Trav/Holiday 172:cov. (c,1) Jl '89
—Gulf War victory celebration (Washing-
ton, D.C.)
Life 14:78–9 (c,1) Ag '91
—Lunar New Year festival (Hong Kong)
Nat Geog 179:100–2 (c,1) F '91
—Moscow, U.S.S.R.
Life 11:80–1 (c,1) Ja '88

—Philadelphia, Pennsylvania
 Am Heritage 38:79 (c,4) My '87
—Riverfest (Cincinnati, Ohio)
 Trav/Holiday 169:58–9 (c,2) My '88
—Statue of Liberty centennial celebration
 (1986)
 Life 10:8–9, 47 (c,1) Ja '87
 Trav/Holiday 19:139 (c,4) Ag '89
 Life 12:184 (c,1) Fall '89
FISH
—Anglerfish
 Nat Wildlife 26:36–7 (c,1) D '87
—Anthiases
 Nat Geog 173:438–9 (c,1) Ap '88
 Nat Geog 178:23 (c,2) O '90
—Black drum
 Natur Hist 99:62–3 (painting,c,1) F '90
—Blenny
 Nat Geog 174:714 (c,4) N '88
 Nat Geog 176:513 (c,4) O '89
 Sports Illus 72:144 (c,3) F 12 '90
 Nat Wildlife 29:2 (c,2) F '91
—Blue devil
 Nat Geog 171:316–17 (c,1) Mr '87
—Blue maomao
 Nat Geog 176:510–11 (c,1) O '89
—Bright colors of coral reef fish
 Smithsonian 21:98–103 (c,2) N '90
—Butterflyfish
 Natur Hist 96:60–1 (c,1) Jl '87
 Trav&Leisure 18:115 (c,4) O '88
 Smithsonian 21:103 (c,4) N '90
—Cardinal fish
 Nat Geog 178:22–3 (c,1) O '90
—Chimaera
 Nat Geog 178:12–13 (c,1) O '90
—Chromis
 Trav/Holiday 175:50–1 (c,1) My '91
—Cichlids
 Smithsonian 19:146–55 (c,1) D '88
 Smithsonian 20:98 (c,4) My '89
 Nat Geog 177:43–51 (c,1) My '90
—Clingfish
 Nat Geog 171:298–9 (c,1) Mr '87
—Clownfish
 Nat Wildlife 25:52–3 (c,1) F '87
 Trav/Holiday 167:cov. (c,1) F '87
 Nat Wildlife 25:22–5 (c,1) O '87
 Smithsonian 20:93 (c,4) My '89
 Natur Hist 98:cov., 44–7 (c,1) S '89
 Nat Wildlife 28:52–3 (c,1) D '89
 Nat Wildlife 29:60 (c,2) D '90
 Trav/Holiday 175:49, 54 (c,4) My '91
 Nat Geog 180:138 (c,4) O '91
—Damselfish
 Nat Geog 173:438–9 (c,1) Ap '88
 Trav/Holiday 172:76 (c,4) Jl '89
 Nat Geog 178:132 (c,4) Jl '90
 Nat Geog 180:126–7 (c,1) O '91

—Domino fish
 Nat Wildlife 28:52–3 (c,1) D '89
—Fish eggs
 Nat Wildlife 29:22–3 (c,1) F '91
—Fish eyes
 Smithsonian 18:172–7 (c,1) N '87
—Fossil fish
 Natur Hist 96:12 (c,3) Mr '87
 Natur Hist 97:20 (c,4) Ap '88
 Nat Geog 175:692 (c,2) Je '89
—Fossil perch consuming herring
 Natur Hist 97:84–5 (c,1) Jl '88
—Goby
 Nat Geog 173:446 (c,4) Ap '88
 Nat Geog 174:715 (c,2) N '88
 Natur Hist 99:46–8 (c,1) Ag '90
 Nat Geog 178:28 (c,4) O '90
 Nat Wildlife 29:44–5 (c,1) Je '91
—Hawkfish
 Nat Wildlife 20:cov. (c,1) Je '91
 Nat Geog 180:139 (c,4) O '91
—Jacks
 Natur Hist 96:88–9 (c,1) S '87
 Nat Geog 174:720–1 (c,1) N '88
 Smithsonian 21:93 (c,3) Jl '90
 Nat Geog 179:44–5 (c,1) Ja '91
—Lake fish
 Nat Geog 172:28–9 (drawing,c,2) Jl '87
—Life cycle of salmon
 Nat Geog 178:26–7 (painting,c,2) Jl '90
—Lionfish
 Nat Geog 172:641 (c,4) N '87
 Natur Hist 97:73 (painting,c,4) N '88
 Nat Geog 178:cov., 24–5 (c,1) O '90
—Lizard fish
 Nat Geog 173:455 (c,2) Ap '88
 Nat Geog 178:22, 30 (c,4) O '90
—Manta rays
 Nat Geog 179:44–5 (c,1) Ja '91
—Molamola
 Nat Geog 177:16 (c,1) F '90
—Morwong
 Nat Geog 171:316 (c,4) Mr '87
 Nat Geog 180:138 (c,4) O '91
—Painting of fish
 Nat Wildlife 26:45–51 (c,1) Ag '88
—Parrot fish
 Trav&Leisure 18:117 (c,4) O '88
 Natur Hist 97:52–3 (c,1) O '88
 Trav&Leisure 19:35 (c,3) S '89
 Smithsonian 21:102 (c,4) N '90
 Nat Wildlife 29:58 (painting,c,4) Ap '91
 Trav/Holiday 175:54 (painting,c,4) My
 '91
—Pigfish
 Nat Geog 176:526–7 (c,1) O '89
—Schools of fish
 Nat Wildlife 26:52–3 (c,1) D '87
 Smithsonian 21:88–93 (c,1) Jl '90

FISHING
Sports Illus 67:26–7 (c,1) Jl 6 '87
—1580s Indians fishing (North Carolina)
Nat Geog 172:491 (drawing,c,4) O '87
—1881 (Colorado)
Nat Geog 175:249 (3) F '89
—Boy at lake
Life 14:56–7 (1) Fall '91
—Boy displaying caught fish (Sudan)
Life 14:18 (c,2) My '91
—George Bush fishing
Life 12:20–1 (c,1) Ja '89
Trav/Holiday 173:66 (c,3) F '90
—Crabs (South Carolina)
Nat Geog 172:738–9 (c,1) D '87
—Displaying caught salmon (Michigan)
Trav&Leisure 18:147 (c,4) My '88
—FDR fishing (Georgia)
Trav/Holiday 173:66–7 (2) F '90
—Fishing camps (Alaska)
Natur Hist 97:54, 58–9 (c,1) My '88
—"Fly fishing only" sign (New Zealand)
Gourmet 47:54 (c,4) Ap '87
—From jetties (Texas)
Trav/Holiday 168:59 (c,4) D '87
—From pier (North Carolina)
Nat Geog 172:484–5 (c,1) O '87
—Halibut (Alaska)
Sports Illus 68:91, 95 (c,3) F 29 '88
—Idaho
Trav/Holiday 167:61 (c,4) My '87
—In Erie Canal, New York
Nat Geog 178:62 (c,3) N '90
—In New York Harbor
Sports Illus 75:7 (c,4) S 16 '91
—Indian fishing with dip net (Washington)
Nat Geog 176:810–11 (c,1) D '89
—Ireland
Trav/Holiday 175:35 (c,2) Je '91
—Louisiana
Sports Illus 67:56 (c,3) Ag 17 '87
—Maryland shore
Trav/Holiday 170:61 (c,1) Jl '88
—Massachusetts
Trav&Leisure 17:100–1 (c,2) My '87
—Mexico
Trav&Leisure 17:88 (c,4) S '87
—Netting tarpon (Florida)
Sports Illus 67:82 (c,4) S 14 '87
—New Jersey
Nat Wildlife 25:24 (c,4) Je '87
—Northwest Territories
Sports Illus 67:54–8 (c,2) Ag 24 '87
—Oysters (Southeast)
Nat Geog 172:759 (c,4) D '87
Smithsonian 18:66 (c,4) Ja '88
—Parisian boy preparing to fish (1918)
Life 11:14 (4) My '88
—Prehistoric salmon fishing camp (France)

Nat Geog 174:457 (painting,c,1) O '88
—Salmon (Washington)
Natur Hist 99:14–15 (c,3) S '90
—Salton Sea, California
Nat Geog 171:74–5 (c,1) Ja '87
—Saskatchewan
Trav/Holiday 168:22 (c,4) S '87
—Seine River, Paris, France
Trav/Holiday 175:66 (c,1) Ap '91
—South
Smithsonian 20:174 (c,4) S '89
—Spearfishing (Bahamas)
Trav&Leisure 17:77 (c,4) Ja '87
—Spearfishing (Cook Island)
Trav/Holiday 172:cov., 44–5 (c,1) S '89
—Tarpons (Costa Rica)
Sports Illus 71:78, 82–5 (c,2) Ag 14 '89
—Teaching fly fishing (Northeast)
Sports Illus 70:101–3 (c,2) My 22 '89
Trav&Leisure 19:E28 (c,4) D '89
—Thailand
Sports Illus 68:120 (c,4) F 15 '88
—Trout
Gourmet 47:57 (c,1) Ap '87
Nat Wildlife 25:54–5, 58–9 (painting,c,1)
Ap '87
Trav/Holiday 169:58–60 (c,1) F '88
—Two men in a canoe
Life 12:88 (c,4) F '89
—U.S.S.R.
Sports Illus 67:76–83 (c,1) O 26 '87
—Weighing caught fish (Alaska)
Trav/Holiday 172:64 (c,4) Ag '89
—Zaire
Natur Hist 100:56 (c,4) O '91
—See also
ICE FISHING
FISHING—HUMOR
Trav/Holiday 173:70–5 (painting,c,4) My
'90
FISHING BOATS
—Australia
Nat Geog 171:294, 309–11 (c,1) Mr '87
—Barbados
Trav&Leisure 18:136–7 (c,1) S '88
—Brazil
Trav/Holiday 168:62–3 (c,2) Jl '87
—Caballito (Peru)
Nat Geog 177:48–9 (c,1) Je '90
—Denmark
Nat Geog 175:622 (c,4) My '89
—Dory (Nova Scotia)
Trav&Leisure 17:106–7 (c,1) Je '87
—Fishermen using inner tubes (Cuba)
Nat Geog 180:98–9 (c,1) Ag '91
—Great Britain
Trav/Holiday 173:58 (c,3) Ap '90
—Iceland
Nat Geog 171:208–9 (c,1) F '87

—Indonesia
 Trav/Holiday 175:cov., 46 (c,1) Ap '91
—Italy
 Trav&Leisure 17:90–1 (c,1) Jl '87
—Lobster boats (Rhode Island)
 Gourmet 50:60 (c,4) Jl '90
—Martinique
 Trav/Holiday 170:54–5 (c,2) N '88
—Maryland
 Trav/Holiday 172:40–1 (c,1) Ag '89
 Trav&Leisure 21:E2 (c,4) Ap '91
—Mexico
 Trav&Leisure 17:86–7 (c,1) F '87
 Gourmet 48:81 (c,4) O '88
 Nat Geog 176:742–3 (c,2) D '89
—Netherlands
 Trav/Holiday 169:17 (4) Ja '88
—Oman
 Trav/Holiday 171:79 (c,3) Mr '89
—Oyster boats (Florida)
 Trav&Leisure 19:91 (c,3) My '89
—Shrimp boats (South)
 Trav&Leisure 18:132–3, 162 (c,2) Mr '88
 Smithsonian 20:44–6, 54–5 (c,1) D '89
 Nat Geog 178:54–5 (c,1) O '90
—Squid trawler
 Natur Hist 98:32 (c,4) Jl '89
—Tanzania
 Trav/Holiday 171:86 (c,3) Ja '89
—Thailand
 Nat Geog 177:116–17 (c,1) Ja '90
—Washington
 Am Heritage 39:81 (c,1) Ap '88
FISHING EQUIPMENT
—1780s fishing reel (New Jersey)
 Life 10:33 (c,4) Fall '87
—1859 Haskell minnow lure
 Sports Illus 69:6 (c,4) S 5 '88
—Bronze age weights and hooks
 Nat Geog 172:721 (c,4) D '87
—Crossbow (Thailand)
 Sports Illus 68:120 (c,4) F 15 '88
—Dangers of monofilament gill nets
 Sports Illus 68:46–8 (c,3) My 16 '88
—Fishing baskets (Botswana)
 Nat Geog 178:48 9 (c,2) D '90
—Fishing nets (Italy)
 Gourmet 50:48 (c,4) Jl '90
—Fishing nets (Spain)
 Life 12:70–1 (1) Je '89
 Gourmet 51:71 (c,4) Mr '91
—Fishing nets (Turkey)
 Nat Geog 176:346–7 (c,1) S '89
—Fishnets drying (Society Islands)
 Gourmet 49:63 (c,1) F '89
—Flies
 Gourmet 47:56 (c,4) Ap '87
—Lobster traps (France)
 Gourmet 47:55 (c,1) Ag '87

—Lobster traps (Maine)
 Trav/Holiday 171:53 (c,4) F '89
—Lures used in ice fishing
 Sports Illus 68:12–14 (c,4) F 15 '88
—Makah Indians (Washington)
 Nat Geog 180:48 (c,4) O '91
—Pacific region hooks and lures
 Smithsonian 18:110 (c,4) Jl '87
—Salmon flies
 Sports Illus 73:22 (c,4) D 17 '90
—Salmon gill net (Alaska)
 Natur Hist 97:52–3, 62–3 (c,1) My '88
FISHING INDUSTRY
—Abalone diver in shark cage (Australia)
 Nat Geog 171:290–1 (c,1) Mr '87
—Aquaculture (Thailand)
 Nat Geog 180:66–7 (c,1) N '91
—Belize
 Natur Hist 98:66–7 (c,4) O '89
—Bluefin tuna (Massachusetts)
 Life 11:58–9 (c,4) D '88
—Dangers of monofilament gill nets
 Sports Illus 68:46–8 (c,3) My 16 '88
—Fish cannery (U.S.S.R.)
 Nat Geog 177:78 (c,4) F '90
—Fish ponds (China)
 Nat Geog 175:306 (c,3) Mr '89
—Fish processing plant (Japan)
 Nat Geog 177:60 (c,4) Ap '90
—Fishermen with nets (Guatemala)
 Nat Geog 173:800–1 (c,1) Je '88
—Fulton Fish Market, New York City,
 New York
 Gourmet 49:36 (painting,c,2) Mr '89
—Green turtles (Nicaragua)
 Natur Hist 99:49 (c,2) N '90
—India
 Nat Geog 180:34–5 (c,1) D '91
—Malawi
 Smithsonian 19:154–5 (c,1) D '88
 Nat Geog 177:8–9 (c,1) My '90
—Monterey, California
 Nat Geog 177:9 (c,1) F '90
—Netting fish (India)
 Natur Hist 99:75 (c,2) My '90
—Preparing fish at docks (South Korea)
 Nat Geog 174:254–5 (c,1) Ag '88
—Salmon (Pacific Northwest)
 Natur Hist 97:52–63 (c,1) My '88
 Nat Geog 178:2–37 (c,1) Jl '90
—Shark fishing
 Life 14:24–5 (c,2) Ag '91
—Southeast
 Trav/Holiday 172:cov., 40–51 (c,1) Ag
 '89
 Smithsonian 20:44–55 (c,1) D '89
—Spain
 Life 12:70–6 (1) Je '89
—Sting rays (Mexico)

—Olympic flag
Sports Illus 66:39 (c,4) Je 8 '87
—Oman
Nat Geog 173:655 (drawing,c,4) My '88
—Palestinian flag
Life 11:34 (c,4) Mr '88
—Poland
Nat Geog 173:85 (drawing,c,4) Ja '88
Nat Geog 175:612 (drawing,c,4) My '89
Nat Geog 179:68–9 (c,1) My '91
—Qatar
Nat Geog 173:655 (drawing,c,4) My '88
—Quebec
Nat Geog 179:60–1 (c,1) Mr '91
—Released U.S. hostage holding U.S. flag
Life 10:18–19 (c,1) Ja '87
—Saudi Arabia
Nat Geog 173:655 (drawing,c,4) My '88
—Sewing U.S. flag
Life 12:96–7 (1) Fall '89
—South Korea
Nat Geog 174:242 (drawing,c,4) Ag '88
—Sweden
Nat Geog 175:612 (drawing,c,4) My '89
—Swiss cantons
Gourmet 51:64 (c,2) F '91
—Texas
Gourmet 47:66 (c,4) O '87
—Uganda
Nat Geog 173:474 (drawing,c,4) Ap '88
—United Arab Emirates
Nat Geog 173:655 (drawing,c,4) My '88
—U.S.S.R.
Sports Illus 69:22 (c,4) Ag 8 '88
Nat Geog 175:613 (drawing,c,4) My '89
Nat Geog 179:3–4 (c,1) F '91
—U.S.
Sports Illus 66:10–11 (c,1) F 16 '87
Am Heritage 38:44–5 (c,1) My '87
Smithsonian 18:24 (c,4) Ag '87
Life 11:116 (c,4) Spring '88
Gourmet 49:102 (c,3) O '89
—U.S. flag displayed on house (Pennsylvania)
Nat Geog 180:126–7 (c,1) D '91
—U.S. flag on Mount Rushmore, South Dakota
Life 10:91 (c,2) S '87
—U.S. flag painted on face for Mardi Gras (Louisiana)
Nat Geog 173:44–5 (c,1) Ja '88
—West Germany
Nat Geog 175:612 (drawing,c,4) My '89
—Yugoslavia
Sports Illus 72:43 (drawing,c,4) Mr 12 '90
FLAGSTAFF, ARIZONA
—Flintstones' store, Bedrock City
Smithsonian 19:112 (c,3) N '88

FLAMINGOS
Life 10:10–11 (c,1) Je '87
Nat Wildlife 25:51 (c,4) Ag '87
Natur Hist 96:104–5 (c,1) O '87
Sports Illus 68:40–1 (c,4) Ja 11 '88
—Aerial view of colony
Nat Wildlife 26:57–7 (c,1) Ap '88
Nat Geog 177:30–1 (c,1) My '90
—Flock in flight
Nat Geog 171:452 (c,1) Ap '87
Nat Geog 176:448–9 (c,1) O '89
FLEA MARKETS
—Antiques fairs (London, England)
Gourmet 49:66–9 (c,1) Je '89
—Berlin, West Germany
Trav&Leisure 17:96 (c,3) S '87
—Florence, Italy
Natur Hist 96:80 (4) Ja '87
—France
Natur Hist 98:87 (3) Ja '89
Trav&Leisure 21:52–6 (c,4) Mr '91
Gourmet 51:72 (c,4) Je '91
—Glasgow, Scotland
Trav/Holiday 174:42 (c,3) N '90
—Israel
Trav&Leisure 21:127 (c,4) Jl '91
—New York City, New York
Trav/Holiday 169:92 (c,4) My '88
—Yard sale
Gourmet 47:122 (drawing,c,2) N '87
FLEAS
Nat Geog 173:672–94 (c,1) My '88
—Flea circus (West Germany)
Nat Geog 173:692–3 (c,1) My '88
FLEMING, SIR ALEXANDER
Smithsonian 21:182, 187 (4) N '90
FLICKERS (BIRDS)
Nat Wildlife 25:48 (c,4) Ap '87
Nat Wildlife 26:8 (c,4) F '88
Nat Wildlife 26:32 (c,4) Ag '88
Nat Wildlife 27:58 (c,4) F '89
Life 14:82–3 (c,1) F '91
FLIES
Nat Geog 175:791 (c,4) Je '89
—Black flies
Natur Hist 97:34–9 (c,1) Je '88
—Flowerflies
Nat Geog 176:414–17 (c,1) S '89
—Fly larvae
Smithsonian 18:107 (c,4) Je '87
Nat Geog 176:414–15 (c,1) S '89
—Medflies
Smithsonian 18:112 (c,4) Je '87
Natur Hist 96:4 (c,4) Je '87
—On boy's nose (Africa)
Nat Geog 172:168–9 (c,2) Ag '87
—See also
FRUIT FLIES
HORSEFLIES

FLORIDA—MAPS
—Baseball spring training sites
Trav/Holiday 171:65 (c,4) F '89
FLORIDA KEYS, FLORIDA
Trav&Leisure 19:167–8 (map,c,4) Ja '89
Trav&Leisure 19:130–9, 182 (map,c,1) D
'89
Trav&Leisure 21:264 (c,3) O '91
—1909 railroad bridge
Am Heritage 42:26 (c,4) Ap '91
—Little Palm Island
Trav&Leisure 20:138–45, 203 (map,c,1)
N '90
FLOUNDER
Sports Illus 72:146 (c,3) F 12 '90
FLOWER INDUSTRY
—1890s seed catalog covers
Natur Hist 99:cov., 44–53 (painting,c,1)
Mr '90
—Flower field (Lisse, Netherlands)
Gourmet 50:74–5 (c,2) Ap '90
—Flower fields for the seed industry (Cali-
fornia)
Life 11:2–3, 46–9 (c,1) Ap '88
—Tulip farm (Washington)
Life 14:5 (c,2) My '91
—Wildflower seed harvesting (Texas)
Nat Geog 173:498–9 (c,1) Ap '88
FLOWERING PLANTS
Trav&Leisure 18:144–8 (painting,c,1)
Mr '88
Smithsonian 19:176 (c,4) F '89
Life 12:84–7 (c,2) Jl '89
—Alpine flowers
Nat Wildlife 25:46–51 (c,1) Je '87
Gourmet 48:cov., 50–5 (c,1) Je '88
—Australian plants
Nat Geog 173:172–3 (c,2) F '88
—Bellingrath Gardens, Alabama
Trav&Leisure 17:92–9 (c,1) F '87
—Bromeliads
Nat Wildlife 26:46–51 (c,2) Je '88
Nat Geog 175:550–1 (c,2) My '89
Smithsonian 21:104 (c,4) Jl '90
Natur Hist 100:76–7 (c,2) O '91
Endangered plants
Nat Geog 178:128–9 (c,4) Ag '90
—Field of flowers (California)
Nat Geog 171:46–7 (c,1) Ja '87
Life 11:2–3, 46–9 (c,1) Ap '88
Nat Wildlife 29:50–1 (c,1) D '90
—Field of wildflowers
Trav/Holiday 169:18 (c,4) Ja '88
Smithsonian 20:37 (c,2) S '89
Smithsonian 21:35 (c,2) S '90
—Firewheel
Nat Wildlife 25:52 (c,1) Ag '87
—French's shooting star
Natur Hist 96:61 (c,1) Ap '87

—Golden club
Natur Hist 99:63 (c,1) Jl '90
—Heliconia
Trav/Holiday 171:58 (c,4) F '89
Trav/Holiday 173:73 (c,4) Mr '90
Sports Illus 72:88 (c,4) Ap 9 '90
—Indian blankets
Smithsonian 18:39, 43 (c,2) Ap '87
—Plants endemic to Hawaii
Nat Geog 178:74–87 (c,1) Jl '90
—Prairie dock
Natur Hist 98:60–1 (c,1) Jl '89
—Scarlet gilia
Natur Hist 97:49–52 (c,1) Je '88
—Silversword plants
Nat Geog 178:84 (c,1) Jl '90
—State flowers
Smithsonian 18:210 (painting,c,4) F '88
—Wildflowers
Smithsonian 18:36–45 (c,1) Ap '87
Nat Wildlife 25:22–8 (c,1) Ap '87
Nat Geog 173:492–511 (c,1) Ap '88
Nat Wildlife 27:60 (c,1) Ap '89
Gourmet 49:108 (c,4) D '89
Nat Wildlife 28:cov., 52–9 (c,1) Ap '90
Smithsonian 21:156 (painting,c,4) D '90
Life 14:50–5 (c,1) Summer '91
—See also
ACACIAS
AMARANTHS
AMARYLLIS
ANEMONES
ASTERS
AZALEAS
BACHELOR'S BUTTONS
BAMBOO PLANTS
BEGONIAS
BIRDS-OF-PARADISE
BLACK-EYED SUSANS
BLADDERWORT PLANTS
BLOODROOT
BLUEBELLS
BLUEBONNETS
BOUGAINVILLEA
BUCKWHEAT
BUNCHBERRIES
CACTUS
CARDINAL FLOWERS
CHRYSANTHEMUMS
CLOVER
COLUMBINES
COREOPSIS
CROCUSES
DAFFODILS
DAISIES
DANDELIONS
ELEPHANT'S-EAR
FLOWER INDUSTRY
FLOWERS

FRUITS
HERBS
RESTAURANTS
SOYBEANS
FOOD INDUSTRY
—Late 19th cent. Coca-Cola ad and letter-
head
Nat Geog 175:34 (c,4) Ja '89
—1922 chocolate ad (France)
Life 12:53 (c,4) Je '89
—1937 Spam introductory advertisement
Life 10:9 (c,4) N '87
—Collecting swiftlet nests for bird's-nest
soup (Thailand)
Nat Geog 177:106–33 (map,c,1) Ja '90
—Santa Claus in 1906 cereal ad
Am Heritage 38:4 (c,3) D '87
FOOD MARKETS
—1890 (New York City, New York)
Natur Hist 100:69 (4) Ja '91
—1898 grocery store (Vermont)
Am Heritage 41:118–19 (1) N '90
—1934 grocery store (Texas)
Am Heritage 38:44–5, 47 (1) Jl '87
—Aerial view of outdoor market (Guada-
lajara, Mexico)
Trav/Holiday 171:55 (c,3) Je '89
—Barcelona, Spain
Trav/Holiday 169:59 (c,2) Je '88
Trav&Leisure 20:141, 148–51 (c,2) Je
'90
—Boston's North End, Massachusetts
Trav&Leisure 18:E2 (painting,c,4) Mr
'88
—Charcuterie (France)
Trav&Leisure 21:139 (c,1) Je '91
—China
Nat Geog 172:68–9 (c,1) Jl '87
—Cleveland market, Ohio
Trav/Holiday 176:74–5 (c,1) O '91
—Diary store (Italy)
Trav&Leisure 19:99 (c,2) Ja '89
—Delicatessens (Italy)
Trav/Holiday 172:63 (c,3) N '89
Trav&Leisure 19:83–8 (c,4) N '89
—Farmers market (British Columbia)
Trav/Holiday 170:64 (c,3) Ag '88
—Farmers market (New York City, New
York)
Trav&Leisure 21:145 (c,4) S '91
—Farmers market (Zagreb, Yugoslavia)
Nat Geog 178:101 (c,1) Ag '90
—Fish market (Seattle, Washington)
Natur Hist 96:88 (4) F '87
—Floating market (Bangkok, Thailand)
Trav&Leisure 19:180 (c,4) S '89
Trav/Holiday 172:52–3 (c,1) O '89
Gourmet 51:80 (c,3) Ja '91
Trav/Holiday 176:48–9, 55 (c,1) N '91

—Floating market (Zambezi River, Zim-
babwe)
Trav&Leisure 21:175 (c,3) O '91
—"Free" market (U.S.S.R.)
Life 14:78–9 (c,1) Je '91
—Fruit stand (Ecuador)
Natur Hist 96:88 (c,4) Ja '87
—Fruit stand (New York)
Natur Hist 97:36–7 (c,3) S '88
—Fruit store (Siena, Italy)
Gourmet 47:cov. (c,1) F '87
—Fulton Fish Market, New York City,
New York
Gourmet 49:36 (painting,c,2) Mr '89
—Garlic (India)
Gourmet 47:71 (c,1) S '87
—Istanbul, Turkey
Trav&Leisure 17:128–9, 185 (c,1) N '87
—Italian deli (New York)
Trav&Leisure 21:NY1 (c,3) Ap '91
—Kathmandu, Nepal
Nat Geog 172:34–5 (c,1) Jl '87
—Lithuania
Nat Geog 178:18–19 (c,2) N '90
—Live chicken market (Israel)
Natur Hist 99:106–7 (2) Ap '90
—London food shops, England
Trav&Leisure 21:80–3 (c,1) Jl '91
—Market stall (Burma)
Trav&Leisure 18:110 (c,4) S '88
—Morelos, Mexico
Trav/Holiday 174:51 (c,4) O '90
—New York City's Ninth Avenue shops
Gourmet 50:54 (painting,c,2) Je '90
—Outdoor (Bruges, Belgium)
Trav&Leisure 18:76–7 (c,1) Jl '88
—Outdoor (Gouda, Netherlands)
Trav/Holiday 168:51 (c,4) Ag '87
—Outdoor (Grenada, Windward Islands)
Gourmet 50:71 (c,3) Ja '90
—Outdoor (Ottawa, Ontario)
Trav/Holiday 169:61 (c,3) Ja '88
—Outdoor (Padua, Italy)
Gourmet 48:cov. (c,1) My '88
—Outdoor (Rome, Italy)
Trav&Leisure 18:159 (c,2) N '88
Trav/Holiday 176:68–9 (c,2) D '91
—Outdoor cheese market (Alkmaar, Neth-
erlands)
Trav/Holiday 168:52–3 (c,2) Ag '87
—Outdoor mushroom stand (U.S.S.R.)
Trav&Leisure 19:133 (c,3) F '89
—Pike Place Market, Seattle, Washington
Nat Geog 176:791 (c,1) D '89
Trav/Holiday 176:63 (c,3) N '91
—Produce markets (Italy)
Trav&Leisure 20:118–19 (c,1) Ap '90
Gourmet 50:68 (painting,c,2) Je '90
—Roadside stand (Germany)

Nat Geog 180:6–7 (c,1) S '91
—Sausage shop (Italy)
Natur Hist 99:78–9 (3) N '90
—Small town grocery store (Mississippi)
Nat Geog 175:332 (c,3) Mr '89
—Small town grocery store (Texas)
Life 12:102–3 (c,1) F '89
—Specialty food shop (New York City,
New York)
Trav&Leisure 21:E14 (c,4) Ja '91
—Spice merchant (Morocco)
Natur Hist 97:83 (c,4) O '88
—See also
BAKERIES
BUTCHERS
STREET VENDORS
SUPERMARKETS
FOOD PROCESSING
—Beef slaughterhouse exterior (Kansas)
Life 11:56 (c,2) N '88
—Cheese factory (1906)
Natur Hist 96:80 (4) Jl '87
—Chinese noodle factory (Hawaii)
Trav&Leisure 19:83 (c,4) Ja '89
—Drying corn on ground (Portugal)
Natur Hist 96:56–7 (c,1) F '87
—Filleting fish in factory (Iceland)
Nat Geog 171:210–11 (c,1) F '87
—Fish cannery (U.S.S.R.)
Nat Geog 177:78 (c,4) F '90
—Fish processing plant (Japan)
Nat Geog 177:60 (c,4) Ap '90
—Frozen food plant (Mexico)
Nat Geog 178:137 (c,4) D '90
—Kiwi fruit (New Zealand)
Nat Geog 171:682–8 (c,1) My '87
—Noodle making (Hong Kong)
Nat Geog 179:120–1 (c,1) F '91
—Pasta industry (Italy)
Smithsonian 22:84–95 (c,1) My '91
—Preparing fish for canning (Spain)
Life 12:76 (3) Je '89
—Pretzel bakery (Pennsylvania)
Trav/Holiday 171:60 (c,3) Je '89
—Shipping frozen lamb (New Zealand)
Nat Geog 171:662 (c,3) My '87
—Soybeans
Nat Geog 172:77, 82–7 (c,1) Jl '87
—Sugar mill (Florida)
Nat Geog 178:102–3 (c,1) Jl '90
—Tomatoes (California)
Gourmet 49:88 (c,4) S '89
Nat Geog 179:54–5 (c,1) F '91
—Tuna being frozen on fishing boat (Australia)
Nat Geog 171:309 (c,3) Mr '87
—See also
ARMOUR, PHILIP DANFORTH
FISHING INDUSTRY

individual food products listed under IN-
DUSTRIES
FOOTBALL
—1934 player kicking ball
Nat Geog 172:467 (2) O '87
—Gaelic football (Ireland)
Sports Illus 67:82 (painting,c,4) Ag 24
'87
FOOTBALL—COLLEGE
Sports Illus 67:entire issue (c,1) Ag 31
'87
Sports Illus 69:cov., 36–129 (c,1) S 5 '88
Sports Illus 69:32–50 (c,1) N 28 '88
Sports Illus 69:cov., 26–36 (c,1) D 5 '88
Sports Illus 71:38–139 (c,1) S 4 '89
Sports Illus 73:26–124 (c,1) S 3 '90
Sports Illus 75:cov., 2–3, 28–116 (c,1) Ag
26 '91
Sports Illus 75:cov., 2–3, 14–21 (c,1) S 23
'91
—1894 Yale team in flying wedge for-
mation
Am Heritage 39:104 (4) S '88
—Early 20th cent. history of college foot-
ball
Am Heritage 39:cov., 102–11 (c,1) S '88
—1913
Sports Illus 74:80–1 (2) Mr 18 '91
—1939
Sports Illus 67:112–20 (1) Ag 31 '87
—1940s
Sports Illus 69:78–9 (3) N 21 '88
—1950s
Sports Illus 73:26–7 (c,1) S 3 '90
Sports Illus 73:92–7 (3) N 12 '90
—1964
Sports Illus 69:12, 17 (4) N 28 '88
—Calling signals
Life 10:45 (c,4) N '87
—Cartoon about players' illegal activities
Sports Illus 70:2–3 (c,1) F 27 '89
—Celebrating touchdown
Sports Illus 70:18 (c,3) Ja 9 '89
—Citrus Bowl 1991 (Georgia Tech vs. Ne-
braska)
Sports Illus 74:2–3 (c,1) Ja 14 '91
—Coach giving pep talk to team
Sports Illus 67:2–3 (c,1) N 30 '87
Sports Illus 73:44–5 (c,1) S 3 '90
—Coaches
Sports Illus 69:26–7, 36 (c,1) D 5 '88
Sports Illus 75:34 (c,2) D 30 '91
—Coaches (1934)
Sports Illus 68:8 (4) Mr 21 '88
—College football festivities
Sports Illus 71:98–112 (c,2) O 23 '89
—College football played by deaf students
Sports Illus 75:104–15 (1) Ag 26 '91
—Cotton Bowl 1954 (Rice vs. Alabama)

Sports Illus 71:38 (4) N 15 '89
—Cotton Bowl 1960 (Syracuse vs. Texas)
Sports Illus 71:139 (2) S 4 '89
—Fiesta Bowl 1987 (Penn State vs. Miami)
Sports Illus 66:12–17 (c,1) Ja 12 '87
—Fiesta Bowl 1989 (North Dakota vs.
West Virginia)
Sports Illus 70:16–21 (c,1) Ja 9 '89
—Football players in prayer circle
Sports Illus 71:82–3 (c,1) N 13 '89
—Heisman Trophy winners (1974–87)
Life 11:108 (c,4) Spring '88
—Huddle
Life 10:43 (c,3) N '87
Sports Illus 69:26–7 (c,1) D 5 '88
—Illegal block
Sports Illus 74:32–3 (c,4) Ja 14 '91
—Intercepting pass
Sports Illus 71:24 (c,2) N 13 '89
Sports Illus 75:36 (c,2) O 7 '91
—Mascots
Sports Illus 67:2–3 (c,1) D 14 '87
Nat Wildlife 27:14–16 (drawing,4) F '89
Sports Illus 72:46–8 (drawing,c,1) My 7
'90
Nat Geog 177:53–4 (c,1) Je '90
Sports Illus 75:88–100 (c,1) O 28 '91
—Orange Bowl 1988 (Miami vs. Okla-
homa)
Sports Illus 68:cov., 16–21 (c,1) Ja 11 '88
—Orange Bowl 1990 (Notre Dame vs. Col-
orado)
Sports Illus 72:16–19 (c,1) Ja 8 '90
—Orange Bowl 1991 (Colorado vs. Notre
Dame)
Sports Illus 74:32–34 (c,4) Ja 14 '91
—Place-kicking
Sports Illus 68:20 (c,4) Ja 11 '88
—Punting (1939)
Sports Illus 67:115 (2) Ag 31 '87
—Receiving
Sports Illus 67:24–5 (c,1) O 19 '87
Sports Illus 69:98–9 (c,1) S 5 '88
—Recruitment process
Sports Illus 70:52–8 (c,1) F 20 '89
—Running
Sports Illus 69:60–9 (c,1) S 5 '88
Sports Illus 75:39 (c,2) O 7 '91
—Sugar Bowl 1988 (Syracuse vs. Auburn)
Sports Illus 68:22–3 (c,2) Ja 11 '88
—Sugar Bowl 1990 (Miami vs. Alabama)
Sports Illus 72:cov., 12–15 (c,1) Ja 8 '90
—Tackling
Sports Illus 67:30–2 (c,1) O 5 '87
Sports Illus 67:20–1 (c,1) N 16 '87
Sports Illus 69:2–3 (c,1) S 19 '88
Sports Illus 71:2–3 (c,1) O 2 '89
Sports Illus 75:2–3, 34–41, 95–7 (c,1) Ag
26 '91

Sports Illus 752–3 (c,1) S 16 '91
—Touchdown catch
Sports Illus 75:40–1 (c,1) O 7 '91
FOOTBALL—HIGH SCHOOL
Sports Illus 69:68–82 (c,1) O 31 '88
Life 12:82–92 (c,1) N '89
Sports Illus 73:82–96 (1) S 17 '90
FOOTBALL—PROFESSIONAL
Sports Illus 67:entire issue (c,1) S 9 '87
Sports Illus 69:36–50, 78–112 (c,1) Ag 29
'88
Sports Illus 71:cov., 2–3, 38–142 (c,1) S
11 '89
Sports Illus 73:50–138 (c,1) S 10 '90
Sports Illus 73:40–7 (c,1) D 3 '90
Sports Illus 73:24–9 (c,1) D 31 '90
Sports Illus 74:18–30 (c,1) Ja 28 '91
Sports Illus 75:cov., 2–3, 30–128 (c,1) S 2
'91
Sports Illus 75:cov., 2–3, 20–5 (c,1) O 7
'91
—1920s
Sports Illus 67:6 (4) S 9 '87
—1930s–1940s
Sports Illus 67:8 (4) Ag 17 '87
Sports Illus 71:130–1, 134–42 (4) S 11 '89
—1958
Sports Illus 66:42, 54 (2) Ja 26 '87
Life 12:102–3 (1) Mr '89
—1970s
Sports Illus 72:58–64 (c,1) Ja 22 '90
—Arena football
Sports Illus 67:22–4 (c,2) Jl 20 '87
Sports Illus 69:26–33 (c,2) Jl 11 '88
—Celebrating touchdown
Sports Illus 70:24–5 (c,2) Ja 9 '89
Sports Illus 75:96–101 (painting,c,1) S 2
'91
—Defeated player on bench
Sports Illus 68:2–3 (c,1) Ja 18 '88
—Downing player by pulling on shoelace
Life 13:12 (c,3) D '90
—Field goal
Sports Illus 66:26 (c,2) Ja 12 '87
Sports Illus 66:20 (c,3) Ja 19 '87
Sports Illus 68:60 (c,4) Ja 18 '88
—Football fans pulling down goalposts
Sports Illus 69:63 (c,3) N 28 '88
—Fumble
Sports Illus 66:48 (c,4) Ja 26 '87
Sports Illus 72:40–1 (c,2) Ja 15 '90
—Giving winning coach Gatorade shower
Sports Illus 66:2–3 (c,1) Ja 19 '87
Life 11:29 (c,4) Ja '88
—Intercepting pass
Sports Illus 67:35 (c,3) N 16 '87
Sports Illus 70:26 (c,3) Ja 9 '89
Sports Illus 75:30–1 (c,1) S 23 '91
—Lining up before calls

Am Heritage 40:10 (painting,c,4) Mr '89
—1916
Am Heritage 39:102 (2) S '88
—1920s
Sports Illus 67:6 (4) S 9 '87
Smithsonian 22:82–3, 86 (4) Ag '91
Sports Illus 75:6 (4) D 9 '91
—1961
Sports Illus 71:76–7 (1) N 15 '89
—Covered with mud
Sports Illus 71:109 (c,2) D 25 '89
—Taped hand of football player after game
Sports Illus 73:2–3 (c,1) D 3 '90
—See also
BROWN, JIM
GRANGE, RED
LOMBARDI, VINCE
ROCKNE, KNUTE
THORPE, JIM
TITTLE, Y. A.
FOOTBALL PLAYERS—HUMOR
Sports Illus 67:20–9 (painting,c,2) S 9
'87
FOOTBALL TEAMS
—1890s college teams
Am Heritage 38:112 (3) D '87
Sports Illus 71:101 (3) O 23 '89
—History of the Green Bay Packers
Smithsonian 22:80–9 (c,2) Ag '91
FOOTBALLS
—Football manufacturing (Ohio)
Sports Illus 73:9–12 (c,3) S 10 '90
FOOTWEAR
—1787 shoe
Life 10:28 (c,4) Fall '87
—Early 20th cent. baby shoes
Smithsonian 18:276 (c,4) N '87
—1934 football shoe
Nat Geog 172:467 (2) O '87
—1940s footwear taken from Auschwitz
victims (Poland)
Nat Geog 173:90 (c,1) Ja '88
—Ancient Anasazi Indians (Colorado)
Trav&Leisure 17:126 (c,4) My '87
—Ancient Etruscan wooden sandals (Italy)
Nat Geog 173:712 (c,4) Je '88
—Athletic footwear
Sports Illus 67:36–7 (c,1) N 18 '87
Sports Illus 72:76–87 (c,4) F 19 '90
—Beat-up sneaker
Sports Illus 72:74–5 (c,1) F 19 '90
—Cowboy boots
Am Heritage 38:34 (sculpture,c,1) D '87
Gourmet 48:56 (c,4) Ja '88
Trav&Leisure 18:243–6 (c,3) N '88
Smithsonian 20:68 (c,4) Ag '89
—Cowboy boots designed for Pope John
Paul II (Texas)
Life 10:8 (c,4) S '87

—Decorated cowboy boots sent to Eisen-
hower
Smithsonian 21:85 (c,4) D '90
—Delaware Indians moccasin
Smithsonian 20:50–1 (c,4) O '89
—Ruby slippers from "The Wizard of Oz"
(1939)
Life 12:6–7 (c,1) Spring '89
—Shoe collection of Imelda Marcos (Phil-
ippines)
Life 10:14–15 (c,1) Ja '87
—"Shoeless Joe" Jackson's shoes
Sports Illus 70:102 (c,4) Je 12 '89
—Shoeshine stand (Indiana)
Nat Geog 173:67 (c,3) Ja '88
—Sioux Indian beaded sneakers (South
Dakota)
Smithsonian 18:236 (c,4) O '87
—Wooden shoes (Netherlands)
Trav/Holiday 168:49 (c,4) Ag '87
Gourmet 49:78 (c,4) Ap '89
Natur Hist 98:69 (c,4) Ag '89
—See also
SHOEMAKING
SNOWSHOES
FOOTWEAR—HUMOR
—Athletic shoe trends
Smithsonian 20:94–104 (painting,c,1) S
'89
FORD, FORD MADOX
Smithsonian 20:138 (4) Mr '90
FORD, GERALD
Life 10:28–9 (c,2) O '87
Life 11:5 (c,4) Ja '88
Trav/Holiday 173:65 (4) F '90
Sports Illus 73:10 (4) O 15 '90
Smithsonian 21:86 (sculpture,c,4) D '90
—Would-be assassin Squeaky Fromme
Life 10:56 (4) Mr '87
FORD, HENRY
Nat Geog 172:79 (4) Jl '87
Smithsonian 20:115 (4) Jl '89
Life 13:113 (1) Fall '90
FORESTS
—Africa
Natur Hist 99:22 (painting,c,3) N '90
—Australia
Natur Hist 97:42 (c,3) Mr '88
—Austria
Trav/Holiday 175:29 (c,4) Ja '91
—Chile
Natur Hist 96:42–7 (c,1) S '87
—China
Life 13:75–7 (c,1) O '90
—Colorado
Natur Hist 96:14–16 (map,c,1) My '87
Natur Hist 98:34–7 (map,c,1) Ap '89
—Devastated by clear-cutting (Oregon)
Life 13:52–3 (c,1) My '90

—Steige
Gourmet 50:82 (c,3) Ap '90
—Vanoise National Park
Natur Hist 99:64–5 (c,2) Je '90
—Varennes
Nat Geog 176:38–9 (c,2) Jl '89
—Vence
Gourmet 49:86–91, 172 (map,c,1) Ap '89
Trav&Leisure 19:56, 61 (c,3) Jl '89
—Vendée region marshlands
Trav&Leisure 20:138 (c,3) Ja '90
—Vézelay
Trav&Leisure 19:195–200 (map,c,4) N
'89
—See also
ALPS
AMIENS
CORSICA
ENGLISH CHANNEL
LOIRE RIVER
LYON
MONT BLANC
MONT ST. MICHEL
NICE
PARIS
SEINE RIVER
STRASBOURG
VERSAILLES PALACE
FRANCE—ARCHITECTURE
—Burgundy rooftops
Gourmet 49:42 (painting,c,2) Ap '89
—Châteaus
Trav/Holiday 167:58–9 (c,2) F '87
Gourmet 47:72–3 (c,4) Ap '87
Gourmet 47:50–3 (c,3) S '87
Smithsonian 18:142 (c,4) S '87
Trav&Leisure 18:28 (c,3) My '88
Trav&Leisure 18:144–7, 154–6 (c,1) O
'88
Trav&Leisure 18:208 (c,4) D '88
Gourmet 49:50–1, 94 (c,1) Jl '89
Trav&Leisure 21:135–7, 142–5 (map,c,1)
Je '91
FRANCE—ART
—14th cent. Angers tapestry
Trav&Leisure 18:206 (c,4) D '88
—Early 20th cent. Fauves works
Smithsonian 21:64–77 (painting,c,1) O
'90
FRANCE—COSTUME
—18th cent. theater costume
Trav/Holiday 172:69 (c,2) Jl '89
—1770s nobility
Nat Geog 176:54–5 (painting,c,1) Jl '89
—1900
Nat Geog 176:158–9 (1) Jl '89
Smithsonian 22:cov., 42–51 (paint-
ing,c,1) Ag '91
—Berets

Trav/Holiday 168:69 (c,2) Jl '87
Nat Geog 173:575 (c,4) My '88
—Breton lace coiffes
Trav/Holiday 168:67 (c,4) Jl '87
Trav&Leisure 172:45 (c,3) Jl '89
Trav&Leisure 20:102, 104–5 (c,1) Ja '90
Sports Illus 75:2–3 (c,1) Ag 5 '91
—Darcey, Burgundy
Nat Geog 176:138–45 (c,1) Jl '89
—Immigrants
Nat Geog 176:120–9 (c,1) Jl '89
—People in 18th cent. garb
Trav/Holiday 172:38, 41, 47 (c,3) Jl '89
FRANCE—HISTORY
—13th cent. Albigensian Crusade
Smithsonian 22:40–51 (c,1) My '91
—1789 cartoon about French privileged
classes
Smithsonian 20:66 (c,2) Jl '89
—1789 fall of the Bastille
Am Heritage 40:120 (painting,3) My '89
Nat Geog 176:18–19 (painting,c,1) Jl '89
Smithsonian 20:70–1 (painting,c,3) Jl '89
Am Heritage 40:72 (engraving,4) Jl '89
—1789 Tennis Court Oath
Nat Geog 176:24–5 (painting,c,2) Jl '89
Am Heritage 40:41 (painting,c,3) Jl '89
—1792 fall of the Louvre
Am Heritage 40:36–7 (painting,c,1) Jl
'89
—1793 execution of Louis XVI
Nat Geog 176:42 (drawing,c,3) Jl '89
—1813 Battle of Leipzig
Smithsonian 21:87 (painting,c,3) Mr '91
—American liberation of Paris (1944)
Am Heritage 40:4 (2) Jl '89
—Artists' views of Paris (1870–1911)
Smithsonian 22:cov., 42–51 (paint-
ing,c,1) Ag '91
—Edouard Deladier
Smithsonian 19:162, 186 (2) O '88
—"Dreyfus Affair" events
Smithsonian 20:114–29 (c,2) Ag '89
—Famous French writers
Smithsonian 20:144–57 (c,4) Ja '90
—French Revolution events
Nat Geog 176:18–49 (map,c,1) Jl '89
Smithsonian 20:66–75 (painting,c,1) Jl
'89
Gourmet 49:28, 124 (c,4) Jl '89
Am Heritage 40:36–45 (painting,c,1) Jl
'89
—Guillotine
Nat Geog 176:21, 42 (c,1) Jl '89
Smithsonian 20:74–5 (1) Jl '89
—History of the Academie Française
Smithsonian 20:144–57 (c,3) Ja '90
—Normandy coast at dawn of D-Day
(1944)

Gourmet 48:62 (c,4) My '88
—Restoration of Sistine chapel frescoes
 (Vatican)
Nat Geog 176:cov., 688–713 (c,1) D '89
Life 14:cov., 28–40, 45 (painting,c,1) N
 '91
FREUD, SIGMUND
Trav&Leisure 18:86 (drawing,4) O '88
Smithsonian 21:101 (3) Ag '90
—Freud's collection of antiquities
Smithsonian 21:100–9 (c,1) Ag '90
—Home (London, England)
Trav&Leisure 18:86–8 (c,4) O '88
Smithsonian 21:100–1 (c,2) Ag '90
FRIEDAN, BETTY
Life 11:96–8 (c,1) F '88
Life 13:107 (1) Fall '90
Smithsonian 22:74 (4) Ag '91
FRIGATE BIRDS
Nat Wildlife 25:44–5 (c,1) Ag '87
Nat Geog 173:122–3, 132 (c,1) Ja '88
Nat Wildlife 27:cov. (c,1) Je '89
Natur Hist 99:88–9 (c,1) Je '90
FRISBEE PLAYING
—1950s frisbees
Sports Illus 66:12–15 (c,4) My 11 '87
—California
Sports Illus 67:2–3 (c,1) S 7 '87
—Dogs playing frisbee
Sports Illus 75:77 (c,4) S 9 '91
—National Championships 1989
Sports Illus 70:10 (c,3) My 8 '89
—U.S. Open 1987
Sports Illus 67:99 (c,4) S 21 '87
FROGS
Natur Hist 96:96–7 (c,1) Mr '87
Natur Hist 96:28–34 (c,1) My '87
Nat Wildlife 26:54–5 (c,1) D '87
Nat Wildlife 26:cov. (c,1) Je '88
Nat Geog 176:458 (c,4) O '89
Natur Hist 99:46–7 (c,2) Ja '90
Nat Wildlife 29:9 (c,1) D '90
—Ancient frog fossil preserved in amber
Natur Hist 97:42–3 (c,1) D '88
—Doing calisthenics
Life 10:84 (c,2) F '87
—Eggs
Natur Hist 96:32–3 (c,1) My '87
Natur Hist 98:112–13 (c,1) F '89
Natur Hist 99:46–7 (c,3) Ja '90
—Poison dart frogs
Life 11:16 (c,4) My '88
Smithsonian 19:70–7 (c,1) Ja '89
Natur Hist 100:76–7 (c,1) Je '91
—See also
BULLFROGS
TREE FROGS
FRUIT FLIES
Smithsonian 18:112 (c,4) Je '87

FRUITS
Gourmet 50:48 (painting,c,3) D '90
—Bowl of fruit
Gourmet 51:48 (woodcut,4) F '91
—Citrus fruits
Gourmet 47:60–2 (c,4) Ja '87
—Kiwi
Nat Geog 171:682–8 (c,1) My '87
—Passion fruit
Trav/Holiday 176:61 (c,4) S '91
—Plantains
Natur Hist 96:56–63 (c,1) O '87
—Quinces
Gourmet 48:90, 154 (drawing,4) O '88
—Seizing contraband foods at airports
Smithsonian 18:106–17 (c,1) Je '87
—Tropical fruits
Gourmet 49:51 (c,1) Mr '89
—See also
APPLES
BANANAS
BERRIES
BLUEBERRIES
BUNCHBERRIES
COCONUTS
CRANBERRIES
GRAPES
GUAVA
MULBERRIES
NUTS
OLIVES
ORANGES
PEACHES
PEARS
PINEAPPLES
PLUMS
RASPBERRIES
STRAWBERRIES
TOMATOES
WATERMELONS
FULTON, ROBERT
Am Heritage 42:74, 78 (painting,c,4) My
 '91
—Fulton's steamboats
Am Heritage 42:78–9 (drawing,4) My '91
—Fulton's submarines (1799)
Am Heritage 42:78–9 (drawing,4) My '91
FUNERAL RITES AND CEREMONIES
—8th cent. depiction of Maya king death
 voyage
Nat Geog 176:468 (c,4) O '89
—16th cent. funeral robe of Philip II
 (Spain)
Smithsonian 18:162 (c,4) D '87
—16th cent. Algonquin ossuary (North
 Carolina)
Nat Geog 173:362–3 (c,2) Mr '88
—1988 reinterment of Matthew Henson
 (Arlington, Virginia)

Nat Geog 174:428–9 (c,1) S '88
—1989 funeral of Ayatollah Khomeini
(Iran)
Life 12:118–19 (c,1) Fall '89
—Ancient Caborn-Welborn Indian burial
(Kentucky)
Nat Geog 175:390–1 (painting,c,2) Mr '89
—Ancient Etruscan civilization (Italy)
Nat Geog 173:706–7, 720–5, 740–1 (c,1)
Je '88
—Ancient Indians (Florida)
Nat Geog 171:406–7 (c,3) Mr '87
—Arkansas
Life 11:93 (3) D '88
—Athapaskan Indians (Alaska)
Nat Geog 177:54–61 (1) F '90
—Burning wife at husband's funeral in sut-
tee rite (India)
Smithsonian 18:47 (painting,c,4) Ja '88
—Burying dead infant (Romania)
Life 13:6–7 (1) Ap '90
—Cameroon
Nat Geog 172:416–17 (c,1) S '87
—Carved bull at cremation ceremony (In-
donesia)
Trav&Leisure 20:131 (c,1) Ja '90
—Child at soldier father's funeral (Califor-
nia)
Life 14:8–9 (c,1) My '91
—China
Natur Hist 97:4, 6 (c,4) D '88
—Chinese funeral (Thailand)
Nat Geog 180:62 (c,4) N '91
—Chinese ritual jade pi disk
Nat Geog 172:285 (c,2) S '87
—Cremation (India)
Trav&Leisure 19:96–7 (c,3) Jl '89
—Elephant at wake of dead elephant
Nat Geog 179:39–41 (c,2) My '91
—Female Gulf War casualty
Life 14:62 (c,2) My '91
—Funeral cortege of the "Maine" victims
(1912)
Am Heritage 41:101 (4) D '90
—Funeral at Armenian nationalist
Life 13:6–7 (c,1) Mr '90
—Funeral of homeless man (Illinois)
Life 14:54 (c,2) Ag '91
—Hirohito's 1989 funeral (Japan)
Life 12:36–7 (c,1) Ap '89
Life 12:76 (c,4) S '89
Life 13:12–13 (c,1) Ja '90
—Honoring dead relatives (Vietnam)
Life 10:67 (c,2) D '87
—Honoring victims of Soviet force (Lithu-
ania)
Life 14:78–9, 82–3, 89 (c,1) Ap '91
—Victor Hugo's 1885 funeral (Paris,
France)

Smithsonian 18:85 (2) Ap '87
Nat Geog 176:165 (1) Jl '89
—Infant's funeral (Ecuador)
Life 14:74–5 (c,1) O '91
—Jazz funeral (New Orleans, Louisiana)
Smithsonian 20:170 (c,4) S '89
—Jews sitting "shiva" (Ohio)
Life 14:7 (c,4) O '91
—Keeping night vigil at coffin (South Af-
rica)
Life 11:75 (c,2) D '88
—Laotian Hmong people (California)
Nat Geog 174:606–7 (c,1) O '88
—Joe Louis (1981)
Smithsonian 19:196 (4) N '88
—Marajoara Indian burial urns (Brazil)
Natur Hist 98:80–3 (c,1) F '89
—Military funeral (Virginia)
Smithsonian 19:106–7 (c,3) My '88
—Moment of silence before basketball
game
Sports Illus 67:30 (c,3) N 23 '87
—Mourning victim of Iraqis (Kuwait)
Nat Geog 180:4–5 (c,1) Ag '91
—Murdered child in coffin (New York)
Life 14:73 (2) Ja '91
—Pallbearer carrying coffin
Life 11:14–15 (c,1) Ja '88
Sports Illus 74:42 (c,4) Mr 11 '91
—Passing infant over grandfather's coffin
(South Carolina)
Nat Geog 172:736–7 (c,1) D '87
—Policeman's funeral (New York)
Life 12:58 (c,2) Ja '89
—Policeman's funeral (South Africa)
Nat Geog 174:582–3 (c,1) O '88
—Reburial festivities (Madagascar)
Natur Hist 98:24–30 (c,2) Ap '89
—South Korea
Nat Geog 174:264–5 (c,1) Ag '88
—Surma tribe (Ethiopia)
Nat Geog 179:90–1 (c,1) F '91
—Victims of violence (Northern Ireland)
Life 11:150–3 (1) My '88
—Vietnamese funeral (Australia)
Nat Geog 173:260–1 (1) F '88
—Wake (Kentucky)
Life 14:82–3 (1) O '91
—Worldwide funeral rites
Life 14:7, 72–85 (c,1) O '91
—Woven burial shrouds (Madagascar)
Natur Hist 98:102–3 (c,4) Mr '89
—See also
CEMETERIES
COFFINS
DEATH MASKS
GRIEF
MUMMIES
TOMBS

TOMBSTONES
FUNGI
Nat Geog 171:238 (c,4) F '87
Natur Hist 97:49 (painting,c,4) My '88
Gourmet 48:24 (painting,c,2) Jl '88
—Ant devoured by fungus
Nat Geog 175:552 (c,2) My '89
—Growing shiitake mushrooms (California)
Nat Geog 179:70–1 (c,1) F '91
—Morels
Natur Hist 99:78 (c,4) D '90
Natur Hist 100:74 (c,1) My '91
—Pig hunting truffles (France)
Nat Geog 176:74 (c,3) Jl '89
Natur Hist 100:80 (c,4) Ja '91
—Truffles
Gourmet 50:104 (c,4) N '90
Natur Hist 100:80 (c,4) F '91
—Witches'-butter fungus
Natur Hist 97:64 (c,3) Ja '88
—See also
MUSHROOMS
FUNSTON, FREDERICK
Smithsonian 20:134–56 (1) My '89
FUR INDUSTRY
—History of Canadian fur trading industry
Nat Geog 172:192–229 (c,1) Ag '87
—Lynx pelts in warehouse (Quebec)
Nat Geog 172:214 (c,1) Ag '87
FURNITURE
—Early 18th cent. Dutch cupboard (New York)
Am Heritage 42:33 (c,2) S '91
—1730s (Virginia)
Am Heritage 40:114–15 (c,1) F '89
—1762 secretary-bookcase (Rhode Island)
Life 12:8 (c,4) Ag '89
—Late 18th cent. Sheraton secretary (New York)
Am Heritage 39:23 (c,1) Jl '88
—1787 commode cabinet

Life 10:30 (c,4) Fall '87
—Late 18th cent. sideboard
Am Heritage 38:95 (c,4) My '87
Life 10:31 (c,4) Fall '87
Am Heritage 42:30–1 (c,1) O '91
—1903 Emile Gallé sideboard
Trav&Leisure 17:26 (c,4) Mr '87
—Early 20th. cent. handicrafts
Am Heritage 38:83–9, 114 (c,3) Jl '87
—Art nouveau style (France)
Smithsonian 18:90 (c,4) N '87
—Hapsburg furniture (Austria)
Gourmet 48:68–9 (c,4) Mr '88
—See also
BATHTUBS
BEDS
CHAIRS
CHESTS
DESKS
FILING CABINETS
HOME FURNISHINGS
LAMPS
SOFAS
TABLES
FUTURE
—Forecasts of pollution's impact on climate
Sports Illus 67:78–92 (c,1) N 16 '87
—History of science fiction
Am Heritage 40:cov., 42–54 (c,1) S '89
—Items doomed to obsolescence
Life 12:94–5 (c,4) F '89
—Predictions for future of Earth's climate
Smithsonian 21:28–37 (painting,c,1) D '90
—Predictions for the future
Life 12:cov., 54–95 (c,1) F '89
—Scenario for 2004 U.S.-Soviet mission to Mars
Nat Geog 174:732–63 (c,1) N '88
—Orville Simpson's future Victory City designs
Life 10:15–18 (drawing,c,3) S '87

- G -

GABLE, CLARK
Life 10:20 (4) Ap '87
Life 12:26–7, 53–4, 104 (1) Spring '89
Life 14:68–9 (1) F '91
—In "Gone with the Wind" (1939)
Life 11:cov., 29 (c,1) My '88
Life 12:26–7 (c,1) Spring '89
GADWALLS (DUCKS)
—Hatchling
Nat Wildlife 26:17 (c,4) Ap '88
GALÁPAGOS ISLANDS, ECUADOR

Nat Geog 173:122–54 (map,c,1) Ja '88
—Galápagos wildlife
Trav&Leisure 20:142–5 (c,1) S '90
GALAXIES
Smithsonian 19:36–53 (c,1) Ja '89
—Large Magellanic cloud
Nat Geog 173:620–1 (c,1) My '88
—M32 in Andromeda constellation
Smithsonian 19:43 (map,c,4) Ja '89
—Sombrero
Smithsonian 19:43 (c,3) Ja '89

—See also
 CONSTELLATIONS
 MILKY WAY
 NEBULAE
 STARS
GALILEO
 Life 12:130 (painting,c,4) My '89
GALLEONS
—Mid-16th cent. galleons
 Smithsonian 18:160 (painting,c,3) D '87
—Spanish galleons
 Life 10:30–1 (painting,c,1) Mr '87
 Nat Geog 178:9, 22–7, 42–3 (c,1) S '90
GALLEY SHIPS
—Mosaic of ancient Roman galley ship
 Natur Hist 96:66–7 (c,1) D '87
GALLUP, GEORGE
 Life 13:52 (4) Fall '90
GALTON, SIR FRANCIS
 Smithsonian 20:210 (4) O '89
GALVESTON, TEXAS
 Trav/Holiday 168:54–7 (c,2) D '87
 Trav&Leisure 18:243–52 (c,2) D '88
GAMBLING
—19th cent. Tlingit Indians gambling sticks
 (Alaska)
 Natur Hist 98:55 (c,4) D '89
—Early 20th cent. (Saratoga, New York)
 Sports Illus 69:80–1 (c,2) Ag 22 '88
—At blackjack table
 Sports Illus 67:45 (c,4) S 28 '87
—Roulette wheel
 Smithsonian 18:127 (c,4) D '87
 Sports Illus 74:66–7 (c,1) F 4 '91
GAMBLING CASINOS
—Abroad cruise ship
 Trav&Leisure 21:124 (c,4) My '91
—Atlantic City, New Jersey
 Trav/Holiday 169:52–7 (c,1) My '88
—Blackjack table (Nevada)
 Sports Illus 74:50 (c,4) Mr 4 '91
—Las Vegas "Strip," Nevada
 Trav&Leisure 20:109, 119 (c,3) N '90
—Monte Carlo, Monaco
 Gourmet 48:69–71 (c,1) My '88
—Stylized depiction of Las Vegas
 Trav&Leisure 19:83 (painting,c,2) Je '89
GAME PLAYING
—1972 hide-and-seek game (Tennessee)
 Life 13:68 (3) Spring '90
—Ancient bone die (Cyprus)
 Nat Geog 174:47 (c,4) Jl '88
—Arcade basketball game (U.S.S.R.)
 Smithsonian 22:34 (c,4) Ag '91
—Backgammon
 Trav&Leisure 18:55 (c,3) F '88
—Blind girl playing hopscotch (Ohio)
 Life 12:7 (3) D '89
—Dominoes (Harlem club, New York)

Nat Geog 177:60–1 (c,1) My '90
—Family playing board games
 Sports Illus 66:82 (c,3) Mr 23 '87
 Sports Illus 68:51 (c,4) F 1 '88
—Foosball (Illinois)
 Life 12:104–5 (c,1) S '89
—"Go"
 Sports Illus 69:6, 83 (c,4) Ag 1 '88
 Trav&Leisure 18:62 (c,4) O '88
—Jukskei horseshoes (South Africa)
 Nat Geog 174:578 (c,4) O '88
—Playing boules (France)
 Gourmet 49:100 (c,4) O '89
—Playing cat's cradle (Australia)
 Nat Geog 173:280 (c,3) F '88
—Playing shuffleboard aboard ship
 Trav/Holiday 168:72 (c,3) O '87
—Playing tic tac toe with live chicken (New
 York)
 Trav&Leisure 19:106 (c,4) Ja '89
—Seesaw jump (South Korea)
 Trav/Holiday 169:68 (c,3) Je '88
—Table hockey
 Sports Illus 68:56–7 (c,2) F 15 '88
—Video game arcade
 Sports Illus 68:74 (c,4) My 9 '88
—"Virtual reality" videogame
 Sports Illus 75:8 (c,4) O 7 '91
—See also
 BILLIARD PLAYING
 CARD PLAYING
 CHESS PLAYING
 CROQUET PLAYING
 FRISBEE PLAYING
 GAMBLING
 MARBLES
 PINBALL MACHINES
 PUZZLES
 SPORTS
 TABLE TENNIS
 TOYS
GAMES
—Late 19th cent. checkerboard
 Am Heritage 41:31 (c,2) F '90
—Captain Video Space Game (1950)
 Smithsonian 20:84 (c,4) Je '89
—Golf video games
 Sports Illus 73:51–3 (c,4) N 5 '90
—Russian version of "Monopoly"
 Life 11:24 (c,4) D '88
—Winnebago Indians game set (Nebraska)
 Smithsonian 20:49 (c,3) O '89
GANGES RIVER, INDIA
—Benares
 Trav&Leisure 19:90–7 (c,1) Jl '89
GANNETS (BIRDS)
 Nat Wildlife 26:54 (c,4) Ap '88
Garbage. See
 TRASH

GARBO, GRETA
 Life 10:20 (4) Ap '87
 Life 12:38–9, 97–100 (c,1) Spring '89
 Life 14:100 (1) Ja '91
 Life 14:76–7 (1) F '91
GARDEN OF THE GODS, COLO-
 RADO SPRINGS, COLORADO
 Am Heritage 40:26 (c,4) Jl '89
—1890
 Nat Geog 175:233 (3) F '89
GARDENING
—19th cent. gardener (Pennsylvania)
 Am Heritage 42:48 (painting,c,4) S '91
—1950s suburbanites gardening
 Am Heritage 42:44 (painting,c,2) S '91
—Bonsai
 Smithsonian 20:138–53 (c,1) O '89
 Nat Geog 176:645 (c,4) N '89
—Cutting weeds (Missouri)
 Trav&Holiday 176:50–1 (1) Jl '91
—Gardening across U.S. map
 Nat Wildlife 29:18–19 (painting,c,1) Je
 '91
—Growing onions on window sill (Siberia,
 U.S.S.R.)
 Nat Geog 177:11 (c,1) Mr '90
—Japan
 Nat Geog 176:645, 649–63 (c,2) N '89
—Latvia
 Nat Geog 178:6–7 (c,1) N '90
—Lawn sprinklers
 Am Heritage 42:50, 54–5 (c,1) S '91
—London, England
 Nat Geog 180:32–3 (c,1) Jl '91
—Mauritania
 Nat Geog 172:162–3 (c,2) Ag '87
—Mowing the lawn (1920s)
 Am Heritage 42:112 (3) Jl '91
—Planting radishes (Nepal)
 Natur Hist 98:48–9 (c,1) Mr '89
—Raking leaves (Ireland)
 Trav&Leisure 18:106–7 (1) Ap '88
—Urban garden (Harlem, New York)
 Nat Geog 177:61 (c,4) My '90
—West Germany
 Nat Geog 176:336 (c,3) S '89
—See also
 LAWN MOWERS
GARDENS
—Early 20th cent. estate gardens
 Smithsonian 22:54–9 (c,2) S '91
—Arnold Arboretum, Boston, Massa-
 chusetts
 Trav&Leisure 18:NY2 (c,4) My '88
—Backyard garden (British Columbia)
 Trav&Holiday 170:64 (c,4) Ag '88
—Bayou Bend, Houston, Texas
 Gourmet 47:72 (c,3) O '87
—Bellingrath, Alabama

Trav&Leisure 17:92–9 (c,1) F '87
Trav/Holiday 167:49 (c,1) Mr '87
—Botanic gardens (Copenhagen, Den-
 mark)
Trav/Holiday 176:71 (c,4) S '91
—Botanic gardens (Glasgow, Scotland)
Trav/Holiday 174:44–5 (c,2) N '90
—Botanic gardens (Padua, Italy)
Gourmet 48:64 (c,4) My '88
—Brazil
Smithsonian 21:96–107 (c,1) Jl '90
—Brooklyn Botanic Garden, New York
Trav&Leisure 19:NY1–4 (c,4) S '89
—Butchart Gardens, Victoria, British Co-
 lumbia
Trav/Holiday 173:62–3 (c,1) Ja '90
—Charlottesville, Virginia
Gourmet 47:66–71, 98 (c,1) Ap '87
—Checkerboard pattern in sand garden
 (Japan)
Nat Geog 176:649 (c,4) N '89
—Chinese emperor Qianlong's palace gar-
 den (1744)
Smithsonian 21:119 (painting,c,4) S '90
—Demboin garden, Tokyo, Japan
Trav&Leisure 19:99–100 (map,c,3) N '89
—Desert garden (Arizona)
Nat Wildlife 27:26–7 (c,2) Ap '89
—English country gardens
Gourmet 48:48–9 (c,1) Jl '88
Trav&Leisure 19:cov., 107, 163 (c,1) My
 '89
Gourmet 50:98–101 (c,1) Mr '90
Trav/Holiday 173:62–9 (map,c,1) My '90
Gourmet 51:63 (c,1) Ag '91
—Exbury Gardens, England
Trav&Leisure 20:162–3 (c,1) Ap '90
—Famous Southern gardens
Trav/Holiday 167:44–9 (c,1) Mr '87
—Formal garden (Scotland)
Gourmet 48:50 (c,4) Ag '88
—Formal gardens (Great Britain)
Trav&Leisure 17:134 (c,4) Je '87
Gourmet 50:48, 126 (drawing,c,2) F '90
—Hampton Court gardens, England
Trav/Holiday 176:66–75 (c,1) N '91
—Herb garden (Ireland)
Gourmet 50:54–5, 102 (c,1) Ag '90
—Illustrated map of British gardens
Gourmet 50:48 (c,2) F '90
—Jamaica
Trav&Leisure 18:40 (c,4) Mr '88
—Japan
Gourmet 48:70–1 (c,2) S '88
Nat Geog 176:638–63 (c,1) N '89
—Japanese gardens (U.S.)
Trav&Leisure 17:94–5 (c,1) F '87
Nat Geog 178:134–5 (c,1) Ag '90
—Keukenhof, Netherlands

Trav&Leisure 18:58, 60 (c,3) Mr '88
—Lawn jockey (New York)
Gourmet 51:50 (c,3) Jl '91
—London, England
Gourmet 51:79 (c,1) Mr '91
—Longleat House, England
Trav&Leisure 20:161 (c,3) Ap '90
—Longwood, Pennsylvania
Trav&Leisure 17:68 (c,4) Ag '87
Am Heritage 41:56–68 (c,1) Ap '90
—Luxembourg Gardens, Paris, France
Gourmet 48:38 (painting,c,3) Ap '88
—Magnolia Gardens, Charleston, South
Carolina
Trav/Holiday 174:66–7 (c,1) N '90
—Mazes in British country gardens
Smithsonian 18:108–19 (c,1) D '87
—Middleton Place gardens, Charleston,
South Carolina
Trav/Holiday 167:44–5 (c,1) Mr '87
—Mirabell, Salzburg, Austria
Trav&Leisure 17:102 (c,4) Je '87
—Missouri Botanical Garden, St. Louis
Nat Geog 178:132–40 (c,1) Ag '90
—Moorish (Alhambra, Spain)
Trav&Leisure 19:81 (c,1) Ag '89
—Netherlands
Gourmet 51:80–3 (c,1) Ap '91
—New York Botanical Garden
Trav&Leisure 21:NY6 (c,3) Ap '91
—Organic gardens (California)
Gourmet 51:76–9 (c,1) Je '91
—Paris courtyard, France
Gourmet 50:68 (c,4) F '90
—Parterres (Scotland)
Trav/Holiday 175:120 (c,4) My '91
—Pitmedden Garden, Scotland
Trav/Holiday 175:120 (c,4) My '91
—Rose trellises
Trav/Holiday 173:75 (c,4) Ap '90
—St. Kitts
Trav&Leisure 20:118–19 (c,1) D '90
—Secret Garden, Seoul, South Korea
Trav/Holiday 169:66–7 (c,2) Je '88
—Suzhou, China
Trav&Leisure 18:184 (c,2) N '88
—Victorian (Smithsonian, Washington,
D.C.)
Smithsonian 18:121–3, 127 (c,1) Jl
'87
—Wales
Nat Geog 179:129 (c,1) Je '91
—Wisley Garden, Surrey, England
Trav/Holiday 173:64–5 (c,2) Ja '90
—See also
FLOWERING PLANTS
FLOWERS
GARDENING
PLANTS

GARFIELD, JAMES
—On deathbed (1881)
Nat Geog 174:374–5 (drawing,3) S '88
GARLAND, JUDY
Smithsonian 18:144 (4) Jl '87
Smithsonian 21:78 (4) F '91
—Ruby slippers from "The Wizard of Oz"
(1939)
Life 12:6–7 (c,1) Spring '89
Trav/Holiday 176:75 (c,4) Jl '91
—"The Wizard of Oz" (1939)
Life 10:16 (4) Ap '87
Life 12:48–9, 103 (c,1) Spring '89
GARMENT INDUSTRY
—Shelf of ribbons and pins
Gourmet 51:132 (drawing,4) O '91
—Levi Strauss emblem
Am Heritage 38:108 (4) D '87
—Sweatshop (South Korea)
Nat Geog 174:252–3 (c,2) Ag '88
—Women in sweatshop (New York City,
New York)
Nat Geog 177:64–5 (c,1) My '90
—See also
CLOTHING
FOOTWEAR
TEXTILE INDUSTRY
GARRICK, DAVID
—18th cent. medallion given to him
Nat Geog 171:249 (c,4) F '87
GARRISON, WILLIAM LLOYD
Am Heritage 40:34 (4) N '89
GARSON, GREER
Life 12:46–7 (1) Spring '89
GARTER SNAKES
Natur Hist 99:44–9 (c,1) Jl '90
Nat Wildlife 29:8 (c,4) D '90
Smithsonian 22:117 (c,4) O '91
GARVEY, MARCUS
Am Heritage 38:58 (4) D '87
GAS, NATURAL
—Natural gas industry (Siberia, U.S.S.R.)
Nat Geog 177:6–7, 14–17 (c,1) Mr '90
—Natural gas rig (Australia)
Nat Geog 179:60–1 (c,1) Ja '91
GASOLINE STATIONS
Nat Geog 171:56–7 (c,1) Ja '87
Trav&Leisure 18:109 (c,3) My '88
Smithsonian 21:97, 106–7 (c,3) O '90
Smithsonian 21:96 (c,4) D '90
—1920s
Nat Geog 174:339 (c,3) S '88
Trav/Holiday 173:57 (c,4) Je '90
—1940 (Pennsylvania)
Smithsonian 21:96 (c,3) O '90
—Air pump
Life 12:54 (4) O '89
—Boat dock gas pumps (New Jersey)
Trav/Holiday 174:50–1, 58–9 (c,1) D '90

—Mural depicting mechanic shop (California)
 Nat Geog 173:72–3 (c,1) Ja '88
—Old gas pump (France)
 Trav/Holiday 174:79 (c,4) N '90
—Old gas station signs
 Smithsonian 19:113, 119 (c,2) N '88
—Saudi Arabia (1974)
 Life 11:73 (4) Mr '88
GATES
—2nd cent. Miletus entry gate, Turkey
 Smithsonian 22:86 (4) O '91
—4th cent. B.C. Etruscan city gate
 (Volterra, Italy)
 Nat Geog 173:703 (c,4) Je '88
—13th cent. city gates (Taroudant, Morocco)
 Trav&Leisure 18:98 (c,2) Jl '88
—Gate of English manor house
 Trav&Leisure 19:107 (c,3) My '89
—Khyber Pass gate, Pakistan
 Smithsonian 19:44 (c,3) D '88
—Locked baseball stadium gate
 Sports Illus 72:2–3 (c,1) Mr 19 '90
—Perugina, Italy
 Gourmet 49:75 (c,1) My '89
—Rigged with counterweight (Kentucky)
 Natur Hist 96:52 (c,4) Jl '87
—San Juan old city gate, Puerto Rico
 Trav/Holiday 173:56 (c,2) F '90
GATEWAY NATIONAL RECREATION AREA, NEW YORK CITY, N.Y.
—Jamaica Bay Wildlife Refuge
 Nat Wildlife 27:32–3 (c,1) Ag '89
GAUDI, ANTONIO
—Structures designed by him (Spain)
 Trav&Leisure 17:44–6 (c,4) Ap '87
 Trav/Holiday 169:54 (c,1) Je '88
GAUGUIN, PAUL
—"Breton Girls Dancing, Pon-Aven"
 Trav&Leisure 18:52–3 (painting,c,4) My '88
—"Ia Orana Maria"
 Trav&Leisure 17:101 (painting,c,2) Mr '87
—Paintings by him
 Smithsonian 19:58–69 (c,1) My '88
 Life 11:46–52 (c,2) Jl '88
—Sculpture by him
 Smithsonian 19:61, 66 (c,3) My '88
—Self-portraits
 Smithsonian 19:58, 61–2 (c,2) My '88
 Life 11:48 (painting,c,4) Jl '88
 Trav&Leisure 19:65 (painting,c,4) O '89
—Vase by him
 Smithsonian 17:58 (c,4) Ja '87
GAVIALS
 Smithsonian 17:106 (C,1) F '87

GAZEBOS
—Antigua
 Gourmet 48:76 (c,4) D '88
—U.S.S.R.
 Sports Illus 67:78 (c,4) O 26 '87
—Virginia
 Sports Illus 69:64 (c,2) D 12 '88
—Wooden mountain perch (New York)
 Gourmet 50:73 (c,1) Jl '90
GAZELLES
 Smithsonian 20:111 (c,4) F '90
—Thomson's gazelle
 Natur Hist 97:26 (c,3) S '88
GDANSK, POLAND
 Nat Geog 173:86–8, 98–9 (c,1) Ja '88
 Trav/Holiday 170:52–7 (c,1) O '88
 Nat Geog 175:616–19 (c,1) My '89
—Old town
 Trav&Leisure 21:120 (c,4) Ja '91
—"Solidarity" scrawled on wall
 Nat Geog 179:17 (c,3) Mr '91
GECKOS
 Trav&Leisure 17:112 (c,4) Mr '87
 Nat Geog 173:285 (c,4) F '88
 Trav/Holiday 175:52 (c,4) Je '91
 Trav&Leisure 21:126–7 (c,2) S '91
GEESE
 Trav&Leisure 20:115 (c,4) Ja '90
 Nat Wildlife 28:18–19 (c,1) Je '90
 Nat Geog 178:10 (c,2) Jl '90
 Nat Geog 179:24 (c,4) Mr '91
—Snow geese
 Natur Hist 96:80–1 (c,2) N '87
 Nat Wildlife 27:60 (c,1) O '89
 Nat Wildlife 28:36 (c,4) Ap '90
 Smithsonian 21:76 (c,3) Mr '91
 Nat Geog 179:70–1 (c,1) Je '91
—See also
 CANADA GEESE
 NENES
GEHRIG, LOU
 Sports Illus 66:79, 86, 89 (4) Je 29 '87
 Sports Illus 68:112–24, 130 (1) Ap 4 '88
 Sports Illus 68:13 (4) My 2 '88
 Sports Illus 71:84 (4) O 9 '89
 Sports Illus 71:20 (4) O 16 '89
 Sports Illus 73:134 (4) S 3 '90
 Sports Illus 73:10 (4) O 8 '90
 Am Heritage 42:41 (4) My '91
—1939 farewell speech
 Sports Illus 66:86 (4) Je 29 '87
 Sports Illus 68:6 (4) My 23 '88
—Lou Gehrig postage stamp
 Sports Illus 70:16 (c,4) Je 19 '89
Gems. See
 JEWELRY
 list under MINERALS

GENETICS
—Computer visualization of DNA mole-
cule
Nat Geog 175:734 (c,4) Je '89
—DNA double helix model
Smithsonian 20:49 (c,2) F '90
—Genetics research
Smithsonian 20:cov., 40–9 (c,1) F '90
—Photos of all 46 human chromosomes
Smithsonian 20:46–7 (c,4) F '90
—Tobacco plant glowing with firefly gene
Smithsonian 18:126 (c,4) Ag '87
—See also
MORGAN, THOMAS HUNT
WATSON, JAMES
GENEVA, SWITZERLAND
Trav&Leisure 17:36–7 (c,3) N '87
Gourmet 49:268 (painting,4) D '89
Gourmet 51:90–1, 170 (c,1) Ja '91
—Clock tower
Gourmet 51:91 (c,1) Ja '91
—See also
LAKE GENEVA
Geological phenomena. See
ANTARCTICA
ARCTIC
AVALANCHES
BEACHES
CANYONS
CAVES
CLIFFS
DESERTS
EARTH
EARTHQUAKES
FARMS
FIELDS
FLOODS
FORESTS
GEYSERS
GLACIERS
GRASSLANDS
ICEBERGS
ISLANDS
MARSHES
MOUNTAINS
MUD
NORTH POLE
RAIN FORESTS
ROCKS
SAND DUNES
VOLCANOES
WATER FORMATIONS
WEATHER PHENOMENA
GEORGE III (GREAT BRITAIN)
Am Heritage 38:12 (painting,c,4) D '87
GEORGE V (GREAT BRITAIN)
Life 10:36 (c,4) S '87
GEORGE VI (GREAT BRITAIN)
Life 10:37 (4) S '87

Smithsonian 20:64 (4) D '89
Smithsonian 21:122 (4) Jl '90
George, David Lloyd. See
LLOYD GEORGE, DAVID
GEORGE, HENRY
Am Heritage 38:10 (4) Ap '87
GEORGIA
—Andersonville Civil War cemetery
Life 14:44 (c,1) Summer '91
—Antebellum houses
Trav/Holiday 169:70–2 (c,2) Je '88
—Blood Mountain
Nat Geog 171:217 (c,2) F '87
—Dahlonega
Trav&Leisure 19:211 (c,4) Mr '89
—Marshes of Glynn
Trav&Leisure 21:48–52 (c,4) N '91
—Plains countryside
Life 11:164–76 (c,1) My '88
—Sea Islands
Nat Geog 172:734–63 (map,c,1) D '87
Trav&Leisure 20:94 (c,3) Mr '90
—See also
ATLANTA
JEKYLL ISLAND
SAVANNAH
SAVANNAH RIVER
SUWANNEE RIVER
GERANIUMS
Natur Hist 97:22 (c,4) Ag '88
GERMAN SHEPHERDS
Life 10:56 (3) N '87
GERMANY
Nat Geog 180:2–41 (map,c,1) S '91
—Fence separating East from West Ger-
many
Nat Geog 180:4–5, 11, 21 (c,1) S '91
GERMANY—COSTUME
Nat Geog 180:2–41 (c,1) S '91
—Renaissance duke
Natur Hist 98:38 (painting,c,1) Je '89
—Traditional (Munich)
Trav&Leisure 21:194 (c,4) My '91
GERMANY—HISTORY
—1813 Battle of Leipzig
Smithsonian 21:87 (painting,c,3) Mr '91
—1937 Nazi exhibit of "degenerate" mod-
ern art
Smithsonian 22:86–95 (c,1) Jl '91
—1938 appeasement of Hitler at Munich
Smithsonian 19:162–80 (1) O '88
—1941 wreck of the "Bismarck"
Nat Geog 176:622–37 (c,1) N '89
—Berlin soldier letting child through
barbed wire (1961)
Nat Geog 177:118 (4) Ap '90
—Cartoon about 1939 Hitler-Stalin pact
Am Heritage 40:34 (4) Jl '89
—German rulers (955–1945)

Smithsonian 21:82–95 (c,1) Mr '91
—Hitler crossing into Czechoslovakia
(1938)
Smithsonian 19:198 (2) O '88
—Karl V
Smithsonian 21:84 (painting,c,4) Mr '91
—Old Reichstag building, Berlin
Trav&Leisure 17.95 (c,4) S '87
—Scenes of German history (955–1945)
Smithsonian 21:82–95 (map,c,1) Mr '91
—See also
BISMARCK, OTTO VON
CONCENTRATON CAMPS
FRANCO-PRUSSIAN WAR
FREDERICK III
FREDERICK THE GREAT
GOEBBELS, PAUL JOSEPH
GOERING, HERMANN
HESS, RUDOLF
HITLER, ADOLF
LUTHER, MARTIN
NAZISM
OTTO I
ROMMEL, ERWIN
THIRTY YEARS' WAR
WILHELM II
WORLD WAR I
WORLD WAR II
GERMANY—MAPS
Trav&Leisure 21:124 (c,4) Ja '91
GERMANY—POLITICS AND GOV-
ERNMENT
—Destroying symbolic Berlin Wall at rock
concert
Trav&Leisure 21:112–13 (c,1) Ja '91
—Neo-Nazi rally (Munich, Germany)
Nat Geog 180:38–9 (c,1) S '91
GERMANY, EAST
—Meissen
Trav&Leisure 21:124 (c,4) Ja '91
—See also
BERLIN WALL
LEIPZIG
POTSDAM
GERMANY, EAST—COSTUME
Nat Geog 177:104–32 (c,1) Ap '90
GERMANY, EAST—HISTORY
—1989 memorial to escaping East German
(Berlin)
Nat Geog 177:119 (c,4) Ap '90
—East German guard escaping to West
(1961)
Life 13:121 (4) Ja '90
GERMANY, EAST—POLITICS AND
GOVERNMENT
—Banner thanking Krenz for new freedom
(1989)
Trav/Holiday 173:8 (c,4) Ja '90
—Fall of Berlin Wall (1989)

Life 13:8–9, 132–3 (c,1) Ja '90
Nat Geog 177:104 32 (map,c,1) Ap '90
—New Year's crowd celebrating freedom
Life 13:4–5 (c,1) F '90
Life 14:6–7 (c,1) Ja '91
—Poster of Communist leaders kissing
(East Germany)
Life 13:6–7 (painting,c,1) S '90
—Refugees from East Germany
Life 12:1, 34–9 (c,1) N '89
GERMANY, WEST
—Berchtesgaden National Park
Natur Hist 99:54–5 (c,1) Je '90
—Burghotel Sababurg
Gourmet 49:53 (c,2) Mr '89
—Cochem
Trav/Holiday 168:72, 75 (c,1) Jl '87
—Countryside
Life 11:16 (c,3) N '88
Smithsonian 21:33 (c,2) Jl '90
—Freiburg
Trav/Holiday 169:66–8 (c,1) Ap '88
—Lindau
Trav&Leisure 19:162–4 (c,2) Ap '89
Gourmet 49:60–3 (c,1) Je '89
—Linderhof Castle
Gourmet 50:51 (c,1) Ag '90
—Main-Danube Canal
Smithsonian 21:34 (c,4) Jl '90
—Mainau castle
Gourmet 49:138 (drawing,4) Je '89
—Meersburg
Trav/Holiday 167:66 (c,1) Mr '87
Trav&Leisure 19:167 (c,2) Ap '89
Gourmet 49:62 (c,1) Je '89
—Neuschwanstein Castle
Trav&Leisure 17:145 (c,2) F '87
—Ottobeuren church interior, Bavaria
Trav&Leisure 19:112–13 (c,1) Ja '89
—Passau
Gourmet 50:79 (c,1) My '90
—Rothenburg
Trav&Leisure 17:35 (c,3) Ap '87
—Rüdesheim
Trav/Holiday 167:34 (c,4) My '87
—Scenes along "Fairy-tale Road"
Gourmet 49:52–5, 80 (map,c,1) Mr '89
—Schrobenhausen, Bavaria
Gourmet 48:146 (drawing,4) Ap '88
—Wattenmeer National Park
Natur Hist 99:58–9 (c,1) Je '90
—See also
BADEN-BADEN
BERLIN
BERLIN WALL
BLACK FOREST
COLOGNE
DUSSELDORF
FRANKFURT

HAMBURG
HEIDELBERG
LAKE CONSTANCE
MUNICH
NUREMBERG
OBERAMMERGAU
STUTTGART
GERMANY, WEST—ART
—Painted building facade (Lindau)
Gourmet 49:63 (c,2) Je '89
GERMANY, WEST—COSTUME
—Hamburg
Trav&Leisure 18:130–8 (c,1) Je '88
—Mardi Gras clowns (Cologne)
Trav/Holiday 172:45 (c,2) D '89
GERMANY, WEST—HOUSING
—Half-timbered houses (Münden)
Gourmet 49:52 (c,3) Mr '89
GERMANY, WEST—MAPS
—Fairy-Tale Road
Gourmet 49:80 (4) Mr '89
—Romantic Road
Trav&Leisure 17:36 (c,4) Ap '87
GERMANY, WEST—RITES AND FES-
TIVALS
—Oktoberfest (Munich)
Nat Geog 180:8–9, 16–17 (c,1) S '91
GERRY, ELBRIDGE
Smithsonian 18:37 (drawing,4) Jl '87
Am Heritage 38:79 (drawing,2) S '87
Life 10:51 (painting,c,4) Fall '87
—1812 cartoon about gerrymandering
Am Heritage 38:53 (4) D '87
GETTY, J. PAUL
—J. Paul Getty Museum, Malibu, California
Trav/Holiday 168:71 (c,3) S '87
—Home (Italy)
Trav&Leisure 21:98–9 (c,1) S '91
GETTYSBURG, PENNSYLVANIA
—1863 Civil War battlefield
Life 11:56–9 (c,1) Ag '88
GEYSERS
—Grotto Geyser, Yellowstone National
Park, Wyoming
Life 12:42 (c,4) Je '89
—Old Faithful, Yellowstone National
Park, Wyoming
Trav&Leisure 17:E1 (c,3) N '87
Nat Geog 175:252–3 (c,1) F '89
Life 12:2–3 (c,1) Je '89
Life 14:110 (c,2) Summer '91
—Old Faithful, Yellowstone, Wyoming
(1872)
Nat Geog 175:228 (4) F '89
GHANA—COSTUME
—Brass band
Natur Hist 100:40 (c,4) S '91
GHANA—HOUSING
Smithsonian 21:132–3 (c,1) My '90

GHANA—SOCIAL LIFE AND CUS-
TOMS
—Funeral with onion-shaped coffin
Life 11:9 (c,4) Je '88
GHENT, BELGIUM
—"Ghent Altarpiece," St. Bavon Ca-
thedral
Trav&Leisure 17:51 (painting,c,4) Jl '87
GHIBERTI, LORENZO
—Baptistry doors (Florence, Italy)
Trav&Leisure 21:26 (c,4) S '91
GHIRLANDAIO, DOMENICO
—"Portrait of Giovanna Tornabuoni"
Trav&Leisure 18:22 (painting,c,4) Mr
'88
GHOST TOWNS
—Bodie, California
Am Heritage 51:cov., 70–7 (c,1) Ap '90
Am Heritage 41:15 (c,4) D '90
—Madrid, New Mexico
Trav&Leisure 20:E12–16 (map,c,3) Ja
'90
—Waxahachie, Texas
Life 12:2–3, 100–4 (c,1) F '89
—See also
VIRGINIA CITY
GIACOMETTI, ALBERTO
Smithsonian 19:112 (2) S '88
—Art works by him
Smithsonian 19:113–21 (c,1) S '88
—"Grande Tete" (1960)
Gourmet 49:90 (sculpture,c,3) Ap '89
GIBBON, EDWARD
Smithsonian 20:170 (4) D '89
GIBBONS
Nat Wildlife 26:55 (c,1) F '88
Smithsonian 20:26 (c,1) Jl '89
GIBRALTAR
Trav/Holiday 170:55 (c,4) Ag '88
GIBRALTAR, STRAIT OF
Nat Geog 174:90–1 (c,1) Jl '88
GIBSON, ALTHEA
Nat Geog 176:220–1 (1) Ag '89
Sports Illus 71:56–7 (1) N 15 '89
GIDE, ANDRÉ
Smithsonian 20:155 (4) Ja '90
GILA MONSTERS
Smithsonian 18:81 (c,4) Ag '87
GILLESPIE, JOHN BIRKS (DIZZY)
Smithsonian 20:178 (4) O '89
GILLETTE, WILLIAM HOOKER
—Gillette Castle, East Haddam, Con-
necticut
Trav/Holiday 169:28, 30 (c,4) Ap '88
GILMAN, NICHOLAS
Life 10:51 (painting,c,4) Fall '87
GIORGIONE
—"Madonna enthroned between Saints
Francis and Liberale"

Trav&Leisure 20:182 (painting,c,4) S '90
—"The Tempest"
Trav&Leisure 20:179 (painting,c,3) S '90
GIOTTO
—Frescoes (Padua, Italy)
Gourmet 48:62 (c,4) My '88
GIRAFFES
Smithsonian 18:24 (c,4) Je '87
Trav/Holiday 168:16 (c,3) Jl '87
Natur Hist 96:64–5 (c,1) N '87
Natur Hist 97:92–3 (c,1) F '88
Trav&Leisure 18:113 (c,4) N '88
Trav/Holiday 171:68–9 (c,1) Ap '89
Natur Hist 98:92–3 (c,1) S '89
Trav&Leisure 20:110–11 (c,1) S '90
Nat Geog 178:52–3 (c,2) D '90
—Carved wooden giraffe (Mexico)
Smithsonian 22:128–9 (c,1) My '91
GIRL SCOUTS
—Activities
Smithsonian 18:46–55 (c,1) O '87
—History
Smithsonian 18:50–1 (4) O '87
—See also
LOW, JULIETTE
GISH, LILLIAN
Trav&Leisure 18:54 (c,4) F '88
GLACIER BAY NATIONAL PARK, ALASKA
Trav/Holiday 172:62, 66 (c,2) Ag '89
Nat Wildlife 28:6–7 (c,1) Je '90
Life 14:86 (c,4) Summer '91
Nat Geog 180:40 (c,3) Ag '91
GLACIER NATIONAL PARK, MONTANA
Trav&Leisure 19:121–3, 170 (c,1) Mr '89
Trav&Leisure 21:cov., 68–9 (c,1) Jl '91
Trav&Leisure 21:262 (c,4) O '91
—Cannon Mountain
Am Heritage 40:106–7 (map,c,1) Ap '89
—Waterton-Glacier International Peace Park, U.S./Canada
Nat Geog 171:796–823 (map,c,1) Je '87
GLACIERS
—Alaska
Nat Geog 171:104–19 (map,c,1) Ja '87
Trav/Holiday 169:50–1 (c,1) Mr '88
Trav/Holiday 172:66 (c,4) Ag '89
Nat Wildlife 28:6–7 (c,1) Je '90
Trav/Holiday 175:67 (c,4) Je '91
Life 14:104 (c,2) Summer '91
—Antarctica
Nat Geog 177:30–1 (c,1) Ap '90
—Glacier flying (Alaska)
Smithsonian 19:cov., 96–107 (c,1) Ja '89
—Ice cave in glacier (Alaska)
Nat Geog 171:78–9 (c,1) Ja '87
—Iceland
Nat Geog 171:212–13 (c,1) F '87

—Mer de Glace, France
Trav/Holiday 171:55 (c,1) My '89
—Moreno Glacier, Argentina
Trav&Leisure 21:126–7, 178 (c,1) N '91
—Research on ancient air trapped in glaciers
Smithsonian 20:78–87 (c,2) My '89
—Skiing on glacier (New Zealand)
Trav/Holiday 170:54 (c,4) Jl '88
—Tasman, New Zealand
Trav&Leisure 17:126–7 (c,1) Je '87
GLACKENS, WILLIAM JAMES
—"Miss Olga D."
Smithsonian 18:168 (painting,c,4) Ja '88
—Painting of Spanish-American War casualties
Am Heritage 39:74 (c,2) D '88
GLADIOLI
Life 12:85 (c,2) Jl '89
GLASGOW, SCOTLAND
Smithsonian 20:124–35 (c,1) O '89
Trav/Holiday 174:40–9 (map,c,1) N '90
—Burrell Museum
Trav/Holiday 174:47 (c,1) N '90
GLASSBLOWING
—Italy
Gourmet 51:52 (c,4) Ag '91
—Ohio
Gourmet 47:84 (c,4) N '87
GLASSMAKING
—Making glass sculpture
Sports Illus 73:24, 27 (c,4) N 26 '90
GLASSWARE
—14th cent. B.C. blue glass techniques
Nat Geog 172:716–17 (c,4) D '87
—14th cent. B.C. rhyton
Nat Geog 172:708 (c,4) D '87
—7th cent. B.C. Phoenician bowl
Smithsonian 19:72 (c,2) Ag '88
—1st cent. B.C. rhyton (Iran)
Smithsonian 18:56 (c,4) S '87
—4th cent. A.D. glass vessel (Cyprus)
Nat Geog 174:47 (c,4) Jl '88
—25 B.C. Roman glass vase
Smithsonian 20:52–63 (c,1) Jl '89
—1598 golden chalice (U.S.S.R.)
Nat Geog 177:86 (c,4) Ja '90
—16th cent. glass cruets (Georgia)
Nat Geog 173:352 (c,4) Mr '88
—17th cent. Cherokee bottle shaped like dog
Natur Hist 98:56 (c,3) S '89
—18th cent. peach bloom vase (China)
Smithsonian 20:107 (c,4) Ag '89
—18th cent. Stiegel glass pocket flask (Pennsylvania)
Am Heritage 41:37 (c,1) My '90
—1830s tea set (U.S.S.R.)
Smithsonian 21:140 (c,4) Ja '91

—1850 silver pitcher
 Am Heritage 38:91 (c,1) S '87
—1880s silver punch bowl
 Am Heritage 38:25 (c,1) D '87
—Early 20th cent. occupational shaving
 mugs
 Am Heritage 40:36–40 (c,4) Ag '89
—1901 glass jar
 Am Heritage 40:106 (c,4) Ap '89
—Ancient ceramic bottle (Peru)
 Am Heritage 98:73 (c,1) F '89
—Art glass (Sweden)
 Trav/Holiday 169:44 (c,4) My '88
—Crystal goblet (Belgium)
 Trav/Holiday 167:24 (c,4) Je '87
—Glass beer mug
 Sports Illus 69:cov. (c,1) Ag 8 '88
—Hand-blown glass (Italy)
 Gourmet 51:52 (c,4) Ag '91
—Hand-blown glass mug (Vermont)
 Gourmet 49:61 (c,4) Ag '89
—Jade bowl and cup (China)
 Nat Geog 172:298–9 (c,1) S '87
—Moorish bronze pitcher (Spain)
 Nat Geog 174:92 (c,4) Jl '88
—Scientific specimen jars
 Nat Wildlife 26:4–6 (c,4) Ap '88
—Silver bowl designed by Frank Lloyd
 Wright
 Am Heritage 39:29 (c,1) N '88
—Silver tea service (California)
 Gourmet 48:76 (c,4) N '88
—Water pitcher
 Gourmet 47:cov. (c,1) Je '87
GLENDALE, CALIFORNIA
—Railroad station
 Am Heritage 40:4 (c,3) Ap '89
GLIDERS
 Sports Illus 66:36–9 (c,2) Ja 5 '87
—1900 Wright Brothers glider
 Am Heritage 39:99, 103 (4) Ap '88
GLOBES
 Life 10:56 (c,4) Ja '87
—Computer images of exploding globe
 Nat Geog 175:732–3 (c,2) Je '89
—Globe containing 51,000 gems (Iran)
 Nat Geog 178:40–1 (c,1) Jl '90
—Versailles Palace, France
 Trav&Leisure 17:64 (c,4) My '87
GLOUCESTER, MASSACHUSETTS
—1918
 Smithsonian 19:82 (painting,c,4) Ap '88
—Brace's Rock (1864)
 Am Heritage 39:46–7 (painting,c,1) Jl
 '88
—Gloucester coast
 Smithsonian 20:28 (c,4) Ag '89
GLOVES
—Boxing gloves

 Sports Illus 71:216 (c,4) N 15 '89
GOATS
 Nat Geog 174:650–1 (c,1) N '88
 Gourmet 50:101 (c,4) Mr '90
 Nat Wildlife 29:44 (c,4) D '90
—See also
 IBEXES
GOBI DESERT, MONGOLIA
 Nat Geog 175:279–80 (c,1) Mr '89
GOD
—Depictions of God in art
 Life 13:47 (painting,c,4) D '90
—See also
 DEITIES
 JESUS CHRIST
 MYTHOLOGY
 specific religions
GODDARD, ROBERT
 Smithsonian 20:46, 50 (4) N '89
—Goddard's first working rocket (1926)
 Smithsonian 20:46 (4) N '89
GOEBBELS, PAUL JOSEPH
 Smithsonian 22:86 (4) Jl '91
GOERING, HERMANN
 Smithsonian 19:186 (4) O '88
 Smithsonian 21:128 (4) Jl '90
GOETHE, JOHANN
—"Goethe slept here" sign (Lucerne,
 Switzerland)
 Gourmet 51:69 (c,4) F '91
GOGGLES
—Ski goggles
 Trav&Leisure 21:104–5 (c,1) Ja '91
—Swimming goggles
 Life 10:50 (c,2) F '87
—U.S. soldiers wearing night-vision gog-
 gles (Korea)
 Life 11:42–3 (c,1) Ap '88
GOLD
—Gold ingot
 Smithsonian 18:138–9 (c,1) N '87
GOLD MINES
—Brazil
 Life 11:148–9 (1) Fall '88
—Nevada
 Smithsonian 21:47 (c,2) S '90
GOLD MINING
—Northwest Territories
 Smithsonian 18:130, 138–9 (c,3) N '87
—Pouring molten gold (Australia)
 Nat Geog 179:27 (c,4) Ja '91
—South Africa
 Nat Geog 174:579 (c,4) O '88
—See also
 GOLD RUSH
 PROSPECTING
GOLD RUSH
—1850s Chinese immigrants (California)
 Smithsonian 21:118 (engraving,4) F '91

—Cypress Point, California
 Am Heritage 42:52–3 (c,1) Ap '91
—Dubai
 Life 13:42–3 (c,1) O '90
—Flooded golf course (New Jersey)
 Sports Illus 73:2–3 (c,1) Ag 20 '90
—Hawaii
 Gourmet 48:46–7 (c,2) Ja '88
 Gourmet 51:96–7 (c,2) D '91
—Impact of drought on golf course (Minnesota)
 Natur Hist 98:62 (c,2) Ja '89
—Island Club, St. Simons, Georgia
 Trav/Holiday 167:20 (c,4) F '87
—Jamaica
 Sports Illus 75:32 (c,2) D 30 '91
—Korean DMZ course
 Sports Illus 69:46–7 (c,2) S 14 '88
—Mackinac, Michigan
 Gourmet 49:74 (c,3) Je '89
—Miniature golf courses
 Smithsonian 18:121–5 (c,2) Je '87
 Life 14:26 (c,4) Ag '91
—Muirfield, Scotland
 Sports Illus 67:54–9 (c,2) Jl 13 '87
—Palm Springs, California
 Trav&Leisure 19:114–15 (c,1) Je '89
—Pebble Beach, California
 Sports Illus 68:42–3 (c,1) F 15 '88
 Am Heritage 42:62–3 (c,1) Ap '91
—Pinehurst, North Carolina
 Gourmet 48:56–9 (c,1) Mr '88
 Trav/Holiday 172:50–9 (c,1) N '89
—Ponkapoag golf course, Boston, Massachusetts
 Sports Illus 68:70–82 (c,1) Je 13 '88
—Royal Dornach, Scotland
 Sports Illus 67:66–83 (c,1) Ag 17 '87
—St. Andrews, Scotland
 Trav/Holiday 167:59 (c,2) Ap '87
 Sports Illus 73:78–89 (c,1) Jl 16 '90
—St. Lucia
 Gourmet 51:85 (c,1) Mr '91
—Sawgrass, Florida
 Trav&Leisure 19:162–5 (c,2) D '89
—Stadium courses
 Sports Illus 73:70–2, 77–8 (c,2) Jl 16 '90
—Texas-shaped green
 Sports Illus 73:64 (c,4) Jl 2 '90
—Town putting green (Scotland)
 Sports Illus 67:57 (c,3) Jl 13 '87
—Tucson, Arizona
 Trav&Leisure 17:98, 100 (c,3) Ja '87
—Turnberry, Scotland
 Sports Illus 71:52–3 (c,3) Ag 21 '89
—Unusual course designs
 Sports Illus 73:60–72, 77–8 (c,1) Jl 16 '90
GOLF TOURNAMENTS
 Sports Illus 66:22–4, 29 (c,2) Mr 2 '87

Sports Illus 66:73–4 (c,2) Je 8 '87
Sports Illus 67:44–5 (c,2) N 9 '87
Sports Illus 68:42–5 (c,1) F 15 '88
Sports Illus 69:2–3, 42–5 (c,1) N 21 '88
Sports Illus 70:20–2, 27 (c,2) Ja 23 '89
Sports Illus 70:2–3, 12–19 (c,1) F 6 '89
—British Open 1985 (Sandwich)
 Sports Illus 71:62 (c,3) Jl 10 '89
—British Open 1987 (Muirfield, Scotland)
 Sports Illus 67:2–3, 18–23 (c,1) Jl 27 '87
—British Open 1988 (Royal Lytham, England)
 Sports Illus 69:26–9 (c,1) Jl 25 '88
—British Open 1989 (Royal Troon, Scotland)
 Sports Illus 71:20–2, 27 (c,2) Jl 31 '89
—British Open 1990 (St. Andrews, Scotland)
 Sports Illus 73:2–3, 34–7 (c,1) Jl 30 '90
—British Open 1991 (Southport, England)
 Sports Illus 75:19–21 (c,1) Jl 29 '91
—Great Britain
 Sports Illus 69:68–9 (c,3) O 17 '88
—Hawaii
 Sports Illus 73:32–3 (c,2) N 19 '90
—International 1987 (Colorado)
 Sports Illus 67:70–1 (c,3) Ag 24 '87
—Japan
 Sports Illus 67:118 (c,2) D 28 '87
—LPGA 1991 (Bethesda, Maryland)
 Sports Illus 75:32–4 (c,2) Jl 8 '91
—Masters 1987 (Augusta, Georgia)
 Sports Illus 66:2–3, 36–43 (c,1) Ap 20 '87
 Sports Illus 67:50 (c,2) D 28 '87
—Masters 1988 (Augusta, Georgia)
 Sports Illus 68:26–33 (c,1) Ap 18 '88
—Masters 1989 (Augusta, Georgia)
 Sports Illus 70:cov., 2–3, 18–25 (c,1) Ap 17 '89
—Masters 1990 (Augusta, Georgia)
 Sports Illus 72:2–3, 18–25 (c,1) Ap 16 '90
—Masters 1991 (Augusta, Georgia)
 Sports Illus 74:cov., 26–31 (c,1) Ap 22 '91
—Par-3 contest (Augusta, Georgia)
 Sports Illus 70:56–65 (painting,c,1) Ap 10 '89
—Pebble Beach National Pro-Am 1991
 Sports Illus 74:50–1 (c,1) F 11 '91
 Sports Illus 75:64–5 (c,1) D 30 '91
—PGA 1987 (Palm Beach, Florida)
 Sports Illus 67:28–30, 33 (c,2) Ag 17 '87
—PGA 1988 (Edmond, Oklahoma)
 Sports Illus 69:26–7 (c,2) Ag 22 '88
—PGA 1989 (Chicago, Illinois)
 Sports Illus 71:28–9 (c,2) Ag 21 '89
—PGA 1990 (Birmingham, Alabama)
 Sports Illus 73:20–5 (c,1) Ag 20 '90
—PGA 1991 (Carmel, Indiana)

Sports Illus 75:cov., 18–21 (c,1) Ag 19 '91
—Players Championship 1988 (Ponte
 Vedra, Florida)
Sports Illus 68:32–3 (c,2) Ap 4 '88
—Players Championship 1989 (Ponte
 Vedra, Florida)
Sports Illus 70:2–3, 26–31 (c,1) Mr 27 '89
—Players Championship 1990 (Ponte
 Vedra, Florida)
Sports Illus 72:34–7 (c,1) Mr 26 '90
—Players Championships 1991 (Ponte
 Vedra, Florida)
Sports Illus 74:28–30, 35 (c,2) Ap 8 '91
—Ryder Cup 1987 (Ohio)
Sports Illus 67:58–61 (c,3) O 5 '87
—Ryder Cup 1989 (Great Britain)
Sports Illus 71:30–5 (c,1) O 2 '89
—Ryder Cup 1991 (South Carolina)
Sports Illus 75:26–8, 33 (c,2) O 7 '91
—Tournament of Champions 1987
 (Carlsbad, California)
Sports Illus 66:50–1 (c,2) Ja 19 '87
—Tournament of Champions 1988
 (Carlsbad, California)
Sports Illus 68:42 (c,4) Ja 25 '88
—Tournament of Champions 1989
 (Carlsbad, California)
Sports Illus 70:2–3, 34–5 (c,1) Ja 16 '89
—Tournament of Champions 1990
 (Carlsbad, California)
Sports Illus 72:80–1 (c,2) Ja 15 '90
—Tournament of Champions 1991
 (Carlsbad, California)
Sports Illus 74:36–8 (c,3) Ja 14 '91
—TPC 1987 (Sawgrass, Florida)
Sports Illus 66:128–30 (c,2) Ap 6 '87
—U.S. amateur championship 1988 (Hot
 Springs, Virginia)
Sports Illus 69:35 (c,3) S 5 '88
—U.S. Open 1950 (Merion, Pennsylvania)
Am Heritage 42:58 (4) Ap '91
—U.S. Open 1966 (San Francisco, Califor-
 nia)
Sports Illus 66:62–74 (painting,c,1) Je 15
 '87
—U.S. Open 1987 (San Francisco, Califor-
 nia)
Sports Illus 66:cov., 20–7 (c,1) Je 29 '87
—U.S. Open 1988 (Brookline, Massa-
 chusetts)
Sports Illus 68:14–21 (c,1) Je 27 '88
—U.S. Open 1989 (Rochester, New York)
Sports Illus 70:cov., 20–5 (c,1) Je 26 '89
—U.S. Open 1990 (Chicago, Illinois)
Sports Illus 72:cov., 16–23 (c,1) Je 25 '90
—U.S. Open 1991 (Chaska, Minnesota)
Sports Illus 74:24–6, 31 (c,1) Je 24 '91
—U.S. Senior Open 1987 (Connecticut)
Sports Illus 67:2–3, 18–19 (c,1) Jl 20 '87

—U.S. Senior Open 1988 (Chicago, Illi-
 nois)
Sports Illus 69:2–3, 26–7 (c,1) Ag 15 '88
—U.S. Senior Open 1990 (Paramus, New
 Jersey)
Sports Illus 73:20–1 (c,2) Jl 9 '90
—U.S. Senior Open 1991 (Birmingham,
 Michigan)
Sports Illus 75:33–4 (c,3) Ag 5 '91
—U.S. Women's Open 1988 (Maryland)
Sports Illus 69:34–5 (c,2) Ag 1 '88
—U.S. Women's Open 1989 (Michigan)
Sports Illus 71:71–2 (c,3) Jl 24 '89
GOLFERS
Gourmet 48:57 (sculpture,c,4) Mr '88
Sports Illus 70:54, 58, 60 (c,2) Ja 30 '89
Sports Illus 73:2–3, 46–52 (c,4) Jl 2 '90
—19th cent. women's golf attire
Sports Illus 66:24 (4) F 9 '87
—1920s
Sports Illus 70:74–86 (1) Jc 19 '89
—Wearing knickers
Sports Illus 66:44–6 (c,2) My 18 '87
—See also
 HAGEN, WALTER
 HOGAN, BEN
 JONES, BOBBY
 NICKLAUS, JACK
 PALMER, ARNOLD
 SNEAD, SAM
GOMPERS, SAMUEL
Life 13:96 (4) Fall '90
GONDOLAS
—18th cent. (Venice, Italy)
Smithsonian 20:80–1 (painting,c,3) N '89
—Construction (Venice, Italy)
Smithsonian 18:96, 102–3 (c,2) Jl '87
—Venice, Italy
Smithsonian 18:96–105 (c,1) Jl '87
Trav&Leisure 17:24 (c,4) N '87
Trav&Leisure 18:98–9, 155 (c,1) F '88
Trav/Holiday 170:32–7 (c,1) D '88
Trav/Holiday 173:61 (2) F '90
Trav/Holiday 173:76–7, 80–1 (c,1) My
 '90
Trav&Leisure 21:84–5, 96–7, 190 (c,1) F
 '91
—Venice Gondola Regatta, Italy
Trav&Leisure 18:168, 178 (c,3) S '88
GOODMAN, BENNY
Life 10:117 (4) Ja '87
GORBACHEV, MIKHAIL
Life 11:26–30 (c,4) Ag '88
Life 13:78, 136 (c,2) Ja '90
GORHAM, NATHANIEL
Life 10:51 (painting,c,4) Fall '87
GORILLAS
Trav&Leisure 17:88 (c,4) D '87
Life 11:102 (c,2) Mr '88

Trav&Leisure 18:184 (c,4) S '88
Trav&Leisure 18:cov., 104–11, 168–70
 (c,1) O '88
Life 11:cov., 38–47 (c,1) O '88
Trav/Holiday 170:10, 14 (c,3) O '88
Natur Hist 98:28–33 (c,3) Ja '89
Life 12:65 (c,4) Ap '89
Nat Wildlife 29:15 (c,4) F '91
—Circus gorilla
Life 12:142 (4) D '89
—Museum specimens
Trav&Leisure 18:82–3 (c,1) Jl '88
GOSHAWKS
Nat Wildlife 25:47 (c,4) Ag '87
Natur Hist 97:47 (c,1) F '88
Nat Geog 174:157 (c,4) Ag '88
Nat Wildlife 29:22–7 (c,1) Ap '91
GOULD, JAY
—Caricature of him
Am Heritage 40:20 (drawing,4) D '89
GOVERNMENT
—Town meeting (Brazil)
Nat Geog 174:774–5 (c,1) D '88
—See also
 ELECTIONS
 GOVERNMENT—LEGISLATURES
 POLITICAL CAMPAIGNS
 TAXATION
 U.S. PRESIDENTS
 specific countries—POLITICS AND
 GOVERNMENT
 list under STATESMEN
GOVERNMENT—LEGISLATURES
—U.S. House of Representatives
Life 10:96–7 (c,1) Fall '87
GOVERNMENT BUILDINGS
—Model of Parliament House, Canberra,
 Australia
Trav/Holiday 169:58 (c,4) Ap '88
—No. 10 Downing Street interior, London,
 England
Life 12:24–33 (c,1) O '89
—Parliament, Budapest, Hungary
Trav/Holiday 171:82–31 (c,1) Mr '89
Smithsonian 21:43 (c,1) Jl '90
—Parliament, London, England
Natur Hist 97:33 (c,4) Ap '88
—Parliament, Oslo, Norway
Trav&Leisure 20:158–9 (c,1) My '90
—Parliament, Victoria, British Columbia
Trav/Holiday 172:84–5 (c,1) D '89
—Room 274 of Old Exec. Office Bldg,
 D.C. (1912–1989)
Am Heritage 40:106–7 (c,2) Mr '89
—Senate Caucus Room, Washington,
 D.C.
Life 10:12–13 (c,1) Jl '87
—State Department reception rooms,
 Washington, D.C.

Gourmet 51:112–15 (c,1) O '91
—Structures along Pennsylvania Avenue,
 Washington, D.C.
Trav&Leisure 20:134–43 (map,c,1) Mr
 '90
—See also
 CAPITOL BUILDING
 CAPITOL BUILDINGS—STATE
 CITY HALLS
 COURTHOUSES
 INDEPENDENCE HALL
 NATIONAL ARCHIVES
 PENTAGON BUILDING
 POST OFFICES
 SUPREME COURT BUILDING
 WHITE HOUSE
GOYA, FRANCISCO
—Art works by him
Smithsonian 19:56–67 (c,2) Ja '89
Life 12:110–16 (c,4) F '89
—"The Bewitched" (1798)
Trav&Leisure 19:44 (painting,c,4) My
 '89
—"Disasters of War"
Natur Hist 99:76–7 (etching,2) O '90
—Goya painting of Kronos eating his child
Smithsonian 17:150 (c,2) Mr '87
—"The Second of May, 1808"
Trav&Leisure 21:161 (painting,c,2) O
 '91
—Self-portrait
Smithsonian 19:56 (drawing,4) Ja '89
GRABLE, BETTY
—World War II pinup photo of Betty Gra-
 ble
Life 11:73 (4) Fall '88
GRAFFITI
—Berlin Wall, Germany
Trav&Leisure 17:98–9 (c,1) S '87
Nat Geog 177:108–11, 132 (c,1) Ap '90
—Black pride graffiti (Atlanta, Geor-
 gia)
Nat Geog 174:14–15 (c,1) Jl '88
—Messages to rock stars (Ireland)
Life 11:86 (c,4) N '88
—New York City, New York
Life 11:72 (c,4) F '88
Natur Hist 98:90 (c,4) Je '89
—"Solidarity" scrawled on wall (Gdansk,
 Poland)
Nat Geog 179:17 (c,3) Mr '91
—South Korea
Sports Illus 66:38 (c,4) Je 8 '87
GRAHAM, MARTHA
Life 13:22 (3) Fall '90
Life 14:34–42 (1) Ag '91
GRAHAME, KENNETH
—*Wind in the Willows* illustrations
Smithsonian 20:114–15 (c,4) Ja '90

Grain industry. See
 BARLEY INDUSTRY
 BUCKWHEAT
 CORN INDUSTRY
 HAY INDUSTRY
 RICE INDUSTRY
 WHEAT INDUSTRY
Granada, Spain. See
 ALHAMBRA
GRAND CANYON, ARIZONA
 Nat Wildlife 25:44–5 (c,4) Je '87
 Natur Hist 96:78 (c,4) Jl '87
 Nat Geog 173:74–5 (c,1) Ja '88
 Sports Illus 68:12, 16 (c,3) My 16 '88
 Trav&Leisure 20:cov., 104–17, 162
 (map,c,1) F '90
 Nat Geog 177:116 (c,4) Mr '90
 Life 14:24–6 (c,1) Summer '91
 Nat Geog 179:5, 18–19 (c,1) Je '91
 Sports Illus 75:60–74 (map,c,1) Jl 1 '91
—1883
 Nat Geog 175:244 (2) F '89
—Mather Point
 Trav/Holiday 174:62–3 (c,1) N '90
—See also
 COLORADO RIVER
GRAND RAPIDS, MICHIGAN
—Old City Hall
 Am Heritage 41:93 (4) Jl '90
GRAND TETON NATIONAL PARK,
 WYOMING
 Trav/Holiday 170:40–1 (c,1) Jl '88
 Trav&Leisure 19:110–11, 118–20 (c,1)
 Mr '89
 Trav&Leisure 21:88–9 (c,1) Ap '91
 Life 14:19 (c,4) Ag '91
GRANGE, RED
 Sports Illus 74:10 (4) F 4 '91
GRANT, CARY
 Life 10:3, 118 (4) Ja '87
 Am Heritage 39:168 (3) N '88
 Am Heritage 39:53 (2) D '88
 Life 14:74–5 (1) F '91
GRANT, ULYSSES S.
 Am Heritage 39:112 (4) My '88
 Am Heritage 41:82 (4) Mr '90
—Caricature
 Am Heritage 39:cov. (c,4) Jl '88
 Am Heritage 41:14 (4) N '90
GRAPE INDUSTRY—HARVESTING
—Chianti, Italy
 Trav/Holiday 174:61–3 (c,1) S '90
—Chile
 Nat Geog 174:81 (c,3) Jl '88
—France
 Gourmet 48:58 (c,4) S '88
 Gourmet 49:44 (painting,4) Ap '89
 Trav/Holiday 173:80 (c,4) Ja '90
—Portugal

Gourmet 51:45–6 (painting,c,2) S '91
Gourmet 51:114 (c,2) D '91
GRAPES
 Trav/Holiday 169:66 (c,4) F '88
 Sports Illus 169:78 (c,4) Mr '88
 Gourmet 48:28 (painting,c,4) Ap '88
 Gourmet 48:41 (c,4) Ag '88
 Gourmet 48:62 (c,4) S '88
 Gourmet 49:56 (drawing,4) My '89
 Gourmet 50:44 (drawing,c,4) Ja '90
 Gourmet 50:66, 220 (drawing,4) My '90
 Gourmet 50:190 (drawing,4) Je '90
—Grapevine
 Gourmet 51:44 (painting,c,4) F '91
GRASS
—Big bluestem tall grass
 Natur Hist 97:12–13 (c,1) Mr '88
—Volkswagen covered with grass
 Life 11:12 (c,4) S '88
—See also
 BAMBOO PLANTS
 GRASSLANDS
GRASSHOPPERS
 Natur Hist 96:86–7 (c,1) Jl '87
 Nat Geog 172:170 (c,4) Ag '87
 Nat Wildlife 28:54 (c,4) D '89
—See also
 LOCUSTS
GRASSLANDS
—Cañada Bonito, New Mexico
 Natur Hist 97:26–31 (map,c,1) N '88
—Kansas
 Am Heritage 39:54–5, 62 (c,1) Ap '88
 Smithsonian 19:58 (c,4) Jl '88
—Newaygo Prairies, Michigan
 Natur Hist 97:12–14 (map,c,1) Mr '88
GRAVITY
—Research on gravity
 Nat Geog 175:562–83 (c,1) My '89
GREAT BARRIER REEF, AUSTRA-
 LIA
 Trav/Holiday 175:46–57 (map,c,1) My
 '91
GREAT BASIN NATIONAL PARK,
 NEVADA
 Life 10:58 (c,4) Jl '87
 Smithsonian 18:68–81 (c,1) N '87
 Life 11:109 (c,4) Ja '88
 Trav&Leisure 18:120–7, 160 (map,c,1)
 Mr '88
 Trav/Holiday 170:41 (c,4) Jl '88
 Natur Hist 97:58–65 (c,1) O '88
 Nat Geog 175:72–5 (c,1) Ja '89
 Nat Geog 180:40 (c,3) Ag '91
—Wheeler Peak
 Smithsonian 18:72–3, 76 (c,1) N '87
 Trav&Leisure 18:124 (c,3) Mr '88
 Natur Hist 97:65 (c,1) O '88
 Nat Geog 175:72–3 (c,1) Ja '89

Nat Wildlife 28:cov., 47 (c,1) Je '90
Nat Wildlife 28:2 (c,2) O '90
Nat Wildlife 29:52–3 (c,1) D '90
Natur Hist 100:84–5 (c,1) Ja '91
Nat Wildlife 29:44–5 (painting,c,1) Ap
'91
—Claws
Nat Geog 177:90–1 (c,1) Ap '90
—Stuffed grizzly
Nat Geog 180:94–5 (c,1) N '91
GROPIUS, WALTER
—Home (Lincoln, Massachusetts)
Trav&Leisure 17:E16 (4) F '87
GROUND HOGS
—Ground Hog Day scene
Gourmet 51:82 (painting,c,3) F '91
GROUPERS (FISH)
Natur Hist 98:40 (c,3) Ja '89
Trav/Holiday 172:76 (c,4) Jl '89
Natur Hist 98:60–9 (c,1) O '89
Smithsonian 21:103 (c,4) N '90
Nat Geog 180:144–5 (c,1) O '91
GROUSE
Nat Geog 175:65 (c,3) Ja '89
Nat Wildlife 27:50–1 (c,1) Je '89
Natur Hist 98:48 (c,1) Ag '89
Nat Wildlife 28:53 (c,4) D '89
Nat Wildlife 28:53 (painting,c,1) O '90
—See also
PRAIRIE CHICKENS
PTARMIGANS
GRÜNEWALD, MATTHIAS
—"Temptation of Saint Anthony"
Smithsonian 19:83 (painting,c,1) Mr '89
GRUNTS (FISH)
Natur Hist 97:53 (c,4) O '88
GUADALAJARA, MEXICO
Trav/Holiday 170:77 (c,2) S '88
Trav/Holiday 171:50–6 (c,1) Je '89
GUANACOS
Nat Geog 179:108–9 (c,1) Ja '91
GUANAJUATO, MEXICO
Trav&Leisure 19:132–31, 186 (c,3) N '89
Nat Geog 178:124–5 (c,1) D '90
GUANS (BIRDS)
Nat Geog 176:457–8 (c,4) O '89
GUARDS
—British palace guards
Life 11:26–7 (c,1) Ap '88
Trav&Leisure 20:cov. (c,1) My '90 supp.
—Changing of Palace guards (Oslo, Nor-
way)
Trav&Leisure 20:158 (c,4) My '90
—Changing of the Guard (Prague, Czecho-
slovakia)
Trav&Leisure 17:111 (c,4) F '87
—Female prison guard (U.S.S.R.)
Nat Geog 179:28–9 (c,1) F '91
—Guard in ceremonial dress (Scotland)

Trav/Holiday 167:60 (c,4) Mr '87
—Kremlin, Moscow, U.S.S.R.
Nat Geog 177:78–9 (c,3) Ja '90
—London's Horse Guard, England
Trav&Leisure 17:24 (c,4) Ag '87
—Museum (London, England)
Gourmet 47:73 (c,4) D '87
—Palace guards (Argentina)
Trav&Leisure 18:134–5 (c,1) D '88
—Royal guards (Denmark)
Trav/Holiday 176:68–9 (c,1) S '91
—Security guard (Tennessee)
Life 10:120 (c,4) N '87
—Soviet gulag (Siberia, U.S.S.R.)
Nat Geog 177:40–9 (c,1) Mr '90
—Taiwan
Gourmet 49:84 (c,4) Ap '89
—Tower of London guard, England
Trav&Leisure 17:30 (c,4) S '87
GUATEMALA
Nat Geog 173:cov., 768–803 (map,c,1) Je
'88
—El Mirador Maya city
Nat Geog 172:316–39 (map,c,1) S '87
—Mayan ruins (Tikal)
Trav/Holiday 170:66–7 (c,2) O '88
Trav&Leisure 18:162–72 (map,c,1) N '88
Nat Geog 176:451 (c,2) O '89
Trav/Holiday 175:44–9, 53–5 (map,c,1)
Je '91
—Sites associated with the Maya
Nat Geog 172:330–1 (map,c,1) S '87
Nat Geog 176:424–505 (map,c,1) O '89
—See also
ANTIGUA
GUATEMALA CITY
MAYA CIVILIZATION
GUATEMALA—COSTUME
Nat Geog 173:cov., 769–803 (c,1) Je '88
—Modern Maya Indians
Trav/Holiday 170:cov., 63–5 (c,1) O '88
GUATEMALA—MAPS
Trav/Holiday 170:65 (c,4) O '88
GUATEMALA—RITES AND FESTI-
VALS
—All Saints' Day horseback fest
Nat Geog 176:476–7 (c,1) O '89
GUATEMALA, ANCIENT—RELICS
—Ancient calendar
Natur Hist 100:28 (c,4) Ap '91
GUATEMALA CITY, GUATEMALA
Nat Geog 173:780–5 (c,2) Je '88
GUAVA
Natur Hist 99:28 (c,4) My '90
GUILLEMOTS
—Guillemot eggs
Smithsonian 22:51 (c,2) Ap '91
GUITAR PLAYING
—Bermuda beach

Trav&Leisure 21:122 (c,3) F '91
—Colombia
Nat Geog 175:508 (c,4) Ap '89
—Country singer
Trav&Leisure 19:212 (c,4) N '89
Life 14:102–3 (1) D '91
—Folk singers
Smithsonian 18:114–20 (3) Ag '87
—Tennessee
Trav/Holiday 175:63 (4) Ja '91
—See also
SEGOVIA, ANDRES
GUITARS
—Decorated leather guitar case (Tennessee)
Smithsonian 18:85 (c,4) Mr '88
—Displayed in music store (Spain)
Gourmet 50:55 (c,3) Jl '90
—Guitar ice sculpture (Illinois)
Nat Wildlife 27:10 (c,4) D '88
—Guitar making (Maryland)
Nat Geog 174:182 (c,4) Ag '88
GULF OF CALIFORNIA, MEXICO
Nat Geog 176:715–16, 720 (c,1) D '89
GULF STREAM
Smithsonian 19:44–59 (map,c,1) F '89
Smithsonian 19:42–55 (c,1) Mr '89
—1769 map of Gulf Stream current by
Franklin
Smithsonian 19:53 (c,4) F '89
—Satellite photo
Natur Hist 99:66–7 (c,1) Mr '90
—Scientific images of the Gulf Stream
Natur Hist 97:34–5 (c,1) Ag '88
Smithsonian 19:42–9 (c,1) Mr '89
—Use of Gulf Stream by mariners through
history
Smithsonian 19:44–59 (map,c,1) F '89
GULF WAR
Life 14:entire issue (c,1) Mr '91
—1991 anti Gulf War protest (Washington)
Life 14:8–9 (c,1) Mr '91
Life 14:10–11 (c,1) Fall '91
—Bombed vehicles of escaping Iraqis (Kuwait)
Nat Geog 180:11 (c,1) Ag '91
—Effects of Kuwait's burning oil fields
Nat Geog 180:cov., 2–33 (map,c,1) Ag
'91
—Gulf War victory parade (New York)
Life 14:80–5 (c,1) Ag '91
—Iraqi attack on Kuwait (1990)
Life 14:5 (c,2) Ja '91
Life 14:42–3 (c,1) Mr '91
—Military women
Life 14:52–7, 61 (c,1) My '91
—U.S. soldiers in Saudi Arabia
Am Heritage 41:cov., 100–1 (c,1) N '90
Life 13:87–91 (1) D '90

Life 14:entire issue (c,1) Mr '91
GULLS
Nat Wildlife 25:19–21 (c,1) Ag '87
Nat Wildlife 26:2 (c,2) F '88
Trav&Leisure 18:52 (c,4) Mr '88
Sports Illus 69:2–3 (c,1) N 21 '88
Gourmet 49:79 (c,3) My '89
Smithsonian 20:72–85 (c,1) O '89
—Brown bear fighting with gulls over fish
Nat Wildlife 28:10–11 (c,1) Je '90
—Gull trapped in six-pack yoke
Nat Wildlife 28:17 (c,1) O '90
GUM CHEWING
—Blowing bubble
Sports Illus 68:53 (c,4) Ap 4 '88
—Football player blowing bubble
Sports Illus 74:50–1 (c,1) Ap 22 '91
GUNS
—18th cent. musket
Nat Geog 171:733 (c,4) Je '87
—1860 Colt revolver
Am Heritage 41:29 (c,1) Mr '90
—1866 Gatling gun
Am Heritage 38:10 (4) N '87
—1890 patent for machine gun
Am Heritage 41:54 (drawing,4) S '90
—1910s Colt-Browning machine gun
Smithsonian 18:204 (4) N '87
—Animal immobilization rifle
Smithsonian 18:146 (c,4) My '87
—Antique gun (Morocco)
Trav&Leisure 17:92 (c,3) Mr '87
—Assault weapons
Life 14:12–13 (c,1) Fall '91
—Browning 19mm semi-automatic pistol
Life 12:160 (c,2) Fall '89
—Congressional gun control hearing
Life 14:12–13 (c,1) Fall '91
—Derringer used to shoot Lincoln
Life 14:60–1 (c,3) Summer '91
—Destroying handguns (Ontario)
Nat Geog 177:101 (c,1) F '90
—Gun store (Poland)
Nat Geog 179:26–7 (c,1) Mr '91
—Machine gun (Pakistan)
Nat Geog 172:545 (c,4) O '87
—.357 Magnum revolver
Life 12:164 (c,2) Fall '89
—.38 caliber handgun
Life 12:163 (c,3) Fall '89
—.22 caliber revolver
Life 12:159 (c,3) Fall '89
—Used to commit sensational 1980s crimes
Life 12:156–64 (c,1) Fall '89
—See also
ARMS
BLOWGUNS
RIFLES
SHOOTING

GUSTAV III (SWEDEN)
 Smithsonian 19:194 (painting,c,4) My '88
GUTHRIE, WOODY
 Smithsonian 18:120 (4) Ag '87
 Am Heritage 42:110 (4) Jl '91
GYMNASTICS
 Sports Illus 67:102 (c,2) D 28 '87
 Sports Illus 68:61–70 (c,4) Je 6 '88
 Sports Illus 71:34–6 (c,1) N 27 '89
—1899 woman hanging from rings
 Sports Illus 67:71 (4) S 28 '87
—1972 Olympics (Munich)
 Sports Illus 68:61–3 (c,4) Je 6 '88
—1976 Olympics (Montreal)
 Sports Illus 68:61, 65–6 (c,4) Je 6 '88
 Sports Illus 71:142 (c,2) N 15 '89
 Life 13:cov., 25–32 (c,1) Mr '90
—1980 Olympics (Moscow)
 Sports Illus 71:41 (c,3) D 11 '89
—1984 Olympics (Los Angeles)
 Sports Illus 68:61, 67–70 (c,4) Je 6 '88
—1988 Olympics (Seoul)
 Sports Illus 69:90–1 (c,3) Ag 15 '88
 Sports Illus 69:72, 75 (c,2) O 3 '88
 Life 12:148–9 (c,1) Ja '89
—Balance beam
 Sports Illus 66:41 (c,4) My 4 '87
 Sports Illus 68:73 (c,4) Mr 14 '88
 Sports Illus 73:23 (c,3) Ag 6 '90
—Boy doing back flip
 Life 13:94–5 (1) N '90
—Cartwheel
 Sports Illus 74:64–5 (c,1) Ja 28 '91
—Cuba
 Sports Illus 75:63–7 (c,2) Jl 29 '91
—Dismounting from rings
 Sports Illus 73:94–5 (c,1) D 31 '90
—Girl doing handstand (Chile)
 Nat Geog 174:76–7 (c,1) Jl '88
—Goodwill Games 1990 (Seattle, Washington)
 Sports Illus 73:22–3 (c,3) Ag 6 '90
—Mass gymnastics display (North Korea)
 Life 14:10–11 (c,1) Ag '91
—On the horse
 Sports Illus 66:40 (c,3) My 4 '87
 Sports Illus 67:74 (c,4) N 2 '87
 Sports Illus 69:102 (c,4) S 14 '88
 Sports Illus 73:22 (c,3) Ag 6 '90
 Nat Geog 180:118–19 (c,1) Jl '91
—Parallel bars
 Sports Illus 69:166 (c,3) S 14 '88
—Rhythmic gymnastics
 Sports Illus 71:100–1 (c,1) D 25 '89
—Rhythmic gymnastics (1988 Olympics)
 Sports Illus 69:26 (c,4) O 10 '88
—Rings
 Sports Illus 66:41 (c,4) My 4 '87
 Sports Illus 68:33 (c,2) Ja 25 '88
 Sports Illus 69:90–1 (c,1) D 26 '88
 Sports Illus 71:29 (c,3) Jl 17 '89
—Small child practicing (China)
 Sports Illus 69:70–5 (c,1) Ag 15 '88
—Split-legged leap
 Life 13:8 (c,3) Ap '90
—U.S. Championships 1988 (Houston)
 Sports Illus 69:32–4 (c,2) Jl 18 '88
—World Championships 1987 (Netherlands)
 Sports Illus 67:74, 77 (c,4) N 2 '87
—World Championships 1991 (Indianapolis, Indiana)
 Sports Illus 75:40–1 (c,3) S 23 '91
GYPSIES
—Great Britain
 Natur Hist 97:50–61 (c,1) F '88
—Gypsy with dancing bear (Bulgaria)
 Nat Geog 176:344 (c,2) S '89
—Romania
 Nat Geog 179:4–5 (c,1) Mr '91
GYPSUM
 Smithsonian 19:56–7 (c,3) N '88
GYPSY MOTHS
 Natur Hist 100:40–5 (c,1) Je '91

- **H** -

HAARLEM, NETHERLANDS
 Gourmet 50:72–7, 144 148 (map,c,1) Ap '90
HADRIAN
—Hadrian's Wall, Northumbria, England
 Natur Hist 98:64–72 (map,c,1) Ap '89
HAGEN, WALTER
 Sports Illus 70:74–86 (1) Je 19 '89
Hagia Sophia Cathedral. See
 ST. SOPHIA CATHEDRAL
THE HAGUE, NETHERLANDS
—Kurhaus resort hotel
 Trav/Holiday 173:68–9 (c,1) Ap '90
—Mauritshuis Museum
 Trav&Leisure 18:49–50 (c,4) Ap '88
HAIDA INDIANS (ALASKA)—RELICS
—19th cent. haida shaman's rattle
 Natur Hist 9849 (c,4) D '89
HAIDA INDIANS (BRITISH COLUMBIA)
 Nat Geog 172:102–27 (c,1) Jl '87

Trav/Holiday 174:62–9 (c,1) O '90
Gourmet 50:cov., 104–9, 146–8
(map,c,1) O '90
—Luna Luna amusement park
Life 10:76–9 (c,1) S '87
HAMILTON, ALEXANDER
Am Heritage 38:49 (painting,c,4) My '87
Smithsonian 18:40 (drawing,3) Jl '87
Life 10:52 (painting,c,4) Fall '87
Smithsonian 19:196 (painting,c,4) Mr '89
Am Heritage 41:41–56 (painting,c,4) Jl
'90
—1873 Hamilton postage stamp
Am Heritage 41:114 (c,4) Jl '90
—Birthplace (Nevis, Leeward Islands)
Trav/Holiday 169:72–3 (c,2) Mr '88
Gourmet 49:63 (c,4) Mr '89
—Home (St. Croix, Virgin Islands)
Am Heritage 38:20 (c,4) Jl '87
—Seen on 19th cent. currency
Am Heritage 41:44–56 (c,4) Jl '90
HAMILTON, BERMUDA
Gourmet 50:85 (c,3) Mr '90
HAMMOCKS
Life 10:28–9 (c,1) Mr '87
Life 11:43 (c,3) S '88
Life 12:54–5 (c,3) N '89
Trav/Holiday 174:27 (drawing,c,4) Jl '90
—1941 soldier asleep in hammock
(Louisiana)
Smithsonian 22:98 (4) S '91
—At resort hotel (Hawaii)
Trav/Holiday 173:44 (c,2) Ja '90
—Caribbean resort
Gourmet 47:45 (c,1) Ja '87
Trav/Holiday 170:68 (c,3) Ag '88
Gourmet 48:78 (c,2) D '88
Trav/Holiday 172:44–5 (c,1) N '89
Trav&Leisure 21:143 (c,1) My '91
—Couple in hammock (California)
Life 12:119 (c,2) F '89
—Ronald Reagan asleep in hammock (California)
Trav/Holiday 173:69 (c,4) F '90
HAMMURABI
—Depicted on stela
Nat Geog 179:113 (c,4) My '91
HAMPTON ROADS, VIRGINIA
Trav/Holiday 169:48–51 (map,c,1) F '88
HANCOCK, JOHN
Life 14:42 (painting,c,4) Fall '91
HAND SHAKING
—High five
Sports Illus 69:33 (c,2) O 17 '88
Sports Illus 73:49 (c,4) Ag 6 '90
—Low five
Sports Illus 68:18 (c,4) Ja 25 '88
—Shaking hands over tennis net
Sports Illus 67:39 (c,3) D 14 '87

HANDBALL PLAYING
Sports Illus 68:22 (4) Ap 4 '88
Sports Illus 69:109 (c,4) S 14 '88
Sports Illus 73:6–8 (c,4) O 1 '90
—Basque handball "pala"
Sports Illus 69:124 (c,4) N 7 '88
HANDICAPPED PEOPLE
—1871 deaf mute children (Massachusetts)
Nat Geog 174:362–3 (2) S '88
—Amputee veterans (Nicaragua)
Life 10:134–5 (1) D '87
—Child with savant syndrome
Life 12:102–4 (c,1) Ap '89
—Child with spina bifida
Sports Illus 67:27 (c,3) D 21 '87
—Children with myoelectric arms
Life 11:113–16 (c,2) D '88
Life 13:16 (3) F '90
—College football played by deaf students
Sports Illus 75:104–15 (1) Ag 26 '91
—Cross-country roll by wheelchair
Trav/Holiday 172:24 (c,4) Jl '89
—Deaf actress accepting Academy Award
Life 11:30 (c,4) Ja '88
—Deaf and blind children
Life 13:88–98 (1) O '90
—English alphabet of visible speech
Nat Geog 174:362 (3) S '88
—Forearm prosthesis
Nat Geog 176:753 (c,2) D '89
—Girl in mobile life-support wheelchair
Life 12:10 (c,4) S '89
—Man with artificial nose (Australia)
Nat Geog 173:189 (c,4) F '88
—Man running on prosthetic legs
Nat Geog 176:747 (c,2) D '89
—Man with no legs
Sports Illus 74:77 (4) Mr 25 '91
—National Veterans Wheelchair Games
Sports Illus 73:14, 17 (c,3) S 10 '90
—One-armed man
Sports Illus 75:34–7 (c,1) Jl 22 '91
—One-handed baseball player
Sports Illus 66:28–9 (c,4) My 25 '87
—One-legged man in New York Marathon
(1989)
Sports Illus 71:2–3 (c,1) N 13 '89
Sports Illus 71:106–7 (c,1) D 25 '89
—One-legged woman skiing
Sports Illus 73:7–8 (c,4) D 31 '90
—Organ transplant recipients in races
Nat Geog 180:90–1 (c,1) S '91
—Paralyzed man in wheelchair
Sports Illus 69:33, 35 (c,2) Jl 25 '88
Sports Illus 74:53, 56 (c,4) Ap 1 '91
—Paralyzed man riding motor cart
Sports Illus 66:37 (c,4) Ja 26 '87
—Special Olympics
Sports Illus 67:38–49 (c,1) Ag 17 '87

Nat Geog 180:34–40 (map,c,1) Jl '91
—Odessa, Ukraine
Nat Geog 171:598–9 (c,1) My '87
—Oslo, Norway
Trav&Leisure 20:154–5 (c,1) My '90
—Rye, England
Trav&Leisure 19:88 (c,4) S '89
—St. Barthélemy, West Indies
Gourmet 47:48–9 (c,4) Mr '87
—St. Michael's harbor, Maryland
Trav&Leisure 21:64 (c,4) Ja '91
—Sydney, Australia
Smithsonian 18:128–9, 138–41 (c,1) Ja
'88
Trav/Holiday 169:40–1 (c,1) Ja '88
Trav/Holiday 170:8–9 (c,2) Ag '88
Trav&Leisure 21:200–1 (c,1) O '91
—Turku, Finland
Trav&Leisure 17:158 (c,4) Je '87
—Veracruz, Mexico
Trav&Leisure 169:72–3 (c,4) My '88
—Wexford, Ireland
Trav&Leisure 21:106–7 (c,1) S '91
—See also
MARINAS
HARDING, WARREN GAMALIEL
Am Heritage 39:45 (4) Mr '88
Life 13:70 (4) Fall '90
—Lover Nan Britton and child
Life 10:75 (4) Ag '87
HARDWARE
—Bent steel bolts from collapsed building
(Missouri)
Smithsonian 19:116–17 (1) My '88
—See also
KEYS
LOCKS
TOOLS
HARDY, THOMAS
—Home (Bockhampton, England)
Trav/Holiday 173:54 (c,1) Ap '90
Hares. See
RABBITS
HARLAN, JOHN M.
Life 14:32 (4) Fall '91
HARLOW, JEAN
Life 11:57 (4) Fall '88
HARP PLAYING
—Child playing with harp (Australia)
Life 13:96 (2) F '90
HARPERS FERRY, WEST VIRGINIA
Nat Geog 171:226–7 (c,1) F '87
Nat Geog 171:740–1 (c,1) Je '87
Am Heritage 39:30 (c,4) N '88
HARPS
—Mangbetu ivory harp (Zaire)
Natur Hist 99:72–3 (c,1) Je '90
HARRIERS (BIRDS)
Trav/Holiday 170:12 (c,4) Ag '88

HARRISON, BENJAMIN
Nat Geog 173:34 (1) Ja '88
Am Heritage 40:148 (2) N '89
HARTFORD, CONNECTICUT
—Memorial Arch
Trav&Leisure 18:NE8 (c,4) My '88
HARVARD UNIVERSITY, CAM-
BRIDGE, MASSACHUSETTS
Gourmet 49:94–5, 186 (c,1) S '89
Trav&Leisure 19:107, 110–12 (c,4) O '89
Harvesting. See
specific crops—HARVESTING
HASTINGS, WARREN
Smithsonian 18:54 (painting,c,4) Ja '88
HATS
—Late 19th cent. bowler
Am Heritage 39:50 (1) D '88
—1880s millinery shop (New York)
Am Heritage 40:116 (painting,c,3) D '89
—1910 men's hats
Am Heritage 42:70–1 (4) O '91
—1915 woman's fur hat
Am Heritage 40:6 (painting,c,2) D '89
—Baseball caps
Sports Illus 69:6 (c,4) Ag 22 '88
—Borsalino fedoras (Italy)
Trav&Leisure 19:51, 54 (4) S '89
—Boy Scout hats
Life 11:50–1 (c,1) N '88
—Churchill Downs hat, Kentucky
Sports Illus 68:15 (c,4) Ap 18 '88
—Donald Duck hats (Florida)
Trav&Leisure 19:141 (c,4) D '89
—Farm workers' hats (China)
Trav&Leisure 18:106–7 (c,1) Ja '88
—Gondolier's hat (Venice, Italy)
Smithsonian 18:105 (c,2) Jl '87
Trav/Holiday 170:33 (c,4) D '88
—Inca hat (Bolivia)
Nat Geog 171:451 (c,2) Ap '87
—Mickey Mouse hat
Trav&Leisure 20:105 (c,4) Mr '90
—National park ranger's hat
Life 14:97 (c,4) Summer '91
—Panama hat
Trav&Leisure 19:82 (c,4) Mr '89
—Selling Soviet officers' caps (Hungary)
Nat Geog 179:20 (c,4) Mr '91
—Traditional hats (Brittany, France)
Trav/Holiday 172:45 (c,3) Jl '89
—Unusual women's hats
Life 12:8 (c,4) Ap '89
—Woman's fashionable straw hat
Sports Illus 68:2–3 (c,1) My 16 '88
HAVANA, CUBA
Nat Geog 180:92–107 (c,1) Ag '91
—Old Havana
Nat Geog 176:278–300 (map,c,1) Ag
'89

—Poland
Nat Geog 173:112–13 (c,1) Ja '88
HAYES, RUTHERFORD B.
—1877 inaugural parade
Am Heritage 38:60 (drawing,4) D '87
HAZELNUT TREES
Gourmet 48:42 (c,2) Ag '88
—Leaves
Natur Hist 99:36 (c,1) My '90
HEADGEAR
—19th cent. Comanche headdress (Oklahoma)
Smithsonian 20:42 (c,1) O '89
—1905 girl wearing coins (Algeria)
Nat Geog 174:322 (4) S '88
—1920 Yoruba helmet mask (Nigeria)
Smithsonian 22:100 (c,4) Je '91
—Ancient Sumerian gold headdress (Iraq)
Smithsonian 19:141 (c,1) D '88
—Beaded headcloths (Saudi Arabia)
Natur Hist 98:68 (c,3) Ag '89
—Bearskin hats of British palace guards
Life 11:26–7 (c,1) Ap '88
—Berets (France)
Trav/Holiday 168:69 (c,2) Jl '87
Nat Geog 173:575 (c,4) My '88
—Birkah head covering (Oman)
Nat Geog 173:658 (c,4) My '88
—Breton lace coiffes (France)
Trav/Holiday 168:67 (c,4) Jl '87
Trav/Holiday 172:45 (c,3) Jl '89
Trav&Leisure 20:102, 104–5 (c,1) Ja '90
Sports Illus 75:2–3 (c,1) Ag 5 '91
—Breton quichenotte (West Indies)
Gourmet 47:47 (c,4) Mr '87
—Ceremonial headgear (Papua New Guinea)
Trav&Leisure 17:cov., 77, 80–4 (c,1) Mr '87
—Crow Indian headdress (Montana)
Trav&Leisure 19:129 (c,2) Mr '89
—Endiablada costume (Cuenca, Spain)
Trav/Holiday 172:46 (c,4) D '89
—Fez (Morocco)
Trav&Leisure 18:76–8 (c,4) Je '88
—Jivaro Indian headdress (Ecuador)
Smithsonian 20:44–5 (c,2) O '89
—Tirío Indians ceremonial headdress (Suriname)
Smithsonian 19:101 (c,1) F '89
—Turbans (Tunisia)
Trav&Leisure 18:99 (c,4) D '88
—Woman's headdress (Tibet)
Smithsonian 22:93 (c,2) Je '91
—See also
CROWNS
GOGGLES
HATS
HELMETS

MASKS
MASKS, CEREMONIAL
WIGS
HEARING AIDS
—Using hair dryer on hearing aid
Sports Illus 67:108–9 (c,2) O 12 '87
HEARST, WILLIAM RANDOLPH
Am Heritage 39:18 (drawing,4) Ap '88
Am Heritage 42:40 (4) My '91
Trav/Holiday 176:82 (4) Jl '91
—Hearst Castle, San Simeon, California
Trav&Leisure 17:132–3 (c,2) S '87
—Patty Hearst during bank robbery (1974)
Life 11:50 (4) Fall '88
HEARTS
—Human infant's heart
Nat Geog 177:125 (c,2) Mr '90
—Jarvik-7 artificial heart
Life 12:142 (c,4) Fall '89
—X-ray of enlarged heart (Bolivia)
Nat Geog 171:446 (c,3) Ap '87
HEIDELBERG, WEST GERMANY
Gourmet 47:48–53, 94 (c,1) Ja '87
—Neckar River
Gourmet 47:49 (c,1) Ja '87
HELICOPTERS
Trav&Leisure 17:40 (c,4) Ag '87
Trav/Holiday 168:48 (c,2) S '87
Sports Illus 68:28–9 (c,2) Ap 25 '88
Nat Geog 175:66–7 (c,1) Ja '89
Life 14:97 (c,4) N '91
—Antarctica
Trav&Leisure 17:96 (c,3) Ag '87
—Army helicopter (Pakistan)
Nat Geog 172:542–3 (c,2) O '87
—Helicopter body factory (Indonesia)
Nat Geog 175:118 (c,2) Ja '89
—In Vietnam War
Am Heritage 42:112–13 (painting,c,2) F '91
—New Zealand
Trav&Leisure 17:124–5 (c,1) Je '87
Nat Geog 172:302 (c,4) S '87
—Norway
Natur Hist 96:39 (c,1) D '87
—Rescuing bighorn (California)
Sports Illus 69:6 (c,4) S 19 '88
—Switzerland
Nat Geog 175:646 (c,1) My '89
—U.S. rescuing sailors from burning ship (Mideast)
Life 11:38–9 (c,1) Ap '88
HELMETS
—16th cent. Ottoman helmet (Turkey)
Trav&Leisure 17:30 (c,4) F '87
Nat Geog 172:587 (c,4) N '87
—1802 Tlingit Indians battle helmet (Alaska)
Smithsonian 19:42–3 (c,1) O '88

—1954 football helmet
 Sports Illus 71:26 (4) N 15 '89
—Ancient Greek helmet
 Nat Geog 173:731 (c,4) Je '88
—Auto racing helmet
 Sports Illus 72:44–5 (c,1) My 28 '90
—Baseball
 Sports Illus 67:46–7 (c,1) Jl 6 '87
—Bomb squad helmet
 Life 12:136 (c,4) Mr '89
—Football helmet (U.S.S.R.)
 Life 13:1 (c,2) Jl '90
—Hard hat with U.S. and Russian flags
 Nat Geog 179:39 (c,4) F '91
—Hard hats
 Smithsonian 17:45 (c,4) F '87
HELSINKI, FINLAND
 Trav&Leisure 18:72, 78 (c,4) My '88
 Trav&Leisure 18:181 (map,c,4) S '88
HEMINGWAY, ERNEST
 Smithsonian 19:65 (4) D '88
 Life 13:38–9 (1) Fall '90
 Trav/Holiday 176:122 (4) Jl '91
 Trav/Holiday 176:79 (4) N '91
—Home (Key West, Florida)
 Trav/Holiday 167:43 (c,3) Ja '87
 Trav&Leisure 19:132 (c,4) D '89
HENIE, SONJA
 Sports Illus 75:8–9 (2) D 16 '91
HENRI, ROBERT
—Painting of Gloria Vanderbilt Whitney
 (1916)
 Am Heritage 40:106 (c,4) S '89
HENRI IV (FRANCE)
 Smithsonian 21:118 (painting,c,4) S '90
HENRY VIII (GREAT BRITAIN)
 Nat Geog 172:563 (painting,c,4) N '87
HENRY, O.
 Am Heritage 41:68–71 (1) D '90
—Home (New York City, New York)
 Am Heritage 41:74 (4) D '90
HENRY, PATRICK
 Smithsonian 18:42 (drawing,4) Jl '87
 Life 10:70 (painting,c,4) Fall '87
 Life 14:42 (painting,c,4) Fall '91
—Patrick Henry's writing desk
 Life 10:70 (c,2) Fall '87
HENSON, MATTHEW
 Nat Geog 174:422 (4) S '88
—1988 reinterment of Matthew Henson
 (Arlington, Virginia)
 Nat Geog 174:428–9 (c,1) S '88
—Eskimo descendants (Greenland)
 Nat Geog 174:423–9 (c,2) S '88
HEPBURN, KATHARINE
 Life 10:118 (4) Ja '87
 Life 11:62–4 (c,1) Mr '88
HERB INDUSTRY
—Flowers drying (Maine)

Nat Geog 176:316–17 (c,2) S '89
HERBERT, VICTOR
 Am Heritage 40:41 (4) F '89
HERBS
—Herb garden (Ireland)
 Gourmet 50:54–5, 102 (c,1) Ag '90
—See also
 LAVENDER
 SAGE
HERCULANEUM, ITALY
 Trav&Leisure 18:78–9 (c,1) Ag '88
HERMIT CRABS
 Nat Wildlife 27:52 (c,3) D '88
 Natur Hist 98:80 (c,4) O '89
 Nat Geog 178:37 (c,4) O '90
HERONS
 Natur Hist 96:40–3 (c,1) Ag '87
 Natur Hist 97:34–9 (c,1) F '88
 Nat Wildlife 26:54 (c,4) F '88
 Smithsonian 19:155 (painting,c,2) My '88
 Trav/Holiday 171:64 (c,4) Ap '89
 Natur Hist 98:96 (c,2) O '89
 Nat Wildlife 28:2 (c,2) Ap '90
—Blue
 Trav/Holiday 170:59 (c,4) Jl '88
 Sports Illus 69:72 (c,4) S 12 '88
—Great blue
 Natur Hist 97:34 (etching,c,2) Mr '88
 Natur Hist 97:84–5 (c,1) Je '88
 Trav/Holiday 170:12 (c,4) Ag '88
 Trav&Leisure 19:172 (c,4) D '89
 Nat Geog 180:17 (c,3) O '91
—Heron on turtle's back
 Nat Wildlife 30:56 (c,2) D '91
—See also
 EGRETS
HERSCHEL, SIR JOHN
 Life 11:58 (4) Fall '88
HESS, RUDOLF
 Life 10:40–2 (c,1) O '87
HEYERDAHL, THOR
—Heyerdahl's raft "Kon-Tiki" (Norway)
 Trav&Leisure 20:157 (c,4) My '90
HIBISCUS
 Trav/Holiday 169:20 (c,2) Mr '88
 Trav/Holiday 171:57 (c,4) F '89
 Life 12:84 (c,4) Jl '89
HIEROGLYPHICS
—Ancient Egypt
 Nat Geog 173:536–7 (c,1) Ap '88
—Ancient Maya (Belize)
 Smithsonian 20:98, 108 (c,1) D '89
—Sumerian cuneiform
 Smithsonian 18:131 (4) My '87
HIGH JUMPING
 Sports Illus 66:50, 53 (c,4) Je 15 '87
 Sports Illus 67:26–7 (c,3) Jl 13 '87
 Sports Illus 70:98 (c,4) Ja 9 '89
 Sports Illus 70:34 (c,4) F 13 '89

Nat Geog 176:390–405 (map,c,1) S '89
—See also
ANNAPURNA MOUNTAIN
MOUNT EVEREST
HIMALAYA MOUNTAINS, TIBET
Nat Geog 174:612–59, 674–9 (map,c,1) N
'88
Hindu Kush Mountains, Afghanistan. See
KHYBER PASS
HINDUISM—ART
—12th cent. Angkor Wat bas relief of myth
(Cambodia)
Smithsonian 21:45–7 (c,1) My '90
—Clay images of goddess Kali (India)
Smithsonian 22:32–3 (c,1) Jl '91
HINDUISM—COSTUME
—Hindu boys (Nepal)
Trav&Leisure 20:62–3 (c,1) F '90
—Hindu guru (India)
Life 14:58–9 (c,1) D '91
HINDUISM—RITES AND FESTIVALS
—Bathing in Narmada River, India
Smithsonian 21:119 (c,2) N '90
—Bathing in Pushkin lake, India
Gourmet 51:80 (c,4) My '91
—Bride marrying five brothers (Nepal/
Tibet)
Natur Hist 96:cov., 38–49 (c,1) Mr '87
—Burning wife at husband's funeral in sut-
tee rite (India)
Smithsonian 18:47 (painting,c,4) Ja '88
—Ceremony honoring Hindu goddess (Ne-
pal)
Nat Geog 174:345 (c,3) S '88
—Maha Kumbh Mela ritual bathing (India)
Nat Geog 177:106–17 (c,1) My '90
—Pooram festival (Trichur, India)
Nat Geog 173:602–3 (c,1) My '88
—Pushkar Fair, India
Trav/Holiday 170:34–9 (c,1) Ag '88
—Rolling on ground during Svasthani
Vrata (Nepal)
Nat Geog 172:36 (c,1) Jl '87
—Siva's Night festival (Nepal)
Nat Geog 172:60–1 (c,1) Jl '87
—Theyyam ritual dance (India)
Nat Geog 173:604–5 (c,1) My '88
HINDUISM—SHRINES AND SYM-
BOLS
—Mt. Kailas, Tibet
Nat Geog 172:768–9 (c,1) D '87
Nat Geog 174:676 (c,1) N '88
—Ramayana hero Hanuman
Smithsonian 19:118 (painting,c,4) Ja '89
—Sri Veeramakaliamman Temple, Sin-
gapore
Trav&Leisure 19:194 (c,2) Mr '89
HIPPOPOTAMI
Trav/Holiday 168:24 (C,3) Jl '87

Trav/Holiday 171:45 (C,4) Ap '89
Nat Geog 178:cov., 9 (c,1) D '90
—Twin babies
Life 12:7 (c,3) Mr '89
HIROHITO (JAPAN)
—Hirohito's 1989 funeral
Life 12:76 (c,4) S '89
Life 13:12–13 (c,1) Ja '90
HIRSCHFELD, AL
—American diners at British hotel (1950)
Trav/Holiday 173:122 (drawing,4) F '90
History. See
specific countries—HISTORY
list under PEOPLE AND CIVILIZA-
TIONS
HITCHCOCK, ALFRED
Life 12:110 (3) Spring '89
HITLER, ADOLF
Am Heritage 39:36 (4) Mr '88
Sports Illus 68:53 (4) Ap 11 '88
Smithsonian 19:162–3, 172, 178, 180, 198
(1) O '88
Smithsonian 19:180 (4) N '88
Life 12:120 (4) N '89
Smithsonian 21:95 (2) Mr '91
Smithsonian 22:86 (4) Jl '91
Am Heritage 42:60, 71, 76 (4) D '91
HOATZINS (BIRDS)
Natur Hist 100:49–55 (c,1) Ag '91
Hoaxes. See
CARDIFF GIANT
HOBBIES
—Gem collecting
Smithsonian 22:60–70 (c,2) S '91
—Unusual collections
Smithsonian 20:59–67 (c,2) Mr '90
HOBOES
—Cartoons about 1929 stock market crash
and Depression
Am Heritage 39:105–9 (3) Jl '88
—Iowa
Trav/Holiday 170:96 (4) N '88
HO CHI MINH (VIETNAM)
—Ho Chi Minh's deathbed (Hanoi, Viet-
nam)
Nat Geog 176:575 (c,4) N '89
HO CHI MINH CITY (SAIGON), VIET-
NAM
Nat Geog 176:604–21 (map,c,1) N '89
Trav&Leisure 21:120–3, 174 (c,1) Je '91
—During Vietnam War
Am Heritage 42:104–5 (painting,c,2) F
'91
—Saigon River
Nat Geog 176:610–13 (c,1) N '89
HOCKEY
—1948 Olympics (St. Moritz)
Sports Illus 75:55–90 (c,1) D 16 '91
—1980 Olympics (Lake Placid)

Sports Illus 67:47, 53–4, 58 (c,2) S 21 '87
Life 12:181 (c,2) Fall '89
Sports Illus 71:161 (c,2) N 15 '89
—1988 Olympics (Calgary)
Sports Illus 68:26–35 (c,1) F 29 '88
Sports Illus 68:74–6 (c,3) Mr 7 '88
—Boys playing on frozen pond
Smithsonian 18:34 (c,4) D '87
Trav&Leisure 21:E1 (c,4) F '91
—Boys playing on roller skates
Sports Illus 70:87 (c,4) Mr 27 '89
—Children playing (Sweden)
Sports Illus 68:144–53 (c,1) Ja 27 '88
—Field hockey (1988 Olympics)
Sports Illus 69:52–3 (c,2) S 26 '88
—Making hockey pucks (Quebec)
Sports Illus 73:14, 18 (c,4) O 8 '90
—U.S.-U.S.S.R. game
Sports Illus 66:2–3, 12–19 (c,1) F 23 '87
Sports Illus 67:24–5 (c,3) S 14 '87
Sports Illus 67:2–3, 50–7 (c,1) D 21 '87
Sports Illus 68:142–3, 169 (c,1) Ja 27 '88
—Women's field hockey
Sports Illus 69:100–1 (c,4) S 14 '88
HOCKEY—COLLEGE
Sports Illus 68:34–7 (c,1) Ja 25 '88
Sports Illus 70:67–8 (c,3) Ja 30 '89
—NCAA Championships 1987 (North Da-
kota vs. Michigan State)
Sports Illus 66:132–4 (c,4) Ap 6 '87
—NCAA Championships 1990
Sports Illus 72:2–3, 76–7 (c,1) Ap 9 '90
—NCAA Championships 1991
Sports Illus 74:72 (c,2) Ap 8 '91
HOCKEY—PROFESSIONAL
Sports Illus 66:37–8 (c,2) Mr 9 '87
Sports Illus 66:26–33 (c,1) Ap 27 '87
Sports Illus 66:20–5 (c,1) My 4 '87
Sports Illus 67:88–110 (c,1) O 12 '87
Sports Illus 68:20–5 (c,1) Mr 21 '88
Sports Illus 68:2–3, 42–5 (c,1) My 2 '88
Sports Illus 71:86–95 (c,2) O 9 '89
Sports Illus 73:58–60, 82–95 (c,1) O 8 '90
Sports Illus 74:cov., 22– (c,1) Mr 18 '91
Sports Illus 74:16–21 (c,1) My 6 '91
Sports Illus 75:68–70, 75–83 (c,1) O 7 '91
Sports Illus 75:80–1 (c,1) D 30 '91
—1958 goalie mask
Sports Illus 71:62 (c,4) N 15 '89
—Aerial view of goal area
Sports Illus 69:2–3 (c,1) O 31 '88
—Checking
Sports Illus 72:2–3, 30 (c,1) Ap 23 '90
—Crashing into goalie
Sports Illus 72:36–40 (c,1) Ap 30 '90
—Fights
Sports Illus 66:24–5 (c,2) Mr 30 '87
Sports Illus 66:25 (c,4) My 4 '87
Sports Illus 69:2–3 (c,1) D 5 '88

Sports Illus 74:40–2 (c,1) Ap 22 '91
—Player slammed against glass
Life 11:118–19 (c,1) Fall '88
—Players piled into goal
Sports Illus 71:142 (c,4) N 15 '89
—Referees
Sports Illus 68:40–2 (c,3) My 16 '88
—Scoring goal
Sports Illus 67:26 (c,2) N 16 '87
—Stanley Cup Playoffs 1987 (Oilers vs.
Flyers)
Sports Illus 66:cov., 26–9 (c,1) Je 1 '87
Sports Illus 66:22–5 (c,1) Je 8 '87
Sports Illus 67:56–7 (c,1) D 28 '87
—Stanley Cup Playoffs 1988 (Oilers vs.
Bruins)
Sports Illus 68:cov., 16–21 (c,1) My 30 '88
Sports Illus 68:42, 47 (c,3) Je 6 '88
—Stanley Cup Playoffs 1989
Sports Illus 70:24–6, 31 (c,1) My 22 '89
Sports Illus 70:22–3 (c,1) My 29 '89
Sports Illus 70:44–7 (c,2) Je 5 '89
—Stanley Cup Playoffs 1990 (Oilers vs.
Bruins)
Sports Illus 72:19–23 (c,1) My 28 '90
Sports Illus 72:46–8, 53 (c,1) Je 4 '90
—Stanley Cup Playoffs 1991 (Penguins vs.
North Stars)
Sports Illus 74:34–6, 41 (c,1) My 20 '91
Sports Illus 74:28–32 (c,1) My 27 '91
Sports Illus 74:36–8, 43 (c,1) Je 3 '91
—Winning team celebrating
Sports Illus 74:43 (c,3) Je 3 '91
HOCKEY—PROFESSIONAL—HU-
MOR
Sports Illus 66:36–9 (drawing,c,1) Ja 19
'87
Sports Illus 68:24–7 (painting,c,1) Ap 25
'88
HOCKEY PLAYERS
—Girls in uniform (Quebec)
Nat Geog 179:72–3 (c,1) Mr '91
—Goalie
Sports Illus 66:2–3 (c,1) F 23 '87
HOCKEY TEAMS
—1990 college team
Sports Illus 72:2–3 (c,1) Ap 9 '90
HOGAN, BEN
Am Heritage 42:58 (4) Ap '91
HOGARTH, WILLIAM
—1721 satire of British stock scandal
Smithsonian 20:174 (engraving,3) D '89
HOGS
Smithsonian 21:127 (c,2) Ap '90
Nat Wildlife 29:45 (c,4) D '90
—Wild hogs
Nat Wildlife 26:16–17 (c,4) Je '88
—See also
WART HOGS

HOLBEIN, HANS THE YOUNGER
—Portrait of Thomas Cromwell
Trav&Leisure 18:118 (painting,c,4) N
'88
—Portrait of Sir Thomas More (1527)
Trav&Leisure 18:117 (painting,c,3) N
'88
HOLIDAY, BILLIE
Life 11:14 (3) N '88
HOLIDAYS
—Bastille Day parade (Paris, France)
Nat Geog 176:6 (c,4) Jl '89
—Good Friday (Guatemala)
Nat Geog 173:cov., 799 (c,1) Je '88
Nat Geog 176:425–6 (c,1) O '89
—Good Friday (Haiti)
Nat Geog 172:668–9 (c,1) N '87
—Good Friday procession (Malta)
Nat Geog 175:710 (c,4) Je '89
—Ground Hog Day scene
Gourmet 51:82 (painting,c,3) F '91
—Receiving tie for Father's Day
Smithsonian 20:122–3 (painting,c,1) My
'89
—Summer solstice ritual at Stonehenge,
England
Smithsonian 18:166 (c,4) Mr '88
—See also
BIRTHDAY PARTIES
CHRISTMAS
EASTER
FESTIVALS
FOURTH OF JULY
HALLOWEEN
LABOR DAY
MAY DAY
MEMORIAL DAY
NEW YEAR'S EVE
NEW YEAR'S DAY
PARADES
PARTIES
RELIGIOUS RITES AND FESTI-
VALS
THANKSGIVING
VETERANS DAY
HOLLYWOOD, CALIFORNIA
—1923 dedication of "Hollywoodland"
sign
Life 10:12–13 (1) Ap '87
—Frances Howard Goldwyn Library
Smithsonian 18:52–3 (c,1) Ap '87
—Hollywood Boulevard scenes
Trav/Holiday 168:42–7 (c,3) Ag '87
—Mann's Chinese Theater
Trav/Holiday 168:45 (c,4) Ag '87
—Stars' names in Hollywood sidewalk
Life 10:107 (c,2) Ap '87
Trav/Holiday 168:45, 47 (c,3) Ag '87
—Sunset Towers building

Trav&Leisure 18:41 (drawing,c,4) Mr
'88
HOLMES, OLIVER WENDELL, JR.
Smithsonian 20:178 (painting,c,4) D '89
Smithsonian 21:192 (4) Je '90
Life 13:87 (4) Fall '90
Life 14:61 (4) Fall '91
HOLMES, SHERLOCK
Smithsonian 17:14 (drawing,4) F '87
Holy Roman Empire. See
MARIA THERESA
HOME FURNISHINGS
—1900 stained glass screen by Tiffany
Am Heritage 39:21 (c,1) S '88
—See also
BLANKETS
CHANDELIERS
CLOCKS
CURTAINS
FURNITURE
GLOBES
HOUSEWARES
INCENSE BURNERS
LAMPS
MIRRORS
PICTURE FRAMES
QUILTS
RUGS
SPINNING WHEELS
WEATHERVANES
HOMER, WINSLOW
—1877 painting of schoolmistress
Am Heritage 41:cov. (c,1) F '90
—"Gulf Stream"
Smithsonian 19:46–7 (painting,c,3) F '89
—Painting of hunter (1891)
Nat Wildlife 25:48–9 (c,1) O '87
—Paintings by him
Smithsonian 21:146 (c,4) Mr '91
—"Rum Cay" (1899)
Smithsonian 18:192 (painting,c,4) S '87
HOMES OF FAMOUS PEOPLE
—Carl Larsson's home (Sundborn, Swe-
den)
Gourmet 47:57–9 (c,1) Jl '87
—Liberace's penthouse (California)
Life 11:8 (c,3) Mr '88
—Henry Phipps, Jr.'s birthplace (Philadel-
phia, Pennsylvania)
Am Heritage 38:104 (4) N '87
—See also
ADAMS, HENRY BROOKS
ADAMS, JOHN
ADAMS, JOHN QUINCY
ANDERSEN, HANS CHRISTIAN
BALZAC, HONORE DE
BEAUMONT, WILLIAM
BELL, ALEXANDER GRAHAM
BIERSTADT, ALBERT

BUSH, GEORGE
CARROLL, CHARLES
CATHER, WILLA
CHURCHILL, WINSTON
COOK, JAMES
COOLIDGE, CALVIN
DIOCLETIAN
DUMAS, ALEXANDRE PERE
EDISON, THOMAS ALVA
EISENHOWER, DWIGHT DAVID
FAIRBANKS, DOUGLAS
FAULKNER, WILLIAM
FRENCH, DANIEL CHESTER
FREUD, SIGMUND
GETTY, J. PAUL
GILLETTE, WILLIAM HOOKER
GRIMM, BROTHERS
GROPIUS, WALTER
HAMILTON, ALEXANDER
HARDY, THOMAS
HAY, JOHN MILTON
HEARST, WILLIAM RANDOLPH
HEMINGWAY, ERNEST
HENRY, O.
HUGO, VICTOR
IRVING, WASHINGTON
JACKSON, ANDREW
JEFFERSON, THOMAS
JOHNSON, LYNDON BAINES
JONES, JOHN PAUL
KAHLO, FRIDA
KING, MARTIN LUTHER, JR.
KIPLING, RUDYARD
LAFAYETTE, MARQUIS DE
LEE, ROBERT E.
LINCOLN, ABRAHAM
LONGFELLOW, HENRY WADS-
 WORTH
LOUIS XIII
MADISON, JAMES
MARSHALL, JOHN
MASON, GEORGE
MELVILLE, HERMAN
MORGAN, JOHN PIERPONT
MOZART, WOLFGANG AMADEUS
NAPOLEON
PACA, WILLIAM
PALMER, POTTER
PICKFORD, MARY
POTTER, BEATRIX
PRESLEY, ELVIS
REMINGTON, FREDERIC
REVERE, PAUL
ROOSEVELT, FRANKLIN DELANO
ROSS, BETSY
ROUSSEAU, JEAN JACQUES
RUTH, GEORGE HERMAN (BABE)
ST. GAUDENS, AUGUSTUS
SÜLEYMAN

THOREAU, HENRY DAVID
TRUMBULL, JOHN
TWAIN, MARK
VAN BUREN, MARTIN
VOLTAIRE
WASHINGTON, BOOKER T.
WASHINGTON, GEORGE
WHARTON, EDITH
WHITE HOUSE
WOOLF, VIRGINIA
WRIGHT, FRANK LLOYD
WRIGHT, WILBUR & ORVILLE
WYETH, ANDREW
HONDURAS
—Copán's Maya ruins
 Nat Geog 176:480–505 (map,c,1) O '89
—Rain forest burning down
 Nat Geog 176:438–9 (c,1) O '89
HONEGGER, ARTHUR
 Nat Geog 176:170 (3) Jl '89
HONEY INDUSTRY
—Gurungs harvesting honey from large
 honeybees (Nepal)
 Nat Geog 174:cov., 660–71 (c,1) N '88
HONG KONG
 Trav&Leisure 18:12, 68–101, 108–30
 (map,c,1) Ja '88
 Nat Geog 173:329 (c,1) Mr '88
 Gourmet 48:62–7 (c,2) Mr '88
 Smithsonian 20:40–53 (c,1) Ap '89
 Trav/Holiday 172:50–9 (c,1) S '89
 Gourmet 50:110–15 (c,1) O '90
 Nat Geog 179:100–31 (map,c,1) F '91
 Trav/Holiday 176:cov., 48–59 (c,1) O
 '91
 Trav&Leisure 21:198 (c,4) O '91
—1900
 Trav&Leisure 18:69–70 (4) Ja '88
—Kowloon
 Nat Geog 179:106–19 (c,1) F '91
 Trav/Holiday 176:49, 58 (c,4) O '91
—Po Lin Monastery, Lantau
 Trav/Holiday 167:64 (c,4) F '87
—Shopping street
 Trav/Holiday 170:43 (c,4) S '88
—Wanchai district
 Trav&Leisure 20:64–5 (c,4) F '90
HONG KONG—ART
—Insects made from grass
 Trav/Holiday 167:34–5 (c,3) Mr '87
HONG KONG—HISTORY
—1793–1850s
 Smithsonian 20:44–8 (painting,c,3) Ap
 '89
HONOLULU, HAWAII
 Trav&Leisure 19:80–95 (c,1) Ja '89
 Trav/Holiday 174:78–86 (map,c,1) O '90
—Ancient Wizard Stones
 Trav/Holiday 174:78–9 (c,1) O '90

HOOD, JOHN BELL
 Am Heritage 41:89 (4) Mr '90
HOOKER, JOSEPH
 Am Heritage 38:56 (4) D '87
 Am Heritage 41:72 (4) Mr '90
HOOVER, HERBERT
 Am Heritage 39:36 (4) Mr '88
 Life 13:70 (4) Fall '90
 Am Heritage 42:75 (4) F '91
—President Hoover playing medicine ball
 Sports Illus 67:6 (4) N 9 '87
HOOVER, J. EDGAR
 Life 13:88 (4) Fall '90
HOOVER DAM, ARIZONA/NEVADA
 Am Heritage 41:38 (c,4) My '90
 Nat Geog 179:12 (c,1) Je '91
—1940
 Am Heritage 39:164 (4) N '88
HOPI INDIANS (ARIZONA)—COS-
 TUME
 Trav/Holiday 170:40–3 (c,2) Ag '88
—Early 20th cent.
 Natur Hist 97:24–6 (2) Ag '88
HOPI INDIANS (ARIZONA)—RITES
 AND FESTIVALS
—Early 20th cent. rain dancers
 Natur Hist 97:24 (2) Ag '88
HOPI INDIANS (SOUTHWEST)—REL-
 ICS
—Kachina doll
 Trav&Leisure 17:125 (c,2) My '87
HOPPER, EDWARD
—"Dawn before Gettysburg" (1934)
 Am Heritage 38:79 (painting,c,3) D '87
—"Early Sunday morning" (1930)
 Am Heritage 40:110–11 (painting,c,3) S
 '89
HOROWITZ, VLADIMIR
 Am Heritage 40:104 (4) F '89
 Trav&Leisure 20:89 (4) Ag '90
HORSE FARMS
—Carolinas
 Gourmet 51:87 (c,1) Ap '91
—Czechoslovakia
 Nat Geog 171:132 (c,4) Ja '87
—Kentucky
 Trav&Leisure 17:43–4 (c,3) Jl '87
 Sports Illus 75:134 (c,4) S 2 '91
—Maryland
 Am Heritage 38:94–5 (c,1) F '87
—"Whoa" stop sign (Virginia)
 Trav/Holiday 173:16 (c,4) Mr '90
—See also
 STABLES
Horse jumping. See
 EQUESTRIAN EVENTS
HORSE RACING
 Sports Illus 66:26–31 (c,1) Ap 13 '87
 Trav/Holiday 168:8, 10 (c,4) Jl '87

 Sports Illus 67:36–8 (c,2) Ag 10 '87
 Sports Illus 68:28–9 (c,2) Mr 14 '88
 Sports Illus 70:83–4 (c,4) Ap 3 '89
 Sports Illus 71:36–7 (c,1) O 2 '89
 Sports Illus 74:40–1 (c,2) Mr 25 '91
 Gourmet 51:85 (c,3) Ap '91
 Sports Illus 74:28–9 (c,1) Ap 29 '91
 Gourmet 51:48–9 (c,1) Jl '91
—16th cent. depiction of Palio race (Siena,
 Italy)
 Smithsonian 22:68–9 (painting,c,1) Jl '91
—1887 (Saratoga, New York)
 Sports Illus 69:78–9 (drawing,3) Ag 22
 '88
—1894 (France)
 Smithsonian 22:47 (painting,c,3) Ag '91
—Early 20th cent.
 Am Heritage 41:99, 102 (painting,c,2) Jl
 '90
—1904 tape starting gate
 Sports Illus 73:92 (4) O 29 '90
—1956
 Sports Illus 71:52–3 (c,1) N 15 '89
—Argentina
 Trav&Leisure 18:139 (c,2) D '88
—Belmont Stakes 1973
 Sports Illus 71:128–9 (c,1) N 15 '89
—Belmont Stakes 1978
 Sports Illus 66:44 (c,2) Je 8 '87
—Belmont Stakes 1987
 Sports Illus 66:26–8, 33 (c,1) Je 15 '87
—Belmont Stakes 1988
 Sports Illus 68:34–5 (c,3) Je 20 '88
—Belmont Stakes 1989
 Sports Illus 70:44–5 (c,2) Je 19 '89
—Belmont Stakes 1990
 Sports Illus 72:38–9 (c,3) Je 18 '90
—Belmont Stakes 1991
 Sports Illus 74:72 (c,4) Je 17 '91
—Breeders' Cup 1984
 Sports Illus 73:123–4, 130 (c,2) O 8 '90
—Breeders' Cup 1986
 Sports Illus 73:126 (c,4) O 8 '90
—Breeders' Cup 1987
 Sports Illus 67:36–8, 43 (c,1) N 30 '87
 Sports Illus 67:116–17 (c,1) D 28 '87
 Sports Illus 71:11, 22 (c,2) O 23 '89
—Breeders' Cup 1988
 Sports Illus 69:5–10 (c,3) O 24 '88
 Sports Illus 69:16–26, 31 (c,1) N 14 '88
 Sports Illus 69:80–1 (c,1) D 26 '88
 Sports Illus 70:40 (c,3) F 6 '89
—Breeders' Cup 1989
 Sports Illus 71:28–30, 35 (c,1) N 13 '89
—Breeders' Cup 1990
 Sports Illus 73:60–7 (c,1) N 5 '90
 Sports Illus 73:70, 92–3 (c,1) D 31 '90
 Sports Illus 75:99 (c,2) O 21 '91
—Breeders' Cup 1991

—Irish mare
 Trav&Leisure 20:cov. (c,1) Je '90
—Robert E. Lee's horse Traveller
 Am Heritage 42:70 (4) My '91
—Miniature horse
 Life 11:12 (c,4) Je '88
 Trav/Holiday 172:106 (c,4) Jl '89
—Piebalds
 Trav&Leisure 20:E10 (c,3) S '90
—Przewalski horses
 Smithsonian 18:144 (c,4) My '87
 Nat Wildlife 29:47 (c,4) D '90
—Saddle making (France)
 Gourmet 47:44 (c,4) F '87
—White horses
 Gourmet 49:48 (c,3) Jl '89
—Wild horses
 Sports Illus 68:28–35 (c,2) Ap 25 '88
—Wild ponies
 Trav/Holiday 170:56–9 (c,1) Jl '88
 Trav&Leisure 19:E10 (c,3) O '89
—See also
 CARRIAGES AND CARTS—
 HORSE-DRAWN
 EQUESTRIAN EVENTS
 HORSE FARMS
 HORSE RACING
 HORSEBACK RIDING
 MUSTANGS
 STABLES
HORSES, RACING
 Sports Illus 66:44 (c,4) My 4 '87
 Sports Illus 71:7 (model,c,4) Jl 24 '89
 Sports Illus 71:76–81 (c,1) O 30 '89
 Trav&Leisure 21:25 (c,4) My '91
 Gourmet 51:49–53 (c,1) Jl '91
—Alydar's grave (Kentucky)
 Sports Illus 75:139 (c,4) S 2 '91
—Dan Patch (early 20th cent.)
 Am Heritage 41:99–104 (painting,c,2) Jl
 '90
—Fallen race horse being destroyed
 Sports Illus 73:60–7 (c,1) N 5 '90
—Grooming race horse
 Sports Illus 74:66–81 (c,1) Je 10 '91
—Injured horse
 Sports Illus 73:70, 92–3 (c,1) D 31 '90
—Kentucky Derby winners 1881–1987
 Sports Illus 70:47–76 (c,2) My 1 '89
—Secretariat
 Sports Illus 72:78–86, 92–6 (painting,c,1)
 Je 4 '90
—Secretariat's grave (Kentucky)
 Sports Illus 71:25 (c,4) O 16 '89
—Whirlaway (1942)
 Sports Illus 75:6–8 (4) N 4 '91
HORSESHOES
—Early 20th cent. Dan Patch horseshoe
 Am Heritage 41:105 (c,4) Jl '90

HOSPITALS
—1890s hospital wards (Northeast)
 Am Heritage 38:36–7 (c,1) F '87
 Am Heritage 38:16 (4) S '87
—1918 makeshift flu ward (Iowa)
 Smithsonian 19:130–1 (1) Ja '89
—Bellevue history, New York City, New
 York
 Am Heritage 38:36–43 (c,1) F '87
—Bethesda Naval Hospital, Maryland
 Life 10:34 (c,4) My '87
—Comatose hospital patients
 Life 12:80–7 (c,1) Ag '89
—Emergency room scenes (Colorado)
 Life 12:48–55 (1) Ap '89
—Hospital patients
 Life 11:42–3, 47 (c,1) Ja '88
 Smithsonian 20:54–67 (2) S '89
—Inner city surgical waiting room (Detroit,
 Michigan)
 Life 14:54 (c,4) Je '91
—Palestinian hospital patients (Israel)
 Life 11:114–20 (1) Je '88
—Rural hospital scenes
 Smithsonian 20:52–67 (1) S '89
HOT SPRINGS, ARKANSAS
 Am Heritage 42:106–15, 138 (c,1) Ap '91
—1930s
 Smithsonian 22:104–15 (c,1) Jl '91
HÔTEL DES INVALIDES, PARIS,
 FRANCE
 Gourmet 49:52–3 (c,1) Jl '89
HOTELS
—19th cent. (Boscobel, Wisconsin)
 Am Heritage 42:105 (c,4) Ap '91
—1860s (New Zealand)
 Nat Geog 171:668–9 (c,1) My '87
—1875 (San Francisco, California)
 Am Heritage 38:98 (4) Ap '87
—Early 20th cent. luggage stickers de-
 picting hotels
 Am Heritage 38:cov., 29–37, 114 (c,4)
 Ap '87
—Early 20th cent. resort hotel (Alberta)
 Nat Geog 171:818–19 (c,1) Je '87
—1920s hotel ceiling (Louisville, Ken-
 tucky)
 Gourmet 48:77 (c,1) My '88
—1930s Arlington lobby, Hot Springs, Ar-
 kansas
 Smithsonian 22:115 (painting,c,2) Jl '91
—1930s resort hotel (St. Augustine, Flor-
 ida)
 Am Heritage 39:30 (4) F '88
—Algonquin lobby, New York City, New
 York
 Trav&Leisure 21:24 (c,4) Ap '91
—Apalachicola, Florida
 Trav&Leisure 19:92 (c,4) My '89

Trav/Holiday 170:11 (c,4) D '88
—Ornate lobby (Richmond, Virginia)
Trav&Leisure 18:118–19 (c,1) Mr '88
Trav/Holiday 170:57 (c,1) D '88
—Overwater hotel bungalows (Society Islands)
Gourmet 49:58, 62 (c,3) F '89
—Peace Hotel lobby, Shanghai, China
Trav&Leisure 17:87 (4) Ag '87
—Plaza, New York City, New York
Trav&Leisure 20:52 (c,3) Ja '90
Gourmet 51:39 (drawing,3) Ja '91
—Resort hotel (Alaska)
Trav/Holiday 171:56–9 (c,2) Ja '89
—Resort hotel (Andalusia, Spain)
Trav&Leisure 21:112–19, 170–2 (map,c,1) Je '91
—Resort hotel (Cancun, Mexico)
Trav&Leisure 17:88–9 (c,2) F '87
—Resort hotel (Capri, Italy)
Trav&Leisure 17:100–5 (c,1) F '87
—Resort hotel (Edmonton, Alberta)
Trav/Holiday 173:38–9 (c,2) Ja '90
—Resort hotel (Mackinac, Michigan)
Gourmet 49:72–4 (c,2) Je '89
—Resort hotel (Naples, Florida)
Trav&Leisure 17:86–93 (c,1) Ja '87
—Resort hotel (New Brunswick)
Am Heritage 42:124 (c,3) Ap '91
—Resort hotel (New Paltz, New York)
Trav/Holiday 168:12 (c,4) D '87
—Resort hotel (Orlando, Florida)
Nat Geog 18:142 (c,4) D '88
Trav/Holiday 173:40–1 (c,2) Ja '90
—Resort hotel (Thailand)
Trav&Leisure 19:cov., 144–51 (c,1) N '89
—Resort hotel scenes (Ontario)
Gourmet 51:90–1 (c,2) My '91
—Resort hotels (Caribbean)
Trav&Leisure 17:72–3 (c,1) Ja '87
Trav&Leisure 20:134–9 (c,1) F '90
Trav&Leisure 20:116–26, 174–6 (c,1) D '90
—Resort hotels (Hawaii)
Trav&Leisure 18:46–7 (c,3) Ag '88
Trav&Leisure 19:80, 87, 90–5 (c,1) Ja '89
Trav/Holiday 173:cov., 36–7, 42–4 (c,1) Ja '90
Trav&Leisure 21:72–3, 76–7 (c,1) Ja '91
—Resort hotels (Queensland, Australia)
Trav&Leisure 18:146–51 (c,1) D '88
—Ritz Hotel, Paris, France
Trav&Leisure 17:12–17 (c,1) Ap '87 supp.
—Room service (London, England)
Trav&Leisure 19:94–5 (c,1) Ag '89
—Sagamore, Lake George, New York
Trav&Leisure 17:94–6, 98–9, 129 (c,1) Jl '87

Trav/Holiday 172:N1 (c,4) O '89
—San Francisco
Trav&Leisure 17:102–5 (c,2) D '87
Trav&Leisure 21:95–9 (c,1) Mr '91
—Savoy Hotel, London, England
Trav&Leisure 19:92–9 (c,1) Ag '89
—Savoy Hotel, New York City (1896)
Life 11:39 (c,4) Fall '88
—Small hotels (New Orleans, Louisiana)
Trav&Leisure 17:134–41 (c,1) N '87
—Small hotels (Paris, France)
Trav&Leisure 18:114–21 (c,1) F '88
—Small inns (Poconos, Pennsylvania)
Trav/Holiday 170:56–61 (c,1) N '88
—Suite hotel lobby (Arizona)
Trav/Holiday 172:92 (c,1) Jl '89
—Switzerland
Trav&Leisure 19:82–9 (c,2) Jl '89
—Trump Taj Mahal Hotel, Atlantic City, New Jersey
Trav&Leisure 20:56 (c,4) Ja '90
—Vienna, Austria
Gourmet 47:64–9 (c,1) Mr '87
—Waldorf-Astoria lobby, New York City, New York
Trav&Leisure 17:140–8 (c,1) S '87
—Watergate, Washington, D.C.
Trav/Holiday 171:34 (c,4) Ja '89
—Willard Hotel, Washington, D.C.
Smithsonian 17:78–89 (c,2) F '87
Trav&Leisure 17:114–21, 143 (c,1) My '87
—Windsor, England
Gourmet 47:64 (c,4) Ap '87
HOUDINI, HARRY
—Houdini's pocket watch (1922)
Am Heritage 38:114 (c,1) S '87
Natur Hist 97:74 (c,3) Mr '88
—Magic items owned by Harry Houdini
Smithsonian 21:116–17 (c,1) Ja '91
HOUDON, JEAN ANTOINE
—Bust of Jefferson (1787)
Am Heritage 42:86 (c,4) Jl '91
—Statue of George Washington (London, England)
Am Heritage 38:76 (c,2) Ap '87
HOUNDS
Sports Illus 66:10 (c,4) F 23 '87
Trav&Leisure 19:121, 190 (c,1) My '89
Nat Geog 176:60–1 (c,1) Jl '89
HOUSEBOATS
Smithsonian 22:70–83 (c,1) N '91
—Amsterdam, Netherlands
Gourmet 49:77 (c,4) Ap '89
—Interior (Kashmir)
Trav&Leisure 17:108 (c,4) S '87
HOUSEHOLD ACTIVITIES
—19th cent. activities (Acadia, New Brunswick)

—Putting up tepee (Montana)
Trav&Leisure 19:128 (c,4) Mr '89
—Pygmies covering roof with leaves (Zaire)
Natur Hist 97:34 (c,2) D '88
—Raising roof on camping shelter (Virginia)
Nat Geog 171:223 (c,4) F '87
—Renovating British prime minister's home (London)
Life 12:28 (c,3) O '89
—Renovating old mansion interior (California)
Life 12:60–1 (c,1) Spring '89
—Repairing house after hurricane damage (Jamaica)
Trav/Holiday 171:85 (c,4) My '89
—Room being remodeled (New Jersey)
Life 11:29 (c,4) Jl '88
—Thatching roof (Great Britain)
Trav&Leisure 20:162 (c,4) Ap '90
Trav/Holiday 173:55 (c,4) Ap '90
—Thatching roof (St. Lucia)
Gourmet 51:84 (c,4) Mr '91
HOUSEWARES
—4th cent. bronze cookware (Cyprus)
Nat Geog 174:46 (c,3) Jl '88
—16th cent. Spanish notions (Florida)
Nat Geog 173:344–5 (c,4) Mr '88
—17th cent. mortar and pestle (Massachusetts)
Am Heritage 42:141 (c,1) N '91
—1787 artifacts of American life
Life 10:28–34 (c,4) Fall '87
—Late 19th cent. one-penny items (Great Britain)
Smithsonian 18:153 (c,1) N '87
—Early 20th cent. art nouveau items (Vienna, Austria)
Trav&Leisure 19:87–90 (c,2) Mr '89
—Early 20th cent. button-hook
Life 13:29 (c,4) S '90
—Early 20th cent. handicrafts
Am Heritage 38:83–9, 114 (c,3) Jl '87
—Museum collection of international housewares (Great Britain)
Smithsonian 18:110–13 (c,2) Jl '87
—See also
BOTTLES
BROOMS
BRUSHES
CANDLES
CHINAWARE
CLOCKS
COOKING UTENSILS
FANS
GLASSWARE
HOME FURNISHINGS
INKSTANDS

KEYS
LOCKS
QUILTS
SCALES
SCISSORS
SILVERWARE
TEAKETTLES
TEAPOTS
WALKING STICKS
HOUSING
—Ancient Marajoara Indian mounds (Brazil)
Natur Hist 98:74–5 (painting,c,1) F '89
—Bungalows (Belize)
Nat Geog 176:466–7 (c,1) O '89
—Compact apartment (Tokyo, Japan)
Life 11:7 (c,4) Ap '88
—Living in restored sheep wagon (Wyoming)
Nat Geog 173:53 (c,2) Ja '88
—Military modular housing units (Falkland Islands)
Nat Geog 173:402–3 (c,1) Mr '88
—Overwater hotel bungalows (Society Islands)
Gourmet 49:58, 62 (c,3) F '89
—Prehistoric mammoth-bone shelters
Nat Geog 174:470–3 (painting,c,1) O '88
—See also
ADOBE HOUSES
APARTMENT BUILDINGS
BIRD CAGES
BIRD HOUSES
CABINS
CASTLES
CHATEAUS
COTTAGES
DOGHOUSES
DOLL HOUSES
FARMHOUSES
HOUSEBOATS
HOUSES
HOUSING DEVELOPMENTS
HUTS
IGLOOS
LOG CABINS
MANSIONS
PALACES
PLANTATIONS
SLUMS
SOD HOUSES
STILT HOUSES
TENTS
TEPEES
YURTS
country or civilization entries—HOUSING
HOUSING DEVELOPMENTS
—Key Largo, Florida

Nat Geog 178:128–9 (c,1) Jl '90
—Mobile home community (Anchorage, Alaska)
Nat Geog 173:380–1 (c,1) Mr '88
—Palm Springs, California
Nat Geog 179:26–7 (c,1) Je '91
—Terraced housing (San Diego, California)
Nat Geog 176:186–7 (c,1) Ag '89
HOUSTON, TEXAS
Gourmet 47:66–73, 160 (c,1) O '87
Nat Geog 175:165 (c,2) F '89
—Menil Collection
Trav&Leisure 18:18, 22 (c,4) F '88
HOWE, ELIAS
—1846 sewing machine patent
Am Heritage 41:49 (drawing,4) S '90
HOWLERS (MONKEYS)
Nat Geog 171:393 (c,4) Mr '87
Nat Geog 176:434 (c,4) O '89
HUANG HO (YELLOW) RIVER, CHINA
Natur Hist 100:28–37 (map,c,1) Ag '91
HUDSON RIVER, NEW YORK
Life 10:58–9 (c,1) O '87
Am Heritage 39:44 (c,4) Ap '88
Trav&Leisure 18:215 (c,4) O '88
Natur Hist 99:48–53 (map,c,1) My '90
Gourmet 51:86, 89 (c,1) My '91
HUE, VIETNAM
Nat Geog 176:594–603 (map,c,1) N '89
—Khai Dinh's tomb
Nat Geog 176:596–9 (c,1) N '89
HUGHES, CHARLES EVANS
Nat Geog 173:39 (4) Ja '88
Life 14:62 (4) Fall '91
HUGHES, HOWARD
Am Heritage 39:34 (4) Jl '88
HUGHES, LANGSTON
Smithsonian 20:175 (painting,c,4) N '89
Smithsonian 21:156 (4) My '90
HUGO, VICTOR
Smithsonian 18:75, 78–9, 84 (c,2) Ap '87
Nat Geog 176:164 (4) Jl '89
—Bedroom (Guernsey home)
Smithsonian 18:82 (c,4) Ap '87
—Caricature
Smithsonian 20:157 (c,3) Ja '90
—Dining room in home (Paris, France)
Smithsonian 18:80 (c,3) Ap '87
—Funeral (Paris, France)
Smithsonian 18:85 (2) Ap '87
Nat Geog 176:165 (1) Jl '89
—Scenes from Hugo's *Les Miserables*
Smithsonian 18:74–7 (c,3) Ap '87
Human sacrifice. See
RELIGIOUS RITES AND FESTIVALS

HUMMINGBIRDS
Life 10:50–1 (c,1) Jl '87
Nat Wildlife 25:42–3 (c,1) Ag '87
Natur Hist 97:51 (c,4) Je '88
Trav&Leisure 18:130 (c,4) O '88
Nat Geog 177:72–5 (c,1) Je '90
Nat Wildlife 28:7 (c,4) Ag '90
—Hummingbird egg
Smithsonian 22:63 (c,1) Ap '91
HUNGARY
Trav&Leisure 20:106–15, 162 (map,c,1) Ja '90
—Barbed wire fence at Austrian border
Nat Geog 177:125 (c,2) Ap '90
—Lake Balaton
Nat Geog 179:62 (c,3) Je '91
—See also
BUDAPEST
DANUBE RIVER
HUNGARY—COSTUME
Nat Geog 174:926–9 (c,1) D '88
—Early 20th cent.
Natur Hist 98:76–8 (3) Je '89
—Horsemen
Nat Geog 176:328–9, 338–9 (c,1) S '89
—Shepherd
Nat Geog 173:cov. (c,2) My '88
HUNGARY—HISTORY
—1526 Battle of Mohács
Nat Geog 172:578–9 (c,2) N '87
—1989 independence celebration
Life 13:129 (c,3) Ja '90
—Statue of Magyar tribesmen (Budapest)
Trav&Leisure 20:112–13 (c,1) Ja '90
—See also
KOSSUTH, LAJOS
HUNTERS
Sports Illus 69:103 (c,4) D 12 '88
—Late 19th cent.
Nat Wildlife 25:48–9 (c,1) O '87
Smithsonian 18:102 (4) Mr '88
—Hunter's den (Arizona)
Sports Illus 71:70 (c,3) Ag 7 '89
—Stone Age cave painting of hunter (Spain)
Nat Wildlife 25:50–1 (c,1) O '87
HUNTING
—17th cent. tiger hunt on elephant-back (India)
Smithsonian 18:46 (painting,c,3) Ja '88
—1883 society woman hunting (New York)
Natur Hist 100:66 (drawing,3) F '91
—Adi tribe (India)
Nat Geog 174:696–7 (c,1) N '88
—Beagling (Virginia)
Sports Illus 74:8 (c,4) Ja 14 '91
—Bird hunting
Sports Illus 73:138, 142, 146 (c,3) D 31 '90

—Celebrating deer kill (Spain)
Nat Geog 179:130–1 (c,1) Ap '91
—Clubbing fur seals (Alaska)
Nat Geog 171:495 (c,4) Ap '87
—Deer (Brazil)
Nat Geog 174:794–5 (c,1) D '88
—Deer (Pennsylvania)
Sports Illus 67:96–7 (c,1) S 9 '87
—Displaying results of 1884 royal hunt (India)
Trav&Leisure 21:186–7 (2) O '91
—Elephants (Africa)
Nat Geog 176:674–7 (c,1) N '89
Nat Geog 179:43–5 (c,1) My '91
—Elk (1853)
Smithsonian 19:150 (drawing,4) My '88
—Eskimos hunting walrus (U.S.S.R.)
Natur Hist 100:30–1, 34–7 (c,1) Ja '91
—Geese
Sports Illus 69:124–33 (c,3) D 19 '88
—Grizzly bear trap in park (Wyoming)
Nat Wildlife 26:26 (c,4) F '88
—History of Canadian fur trading industry
Nat Geog 172:192–229 (c,1) Ag '87
—Hunting with bow and arrows (Suriname)
Smithsonian 19:96 (c,4) F '89
—Indian killing buffalo
Smithsonian 21:93 (painting,c,3) F '91
—Kangaroos (Australia)
Nat Geog 173:202 (c,4) F '88
—Killing tapir with poison arrows (Brazil)
Nat Geog 174:806–7 (c,1) D '88
—Lions (Africa)
Sports Illus 70:89 (c,4) F 13 '89
—Moose (Alaska)
Nat Geog 172:276–9 (c,1) Ag '87
—Narwhals (Greenland)
Life 12:140–5 (1) Mr '89
—Paintings of hunting
Nat Wildlife 25:cov., 48–57 (c,1) O '87
—Prehistoric men hunting game
Nat Geog 174:454–5 (painting,c,3) O '88
—Puffins (Iceland)
Nat Geog 171:203 (c,4) F '87
—Pygmies (Zaire)
Natur Hist 97:38–9 (c,3) D '88
Nat Geog 176:666–73 (c,1) N '89
—Setting trap for marten (Alaska)
Nat Geog 177:64–5 (1) F '90
—Squirrels (Missouri)
Nat Geog 175:211 (4) F '89
—State wildlife stamps
Nat Wildlife 27:34–40 (painting,c,2) D '88
—Swans (North Carolina)
Nat Geog 172:506–7 (c,1) O '87
—Transporting dead reindeer by helicopter (Norway)

Natur Hist 96:39 (c,1) D '87
—Venetians shooting birds with arrows (1495)
Smithsonian 22:52 (painting,c,4) Jl '91
—Wild turkeys (Australia)
Nat Geog 179:9 (c,1) Ja '91
—See also
FOX HUNTING
WHALING
HUNTING EQUIPMENT
—15th cent. Eskimos (Alaska)
Nat Geog 171:830, 832, 834 (c,4) Je '87
—19th cent. (Canada)
Nat Geog 172:207 (c,1) Ag '87
—Trapping snares (Northwest Territories)
Nat Geog 172:213 (c,4) Ag '87
HUNTLEY, CHET
Smithsonian 20:86–7 (3) Je '89
HURDLING
Sports Illus 66:16–17 (c,2) Ja 26 '87
Sports Illus 66:22–3 (c,2) Mr 16 '87
Sports Illus 66:83 (c,3) Ap 27 '87
Sports Illus 69:28 (c,4) Jl 4 '88
Sports Illus 69:23 (c,3) Ag 1 '88
Sports Illus 69:46–7 (c,2) S 12 '88
Sports Illus 70:33 (c,2) F 13 '89
Sports Illus 71:55 (c,4) Jl 31 '89
Sports Illus 71:16–17 (c,1) Ag 28 '89
Sports Illus 71:66 (c,4) O 16 '89
Sports Illus 74:52 (c,2) Mr 4 '91
Sports Illus 75:88–9 (c,1) D 30 '91
—1984 Olympics (Los Angeles)
Sports Illus 71:180 (c,4) N 15 '89
—1988 Olympics (Seoul)
Sports Illus 69:45 (c,4) O 3 '88
—Pan American Games 1987 (Indiana)
Sports Illus 67:20 (c,2) Ag 24 '87
—World Track & Field Championships 1987 (Rome, Italy)
Sports Illus 67:18–19, 22–3 (c,1) S 14 '87
HURLING
—Ireland
Sports Illus 67:82 (painting,c,4) Ag 24 '87
HURRICANES
—1988 Hurricane Gilbert (Texas)
Life 12:14–15 (c,1) Ja '89
HURRICANES—DAMAGE
—1938 damage to house (Rhode Island)
Am Heritage 39:32 (4) S '88
—1989 Hurricane Hugo (Charleston, South Carolina)
Sports Illus 71:8–10 (c,3) O 23 '89
Trav&Leisure 20:79 (c,4) Ja '90
Life 13:20 (c,1) Ja '90
Life 13:40–51 (1) S '90
—Cayman Islands house
Trav&Leisure 19:91, 94 (c,4) F '89
—Men in flood (Colombia)

Life 12:18 (c,2) Ja '89
—Repairing house after hurricane damage
 (Jamaica)
 Trav/Holiday 171:85 (c,4) My '89
Huskies. See
 SIBERIAN HUSKIES
HUTS
—Cameroon
 Natur Hist 96:48–9 (c,1) Ag '87
—Thatched huts (Fiji)
 Trav/Holiday 171:116–17 (c,2) Ja '89
—Thatched mud huts (Mali)

Trav&Leisure 17:116 (c,4) Ja '87
—Windward Islands
 Natur Hist 99:34 (c,4) O '90
HYDERABAD, INDIA
 Gourmet 50:92–7, 200 (c,1) Mr '90
HYDRANGEAS
 Trav&Leisure 17:92–3 (c,1) F '87
HYENAS
 Smithsonian 20:111 (c,4) F '90
 Natur Hist 99:106–7 (c,1) My '90
Hypnotism. See
 MESMER, FRANZ ANTON

- I -

IBEXES
 Natur Hist 96:68–9 (c,1) My '87
 Smithsonian 18:68–77 (c,1) D '87
 Smithsonian 20:107 (c,4) F '90
IBISES
—In silhouette
 Nat Wildlife 27:2 (c,2) D '88
ICE
—1895 ice palace (Leadville, Colorado)
 Nat Geog 175:232 (3) F '89
—Artistic natural designs in ice
 Nat Geog 171:80–1 (c,1) Ja '87
—Climbing up glacial ice (French Alps)
 Sports Illus 67:26 (c,2) D 28 '87
—Driving on ice (Arctic, Canada)
 Nat Geog 178:12 (c,1) Ag '90
—Frost on spider's web
 Nat Wildlife 29:60 (c,1) F '91
—Frozen spring (India)
 Life 12:112–13 (c,1) D '89
—Guitar ice sculpture (Illinois)
 Nat Wildlife 27:10 (c,4) D '88
—Ice cave in glacier (Alaska)
 Nat Geog 171:78–9 (c,1) Ja '87
—Ice climbing (Alaska)
 Smithsonian 18:cov., 102–11 (c,1) Ja '88
—Ice crevasses (Antarctica)
 Nat Geog 177:35 (c,3) Ap '90
—Ice crystals on window
 Nat Wildlife 26:60 (c,1) D '87
—Ice floes (Antarctica)
 Trav&Leisure 21:150–1 (c,1) O '91
—Ice floes (Canada)
 Nat Geog 178:8, 16–17 (c,1) Ag '90
 Nat Geog 180:4–5, 10–11 (c,1) Jl '91
—Ice motorcycle racing (Germany)
 Sports Illus 74:2–3 (c,1) Mr 18 '91
—Ice sculpture (Alberta)
 Trav/Holiday 176:cov. (c,1) D '91
—Icefields Parkway, Alberta/British Co-
 lumbia

Trav&Leisure 19:187–8 (map,c,4) Je '89
 Trav&Leisure 21:260 (c,3) O '91
—Icicles hanging from roof (New Zealand)
 Nat Wildlife 27:6–7 (c,1) D '88
—Lighted ice sculptures (China)
 Nat Geog 173:308–9 (c,1) Mr '88
—Quelccaya Ice Cap, Peru
 Nat Geog 171:102 (c,3) Ja '87
—Role of ice in earth's climate
 Nat Geog 171:78–119 (c,1) Ja '87
—Studying ancient ice core
 Life 11:104–5 (c,1) S '88
 Nat Geog 177:34 (c,4) Ap '90
—Thompson Ice House, Maine
 Am Heritage 42:75 (c,4) Jl '91
—Winter carnival ice palaces
 Smithsonian 17:62–9 (c,1) Ja '87
—Zamboni machine used to clean stadium
 ice
 Sports Illus 66:38–40, 45 (c,2) Mr 30 '87
 Sports Illus 66:8 (c,4) Ap 27 '87
—See also
 GLACIERS
ICE FISHING
—Canada
 Sports Illus 68:181 (c,4) Ja 27 '88
—Finland
 Nat Geog 175:621 (c,2) My '89
—Minnesota
 Nat Wildlife 27:24–8 (c,1) F '89
—New York
 Sports Illus 68:10–14 (c,4) F 15 '88
—U.S.S.R.
 Life 14:80 (c,4) Je '91
ICE INDUSTRY
—19th cent. New England ice trade with
 India
 Am Heritage 42:71–6 (c,3) Jl '91
—1850 ice production (India)
 Nat Geog 171:94 (drawing,4) Ja '87
—Harvesting ice blocks (New York)

Nat Geog 171:92–3 (c,1) Ja '87
Ice skating. See
SKATING
ICEBERGS
Nat Geog 171:86 (c,4) Ja '87
Trav&Leisure 18:138–9 (c,1) O '88
Smithsonian 19:55 (c,3) Mr '89
Life 14:76 (c,2) My '91
Trav&Leisure 21:122 (c,2) N '91
—Antarctica
Trav&Leisure 17:99 (c,2) Ag '87
Nat Geog 177:4–6, 36–7 (c,1) Ap '90
Trav&Leisure 20:127 (c,2) S '90
Natur Hist 100:54–5 (c,1) Ja '91
—Windsurfing among icebergs (Alaska)
Nat Geog 173:cov. (c,1) Mr '88
ICEBOXES
—1930s icebox
Nat Geog 171:92 (4) Ja '87
ICELAND
Nat Geog 171:184–215 (map,c,1) F '87
—1963 creation of Surtsey by volcano
Natur Hist 96:2–4 (c,2) Ag '87
—Hot mud puddles, solfaturas
Trav&Leisure 19:75 (c,4) Ap '89
—Jökulsárlón
Trav&Leisure 19:78 (c,4) Ap '89
—Thermal bath
Trav&Leisure 21:278 (c,3) O '91
—See also
REYKJAVIK
ICELAND—ART
—Paintings by Louisa Matthiasdottir
Trav/Holiday 173:50–3 (c,2) Je '90
ICELAND—COSTUME
Nat Geog 171:cov., 184–211 (c,1) F '87
IDAHO
—Bruneau River area
Natur Hist 100:56–7 (c,2) Ap '91
—Countryside
Am Heritage 39:58–9 (c,1) Ap '88
Smithsonian 21:88, 98, 101 (c,3) Ap '90
Trav&Leisure 21:124–9 (c,1) D '91
—Mt. Heyburn
Trav&Leisure 19:176 (c,4) Mr '89
—Potato field
Smithsonian 22:64–5 (c,1) Ag '91
—Salmon River
Gourmet 48:60–5, 102 (map,c,1) Jl '88
Trav&Leisure 19:136–9, 177 (c,1) Mr '89
—Salmon River area
Trav/Holiday 167:56–61 (c,2) My '87
Gourmet 48:60–5, 102 (map,c,1) Jl '88
Trav&Leisure 19:136–41, 177 (c,1) Mr '89
—Stanley area
Trav&Leisure 19:136–41, 177 (c,1) Mr '89
—Sun Valley ski area

Gourmet 50:74–7 (c,1) F '90
—See also
SNAKE RIVER
IGLOOS
—Constructing igloo (Northwest Territories)
Trav&Leisure 18:142 (c,4) O '88
IGUAÇÚ FALLS, SOUTH AMERICA
Trav/Holiday 167:54–5 (c,1) Mr '87
IGUANAS
Smithsonian 18:87 (c,1) Ag '87
Nat Geog 173:124–5, 130–1, 151 (c,1) Ja '88
Trav/Holiday 170:24 (c,4) Jl '88
Trav&Leisure 18:180 (c,4) O '88
Natur Hist 99:51 (c,1) Ja '90
Life 14:74 (3) D '91
ILLINOIS
—Camel Rock, Shawnee National Forest
Natur Hist 96:66–7 (c,1) Je '87
Natur Hist 98:60 (c,3) Ja '89
—Garden of the Gods
Natur Hist 96:66–8 (map,c,1) Je '87
—Grantsburg Swamp
Natur Hist 100:22–4 (map,c,1) Jl '91
—Shawnee National Forest
Natur Hist 97:cov., 22–4 (map,c,1) S '88
—See also
SPRINGFIELD
CHICAGO
Illnesses. See
DISEASES
IMMIGRANTS
—19th cent. Chinese immigrants in U.S.
Smithsonian 21:114–25 (c,1) F '91
—Early 20th cent. immigrants at Ellis Island, New York
Nat Geog 178:88–101 (1) S '90
Trav&Leisure 20:76, 80 (3) S '90
Trav/Holiday 174:39–49 (1) S '90
Life 13:cov., 27–38 (c,1) S '90
—1950 Italian immigrants (New York)
Smithsonian 21:88 (2) Je '90
—Cartoon about 1892 Exclusion Act
Smithsonian 21:120 (c,4) F '91
—History of Ellis Island, New York
Smithsonian 21:88–97 (c,1) Je '90
Nat Geog 178:88–101 (map,c,1) S '90
Trav&Leisure 20:73–80 (c,2) S '90
Trav/Holiday 174:cov., 39–50 (c,1) S '90
Life 13:cov., 26–38 (c,1) S '90
—Illegal alien warning sign on freeway (California)
Trav/Holiday 175:24 (4) Mr '91
INCA CIVILIZATION
—Inca theory of the universe
Nat Geog 177:83 (painting,c,1) Mr '90
—See also
MACHU PICCHU

—Bejeweled dancer
Trav/Holiday 171:73 (c,4) Ja '89
—Children in traditional finery
Trav&Leisure 20:150–1 (c,1) D '90
—Fisherman (Calcutta)
Natur Hist 99:75 (c,2) My '90
—Hardware vendor (Bombay)
Natur Hist 96:74 (c,3) Je '87
—Kathakali dancer (1966)
Smithsonian 22:161 (c,4) My '91
—Mother Teresa
Life 11:30–1 (c,2) Ap '88
Life 13:90 (c,4) Mr '90
—Rajasthan
Trav/Holiday 170:34–9 (c,1) Ag '88
Trav&Leisure 19:140 (c,1) Ap '89
—Saris
Trav&Leisure 19:91–5 (c,1) Jl '89
INDIA—HISTORY
—14th cent. Delhi sultan Ibn Tughluq
Nat Geog 180:33 (painting,c,4) D '91
—19th cent. thugs strangling victim
Smithsonian 18:47 (painting,c,4) Ja '88
—Late 1830s scenes of India
Smithsonian 21:118–29 (painting,c,3) Ag
'90
—1846 battle of Sobraon
Smithsonian 18:50–1 (painting,c,1) Ja '88
—Akbar's Fatehpur Sikri
Trav&Leisure 20:150–3 (c,1) Ap '90
—History of British rule in India
Smithsonian 18:42–57 (map,c,1) Ja '88
—Jiwaji Rao Scindia
Life 13:44 (4) Mr '90
—Last words of Indira Ghandi (1984)
Trav/Holiday 171:17 (c,4) F '89
—See also
CLIVE, ROBERT
HASTINGS, WARREN
INDIA—HOUSING
—Illam (Kerala)
Nat Geog 173:600 (c,3) My '88
INDIA—MAPS
—1876 physical map
Smithsonian 18:178 (2) O '87
—Calcutta area
Natur Hist 99:76 (c,4) My '90
INDIA—RITES AND FESTIVALS
—Burning wife at husband's funeral in sut-
tee rite
Smithsonian 18:47 (painting,c,4) Ja '88
—Children preparing to wed
Life 14:58 (4) O '91
—Cremation
Trav&Leisure 19:96–7 (c,3) Jl '89
—Maha Kumbh Mela ritual bathing
Nat Geog 177:106–17 (c,1) My '90
—Pooram festival (Trichur)
Nat Geog 173:602–3 (c,1) My '88

—Pushkar Fair
Trav/Holiday 170:34–9 (c,1) Ag '88
INDIA—SOCIAL LIFE AND CUS-
TOMS
—Early lifestyle of British in India
Smithsonian 18:42–57 (c,1) Ja '88
INDIAN OCEAN
—Mauritius
Gourmet 49:96–7, 101 (c,1) N '89
INDIAN PAINTBRUSH (FLOWERS)
Smithsonian 18:41, 44 (c,4) Ap '87
Nat Wildlife 25:50–1 (c,1) Je '87
Nat Wildlife 28:52–3, 57 (c,1) Ap '90
Trav&Leisure 20:49 (c,4) N '90
INDIAN PIPE PLANTS
Nat Geog 171:238 (c,4) F '87
INDIAN RESERVATIONS
—Hopi reservation (Arizona)
Trav/Holiday 170:42–3 (map,c,3) Ag '88
INDIAN WARS
—1570 Indian attack on Chesapeake Bay
mission
Nat Geog 173:361 (painting,c,2) Mr '88
—Early 19th cent. fight for Florida
Smithsonian 19:140–54 (painting,c,4) Ap
'88
—1813 Creek Indian defense (Tennessee)
Am Heritage 39:34 (drawing,4) N '88
—1838 Cherokee eviction announcement
(Tennessee)
Natur Hist 98:59 (c,1) S '89
—Battle of Little Big Horn (1876)
Trav&Leisure 18:E6 (painting,c,3) Ap
'88
Trav/Holiday 173:76–9, 129 (map,c,1)
Ap '90
Natur Hist 99:90 (painting,c,4) N '90
Smithsonian 22:3 (painting,c,4) S '91
—Creek leader surrendering to Andrew
Jackson (1814)
Am Heritage 40:30 (painting,4) Mr '89
—Second Seminole War
Smithsonian 22:94 (etching,4) Ag '91
INDIANA
—Columbus
Gourmet 50:104–5 (c,2) D '90
—Country road
Gourmet 50:113 (c,1) N '90
—Empire Hole abandoned quarry
Smithsonian 19:95 (c,4) O '88
—Hoosier National Forest
Natur Hist 98:98–100 (map,c,1) N '89
—Northern Indiana
Gourmet 50:106–13, 234 (map,c,1) N '90
—Ruthmere Museum, Elkhart
Gourmet 50:108 (c,4) N '90
—Southern Indiana
Gourmet 50:102–7, 220 (map,c,1) D '90
—See also

INDONESIA—COSTUME
 Trav/Holiday 170:62–7 (c,1) Jl '88
 Nat Geog 175:96–127 (c,1) Ja '89
 Trav&Leisure 20:122–33 (c,1) Ja '90
—Bali
 Trav&Leisure 17:cov., 70–81 (c,1) Jl
 '87
 Trav&Leisure 20:191–2 (c,4) F '90
 Trav/Holiday 175:40–5 (c,1) Ap '91
 Gourmet 51:68–9, 72 (c,1) Ap '91
—Dancers
 Trav&Leisure 21:284 (c,3) O '91
—Dayak woman with stretched earlobes
 (Borneo)
 Nat Geog 175:105 (c,4) Ja '89
INDONESIA—MAPS
 Natur Hist 97:69 (c,4) Je '88
INDONESIA—RITES AND FESTI-
 VALS
—Carved bull at cremation ceremony
 Trav&Leisure 20:131 (c,1) Ja '90
—Firewalking dance
 Trav&Leisure 20:191 (c,4) F '90
—Spring Nyepi festival (Bali)
 Trav&Leisure 17:80 (c,3) Jl '87
INDONESIA—SOCIAL LIFE AND
 CUSTOMS
—Barong dance (Denjalan)
 Trav/Holiday 170:62–3, 67 (c,1) Jl '88
—Javanese shadow puppet show
 Natur Hist 96:68–76 (c,1) N '87
 Trav&Leisure 170:63 (c,4) Jl '88
—Temple dances (Bali)
 Trav/Holiday 175:41, 44–5 (c,1) Ap '91
 Gourmet 51:68–9 (c,1) Ap '91
INDUS RIVER, KASHMIR/PAKISTAN
 Nat Geog 172:528–9 (c,1) O '87
Industries. See
 ALUMINUM
 ARTICHOKES
 AUTOMOBILES
 AVIATION
 BANANAS
 BANKING
 BARLEY
 BEEKEEPING
 BEER
 BICYCLES
 CHEESE
 CHESTNUTS
 CIGARETTES
 CIGARS
 CLOCKS
 COAL
 COCONUTS
 COFFEE
 CORN
 COTTON
 CRABS
 CRANBERRIES
 DAIRYING
 DIAMONDS
 DRUGS
 ELECTRICITY
 ELECTRONICS
 EMERALDS
 FACTORIES
 FARMING
 FISHING
 FLOWERS
 FOOD
 FOOD PROCESSING
 FUR
 GARMENTS
 GAS, NATURAL
 HAY
 HERBS
 HONEY
 HUNTING
 IRON
 JADE
 LEATHER
 LETTUCE
 LIQUOR
 LOBSTERS
 LUMBERING
 MANUFACTURING
 MINING
 MOTION PICTURES
 MOVING INDUSTRY
 OIL
 OYSTERS
 PAPER
 PEARLS
 PEAT
 PEPPERS
 PERFUME
 PINEAPPLES
 POTATOES
 POTTERY
 PRINTING
 RANCHING
 RICE
 RUBBER
 SAFFRON
 SALT
 SARDINES
 SHIPBUILDING
 SHOEMAK' JG
 SHRIMP
 SILK
 SORGHUM
 SOYBEANS
 SPICES
 STEEL
 STOCK EXCHANGES
 SUGAR CANE
 TEA

TELEPHONES
TEXTILES
TIRES
TOBACCO
TRUCKING
WHALING
WHEAT
WINE
WOOL
YARN
INFLUENZA
—1918 flu victim in hospital (New York)
 Nat Geog 179:127 (3) Ja '91
—1918 influenza epidemic
 Smithsonian 19:130–45 (1) Ja '89
INGERSOLL, JARED
 Life 10:55 (painting,c,4) Fall '87
INGRES, JEAN-DOMINIQUE
—"Vierge a l'Hostie" (1854)
 Smithsonian 17:92 (painting,c,4) Mr
 '87
INJURED PEOPLE
—1963 black victim of bombing
 Life 11:18–19 (1) Spring '88
—Applying ice to football player's back
 Sports Illus 67:2–3 (c,1) O 19 '87
—Arm in sling
 Sports Illus 67:72–3 (c,1) Ag 24 '87
—Baseball hitting player in face
 Sports Illus 67:cov. (c,1) Jl 20 '87
—Baseball players
 Sports Illus 71:22–5 (c,3) Ag 28 '89
—Battered abused women
 Life 11:120–31 (1) O '88
—Boxer with arm in cast
 Sports Illus 69:28 (c,4) S 5 '88
—Boy hit by car (Texas)
 Life 13:8 (2) O '90
—Burn victim in mask and body suit
 (Alaska)
 Nat Geog 177:65 (4) F '90
—Car crash victims
 Life 13:14 (2) F '90
—Child bomb victim (Laos)
 Nat Geog 171:777 (c,4) Je '87
—Child rescued from falling in well (Texas)
 Life 10:42–3 (c,1) D '87
 Life 11:20–1 (1) Ja '88
 Life 12:150 (c,4) Fall '89
—Child with eye injury (Arizona)
 Life 13:21 (c,1) Spring '90
—Emergency room scenes (Colorado)
 Life 12:48–55 (1) Ap '89
—Fallen basketball player
 Sports Illus 74:62–3 (c,1) Mr 4 '91
 Sports Illus 74:52–3 (c,1) Ap 29 '91
—Football players
 Sports Illus 69:16–26, 31 (c,1) O 31 '88
 Sports Illus 71:76–7 (2) D 18 '89

—Gunshot victim on New York City sub-
 way
 Life 13:14–15 (1) S '90
—Gymnast breaking leg
 Sports Illus 67:74 (c,4) N 2 '87
—Head scar from tiger attack (India)
 Smithsonian 18:55 (c,4) N '87
—Hockey players
 Sports Illus 68:44 (c,4) My 2 '88
 Sports Illus 69:56–8 (c,2) D 5 '88
—Injured student demonstrators (China)
 Life 12:39–44 (c,1) Jl '89
—Leg in cast
 Sports Illus 66:38–40 (c,2) My 18 '87
 Sports Illus 68:49 (c,4) Ja 25 '88
 Sports Illus 70:106 (c,4) Mr 20 '89
—Man on crutches
 Sports Illus 67:2–3 (c,1) Jl 20 '87
 Sports Illus 74:60 (c,4) Mr 25 '91
—Marilyn Monroe on crutches
 Am Heritage 40:105 (1) F '89
—Painting of Spanish-American War casu-
 alties
 Am Heritage 39:74 (c,2) D '88
—Palestinian victim of beating (Israel)
 Life 11:30–1 (c,1) Mr '88
—Plane crash survivors
 Life 12:cov., 28–39 (c,1) S '89
 Sports Illus 71:60 (c,4) O 16 '89
—Racing car driver
 Sports Illus 73:32 (c,4) Ag 13 '90
—Radiation burn on leg (Brazil)
 Nat Geog 175:414–15 (c,1) Ap '89
—Rescuing plane crash survivor (Mon-
 tana)
 Nat Geog 171:810–11 (c,2) Je '87
—Scud missile victim (Saudi Arabia)
 Life 14:68–9 (c,1) Mr '91
—Soccer game riot (Düsseldorf, West Ger-
 many)
 Sports Illus 68:49–53 (c,3) Je 27 '88
—Street brawl victims
 Sports Illus 69:28 (c,2) S 5 '88
—Stress fractures of basketball players
 Sports Illus 66:60–6 (c,1) Ap 27 '87
—Taped up feet of athletes
 Sports Illus 67:96 (c,4) N 9 '87
—Tear gas victim (Chile)
 Nat Geog 174:70–1 (c,1) Jl '88
—Toddler survivor of plane crash
 Life 11:109 (c,4) Ja '88
 Life 11:cov. (4) Ap '88
—TV personality with broken nose
 Life 12:107 (c,4) Ja '89
—Victims of 1986 Chernobyl nuclear disas-
 ter, U.S.S.R.
 Life 10:43 (c,4) Ja '87
 Nat Geog 171:632–3, 638 (c,1) My '87
—Victims of lightning (Minnesota)

—Alcatraz, California
 Nat Wildlife 25:18 (c,4) Ag '87
—Dry Tortugas, Florida
 Trav&Leisure 19:E15–16 (c,3) F '89
—Gulf Islands, British Columbia
 Trav/Holiday 170:60–1 (c,1) Ag '88
—Kornati archipelago, Yugoslavia
 Nat Geog 178:106 (c,4) Ag '90
—Lacepede Islands, Australia
 Nat Geog 180:116–17 (c,1) D '91
—Lambi, Haiti
 Nat Geog 172:659 (c,1) N '87
—Little Diomede Island, Alaska
 Nat Geog 174:476–7 (c,2) O '88
—Lord Howe Island, Australia
 Nat Geog 180:134–5 (c,1) O '91
—Necker Island, British Virgin Islands
 Life 12:40–4 (c,1) Ap '89
—Oak Island, Nova Scotia
 Smithsonian 19:53 (c,3) Je '88
—San Juan Islands, Washington
 Trav/Holiday 172:79 (c,3) N '89
—Tobago Cays, Grenadines
 Trav&Leisure 21:156 (c,4) S '91
ISRAEL
 Trav/Holiday 170:66–71 (map,c,1) S '88
—Ancient Roman Caesarea Maritima
 Nat Geog 171:260–78 (map,c,1) F '87
—Beit Shean amphitheater
 Trav/Holiday 174:85 (c,4) N '90
—Caesarea
 Trav/Holiday 170:68–9 (c,2) S '88
—Makhtesh-Ramon
 Smithsonian 20:106–7 (c,2) F '90
—Shulamit waterfall, Ein Gedi
 Smithsonian 20:114 (c,4) F '90
—Wildlife reserve of Bible animals
 Smithsonian 20:106–15 (c,2) F '90
—See also
 DEAD SEA
 JAFFA
 JERUSALEM
 NEGEV
 TEL AVIV
ISRAEL—COSTUME
—Palestinian hospital patients
 Life 11:114–20 (1) Je '88
—Soldiers
 Life 13:20 (c,3) D '90
ISRAEL—HISTORY
—British entering Jerusalem (1917)
 Smithsonian 22:138 (painting,c,4) My '91
—Prime Minister Yitzhak Shamir
 Life 14:68 (c,4) Mr '91
ISRAEL—POLITICS AND GOVERN-
 MENT
—Palestinian uprising
 Life 11:26–34 (c,1) Mr '88
 Life 12:92–3 (c,1) Ja '89

Israel, ancient. See
 SOLOMON
ISTANBUL, TURKEY
 Nat Geog 172:554–5, 588–9 (c,1) N '87
 Trav&Leisure 17:124–33, 185, 190–2
 (c,1) N '87
 Gourmet 48:92–7, 226 (c,3) D '88
—Grand Bazaar
 Trav&Leisure 20:142–3 (c,1) Ja '90
—Süleymaniye Mosque
 Smithsonian 18:142–3 (c,3) S '87
 Trav&Leisure 17:124–5, 132–3 (c,1) N
 '87
—Topkapi karem room
 Trav&Leisure 17:127 (c,4) N '87
—See also
 ST. SOPHIA CATHEDRAL
ITALY
 Trav&Leisure 18:156–9, 217 (c,2) N '88
 Trav&Leisure 19:87–93 (c,2) Ap '89
—11th cent. abbey (Chianti)
 Gourmet 47:70–5, 176 (c,1) My '87
—Amalfi coast
 Trav&Leisure 17:50 (map,c,4) Ag '87
 Trav&Leisure 18:cov., 64–73, 116–19
 (map,c,1) Ag '88
—Ancient Etruscan tombs (Cerveteri)
 Nat Geog 173:724–5, 727, 738–9 (c,1) Je
 '88
—Apulia region
 Gourmet 48:80–5, 130, 134 (map,c,1) N
 '88
—Argentario area
 Gourmet 48:54–8, 92 (map,c,1) Jl '88
—Assisi
 Trav&Leisure 19:154–61 (map,c,1) N '89
 Trav&Leisure 20:136–7 (c,1) Ja '90
—Basilicata
 Gourmet 48:74–9, 172–8 (map,c,1) O '88
—Bassano del Grappa
 Trav&Leisure 19:60 (c,4) Ap '89
—Bergamo
 Gourmet 47:60–5 (c,1) S '87
 Trav&Leisure 18:28–30 (c,2) Jl '88
—Calabria
 Gourmet 48:74–9, 172–8 (map,c,1) O '88
—Capri
 Trav&Leisure 17:103 (c,1) F '87
 Trav&Leisure 20:116–27, 193–4 (c,1) Ap
 '90
 Gourmet 50:72–7, 166, 170 (map,c,1) Je
 '90
—Carrara marble mines
 Trav&Leisure 17:98–9 (c,1) Ap '87
—Castelfranco Veneto fortress
 Trav&Leisure 20:186 (c,4) S '90
—Cheese industry (Parma)
 Gourmet 47:74–9 (c,1) O '87
—Chianti region

Smithsonian 20:cov., 54–65 (c,1) Ja '90
—17th–18th cent. miniature creches
(Naples)
Smithsonian 22:cov., 100–5 (c,1) D '91
—Etruscan tomb paintings (Tarquinia, It-
aly)
Nat Geog 173:696–7, 700–5, 722–3 (c,1)
Je '88
ITALY—COSTUME
Trav&Leisure 17:126–31 (c,1) Ap '87
Gourmet 47:74–7 (c,1) O '87
Trav&Leisure 19:96–103 (c,1) Ja '89
Trav&Leisure 21:98–110 (c,1) Jl '91
—15th cent. (Venice)
Smithsonian 22:31 (painting,c,4) D '91
—1950 Italian immigrants (New York)
Smithsonian 21:88 (2) Je '90
—Boys (Naples)
Trav&Leisure 18:96–7 (c,1) Je '88
—Festival jewelry (Sardinia)
Trav/Holiday 171:72 (c,4) Ja '89
—Gondolier (Venice)
Trav&Leisure 17:24 (c,4) N '87
Trav/Holiday 170:37 (c,4) D '88
—Policemen (Sicily)
Life 11:147 (2) Fall '88
ITALY—HISTORY
—1571 naval battle of Lepanto (Greece)
Smithsonian 18:160 (painting,c,3) D '87
—1944 attack on Monte Cassino
Smithsonian 18:128–55 (c,2) Ap '87
—Louis II, Duc d'Anjou
Smithsonian 21:124 (painting,c,3) S '90
—Scenes from Tuscan history
Trav&Leisure 17:100–1 (c,4) Ap '87
—See also
ETRUSCAN CIVILIZATION
MUSSOLINI, BENITO
ROMAN EMPIRE

SAVONAROLA, GIROLAMO
ITALY—MAPS
—1631
Trav&Leisure 21:22 (painting,c,4) My
'91
—Etruscan world
Nat Geog 173:710–11 (c,1) Je '88
—Padua area
Gourmet 48:132 (4) My '88
ITALY—RITES AND FESTIVALS
—16th cent. depiction of Palio race (Siena)
Smithsonian 22:68–9 (painting,c,1) Jl '91
—Marostica's living chess game
Trav/Holiday 171:92 (c,4) Ja '89
—Palio (Siena)
Trav&Leisure 17:126–31 (c,1) Ap '87
Sports Illus 67:42–9 (c,1) Jl 20 '87
Nat Geog 173:744–9 (c,1) Je '88
Life 14:59–62 (c,2) S '91
—Palio della Balestra, Gubbio
Gourmet 50:103 (c,1) N '90
—Passing boy through split sapling
Life 14:30–1 (1) O '91
ITALY—SOCIAL LIFE AND CUS-
TOMS
—Daily life (Rome)
Trav/Holiday 176:66–73 (c,2) D '91
—Italian men leering at woman on street
(1951)
Life 11:14–15 (1) Fall '88
IVAN IV (RUSSIA)
Nat Geog 172:563 (painting,c,4) N '87
IVES, CHARLES
Sports Illus 75:106, 108 (4) O 7 '91
IVORY COAST
—Basilica of Our Lady of Peace
Life 12:52 (c,4) S '89
—Construction of basilica
Life 11:25 (c,3) D '88

- J -

JACANAS (BIRDS)
Trav/Holiday 175:51 (c,4) Je '91
JACK-IN-THE-PULPIT PLANTS
Smithsonian 19:176 (painting,c,4) F '89
JACKSON, ANDREW
Smithsonian 19:134–5, 160 (painting,c,3)
Ap '88
Am Heritage 40:30 (painting,4) Mr '89
—Autograph
Smithsonian 17:30 (c,4) Mr '87
—Caricature
Smithsonian 21:76 (painting,c,4) My '90
—Hermitage graveyard, Nashville, Tennes-
see

Trav&Leisure 19:214 (c,4) N '89
Trav/Holiday 175:62–3 (1) Ja '91
—Andrew Jackson's 1818 invasion of Flor-
ida
Smithsonian 19:140–54 (painting,c,4) Ap
'88
—Log cabin home (Jonesborough, Ten-
nessee)
Am Heritage 42:26 (c,4) O '91
JACKSON, "SHOELESS JOE"
Sports Illus 73:6 (4) S 24 '90
JACKSON, STONEWALL
Am Heritage 39:34 (painting,4) My
'88

Am Heritage 41:70, 111 (painting,c,4) Mr '90

JADE
Nat Geog 172:cov., 282–315 (c,1) S '87
—Jade carving (China)
Nat Geog 172:287, 292–3 (c,1) S '87
JADE INDUSTRY
—China
Nat Geog 172:286–7, 292–3 (c,1) S '87
—Chopping jade (British Columbia)
Nat Geog 172:304 (c,1) S '87
JAFFA, ISRAEL
Trav&Leisure 21:88–95, 127–30 (c,1) Jl '91
JAGUARS
Trav&Leisure 20:192 (c,4) Mr '90
Trav&Leisure 21:74 (c,4) S '91
JAI ALAI
Sports Illus 67:86 (c,4) Ag 10 '87
JAIPUR, INDIA
Gourmet 51:78–85, 142 (c,1) My '91
—Amber Palace
Gourmet 51:82–3 (c,1) My '91
—Hawa Mahal
Gourmet 51:82 (c,4) My '91
JAMAICA
Trav&Leisure 21:136–9 (map,c,1) D '91
—Gardens of Cariñosa
Trav&Leisure 18:40 (c,4) Mr '88
—Harmony Hall gallery
Trav/Holiday 167:49 (c,3) Ja '87
—Repairing house after hurricane damage
Trav/Holiday 171:85 (c,4) My '89
—Round Hill
Trav&Leisure 19:178–85, 222–4 (c,1) O '89
—Ys cascade
Trav&Leisure 21:25 (c,3) Je '91
JAMAICA—ART
—Crafts
Trav/Holiday 167:48–51 (c,3) Ja '87
JAMAICA—COSTUME
Trav&Leisure 21:136–8, 168 (c,1) D '91
—Rastafarian
Natur Hist 99:100 (2) My '90
JAMAICA—MAPS
Trav/Holiday 167:50 (c,4) Ja '87
JAMAICA—RITES AND FESTIVALS
—Rastafarian girls smoking marijuana
Life 14:34–5 (c,1) O '91
JAMES, JESSE
Am Heritage 42:44 (4) F '91
JAMES, WILL
Smithsonian 18:168–79 (c,1) F '88
—Art works by him
Smithsonian 18:168–79 (c,1) F '88
—Self-portrait
Smithsonian 18:168 (painting,c,4) F '88

JAPAN
Trav&Leisure 20:103–16 (c,1) Ag '90
Nat Geog 180:36–49 (map,c,1) N '91
—19th cent. lacquer wedding carriage
Smithsonian 19:212 (c,4) O '88
—Japanese gardens
Gourmet 48:70–1 (c,2) S '88
Nat Geog 176:638–63 (c,1) N '89
—Kanazawa
Gourmet 48:70–5, 176 (map,c,2) S '88
—Kobe
Trav&Leisure 18:215–18 (c,3) D '88
—Kyoto temple grounds
Trav/Holiday 167:68 (c,4) F '87
Trav&Leisure 18:35 (c,4) Je '88
Trav&Leisure 20:181, 183 (c,4) Je '90
Trav&Leisure 20:112–13 (c,1) Ag '90
—Noto peninsula
Gourmet 48:70–5, 176 (map,c,1) S '88
—Railroad scenes
Trav&Leisure 19:121–6 (map,c,4) O '89
—Suruga Bay marine life
Nat Geog 178:cov., 2–39 (map,c,1) O '90
—See also
HIROSHIMA
MOUNT FUJI
OSAKA
SHINTOISM
TOKYO
JAPAN—ARCHITECTURE
—Design elements
Smithsonian 21:77 (c,3) Ja '91
—Japanese house
Trav&Leisure 17:34 (c,4) N '87
—Traditional inn "ryokan"
Trav/Holiday 168:60–5 (c,1) N '87
Trav&Leisure 19:65 (painting,c,4) Ag '89
JAPAN—ART
—16th cent. paintings
Smithsonian 19:75–9 (c,3) N '88
—Mid 19th cent. prints depicting westerners
Smithsonian 21:139 (c,4) Jl '90
—1848 print of samurai slaying whale
Natur Hist 98:76–7 (c,2) Mr '89
—Buddha sculpture (Kamakura)
Trav/Holiday 167:70 (c,4) F '87
—Edo Period works
Smithsonian 22:112–14, 120–1 (c,2) Ap '91
—Japanese style and aesthetics (Kyoto)
Smithsonian 21:74–9 (c,1) Ja '91
—Treasures from daimyo Japan (1185–1868)
Smithsonian 19:68–79 (c,1) N '88
—Woodblock prints
Trav&Leisure 17:54, 57–8 (c,4) Ag '87

—Scrub jay drinking from faucet
Nat Wildlife 28:57 (c,4) D '89
—Steller's jay
Nat Wildlife 26:45 (c,4) D '87
Natur Hist 99:50 (c,4) Jl '90
—See also
BLUE JAYS
JEEPS
—1940s
Am Heritage 42:35 (c,1) D '91
JEFFERSON, THOMAS
Nat Geog 172:361 (painting,c,4) S '87
Smithsonian 18:82, 86 (painting,c,4) S '87
Life 10:74 (painting,c,4) Fall '87
Trav&Leisure 18:116 (drawing,4) Mr '88
Nat Geog 176:52 (painting,c,4) Jl '89
Nat Geog 178:112 (painting,c,4) D '90
Am Heritage 42:86 (sculpture,c,4) Jl '91
—Monticello, Charlottesville, Virginia
Gourmet 47:70 (c,3) Ap '87
Life 10:74 (c,2) Fall '87
—Mount Rushmore sculpture, South Dakota
Life 13:2–3, 50–2 (c,1) F '90
JEFFERSON MEMORIAL, WASHINGTON, D.C.
Trav&Leisure 17:20 (c,4) Ap '87
JEFFRIES, JAMES
Am Heritage 42:70 (4) O '91
JEKYLL ISLAND, GEORGIA
Trav&Leisure 18:128–35, 162–5 (c,3) Mr '88
Am Heritage 41:38 (c,4) D '90
JELLYFISH
Natur Hist 96:88–9 (c,1) S '87
Nat Geog 177:17 (c,3) F '90
Nat Geog 177:41 (c,1) Ap '90
Natur Hist 99:cov. (c,1) Je '90
Nat Geog 179:54–5 (c,2) Ja '91
Smithsonian 21:100–11 (c,1) F '91
Natur Hist 100:cov., 62–3 (c,1) My '91
Natur Hist 100:66–71 (c,1) O '91
—Starfish eating jellyfish
Smithsonian 21:104 (c,4) F '91
—See also
PORTUGUESE MAN-OF-WAR
JENIFER, DANIEL OF ST. THOMAS
Life 10:55 (painting,c,4) Fall '87
JERUSALEM, ISRAEL
Trav/Holiday 170:66–7 (c,1) S '88
—Newsstand
Natur Hist 97:90 (4) N '88
—Stylized depiction
Trav/Holiday 176:35 (painting,c,4) O '91
—Western Wall
Trav/Holiday 170:66–7 (c,1) S '88
Trav&Leisure 20:56–7 (c,2) Mr '90
JESUS CHRIST
—6th cent. mosaic (Italy)

Smithsonian 20:62 (c,4) Ja '90
—12th cent. sculpture
Gourmet 50:19 (c,4) O '90
—15th cent. fresco (Italy)
Smithsonian 20:98–9 (painting,c,1) F '90
—Altarpiece crucifixion scene (Colmar, France)
Trav&Leisure 19:73–4 (painting,c,2) My '89
—Bosch painting of Christ
Smithsonian 18:42 (c,4) Mr '88
—Decorated Easter statue of Christ (Chile)
Nat Geog 174:58–9 (c,1) Jl '88
—Dürer's "Adoration of the Magi" (1504)
Natur Hist 96:4 (painting,c,4) S '87
—Mock photo of Jesus walking on street (1930s)
Am Heritage 39:129 (1) N '88
—Mosaic (Turkey)
Trav&Leisure 17:126–7 (c,1) N '87
—Portrayed in Russian icon
Smithsonian 20:133 (painting,c,4) Ap '89
—Shroud of Turin
Life 11:12 (c,4) S '88
JEWELRY
—14th cent. B.C. Canaanite bracelets
Nat Geog 172:719 (c,4) D '87
—600 B.C. bronze necklace (Denmark)
Nat Geog 171:415 (c,4) Mr '87
—16th cent. Indian crucifixes (Georgia)
Nat Geog 173:355 (c,4) Mr '88
—17th cent. Far Eastern jewelry
Nat Geog 178:39, 48–53 (c,1) S '90
—Early 20th cent. Van Cleef & Arpels pieces
Smithsonian 21:164 (c,4) S '90
—1901 pearl pendant
Am Heritage 38:93 (c,1) S '87
—1918 engagement ring with concealed diamond
Am Heritage 39:10 (4) F '88
—Appraising jewelry
Smithsonian 21:114 (c,4) D '90
—Ancient Bactria
Nat Geog 177:50–75 (c,1) Mr '90
—Ancient Celtic bracelet (Great Britain)
Natur Hist 98:86 (c,4) Ap '89
—Ancient Etruscan gold jewelry (Italy)
Nat Geog 173:716–17 (c,4) Je '88
—Ancient Greek gold jewelry
Smithsonian 21:202 (c,4) N '90
—Ancient Maya jade pieces (Honduras)
Nat Geog 176:483–4 (c,2) O '89
—Ancient Moche pieces (Peru)
Nat Geog 174:512–47 (c,1) O '88
Nat Geog 177:24–7 (c,1) Je '90
—Ancient Phoenician jewelry
Smithsonian 19:68–9 (c,1) Ag '88
—Ancient Roman

Nat Geog 171:272 (c,1) F '87
Natur Hist 98:68–9 (c,1) Ap '89
—Bakelite bracelets
Smithsonian 20:67 (c,2) Mr '90
—British royal jewels
Life 10:44–8 (c,1) O '87
—Charm bracelets
Life 12:7 (c,4) Ag '89
—Dogon nose and lip rings (Mali)
Nat Geog 178:114 (c,1) O '90
—Emerald jewelry
Nat Geog 178:38–67 (c,1) Jl '90
—Glass bead necklaces (Kenya)
Natur Hist 96:40 (c,4) Ja '87
—India
Gourmet 47:68 (c,4) S '87
Gourmet 50:94 (c,4) Mr '90
—Jadeite ring (Burma)
Nat Geog 172:301 (c,4) S '87
—Jewelry of the Duchess of Windsor
Life 10:12–13 (c,1) Mr '87
—Live beetles worn as jewelry (Mexico)
Smithsonian 18:116 (c,4) Je '87
—Navajo necklace (Arizona)
Trav/Holiday 170:44 (c,4) Ag '88
—Olympic pins
Sports Illus 68:74–9 (c,4) Ja 27 '88
Sports Illus 68:78–9 (c,1) F 29 '88
—Sapphire and ruby industry
Nat Geog 180:100–25 (c,1) O '91
—Surma lip plates (Ethiopia)
Nat Geog 179:78–9, 88–9 (c,1) F '91
—Treasures from Tiffany
Trav&Leisure 17:28 (c,3) S '87
Smithsonian 18:52–65 (c,1) D '87
—West African gold jewelry
Smithsonian 20:180 (c,4) Je '89
Jewels. See
list under MINERALS
JEWFISH
Trav&Leisure 21:120–1 (c,1) D '91
Jews. See
JUDAISM
JIDDAH, SAUDI ARABIA
Nat Geog 172:432–3, 444–5 (c,1) O '87
JIVARO INDIANS—COSTUME
—Jivaro Indian headdress (Ecuador)
Smithsonian 20:44–5 (c,2) O '89
JOCKEYS
Sports Illus 69:28 (c,4) N 7 '88
Sports Illus 70:74–9 (c,1) My 1 '89
Sports Illus 71:24 (c,2) O 23 '89
Sports Illus 72:55–9 (c,1) F 5 '90
Sports Illus 74:94 (c,4) Je 17 '91
Sports Illus 75:70–1 (c,1) Jl 15 '91
—Child jockeys in camel race (Dubai)
Life 12:79–80 (c,1) Ap '89
—France
Trav&Leisure 20:68 (c,4) My '90

—Jockey hanging from horse's neck
Sports Illus 70:14 (4) F 20 '89
—Robot jockeys on miniature horses (Alabama)
Sports Illus 66:8 (c,4) Ja 26 '87
—Woman jockey
Sports Illus 70:cov., 84–99 (c,1) My 22 '89
JOGGING
—Aboard cruise ship
Trav&Leisure 17:116–17 (c,1) O '87
—George Bush jogging
Life 13:24 (c,3) Ja '90
—China
Life 11:102 (c,3) D '88
—Jogging with dog
Sports Illus 73:30 (c,1) N 12 '90
—Juggling while jogging
Sports Illus 73:9 (c,4) S 17 '90
—On city streets (Utah)
Life 10:46–7 (c,1) F '87
—Ridge Trail, San Francisco, California
Nat Geog 177:99 (c,1) Je '90
—Wisconsin trail
Nat Wildlife 26:42 (c,3) Ag '88
JOHANNESBURG, SOUTH AFRICA
Nat Geog 174:562–3 (c,1) O '88
JOHN DORY FISH
Nat Geog 176:513 (c,4) O '89
JOHNSON, ANDREW
Am Heritage 40:111 (engraving,4) Jl '89
Am Heritage 42:34 (4) Jl '91
JOHNSON, JACK
Sports Illus 72:111–16 (4) My 14 '90
Am Heritage 42:70 (4) O '91
JOHNSON, LYNDON BAINES
Life 10:75 (4) Ag '87
Am Heritage 41:42 (4) F '90
Am Heritage 41:112 (3) Ap '90
Am Heritage 41:cov., 48–51 (c,1) My '90
Am Heritage 42:14, 85 (1) S '91
—Caricature
Am Heritage 41:cov. (c,1) My '90
Am Heritage 42:14 (4) S '91
—Depicted as macho western hero
Am Heritage 40:43 (painting,c,4) N '89
—Fiberglass sculpture of LBJ
Smithsonian 21:82 (c,1) D '90
—In swimming pool
Trav/Holiday 173:64–5 (c,2) F '90
—Ladybird Johnson
Life 10:95 (2) S '87
Nat Geog 173:493 (c,4) Ap '88
—Lynda Byrd Johnson in bridal gown (1967)
Life 11:23 (c,4) My '88
—Lyndon Johnson taking oath of office aboard plane (1963)
Am Heritage 39:148–9 (2) N '88

—LBJ ranch (Austin, Texas)
Nat Geog 173:496–7 (c,2) Ap '88
JOHNSON, WALTER
Sports Illus 67:127, 131 (4) O 26 '87
Sports Illus 70:84 (drawing,4) My 8 '89
Sports Illus 71:6 (4) Jl 10 '89
JOHNSON, WILLIAM SAMUEL
Life 10:51 (painting,c,4) Fall '87
JOHNSTON, JOSEPH E.
Am Heritage 41:88 (4) Mr '90
JOHNSTOWN, PENNSYLVANIA
—1889 Johnstown Flood
Life 12:144–8 (c,1) My '89
Smithsonian 20:50–61 (c,1) My '89
Am Heritage 40:38 (4) My '89
JONES, BOBBY
Sports Illus 75:76 (4) Jl 29 '91
JONES, JOHN PAUL
—Home (Portsmouth, New Hampshire)
Trav/Holiday 167:74 (c,3) My '87
JORDAN
—Ancient Roman ruins
Smithsonian 18:100–13 (map,c,1) N '87
—See also
AMMAN
PETRA
JORDAN—COSTUME
—King Hussein
Life 13:6–7 (c,1) O '90
—Petra
Trav/Holiday 172:46–9 (c,2) O '89
JORDAN—HISTORY
—Chronology of Petra history
Trav/Holiday 172:48–9 (c,4) O '89
JOSEPHINE
Trav&Leisure 20:55 (painting,c,4) My
'90
—Statue (Martinique)
Trav/Holiday 169:74 (c,4) Mr '88
JOSHUA TREE NATIONAL MONU-
MENT, CALIFORNIA
Trav&Leisure 17:E2–4 (c,4) O '87
JOSHUA TREES
Trav&Leisure 17:E2 (c,4) O '87
Trav/Holiday 174:cov. (c,1) Ag '90
Smithsonian 21:36 (c,4) S '90
JOURNALISTS
—1898
Nat Geog 174:215 (3) Ag '88
—Civil War reporter on horseback
Am Heritage 38:30 (drawing,4) Jl '87
—History of television journalism
Smithsonian 20:74–80, 86–9 (2) Je '89
—Polly Pry
Smithsonian 21:49–57 (drawing,c,1) Ja
'91
—See also
BLY, NELLIE
HEARST, WILLIAM RANDOLPH

NEWSPAPER INDUSTRY
SPORTS ANNOUNCERS
STANLEY AND LIVINGSTONE
TELEVISION NEWSCASTERS
THOMPSON, DOROTHY
WINCHELL, WALTER
JOYCE, JAMES
Smithsonian 20:129, 134–44 (3) Mr '90
—Joyce's family
Smithsonian 20:136, 144 (3) Mr '90
—*Ulysses* page proof
Smithsonian 20:132 (3) Mr '90
JUDAISM
—Hebrew class (Moscow, U.S.S.R.)
Nat Geog 179:23 (c,3) F '91
—Jewish Historical Museum, Amsterdam,
Netherlands
Trav&Leisure 18:39 (c,4) Ap '88
—Jewish Museum exhibit (London, En-
gland)
Gourmet 47:76 (c,2) D '87
—Yiddish books
Smithsonian 21:60, 62–6 (c,4) Ja '91
JUDAISM—COSTUME
—Hasidic students
Life 13:64 (4) D '90
—Orthodox Jews (Brooklyn, New York)
Smithsonian 19:123, 125 (c,3) D '88
—Rabbi (Israel)
Life 14:64 (c,3) D '91
JUDAISM—HISTORY
—1940s murals painted by Auschwitz in-
mates, Poland
Life 12:79–82 (c,2) S '89
—1945 concentration camp corpses (Buch-
enwald)
Life 11:48 (3) Fall '88
—Burning Jews during European plague
era
Smithsonian 20:72 (painting,c,4) F '90
—See also
CONCENTRATION CAMPS
DREYFUS, ALFRED
JUDAISM—RITES AND FESTIVALS
—Bar mitzvah
Life 14:38 (3) O '91
—Braiding challah
Gourmet 48:164 (drawing,4) S '88
—Circumcision of Jewish infant (Israel)
Life 14:18 (c,3) O '91
—Jews sitting "shiva" (Ohio)
Life 14:7 (c,4) O '91
—Orthodox divorce ceremony
Life 14:70 (2) O '91
—Orthodox Jewish wedding ceremony
(New York)
Smithsonian 19:125 (c,2) D '88
—"Purim" by Chagall (1910s)
Smithsonian 22:91 (painting,c,3) Jl '91

Nat Wildlife 28:10–11 (c,1) F '90
—Recycling landfill contents (Florida)
Natur Hist 99:58–9, 62–3 (c,1) My '90
—Scrap metal yard (Pennsylvania)
Life 12:90 (c,4) D '89
—Smoldering trash dump (Manila)
Natur Hist 99:cov. (c,1) My '90
—Tire junkyard
Natur Hist 100:56–7 (c,1) Jl '91
—Tire junkyard on fire (Colorado)
Life 11:13 (c,3) Jl '88
JUPITER
—Ancient Roman bronze sculpture
Nat Geog 171:269 (c,1) F '87
JUPITER (PLANET)
Life 12:106–7 (c,1) N '89
Nat Geog 178:50–1, 59–61 (c,1) Ag '90
Life 14:26 (c,1) D '91
—Moon Europa
Nat Geog 178:62–3 (c,2) Ag '90
—Moon Io
Smithsonian 19:46–7 (c,4) S '88
Nat Geog 178:65 (c,3) Ag '90
JURA MOUNTAINS, SWITZERLAND
Trav/Holiday 167:52–3 (c,1) My '87
JUSTICE, ADMINISTRATION OF
—1948 trial (Indiana)

Life 14:20–1 (1) Fall '91
—1965 divorce hearing (China)
Life 11:72 (3) Mr '88
—Boxes of documents used in court cases
Life 14:22–3 (c,1) Fall '91
—British legal system
Smithsonian 22:76–89 (c,1) Je '91
—Inns of Court (London, England)
Smithsonian 22:78–89 (c,1) Je '91
—Landmark Supreme Court decisions
Life 10:84–8 (c,2) Fall '87
—Trial (Romania)
Life 14:120–1 (c,1) Ja '91
—See also
CAPITAL PUNISHMENT
COURTHOUSES
COURTROOMS
CRIME AND CRIMINALS
JUDGES
LAWYERS
POLICE WORK
PRISONS
PUNISHMENT
SUPREME COURT
SUPREME COURT JUSTICES
JUSTINIAN
Smithsonian 20:168 (mosaic,c,4) Je '89

- K -

KAHLO, FRIDA
Trav&Leisure 18:89 (4) D '88
—Art works by her
Trav&Leisure 18:89–94 (c,2) D '88
—Home (Mexico City, Mexico)
Trav&Leisure 18:89, 94 (c,2) D '88
—Self-portrait
Trav&Leisure 18:90 (painting,c,3) D '88
KALAHARI DESERT, BOTSWANA
Natur Hist 96:34–9 (c,1) Je '89
Nat Geog 178:2–37 (map,c,1) D '90
KALAMAZOO, MICHIGAN
—Kalamazoo River
Sports Illus 71:76–90 (painting,c,1) Jl 24 '89
KAMPALA, UGANDA
Nat Geog 173:476–9 (c,1) Ap '88
KANDINSKY, VASILY
—"Composition Silence"
Smithsonian 22:91 (painting,c,3) Jl '91
KANGAROOS
Trav/Holiday 169:44 (c,4) Ja '88
Nat Geog 173:160–1 (c,1) F '88
Nat Wildlife 28:40–1 (c,1) O '90
—Tree kangaroos
Natur Hist 99:60–7 (c,1) Ja '90

—Wallabies
Trav/Holiday 171:66 (c,4) Ap '89
—Wallaroos
Nat Geog 173:285 (c,4) F '88
KANSAS
—Oil industry
Smithsonian 21:cov., 36–47 (1) Mr '91
—Prairie land
Am Heritage 39:54–5, 62 (c,1) Ap '88
Smithsonian 19:58 (c,4) Jl '88
—See also
ABILENE
TOPEKA
KANSAS CITY, MISSOURI
—1981 hotel collapse
Smithsonian 19:122 (c,4) My '88
Karakoram Range. See
HIMALAYA MOUNTAINS
KARATE
Sports Illus 68:42 (c,3) Mr 28 '88
KARL X GUSTAV (SWEDEN)
Smithsonian 19:194 (painting,c,4) My '88
KASHMIR
Trav&Leisure 17:100–9, 191–4 (map,c,1) S '87
Life 11:71 (c,3) S '88

Am Heritage 40:1a–6a (map,c,4) My '89
—See also
LOUISVILLE
MAMMOTH CAVE NATIONAL
PARK
KENYA
Life 12:90–5 (c,1) Ag '89
Trav&Leisure 20:139 (c,3) Ja '90
Sports Illus 72:72–80 (map,c,1) F 26 '90
—Farm
Nat Geog 174:919 (c,1) D '88
—Lamu Island
Trav/Holiday 170:46–51 (map,c,1) Ag
'88
Trav/Holiday 175:64–71 (map,c,1) Mr
'91
—Masai village
Life 12:93 (c,2) Ag '89
—See also
NAIROBI
KENYA—COSTUME
Trav/Holiday 170:46–51 (c,1) Ag '88
Nat Geog 174:918–21 (c,1) D '88
Sports Illus 72:72–84 (c,1) F 26 '90
—Ariaal people
Natur Hist 98:46–9 (c,1) My '89
—Ngisonyoka tribe
Natur Hist 96:32–41 (c,1) Ja '87
—Rendille people
Natur Hist 98:40–5 (c,1) My '89
KENYA—HOUSING
—Ariaal tribe's nkajis
Natur Hist 98:48–9 (c,2) My '89
KEROUAC, JACK
Sports Illus 71:122–4, 132–4 (4) O 23 '89
Life 13:102 (4) Fall '90
KESTRELS
Trav/Holiday 170:14 (c,3) Ag '88
Nat Wildlife 29:20–4 (c,1) Ag '91
—Kestrel chicks
Smithsonian 21:91, 100 (c,4) Ap '90
Nat Wildlife 29:23 (c,1) Ag '91
KEY WEST, FLORIDA
Trav/Holiday 167:38–43, 64 (c,1) Ja '87
Trav&Leisure 19:134–9 (c,2) D '89
KEYS
Trav/Holiday 174:13 (drawing,c,4) D '90
—Ancient Roman (Caesarea)
Nat Geog 171:275 (c,4) F '87
KHARTOUM, SUDAN
Life 13:4–5 (c,1) S '90
KHRUSHCHEV, NIKITA
Smithsonian 17:188 (painting,c,4) Mr '87
Life 11:58 (4) Fall '88
Life 12:110 (4) Mr '89
KHUFU (EGYPT)
Nat Geog 173:535 (sculpture,c,4) Ap '88
KHYBER PASS, AFGHANISTAN/PAK-
ISTAN

Smithsonian 19:42–53 (map,c,1) D '88
KIEV, UKRAINE
Nat Geog 171:610–11, 620–3, 630 (c,1)
My '87
KILAUEA VOLCANO, HAWAII
Natur Hist 97:98 (painting,c,4) O '88
—Eruption
Trav&Leisure 18:16, 26 (c,4) S '88 supp.
Life 12:2–3 (c,1) Ag '89
Trav/Holiday 173:18 (c,4) Ja '90
Life 14:18 (c,2) Ap '91
Natur Hist 100:cov., 50–3, 60–1 (c,1) Ap
'91
Life 14:105 (c,2) Summer '91
KILLER WHALES
Nat Geog 171:492–3 (c,1) Ap '87
Trav/Holiday 169:10 (c,4) My '88
Nat Geog 174:876–7, 882–3 (c,1) D '88
Nat Geog 176:176–7 (c,1) Ag '89
Nat Wildlife 27:42–3 (c,1) Ag '89
Natur Hist 100:cov., 68–70, 74 (c,3) Mr
'91
KING, MARTIN LUTHER, JR.
Smithsonian 17:188 (c,4) Mr '87
Life 11:cov., 26–30 (1) Spring '88
Am Heritage 39:35 (4) Jl '88
Am Heritage 41:38 (4) Mr '90
Life 13:9 (4) Fall '90
Trav/Holiday 176:77 (c,4) Jl '91
—Birthplace (Atlanta, Georgia)
Life 14:47 (c,4) Summer '91
—Martin Luther King's assassin James
Earl Ray
Life 11:6 (4) Mr '88
—Motel site of 1968 King assassination
(Tennessee)
Life 11:8 (c,4) Ap '88
Sports Illus 75:62 (4) Ag 5 '91
—Tomb (Georgia)
Life 11:30 (c,4) Spring '88
KING, RUFUS
Life 10:51 (painting,c,4) Fall '87
KING CANYON NATIONAL PARK,
CALIFORNIA
Nat Geog 175:482–5, 488–9 (c,1) Ap '89
Natur Hist 100:68–9 (1) My '91
KINGFISHERS
Smithsonian 17:24 (c,4) F '87
Natur Hist 97:cov., 38–45 (c,1) My '88
Nat Wildlife 26:12–13 (painting,c,1) Ag
'88
Natur Hist 99:38–9 (c,4) Je '90
Natur Hist 99:4–5 (c,4) D '90
Kings. See
RULERS AND MONARCHS
KINGSTON, ONTARIO
—1840s martello guard tower
Am Heritage 39:26 (c,4) My '88
—McIntosh Castle

Trav/Holiday 167:22 (4) Ja '87
—Old Fort Henry
Trav/Holiday 167:20 (c,4) Ja '87
KINKAJOUS
Nat Geog 176:458 (c,4) O '89
KINSHASA, ZAIRE
Nat Geog 180:26–7 (c,2) N '91
KIOWA INDIANS (SOUTHWEST)—
RELICS
—1870s baby cradleboard
Smithsonian 18:276 (c,4) N '87
KIPLING, RUDYARD
—Home (East Sussex, England)
Gourmet 48:53 (c,1) Jl '88
KISSING
—1950 Parisians kissing on street (France)
Life 13:46 (4) Ap '90
—Baseball player kissing woman
Sports Illus 67:106 (c,2) D 28 '87
Nat Geog 179:48–9 (c,1) Ap '91
—Couple kissing on street
Trav&Leisure 18:cov. (1) F '88
—Famous screen kisses
Life 14:68–77 (1) F '91
—Father kissing daughter (Illinois)
Nat Geog 179:70–1 (c,1) My '91
—Golfer kissing trophy
Sports Illus 73:2–3 (c,1) Jl 30 '90
—In restaurant (Paris, France)
Trav&Leisure 18:115, 119 (4) F '88
—Kissing on park bench (Yugoslavia)
Nat Geog 178:111 (c,2) Ag '90
—Men kissing (Siberia)
Life 14:52 (3) Fall '91
—Poster of Communist leaders kissing
(East Germany)
Life 13:6–7 (painting,c,1) S '90
—Teens kissing
Life 13:44 (4) Ap '90
—Winning football player kissing cheer-
leader
Sports Illus 68:cov. (c,1) Ja 11 '88
—Woman kissing shadow of man's face
Trav&Leisure 20:153 (c,2) O '90
KISSINGER, HENRY
Life 10:31 (4) S '87
KITCHENER, HORATIO HERBERT
Smithsonian 22:134 (4) My '91
KITCHENS
—1830 Shaker kitchen (Massachusetts)
Trav&Leisure 21:E1 (c,3) My '91
—1890s mansion (North Carolina)
Trav/Holiday 175:58 (c,3) Ap '91
—Brodick Castle, Scotland
Gourmet 49:82–3, 124 (c,1) My '89
—Eisenhower's kitchen (Kansas)
Trav/Holiday 174:75 (c,4) O '90
—Ellis Island, New York
Smithsonian 21:95 (c,2) Je '90

—French chateau
Gourmet 49:51 (c,1) Jl '89
—Italy
Gourmet 51:58 (drawing,c,3) O '91
—Lincoln's home (Springfield, Illinois)
Trav/Holiday 167:49 (c,2) F '87
—Messy family kitchen (California)
Life 11:74 (c,3) Ag '88
—Restaurant (Austria)
Gourmet 51:117 (c,4) O '91
—Restaurant (California)
Gourmet 47:100, 102 (drawing,4) S '87
Gourmet 49:28 (drawing,4) My '89
Trav&Leisure 20:63 (c,4) Ap '90
Gourmet 51:28 (drawing,4) F '91
Gourmet 51:26 (painting,c,2) Jl '91
—Restaurant (New York)
Gourmet 47:28 (drawing,4) F '87
Gourmet 47:28 (painting,c,2) O '87
Gourmet 48:24 (drawing,4) Mr '88
Gourmet 48:32 (drawing,4) N '88
Gourmet 50:28 (painting,c,2) F '90
Gourmet 50:33 (painting,c,2) Jl '90
—Wood cabin (Brazil)
Nat Geog 174:784 (c,4) D '88
—See also
COOKING
STOVES
KITE FLYING
Smithsonian 20:cov., 69–75 (c,1) My '89
—1908 experimental kite by Bell
Nat Geog 174:376–7 (1) S '88
Am Heritage 41:46–7 (1) S '90
—Guatemala
Nat Geog 176:473 (c,4) O '89
—Thailand
Gourmet 48:86–7 (c,2) N '88
KITES
—Kite shaped like hawk (Indonesia)
Gourmet 51:72 (c,4) Ap '91
KITES (BIRDS)
Natur Hist 97:cov., 42–51 (c,1) Ja '88
Smithsonian 19:54–63 (c,2) Jl '88
KITTIWAKES
Smithsonian 17:137 (painting,c,4) Ja '87
KLEE, PAUL
—Self-portrait (1911)
Smithsonian 17:65 (drawing,4) F '87
—Works by him
Smithsonian 17:64–75 (painting,c,2) F
'87
KLUANE NATIONAL PARK, YUKON
Trav&Leisure 17:116–17 (c,1) D '87
KNIGHTS
—Knight Godfrey on 1096 Crusade
Nat Geog 176:333, 345, 349, 364 (paint-
ing,c,2) S '89
Knights of Malta. See
KNIGHTS OF ST. JOHN

KNIGHTS OF ST. JOHN
 Nat Geog 175:702 (c,3) Je '89
—16th cent. cross of Knight of St. John of
 Jerusalem
 Natur Hist 97:53 (c,4) S '88
—Jean Parisot de la Valette
 Nat Geog 172:563 (painting,c,4) N '87
KNIVES
—Ivory-handled knife (Middle East)
 Natur Hist 98:40–1 (c,4) Je '89
—Swiss army knives
 Trav&Leisure 18:36–7 (c,2) Jl '88
 Smithsonian 20:106–16 (painting,c,1) O
 '89
 Trav&Leisure 20:75 (c,4) Ap '90
KOALAS
 Trav&Leisure 17:A22 (c,4) O '87 supp.
 Trav/Holiday 171:61 (c,1) Ap '89
 Natur Hist 99:cov., 34–43 (c,1) Ag '90
KOKOSCHKA, OSKAR
—"Old Man"
 Smithsonian 22:90 (painting,c,4) Jl '91
KOREA—COSTUME
—Early 20th cent.
 Natur Hist 97:90–3 (3) Ap '88
KOREA—HISTORY
—1590s invasion of Korea by Japanese
 Smithsonian 19:50–1 (painting,c,3) Ag
 '88
—1966 guards at border
 Smithsonian 19:52 (4) Ag '88
KOREA—SHRINES AND SYMBOLS
—Korean yin and yang symbol
 Smithsonian 19:47 (c,4) Ag '88
KOREA, ANCIENT—RELICS
—Silla dynasty artifacts (Kyongju)
 Trav/Holiday 167:24–6 (c,3) Ja '87
 Nat Geog 174:258–68 (c,1) Ag '88
KOREA, NORTH
 Life 11:86–92 (c,1) S '88
—Life in the DMZ
 Sports Illus 69:46–50 (c,2) S 14 '88
KOREA, NORTH—COSTUME
 Life 11:86–92 (c,1) S '88
KOREA, NORTH—POLITICS AND
 GOVERNMENT
—Bowing to leader Kim
 Life 11:92 (c,3) S '88
KOREA, NORTH—RITES AND FESTI-
 VALS
—Mass gymnastics display
 Life 14:10–11 (c,1) Ag '91
KOREA, SOUTH
 Life 10:20–7 (c,1) S '87
 Nat Geog 174:131, 232–68 (map,c,1) Ag
 '88
 Smithsonian 19:46–59 (c,1) Ag '88
—Kyongju
 Trav/Holiday 167:24–6 (c,3) Ja '87

 Nat Geog 174:258–68 (c,1) Ag '88
—Life in the DMZ
 Sports Illus 69:46–50 (c,2) S 14 '88
—Mt. Soraksan
 Smithsonian 19:59 (c,1) Ag '88
—See also
 PUSAN
 SEOUL
KOREAN, SOUTH—COSTUME
 Life 10:20–7 (c,1) S '87
 Nat Geog 174:235–57 (c,1) Ag '88
 Smithsonian 19:48–58 (c,1) Ag '88
—Children
 Trav&Leisure 18:104–5 (c,1) Ag '88
—Traditional costume
 Trav/Holiday 167:74 (c,4) F '87
 Sports Illus 69:2–3, 42 (c,1) S 26 '88
—Traditional hanbok costume (Seoul)
 Trav&Leisure 18:107 (c,4) Ag '88
—Traditional long skirts
 Smithsonian 19:57 (c,2) Ag '88
KOREA, SOUTH—HOUSING
—Small houses (Seoul)
 Trav&Leisure 18:106–7 (c,1) Ag '88
KOREA, SOUTH—POLITICS AND
 GOVERNMENT
—Police arresting demonstrator
 Life 11:74 (c,4) Ja '88
—Putting vote in ballot box
 Nat Geog 174:248–9 (c,2) Ag '88
—Student protest
 Life 10:20–1 (c,1) S '87
 Sports Illus 69:26–7, 33 (c,1) Jl 4 '88
 Nat Geog 174:244–7 (c,1) Ag '88
 Smithsonian 19:54 (c,3) Ag '88
—Woman hit by firebomb
 Life 12:98 (c,1) Ja '89
KOREA, SOUTH—RITES AND FESTI-
 VALS
—Ancestors' day feast
 Nat Geog 174:267 (c,3) Ag '88
—Feast of the Lanterns
 Nat Geog 174:240–1 (c,1) Ag '88
 Trav&Leisure 18:108 (c,2) Ag '88
KOREAN WAR
—Coffin of North Korean soldier
 Life 10:26 (c,4) S '87
—Monument to Korean War soldiers
 (South Korea)
 Trav/Holiday 169:68 (c,4) Je '88
—Rock identifying 38th Parallel
 Life 10:26 (c,4) S '87
KOSCIUSZKO, THADDEUS
 Am Heritage 41:52 (painting,c,3) N '90
—Statue (New York)
 Am Heritage 39:47 (c,4) Ap '88
 Am Heritage 41:55 (c,4) N '90
KOSSUTH, LAJOS
 Am Heritage 41:6, 49 (4) N '90

—Statue (Budapest, Hungary)
 Gourmet 48:72 (c,2) O '88
—Statue (New York City, New York)
 Am Heritage 41:55 (c,4) N '90
KOUFAX, SANDY
 Sports Illus 67:60 (4) O 12 '87
 Sports Illus 71:86 (c,2) N 15 '89
KRAKOW, POLAND
—View from church tower
 Nat Geog 173:80–1 (c,1) Ja '88
KREMLIN, MOSCOW, U.S.S.R.
 Life 10:33 (c,1) O '87
 Nat Geog 177:62–105 (map,c,1) Ja '90
—History of the Kremlin
 Nat Geog 177:81–92 (painting,c,3) Ja '90
—Palace of Congresses
 Nat Geog 177:74–5 (c,1) Ja '90
KRISTINA (SWEDEN)
 Smithsonian 19:194 (painting,c,4) My
 '88
KU KLUX KLAN
 Life 11:76–7 (c,1) Ja '88
—1925 KKK parade (Washington, D.C.)
 Am Heritage 39:52 (2) Mr '88
KUALA LUMPUR, MALAYSIA
—Railroad station
 Trav/Holiday 168:47 (c,2) D '87
KUBLAI KHAN
 Natur Hist 98:6 (drawing,4) Ja '89
 Natur Hist 98:42–3 (painting,c,1) Je '89
KUWAIT
—Effects of Kuwait's burning oil fields
 Nat Geog 180:cov., 2–33 (map,c,1) Ag
 '91
—Saving Kuwait's oil fields
 Life 14:42–50 (c,1) Jl '91
 Nat Geog 180:17, 24–6, 30–1 (c,1) Ag
 '91

KUWAIT—COSTUME
 Nat Geog 173:661 (c,3) My '88
 Nat Geog 180:4–5 (c,1) Ag '91
 Nat Wildlife 29:15 (c,2) Ag '91
KUWAIT—HISTORY
—1990–1991 Gulf Crisis
 Life 14:entire issue (c,1) Mr '91
 Life 14:4–8 (c,1) Ap '91
—Anti-Hussein demonstration (Abu
 Dhabi)
 Am Heritage 41:103 (c,4) N '90
—Iraqi attack on Kuwait (1990)
 Life 14:5 (c,2) Ja '91
 Life 14:42–3 (c,1) Mr '91
—See also
 GULF WAR
KUWAIT—POLITICS AND GOVERN-
 MENT
—Persian Gulf naval attacks
 Life 11:122–5 (map,c,1) Ja '88
—Searching suspected traitor
 Life 14:4–5 (c,1) Ap '91
KUWAIT CITY, KUWAIT
 Life 14:42–3 (c,1) Mr '91
KWAKIUTL INDIANS (NORTH-
 WEST)—COSTUME
—1890s
 Natur Hist 100:50–1 (2) O '91
KWAKIUTL INDIANS (NORTH-
 WEST)—RELICS
—19th cent. bowl and masks
 Natur Hist 97:50–7 (c,1) N '88
KWAKIUTL INDIANS (NORTH-
 WEST)—RITES AND FESTIVALS
—1897 potlatch
 Natur Hist 100:50–1 (2) O '91
—Dance performance of Siwidi legend
 Natur Hist 100:42–7 (c,1) O '91

- L -

LABOR DAY
—Crowd of boaters (Lake Havasu, Ari-
 zona/California)
 Nat Geog 179:6–7 (c,1) Je '91
LABOR UNIONS
—Coal miners on strike (Siberia,
 U.S.S.R.)
 Nat Geog 177:29 (c,4) Mr '90
—NFL players on strike
 Sports Illus 67:46 (c,4) O 12 '87
—Max Zaritsky
 Am Heritage 42:26 (4) Jl '91
—See also
 DEBS, EUGENE V.
 GOMPERS, SAMUEL

LEWIS, JOHN L.
LABORATORIES
—Aboard airplane
 Smithsonian 18:146–7 (c,2) F '88
—Blood analysis lab (Uganda)
 Nat Geog 173:473 (c,4) Ap '88
—Cold Spring Harbor Laboratory, Long
 Island, New York
 Smithsonian 20:43 (c,3) F '90
—Edison's laboratory (Ft. Myers, Florida)
 Trav&Leisure 19:177 (c,4) D '89
—Edison's laboratory (New Jersey)
 Life 14:46 (c,4) Summer '91
—Marine Biological Laboratory, Woods
 Hole, Massachusetts

Smithsonian 19:91 (c,2) Je '88
—Alfred Nobel's lab (Italy)
Smithsonian 19:214 (4) N '88
—Sandia National Labs, Albuquerque,
New Mexico
Nat Geog 172:608–9 (c,1) N '87
—Scientific specimen jars
Nat Wildlife 26:4–6 (c,4) Ap '88
LABORERS
—1830s work gang (Australia)
Nat Geog 173:236 (lithograph,3) F '88
—Australia
Smithsonian 18:137 (c,2) Ja '88
Nat Geog 173:208–9 (c,1) F '88
—Bangladesh
Life 12:64–8 (1) Ag '89
—Cleaning 1989 Alaskan oil spill
Nat Geog 177:2–4, 22, 40–1 (c,1) Ja '90
—English Channel tunnel workers
Life 13:27–39 (1) N '90
—Hanson sculpture of workman
Smithsonian 18:93 (c,4) N '87
—India
Nat Geog 177:124–8 (c,1) My '90
—Indians crushing stones (Bhutan)
Nat Geog 179:84–5 (c,1) My '91
—London docks, England
Nat Geog 180:40, 52–3 (c,3) Jl '91
—Oil industry workers (Alaska)
Nat Geog 177:56 (3) F '90
—Oil industry workers (Kansas)
Smithsonian 21:cov., 36–43 (1) Mr '91
—Pakistan
Smithsonian 21:30–41 (c,1) Je '90
—Steamboat workers
Smithsonian 22:42–5 (2) O '91
—Transporting stone (China)
Natur Hist 98:49 (c,4) O '89
—See also
FACTORY WORKERS
FARM WORKERS
RAILROAD WORKERS
LABRADOR RETRIEVERS
Sports Illus 73:134–49 (c,1) D 31 '90
LABYRINTHS
—Garden maze (Weldam, Netherlands)
Gourmet 51:82 (c,3) Ap '91
—Japanese mazes
Smithsonian 18:114 (c,4) D '87
Trav/Holiday 169:120 (c,4) Ap '88
—Japanese walk-through maze (Cali-
fornia)
Life 11:8 (c,4) O '88
—Mazes in British country gardens
Smithsonian 18:108–19 (c,1) D '87
Trav/Holiday 176:69 (c,4) N '91
LACE MAKING
—Italy
Gourmet 51:52 (c,4) Ag '91

LACEWINGS
Nat Geog 176:422 (c,2) S '89
LACROSSE
Nat Geog 172:376 (c,2) S '87
—19th cent. Iroquois game
Nat Geog 172:377 (painting,c,4) S '87
LACROSSE—COLLEGE
Sports Illus 66:69–70 (c,4) My 4 '87
Sports Illus 72:62–4 (c,4) My 28 '90
LACROSSE—PROFESSIONAL
—Box lacrosse
Sports Illus 66:56–7 (c,4) Mr 30 '87
LADYBUGS
Nat Wildlife 27:56 (c,2) Ap '89
Nat Geog 176:420–1 (c,1) S '89
LADY'S SLIPPERS (FLOWERS)
Nat Geog 171:224 (c,4) F '87
LA FARGE, JOHN
—Art works by him
Smithsonian 18:cov., 47–59 (c,1) Jl '87
—Painting of peonies
Am Heritage 38:73 (c,4) D '87
—Self-portrait (1859)
Smithsonian 18:47 (painting,c,2) Jl '87
LAFAYETTE, MARQUIS DE
Nat Geog 176:30, 50–1 (painting,c,3) Jl
'89
Am Heritage 40:43–51 (painting,c,1) Jl
'89
—Depicted on American objects
Am Heritage 40:48–51 (c,1) Jl '89
—Home (Chavaniac, France)
Nat Geog 176:30–1 (c,2) Jl '89
LA GUARDIA, FIORELLO
Smithsonian 19:185 (4) D '88
—Caricature
Am Heritage 41:16 (drawing,4) F '90
LAKE BAYKAL, SIBERIA, U.S.S.R.
Nat Geog 177:24–5 (c,2) Mr '90
LAKE CHAMPLAIN, NEW YORK/
VERMONT
Gourmet 48:66–7 (c,1) S '88
Trav/Holiday 173:54–5, 59–67 (map,c,1)
Je '90
—Early 19th cent. horse ferry
Nat Geog 176:548–56 (c,1) O '89
—Plaque dedicated to Lake Champlain's
Champ (N.Y.)
Trav&Leisure 17:E4 (c,4) Je '87
LAKE CLARK NATIONAL PARK,
ALASKA
Nat Geog 180:54–5 (c,1) Ag '91
LAKE COMO, ITALY
Gourmet 49:54–5 (c,1) Ag '89
LAKE CONSTANCE, EUROPE
Trav&Leisure 19:162–70 (map,c,1) Ap
'89
Gourmet 49:6, 60–1, 64, 136 (map,c,1) Je
'89

—LAKE GENEVA, SWITZERLAND
Gourmet 51:90 (c,3) Ja '91
LAKE GEORGE, NEW YORK
Trav&Leisure 17:94–6, 98–9 (c,1) Jl '87
LAKE HURON, MIDWEST
—Michigan
Trav&Leisure 18:146–7 (c,1) My '88
Gourmet 49:75 (c,1) Je '89
LAKE LOUISE, ALBERTA
Trav/Holiday 176:45 (c,1) D '91
LAKE LUGANO, SWITZERLAND
Life 11:134–5 (c,1) O '88
LAKE MICHIGAN, MIDWEST
—Chicago shore, Illinois
Trav&Leisure 20:166–7 (c,1) O '90
—Flooding (Chicago, Illinois)
Nat Geog 172:2–7 (c,1) Jl '87
LAKE NYASA, MALAWI
Smithsonian 19:144–55 (c,1) D '88
Nat Geog 176:380 (c,4) S '89
Nat Geog 177:8–9, 42–51 (map,c,1) My
'90
LAKE OKEECHOBEE, FLORIDA
Nat Geog 178:92–3 (c,3) Jl '90
LAKE SUPERIOR, MIDWEST
Nat Geog 172:16 (c,1) Jl '87
Trav/Holiday 168:56–9 (c,2) Jl '87
LAKE TAHOE, CALIFORNIA/NE-
VADA
Trav/Holiday 171:89–95 (map,c,1) Mr
'89
LAKE TANGANYIKA, AFRICA
Nat Geog 177:38–9 (c,1) My '90
LAKE TITICACA, PERU/BOLIVIA
Nat Geog 171:440–1 (c,1) Ap '87
LAKES
—1986 fatal gas burst at Lake Nyos, Ca-
meroon
Natur Hist 96:44–9 (map,c,1) Ag '87
Nat Geog 172:404–19 (map,c,1) S '87
—Adirondack region, New York
Trav/Holiday 168:34, 37 (c,3) N '87
—Alster lakes, Hamburg, West Germany
Trav&Leisure 18:134–5 (c,1) Je '88
—Borax Lake, Oregon
Nat Geog 174:838–9 (c,1) D '88
—Dal Lake, Kashmir
Trav&Leisure 17:101, 106–7 (c,1) S '87
—Drought's effect on Saskatchewan lake
Natur Hist 98:48–9 (c,3) Ja '89
—Finger Lakes, New York
Trav/Holiday 168:44–9 (c,2) Jl '87
Nat Geog 172:382–3 (c,1) S '87
—Guatavita lagoon, Colombia
Life 10:32–3 (c,1) Mr '87
—Image lake, Glacier Peak Wilderness,
Washington
Nat Wildlife 27:53 (c,2) O '89
—Kariba Lake, Zimbabwe

Trav&Leisure 20:110 (c,4) S '90
—Killarney National Park, Ireland
Trav/Holiday 176:82 (c,1) O '91
—Kootenai Lake, Montana
Trav&Leisure 19:170 (c,4) Mr '89
—Lac d'Annecy, France
Gourmet 47:64–9 (c,1) My '87
—Laguna Colorada, Bolivia
Nat Geog 171:452–3 (c,1) Ap '87
—Laigne Lake, Jasper National Park, Al-
berta
Trav/Holiday 167:24 (c,4) My '87
—Lake Isabelle, Colorado
Trav/Holiday 171:51 (c,4) My '89
—Lake Kivu, Rwanda/Zaire
Trav&Leisure 18:166 (c,4) O '88
—Lake Lucerne, Switzerland
Gourmet 51:65 (c,1) F '91
—Lake McDonald, Montana
Trav&Leisure 21:68–9 (c,1) Jl '91
—Lake Powell, Arizona
Trav/Holiday 171:16 (c,4) Mr '89
—Lake Taupo, New Zealand
Gourmet 47:54–5, 132 (map,c,1) Ap '87
—Man-made lake containing alligators
(Florida)
Smithsonian 17:46–7 (c,1) Ja '87
—Man-made lake in desert (California)
Nat Geog 179:26–7 (c,1) Je '91
—Mountains reflected in lake
Nat Wildlife 28:4–5 (c,1) Je '90
Natur Hist 99:41 (c,4) Je '90
—Ontario
Gourmet 51:90–1 (c,2) My '91
—Otsego Lake, Cooperstown, New York
Gourmet 49:104–5 (c,2) O '89
—Pipes Lake, Mississippi
Natur Hist 98:74–6 (map,c,1) My '89
—Pyramid Lake, Nevada
Sports Illus 71:4–5 (c,4) N 6 '89
—Rainbow Lake, Maine
Nat Geog 171:241 (c,2) F '87
—Ring lake caused by meteorites (Quebec)
Smithsonian 20:84 (c,4) S '89
Natur Hist 100:50–1 (c,1) Je '91
—Stella Lake, Nevada
Smithsonian 18:72–3 (c,1) N '87
—Sun Moon Lake, Taiwan
Trav&Leisure 17:138 (c,4) Mr '87
—See also
CRATER LAKE
GREAT LAKES
GREAT SALT LAKE
LAKE BAYKAL
LAKE CHAMPLAIN
LAKE COMO
LAKE CONSTANCE
LAKE GENEVA
LAKE GEORGE

LAKE HURON
LAKE LOUISE
LAKE LUGANO
LAKE MICHIGAN
LAKE NYASA
LAKE OKEECHOBEE
LAKE SUPERIOR
LAKE TAHOE
LAKE TANGANYIKA
LAKE TITICACA
LOCH NESS
SALTON SEA
LAMPS
—4th cent. bronze oil lamp (Cyprus)
 Nat Geog 174:52 (c,1) Jl '88
—16th cent. Ottoman mosque lamp (Turkey)
 Trav&Leisure 17:30 (c,4) F '87
—1870 gas lamp
 Am Heritage 40:111 (c,4) D '89
—Early 20th cent. pairpoint "Puffy" lamp
 Am Heritage 42:31 (c,1) Ap '91
—1920s cloisonne office lamp (New York)
 Am Heritage 39:94 (c,4) N '88
—Ancient Roman (Caesarea)
 Nat Geog 171:274–5 (c,2) F '87
—Kerosene lamp (Kenya)
 Sports Illus 72:84 (c,4) F 26 '90
—Tiffany lamps
 Trav&Leisure 17:26 (c,4) Mr '87
 Smithsonian 18:97 (c,1) N '87
 Trav/Holiday 172:19 (c,4) D '89
 Trav&Leisure 21:56 (c,4) Je '91
—Unusual fish lamp
 Smithsonian 18:59 (c,1) Ap '87
—See also
 LANTERNS
LAND, EDWIN
 Life 11:99 (c,4) Fall '88
 Life 13:109 (4) Fall '90
Landfills. See
 JUNKYARDS
LANDON, ALFRED M.
 Life 10:6 (c,4) O '87
LANGDON, JOHN
 Life 10:51 (painting,c,4) Fall '87
LANGLEY, SAMUEL PIERPONT
 Smithsonian 21:126 (4) D '90
LANGTRY, LILY
 Trav/Holiday 169:79 (painting,c,4) Mr '88
LANGUAGE
—Humorous depictions of Esperanto
 Smithsonian 17:112–25 (drawing,c,1) Ja '87
—Map of linguistic families in the Americas
 Natur Hist 96:8 (c,2) Mr '87

LANTERNS
—1920s wrought iron lantern (Florida)
 Am Heritage 41:92 (c,4) My '90
Buddhist Feast of the Lanterns (South Korea)
 Nat Geog 174:240–1 (c,1) Ag '88
 Trav&Leisure 18:108 (c,2) Ag '88
—Hong Kong
 Gourmet 50:112 (c,4) O '90
—Outdoor Christmas lanterns (Santa Fe, New Mexico)
 Am Heritage 39:24 (c,4) D '88
 Trav/Holiday 174:60–1, 65 (c,1) D '90
—Outdoor farolitos (New Mexico)
 Gourmet 49:86 (c,3) D '89
—Paper lanterns (Massachusetts)
 Trav&Leisure 17:96–7 (c,1) My '87
LAOS
 Nat Geog 171:772–95 (map,c,1) Je '87
—See also
 MEKONG RIVER
LAOS—COSTUME
 Nat Geog 171:774–95 (c,1) Je '87
—Hmong people
 Nat Geog 171:782, 786–7 (c,2) Je '87
—Hmong people (U.S.)
 Nat Geog 174:586–610 (c,2) O '88
LAOS—HISTORY
—Hmong people story cloths (Laos)
 Nat Geog 174:589–91 (c,1) O '88
—Maps of Laos history
 Nat Geog 171:779 (c,4) Je '87
LAOS, ANCIENT—RELICS
—Ancient sandstone urns (Plain of Jars)
 Nat Geog 171:790–1 (c,1) Je '87
LA PAZ, BOLIVIA
 Nat Geog 171:426–7 (c,1) Ap '87
LAPP PEOPLE—COSTUME
—Norway
 Natur Hist 96:34–8 (c,2) D '87
LARDNER, RING
 Sports Illus 73:118 (4) O 15 '90
LARKSPURS
 Nat Wildlife 25:24 (drawing,c,4) Ap '87
LA SALLE, SIEUR DE
—Death of La Salle (1687)
 Am Heritage 38:108 (painting,4) F '87
LAS VEGAS, NEVADA
 Trav&Leisure 20:109–16 (map,c,3) N '90
 Trav&Leisure 21:117–32, 150 (painting,c,1) S '91
—Caesar's Palace
 Trav&Leisure 20:137 (c,4) Ja '90
—Hotel's mock volcano
 Nat Geog 179:3 (c,4) Je '91
—Stylized depiction of Las Vegas
 Trav&Leisure 19:83 (painting,c,2) Je '89
LASERS
—Laser beams piercing flame

Smithsonian 18:70–7 (c,1) O '87
—Laser lights fired at moon
Smithsonian 21:130–1 (c,3) O '90
—Laser pictures
Smithsonian 17:118–21 (c,1) F '87
—Outdoor laser show (San Diego, California)
Nat Geog 176:187 (c,4) Ag '89
—Scientific study of latent fingerprints
Smithsonian 20:201–18 (c,3) O '89
Latin America—history. See
AMERICA—DISCOVERY AND EXPLORATION
LATIN AMERICA—MAPS
—Principal Maya regions
Natur Hist 100:8 (c,3) Ja '91
LATVIA
Nat Geog 178:3–37 (map,c,1) N '90
—See also
RIGA
LATVIA—COSTUME
Nat Geog 178:4–7, 16–27, 33 (c,1) N '90
—Traditional apparel
Nat Geog 175:631 (c,3) My '89
LAUNDRY
—1860s clothes wringer
Am Heritage 40:111 (4) N '89
—Early 20th cent. commercial dryer (New York)
Trav/Holiday 174:45 (1) S '90
—Clothes hanging on line (Ireland)
Trav&Leisure 20:116 (c,3) Je '90
—Coach scrubbing stains from football uniforms
Sports Illus 71:122 (c,2) S 4 '89
—Early washing machines
Am Heritage 38:72 (drawing,2) S '87
—Family doing wash (California)
Life 10:46–7 (c,1) Ag '87
—Hanging clothes on line
Sports Illus 75:54–5 (c,1) Ap 15 '91
Life 14:80–1 (1) D '91
—Hanging wash on balcony (Japan)
Nat Geog 177:71 (c,3) Ap '90
—Laundermat (Arizona)
Smithsonian 21:94–5 (c,3) D '90
—Laundermat (British Columbia)
Life 13:116 (c,2) Mr '90
—Monks hanging clothes on line (Yugoslavia)
Nat Geog 178:122–3 (c,1) Ag '90
—Towels hanging on summer camp clothesline (Maryland)
Smithsonian 21:97 (c,3) Ag '90
LAUREL AND HARDY
—Stan Laurel
Smithsonian 22:163 (4) O '91
Lava. See
VOLCANOES

LAVENDER
—Lavender field (France)
Sports Illus 71:16–17 (c,1) Jl 31 '89
LAVOISIER, ANTOINE LAURENT
Am Heritage 40:4 (painting,c,3) Jl '89 supp.
Law. See
JUSTICE, ADMINISTRATION OF
LAW, JOHN
Smithsonian 20:161, 168 (painting,c,4) D '89
LAWN MOWERS
—1855
Sports Illus 66:92 (c,4) Je 29 '87
LAWRENCE, D. H.
Smithsonian 22:129 (4) Je '91
LAWRENCE, THOMAS EDWARD
Smithsonian 18:252 (4) N '87
Smithsonian 21:133 (drawing,4) Jl '90
Smithsonian 22:145, 148 (4) My '91
—Lawrence of Arabia's motorcycle
Sports Illus 74:2–3 (c,1) Ap 1 '91
LAWYERS
—Barristers (Great Britain)
Smithsonian 22:79–89 (c,1) Je '91
—See also
DARROW, CLARENCE
DEMOSTHENES
EVARTS, WILLIAM
JUDGES
JUSTICE, ADMINISTRATION OF
SUPREME COURT JUSTICES
LAWYERS—HUMOR
—Lawyers in the ancient world
Smithsonian 18:122–31 (drawing,c,1) O '87
LEAFHOPPERS
Nat Geog 178:86 (c,4) Jl '90
LEANING TOWER OF PISA, ITALY
Trav/Holiday 167:69 (c,4) Mr '87
Life 13:94–5 (c,1) F '90
Trav&Leisure 20:96 (painting,c,2) Ap '90
Trav/Holiday 20:132 (c,4) S '90
LEAR, EDWARD
—Painting of stork
Natur Hist 97:36 (c,1) Mr '88
LEATHER INDUSTRY
—Examining skins (France)
Gourmet 47:43 (c,1) F '87
—Tanners dyeing skins (Morocco)
Gourmet 50:80 (c,2) S '90
Nat Geog 180:14–15 (c,1) D '91
LEAVES
Natur Hist 99:36 (c,1) My '90
Nat Wildlife 29:47 (c,2) Ag '91
—Autumn leaves
Nat Wildlife 26:10–15 (c,1) O '88
Natur Hist 99:39 (c,1) My '90

Trav/Holiday 175:26 (c,3) Je '91
—Grand Palace's Grand Cascade (Pet-
rodvorets)
Trav/Holiday 167:6 (c,3) F '87
—Nevsky Prospekt
Nat Geog 175:608–9 (c,1) My '89
—Peter the Great's palace
Trav&Leisure 20:140 (c,4) Ja '90
—See also
NEVA RIVER
LENNON, JOHN
Life 11:59 (c,1) Fall '88
LEONARDO DA VINCI
—Models of his inventions
Smithsonian 18:90–5 (c,1) Ag '87
LEOPARDS
Life 12:65 (c,4) Ap '89
Smithsonian 20:26 (c,4) Ap '89
Natur Hist 99:cov., 52–61 (c,1) F '90
Natur Hist 99:42–3 (c,1) S '90
Nat Wildlife 29:49 (c,3) Ag '91
Nat Wildlife 30:2–3 (c,1) D '91
—Silhouette of leopard in mid-leap
Nat Geog 177:102–3 (c,1) Ap '90
LETTUCE INDUSTRY
—Field of lettuce (Hong Kong)
Trav&Leisure 18:99 (c,3) Ja '88
—Packing lettuce for shipment (California)
Nat Geog 179:50–1 (c,1) F '91
LEUKEMIA
—Child with leukemia
Life 14:58–67 (1) Ag '91
—Leukemia victim
Life 13:106–15 (c,1) Je '90
LEWIS, JERRY
Life 14:80–1 (1) S '91
LEWIS, JOHN L.
Life 13:62 (1) Fall '90
LHASA, TIBET
—Potala
Nat Geog 172:784–5 (c,2) D '87
LIBERTY, STATUE OF, NEW YORK
CITY, NEW YORK
Trav&Leisure 19:139–41 (c,2) Ag '89
Trav/Holiday 172:NE1–NE5 (c,1) N '89
Sports Illus 71:142 (c,4) N 15 '89
Life 13:33 (c,4) S '90
Am Heritage 41:10 (c,4) D '90
Trav&Leisure 21:92 (c,2) Je '91
—Ice sculpture (Quebec)
Sports Illus 66:13 (c,4) F 23 '87
—Model of statue in car lot (Japan)
Nat Geog 180:45 (c,4) N '91
—100th birthday celebration (1986)
Life 10:8–9, 24, 47–50 (c,1) Ja '87
Trav&Leisure 19:139 (c,4) Ag '89
Life 12:184 (c,1) Fall '89
—Statue of Liberty souvenir hat
Trav/Holiday 172:NE4 (c,4) N '89

—Used as symbol of 1989 Chinese student
revolt
Life 12:5 (c,2) Fall '89
LIBERTY BELL
Trav/Holiday 167:45 (c,4) Ap '87
—Blind child touching Liberty Bell
Life 13:8 (c,3) Ap '90
—Dover, Delaware
Trav/Holiday 170:8 (c,3) D '88
LIBRARIES
—Adams home (Quincy, Massachusetts)
Life 14:42–3 (c,1) Summer '91
—Ancient Ephesus, Turkey
Trav&Leisure 17:104 (c,2) Mr '87
—Bibliothèque Nationale, Paris, France
Smithsonian 21:114–17, 126 (c,1) S '90
—British Museum reading room, London,
England
Trav&Leisure 19:215 (c,4) D '89
—Child applying for library card
Life 13:38 (c,4) Spring '90
—French villa
Smithsonian 17:54–5 (c,3) Ja '87
—Glasgow Art School, Scotland
Smithsonian 20:130 (c,3) O '89
—Hollywood, California
Smithsonian 18:52–3 (c,1) Ap '87
—John F. Kennedy Library, Boston, Mas-
sachusetts
Life 11:64–9 (c,1) D '88
—Malatesta Library, Italy
Trav&Leisure 19:251–3 (c,3) D '89
—Melk, Austria
Gourmet 50:80 (c,2) My '90
Trav&Leisure 20:188 (c,4) D '90
—Pierpont Morgan Library study, New
York City, New York
Am Heritage 42:4 (c,2) N '91
—Newberry Library, Chicago, Illinois
Smithsonian 18:125–35 (c,1) Mr '88
—Palace library (Spain)
Smithsonian 18:154–5 (c,2) D '87
—Sing Sing prison, New York (1878)
Am Heritage 38:100 (drawing,c,4) Jl '87
—Theological (Prague, Czechoslovakia)
Trav&Leisure 17:112–13 (c,2) F '87
—Trinity College, Dublin, Ireland
Trav&Leisure 18:113 (4) Ap '88
—Versailles Palace, France
Trav&Leisure 17:62 (c,3) My '87
—Wooden card catalog (Great Britain)
Smithsonian 18:117 (c,1) Jl '87
—Carter Woodson Library, Chicago, Illi-
nois
Smithsonian 21:62 (c,2) Jl '90
—Yale University, New Haven, Con-
necticut
Am Heritage 41:102 (c,4) Ap '91
—See also

FOLGER SHAKESPEARE LIBRARY

—Life in Harlem, New York City, New
 York
 Nat Geog 177:cov., 52–75 (c,1) My '90
—Life in small Southern town
 Life 10:128–35 (1) Fall '87
 Nat Geog 175:312–39 (c,1) Mr '89
—Life of working mother (New Jersey)
 Life 13:54–62 (1) Ag '90
—Lifestyles of Chinese youth
 Nat Geog 180:110–36 (c,1) Jl '91
—Lifestyle of migrant farm worker family
 (Florida)
 Life 11:126–32 (1) D '88
—Lifestyles of the rural West
 Nat Geog 175:52–71, 76–83 (c,1) Ja '89
—Living in drug culture (Northeast)
 Life 11:92–100 (1) Jl '88
 Life 13:30–41 (1) Je '90
—Middle-class blacks (Georgia)
 Life 11:46–50 (c,1) Spring '88
—Reenactment of 18th cent. life (Wil-
 liamsburg, Virginia)
 Trav&Leisure 19:100–14 (c,1) Jl '89
—Role of women in Japanese life
 Nat Geog 177:52–83 (c,1) Ap '90
—Scenes of Chicago life, Illinois
 Nat Geog 179:51–77 (c,1) My '91
—Scenes of contemporary American life
 Nat Geog 173:44–79 (c,1) Ja '88
 Life 12:96–105 (1) Fall '89
—Shanghai, China
 Trav&Leisure 17:76–87 (1) Ag '87
—Small-town Missouri life (1950–1985)
 Nat Geog 175:186–215 (1) F '89
—Social history of Missouri shown in Ben-
 ton murals
 Smithsonian 20:cov., 88–97 (paint-
 ing,c,1) Ap '89
—South African Afrikaners
 Nat Geog 174:556–85 (c,1) O '88
—Southern California outdoor sports and
 activities
 Sports Illus 67:cov., 2–3, 50–72 (c,1) S 7
 '87
—Teenage sexuality
 Life 12:24–30 (1) Jl '89
—Televangelists
 Life 10:54–62 (c,1) Je '87
—Vietnam
 Smithsonian 18:62–71 (c,1) Ap '87
—Welfare families
 Life 11:78–81 (1) Spring '88
—Young woman settling in New York City
 Life 13:68–79 (c,1) Mr '90
—See also
 COLLEGE LIFE
 FAMILY LIFE
 FARM LIFE
 MILITARY LIFE

POVERTY
U.S.—SOCIAL LIFE AND CUSTOMS
WESTERN FRONTIER LIFE
LIFESTYLES—HUMOR
—British royalty flaunting coats of arms
 Gourmet 47:28, 32 (drawing,c,3) My '87
LIGHT BULBS
—1880 patent for light bulb
 Am Heritage 41:54 (drawing,4) S '90
LIGHTHOUSES
 Smithsonian 18:cov., 98–109 (c,1) Ag '87
 Life 10:3, 36–42 (c,1) Ag '87
 Trav&Leisure 18:54 (c,4) Mr '88
—Ancient Roman (Caesarea, Israel)
 Nat Geog 171:262–3 (drawing,c,1) F '87
—Annapolis, Maryland
 Nat Geog 174:173 (c,4) Ag '88
—Block Island lighthouse, Rhode Island
 Life 10:36–7 (c,1) Ag '87
 Gourmet 49:78–81 (c,1) My '89
—Brittany, France
 Trav/Holiday 168:66–7 (c,1) Jl '87
—Cape Cod, Massachusetts
 Life 10:3 (c,2) Ag '87
—Cape Disappointment, Washington
 Am Heritage 39:78–9 (c,1) Ap '88
—Hilton Head, South Carolina
 Trav/Holiday 168:24 (c,3) Ag '87
—Hooper's Strait Lighthouse, Maryland
 Trav&Leisure 21:E1 (c,3) Ap '91
—Kilauea, Kauai, Hawaii
 Gourmet 48:46 (c,4) Ja '88
—Langara Island, British Columbia
 Nat Geog 172:119 (c,4) Jl '87
—Mackinac, Michigan
 Trav&Leisure 18:146–7 (c,1) My '88
—Maine
 Life 10:38–40 (c,1) Ag '87
 Trav&Leisure 18:119 (c,2) Jl '88
 Trav/Holiday 171:49 (c,2) F '89
—Maine (1900)
 Am Heritage 40:135 (4) D '89
—Martha's Vineyard, Massachusetts
 Trav&Leisure 17:cov., 94–5, 105, 162
 (c,1) My '87
 Gourmet 48:64 (c,4) F '88
 Life 11:2–3 (c,1) Ag '88
—Montauk Point, New York
 Trav&Leisure 17:E16 (painting,4) Je '87
—Nantucket, Massachusetts
 Smithsonian 18:102 (c,4) Ag '87
 Trav/Holiday 169:cov. (c,1) My '88
 Trav/Holiday 174:64–5 (c,1) N '90
—New Brunswick
 Trav&Leisure 18:E14 (c,3) S '88
 Trav/Holiday 171:44 (c,3) F '89
—Newport, Rhode Island
 Gourmet 50:61 (c,1) Jl '90
—North Herald, Washington

Smithsonian 18:cov. (c,1) Ag '87
—Nova Scotia
 Trav&Leisure 21:206 (c,4) Je '91
—Ocean storm around lighthouse (France)
 Life 13:6–7 (c,1) My '90
—Point Reyes, California
 Gourmet 49:100–1 (c,1) D '89
—Puerto Rico
 Trav/Holiday 176:77 (c,4) D '91
—St. Joseph North Pier light, Michigan
 Smithsonian 18:98–9 (c,1) Ag '87
LIGHTING
—Mechanics of strobe light operation
 Nat Geog 172:469 (drawing,c,4) O '87
—See also
 CHANDELIERS
 ELECTRICITY
 LAMPS
 LANTERNS
 STREET LIGHTS
 TRAFFIC LIGHTS
LIGHTNING
 Nat Geog 171:694–5, 710–11 (c,1) Je '87
 Natur Hist 96:2–4 (c,2) Ag '87
 Smithsonian 19:110–21 (c,1) Jl '88
 Nat Geog 175:246 (c,4) F '89
 Nat Geog 179:107 (c,3) Mr '91
 Life 14:108–9 (c,1) Summer '91
 Trav&Leisure 21:128–9 (c,1) S '91
—Lightning hitting Goodyear blimp
 Life 12:7 (c,4) O '89
—Simulated lightning
 Nat Geog 180:63 (c,1) Ag '91
—Striking downtown Toronto, Ontario
 Life 13:6–7 (c,1) N '90
—Striking storage tanks (Arizona)
 Life 12:7 (c,2) F '89
—Victims of lightning (Minnesota)
 Sports Illus 74:26 (c,4) Je 24 '91
LILACS
 Trav&Leisure 18:144 (painting,c,3) Mr
 '88
LILIES
 Nat Wildlife 26:51, 54–5 (c,1) D '87
 Nat Geog 173:283 (c,4) F '88
 Nat Wildlife 26:cov. (c,1) Ag '88
 Life 12:84–5 (c,2) Jl '89
 Trav&Leisure 20:178 (drawing,c,4) My
 '90
 Nat Geog 178:29 (c,1) D '90
 Smithsonian 21:156 (painting,c,4) D '90
Lilies, water. See
 WATER LILIES
LIMESTONE
 Smithsonian 19:86–96 (c,1) O '88
—Ancient Wall Range, Jasper National
 Park, Alberta
 Nat Geog 175:678–9 (c,2) Je '89
—The Burren, Ireland

Trav/Holiday 176:84 (c,4) O '91
—Limestone cliffs (Wyoming)
 Natur Hist 99:110–11 (c,1) Ap '90
—Limestone hoodoos (Utah)
 Life 14:101 (c,4) Summer '91
—Limestone needles (Madagascar)
 Nat Geog 171:150–1 (c,1) F '87
—Limestone pinnacles (Australia)
 Nat Geog 173:162–3 (c,1) F '88
—Limestone rocks (Idaho)
 Smithsonian 21:39 (c,3) S '90
LIMESTONE INDUSTRY
—Quarrying (Indiana)
 Smithsonian 19:86–96 (c,1) O '88
—Quarrying (Malta)
 Nat Geog 175:712 (c,1) Je '89
 Trav&Leisure 20:216 (c,4) S '90
LIMPETS
 Nat Geog 177:18 (c,4) F '90
LINCOLN, ABRAHAM
 Life 10:74 (4) Jl '87
 Life 10:92 (painting,c,4) Fall '87
 Am Heritage 38:85 (1) D '87
 Am Heritage 39:45 (3) Mr '88
 Am Heritage 39:96–7 (3) Jl '88
 Life 11:48 (4) Fall '88
 Am Heritage 40:71 (4) Ap '89
 Am Heritage 40:14 (drawing,4) S '89
 Am Heritage 41:92–7 (c,1) Mr '90
 Am Heritage 41:3 (painting,4) S '90
 Smithsonian 21:50 (4) O '90
 Life 14:cov., 22–34 (c,1) F '91
—1860 presidential campaign para-
 phernalia
 Am Heritage 39:109–26 (c,4) N '88
—1863 allegorical print of Emancipation
 Am Heritage 39:28 (4) F '88
—Bronze cast of Lincoln's hand
 Am Heritage 38:86 (c,4) D '87
—Caricature
 Life 14:24 (4) F '91
 Trav/Holiday 176:81 (4) Jl '91
—Cartoon about 1840 Illinois legislative
 campaign
 Smithsonian 19:152 (painting,c,4) O '88
—Derringer used to shoot Lincoln
 Life 14:60–1 (c,3) Summer '91
—Draft of the Gettysburg Address
 Am Heritage 39:38–9 (4) N '88
—Family photographs
 Life 10:74–8 (3) Jl '87
—Home (New Salem, Illinois)
 Trav/Holiday 175:103 (painting,c,4) F
 '91
—Home (Springfield, Illinois)
 Trav/Holiday 167:46–9 (c,2) F '87
 Am Heritage 40:112 (c,2) Mr '89
 Am Heritage 40:69–79 (c,1) Ap '89
—Mary Lincoln

—Desert lizards
Smithsonian 18:78–87 (c,1) Ag '87
—Frilled lizard
Nat Geog 173:284 (c,2) F '88
—Fringe-toed lizard
Nat Wildlife 27:18 (c,4) Ap '89
Life 12:8 (c,4) Ag '89
—Testing athletic prowess of lizards
Sports Illus 70:6–10 (c,3) Ap 3 '89
—Whiptails
Smithsonian 18:83 (c,4) Ag '87
Natur Hist 99:48–9 (c,2) Ja '90
—See also
CHAMELEONS
CHUCKWALLAS
GECKOS
GILA MONSTERS
IGUANAS
SNAKES
LLAMAS
Smithsonian 21:43 (c,4) F '91
—Used in hiking trips (Colorado)
Trav/Holiday 170:48, 50 (c,3) Jl '88
—Used in pet therapy for the ill
Life 10:9 (c,4) D '87
LLOYD, HAROLD
Trav&Leisure 19:13 (4) Je '89
Life 13:35 (4) Fall '90
LLOYD GEORGE, DAVID
Smithsonian 22:144 (4) My '91
LOBSTER INDUSTRY
—Catching spiny lobsters (Mexico)
Nat Geog 176:440 (c,4) O '89
—Lobster traps (France)
Gourmet 47:55 (c,1) Ag '87
—Lobster traps (Maine)
Trav/Holiday 171:53 (c,4) F '89
—Lobsters in trap (Australia)
Nat Geog 171:312–13 (c,1) Mr '87
—Nova Scotia
Trav&Leisure 20:88 (c,3) Ap '90
LOBSTERS
Nat Geog 171:312–13 (c,1) Mr '87
Nat Wildlife 25:18–21 (c,1) Ap '87
Trav&Leisure 18:112–13 (c,1) Jl '88
—Lobster fossil
Nat Geog 177:29 (c,4) Ap '90
—Spiny lobster
Nat Geog 174:725 (c,2) N '88
LOCH NESS, SCOTLAND
Life 10:12 (c,4) D '87
—Sonar search for Loch Ness monster
Life 10:12 (c,4) D '87
LOCKER ROOMS
—Baseball
Life 10:81 (c,4) Ag '87
Sports Illus 73:79 (c,2) Jl 23 '90
Nat Geog 178:50–1 (c,3) N '90
Nat Geog 179:55, 66–7 (c,1) Ap '91

—College football
Sports Illus 69:70–1 (c,1) S 5 '88
Sports Illus 71:118–19 (c,1) S 4 '89
Sports Illus 71:25 (c,4) N 13 '89
Sports Illus 73:116 (c,1) S 3 '90
—Football
Sports Illus 69:96–7 (c,2) N 14 '88
Sports Illus 69:94 (c,3) D 12 '88
Sports Illus 72:14–19 (1) F 5 '90
—Hockey
Sports Illus 69:84–5 (c,1) D 12 '88
LOCKS
—Early 20th cent. padlocks
Am Heritage 41:104 (c,4) Jl '90
—International lock and key collection
(Great Britain)
Smithsonian 18:110 (c,4) Jl '87
LOCOMOTIVES
—1863 locomotive
Trav/Holiday 172:70 (c,4) O '89
—1864 Currier and Ives print
Am Heritage 39:21 (c,3) D '88
—Early 20th cent. steam engine (Cali-
fornia)
Trav&Leisure 19:E6 (c,3) Jl '89
—1915
Life 11:46 (3) Ag '88
—1940s steam locomotive (Illinois)
Am Heritage 39:104–5 (2) Mr '88
—Steam engine buried in Michigan snow
drift (1888)
Smithsonian 18:75 (4) Mr '88
—Steam locomotive (Pennsylvania)
Trav&Leisure 19:E8 (c,3) Ap '89
—Steam locomotive factory (China)
Nat Geog 173:300–1 (c,1) Mr '88
—Steam locomotives (China)
Nat Geog 173:296–7, 304–5 (c,1) Mr '88
—See also
RAILROADS
TRAINS
LOCUSTS
—Plague (Morocco)
Life 11:10 (c,4) Je '88
LODGE, HENRY CABOT, JR.
Am Heritage 39:42 (4) N '88
LOG CABINS
—1778 log cabin (Jonesborough, Ten-
nessee)
Am Heritage 42:26 (c,4) O '91
—Early 19th cent.
Trav/Holiday 170:18 (c,2) Jl '88
Am Heritage 41:70 (painting,c,4) N '90
—1889 homesteaders (Oklahoma)
Smithsonian 20:201 (4) N '89
—1900 (Virginia)
Nat Geog 177:138–9 (c,2) F '90
—Slave cabin home of Booker T. Washing-
ton (Virginia)

—Phipps mansion (Westbury)
 Am Heritage 38:104–11 (1) N '87
—Shelter Island
 Trav&Leisure 20:122–3 (c,1) S '90
LONGFELLOW, HENRY WADS-
 WORTH
—Home (Cambridge, Massachusetts)
 Am Heritage 40:6 (c,2) F '89
 Gourmet 49:97, 184 (c,4) S '89
LOONS
 Smithsonian 18:210 (painting,c,4) F '88
 Smithsonian 19:86 (c,3) Jl '88
 Smithsonian 19:59–67 (c,2) Mr '89
 Nat Geog 175:cov., 510–24 (c,1) Ap '89
 Nat Wildlife 28:50–1 (c,1) D '89
 Nat Wildlife 28:23 (c,1) Je '90
LOREN, SOPHIA
—As a child
 Life 12:135 (4) D '89
LOS ANGELES, CALIFORNIA
 Trav&Leisure 17:51 (drawing,c,4) Ja '87
 Life 11:8 (2) Ap '88
 Trav/Holiday 169:64–5 (c,1) My '88
 Am Heritage 39:107 (c,2) D '88
 Nat Geog 179:114–15 (c,1) Ap '91
—1903 downtown scene
 Am Heritage 39:106 (2) D '88
—1934 street scene
 Am Heritage 39:34–5 (1) S '88
—Aerial view of Dodger Stadium
 Sports Illus 67:68 (c,4) S 7 '87
—Billboard art
 Smithsonian 21:98–111 (c,1) S '90
—Blanketed in smog
 Nat Wildlife 25:34–5 (c,1) O '87
—Famous old Los Angeles restaurants
 Gourmet 51:58 (drawing,c,2) Ja '91
—Hale House
 Trav&Leisure 19:E14 (c,4) My '89
—Los Angeles County Museum of Art
 Trav&Leisure 17:68 (c,4) S '87
 Trav&Leisure 18:52 (c,4) S '88
—Los Angeles freeway
 Trav/Holiday 174:65 (c,4) Ag '90
 Nat Wildlife 29:12 (c,4) Ag '91
—Los Angeles Japanese Art Pavilion
 Smithsonian 22:112–13, 118–19 (c,2) Ap
 '91
—Map of Westwood
 Trav/Holiday 174:22 (c,4) Jl '90
—Museum of Contemporary Art
 Trav&Leisure 17:128–37 (c,1) My '87
 Trav/Holiday 168:69 (c,1) S '87
—Museums
 Trav/Holiday 168:69–73 (c,1) S '87
—Office building fire
 Life 11:7 (c,2) Jl '88
 Nat Geog 175:152 (c,1) F '89
—Pacific Design Center

 Gourmet 51:74 (c,3) Ap '91
—Polo Lounge
 Trav&Leisure 19:64 (c,4) Jl '89
—Southern California outdoor sports and
 activities
 Sports Illus 67:cov., 2–3, 50–72 (c,1) S 7
 '87
—Southwest Museum
 Smithsonian 21:124 (c,4) My '90
—Stores
 Gourmet 51:74–9 (c,2) Ap '91
—Sunset Boulevard sights
 Trav&Leisure 20:83–8 (map,c,3) S '90
—Watts after 1965 riot
 Am Heritage 41:39 (4) Jl '90
—See also
 CATALINA ISLAND
 CHINATOWN
 HOLLYWOOD
 SANTA MONICA
LOTUS PLANTS
—Harvesting lotus plants (Cambodia)
 Nat Geog 179:92 (c,4) Ap '91
LOUIS, JOE
 Smithsonian 19:170–94 (2) N '88
 Sports Illus 72:111 (4) My 14 '90
 Am Heritage 42:75, 77 (1) O '91
—1981 funeral (Virginia)
 Smithsonian 19:196 (4) N '88
LOUIS XIII (FRANCE)
—Home (Brissac-Quince, France)
 Trav&Leisure 21:142–3 (c,1) Je '91
LOUIS XIV (FRANCE)
 Smithsonian 22:127 (painting,c,4) O '91
LOUIS XVI (FRANCE)
 Nat Geog 176:43 (painting,c,2) Jl '89
—1789 capture (Varennes, France)
 Nat Geog 176:38 (drawing,4) Jl '89
 Smithsonian 20:72–3 (painting,c,3) Jl '89
—1793 execution of Louis XVI
 Nat Geog 176:42 (drawing,c,3) Jl '89
LOUISIANA
—Atchafalaya Basin and Floodway
 Nat Wildlife 27:44 (c,4) D '88
 Gourmet 50:86 (c,2) Mr '90
 Nat Geog 178:64–5 (c,2) O '90
—Avery Island
 Trav&Leisure 21:E1 (c,3) N '91
—Cajun festival
 Smithsonian 18:120 (c,3) F '88
—Cajun life
 Nat Geog 178:40–65 (map,c,1) O '90
—Christmas levee bonfires
 Smithsonian 20:146–51 (c,1) D '89
—Kisatchie National Forest
 Natur Hist 98:30–2 (map,c,1) F '89
—Louisiana rice festival
 Gourmet 48:100 (painting,c,2) O '88
—Louisiana swamp

Smithsonian 18:112 (c,4) F '88
Gourmet 50:87–91 (c,2) Mr '90
—Plantation houses (Louisiana)
Trav&Leisure 19:cov., 96–105, 146–8
(map,c,1) F '89
Am Heritage 41:85 (c,4) N '90
—Timbalier Bay
Nat Geog 178:42–3 (c,1) O '90
—See also
NEW ORLEANS
LOUISIANA—MAPS
Gourmet 50:128 (c,2) N '90
—Cajun country
Trav&Leisure 21:E2 (c,4) N '91
LOUISVILLE, KENTUCKY
—Kentucky Derby Museum
Trav/Holiday 169:62–3 (c,1) Mr '88
LOUVRE, PARIS, FRANCE
Trav&Leisure 17:118–19 (c,1) Je '87
—Excavation of fortress beneath the
Louvre
Nat Geog 176:102 (c,4) Jl '89
—Glass pyramid at entrance
Trav&Leisure 17:146 (drawing,c,4) D
'87
Life 11:36–7 (c,1) O '88
Trav&Leisure 18:144–5 (c,1) D '88
Nat Geog 176:12–14, 106 (c,1) Jl '89
Trav/Holiday 172:63 (c,2) Jl '89
Trav&Leisure 20:49 (c,4) Mr '90
LOW, JULIETTE
Smithsonian 18:50 (4) O '87
LOWELL, PERCIVAL
—Percival Lowell's sketch of canals on
Mars (1907)
Smithsonian 18:38 (c,4) Ja '88
LOWELL, MASSACHUSETTS
—Old Mill
Trav&Leisure 20:E1 (c,3) My '90
LUCE, CLARE BOOTH
Life 11:115 (c,4) Ja '88
LUCE, HENRY
Life 12:4 (4) Ap '89
Sports Illus 71:8 (c,4) N 15 '89
Life 13:80 (4) Fall '90
LUCERNE, SWITZERLAND
Gourmet 51:64–9 (c,1) F '91
Trav&Leisure 21:148 (c,4) Jl '91
LUGE
Smithsonian 18:146 (c,3) D '87
Sports Illus 68:48 (c,2) Ja 25 '88
Sports Illus 68:12, 94–5, 186–94, 276
(c,1) Ja 27 '88
Sports Illus 75:132 (c,4) D 16 '91
—1980 Olympic luge events (Lake Placid)
Sports Illus 67:54, 57 (c,2) D 14 '87
—1988 Olympics (Calgary)
Sports Illus 68:62–3 (c,2) F 29 '88
—Lake Placid luge run, New York

Sports Illus 69:40–1 (c,3) S 12 '88
LUGGAGE
Sports Illus 67:94–5 (c,1) Jl 6 '87
Trav&Leisure 20:47–8 (c,4) S '90
—Early 20th cent. luggage
Trav/Holiday 170:96 (4) S '88
—Putting luggage into car trunk
Sports Illus 72:53 (c,3) My 7 '90
—Robotic suitcase carrier
Smithsonian 21:73 (c,1) S '90
LUMBERING
—Early 20th cent. (Canaan Valley, West
Virginia)
Am Heritage 42:93–6 (4) F '91
—Alaska
Life 10:96 (c,4) N '87
Sports Illus 68:80 (c,4) Mr 14 '88
—British Columbia
Nat Geog 172:112–13 (c,1) Jl '87
Nat Geog 178:34–5 (c,2) Jl '90
—California
Sports Illus 73:55 (c,4) N 5 '90
—Chile
Nat Geog 174:80–1 (c,2) Jl '88
—Chinese cooks at lumber camp (1880s)
Am Heritage 38:101 (3) D '87
—Clear-cut areas (Alaska)
Natur Hist 97:62–3 (c,1) Ag '88
Nat Wildlife 28:8 (c,4) Je '90
Nat Wildlife 30:42–3 (c,2) D '91
—Clear-cut areas (Oregon)
Life 13:52–3 (c,1) My '90
—Lumberjack World Championships
Sports Illus 67:2–3, 54–9 (c,1) Ag 10 '87
—Malaysia
Nat Geog 180:52–3 (c,1) N '91
—Southern pine logs
Nat Wildlife 28:25 (c,1) O '90
—Studying tree stumps to catch illegal log-
gers
Nat Wildlife 26:12 (c,2) Je '88
—Tibet
Nat Geog 174:633–5 (c,4) N '88
—Washington
Nat Wildlife 26:48–9 (c,1) Ap '88
Nat Geog 176:782–3, 812 (c,1) D '89
Nat Geog 178:106–7, 122–5 (c,1) S '90
—See also
SAWMILLS
LUMBERING—TRANSPORTATION
—Brazil
Smithsonian 20:75 (c,1) N '89
Natur Hist 99:33 (c,4) Mr '90
—Loading wood chips onto freighter (Ore-
gon)
Life 13:54–5 (c,2) My '90
—Logs on river (Alaska)
Nat Geog 178:126 (c,1) S '90
—Towing log (Costa Rica)

Smithsonian 17:56–7 (c,1) Mr '87
LUMBERJACKS
—Oregon
Life 14:52–3 (c,1) Ja '91
LUNCHBOXES
—1967 Dick Tracy lunchbox
Smithsonian 20:83 (c,4) Je '89
—Children's lunchboxes (1950s–1970s)
Life 12:116–19 (c,4) Mr '89
LUPINES
Natur Hist 97:68 (c,4) My '88
LUTHER, MARTIN
Nat Geog 172:563 (painting,c,4) N '87
Smithsonian 21:84 (painting,c,4) Mr '91
LUXEMBOURG
Trav/Holiday 168:34–41 (c,1) D '87
—Battle of the Bulge museum, Luxembourg
Trav/Holiday 168:34–5 (c,1) D '87
—Esch-sur-Sûre
Gourmet 51:62 (painting,c,2) Ap '91
—Monuments to World War II Americans
Trav/Holiday 168:34–41 (c,1) D '87
LVOV, UKRAINE

Nat Geog 171:602–3 (c,1) My '87
LYNCHINGS
—1863 lynching by draft protesters (New York)
Smithsonian 21:49 (engraving,c,4) O '90
—1930 (Ohio)
Life 11:8–9 (1) Spring '88
LYNXES
Nat Wildlife 26:cov. (c,1) D '87
Smithsonian 18:78–87 (c,1) F '88
Nat Wildlife 27:cov. (c,1) F '89
Nat Wildlife 28:56–7 (c,1) F '90
Nat Wildlife 28:9 (c,3) Je '90
Nat Wildlife 29:46–51 (c,1) F '91
Nat Wildlife 29:50–1 (painting,c,1) Ap '91
Life 14:81 (c,4) Summer '91
LYON, FRANCE
Nat Geog 176:68 (c,3) Jl '89
—1856 flood
Life 11:90–1 (1) Fall '88
—Restaurants
Trav&Leisure 19:130–7 (c,1) S '89

- M -

Maas River. See
MEUSE RIVER
MacARTHUR, DOUGLAS
Am Heritage 40:33 (4) Ap '89
Life 13:92 (1) Fall '90
—1951 ticker-tape parade (New York)
Life 10:10–11 (1) Fall '87
—MacArthur returning to the Philippines (1945)
Life 12:125 (3) D '89
—Statue (New York)
Am Heritage 39:47 (c,4) Ap '88
MACAU
Gourmet 51:56–9, 105, 108 (map,c,1) Ag '91
—St. Paul's church facade
Trav&Leisure 18:102–3 (c,1) Ja '88
MACAU—COSTUME
Trav&Leisure 18:102–6, 124 (c,1) Ja '88
MACAWS
Sports Illus 66:71 (c,4) Ap 13 '87
Trav/Holiday 168:61 (c,4) Jl '87
Smithsonian 19:28 (c,4) Ap '88
Trav&Leisure 19:125 (c,4) F '89
Gourmet 50:110 (c,4) D '90
Trav&Leisure 21:65 (c,4) Mr '91
MACHU PICCHU, PERU
Nat Geog 177:86–7 (c,1) Mr '90
—1911 discovery of Inca ruins

Am Heritage 38:54–63 (map,c,1) Jl '87
MACKENZIE, ALEXANDER
—1793 monument to cross-Canada trip (British Columbia)
Nat Geog 172:218 (c,4) Ag '87
MACKINAC ISLAND, MICHIGAN
Trav&Leisure 18:146–51 (c,1) My '88
Trav/Holiday 170:48–9 (c,2) N '88
Gourmet 49:70–5, 144 (map,c,1) Je '89
MADAGASCAR
Nat Geog 171:148–83 (map,c,1) F '87
Natur Hist 97:46–59 (map,c,1) Jl '88
Nat Geog 174:140 (map,c,2) Ag '88
MADAGASCAR—COSTUME
Nat Geog 171:148–9, 161–81 (c,1) F '87
Natur Hist 98:24–30 (c,2) Ap '89
—Mikea people
Nat Geog 174:146–7 (c,1) Ag '88
—Woven burial shrouds
Natur Hist 98:102–3 (c,4) Mr '89
MADAGASCAR—HOUSING
—Hut
Nat Geog 178:130 (c,2) Ag '90
MADAGASCAR—RITES AND FESTIVALS
—Sacrifice of zebu cattle
Nat Geog 171:178–9 (c,1) F '87
MADAGASCAR—SOCIAL LIFE AND CUSTOMS

—Reburial festivities for ancestors
Natur Hist 98:24–30 (c,2) Ap '89
MADISON, DOLLEY
Nat Geog 172:367 (painting,c,2) S '87
Smithsonian 18:79, 88 (c,4) S '87
Gourmet 49:130 (painting,c,4) D '89
MADISON, JAMES
Am Heritage 38:47 (painting,c,4) My '87
Smithsonian 18:32, 34 (drawing,4) Jl '87
Nat Geog 172:341, 350 (painting,c,2) S
'87
Smithsonian 18:76–89 (c,1) S '87
Life 10:56, 67 (painting,c,4) Fall '87
Am Heritage 40:108 (painting,4) Jl '89
Smithsonian 20:184 (painting,c,4) S '89
Am Heritage 42:8 (painting,4) Ap '91
Life 14:42 (painting,c,2) Fall '91
—Home (Montpelier, Virginia)
Am Heritage 38:4 (c,2) Jl '87
Nat Geog 172:358–9 (c,1) S '87
Life 10:66 (c,2) Fall '87
—Sites associated with him
Nat Geog 172:341–67 (c,1) S '87
MADRAS, INDIA
—1639
Smithsonian 18:44–5 (painting,c,2) Ja '88
MADRID, SPAIN
Gourmet 50:84–8 (c,3) Je '90
—Early 19th cent. painting by Goya
Smithsonian 19:58–9 (c,2) Ja '89
—Prado Museum
Trav&Leisure 19:39 (c,4) My '89
MAGAZINES
—1895 *The Rolling Stone*
Am Heritage 41:72 (4) D '90
—1930s—1940s science fiction magazine
covers
Am Heritage 40:48, 50 (c,2) S '89
—1940s movie magazine covers
Trav&Leisure 19:NY1 (c,4) Mr '89
—Cartoons about *National Geographic*
Nat Geog 174:254–7 (c,2) S '88
—Covers of *National Geographic* (1888–
1988)
Nat Geog 174:271–86 (c,4) S '88
—*Harper's Weekly* (1857)
Life 10:31 (c,2) Mr '87
—History of *Sports Illustrated* (1954–1989)
Sports Illus 71:entire issue (c,1) N 15 '89
—*Life* covers (1929–1988)
Life 11:65–116 (c,4) My '88
Am Heritage 39:4, 107 (painting,c,2) Jl
'88
—Parodies of *National Geographic*
Nat Geog 174:352 (c,4) S '88
—*Popular Mechanics* cover (1951)
Smithsonian 19:148 (c,4) F '89
—*Saturday Evening Post* baseball covers
Sports Illus 73:50–5 (c,2) Ag 6 '90

—*Smart Set* cover (1922)
Smithsonian 19:cov. (painting,c,1) Mr
'89
—*Sports Illustrated* covers (1954–1989)
Sports Illus 72:entire issue (c,3) Mr 28
'90
—*Time*'s men of the year (1957–63)
Smithsonian 17:188 (c,4) Mr '87
—See also
LUCE, HENRY
MAGELLAN, FERDINAND
Smithsonian 22:84–5, 92, 95 (paint-
ing,c,3) Ap '91
Smithsonian 22:18 (painting,c,4) My
'91
—1519–1521 world voyage of Magellan
Smithsonian 22:84–95 (map,c,3) Ap '91
—1521 death (Mactan, Philippines)
Smithsonian 22:95 (engraving,c,3) Ap
'91
MAGIC ACTS
—1880 magic kit (France)
Smithsonian 21:115 (c,4) Ja '91
—1920 trick boxes
Smithsonian 21:113 (c,4) Ja '91
—Magic items owned by Harry Houdini
Smithsonian 21:116–17 (c,1) Ja '91
—Paraphernalia for magic tricks
Smithsonian 21:108–17 (c,1) Ja '91
—Pulling rabbit from hat (1920s carving)
Am Heritage 38:44 (c,1) D '87
MAGICIANS
—Wizard concocting foods
Gourmet 51:69 (painting,c,4) My '91
—See also
HOUDINI, HARRY
MAGNETS
—Huge octagonal magnet
Smithsonian 19:108 (c,4) Mr '89
MAGNOLIA TREES
Smithsonian 18:120 (c,4) Jl '87
Am Heritage 41:66 (c,4) Ap '90
Life 13:42 (c,4) My '90
Trav/Holiday 174:66–7 (c,1) N '90
MAGPIES
Nat Wildlife 26:45 (c,4) D '87
Natur Hist 100:64–5 (painting,c,1) S '91
MAIDS
—1942 charwoman (Washington, D.C.)
Smithsonian 20:68 (4) Ap '89
MAIDU INDIANS (CALIFORNIA)—
HOUSING
—Maidu roundhouse
Natur Hist 98:58 (c,4) Jl '89
MAILBOXES
—1927 office building mailbox (New York)
Am Heritage 39:89 (c,2) N '88
—Unusual rural mailboxes
Smithsonian 20:186–9 (c,3) N '89

MAINE
Nat Geog 171:218–19, 236–7, 242–3 (c,1) F '87
Trav/Holiday 172:cov. (c,1) O '89
Trav&Leisure 21:E1–E4 (map,c,2) Je '91
—1718 Sayward-Wheeler House, York Harbor
Trav&Leisure 20:E4 (c,3) My '90
—Appledore, Isles of Shoals
Smithsonian 21:72–4 (c,2) D '90
—Appledore, Isles of Shoals (early 20th cent.)
Smithsonian 21:71–9 (painting,c,2) D '90
—Bar Harbor
Trav/Holiday 171:50 (c,4) F '89
Trav&Leisure 20:110–11 (c,1) Jl '90
—Bass Harbor lighthouse
Trav/Holiday 171:49 (c,2) F '89
Trav&Leisure 20:112 (c,4) Jl '90
—Belfast
Trav&Leisure 20:E1 (c,3) Ag '90
—Camden
Trav&Leisure 18:112–23 (map,c,1) Jl '88
Trav&Leisure 21:E1 (c,2) Je '91
—Lighthouses
Life 10:38–40 (c,1) Ag '87
—Maine-Quebec border
Nat Geog 177:96–9, 118 (c,1) F '90
—Monhegan Island
Trav&Leisure 18:NE3, NE12, NE16 (c,4) My '88
Nat Geog 180:102–3 (1) Jl '91
—Mount Desert Island
Trav/Holiday 171:49–55 (map,c,1) F '89
Trav&Leisure 20:108–13, 118 (map,c,1) Jl '90
—Ogunquit trolley
Trav&Leisure 19:220 (c,4) D '89
—Thompson Ice House, Maine
Am Heritage 42:75 (c,4) Jl '91
—See also
ACADIA NATIONAL PARK
BATH
KENNEBEC RIVER
MAJORCA, SPAIN
Gourmet 48:50–5, 142–5 (map,c,1) Mr '88
Trav&Leisure 18:22, 134–43, 180 (map,c,1) My '88
—Valldemossa
Trav&Leisure 18:22 (c,4) My '88
MALARIA
—Map of malaria occurrence
Natur Hist 100:59, 64–5 (c,4) Jl '91
MALAWI
Nat Geog 176:370–89 (map,c,1) S '89
—See also
LAKE NYASA

MALAWI—COSTUME
Nat Geog 176:370–89 (c,1) S '89
—Dancer
Nat Geog 177:40 (c,1) My '90
—Fisherman
Smithsonian 19:154–5 (c,1) D '88
—President Banda
Nat Geog 176:374–5 (c,4) S '89
MALAWI—SHRINES AND SYMBOLS
—President's ceremonial fly whisk
Nat Geog 176:374 (c,4) S '89
MALAYSIA
—Coconut harvesting
Smithsonian 19:110–19 (c,1) Ja '89
—Singapore River
Trav/Holiday 168:44–5 (c,2) D '87
—See also
KUALA LUMPUR
MALAYSIA—COSTUME
Nat Geog 180:50–3 (c,1) N '91
—Beladau village
Smithsonian 19:110–19 (c,1) Ja '89
MALCOLM X
Life 11:32 (4) Spring '88
Am Heritage 41:43 (4) F '90
Life 13:106 (1) Fall '90
MALDIVE ISLANDS
Nat Geog 180:36 (c,4) D '91
MALI
Nat Geog 178:100–27 (map,c,1) O '90
—16th cent. Tellem burial caves
Nat Geog 178:106–7 (c,1) O '90
—Djénné mosque
Nat Geog 180:44–5 (c,1) D '91
—Sahel area
Nat Geog 172:144–5, 176–7 (map,c,1) Ag '87
—See also
NIGER RIVER
TIMBUKTU
MALI—ART
—Djénné bronze sculptures
Trav&Leisure 17:116 (c,4) Ja '87
MALI—COSTUME
Nat Geog 172:cov., 158–9 (c,1) Ag '87
Nat Geog 180:46–7 (c,3) D '91
—Dogon people
Nat Geog 178:100–27 (c,1) O '90
MALI—HOUSING
—Thatched mud huts (Mali)
Trav&Leisure 17:116 (c,4) Ja '87
MALLARDS
Nat Wildlife 25:cov., 56 (painting,c,1) O '87
Nat Wildlife 26:15 (c,1) Ap '88
Nat Wildlife 27:6–7 (painting,c,1) O '89
Nat Wildlife 28:26–7 (c,1) F '90
Life 13:4–5 (c,1) Mr '90

MALNUTRITION
—1984 dehydrated child (Mali)
　　Life 11:131 (2) Fall '88
—Ethiopia (1985)
　　Life 12:24–5 (1) Fall '89
—Mauritania
　　Nat Geog 172:152–5 (c,2) Ag '87
—Nigeria
　　Nat Geog 174:335 (c,3) S '88
　　Nat Geog 179:102–3 (c,1) Ap '91
—Sudan
　　Life 12:118–19 (1) Ja '89
　　Life 12:28–34 (c,1) Mr '89
MALTA
　　Nat Geog 172:598–9 (c,2) N '87
　　Nat Geog 175:700–17 (map,c,1) Je '89
—See also
　　KNIGHTS OF ST. JOHN
MALTA—COSTUME
　　Nat Geog 175:702–17 (c,1) Je '89
MALTA—POLITICS AND GOVERN-
　　MENT
—Swearing in prime minister
　　Nat Geog 175:705 (c,4) Je '89
MAMMOTH CAVE NATIONAL PARK,
　　KENTUCKY
—1912 wedding in park
　　Life 14:34–5 (1) Summer '91
MAMMOTHS
—Extinct woolly mammoth
　　Nat Geog 175:694–5 (c,2) Je '89
—Mammoth site (South Dakota)
　　Trav/Holiday 169:80–1 (c,4) F '88
MAN
—Important events in human lives
　　Life 14:entire issue (c,1) O '91
MAN, PREHISTORIC
—2nd cent. B.C. man preserved in peat
　　(Great Britain)
　　Smithsonian 18:147 (c,2) Mr '88
—1922 depiction of Hesperopithecus cou-
　　ple (Great Britain)
　　Natur Hist 98:22 (painting,4) Ja '89
—Ancient human sacrifice victims (Den-
　　mark)
　　Nat Geog 171:408–10 (c,1) Mr '87
—Cro-Magnon skull
　　Smithsonian 22:114 (c,4) D '91
—4,000 year old skull (Florida)
　　Natur Hist 96:10 (4) Jl '87
—"Heidelberg man" jawbone
　　Gourmet 47:52 (c,4) Ja '87
—Map of sites of early man
　　Nat Geog 174:436–7, 446–7 (c,1) O '88
—Neanderthal skull and bones
　　Nat Geog 174:464–5 (c,4) O '88
　　Smithsonian 22:115–16, 126–7 (c,2) D '91
—People from 3.7 million years ago (Af-
　　rica)

　　Nat Geog 174:310–11 (painting,c,1) S '88
—Prehistoric Indian settlements (Ten-
　　nessee)
　　Natur Hist 98:52–7 (painting,c,1) S '89
—Stone Age man eating oyster (1879 draw-
　　ing)
　　Smithsonian 18:70 (4) Ja '88
—See also
　　ARCHAEOLOGICAL SITES
　　FOSSILS
MAN, PREHISTORIC—ARCHITEC-
　　TURE
—Prehistoric mammoth-bone shelters
　　Nat Geog 174:470–3 (painting,c,1) O '88
MAN, PREHISTORIC—ART
—Ancient cave paintings (Altamira, Spain)
　　Trav&Leisure 17:70 (c,4) D '87
—Ancient cave paintings (Lascaux,
　　France)
　　Natur Hist 96:84–6 (c,3) O '87
　　Nat Geog 174:482–99 (c,1) O '88
　　Trav/Holiday 175:82–4 (c,1) My '91
—Ancient Pedra Furada rock art (Brazil)
　　Natur Hist 96:8–10 (c,4) Ag '87
—Ancient rock paintings (Algeria)
　　Nat Geog 172:180–91 (c,1) Ag '87
—Ice Age cave paintings (France)
　　Life 14:50–6 (c,1) D '91
—Ice Age sculpture of male head (Czecho-
　　slovakia)
　　Nat Geog 174:cov., 478–81 (c,1) O '88
—Sculptures of bison (France)
　　Nat Geog 174:442–3, 453 (c,1) O '88
—Stone Age cave painting of hunter
　　(Spain)
　　Nat Wildlife 25:50–1 (c,1) O '87
MAN, PREHISTORIC—RELICS
　　Nat Geog 174:440–75 (c,1) O '88
—Ancient Olmec jade sculpture (Mexico)
　　Natur Hist 100:4, 10 (c,4) Ag '91
—Clovis projectile points
　　Smithsonian 21:144 (c,4) Mr '91
—Earliest evidence of American man
　　Smithsonian 21:130–44 (c,1) Mr '91
—Grand Menhir Brisé, Brittany, France
　　Smithsonian 20:148 (c,4) S '89
—Prehistoric arrowheads (Ohio)
　　Smithsonian 20:50 (c,2) O '89
—Prehistoric stone tools (Asia)
　　Natur Hist 98:50 (c,4) O '89
—Site of ancient hunter-gatherers (Chile)
　　Natur Hist 96:8–10 (map,c,4) Ap '87
—Stone Age jade war club (New Zealand)
　　Nat Geog 172:303 (c,4) S '87
—Prehistoric passage graves (Brittany,
　　France)
　　Smithsonian 20:146–7, 154 (c,1) S '89
—Stone megaliths (Brittany, France)
　　Smithsonian 20:148–53, 158–9 (c,1) S '89

—13,000 year old human footprint (Chile)
Smithsonian 21:130 (c,4) Mr '91
—3.5 million-year-old footprints (Laetoli,
Tanzania)
Natur Hist 99:60–3 (c,1) Mr '90
—See also
STONEHENGE
Manatees. See
SEA COWS
MANAUS, BRAZIL
Trav&Leisure 19:120–7 (map,c,1) F '89
—Teatro Amazonas
Trav/Holiday 168:63 (c,4) Jl '87
Trav&Leisure 17:LA6 (c,4) N '87 supp.
Trav&Leisure 19:124 (c,4) F '89
MANCHESTER, NEW HAMPSHIRE
—Usonian home by Frank Lloyd Wright
Trav&Leisure 21:18 (c,4) Jl '91
MANET, EDOUARD
—"At the Cafe"
Smithsonian 20:106 (painting,c,4) Ag
'89
—"Bar at the Folies-Bergère" (1882)
Trav&Leisure 17:28 (painting,c,3) Ja '87
—"Brioche with Pears" (1876)
Smithsonian 17:57 (painting,c,4) Ja '87
—"L'Amazone de Face"
Life 11:139 (painting,c,4) O '88
MANGROVE TREES
Natur Hist 97:53 (c,4) Mr '88
Nat Geog 180:11 (c,4) N '91
MANILA, PHILIPPINES
—18th cent. map of Intramuros
Nat Geog 178:22 (c,4) S '90
—San Agustín's Church
Nat Geog 178:15 (c,1) S '90
MANITOBA
—Hayes River
Nat Geog 172:202–3 (c,1) Ag '87
—Wilderness areas
Nat Geog 172:194–227 (map,c,1) Ag '87
—York Factory
Nat Geog 172:200–1, 204–5, 225
(map,c,1) Ag '87
MANN, HORACE
Am Heritage 38:62 (4) S '87
Am Heritage 41:104 (4) S '90
MANNEQUINS
Smithsonian 22:cov., 66–78 (c,1) Ap '91
—U.S. military clothing store mannequins
(Virginia)
Life 12:64–5 (c,1) D '89
MANSHIP, PAUL
—Sculpture by him
Smithsonian 20:168 (c,4) My '89
MANSIONS
—18th cent. mansions (Virginia)
Life 10:66–74 (c,1) Fall '87
Am Heritage 40:110–15 (c,1) F '89

—1748 Van Cortlandt house, Bronx, New
York
Am Heritage 42:98–9 (c,2) My '91
—1765 Morris-Jumel mansion, New York
City, New York
Am Heritage 42:100–1 (c,2) My '91
—1870 Martin Flynn mansion, Iowa
Trav/Holiday 171:98 (c,4) Mr '89
—Late 19th cent. Potter Palmer home
(Chicago, Illinois)
Am Heritage 38:44–5 (1) N '87
—1881 manor house (Rutland, England)
Trav&Leisure 18:122–4 (c,1) Ap '88
—1920s homes (Palm Beach, Florida)
Am Heritage 41:88–95, 122 (c,1) My '90
—Antebellum houses (Georgia)
Trav/Holiday 169:70–2 (c,2) Je '88
—Antebellum mansion (Natchez, Missis-
sippi)
Am Heritage 39:24 (c,4) Jl '88
Trav&Leisure 21:186 (c,4) F '91
—Biddle's Andalusia (Pennsylvania)
Am Heritage 41:80–7 (c,1) N '90
—Biltmore Estate, Asheville, North Caro-
lina
Trav/Holiday 175:54–61 (c,1) Ap '91
—Blithewold, Rhode Island
Trav/Holiday 169:38 (c,4) Mr '88
—Charlecote, Warwickshire, England
Trav&Leisure 19:132–3 (c,1) My '89
—Charleston, South Carolina
Trav/Holiday 167:44–5 (c,1) Mr '87
Life 11:26–7 (c,1) My '88
—Clivedon, Berkshire, England
Trav&Leisure 17:132–8 (c,1) Je '87
—Dover, Delaware
Trav/Holiday 170:10 (c,4) D '88
—English country houses (East Sussex)
Gourmet 48:50, 53 (c,3) Jl '88
—Gracie Mansion, New York City, New
York
Gourmet 48:46 (painting,c,2) S '88
Am Heritage 42:102–3 (c,1) My '91
—Guatemala
Nat Geog 173:794–5 (c,2) Je '88
—Hempstead House, Sands Point, New
York
Trav/Holiday 168:28 (c,4) O '87
—Sam Lord's 1820 castle, Barbados
Trav/Holiday 170:30, 36 (c,4) O '88
—Lugano, Switzerland
Trav&Leisure 18:26 (c,4) Mr '88
Life 11:134–9 (c,1) O '88
—Melford Hall, Suffolk, England
Gourmet 47:58 (c,3) Je '87
—New Jersey
Sports Illus 68:37 (c,3) Je 13 '88
—Newport, Rhode Island
Trav/Holiday 167:72 (c,3) My '87

—Bonsai Japanese maple
Nat Geog 176:645 (c,4) N '89
—Leaves
Nat Geog 171:238 (c,3) F '87
Nat Wildlife 25:4–5, 7 (c,1) O '87
Smithsonian 21:112–17 (c,2) Mr '91
—Sugar maple
Trav&Leisure 17:74 (c,4) Ag '87
Life 13:29, 36–7 (c,1) My '90
MAPS
—14th cent. B.C. Mediterranean trade
Nat Geog 172:697–8 (c,1) D '87
—2nd cent. map by Ptolemy
Smithsonian 22:36 (c,4) D '91
—Late 15th cent. map of New World
Trav/Holiday 176:68–9 (c,1) O '91
—16th cent. Ottoman Empire
Nat Geog 172:559–60 (c,1) N '87
—17th cent. New World treasure fleet
route
Smithsonian 17:100 (c,3) Ja '87
—1935 mapmaking (Washington, D.C.)
Nat Geog 178:130 (3) N '90
—Cartographic equipment
Am Heritage 42:94–7 (c,1) S '91
—Collage of man reading map
Trav&Leisure 17:86 (c,3) My '87
—History of road maps
Am Heritage 39:34–41 (c,2) Ap '88
—Holograph of earth
Nat Geog 174:cov. (c,1) D '88
—Map of sites of early man
Nat Geog 174:436–7, 446–7 (c,1) O '88
—Mapmaking by computer (1990)
Nat Geog 178:134 (c,3) N '90
—Mapping Mount Everest (Nepal)
Nat Geog 174:652–9 (c,1) N '88
—Maps of Shaker villages
Natur Hist 96:48–57 (c,1) S '87
Nat Geog 176:312–13 (c,2) S '89
—Microfix mapping equipment
Am Heritage 42:94–5 (c,1) S '91
—See also
EARTH—MAPS
GLOBES
individual countries—MAPS
MARAT, JEAN PAUL
—Death mask
Nat Geog 176:41 (c,4) Jl '89
MARATHONS
—1904 Olympics (St. Louis)
Am Heritage 39:45–6 (2) My '88
—1988 Olympic trials
Sports Illus 68:75–6 (c,3) My 2 '88
Sports Illus 68:49–50 (c,3) My 9 '88
—1990 (Berlin, Germany)
Life 13:8–9 (c,1) D '90
—"Human centipede" of runners
Sports Illus 66:88–9 (c,4) Ap 27 '87

—New Jersey Waterfront Marathon 1988
Sports Illus 68:75–6 (c,3) My 2 '88
—New York (1986)
Sports Illus 67:110 (c,4) D 14 '87
—New York (1987)
Sports Illus 67:24–5 (c,2) N 9 '87
Sports Illus 67:18 (c,4) N 16 '87
—New York (1988)
Sports Illus 69:2–3, 76–8 (c,1) N 14 '88
—New York (1989)
Sports Illus 71:2–3, 46–8 (c,1) N 13 '89
—New York (1990)
Sports Illus 73:58, 61 (c,3) N 12 '90
—One-legged man in New York marathon
(1989)
Sports Illus 71:2–3 (c,1) N 13 '89
Sports Illus 71:106–7 (c,1) D 25 '89
—10K mini-marathon (New York)
Sports Illus 68:40–3 (c,4) Je 13 '88
—See also
BOSTON MARATHON
MARBLE INDUSTRY
—Polishing marble (Portugal)
Trav/Holiday 174:59 (c,4) N '90
MARBLE MINES
—Carrara, Italy
Trav&Leisure 17:98–9 (c,1) Ap '87
MARBLES
Smithsonian 19:cov., 94–103 (c,1) Ap
'88
—1780s
Life 10:33 (c,4) Fall '87
—1930s marbles decorated with comic
strips
Smithsonian 19:96 (c,4) Ap '88
—Playing marbles
Smithsonian 19:94–9 (c,3) Ap '88
Marching bands. See
BANDS, MARCHING
MARCOS, FERDINAND
—Ferdinand and Imelda Marcos
Life 12:30 (c,4) Je '89
—Shoe collection of Imelda Marcos (Phil-
ippines)
Life 10:14–15 (c,1) Ja '87
MARGAYS
Nat Wildlife 27:8–9 (c,2) Ag '89
Nat Geog 176:457–8 (c,2) O '89
MARIA THERESA (AUSTRIA)
Smithsonian 21:90 (painting,c,4) Mr '91
—Portrait by Velázquez
Trav&Leisure 19:69 (painting,c,4) O '89
Mariana Islands. See
SAIPAN
MARIE ANTOINETTE
Nat Geog 176:43 (painting,c,2) Jl '89
—18th cent. bed of Marie Antoinette (Ver-
sailles, France)
Nat Geog 176:36–7 (c,2) Jl '89

Trav/Holiday 167:66 (c,4) F '87
—Herb vendor (Peru)
Nat Geog 171:439 (c,1) Ap '87
—Ice (China)
Nat Geog 171:95 (c,3) Ja '87
—Istanbul's Grand Bazaar, Turkey
Trav&Leisure 20:142–3 (c,1) Ja '90
—Ivory (Zaire)
Natur Hist 96:76 (4) Ap '87
—Jewelry stand (Saudi Arabia)
Nat Geog 172:441 (c,2) O '87
—Kinshasa, Zaire
Nat Geog 180:26–7 (c,2) N '91
—Morocco
Trav&Leisure 17:90 (c,4) Mr '87
Trav&Leisure 18:96–7 (c,1) Jl '88
—Motorbike market (Thailand)
Trav&Leisure 20:146–7 (c,1) F '90
—Outdoor (Annecy, France)
Gourmet 47:67, 137 (c,4) My '87
—Outdoor (Jamaica)
Trav/Holiday 167:18 (c,3) Ja '87
—Outdoor (Madagascar)
Nat Geog 171:170 (c,3) F '87
—Outdoor (Mexico)
Trav&Leisure 21:101 (c,3) Ap '91
—Outdoor (Peru)
Natur Hist 100:80–1 (c,2) My '91
—Outdoor (Rome, Italy)
Trav&Leisure 17:149 (drawing,c,3) Mr
'87
—Outdoor art market (Quebec City, Que-
bec)
Trav/Holiday 171:24 (c,4) My '89
—Outdoor stalls (Bucharest, Romania)
Trav/Holiday 169:68–9 (c,1) Mr '88
—Wine at outdoor market (West Ger-
many)
Trav/Holiday 167:32 (c,4) My '87
—See also
FLEA MARKETS
FOOD MARKETS
SHOPPING CENTERS
STORES
STREET VENDORS
SUPERMARKETS
MARLOWE, JULIA
Am Heritage 39:78 (painting,c,1) S '88
MARMOSETS
Nat Geog 171:392–3 (c,2) Mr '87
Natur Hist 100:38–43 (c,1) Ja '91
MARMOTS
Nat Wildlife 25:cov. (c,1) Ag '87
Nat Wildlife 26:2, 34–7 (c,1) Ap '88
MARRAKESH, MOROCCO
—Art deco hotel
Trav&Leisure 18:140–7 (c,1) N '88
—Koutoubia minaret
Trav&Leisure 17:88–9 (c,1) Mr '87

MARRIAGE RITES AND CUSTOMS
—1787 wedding certificate
Life 10:30 (c,4) Fall '87
—19th cent. lacquer wedding carriage (Ja-
pan)
Smithsonian 19:212 (c,4) O '88
—1880 marriage license of R. L. Stevenson
Am Heritage 39:82 (4) D '88
—1910 (Montana)
Smithsonian 21:56 (4) N '90
—1912 wedding in Mammoth Cave Na-
tional Park, Kentucky
Life 14:34–5 (1) Summer '91
—1980s celebrity weddings
Life 10:72–8 (c,1) Ja '87
Life 13:62–6 (c,1) Ja '90
Life 13:102–13 (c,1) Mr '90
—1981 wedding of Prince Charles and Di-
ana (Great Britain)
Life 11:6 (c,4) Ja '88
Life 12:72 (c,4) Mr '89
Life 12:16–17 (c,1) Fall '89
—1986 wedding of Prince Andrew and
Sarah (Great Britain)
Life 10:72–3, 128 (c,1) Ja '87
—Alabama
Life 13:122–7 (c,1) Je '90
—Alberta
Sports Illus 69:2–3 (c,1) Jl 25 '88
Sports Illus 69:22–3 (c,2) Ag 22 '88
—Algerian (France)
Nat Geog 176:128 (c,3) Jl '89
—Bride escorted by marching band (Ne-
pal)
Natur Hist 100:cov., 38–9, 46–7 (c,1) S
'91
—Bringing money to groom (India)
Life 14:67 (c,4) O '91
—Children preparing to wed (India)
Life 14:58 (4) O '91
—China
Nat Geog 180:126–7 (c,3) Jl '91
—Czechoslovakia
Nat Geog 171:138–41 (c,1) Ja '87
—East Midlands, England
Trav&Leisure 18:127 (c,2) Ap '88
—Elaborate wedding cake
Life 11:86–7 (c,1) Jl '88
—France
Life 11:116–17 (c,1) Jl '88
Life 14:54–5 (c,1) O '91
—Guatemala Indians
Nat Geog 173:776–7 (c,1) Je '88
—Hindu bride with five grooms (Nepal/
Tibet)
Natur Hist 96:cov., 38–49 (c,1) Mr '87
—Malay wedding (Singapore)
Natur Hist 99:30 (c,4) Mr '90
—Newlyweds in car (Mexico)

MASQUERADE COSTUME
—1910 patriotic costume (Montana)
 Smithsonian 21:57 (4) N '90
—1916 country club costume ball (Connecticut)
 Am Heritage 41:76–7 (2) S '90
—Boys dressed as Satan (Mexico)
 Smithsonian 22:124–5 (c,2) My '91
—Carnival (Brazil)
 Nat Geog 171:356–7 (c,1) Mr '87
—Carnival (Venice, Italy)
 Trav/Holiday 172:42, 44–5 (c,1) D '89
 Trav&Leisure 20:74–82 (c,2) N '90
—Children dressed as angels (Mexico)
 Trav&Leisure 21:100 (c,3) Ap '91
 Smithsonian 22:127 (c,4) My '91
—Children in butterfly costumes (California)
 Life 10:27 (c,4) My '87
—Fasnacht (Basel, Switzerland)
 Trav/Holiday 172:46 (c,2) D '89
—Mardi Gras (Cologne, West Germany)
 Trav/Holiday 172:45 (c,2) D '89
—Mardi Gras (Mamou, Louisiana)
 Nat Geog 178:52–3 (c,1) O '90
—Mardi Gras (New Orleans, Louisiana)
 Nat Geog 179:90–1 (c,1) Ja '91
 Trav&Leisure 21:NY1–2 (c,3) F '91
—Mardi Gras Gilles (Binche, Belgium)
 Trav/Holiday 172:44 (c,4) D '89
—Masked revelers (Spain)
 Trav&Leisure 20:144 (c,2) Je '90
—New Year's costumes (Bahamas)
 Natur Hist 100:22, 26 (c,2) D '91
—People dressed as clowns (Utah)
 Trav/Holiday 169:53 (c,1) Je '88
—Shipboard nautical theme party
 Nat Geog 179:47 (c,3) F '91
—Teenage Mutant Ninja Turtles costumes
 Life 14:93 (c,2) Ja '91
—U.S. flag painted on face for Mardi Gras (Louisiana)
 Nat Geog 173:44–5 (c,1) Ja '88
MASS TRANSIT
—Atlantic City boardwalk tram, New Jersey
 Trav/Holiday 169:57 (c,3) My '88
—Commuters boarding minibuses (Kampala, Uganda)
 Nat Geog 173:478–9 (c,1) Ap '88
—See also
 BUSES
 COMMUTERS
 SUBWAYS
 TAXICABS
 TROLLEY CARS
MASSACHUSETTS
—1683 parson's house (Topsfield)
 Am Heritage 42:134–41 (c,1) N '91

—Berkshires area
 Trav&Leisure 20:cov., 122–33 (map,c,1) Mr '90
—Chappaquiddick Island
 Gourmet 48:66–7 (c,1) F '88
—Hancock Shaker Village
 Trav&Leisure 21:E1–4 (map,c,3) My '91
—Marblehead
 Trav/Holiday 167:68 (c,3) My '87
—Nashua River
 Nat Wildlife 27:6–7 (c,2) Ag '89
—Nauset Trail, Cape Cod
 Trav&Leisure 20:NY1–3 (c,3) Ag '90
—Newton in autumn
 Smithsonian 21:170–1 (c,1) Ap '90
—Old Sturbridge Village
 Trav/Holiday 168:60–3 (c,1) O '87
—Plimouth Plantation
 Trav/Holiday 170:38–9 (c,3) N '88
—Walden Pond
 Sports Illus 67:6 (c,4) O 19 '87
—Williamstown
 Gourmet 47:56–9 (c,1) Ag '87
—Woods Hole
 Smithsonian 19:91 (c,2) Je '88
 Trav/Holiday 171:35–7 (c,4) Ja '89
 Life 14:10–11 (c,1) N '91
—See also
 BOSTON
 BUNKER HILL, BATTLE OF
 CAMBRIDGE
 CAPE COD
 CONCORD
 CONNECTICUT RIVER
 LOWELL
 MARTHA'S VINEYARD
 NANTUCKET
 SALEM
MASSACHUSETTS—MAPS
—Mohawk Trail
 Trav&Leisure 20:209 (c,4) S '90
MASSAGES
 Life 10:85 (c,4) Jl '87
 Trav&Leisure 17:98 (c,3) Jl '87
 Sports Illus 69:84–5 (c,1) N 28 '88
—Massages at spas
 Trav&Leisure 17:99 (c,3) Ja '87
 Trav&Leisure 17:108 (c,3) D '87
 Trav&Leisure 21:142 (c,4) N '91
—Turkey
 Trav&Leisure 17:192 (c,4) N '87
MASTODONS
 Natur Hist 97:100 (painting,c,3) N '88
 Natur Hist 98:96–7 (painting,c,4) Mr '89
 Natur Hist 99:66–7 (painting,c,2) S '90
—Mastodon reproduction
 Natur Hist 96:10 (c,4) My '87
—Skeleton
 Nat Geog 178:108 (c,1) D '90

Nat Geog 171:333 (c,4) Mr '87
—Monitoring body functions on treadmill
(Massachusetts)
Life 10:56–7 (c,1) F '87
Nat Geog 179:131 (c,2) Ja '91
—Monitoring infant's vital functions during
sleep
Nat Geog 172:788–9 (c,1) D '87
—Organ transplants
Nat Geog 180:66–93 (c,1) S '91
—Premature baby on monitors
Nat Geog 173:378–9 (c,1) Mr '88
—Radiation treatment for cancer
Nat Geog 175:402–3, 411 (c,1) Ap '89
—Salt mine cure for asthma (Romania)
Life 12:8 (c,4) F '89
—Taking blood samples (Uganda)
Nat Geog 173:472–3 (c,1) Ap '88
—Testing miners' lungs (U.S.S.R.)
Nat Geog 171:624 (c,4) My '87
—Treating headache with leaves (Nigeria)
Nat Geog 179:93 (c,1) Ap '91
—See also
 CHILDBIRTH
 DENTISTRY
 DOCTORS
 DRUGS
 HOSPITALS
 INJURED PEOPLE
 MEDICAL INSTRUMENTS
 NURSES
 SURGERY
 THERAPY
 VACCINATIONS
 VETERINARIANS
 X-RAYS
Medicine. See
 DRUGS
MEDITATION
 Life 13:3, 82–92 (c,1) N '90
—Athlete meditating
 Sports Illus 75:94 (c,4) D 9 '91
—Boy doing breathing exercises at ashram
(India)
 Life 13:3 (c,2) N '90
—Maharishi Mahesh Yogi
 Life 13:82–3, 92 (c,1) N '90
—Meditative breathing exercise (California)
 Nat Geog 176:196–7 (c,1) Ag '89
MEDUSA
—3rd cent. mosaic (Tunisia)
 Trav&Leisure 17:51 (c,4) D '87
MEKONG RIVER, LAOS
 Nat Geog 171:788–9 (c,1) Je '87
MELBOURNE, AUSTRALIA
 Trav&Leisure 17:A24 (c,4) O '87 supp.
 Nat Geog 173:181–3 (c,1) F '88
MELVILLE, HERMAN
 Trav/Holiday 176:84 (engraving,4) Jl '91

—Home (Pittsfield, Massachusetts)
 Trav&Leisure 17:E16 (3) O '87
MEMLING, HANS
—Triptych (Bruges, Belgium)
 Trav&Leisure 18:74–5 (painting,c,1) Jl
 '88
MEMORIAL DAY
—South Korea
 Life 10:22–3 (c,1) S '87
Memorials. See
 MONUMENTS
MEMPHIS, TENNESSEE
—Motel site of 1968 King assassination
 Life 11:8 (c,4) Ap '88
MEN
—7'6" + basketball players
 Sports Illus 71:186 (c,4) N 15 '89
 Sports Illus 72:59 (c,4) Ap 23 '90
—Short woman dancing with tall man
(Utah)
 Life 13:12 (3) Je '90
MEN—HUMOR
—History of the necktie
 Smithsonian 20:122–33 (painting,c,1) My
 '89
MENCKEN, HENRY LOUIS
 Am Heritage 40:14 (drawing,4) D '89
MENNINGER, KARL A.
 Life 13:83 (4) Fall '90
MENNONITES
—Mennonite farmer (Ontario)
 Gourmet 51:110–11 (c,1) N '91
MENTAL ILLNESS
—Children with mental illness (Eastern
Europe)
 Nat Geog 179:60–1 (c,1) Je '91
—Paranoid schizophrenic man
 Life 12:94–102 (1) N '89
—Patients at Russian mental hospital
 Life 14:80 (c,3) N '91
—See also
 FREUD, SIGMUND
 THERAPY
MERMAIDS
—Mermaid hotel sign (Italy)
 Gourmet 51:72 (c,4) My '91
MERRY-GO-ROUNDS
—Early 20th cent. (Kansas)
 Am Heritage 38:112 (4) N '87
—1914 horses
 Trav&Leisure 20:NY1 (c,4) F '90
—London, England
 Trav&Leisure 20:162–3 (c,1) N '90
—Teenager on carousel
 Life 11:131 (c,3) My '88
MESA VERDE NATIONAL PARK,
 COLORADO
 Trav&Leisure 17:122–7 (c,1) My '87
 Trav/Holiday 170:36–7, 70 (c,3) Jl '88

Trav/Holiday 176:60–1 (c,1) Jl '91
Trav&Leisure 21:146–7 (c,1) D '91
MESMER, FRANZ ANTON
Natur Hist 98:14 (painting,3) Jl '89
METALWORKING
—Chile
Nat Geog 174:78 (c,4) Jl '88
—Creating metal sculpture (Illinois)
Smithsonian 21:60–1 (c,1) Jl '90
—Engraving brass plate (Egypt)
Trav/Holiday 169:36 (c,4) F '88
—Grinding titanium hip joint
Smithsonian 18:89 (c,4) My '87
—Making reproductions of 16th cent. armor
Smithsonian 20:118–19 (c,3) D '89
—Steel worker (South Africa)
Nat Geog 174:556–7 (c,1) O '88
—Welding (Pakistan)
Smithsonian 21:35 (c,2) Je '90
—Welding masks
Smithsonian 21:66 (c,3) Jl '90
—See also
BLACKSMITHS
METEORITES
Smithsonian 20:85 (c,4) S '89
—Evidence of meteorite impact on Earth
Smithsonian 20:80–93 (map,c,1) S '89
—Ring lake caused by meteorite (Quebec)
Smithsonian 20:84 (c,4) S '89
Natur Hist 100:50–1 (c,1) Je '91
—34 ton Ahnighito meteorite
Trav&Leisure 18:90 (c,3) Jl '88
METEORS
Natur Hist 97:64 (4) Ag '88
—1833 depiction of falling meteors
Smithsonian 20:83 (engraving,4) S '89
—Meteor Crater, Arizona
Smithsonian 20:93 (c,1) S '89
METROPOLITAN MUSEUM OF ART, NEW YORK CITY, NEW YORK
Smithsonian 19:121 (c,4) F '89
Gourmet 50:68 (drawing,c,3) D '90
—Cloisters
Gourmet 48:28 (painting,c,2) Mr '88
Trav&Leisure 19:154–61 (c,1) Ap '89
—Lila Acheson Wallace wing of modern art
Smithsonian 18:46–57 (c,1) My '87
Trav&Leisure 17:66 (c,4) S '87
MEUSE RIVER, NETHERLANDS
Trav&Leisure 21:112–15 (c,1) Ap '91
MEXICO
Trav&Leisure 19:M1–M25 (c,1) D '89 supp.
Trav&Leisure 21:1–32 (map,c,1) D '91 supp.
—Baja California
Gourmet 48:80–5, 110 (c,1) O '88

Nat Geog 176:714–45 (map,c,1) D '89
Natur Hist 100:55–9 (c,1) Je '91
—Bajío
Nat Geog 178:122–43 (map,c,1) D '90
—Cabo San Lucas, Baja California
Trav&Leisure 17:80–9, 180–2 (map,c,1) S '87
—Cancun
Trav&Leisure 17:88–91 (c,1) F '87
Nat Geog 176:441 (c,4) O '89
—Cholula
Nat Geog 178:36–7 (c,1) S '90
—Copala
Trav&Leisure 21:128–9 (c,4) My '91
—Copper Canyon
Trav/Holiday 168:58–63 (map,c,1) S '87
Trav&Leisure 20:52, 55 (map,c,4) N '90
—Costa Careyes
Trav&Leisure 20:59–64 (map,c,3) Ag '90
—Cozumel
Nat Geog 174:122–3 (c,1) Jl '88
—Izamal
Nat Geog 176:446–7 (c,1) O '89
—Matamoros
Trav/Holiday 169:60–3 (c,1) Je '88
—Maya ruins (Chichén Itzá)
Trav/Holiday 167:52–3 (c,1) F '87
Trav&Leisure 17:cov., 80–3 (c,1) F '87
Trav&Leisure 17:114–15 (c,1) D '87
Natur Hist 100:6–7, 10–11 (painting,c,1) Ja '91
—Maya ruins (Palenque)
Natur Hist 99:50 (c,3) Ja '90
—Maya ruins (Uxmal)
Trav&Leisure 17:78–80 (c,1) F '87
Nat Geog 177:100–1 (c,1) Mr '90
—Maya ruins (Yucatán)
Trav/Holiday 167:51–5 (c,1) F '87
Trav&Leisure 17:cov., 78–83, 132 (map,c,1) F '87
—Maya sites
Nat Geog 176:424–505 (map,c,1) O '89
—Mazatlán
Trav&Leisure 21:121, 126–9 (c,2) My '91
—Morelos
Trav/Holiday 174:cov., 46–55 (map,c,1) O '90
—Pacific coast
Sports Illus 70:258–74 (c,1) F 10 '89
—Pátzcuaro
Trav&Leisure 18:86, 92 (c,4) S '88
—Puebla church
Trav/Holiday 167:23 (c,4) Ap '87
—Puerto Vallarta
Trav&Leisure 17:106–7 (c,1) O '87
Trav/Holiday 172:cov., 38–49 (map,c,1) N '89
—San Cristóbal

Trav&Leisure 21:96–105, 154–8 (map,c,1) Ap '91
—San Miguel de Allende
Trav&Leisure 19:127–35 (map,c,1) N '89
—Sonoran Desert
Natur Hist 99:18–20 (c,3) Je '90
—Taxco
Gourmet 49:64–9 (map,c,1) F '89
Trav&Leisure 19:209–10 (c,3) D '89
Nat Geog 178:32–3 (c,1) S '90
—Usumacinta River
Trav&Leisure 20:100, 105 (map,c,4) O '90
—Yucatán
Trav/Holiday 167:51–5 (map,c,1) F '87
Trav&Leisure 17:78–91, 132 (map,c,1) F '87
—Zacatecas bullring
Trav/Holiday 176:39 (c,3) O '91
—See also
ACAPULCO
CUERNAVACA
GUADALAJARA
GUANAJUATO
GULF OF CALIFORNIA
MEXICO CITY
OAXACA
VERACRUZ
MEXICO—ART
—Carved wooden animals
Smithsonian 22:cov., 120–9 (c,1) My '91
—San Angel fountain
Nat Geog 178:31 (c,1) S '90
—Skeletons from "Day of Dead" festival
Natur Hist 99:cov., 66–73 (c,1) O '90
MEXICO—COSTUME
Trav&Leisure 17:85 (c,4) F '87
Trav/Holiday 171:50–6 (c,1) Je '89
Trav&Leisure 19:128–33 (c,4) N '89
Nat Geog 176:723–45 (c,1) D '89
Trav/Holiday 174:48–9 (c,1) O '90
Nat Geog 178:122–43 (c,1) D '90
Trav&Leisure 21:28–106, 154–8 (c,1) Ap '91
Smithsonian 22:118–29 (c,1) My '91
—"China poblano" dresses (Acapulco)
Nat Geog 178:5–7 (c,1) S '90
—Matamoros vendors
Trav/Holiday 169:62–3 (c,3) Je '88
—School children
Trav&Leisure 18:86 (c,4) S '88
—Tarahumara Indians
Trav/Holiday 168:60–1 (c,4) S '87
—Traditional Mexican dancers
Trav/Holiday 170:90–1 (c,3) S '88
MEXICO—HISTORY
—1830s War of the Castes (Mexico)
Nat Geog 176:462 (painting,c,3) O '89

—1913 cartoon about ineffectual Wilson chiding Mexico
Am Heritage 39:40 (drawing,4) N '88
—Pershing hunting for Pancho Villa (1916)
Am Heritage 42:43 (4) Ap '91
—Spanish Mexico-Philippines trade routes (1586–1815)
Nat Geog 178:4–53 (map,c,1) S '90
—See also
ALAMO
AZTEC CIVILIZATION
MAYA CIVILIZATION
VILLA, PANCHO
ZAPATA, EMILIANO
MEXICO—MAPS
—Yucatán vegetation map
Natur Hist 99:47 (c,4) Ja '90
MEXICO—RITES AND FESTIVALS
—Fiestas de Octubre (Guadalajara)
Trav/Holiday 171:50–6 (c,1) Je '89
—Harvest celebration (Oaxaca)
Natur Hist 100:40–1 (2) S '91
—Mexico's Day of the Dead festival
Natur Hist 99:cov., 66–73 (c,1) O '90
Life 14:85 (c,3) O '91
—Mock bull charge at fiesta (Atotonilco)
Nat Geog 178:134–5 (c,1) D '90
MEXICO—SIGNS AND SYMBOLS
—Mexican motif
Gourmet 49:124 (drawing,4) N '89
Trav&Leisure 20:78 (c,2) Ap '90
MEXICO—SOCIAL LIFE AND CUSTOMS
—Hitting piñata
Sports Illus 68:6 (c,4) F 22 '88
MEXICO, ANCIENT—RELICS
—Ancient calendars
Natur Hist 100:28 (c,4) Ap '91
—Ancient Olmec head sculpture
Nat Geog 174:309 (4) S '88
MEXICO CITY, MEXICO
Nat Geog 171:508–9 (c,1) Ap '87
MIAMI, FLORIDA
Trav&Leisure 19:119–27 (map,c,1) S '89
—Glenn Curtiss's 1926 Opa-Locka city hall
Am Heritage 39:4 (c,2) My '88
—Highway overpasses
Nat Geog 178:92 (c,3) Jl '90
—Fountainebleu Hotel
Trav&Leisure 19:166–9 (c,1) D '89
MICE
Smithsonian 19:72–83 (c,1) O '88
—Entering mouse hole in wall
Smithsonian 19:83 (c,1) O '88
—Snake eating mouse
Nat Wildlife 26:22–3 (c,1) O '88
—See also
MICKEY MOUSE
VOLES

WHITE-FOOTED MICE
MICHELANGELO
—"Creation of Adam"
Life 11:47–51 (painting,c,1) Je '88
—"Pietà"
Smithsonian 18:246 (sculpture,4) N '87
—Restoration of Sistine Chapel frescoes
(Vatican)
Nat Geog 176:cov., 688–713 (c,1) D '89
Life 14:cov., 28–40, 45 (painting,c,1) N
'91
—Sculptures by him
Trav&Leisure 17:98 (c,4) Ap '87
—Self-portrait from "The Last Judgment"
Smithsonian 19:160 (painting,c,4) My '88
MICHIGAN
—Lighthouses
Smithsonian 18:98–9, 102, 109 (c,1) Ag
'87
—Newaygo Prairies
Natur Hist 97:12–14 (map,c,1) Mr '88
—Olympic training center (Marquette)
Sports Illus 69:40 (c,4) S 12 '88
—See also
DETROIT
DETROIT RIVER
GRAND RAPIDS
KALAMAZOO
LAKE HURON
LAKE SUPERIOR
MACKINAC ISLAND
SLEEPING BEAR DUNES NA-
TIONAL LAKESHORE
MICKEY MOUSE
Sports Illus 69:48 (c,4) S 5 '88
Trav&Leisure 19:57 (c,4) Ap '89
Sports Illus 71:46 94) N 15 '89
—1928 depiction
Am Heritage 40:154 (4) N '89
—Mickey Mouse balloon in parade
Trav/Holiday 172:82–3 (c,1) N '89
—Mickey Mouse hat
Trav&Leisure 20:105 (c,4) Mr '90
—Mickey Mouse's 60th birthday party
Trav/Holiday 170:10 (c,4) S '88
MICROPHONES
—Classic radio mike
Smithsonian 17:78 (3) Mr '87
—Microphones thrust at baseball manager
Sports Illus 68:2–3 (c,1) My 9 '88
—Sports figure talking into mikes
Sports Illus 73:34–5 (c,1) O 8 '90
MICROSCOPES
Smithsonian 22:63 (c,3) S '91
—Looking through microscope
Smithsonian 21:65 (c,4) S '90
MIDDLE AGES
—15th cent. lady lowering lover from castle
turret

Smithsonian 20:211 (painting,c,4) N '89
—Cemetery for 1349 plague victims (Lon-
don, England)
Life 11:100–1 (c,1) Mr '88
—Medieval-style costumes (British Colum-
bia)
Trav/Holiday 168:66 (c,1) N '87
—See also
BUBONIC PLAGUE
CASTLES
CATAPULTS
CRUSADES
FORTRESSES
KNIGHTS
POLO, MARCO
MIDDLE AGES—ARCHITECTURE
—The Cloisters, New York City, New
York
Gourmet 48:28 (painting,c,2) Mr '88
Trav&Leisure 19:154–61 (c,1) Ap '89
—Medieval walls (Maastricht, Nether-
lands)
Trav&Leisure 21:119 (c,4) Ap '91
MIDDLE EAST
—Persian Gulf naval attacks
Life 11:122–6 (map,c,1) Ja '88
—Political tensions in the Persian Gulf
Nat Geog 173:649–71 (map,c,1) My '88
—Scenes of everyday life
Nat Geog 180:2–49 (c,1) D '91
—U.S. helicopter rescuing sailors from
burning ship
Life 11:38–9 (c,1) Ap '88
MIDDLE EAST—HISTORY
—14th cent. travels of Ibn Battuta
Nat Geog 180:2–49 (map,c,1) D '91
—Early 20th cent. history
Smithsonian 22:132–48 (map,2) My '91
—See also
GULF WAR
PALESTINIANS
MIDDLE EAST—MAPS
—Location of Garden of Eden
Smithsonian 18:128, 132–3 (c,2) My '87
Midgets. See
THUMB, TOM
MIDWEST
—Land sculptures on midwestern farm-
lands
Nat Wildlife 27:30–3 (c,1) Je '89
—See also
GREAT LAKES
MISSISSIPPI RIVER
MIDWEST—MAPS
—1830s
Am Heritage 38:122 (c,2) My '87
MIFFLIN, THOMAS
Life 10:55 (painting,c,4) Fall '87
Migrant workers. See

FARM WORKERS
MILAN, ITALY
 Trav/Holiday 168:50–7 (map,c,1) S '87
 Gourmet 47:230 (drawing,4) N '87
 Trav&Leisure 20:36 (map,c,4) Je '90
—Elegant shop interiors
 Gourmet 47:86–91 (c,3) N '87
—Excelsior Hotel
 Trav/Holiday 176:24 (c,4) S '91
—Stazione Centrale
 Trav&Leisure 17:112–15 (c,1) S '87
 Trav&Leisure 19:104 (c,2) Je '89
MILITARY COSTUME
—1st cent. Caledonian swordsman (Great
 Britain)
 Natur Hist 98:82 (painting,c,3) Ap '89
—14th cent. Japanese warrior
 Smithsonian 19:73 (painting,c,4) N '88
—18th cent. reproductions (Williamsburg,
 Virginia)
 Trav&Leisure 19:100–1, 106–7 (c,1) Jl
 '89
—Late 18th cent. (France)
 Trav/Holiday 172:47 (c,3) Jl '89
—Late 18th cent. (U.S.)
 Nat Geog 172:348–9 (c,1) S '87
 Smithsonian 18:cov., 40–9 (painting,c,1)
 D '87
—1855 Massachusetts militia
 Am Heritage 38:99–100 (4) F '87
—1860s (U.S.)
 Am Heritage 38:29 (4) Jl '87
 Am Heritage 39:56, 79 (c,3) D '87
 Am Heritage 39:45 (3) Mr '88
 Am Heritage 39:108 (c,2) My '88
 Am Heritage 39:73 (painting,c,2) D '88
 Am Heritage 40:111 (4) Ap '89
 Am Heritage 41:112 (3) F '90
 Am Heritage 42:11 (4) F '91
—1875 West Point cadets
 Am Heritage 39:48 (4) Ap '88
—1897 U.S. cavalry troop
 Life 14:14–15 (1) Fall '91
—20th cent. uniforms
 Life 14:56–63 (c,2) Ap '91
—1905 Chinese Imperial Army uniform
 Am Heritage 39:98 (4) My '88
—1910s (Canada)
 Smithsonian 18:208–30 (4) N '87
—1910s (U.S.)
 Smithsonian 18:128–9 (2) Je '87
 Life 14:56–7 (c,2) Ap '91
—1915 black cavalry "Buffalo Soldiers"
 Smithsonian 20:62–3 (2) Ag '89
—1940s (U.S.)
 Sports Illus 67:123–4 (3) Ag 31 '87
 Nat Geog 173:426 (4) Ap '88
 Am Heritage 40:36–43 (c,1) Mr '89
 Am Heritage 40:8 (painting,c,4) My '89

 Life 12:125–37 (c,4) D '89
 Am Heritage 41:6 (2) Ap '90
 Am Heritage 42:entire issue (1) D '91
—1940s bomber crew (U.S.)
 Nat Geog 173:426 (4) Ap '88
 Am Heritage 40:155 (4) N '89
—1960s (U.S.)
 Am Heritage 39:8 (4) Jl '88
 Am Heritage 42:111–13 (painting,c,2) F
 '91
 Life 14:62–3 (c,2) Ap '91
—Afghanistan
 Life 10:6–7 (c,1) Je '87
 Life 12:124 (c,4) Fall '89
—Chile
 Nat Geog 174:54–5 (c,1) Jl '88
—China
 Life 13:54 (c,2) Ja '90
—Female soldiers (Japan)
 Nat Geog 177:58–9 (c,1) Ap '90
—Generals (Nepal)
 Nat Geog 172:45 (c,4) Jl '87
—Guatemalan military leaders
 Nat Geog 173:779 (c,3) Je '88
—History of women in the U.S. military
 Life 14:52–62 (c,1) My '91
—Hungary
 Trav/Holiday 171:86 (c,4) Mr '89
—Israel
 Life 13:20 (c,3) D '90
—Men in British Redcoat costumes (Mas-
 sachusetts)
 Trav/Holiday 170:30 (c,3) Jl '88
—Reenacting Civil War battle (Virginia)
 Trav/Holiday 167:52–5 (c,1) Je '87
—Shell-shocked soldiers
 Am Heritage 41:74–87 (c,2) My '90
—South Korea
 Life 10:26–7 (c,1) S '87
 Nat Geog 174:242 (c,4) Ag '88
—U.S.S.R.
 Life 11:84–5 (c,1) Ja '88
 Life 11:100–6 (c,1) F '88
 Nat Geog 175:605 (c,4) My '89
 Nat Geog 178:4–5 (c,1) N '90
 Nat Geog 179:16 (c,4) F '91
—U.S.
 Life 13:24–7, 37 (c,1) O '90
 Am Heritage 41:cov., 100–1 (c,1) N '90
—U.S. Marines (1969)
 Life 10:32–4 (c,1) My '87
—U.S. military clothing store mannequins
 (Virginia)
 Life 12:64–5 (c,1) D '89
—U.S. paratrooper
 Sports Illus 69:72–3 (c,2) S 14 '88
—U.S. soldiers wearing night-vision gog-
 gles (Korea)
 Life 11:42–3 (c,1) Ap '88

MILKWEED
 Nat Wildlife 25:27 (drawing,c,4) Ap '87
 Natur Hist 99:44–6 (c,1) F '90
MILKY WAY
 Smithsonian 19:36–7, 40–2, 53 (c,1) Ja
 '89
MILLER, ARTHUR
 Life 10:72–88 (c,1) N '87
 Life 11:54–5 (1) Fall '88
—1956 marriage to Marilyn Monroe
 Life 10:78 (4) N '87
MILLER, HENRY
 Life 11:182 (3) D '88
—Henry Miller Memorial Library, Califor-
 nia
 Life 11:181 (c,2) D '88
MILLIPEDES
 Nat Geog 175:789 (c,1) Je '89
MILLS
—18th cent. water mills (Virginia)
 Nat Geog 171:734–5 (c,1) Je '87
—Bobbin mill (Great Britain)
 Trav/Holiday 170:47 (c,4) O '88
—Camel driving sesame mill (Yemen)
 Nat Geog 180:26–7 (c,1) D '91
—Limestone mill (Indiana)
 Smithsonian 19:88–9 (c,3) O '88
—Lowell, Massachusetts
 Trav&Leisure 20:E1 (c,4) My '90
—Simulated computer image of steel mill
 Nat Geog 175:743 (c,2) Je '89
—Steel (Poland)
 Nat Geog 173:108–9 (c,1) Ja '88
—Steel (Siberia, U.S.S.R.)
 Nat Geog 177:17, 28–9 (c,1) Mr '90
—Sugar mill (Nevis)
 Gourmet 49:61 (c,2) Mr '89
—See also
 FACTORIES
 MANUFACTURING
 SAWMILLS
MILWAUKEE, WISCONSIN
—City hall
 Trav/Holiday 168:25 (c,4) D '87
—Milwaukee Grain Exchange
 Am Heritage 42:106–7 (c,2) Jl '91
—Milwaukee Grain Exchange (1880)
 Am Heritage 42:106 (2) Jl '91
MINERALS
—Gem collecting
 Smithsonian 22:60–70 (c,2) S '91
—Metals formed in ocean hot spots
 Natur Hist 97:52–7 (painting,c,1) Ja '88
—See also
 AMBER
 ASBESTOS
 COAL
 COPPER
 CRYSTALS

DIAMONDS
EMERALDS
GOLD
GYPSUM
IRON
JADE
JEWELRY
LIMESTONE
MARBLE
OPALS
PEARLS
QUARTZ
RUBIES
SANDSTONE
SAPPHIRES
SULPHUR
TIN
TITANIUM
TOPAZ
URANIUM
MINERS
—1911 boy miners (Pennsylvania)
 Life 11:126–7 (1) Fall '88
—Botswana
 Nat Geog 178:74–5 (c,1) D '90
—Coal (Poland)
 Nat Geog 173:108 (c,3) Ja '88
 Nat Geog 179:42–3 (c,1) Je '91
—Coal (U.S.S.R.)
 Nat Geog 171:624 (c,4) My '87
—Gold (Brazil)
 Nat Geog 171:372 (c,4) Mr '87
 Life 11:148–9 (1) Fall '88
—Romania
 Nat Geog 179:28–9 (c,1) Mr '91
—Zinc (Australia)
 Nat Geog 173:228–9 (c,1) F '88
MINES
—Ruby mine (Kenya)
 Nat Geog 180:108–9 (c,1) O '91
MINES, EXPLODING
—Falkland Islands
 Nat Geog 173:397 (c,3) Mr '88
MINING
—Burma
 Nat Geog 180:104–5 (c,1) O '91
—Emerald mining (Brazil)
 Nat Geog 178:45, 68–9 (c,1) Jl '90
—Emerald mining (Colombia)
 Nat Geog 178:44, 46–7 (c,1) Jl '90
—Mining shovel (Australia)
 Nat Geog 180:58–9 (c,1) N '91
—Sand mining (New York)
 Natur Hist 97:70 (c,4) My '88
—Sapphire and ruby industry
 Nat Geog 180:100–25 (c,1) O '91
—Titanium (Australia)
 Smithsonian 18:86 (c,1) My '87
—See also

—Map of upper Mississippi River
Trav&Leisure 18:210 (c,4) Ap '88
MISSISSIPPI RIVER, IOWA
Trav&Leisure 18:209 (c,4) Ap '88
Nat Geog 179:42–3 (c,1) Ap '91
MISSISSIPPI RIVER, LOUISIANA
Trav&Leisure 21:84–95 (map,c,1) Ag '91
MISSISSIPPI RIVER, MISSISSIPPI
Trav/Holiday 171:68–9 (c,2) Ja '89
Trav&Leisure 21:183 (c,4) F '91
Trav&Leisure 21:84–95 (map,c,1) Ag '91
MISSISSIPPI RIVER, MISSOURI
—Hannibal
Trav/Holiday 176:48–9 (1) Jl '91
MISSISSIPPI RIVER, TENNESSEE
—During drought
Nat Geog 178:84–5 (c,2) O '90
MISSOURI
—Clinton town square (1982)
Nat Geog 175:212 (3) F '89
—Countryside
Trav/Holiday 172:N12–13 (c,1) S '89
—Cuppola Pond
Natur Hist 97:62–4 (map,c,1) Ja '88
—Independence (1951)
Am Heritage 38:36–7 (1) My '87
—Indian Creek
Natur Hist 97:20–2 (map,c,1) Ag '88
—Kaintuck Hollow
Natur Hist 100:74–7 (map,c,1) S '91
—Missouri history depicted in Benton murals
Smithsonian 20:cov., 88–97 (painting,c,1) Ap '89
—Rimstone River caves waterfall
Nat Wildlife 29:53 (c,4) D '90
—Rolla (1955)
Nat Geog 175:187 (2) F '89
—Small-town Missouri life (1950–1985)
Nat Geog 175:186–215 (1) F '89
—See also
KANSAS CITY
MISSOURI RIVER
OZARK MOUNTAINS
ST. LOUIS
MISSOURI RIVER, MONTANA
—Missouri River Breaks
Smithsonian 21:40 (c,3) S '90
MISTLETOE
—How it grows
Nat Wildlife 26:40–1 (painting,c,1) D '87
MITES
Natur Hist 98:80–1 (c,1) My '89
MIX, TOM
Life 10:101 (4) N '87
MOAS (BIRDS)
Life 12:64 (4) Ap '89
MOBILE, ALABAMA
—Harbor

Am Heritage 41:30 (c,4) Mr '90
MOBILES
—By Alexander Calder (France)
Trav&Leisure 18:109 (c,1) Jl '88
MOCKINGBIRDS
Nat Wildlife 25:49 (c,4) Ag '87
Nat Geog 173:130, 141 (c,2) Ja '88
Smithsonian 18:210 (painting,c,4) F '88
Nat Wildlife 26:58 (c,3) O '88
Nat Wildlife 27:22 (c,4) D '88
Natur Hist 98:6–13 (c,2) Je '89
MODELS
—Late 19th cent. artist's model (France)
Smithsonian 20:170 (4) Je '89
—1940s
Life 14:110–11 (1) N '91
—1949 fashion model (France)
Smithsonian 20:71 (4) Ap '89
—China
Life 12:80 (c,2) Je '89
—Fashion models (Paris, France)
Nat Geog 176:146–57 (c,1) Jl '89
—Photography shoot (Prague, Czechoslovakia)
Trav&Leisure 17:116 (c,4) F '87
—Swimsuit models setting up poses
Sports Illus 70:52–6 (c,4) F 10 '89
—Twiggy (1965)
Sports Illus 71:89 (c,4) N 15 '89
—See also
FASHION SHOWS
MANNEQUINS
MODIGLIANI, AMADEO
—Painting of Chaim Soutine (1917)
Smithsonian 19:131 (c,4) N '88
Mold. See
SLIME MOLD
MOLLUSKS
—Ammonite fossil
Nat Geog 177:28 (c,2) Ap '90
—Cephalopods
Natur Hist 100:35 (c,4) F '91
—Sea butterflies
Nat Wildlife 27:2 (c,2) O '89
Nat Wildlife 29:18–19 (c,1) F '91
—See also
COWRIES
CUTTLEFISH
LIMPETS
MUSSELS
NAUTILUSES
OCTOPI
OYSTERS
SCALLOPS
SLUGS
SNAILS
SQUID
MONACO
—Peillon

Gourmet 48:68 (c,4) My '88
—See also
MONTE CARLO
Monarchs. See
RULERS AND MONARCHS
MONASTERIES
—11th cent. abbey (Italy)
Gourmet 47:70–5, 176 (c,1) My '87
—Benedictine (Weltenburg, West Germany)
Smithsonian 21:33 (c,2) Jl '90
—Fontfroide monastery, France
Smithsonian 22:42 (c,3) My '91
—Melk abbey, Austria
Trav&Leisure 19:143 (c,4) Ag '89
Trav&Leisure 20:136–41, 188 (c,1) D '90
—Meteora monastery, Greece
Life 13:64 (c,4) D '90
—Monte Cassino, Italy
Smithsonian 18:128–55 (c,2) Ap '87
—Po Lin, Lantau, Hong Kong
Trav/Holiday 167:64 (c,4) F '87
—St. Catherine's monastery, Sinai, Egypt
Trav/Holiday 170:28 (c,3) N '88
—Thailand
Nat Geog 172:800 (c,1) D '87
—Tibet
Nat Geog 174:636–75 (c,1) N '88
Natur Hist 98:40–5 (c,1) Mr '89
—U.S.S.R.
Nat Geog 171:612–13 (c,1) My '87
Smithsonian 20:130–1, 136, 140 (c,1) Ap '89
—La Verna, Italy
Trav&Leisure 17:94 (c,3) Ap '87
—See also
CONVENTS
MONT ST. MICHEL
MONDRIAN, PIET
—Painting of a tree
Life 13:29 (c,4) My '90
MONET, CLAUDE
—"Femmes au Jardin"
Trav&Leisure 17:116 (c,4) Je '87
Money. See
COINS
CURRENCY
Mongol Empire. See
KUBLAI KHAN
MONGOLIA
—1922 exploration by Andrews
Smithsonian 18:94–105 (1) D '87
—See also
GOBI DESERT
MONGOOSES
Nat Geog 174:144–5 (c,2) Ag '88
Natur Hist 99:28 (c,3) D '90
—Dwarf mongooses
Natur Hist 97:cov., 40–5 (c,1) F '88

—Meerkats
Natur Hist 96:cov., 34–9 (c,1) Je '87
Nat Wildlife 30:57 (c,4) D '91
—Mongooses mating
Natur Hist 97:43 (c,4) F '88
MONITOR AND MERRIMACK (SHIPS)
—Civil War battle
Trav/Holiday 169:33 (drawing,4) Mr '88
—Image of Monitor on ocean floor
Nat Geog 172:470 (4) O '87
MONK, THELONIOUS
Smithsonian 20:178 (4) O '89
MONKEYS
Life 11:18–19 (c,1) Fall '88
Trav/Holiday 171:74 (c,4) My '89
Smithsonian 20:74–9 (painting,c,1) S '89
Natur Hist 99:32, 36–41 (c,1) Mr '90
Natur Hist 99:38–47 (c,1) S '90
—In Russian space capsule
Life 11:105 (c,4) Ja '88
—Langurs
Natur Hist 97:cov. (c,1) Ap '88
Trav&Leisure 20:147 (c,4) S '90
—Macaques
Smithsonian 19:110–19 (c,2) Ja '89
Natur Hist 98:10 (c,4) Ja '89
—Macaques picking coconuts (Malaysia)
Smithsonian 19:110–19 (c,1) Ja '89
—Spider monkeys
Nat Geog 171:386–95 (c,1) Mr '87
Natur Hist 97:82–3 (c,1) Ap '88
—Squirrel monkeys
Natur Hist 99:36 (c,4) Mr '90
Trav/Holiday 173:72 (c,2) Mr '90
—Tamarins
Nat Geog 171:392 (c,3) Mr '87
Smithsonian 18:182 (c,4) Mr '88
Life 12:68–9 (c,3) Ap '89
Smithsonian 20:cov. (c,1) Jl '89
Nat Wildlife 29:14–15 (c,2) F '91
—See also
BABOONS
CAPUCHIN MONKEYS
HOWLERS
LEMURS
MARMOSETS
Monks. See
BUDDHISM—COSTUME
MONROE, JAMES
Life 10:71 (painting,c,4) Fall '87
Smithsonian 19:136 (painting,c,4) Ap '88
MONROE, MARILYN
Life 10:64–6 (1) F '87
Life 10:66–70 (1) Je '87
Life 10:72, 78–9 (c,1) N '87
Trav&Leisure 18:35 (4) Ap '88
Life 11:12 (c,4) Je '88
Life 11:54–5 (1) Fall '88

Am Heritage 40:92–103 (c,1) Ap '89
—Civil War memorial (Gettysburg, Pennsylvania)
Life 11:56–7 (c,1) Ag '88
—Civil War memorial (Vicksburg, Mississippi)
Trav/Holiday 171:67 (c,3) Ja '89
—Fallen statue of Lenin (Hungary)
Life 13:16–17 (c,1) Ag '90
—Guadalcanal memorial
Am Heritage 42:91 (c,4) D '91
—Iwo Jima memorial (Washington, D.C.)
Life 14:78–9 (c,1) Ag '91
—Memorial to 1889 Johnstown Flood victims, Pennsylvania
Smithsonian 20:61 (c,2) My '89
—Millennium Monument, Budapest, Hungary
Gourmet 50:78 (c,2) My '90
—Monument at 1945 first atom bomb site (New Mexico)
Nat Geog 172:613 (c,4) N '87
—Monument to Korean War soldiers (South Korea)
Trav/Holiday 169:68 (c,4) Je '88
—Monument to the Discoverers (Lisbon, Portugal)
Trav&Leisure 19:103 (c,2) S '89
—Monument to the "Maine" (Florida)
Am Heritage 38:50 (4) D '87
—Monument to St. Bernard rescue dog (France)
Smithsonian 20:73 (c,4) Mr '90
—"Mother Russia" statue, Volgograd, U.S.S.R.
Nat Geog 179:34–5 (c,1) F '91
—My Lai massacre memorial (Vietnam)
Life 11:6 (c,4) Mr '88
—Nelson's Column, Trafalgar, London, England
Trav&Leisure 17:47 (c,4) O '87
—Pilgrim Monument, Provincetown, Massachusetts
Trav&Leisure 19:101 (c,2) Je '89
—Pioneer Monument, San Francisco, California
Am Heritage 38:94 (c,3) Ap '87
—Roadside war memorials (Afghanistan)
Smithsonian 19:53 (c,2) D '88
—Russian-Ukraine reunification statue, Kiev
Nat Geog 171:630 (c,1) My '87
—Silhouettes of famous world monuments
Trav/Holiday 174:76 (c,4) Jl '90
—Johann Strauss monument (Vienna, Austria)
Trav&Leisure 18:127 (c,4) N '88
—U.S. monuments to eastern European heroes

Am Heritage 41:54–5 (c,4) N '90
—Vietnam Veterans Memorial, Washington, D.C.
Smithsonian 17:149 (4) F '87
Am Heritage 39:112 (c,4) Ap '88
Trav/Holiday 169:11, 14 (c,4) Ap '88
Trav&Leisure 18:122–3 (c,1) S '88
Life 12:18–19 (c,1) Fall '89
Life 14:46–7 (c,1) Summer '91
—Washington Square Arch, Greenwich Village, New York City
Trav&Leisure 17:38 (c,4) Ag '87
—World War II memorial (Gdansk, Poland)
Trav/Holiday 170:52–3 (c,1) O '88
—World War II memorial (Leningrad, U.S.S.R.)
Trav&Leisure 19:130 (c,4) F '89
—World War II memorial (Warsaw, Poland)
Nat Geog 173:118–19 (c,1) Ja '88
—World War II memorial to U.S. dead (Philippines)
Trav/Holiday 172:60–1 (c,1) S '89
—Wright Brothers Memorial, Kitty Hawk, North Carolina
Am Heritage 39:4 (c,2) Ap '88
—See also
ARC DE TRIOMPHE
COLOSSEUM
EIFFEL TOWER
GREAT WALL OF CHINA
JEFFERSON MEMORIAL
LEANING TOWER OF PISA
LIBERTY, STATUE OF
LINCOLN MEMORIAL
MOUNT RUSHMORE
STONEHENGE
TAJ MAHAL
WASHINGTON MONUMENT
MOON
Trav/Holiday 169:11 (c,4) Ja '88
Life 12:58–67 (c,1) Jl '89
Nat Geog 178:53 (c,4) Ag '90
Natur Hist 100:48 (2) Je '91
—1969 moon landing
Life 12:108 (c,4) Ag '89
Am Heritage 42:11 (4) F '91
—Full moon
Nat Wildlife 27:60 (c,1) O '89
—Man walking on moon (1972)
Life 12:62–3 (c,4) Jl '89
—Map of moon landing sites
Life 12:66–7 (2) Jl '89
—Moon rocks
Life 12:58–9 (c,1) Jl '89
—Theory of how the moon was created
Nat Geog 98:cov., 68–77 (c,1) N '89

MOORE, HENRY
 Life 10:120 (4) Ja '87
 Trav&Leisure 19:53 (3) Je '89
—Sculpture by him
 Trav/Holiday 168:44–6 (c,1) O '87
 Trav&Leisure 19:53 (c,3) Je '89
MOORS
—Artifacts from Moorish occupation of
 Spain (711–1492)
 Nat Geog 174:86–119 (map,c,1) Jl '88
—See also
 ALHAMBRA
MOOSE
 Nat Wildlife 25:34–5 (painting,c,1) Ag
 '87
 Nat Geog 172:260–80 (c,1) Ag '87
 Life 14:86 (c,2) Summer '91
—Bull moose confronting each other
 Nat Wildlife 28:50–1 (c,1) Je '90
—Moose crossing city street (Alaska)
 Nat Wildlife 28:14–15 (c,1) Je '90
MORE, SIR THOMAS
—Portrait by Holbein (1527)
 Trav&Leisure 18:117 (painting,c,3) N
 '88
MORGAN, JOHN PIERPONT
 Am Heritage 38:57 (4) D '87
 Am Heritage 40:78–90 (1) Jl '89
—Home (New York City, New York)
 Am Heritage 40:85 (4) Jl '89
—Pierpont Morgan Library study, New
 York City, New York
 Am Heritage 42:4 (c,2) N '91
MORGAN, THOMAS HUNT
 Smithsonian 18:104 (4) S '87
MORMON RITES AND FESTIVALS
—Mormon baby receiving blessing
 Life 14:14–15 (c,1) O '91
MORMONS
—Angel Moroni giving gift to Mormon
 Smith
 Life 14:38 (painting,c,4) Jl '91
—Rudger Clawson
 Am Heritage 41:82–92 (c,1) F '90
—See also
 SMITH, JOSEPH
MORNING GLORIES
 Life 12:87 (c,4) Jl '89
MOROCCO
 Trav&Leisure 17:88–99 (map,c,1) Mr '87
 Nat Geog 174:90–1, 104–5 (c,1) Jl '88
—Taroudant
 Trav&Leisure 18:92–101 (map,c,1) Jl '88
—See also
 FEZ
 MARRAKESH
MOROCCO—ARCHITECTURE
—Ancient casbahs
 Trav&Leisure 17:91, 94–5 (c,1) Mr '87

—Construction of huge mosque (Cas-
 ablanca)
 Life 12:47–9 (c,1) S '89
MOROCCO—COSTUME
 Trav&Leisure 17:90–7 (c,2) Mr '87
 Nat Geog 174:104–11 (c,1) Jl '88
 Trav&Leisure 18:cov., 92–101 (c,1) Jl
 '88
—Berber people
 Trav&Leisure 17:92–3 (c,3) Mr '87
—Djellabas
 Life 12:47 (c,4) S '89
—Spice merchant
 Natur Hist 97:83 (c,4) O '88
—Touareg women
 Trav&Leisure 17:97 (c,2) Mr '87
—Women decorated with henna tattoos
 Natur Hist 97:40–5 (c,1) S '88
MOROCCO—HISTORY
—14th cent. travels of Ibn Battuta
 Nat Geog 180:2–49 (map,c,1) D '91
MOROCCO—POLITICS AND GOV-
 ERNMENT
—Sand wall defense against Polisario guer-
 rillas
 Life 11:14 (c,4) My '88
MORRIS, GOUVERNEUR
 Am Heritage 38:46 (painting,c,4) My '87
 Smithsonian 18:32 (drawing,4) Jl '87
 Life 10:55 (painting,c,4) Fall '87
MORRIS, ROBERT
 Am Heritage 38:46 (painting,c,4) My '87
 Life 10:55 (painting,c,4) Fall '87
 Am Heritage 39:13 (drawing,4) N '88
 Smithsonian 19:196 (painting,c,4) Mr '89
MORSE, SAMUEL F. B.
 Am Heritage 39:26 (painting,4) F '88
MOSAICS
—3rd cent. head of Medusa (Tunisia)
 Trav&Leisure 17:51 (c,4) D '87
—4th cent. Roman Aphrodite mosaic (Is-
 rael)
 Life 10:7 (c,4) O '87
—11th cent. (Sicily, Italy)
 Trav/Holiday 173:70 (c,4) F '90
—Ancient Carthage
 Natur Hist 96:58–9, 65–70 (c,1) D '87
—Ancient Roman (Ephesus, Turkey)
 Trav&Leisure 17:108 (c,2) Mr '87
—Ancient Roman (Pompeii)
 Trav&Leisure 18:75 (c,1) Ag '88
—Ancient Sumerian mosaic panel
 Smithsonian 19:132–3 (c,3) D '88
—Decorated stone pavement (Italy)
 Gourmet 51:42, 46 (c,3) Jl '91
—Miro mosaic in Barcelona street, Spain
 Trav/Holiday 169:56 (c,4) Je '88
—Mosaic of ancient Roman galley ship
 Natur Hist 96:66–7 (c,1) D '87

—Mosaic of Jesus Christ (Istanbul, Turkey)
Trav&Leisure 17:126–7 (c,1) N '87
—Mosque ceiling (Iran)
Life 11:70 (c,4) S '88
—Ravenna, Italy
Trav/Holiday 172:62–3, 68–9 (c,1) N '89
Smithsonian 20:cov., 54–65 (c,1) Ja '90
—St. Louis Catholic Cathedral, Missouri
Life 11:16 (c,4) My '88
MOSBY, JOHN SINGLETON
Am Heritage 39:32 (4) Mr '88
MOSCOW, U.S.S.R.
Trav/Holiday 168:60–5 (c,1) Ag '87
Life 11:80–6 (c,1) Ja '88
Trav/Holiday 174:50 (map,c,4) Ag '90
Trav&Leisure 20:cov., 130–45, 192
(map,c,1) O '90
—Arbat district
Nat Geog 179:19 (c,3) F '91
—Arbat district (1932)
Life 11:59 (4) Je '88
—Churches
Trav/Holiday 176:cov., 46–57 (map,c,1)
S '91
—GUM department store
Trav&Leisure 17:96–7 (c,1) D '87
—Red Square
Life 10:42–3 (c,1) Mr '87
Life 10:66–9 (1) Ag '87
Trav&Leisure 11:89 (2) Ja '88
Trav&Leisure 21:158–60 (c,1) O '91
—St. Basil's Cathedral
Trav/Holiday 168:60–3 (c,1) Ag '87
Life 11:89 (2) Ja '88
Trav/Holiday 176:49–53 (c,1) S '91
—Smolensky Cathedral
Trav/Holiday 176:54 (c,1) S '91
—See also
KREMLIN
MOSLEM RITES AND FESTIVALS
—1974 Moslem praying toward Mecca
(Saudi Arabia)
Life 11:73 (4) Mr '88
—Children studying the Koran (Morocco)
Nat Geog 180:10–11 (c,1) D '91
—Pilgrimage to Mecca
Life 11:107 (c,4) Ja '88
—Pilgrims donning ihram (Mecca, Saudi
Arabia)
Nat Geog 180:23 (c,4) D '91
—Reading the Koran (Kashmir)
Nat Geog 172:533 (c,4) O '87
—Shiite observance of Husain's martyrdom (India)
Natur Hist 99:50–7 (c,1) S '90
—Shiite self-flagellation rites (India)
Natur Hist 99:50–3 (c,1) S '90
—Slaughtered sheep (Paris, France)

Nat Geog 176:126–7 (c,1) Jl '89
MOSLEM SHRINES AND SYMBOLS
—Hand of Fatima
Nat Geog 174:88 (c,4) Jl '88
—Kaaba, Mecca, Saudi Arabia
Nat Geog 180:24–5 (c,1) D '91
—Karbala mosque, Iraq
Nat Geog 179:114 (c,3) My '91
—See also
MOORS
MOSLEMS—ARCHITECTURE
—Minaret (Samarra, Iraq)
Nat Geog 179:115 (c,2) My '91
MOSLEMS—ART
—Moorish design (Spain and Morocco)
Nat Geog 174:100–3 (c,2) Jl '88
MOSLEMS—COSTUME
—Grand Mufti (Egypt)
Life 14:60 (c,3) D '91
—Muslin girl with head covering (Australia)
Nat Geog 173:258 (2) F '88
MOSLEMS—HISTORY
—14th cent. travels of Ibn Battuta
Nat Geog 180:2–49 (map,c,1) D '91
—Mecca worshipers dead in airless tunnel,
Saudi Arabia
Life 13:10–11 (c,1) S '90
MOSQUES
—Borneo
Trav/Holiday 172:76–7 (c,1) S '89
—Dome of the Rock, Jerusalem, Israel
Trav/Holiday 170:67 (c,1) S '88
—India
Nat Geog 173:607 (c,4) My '88
—Kairouan, Tunisia
Trav&Leisure 18:99 (c,3) D '88
Gourmet 50:44–5 (c,2) Ag '90
—Karbala mosque, Iraq
Nat Geog 179:114 (c,3) My '91
—Kenya
Trav/Holiday 170:51 (c,4) Ag '88
—Mali
Nat Geog 178:126 (c,4) O '90
Nat Geog 180:44–5 (c,1) D '91
—Mauritius
Trav&Leisure 18:79 (c,4) N '88
—Seljuk minaret (Turkey)
Smithsonian 21:36 (c,4) Ag '90
—Süleymaniye Mosque, Istanbul, Turkey
Smithsonian 18:142–3 (c,3) S '87
Trav&Leisure 17:124–5, 132–3 (c,1) N '87
—Turkey
Nat Geog 172:556–8 (c,1) N '87
Trav&Leisure 17:190 (c,4) N '87
Smithsonian 21:40 (c,4) Ag '90
MOSQUES—CONSTRUCTION
—Huge enclosed mosque (Casablanca,
Morocco)

Sports Illus 72:51–2, 57 (c,1) Jc 11 '90
Life 13:66–7 (c,1) Je '90
—"Dirty Dancing" fad
Life 11:132–3 (c,1) Ja '88
—"Dragnet" (1987)
Life 10:26–32 (c,1) Ap '87
—"Eight Men Out" (1988)
Sports Illus 69:18 (c,4) S 12 '88
Sports Illus 69:5–6 (c,4) O 31 '88
—"E.T." (1982)
Life 12:51 (c,4) Jl '89
Life 12:154–5 (c,1) Fall '89
Sports Illus 71:168 (c,4) N 15 '89
—Famous screen kisses
Life 14:68–77 (1) F '91
—"Fatal Attraction" (1987)
Life 10:20 (c,2) Ap '87
Life 11:110 (c,4) Ja '88
—Film cans in vault
Sports Illus 71:132 (c,4) S 11 '89
—Film depictions of space creatures
Life 12:48–57 (c,1) Jl '89
—Films about the Civil War
Am Heritage 40:58–9, 62–3 (c,1) Mr '89
—Films of Agatha Christie books
Smithsonian 21:92 (c,4) S '90
—"The First Emperor" (1989)
Natur Hist 98:66–9 (c,1) Jl '89
—"Flesh and the Devil" (1927)
Life 14:76–7 (1) F '91
—"Flying Down to Rio" (1933)
Trav&Leisure 19:225 (3) N '89
—"From Here to Eternity" (1953)
Trav/Holiday 173:44, 47 (c,4) Mr '90
Life 14:71 (4) F '91
—"Glory" (1990)
Life 13:90–3 (c,1) F '90
—"Godfather III" (1990)
Life 13:50–65 (c,1) N '90
—"Goldfinger" (1964)
Life 10:116 (4) Ap '87
Trav&Leisure 19:168 (4) D '89
—"Gone with the Wind" (1939)
Life 11:cov., 28–32 (c,1) My '88
Life 12:26–7 (1) Spring '89
Am Heritage 40:58–9, 62–3 (1) Mr '89
Am Heritage 40:44 (4) D '89
Life 14:cov. (c,1) S '91
—"Goodbye, Mr. Chips" (1939)
Life 12:46–7 (1) Spring '89
—"Gorillas in the Mist" (1988)
Life 11:cov., 38–47 (c,1) O '88
Trav&Leisure 20:130 (c,4) S '90
—"Hamlet" (1990)
Life 14:36–46 (c,1) F '91
—Hamlet played by famous actors
Life 14:40–1 (4) F '91
—Hawaiian sites from *From Here to Eternity*

Trav/Holiday 173:cov., 42–51 (c,1) Mr '90
—"Hunt for Red October" (1989)
Life 12:88–9 (c,1) S '89
—Indiana Jones films
Trav&Leisure 20:146–51 (c,1) My '90
—"Indio" (1990)
Sports Illus 73:40–1 (c,2) Jl 2 '90
—"Intermezzo" (1939)
Life 12:40–1 (1) Spring '89
—James Bond movies artifacts
Life 10:114–15 (c,1) Ap '87
—"La Dolce Vita" (1961)
Trav&Leisure 18:50 (3) N '88
—"Lady and the Tramp" (1955)
Trav&Leisure 18:112–13 (c,1) F '88
—"The Last Emperor" (1987)
Life 10:36–40 (c,1) Ap '87
—Movie poster (India)
Trav/Holiday 170:108 (4) O '88
—Movie westerns
Am Heritage 40:64–5 (c,4) Mr '89
—"Mutiny on the Bounty" (1935 and 1962)
Smithsonian 18:99 (4) F '88
—"Nadine" (1987)
Life 10:61–4 (2) Jl '87
—"North by Northwest" (1959)
Life 14:74–5 (1) F '91
Trav/Holiday 175:79 (4) F '91
—"On Her Majesty's Secret Service" (1969)
Life 10:116, 120 (4) Ap '87
—"On the Waterfront" (1954)
Trav&Leisure 18:126–7 (1) Je '88
Life 14:70–1 (1) F '91
—"Our Gang" kids
Sports Illus 67:76 (4) Jl 27 '87
—"Revolution" (1985)
Am Heritage 40:60–1 (c,2) Mr '89
—Rocky films
Sports Illus 73:74–7 (c,1) N 12 '90
—Ruby slippers from "The Wizard of Oz" (1939)
Life 12:6–7 (c,1) Spring '89
Trav/Holiday 176:75 (c,4) Jl '91
—"Ryan's Daughter" (1970)
Trav/Holiday 174:32–5 (c,1) D '90
—Scenes from 1939 films
Life 12:26–49 (c,1) Spring '89
—Scenes from James Bond films
Life 10:114–20 (c,1) Ap '87
—Scenes from Tarzan movies
Sports Illus 67:82–3 (2) D 7 '87
—"Snow White" (1937)
Life 10:52–6 (c,1) Ap '87
Life 11:107 (c,4) Ja '88
—"Some Like it Hot" (1959)
Trav&Leisure 18:56 (4) F '88
Trav&Leisure 19:226 (4) N '89

—"Spaceballs" (1987)
 Life 10:16–17 (c,1) Ap '87
—"The Spy who Loved Me" (1977)
 Life 10:116, 120 (4) Ap '87
—"Stagecoach" (1939)
 Life 12:32–3 (c,1) Spring '89
—"Star Wars" characters (1977)
 Sports Illus 71:148 (c,4) N 15 '89
 Trav&Leisure 20:57 (c,4) My '90
 Smithsonian 21:124–5 (c,1) O '90
—"Steel Magnolias" (1989)
 Life 12:82–4 (c,1) O '89
—"Sunset" (1987)
 Life 10:110–2 (c,1) N '87
—"Sunset Boulevard" (1950)
 Trav&Leisure 20:83 (3) S '90
—"Tarzan and his Mate" (1954)
 Life 14:72 (3) F '91
—"They Died with their Boots On"
 (1941)
 Am Heritage 40:64–5 (c,3) Mr '89
—"Two-Faced Woman" (1941)
 Life 12:100 (3) Spring '89
—"Union Pacific" (1939)
 Am Heritage 40:120 (3) F '89
—U.S. history depicted in movies
 Am Heritage 40:58–72 (c,1) Mr '89
—"The Untouchables" (1987)
 Life 10:18–19 (c,1) Ap '87
—"Valmont" (1989)
 Life 12:72–5 (c,1) Spring '89
—"Willow" (1988)
 Life 11:88 (c,2) Je '88
—"Wizard of Oz" (1939)
 Life 10:16 (4) Ap '87
 Life 12:6–7, 48–9 (c,1) Spring '89
—"The Women" (1939)
 Life 12:28–9 (c,1) Spring '89
—"You Were Never Lovelier" (1942)
 Life 11:119 (2) Ja '88
MOTORBOAT RACES
—Alaska
 Nat Geog 177:62–3 (1) F '90
—Florida
 Sports Illus 69:26–7 (c,2) N 21 '88
—Offshore Powerboat Championships
 1987 (Florida)
 Sports Illus 67:28–9 (c,2) N 23 '87
—Record-breaking Atlantic crossing by
 motorboat
 Sports Illus 71:2–3 (c,1) Ag 7 '89
MOTORBOATS
—Aerial view of small motorboat
 Trav/Holiday 174:cov. (c,1) D '90
—Homemade floating hot tub (Wash-
 ington)
 Nat Geog 176:797 (c,3) D '89
MOTORCYCLE RACES
—Ice motorcycle racing (Germany)

 Sports Illus 74:2–3 (c,1) Mr 18 '91
—Mojave Desert, California
 Smithsonian 21:34 (c,4) S '90
—Wisconsin
 Sports Illus 68:16 (c,4) Ap 18 '88
MOTORCYCLE RIDING
—Afghanistan
 Life 12:121 (c,2) My '89
—Biker rally (South Dakota)
 Life 13:11 (c,3) O '90
—Colorado
 Life 13:68–9, 74–5 (c,1) S '90
—Farmer on motorcycle (New Zealand)
 Trav&Leisure 18:98 (c,4) O '88
—Knievel motorcycling over buses (1975)
 Sports Illus 71:4 (4) Ag 7 '89
—Motorbiking (Bermuda)
 Trav&Leisure 21:124–5 (c,1) F '91
—Motorcycling over fountain (Nevada)
 Sports Illus 70:26–7 (c,1) Ap 24 '89
 Sports Illus 73:6 (2) N 12 '90
MOTORCYCLES
—Lawrence of Arabia's motorcycle
 Sports Illus 74:2–3 (c,1) Ap 1 '91
—Motor scooters (Florida)
 Trav&Leisure 19:135 (c,3) D '89
—Motorbike
 Trav&Leisure 18:cov. (c,1) Ag '88
—Motorbike market (Thailand)
 Trav&Leisure 20:146–7 (c,1) F '90
—Stuck in sand (Africa)
 Sports Illus 68:2–3 (c,1) F 1 '88
MOUNT COOK, NEW ZEALAND
 Trav&Leisure 17:124–8 (c,1) Je '87
MOUNT ETNA, SICILY, ITALY
 Gourmet 48:77 (c,1) O '88
 Trav/Holiday 173:73–4 (c,2) F '90
MOUNT EVANS, COLORADO
 Nat Wildlife 25:46–7 (c,1) Je '87
MOUNT EVEREST, NEPAL
 Smithsonian 18:176 (c,2) O '87
 Nat Geog 174:612–59 (map,c,1) N '88
 Sports Illus 70:62–74 (c,1) Ja 16 '89
 Life 14:40–56 (c,1) S '91
MOUNT FUJI, JAPAN
 Trav/Holiday 170:18 (c,3) O '88
 Nat Geog 178:3–4 (c,1) O '90
 Nat Geog 180:48–9 (c,1) N '91
MOUNT HOOD, OREGON
 Trav&Leisure 17:20 (c,4) Ja '87
MOUNT MCKINLEY, ALASKA
 Nat Geog 172:262–3 (c,1) Ag '87
 Life 14:106–7 (c,1) Summer '91
MOUNT OF THE HOLY CROSS, COL-
 ORADO
 Nat Geog 175:239 (c,2) F '89
MOUNT RAINIER, WASHINGTON
 Nat Geog 176:782–3 (c,1) D '89
 Life 14:cov., 33 (c,1) Summer '91

Trav&Leisure 20:104–5 (c,1) Jl '90
—Snake Range, Nevada
 Smithsonian 18:69, 72–3 (c,1) N '87
—Square Top Mountain, Wyoming
 Natur Hist 100:71 (c,1) Je '91
—Sugarloaf Mountain, Rio de Janeiro,
 Brazil
 Trav&Leisure 20:74–5 (c,1) Ag '90
—Tatra Mountains, Czechoslovakia
 Nat Geog 171:120–1, 128–9 (c,1) Ja
 '87
—Truchas peaks, New Mexico
 Trav/Holiday 174:62–3 (c,1) D '90
—Wallowa Mountains, Oregon
 Natur Hist 96:42–3 (c,1) N '87
—Wheeler Peak, Nevada
 Smithsonian 18:72–3, 76 (c,1) N '87
 Trav&Leisure 18:124 (c,3) Mr '88
 Natur Hist 97:65 (c,1) O '88
 Nat Geog 175:72–3 (c,1) Ja '89
—Wilson Peak, Colorado
 Smithsonian 21:37 (c,4) S '90
—See also
 ACONCAGUA
 ADIRONDACK MOUNTAINS
 ALASKA RANGE
 ALPS
 ANDES
 ANNAPURNA
 AVALANCHES
 CASCADE RANGE
 CATSKILL MOUNTAINS
 DOLOMITES
 GREEN MOUNTAINS
 HIMALAYA MOUNTAINS
 JUNGFRAU
 JURA
 MATTERHORN
 MOUNT COOK
 MOUNT EVANS
 MOUNT EVEREST
 MOUNT FUJI
 MOUNT HOOD
 MOUNT McKINLEY
 MOUNT OF THE HOLY CROSS
 MOUNT RAINIER
 MOUNT ST. HELENS
 MOUNT WASHINGTON
 MOUNT WHITNEY
 OZARK MOUNTAINS
 PAMIR RANGE
 PIKES PEAK
 ROCKY MOUNTAINS
 ST. ELIAS RANGE
 SIERRA NEVADA
 TETON RANGE
 WHITE MOUNTAINS
Movies. See
 MOTION PICTURES

MOVING INDUSTRY
—Moving house by truck (North Carolina)
 Nat Geog 172:497 (c,4) O '87
—Moving into suburban home (1950s)
 Am Heritage 42:51 (3) My '91
MOZART, WOLFGANG AMADEUS
 Trav&Leisure 20:44 (painting,c,3) Ag
 '90
 Trav/Holiday 175:108 (painting,4) Mr
 '91
—Birthplace (Salzburg, Austria)
 Trav&Leisure 17:cov. (c,1) Je '87
MUD
—Hot mud puddles, solfaturas (Iceland)
 Trav&Leisure 19:75 (c,4) Ap '89
—People in Amazon mud (Peru)
 Sports Illus 66:60–1, 72 (c,1) Ap 13 '87
MUD HENS
 Smithsonian 21:174 (c,1) Ap '90
MUIR, JOHN
 Nat Geog 175:470 (4) Ap '89
 Smithsonian 21:208 (4) Ap '90
 Life 14:36 (4) Summer '91
—Actor playing John Muir
 Trav&Leisure 20:36 (c,4) Ag '90
—John Muir Trail, Sierra Nevada, Califor-
 nia
 Nat Geog 175:466–93 (map,c,1) Ap
 '89
MULBERRIES
 Natur Hist 96:4 (c,4) N '87
 Nat Wildlife 26:16 (c,4) Ag '88
MULE DEER
 Natur Hist 97:53 (c,1) Je '88
 Nat Wildlife 27:12–13 (c,1) F '89
 Nat Wildlife 28:34–5, 38–9 (c,1) D '89
 Nat Wildlife 28:4–9 (c,1) O '90
 Nat Wildlife 30:7 (c,1) D '91
MULES
—Jumping over fence
 Nat Geog 175:210 (2) F '89
MUMMIES
—11th cent. Indian mummy (Chile)
 Nat Geog 174:74–5 (c,2) Jl '88
—1892 photo of mummy (Peru)
 Smithsonian 21:121 (4) My '90
—Egypt
 Life 10:106–9 (c,1) O '87
 Life 12:8 (c,4) Je '89
 Nat Geog 178:117 (c,3) D '90
 Nat Geog 179:8 (c,2) Ap '91
—Inca mummies (Argentina)
 Natur Hist 100:64, 66 (c,3) Ap '91
—Mummy of Ramses II (Egypt)
 Nat Geog 179:8 (c,2) Ap '91
MUNCH, EDVARD
—"The Day After"
 Trav&Leisure 20:157 (painting,c,4) My
 '90

Trav/Holiday 168:71 (c,3) S '87
—Gilcrease Museum, Tulsa, Oklahoma
Am Heritage 41:94–105 (c,1) F '90
—Hermitage staircase, Leningrad,
U.S.S.R.
Life 11:58–9 (c,1) My '88
—International Museum of Children's Art,
Oslo, Norway
Smithsonian 21:148–57 (c,2) O '90
—Kentucky Derby Museum, Louisville,
Kentucky
Trav/Holiday 169:62–3 (c,1) Mr '88
—Living History Farms, Iowa
Trav/Holiday 171:96–9 (c,3) Mr '89
—London Transport Museum, England
Gourmet 47:74 (c,2) D '87
—Los Angeles, California
Trav/Holiday 168:69–73 (c,1) S '87
—Los Angeles County Museum of Art,
California
Trav&Leisure 17:68 (c,4) S '87
Trav&Leisure 18:52 (c,4) S '88
—Los Angeles Japanese Art Pavilion, Cali-
fornia
Smithsonian 22:112–13, 118–19 (c,2) Ap
'91
—Maritime Center, Norwalk, Connecticut
Trav/Holiday 171:102, 105 (c,1) Mr '89
—Mauritshuis Museum, The Hague, Neth-
erlands
Trav&Leisure 18:49–50 (c,4) Ap '88
—Menil Collection, Houston, Texas
Trav&Leisure 18:18, 22 (c,4) F '88
—Mercer museum, Pennsylvania
Smithsonian 19:110, 121 (c,1) O '88
—Musée Carnavalet, Paris, France
Gourmet 49:50 (painting,c,2) O '89
—Musée d'Orsay, Paris, France
Smithsonian 17:82–95 (c,1) Mr '87
Gourmet 47:28, 37 (drawing,2) Ap '87
Trav&Leisure 17:114–23, 156 (c,1) Je '87
Trav&Leisure 20:24 (c,3) D '90
—Musée Français du Pain, Paris, France
Gourmet 49:58–9 (c,1) Mr '89
—Museo del Maiz exhibit, Matamoros,
Mexico
Trav/Holiday 169:60–1 (c,1) Je '88
—Museum of Cartoon Art, Rye Brook,
New York
Trav/Holiday 169:26–8 (c,3) Ja '88
—Museum of Civilization, Ottawa, On-
tario
Smithsonian 20:114–25 (c,1) Mr '90
—Museum of Contemporary Art, Los An-
geles, California
Trav&Leisure 17:128–37 (c,1) My '87
Trav/Holiday 168:69 (c,1) S '87
—Museum of English Folk Art, Bath, En-
gland

Gourmet 50:68 (c,3) Jl '90
—Museum of Fine Arts, Santa Fe, New
Mexico
Trav/Holiday 168:67 (c,3) S '87
Gourmet 49:92 (c,4) D '89
—Museum of International Folk Art,
Santa Fe, New Mexico
Gourmet 49:90–1 (c,1) D '89
—Museum of the Moving Image, London,
England
Trav&Leisure 20:43–6 (c,3) Jl '90
—Music Valley Wax Museum, Nashville,
Tennessee
Smithsonian 18:84–91 (c,1) Mr '88
—National Museum of Natural History,
Paris, France
Natur Hist 98:48–55 (painting,c,1) Jl '89
—National Museum of Women in the Arts,
Washington, D.C.
Trav&Leisure 18:E1 (c,3) F '88
—Naylor Museum of Photography, Massa-
chusetts
Smithsonian 18:110–19 (c,2) O '87
—Newark Museum, New Jersey
Trav/Holiday 175:102 (c,4) Ap '91
Smithsonian 22:92–101 (c,2) Je '91
—Noguchi Museum, Queens, New York
Trav&Leisure 17:34–6 (c,4) Je '87
—Pergamon Museum, Berlin, Germany
Smithsonian 22:76–90 (c,1) O '91
—Pitt Rivers Museum, Oxford, England
Smithsonian 18:108–17 (c,1) Jl '87
—Pitti Palace, Florence, Italy
Trav&Leisure 17:109 (c,2) Ap '87
—Prado, Madrid, Spain
Trav&Leisure 19:39 (c,4) My '89
—Railroad Museum, Sacramento, Califor-
nia
Trav/Holiday 172:64–70 (c,1) O '89
—Rodin Museum, Philadelphia, Pennsyl-
vania
Trav/Holiday 167:49 (c,1) Ap '87
—"Sixth Floor" museum of JFK as-
sassination, Dallas, Texas
Trav/Holiday 172:46 (c,4) Ag '89
—Texas museums
Trav&Leisure 21:100–11, 158–60 (c,1) Je
'91
—Textile Museum, Washington, D.C.
Smithsonian 17:108–17 (c,1) Mr '87
—Toronto, Ontario
Trav/Holiday 168:44–9 (c,1) O '87
—Unusual Florida tourist attractions
Trav&Leisure 19:159–61 (c,3) D '89
—Virginia Museum of Fine Arts's Lewis
collection
Smithsonian 18:84–97 (c,1) N '87
—Walters Art Gallery, Baltimore, Mary-
land

Smithsonian 20:102–13 (c,1) Ag '89
—See also
　AMERICAN MUSEUM OF NATU-
　　RAL HISTORY
　BRITISH MUSEUM
　FOLGER SHAKESPEARE LIBRARY
　LOUVRE
　METROPOLITAN MUSEUM OF
　　ART
　NATIONAL ARCHIVES
　NATIONAL GALLERY OF ART
　SMITHSONIAN INSTITUTION
MUSHROOM INDUSTRY
—Growing shiitake mushrooms (Arizona)
　Nat Geog 179:24 (c,4) Je '91
MUSHROOMS
　Nat Wildlife 26:6 (c,2) F '88
　Nat Wildlife 27:2 (c,2) F '89
　Trav/Holiday 171:22–4 (c,4) F '89
—Porcini mushrooms
　Gourmet 50:104 (c,4) N '90
—Wild mushrooms
　Smithsonian 19:134 (c,1) F '89
MUSIC
—Country music shrines (Nashville, Ten-
　nessee)
　Smithsonian 18:84–94 (c,1) Mr '88
MUSIC EDUCATION
—1925 singing class (Minnesota)
　Am Heritage 41:72 (4) F '90
—Accordion class (North Korea)
　Life 11:88–9 (c,1) S '88
—Children's violin class (Japan)
　Smithsonian 17:49 (c,4) Mr '87
MUSICAL INSTRUMENTS
—1780s pianoforte
　Life 10:29 (c,4) Fall '87
—Late 19th cent. brass band instruments
　Trav/Holiday 169:32 (c,4) Ap '88
—Ancient Persian instruments
　Trav/Holiday 169:34 (c,4) Ap '88
—Apache Indians fiddle and bow
　Smithsonian 20:52 (c,4) O '89
—Concertina
　Nat Geog 179:74 (c,3) Ja '91
—Gypsy gadulka (Bulgaria)
　Nat Geog 176:344 (c,2) S '89
—Khalam made from gourds (Senegal)
　Trav/Holiday 173:55 (c,4) Ja '90
—Making dulcimer (Kentucky)
　Gourmet 48:74 (c,4) My '88
—Music boxes
　Gourmet 47:28 (painting,c,4) S '87
—Unusual instruments played by Peter
　Schickele
　Smithsonian 20:90–1 (c,4) F '90
—Violin store (Paris, France)
　Gourmet 50:72 (c,4) F '90
—See also

ACCORDIONS
BANDS
BANDS, MARCHING
BELLS
CALLIOPES
CELLOS
CONCERTS
CONDUCTORS, MUSIC
DRUMS
FLUTES
GUITARS
HARPS
MUSICAL SCORES
MUSICIANS
ORGANS
PIANOS
SAXOPHONES
TRUMPETS
TUBAS
VIOLINS
MUSICAL SCORES
—Early 19th cent. carol songsheets
　Natur Hist 99:60–1, 64 (c,1) D '90
—1869 baseball song cover
　Am Heritage 39:109 (4) D '88
—Cover commemorating 1888 Nebraska
　blizzard heroine
　Smithsonian 18:72 (4) Mr '88
—Cover of 1930s miniature golf song
　Smithsonian 18:120 (c,4) Je '87
—Italian Renaissance lute tablature
　Smithsonian 18:130 (c,4) Mr '88
MUSICIANS
—1898 organ grinder
　Life 11:38 (4) Fall '88
—American folk artists and musicians
　Nat Geog 179:75–101 (c,1) Ja '91
—Bluegrass jamboree (Arkansas)
　Trav&Leisure 20:E8 (painting,c,3) Je '90
—Bluesman Robert Johnson
　Am Heritage 42:50, 56 (1) Jl '91
—Cajun music (Louisiana)
　Smithsonian 18:113–25 (c,2) F '88
　Nat Geog 178:46–7 (c,1) O '90
—Carter family
　Life 14:102–14 (c,1) D '91
—Country music star A. P. Carter
　Life 14:102–14 (c,1) D '91
—Great 20th cent. musicians
　Smithsonian 21:71–3 (3) F '91
—Jazz musicians
　Smithsonian 20:176–80, 195–8 (c,2) O '89
　Trav/Holiday 175:cov., 46–7, 53, 55 (c,1)
　Mr '91
—Making music in black homes (Pennsyl-
　vania)
　Nat Geog 178:72–3 (4) Ag '90
—Jelly Roll Morton
　Trav&Leisure 19:112 (4) F '89

—Street musicians (Argentina)
Trav&Leisure 18:138 (c,2) D '88
—Street musicians (Hungary)
Gourmet 48:72–3 (c,1) O '88
—Street musicians (India)
Trav&Leisure 20:153, 159 (c,3) D '90
—Street musicians (New York)
Smithsonian 19:120 (c,4) F '89
—String section of orchestra (Netherlands)
Trav&Leisure 20:12 (c,4) F '90 supp.
—See also
ARMSTRONG, LOUIS
BANDS
BANDS, MARCHING
BERNSTEIN, LEONARD
CONCERTS
CONDUCTORS, MUSIC
DAVIS, MILES
ELLINGTON, DUKE
GILLESPIE, JOHN BIRKS (DIZZY)
GOODMAN, BENNY
HOROWITZ, VLADIMIR
MONK, THELONIOUS
PADEREWSKI, IGNACE JAN
PARKER, CHARLIE
SEGOVIA, ANDRES
MUSK DEER
Nat Geog 174:648–9 (c,1) N '88
MUSK OXEN
Nat Wildlife 25:cov. (c,1) Je '87
Nat Geog 173:759 (c,3) Je '88
Trav/Holiday 169:28 (c,4) Je '88
Nat Wildlife 27:57 (c,2) O '89
Natur Hist 98:50–9 (c,1) N '89
Natur Hist 99:2 (c,3) Mr '90
—Attacked by wolves
Nat Geog 171:572–9 (c,1) My '87
MUSSELS
Sports Illus 73:88–9 (c,4) O 15 '90
MUSSOLINI, BENITO
Smithsonian 19:163, 172, 190 (2) O '88
Am Heritage 42:76 (4) D '91
MUSTANGS
Nat Geog 175:66–7 (c,1) Ja '89
Am Heritage 41:69 (sculpture,c,1) My
'90
Trav&Leisure 21:92–3 (c,1) Ap '91
MYRTLE
—Periwinkle flowers
Nat Geog 171:173 (c,4) F '87
MYSTIC, CONNECTICUT
Trav&Leisure 18:120–2 (c,2) Je '88
Trav/Holiday 172:100 (c,3) Jl '89
—1880s winter scene
Trav&Leisure 18:121 (4) Je '88
MYTHOLOGY
—Astronomy activities of ancient Ameri-
cans
Nat Geog 177:76–107 (c,1) Mr '90

—Egyptian goddess Sakhmet
Smithsonian 19:87 (sculpture,c,3) Je '88
—Gilgamesh relief (Assyria)
Smithsonian 18:130 (c,3) My '87
—Haida Indians creation story (British Co-
lumbia)
Nat Geog 172:106 (sculpture,c,3) Jl '87
—Hindu "Churning of Sea of Milk" myth
(Cambodia)
Smithsonian 21:45–7 (sculpture,c,1) My
'90
—Japanese earthquake legend
Life 12:49 (painting,c,4) F '89
—Pre-Columbian theories of the universe
Nat Geog 177:81–3 (painting,c,1) Mr '90
—See also
DEITIES
DRAGONS
MERMAIDS
MYTHOLOGY—GREEK AND RO-
MAN
—5th cent. B.C. Etruscan chimera
Nat Geog 173:737 (sculpture,c,4) Je '88
—4th cent. Roman Aphrodite mosaic (Is-
rael)
Life 10:7 (c,4) O '87
—16th cent. fresco of the constellations
Smithsonian 22:108–15 (painting,c,1) N
'91
—Bernini sculpture of Proserpine
Smithsonian 19:22 (c,3) Ap '88
—Danae being ravished by Jupiter
Smithsonian 21:64–5 (painting,c,1) N '90
—Diana sculpture by St. Gaudens
Trav&Leisure 21:E14 (c,4) Ap '91
Trav&Leisure 21:103 (c,1) Je '91
—Etruscan sculpture of Apollo
Nat Geog 173:729 (c,3) Je '88
—Etruscan view of underworld's Charon
Nat Geog 173:697 (painting,c,1) Je '88
—Goya painting of Kronos eating his child
Smithsonian 17:150 (c,2) Mr '87
—Greek Gigantomachy frieze (Pergamon,
Turkey)
Smithsonian 22:76–84 (c,1) O '91
—Hypnos, god of sleep
Nat Geog 172:816 (sculpture,c,4) D '87
—Neptune sculpture
Trav/Holiday 167:52 (c,3) Ja '87
—Penthesilea and Achilles (Turkey)
Smithsonian 19:154–5 (sculpture,c,1) Mr
'89
—Relief sculpture of Medusa (Ephesus,
Turkey)
Trav&Leisure 17:105 (c,4) Mr '87
—Romulus and Remus symbols of Rome
Nat Geog 173:737 (sculpture,c,3) Je '88
—Statue of Ceres (Canada)
Gourmet 51:82 (c,2) Je '91

—Two-faced Janus (France)
Smithsonian 18:154 (sculpture,c,4) O '87
—See also
APHRODITE

GRIFFINS
JUPITER
MEDUSA
VENUS

- N -

NABOKOV, VLADIMIR
Smithsonian 17:175 (4) Mr '87
Natur Hist 97:69 (4) My '88
NADER, RALPH
Life 13:19 (4) Fall '90
NAIROBI, KENYA
Trav&Leisure 20:96, 98, 102 (c,4) N '90
NAMIBIA—COSTUME
—Children
Natur Hist 99:45 (c,4) Je '90
NANTUCKET, MASSACHUSETTS
Gourmet 47:66–71, 222 (map,c,1) D '87
Trav/Holiday 169:cov., 36, 38 (c,1) My
'88
Trav/Holiday 171:70P (c,4) My '89
Trav/Holiday 174:64–5 (c,1) N '90
Trav&Leisure 21:E1–E4 (map,c,3) Jl '91
—Lighthouse
Smithsonian 18:102 (c,4) Ag '87
Trav/Holiday 169:cov. (c,1) My '88
Trav/Holiday 174:64–5 (c,1) N '90
NAPLES, ITALY
Trav&Leisure 18:96–105 (c,1) Je '88
—S. Carlo Opera House
Trav&Leisure 19:90 (c,2) Ap '89
NAPOLEON
Gourmet 50:74 (painting,c,4) O '90
Smithsonian 21:90 (painting,c,4) Mr '91
—Home (Elba, Italy)
Trav&Leisure 20:124–5, 132–3 (c,1) F
'90
—See also
JOSEPHINE
NAPOLEON III (FRANCE)
Am Heritage 39:28 (painting,4) F '88
Smithsonian 21:92 (4) Mr '91
NARWHALS
Nat Geog 174:880–2 (c,1) D '88
Nat Geog 180:24–5 (c,1) Jl '91
NASHVILLE, TENNESSEE
Trav/Holiday 170:58–61 (c,1) O '88
Trav/Holiday 175:56–65 (map,c,1) Ja '91
—1860s
Am Heritage 41:90–1 (2) Mr '90
—Country music shrines
Smithsonian 18:84–94 (c,1) Mr '88
—Full-scale model of the Parthenon
Trav&Leisure 19:211 (c,4) N '89
—Grand Ole Opry

Trav/Holiday 170:58–9, 61 (c,1) O '88
NATCHEZ, MISSISSIPPI
—Antebellum parlor
Am Heritage 39:24 (c,4) Jl '88
—Melrose Plantation house
Trav&Leisure 19:102–3 (c,1) F '89
NATION, CARRY
Smithsonian 20:147–66 (2) Ap '89
NATIONAL ARCHIVES, WASHING-
TON, D.C.
Nat Geog 172:342–3 (c,1) S '87
Trav&Leisure 17:NY6, NY10–11 (c,3) S
'87
—Display of the Constitution
Life 10:2–3, 62–3, 136 (c,1) Fall '87
NATIONAL GALLERY OF ART,
WASHINGTON, D.C.
Trav&Leisure 18:119 (c,4) S '88
Smithsonian 21:50–65 (c,1) Mr '91
NATIONAL GEOGRAPHIC SOCIETY
—1888 founding of the Society
Nat Geog 173:5–7 (painting,c,1) Ja '88
—1913 trustees
Nat Geog 173:43 (3) Ja '88
—Cartoons about *National Geographic*
Nat Geog 174:254–7 (c,2) S '88
—Covers of *National Geographic* (1888–
1988)
Nat Geog 174:271–86 (c,4) S '88
—History
Nat Geog 173:5–7, 38–43 (c,1) Ja '88
Nat Geog 174:entire issue (c,1) S '88
—Parodies of *National Geographic*
Nat Geog 174:352 (c,4) S '88
—Trustees
Nat Geog 173:5–7, 38–43 (c,1) Ja '88
NATIONAL PARKS
—19th cent. views of wilderness
Smithsonian 21:36–43 (c,2) Ap '90
—Activities of National Park Service
Nat Geog 180:36–59 (map,c,1) Ag '91
—Berchtesgaden, West Germany
Natur Hist 99:54–5 (c,1) Je '90
—Chobe, Botswana
Trav&Leisure 18:116, 118–19 (c,1) My
'88
—Corbett, India
Smithsonian 18:61 (c,4) N '87
—European national parks

Nat Geog 171:198 (c,2) F '87
—Lace city scene (Quebec)
Gourmet 51:84 (c,2) Je '91
—Life-size wool dummies knitting (New
Zealand)
Nat Geog 173:582 (c,1) My '88
—Making lace (Spain)
Gourmet 51:71 (c,4) Mr '91
—"Overlord Embroidery" tribute to D-
Day (Great Britain)
Am Heritage 40:108–13 (c,2) My '89
—Woman crocheting
Life 11:73 (c,2) N '88
—See also
SEWING
TAPESTRIES
NEFERTITI (EGYPT)
Nat Geog 172:700 (painting,c,4) D '87
Life 11:143 (painting,c,2) D '88
Nat Geog 179:24 (painting,c,2) Ap '91
—Tomb (Thebes, Egypt)
Nat Geog 179:24–5 (c,2) Ap '91
NEGEV, ISRAEL
Natur Hist 100:38–9 (c,1) Jl '91
NELSON, HORATIO
—Emma Hamilton
Smithsonian 18:162 (painting,c,4) Ja '88
—Nelson's Column, Trafalgar, London,
England
Trav&Leisure 17:47 (c,4) O '87
NENES (BIRDS)
Nat Geog 178:85 (c,4) Jl '90
Neon signs. See
SIGNS AND SIGNBOARDS
NEPAL
Trav/Holiday 167:42–7, 81 (map,c,1) My
'87
Nat Geog 174:638–51 (c,1) N '88
Nat Geog 176:390–405 (map,c,1) S '89
Trav&Leisure 21:26 (c,4) S '91
—Annapurna Range area
Natur Hist 97:26–35 (c,1) Ja '88
Nat Geog 176:390–405 (map,c,1) S '89
—Gurungs harvesting honey from large
honeybees
Nat Geog 174:cov., 660–71 (c,1) N '88
—Kathmandu Valley area
Nat Geog 172:32–65 (map,c,1) Jl '87
—Khumbu region
Natur Hist 100:38–45 (c,1) F '91
—Sagarmatha National Park
Nat Geog 174:626–7, 638–51 (c,1) N '88
—See also
ANNAPURNA MOUNTAIN
HIMALAYA MOUNTAINS
KATHMANDU
MOUNT EVEREST
NEPAL—COSTUME
Trav/Holiday 167:46 (c,4) My '87

Nat Geog 172:32–61 (c,1) Jl '87
Life 11:90 (c,1) Mr '88
Nat Geog 174:345 (c,3) S '88
Nat Geog 174:638–47 (c,1) N '88
Trav&Leisure 19:179–83 (c,4) F '89
Nat Geog 176:396–401 (c,2) S '89
—Gurung people
Nat Geog 174:cov., 660–71 (c,1) N '88
—Hindu people
Natur Hist 96:cov., 38–49 (c,1) Mr '87
Trav&Leisure 20:62–3 (c,1) F '90
—Holy man
Trav/Holiday 167:cov. (c,1) My '87
—Honey hunter
Natur Hist 99:56–7 (c,1) D '90
—Marching band
Natur Hist 100:cov., 38–9, 42–7 (c,1) S
'91
—Sherpa people
Natur Hist 100:40–5 (c,1) F '91
NEPAL—RITES AND FESTIVALS
—Ceremony honoring Hindu goddess
Nat Geog 174:345 (c,3) S '88
—Hindu bride marrying five brothers
Natur Hist 96:cov., 38–49 (c,1) Mr '87
—Rolling on ground during Hindu festival
Nat Geog 172:36 (c,1) Jl '87
NEPAL—SOCIAL LIFE AND CUS-
TOMS
—Bride escorted by marching band
Natur Hist 100:cov., 38–9, 46–7 (c,1) S
'91
NEPTUNE (PLANET)
Smithsonian 19:43 (painting,c,3) S '88
Life 12:3 (c,3) O '89
Life 12:112–13 (c,1) N '89
Natur Hist 98:27 (c,3) D '89
Nat Geog 178:34–46, 51, 59–60 (c,1) Ag
'90
—Moon Triton
Life 13:10–11 (c,1) Ja '90
Natur Hist 99:76–7 (painting,c,3) Ja '90
Nat Geog 178:64 (c,1) Ag '90
NESTS
—Wasps
Natur Hist 97:34–7 (c,1) Jl '88
Natur Hist 98:52–61 (c,1) Ag '89
—See also
BIRD NESTS
NETHERLANDS
Trav/Holiday 168:48–53 (map,c,1) Ag
'87
Trav&Leisure 20:16–26 (c,2) F '90 supp.
Trav&Leisure 21:14–32 (map,c,3) F '91
supp.
—Alkmaar
Trav/Holiday 168:52–3 (c,2) Ag '87
—Gardens
Gourmet 51:80–3, 138 (map,c,1) Ap '91

Am Heritage 42:6 (painting,c,2) My '91
—1920s
Am Heritage 39:128 (3) S '88
Am Heritage 39:cov., 4, 44–95 (c,1) N '88
—1941 Pearl Harbor news flash on *N.Y. Times* building
Am Heritage 40:52–3 (1) N '89
—1950s night scene
Smithsonian 22:160 (4) My '91
—1965 blackout skyline
Smithsonian 17:39 (c,2) F '87
—1980 scene predicted in 1930 movie
Am Heritage 40:51 (4) S '89
—Aerial view
Trav&Leisure 17:50 (c,4) N '87
Trav&Leisure 18:93 (c,4) Je '88
—American Museum of the Moving Image, Queens
Trav&Leisure 19:NY1–2 (c,4) Mr '89
—Apollo Theater, Harlem
Trav/Holiday 169:24 (c,4) Ja '88
—Alice Austen House, Staten Island
Am Heritage 38:90 (c,4) Ap '87
—Bellevue Hospital
Am Heritage 38:42–3 (c,1) F '87
—Bridges across the Harlem River
Am Heritage 38:102–3 (c,2) Ap '87
—Broadway
Gourmet 47:126 (drawing,4) Ap '87
Nat Geog 178:54–87 (map,c,1) S '90
—Broadway during snow storm (early 20th cent.)
Smithsonian 19:76 (painting,c,4) Ap '88
—Brownstone buildings
Gourmet 48:50 (drawing,4) O '88
—Carnegie Hall
Trav/Holiday 167:30 (4) Mr '87
Trav&Leisure 17:E2–4 (c,3) S '87
Trav&Leisure 20:84–9, 95 (c,1) Ag '90
Smithsonian 21:68–80 (c,1) F '91
Gourmet 51:44 (painting,c,2) Mr '91
—Chrysler Building
Am Heritage 39:cov. (c,1) N '88
Nat Geog 175:143–5 (c,1) F '89
Trav&Leisure 19:126–7 (c,1) Je '89
—City Hall
Trav&Leisure 17:NY2 (drawing,c,4) F '87
—City Hall subway station
Smithsonian 18:41 (c,4) Ag '87
—Cooper-Hewitt Museum
Trav&Leisure 18:E2 (c,3) Ap '88
—Ellis Island history
Smithsonian 21:88–97 (c,1) Je '90
Nat Geog 178:88–101 (map,c,1) S '90
Trav&Leisure 20:73–80 (c,2) S '90
Trav/Holiday 174:cov., 39–50 (c,1) S '90
Life 13:cov., 26–38 (c,1) S '90

—Ethnic enclaves in New York City
Trav/Holiday 174:51–9 (map,c,1) S '90
—Federal Hall
Trav&Leisure 19:70 (c,4) S '89
Life 14:42–3 (c,1) Fall '91
—Flatiron Building
Trav&Leisure 17:39 (c,2) Ag '87
Trav&Leisure 21:84–5 (c,1) S '91
—Fraunces Tavern
Gourmet 47:40 (painting,c,3) Je '87
—Fulton Fish Market
Gourmet 49:36 (painting,c,2) Mr '89
—Gracie Mansion
Gourmet 48:46 (painting,c,2) S '88
Am Heritage 42:102–3 (c,1) My '91
—Grand Central Terminal
Gourmet 49:106–11, 260 (c,1) N '89
—Grand Central Terminal interior (1930)
Am Heritage 39:30 (4) F '88
—Greenwich Village
Gourmet 47:78–9 (painting,c,1) Ap '87
Trav&Leisure 18:NY2 (c,2) Je '88
—Greenwich Village (1920s)
Am Heritage 39:44–7, 50 (painting,c,1) N '88
—Guggenheim Museum interior
Trav&Leisure 18:44 (c,4) Jl '88
—Harlem
Nat Geog 177:52–75 (c,1) My '90
—Harlem River (1890)
Nat Geog 175:248 (3) F '89
—Hell Gate (1777)
Gourmet 48:48 (drawing,4) S '88
—Little Italy
Gourmet 51:79 (c,1) Ja '91
—Lower East Side (1905)
Am Heritage 39:54–5 (painting,c,1) F '88
—McSorley's Bar (early 20th cent.)
Smithsonian 19:78–9 (painting,c,2) Ap '88
Am Heritage 39:54 (painting,c,2) N '88
—Neon model of skyline
Trav/Holiday 170:cov. (c,1) S '88
—Night scene
Trav/Holiday 167:10 (c,4) Ja '87
Trav&Leisure 18:108–9 (c,1) Mr '88
—Noguchi Museum, Queens
Trav&Leisure 17:34–6 (c,4) Je '87
—Penn Station (early 20th cent.)
Life 11:137 (4) Fall '88
—Penn Station interior (1943)
Life 13:2–3 (2) S '90
—Radio City Music hall
Trav&Leisure 18:13, 148–55, 219–20 (c,1) N '88
Gourmet 51:66 (painting,c,2) D '91
—Rhinelander Mansion
Trav&Leisure 18:NY2 (c,4) D '88
—Richmondtown Restoration, Staten Island

Natur Hist 96:32–41 (c,1) Ja '87
—Tibet
Nat Geog 172:764–84 (c,1) D '87
Nat Geog 175:752–81 (c,1) Je '89
—See also
BEDOUINS
BERBER PEOPLE
GYPSIES
NORTH CAROLINA
—Cape Hatteras National Seashore
Life 14:74 (c,2) Summer '91
—Kitty Hawk (early 20th cent.)
Am Heritage 39:4, 94–103 (c,1) Ap '88
—Oconaluftee Pioneer Farmstead
Trav&Leisure 20:90 (c,4) Je '90
—Outer Banks
Nat Geog 172:484–513 (map,c,1) O '87
—Paint Rock
Natur Hist 98:64–5 (map,c,1) Ag '89
—Pinehurst
Gourmet 48:56–61 (c,1) Mr '88
Trav/Holiday 172:50–9 (c,1) N '89
—Roan Mountain
Nat Geog 171:224–5 (c,2) F '87
—Salem farmland (1787)
Life 10:40 (painting,c,4) Fall '87
—Wilmington
Trav&Leisure 19:115, 118 (c,3) D '89
—See also
ASHEVILLE
CAPE HATTERAS
CHARLOTTE
GREAT SMOKY MOUNTAINS NA-
TIONAL PARK
NORTH CAROLINA—MAPS
—Outer Banks (1580s)
Nat Geog 172:491 (c,4) O '87
NORTH DAKOTA
Nat Geog 171:320–47 (map,c,1) Mr '87
—Spearfish
Sports Illus 71:32–3 (c,1) Jl 31 '89
—See also
FARGO
NORTH POLE
Nat Geog 177:45, 52–5, 61 (c,1) Ja '90
—1909 Peary expedition to North Pole
Nat Geog 174:386–413 (1) S '88
Natur Hist 98:28, 34–6 (3) N '89
Nat Geog 177:44–61 (1) Ja '90
—Snow sculpture at North Pole
Life 12:7 (c,3) S '89
—See also
PEARY, ROBERT E.
NORTH SEA, EUROPE
—Wattenmeer National Park, West Ger-
many
Natur Hist 99:58–9 (c,1) Je '90
NORTHERN IRELAND
—1969–1988 photographs

Life 12:92–100 (1) S '89
NORTHERN IRELAND—COSTUME
Life 12:94–100 (1) S '89
NORTHERN IRELAND—POLITICS
AND GOVERNMENT
—IRA firebombing vehicle (1981)
Life 12:96–7 (c,1) My '89
—IRA funeral
Life 11:150–3 (1) My '88
—Murdered British soldier
Life 12:94–5 (c,1) Ja '89
—Scenes of the Troubles (1969–88)
Life 12:92–100 (1) S '89
—Teens attacking British armored car
(1972)
Life 12:96–7 (1) S '89
Northern Lights. See
AURORA BOREALIS
NORTHWEST
—Pacific Northwest nature scenes
Life 12:21–4 (c,4) My '89
Nat Geog 178:106–35 (map,c,1) S '90
—See also
CASCADE RANGE
COLUMBIA RIVER
NORTHWEST ORDINANCE (1787)
Life 10:34 (c,4) Fall '87
NORTHWEST TERRITORIES
—Arctic gold mining camp
Smithsonian 18:128–39 (c,1) N '87
—Axel Heiberg Island
Natur Hist 100:58–61 (map,c,1) Ja '91
—Creswell Bay area
Sports Illus 67:54–8 (c,2) Ag 24 '87
—Inuvik
Sports Illus 68:174–85 (map,c,1) Ja 27
'88
—Northwest Passage route
Nat Geog 175:584–601 (map,c,1) My '89
—Pond Inlet
Smithsonian 19:80–1, 88–91 (c,3) F '89
—Wilderness area
Sports Illus 66:186–98 (c,4) F 9 '87
—See also
ARCTIC
BAFFIN ISLAND
ELLESMERE ISLAND
NORWALK, CONNECTICUT
—Maritime Center
Trav/Holiday 171:102, 105 (c,1) Mr '89
NORWAY
—Fjords
Trav&Leisure 17:88–91 (c,1) O '87
—Geiranger
Trav&Leisure 17:88 (c,1) O '87
—See also
BERGEN
OSLO
VIKINGS

Nat Geog 175:627 (c,4) My '89
—Yugoslavia
Nat Geog 178:112–13 (c,1) Ag '90
NUDITY
—Man streaking (1974)
Trav&Leisure 21:31 (4) O '91
NUREMBERG, WEST GERMANY
—Christkindlmarkt
Trav/Holiday 169:125 (c,4) Mr '88
NURSES
Life 12:42–8 (1) O '89
—1890s (New York)
Am Heritage 38:36–41 (1) F '87
—1918 (Massachusetts)
Smithsonian 19:145 (3) Ja '89

—Civil War nurses
Life 14:58 (4) My '91
—See also
BARTON, CLARA
NUTMEG
Gourmet 50:71–2 (c,4) Ja '90
Nutrias. See
COYPUS
NUTS
—Coco-de-mer palm nut
Trav&Leisure 17:113 (c,1) Mr
'87
—See also
ALMOND TREES
CHESTNUT TREES

- O -

OAK TREES
Natur Hist 97:64–5 (c,2) F '88
Life 13:42 (c,4) My '90
Smithsonian 22:114 (c,2) O '91
—Insect life in acorns
Nat Geog 175:782–96 (c,1) Je '89
—Oak tree seedling
Natur Hist 99:60–1 (c,1) Jl '90
—Very old oak tree (South Carolina)
Life 11:7 (c,4) Ap '88
Oakland, California. See
SAN FRANCISCO-OAKLAND BAY
BRIDGE
OAKLEY, ANNIE
Smithsonian 21:131–48 (2) S '90
OAXACA, MEXICO
Trav&Leisure 19:43 (c,3) N '89
Gourmet 51:58–63, 130 (map,c,1) F '91
OBERAMMERGAU, GERMANY
Gourmet 50:48–53 (c,1) Ag '90
OBESITY
—Teenage dieting program (California)
Life 10:34–40 (1) F '87
OBSERVATORIES
—7th cent. Kyongju, South Korea
Nat Geog 174:258–9 (c,1) Ag '88
—Airborne observatory in plane
Nat Geog 173:636–7 (c,1) My '88
—Cambridge, Massachusetts
Smithsonian 21:125 (c,3) D '90
—Chile
Smithsonian 19:50–1, 54 (c,2) Ap '88
Nat Geog 173:618–31, 646–7 (c,1) My '88
Smithsonian 21:132 (c,3) O '90
—Collapsed observatory (West Virginia)
Life 12:136 (c,4) Ja '89
—Crimean Astrophysical Observatory,
U.S.S.R.

Smithsonian 21:133 (c,3) O '90
—Kitt Peak, Arizona
Smithsonian 19:110–11 (c,4) Jl '88
Smithsonian 20:38 (c,4) Mr '90
—Palomar, California
Smithsonian 18:45–7 (c,1) Je '87
—See also
TELESCOPES
Occupations. See
ABOLITIONISTS
ACROBATS
ACTORS
AIRPLANE PILOTS
ANIMAL TRAINERS
ARCHAEOLOGISTS
ARCHITECTS
ARTISTS
ASTRONAUTS
ATHLETES
AUTOMOBILE MECHANICS
BAKERS
BARBERS
BEEKEEPING
BEGGARS
BLACKSMITHS
BUSINESSMEN
BUTCHERS
CARPENTRY
CARTOONISTS
CHEFS
CHIMNEY SWEEPS
CLOWNS
COMPOSERS
CONDUCTORS, MUSIC
COWBOYS
CRIME AND CRIMINALS
CUSTOMS OFFICIALS
DISC JOCKEYS

DOCTORS
DOORMEN
ENTERTAINERS
EXPLORERS
FACTORY WORKERS
FARM WORKERS
FARMERS
FIRE FIGHTERS
FISHERMEN
FORTUNE TELLERS
GUARDS
HOBOES
HUNTERS
INVENTORS
JOCKEYS
JOURNALISTS
JUDGES
JUGGLERS
LABORERS
LAWYERS
LIFEGUARDS
LUMBERJACKS
MAGICIANS
MAIDS
MATADORS
METALWORKING
MILITARY COSTUME
MINERS
MODELS
MUSICIANS
NURSES
PAINTERS
PHOTOGRAPHERS
PIRATES
PLUMBERS
POLICEMEN
PORTERS
POSTAL WORKERS
PROSTITUTION
RAILROAD CONDUCTORS
RAILROAD WORKERS
RULERS AND MONARCHS
SAILORS
SCHOLARS
SCIENTISTS
SERVANTS
SHEPHERDS
SINGERS
SPIES
SPORTS ANNOUNCERS
STATESMEN
STREET VENDORS
TAILORS
TEACHERS
TELEVISION NEWSCASTERS
TRUCK DRIVERS
VETERINARIANS
WAITERS
WAITRESSES

WRITERS
OCEAN CRAFT
—1934 research bathysphere
 Nat Geog 174:315 (4) S '88
—Coastal research amphibious buggy
 (North Carolina)
 Nat Geog 172:508 (c,4) O '87
—Research vessel (California)
 Nat Geog 177:30–1 (c,3) F '90
—Research vessel (U.S.S.R.)
 Nat Wildlife 29:4–5 (c,1) Ap '91
—Submersibles
 Nat Geog 174:712–13, 718–19, 729 (c,1)
 N '88
 Nat Geog 178:3, 11 (c,1) O '90
 Nat Geog 179:38–43 (c,1) F '91
OCEANS
—Animals harmed by plastic debris in
 oceans
 Smithsonian 18:58–67 (c,1) Mr '88
—Australia
 Nat Geog 171:287 (c,1) Mr '87
 Trav&Leisure 20:140–1 (c,1) S '90
—Marine biology research activities (Mas-
 sachusetts)
 Smithsonian 19:90–103 (c,2) Je '88
—Ocean currents
 Natur Hist 96:2 (c,3) Je '87
—Ocean research expeditions
 Nat Geog 179:38–47 (c,1) F '91
—See also
 ATLANTIC OCEAN
 GULF STREAM
 INDIAN OCEAN
 PACIFIC OCEAN
 WAVES
OCOTILLO PLANTS
 Nat Wildlife 27:19 (c,2) Ap '89
OCTOPI
 Nat Wildlife 25:56 (c,3) F '87
 Nat Geog 171:302–3 (c,1) Mr '87
 Smithsonian 18:30 (c,4) My '87
 Smithsonian 20:103 (c,4) Jl '89
 Natur Hist 100:36–7 (c,1) F '91
—Giant octopi
 Nat Geog 179:86–97 (c,1) Mr '91
—Octopus emerging from egg
 Natur Hist 100:34–5 (c,2) F '91
 Smithsonian 22:124–6 (c,2) Ap '91
—Octopus eye
 Nat Geog 178:32 (c,4) O '90
ODESSA, UKRAINE, U.S.S.R.
—Harbor
 Nat Geog 171:598–9 (c,1) My '87
OFFICE BUILDINGS
—1888 (New York City, New York)
 Am Heritage 40:146 (c,4) N '89
—Atlanta, Georgia
 Nat Geog 174:2–3, 29 (c,1) Jl '88

—Chicago, Illinois
Nat Geog 175:160–1, 174–85 (c,1) F '89
Nat Geog 179:52–3, 61 (c,1) My '91
—Chicago Tribune tower, Chicago, Illinois
Am Heritage 40:147 (c,4) N '89
—Chrysler Building, New York City, New
York
Am Heritage 39:cov. (c,1) N '88
Nat Geog 175:143–5 (c,1) F '89
Trav&Leisure 19:126–7 (c,1) Je '89
—Circular Capitol Records Tower, Los
Angeles, California
Trav&Leisure 20:84 (c,4) S '90
—Coca-Cola headquarters, Atlanta, Geor-
gia
Trav&Leisure 21:25 (c,4) D '91
—Flatiron Building, New York City, New
York
Trav&Leisure 17:39 (c,2) Ag '87
Trav&Leisure 21:84–5 (c,1) S '91
—Foshay Building, Minneapolis, Minne-
sota
Am Heritage 40:106–7 (c,2) Jl '89
—Hong Kong
Smithsonian 20:42–3 (c,1) Ap '89
—Honolulu, Hawaii
Trav/Holiday 174:80–1 (c,1) O '90
—Los Angeles, California
Nat Geog 179:114–15 (c,1) Ap '91
—Modern office building interior (Calgary,
Alberta)
Gourmet 48:56–7 (c,1) Ja '88
—Montreal, Quebec
Gourmet 49:65, 68 (c,1) My '89
—Mountain climbers cleaning high win-
dows (France)
Life 12:8 (c,4) O '89
—New York City, New York
Am Heritage 38:53–68 (painting,c,4) N
'87
Life 11:120 (c,1) D '88
—Office building fire (Los Angeles, Cali-
fornia)
Life 11:7 (c,2) Jl '88
Nat Geog 175:152 (c,1) F '89
—Pittsburgh, Pennsylvania
Am Heritage 40:146–7 (c,4) N '89
—Room 274 of Old Exec. Office Building,
Washington, D.C. (1912–1989)
Am Heritage 40:106–7 (c,2) Mr '89
—See-through building (Paris, France)
Life 12:8 (c,4) Ag '89
—Skyscrapers
Nat Geog 175:140–79 (c,1) F '89
—Toronto, Ontario
Nat Geog 172:197 (c,4) Ag '87
—Wind damage to Hancock Tower win-
dows, Boston, Mass.
Smithsonian 19:122 (c,4) My '88

—Woolworth Building, New York City,
New York
Am Heritage 40:16 (drawing,4) Jl '89
—Wright office building (Oklahoma)
Smithsonian 22:116 (c,4) Ap '91
—Wrigley Building, Chicago, Illinois
Trav/Holiday 167:12 (c,4) Je '87
—See also
EMPIRE STATE BUILDING
ROCKEFELLER CENTER
SEARS TOWER
WORLD TRADE CENTER
OFFICE BUILDINGS—CONSTRUC-
TION
—Bamboo scaffolding (Hong Kong)
Natur Hist 98:56–7 (c,1) O '89
—Chicago Daily News Building, Illinois
(1929)
Am Heritage 38:118 (2) My '87
—Empire State Building, New York City
(1931)
Nat Geog 175:151 (4) F '89
—Hanging building keystone (Boston,
Massachusetts)
Smithsonian 19:97 (c,2) O '88
—Indianapolis, Indiana
Trav/Holiday 172:83 (c,3) S '89
—London, England
Nat Geog 180:32–3, 54–5 (c,1) Jl '91
—New York City skyscraper, New York
Life 10:10 (c,4) D '87
—Reliance Building, Chicago, Illinois
(1894)
Am Heritage 39:166 (4) N '88
OFFICES
—Aerial view of desks (California)
Smithsonian 17:46 (c,3) F '87
—Man working at desk
Sports Illus 75:75 (painting,c,3) N 4 '91
—Senate Caucus Room, Washington,
D.C.
Life 10:12–13 (c,1) Jl '87
—See also
DESKS
NEWSPAPER OFFICES
OHIO
—Ashtabula
Sports Illus 70:70 (c,3) F 20 '89
—Autumn countryside in Holmes County
Gourmet 47:84–5 (c,1) N '87
—Buffalo Beats
Natur Hist 100:18–20 (map,c,2) D '91
—Martins Ferry
Sports Illus 68:80 (c,2) My 23 '88
—Richfield (1855)
Am Heritage 41:93 (painting,c,2) D '90
—See also
CINCINNATI
CLEVELAND

DAYTON
OHIO RIVER
OHIO RIVER, CINCINNATI, OHIO
Trav/Holiday 169:58–63 (c,2) My '88
—Ohio River scene in winter (1857)
Am Heritage 40:98–9 (painting,c,1) D
'89
OHIO RIVER, ILLINOIS
—Impact of 1988 drought on Ohio River
Life 12:12–13 (c,1) Ja '89
OIL INDUSTRY
—Effects of Kuwait's burning oil fields
Nat Geog 180:cov., 2–33 (map,c,1) Ag
'91
—Kansas
Smithsonian 21:cov., 36–47 (1) Mr '91
—Kuwaiti holding glass of crude oil
Nat Wildlife 29:15 (c,2) Ag '91
—Middle Eastern oil fields and pipelines
Nat Geog 173:651–3 (map,c,1) My '88
—Oil exploration practices
Nat Geog 176:226–59 (c,1) Ag '89
—Saving Kuwait's oil fields
Life 14:42–50 (c,1) Jl '91
—Vibrator trucks used in oil exploration
(Oman)
Nat Geog 176:242–3 (c,1) Ag '89
—See also
ALASKA PIPELINE
ROCKEFELLER, JOHN D.
OIL INDUSTRY—DRILLING
—"Grasshopper" oil pumps (California)
Nat Geog 179:68–9 (c,1) F '91
—Offshore oil rig (Alaska)
Nat Geog 171:88–9 (c,2) Ja '87
Nat Geog 174:865 (c,2) D '88
—Offshore oil rig (North Sea)
Nat Geog 176:226–7 (c,1) Ag '89
—Offshore oil rigs (Texas/Louisiana)
Nat Geog 176:252 (c,3) Ag '89
—Oil pump
Natur Hist 100:20 (c,4) D '91
OIL INDUSTRY—HUMOR
—History of oil
Smithsonian 22:108–112 (painting,c,1) D
'91
OIL SPILLS
—1989 Prince William Sound oil spill,
Alaska
Nat Wildlife 27:4–9, 25–6 (c,1) Je '89
Trav&Leisure 19:48, 53 (map,c,4) Jl '89
Nat Geog 176:260–3 (c,2) Ag '89
Nat Geog 177:2–43 (map,c,1) Ja '90
Nat Wildlife 28:34–42 (map,c,1) Je '90
—Birds covered with oil from spill
Life 12:26–7 (c,1) My '89
Nat Wildlife 27:4–5 (c,1) Je '89
Life 12:137 (c,4) Fall '89
Nat Wildlife 28:60 (c,1) F '90

Nat Geog 180:6–7, 26 (c,1) Ag '91
—Cleaning 1970 oil spill with straw (Cali-
fornia)
Nat Wildlife 28:6 (c,4) F '90
—Cleaning Prince William Sound after oil
spill (Alaska)
Nat Wildlife 28:6–7 (c,2) F '90
Nat Wildlife 28:36–7 (c,1) Je '90
—Exxon Valdez after 1989 oil spill
Nat Wildlife 27:6–7 (c,2) Je '89
Life 13:16–17 (c,1) Ja '90
Nat Wildlife 28:38–9 (c,1) Je '90
O'KEEFFE, GEORGIA
Life 10:120 (4) Ja '87
Am Heritage 38:44 (4) S '87
Smithsonian 18:156–7 (2) N '87
Trav&Leisure 17:160 (4) N '87
—"From the Faraway Nearby" (1937)
Trav&Leisure 17:162 (painting,c,4) N
'87
—"Jack-in-the-Pulpit"
Trav&Leisure 17:160 (painting,c,4) N
'87
—"Kachina" (1931)
Natur Hist 99:90 (painting,c,3) N '90
—Paintings by her
Am Heritage 38:cov., 45–57 (c,1) S '87
Smithsonian 18:154–5, 159–69 (c,1) N '87
OKLAHOMA
—1889 homesteading movement
Am Heritage 40:32 (4) Ap '89
Smithsonian 20:192–206 (2) N '89
—1930s Dust Bowl scenes
Smithsonian 20:cov., 44–57 (1) Je '89
—Shidler
Am Heritage 40:114–16 (c,4) Ap '89
—See also
OKLAHOMA CITY
TULSA
OKLAHOMA CITY, OKLAHOMA
—1889
Smithsonian 20:202 (4) N '89
—Myriad Gardens Crystal Bridge
Nat Geog 176:771 (c,2) D '89
OLIVE TREES
Gourmet 48:51 (c,1) Mr '88
Natur Hist 98:82 (c,3) Mr '89
Trav&Leisure 21:116 (c,3) Je '91
OLIVES
Natur Hist 98:4 (c,4) Ag '89
OLIVIER, SIR LAURENCE
Life 13:109 (c,3) Ja '90
OLYMPIC NATIONAL PARK, WASH-
INGTON
Trav/Holiday 173:86–7 (map,c,1) F '90
Life 14:12–13 (c,1) Summer '91
OLYMPICS
—Carrying Olympic torch
Sports Illus 66:168 (drawing,c,3) F 9 '87

—History of Russian Olympic athletes
 Life 11:48–9, 86 (c,4) O '88
—Olympic flag
 Sports Illus 66:39 (c,4) Je 8 '87
—Olympic pins
 Sports Illus 68:74–9 (c,4) Ja 27 '88
 Sports Illus 68:78–9 (c,1) F 29 '88
—Olympic rings in skywriting
 Trav&Leisure 21:34 (c,4) O '91
—Olympic training center (Marquette, Michigan)
 Sports Illus 69:40 (c,4) S 12 '88
—Senior Olympics (Missouri)
 Sports Illus 71:38–41 (c,3) Jl 3 '89
—Skiing events history
 Sports Illus 67:41–57 (c,2) N 23 '87
—Special Olympics 1987 (Indiana)
 Sports Illus 67:38–49 (c,1) Ag 17 '87
—Special Olympics athletes
 Sports Illus 70:49–55 (c,4) Mr 27 '89
—Use of "Olympic" in company names
 Sports Illus 69:208–13 (c,4) S 14 '88
OLYMPICS—1896 (ATHENS)
—Winners' parade
 Am Heritage 39:42 (drawing,4) My '88
OLYMPICS—1904 (ST. LOUIS)
 Am Heritage 39:39–46 (2) My '88
OLYMPICS—1924 SUMMER (PARIS)
 Am Heritage 40:66–71 (c,1) Jl '89
—Swimming
 Sports Illus 69:45 (4) Ag 1 '88
—Tennis
 Sports Illus 69:150 (4) S 14 '88
OLYMPICS—1924 WINTER (CHAMONIX)
—Speed skating
 Sports Illus 67:59 (4) D 14 '87
OLYMPICS—1928 WINTER (ST. MORITZ)
—Bobsledding
 Sports Illus 67:60 (3) D 14 '87
OLYMPICS—1948 SUMMER (LONDON)
—Track
 Sports Illus 69:49 (3) Jl 4 '88
OLYMPICS—1948 WINTER (ST. MORITZ)
 Sports Illus 68:116 (4) Ja 27 '88
—Hockey
 Sports Illus 75:55–90 (c,1) D 16 '91
OLYMPICS—1952 SUMMER (HELSINKI)
—Track
 Sports Illus 72:54–6 (1) Mr 26 '90
—Water events
 Sports Illus 69:47, 49 (3) Ag 1 '88
OLYMPICS—1956 SUMMER (MELBOURNE)
—Track

Sports Illus 71:50 (c,4) N 15 '89
OLYMPICS—1956 WINTER (CORTINA)
—Figure skating
 Sports Illus 67:59–60 (c,4) O 19 '87
OLYMPICS—1960 SUMMER (ROME)
—Basketball
 Sports Illus 69:71–4 (3) Ag 29 '88
—Track
 Sports Illus 69:40 (c,3) Ag 8 '88
 Sports Illus 71:69 (2) N 15 '89
OLYMPICS—1960 WINTER (SQUAW VALLEY)
 Sports Illus 67:49 (c,2) S 21 '87
OLYMPICS—1964 SUMMER (TOKYO)
—Track
 Sports Illus 66:79 (4) My 18 '87
OLYMPICS—1968 SUMMER (MEXICO CITY)
—Black Power salute at 1968 Olympics
 Sports Illus 71:106 (c,4) N 15 '89
 Sports Illus 75:60–1, 77 (1) Ag 5 '91
 Sports Illus 75:60–1 (1) Ag 12 '91
—Jumping
 Sports Illus 66:49 (2) Je 29 '87
 Sports Illus 71:107 (2) N 15 '89
—Track
 Sports Illus 66:48 (3) Je 29 '87
 Sports Illus 69:20 (4) Ag 29 '88
 Sports Illus 75:60–1, 64–5, 75–7 (1) Ag 5 '91
OLYMPICS—1968 WINTER (GRENOBLE)
—Figure skating
 Sports Illus 71:106 (c,3) N 15 '89
—Slalom
 Sports Illus 72:212 (c,4) F 12 '90
OLYMPICS—1972 SUMMER (MUNICH)
—Gymnastics
 Sports Illus 68:61–3 (c,4) Je 6 '88
—Swimming
 Sports Illus 71:124–5 (c,1) N 15 '89
—Terrorists at 1972 Olympics
 Sports Illus 71:124 (c,4) N 15 '89
OLYMPICS—1976 SUMMER (MONTREAL)
—Gymnastics
 Sports Illus 68:61, 65–6 (c,4) Je 6 '88
 Sports Illus 71:142 (c,2) N 15 '89
OLYMPICS—1980 SUMMER (MOSCOW)
 Sports Illus 71:41 (c,3) D 11 '89
OLYMPICS—1980 WINTER (LAKE PLACID)
—Hockey
 Sports Illus 67:47, 53–4, 58 (c,2) S 21 '87
 Life 12:181 (c,2) Fall '89
 Sports Illus 71:161 (c,2) N 15 '89

—Oil exploration sites
 Nat Geog 176:240–5 (c,1) Ag '89
OMAN—COSTUME
 Nat Geog 173:658–9 (c,1) My '88
 Trav/Holiday 171:77–81 (c,1) Mr '89
—Men's dishdasha
 Trav/Holiday 171:79 (c,4) Mr '89
ONAGERS
 Smithsonian 20:111 (c,4) F '90
O'NEILL, EUGENE
 Smithsonian 20:132 (4) Ag '89
 Life 13:78 (4) Fall '90
ONTARIO
—Fort William (1857)
 Nat Geog 172:216–17 (painting,c,1) Ag
 '87
—Niagara-on-the-Lake
 Trav&Leisure 21:E10 (c,3) Je '91
 Gourmet 51:111 (c,4) N '91
—Southern Ontario
 Gourmet 51:108–13, 270 (map,c,1) N '91
—Stratford
 Trav/Holiday 167:57–61 (c,1) Je '87
—Thunder Bay railroad station
 Sports Illus 68:304 (c,4) Ja 27 '88
—See also
 DETROIT RIVER
 KINGSTON
 NIAGARA FALLS
 OTTAWA
 TORONTO
OPAL MINING
—Australia
 Nat Geog 173:193 (c,3) F '88
OPALS
 Nat Geog 173:193 (c,4) F '88
Opera. See
 THEATER
OPOSSUMS
 Smithsonian 17:36 (c,4) F '87
 Nat Wildlife 26:57 (c,4) F '88
 Natur Hist 97:75 (c,3) Ap '88
 Smithsonian 20:108–19 (c,1) N '89
 Nat Wildlife 29:58–9 (c,1) D '90
 Nat Geog 180:101 (c,4) D '91
—17th cent. drawing
 Natur Hist 99:64 (4) Jl '90
—See also
 CUSCUS
OPPENHEIMER, J. ROBERT
 Life 13:24 (4) Fall '90
ORANGE TREES
 Gourmet 48:52–3 (c,2) Mr '88
—Orange grove (Brazil)
 Nat Geog 171:377 (c,1) Mr '87
ORANGUTANS
 Trav&Leisure 18:80 (c,2) Je '88
 Life 13:70–5 (c,1) Ag '90
 Life 14:118 (c,2) N '91

ORCHIDS
 Nat Geog 171:412 (c,4) Mr '87
 Sports Illus 72:86 (c,4) Ap 9 '90
 Nat Geog 178:86 (c,4) Jl '90
 Trav&Leisure 20:217 (c,4) S '90
 Trav/Holiday 176:64 (c,4) S '91
—See also
 LADY'S SLIPPERS
OREGON
—Borax Lake
 Nat Geog 174:838–9 (c,1) D '88
—Coastline
 Trav/Holiday 170:68–71 (map,c,1) N '88
 Trav/Holiday 175:80–6 (painting,c,1) Mr
 '91
 Trav&Leisure 21:168–72 (map,c,1) S '91
—Columbia River Gorge
 Trav/Holiday 168:12 (c,3) Jl '87
 Am Heritage 39:84–5, 114 (c,1) Ap '88
—Coos Bay
 Life 13:54–60 (c,2) My '90
—Countryside
 Gourmet 48:40–3, 102 (map,c,1) Ag '88
—Covered bridges
 Trav/Holiday 167:71–2 (map,c,4) Ja '87
—Haystack Rock
 Trav/Holiday 175:80–1 (painting,c,1) Mr
 '91
 Trav&Leisure 21:168 (c,4) S '91
—Lavalands
 Natur Hist 99:76–81 (map,c,1) S '90
—Lincoln City beach
 Gourmet 48:40–1 (c,1) Ag '88
—McKenzie River
 Life 10:40–1 (c,1) Jl '87
—Mount Hood Wilderness
 Nat Wildlife 27:50–1 (c,1) O '89
—Multnomah Falls
 Am Heritage 39:84 (c,2) Ap '88
—Sites along the Columbia River
 Am Heritage 39:cov., 78–85, 114
 (map,c,1) Ap '88
—Umpqua Dunes
 Natur Hist 97:28–30 (map,c,1) Ap '88
—Wallowa Mountains
 Natur Hist 96:42–3 (c,1) N '87
—Willamette National Forest
 Nat Wildlife 26:50 (c,4) Ap '88
—See also
 BONNEVILLE DAM
 CASCADE RANGE
 COLUMBIA RIVER
 CRATER LAKE
 MOUNT HOOD
 PORTLAND
 WILLAMETTE RIVER
ORGAN PLAYING
—At pub (Great Britain)
 Natur Hist 99:65 (c,1) D '90

Natur Hist 100:40 (c,4) N '91
—Long-eared owl
Nat Wildlife 28:60 (c,1) O '90
—Saw-whet owls
Smithsonian 17:34 (c,4) F '87
Nat Wildlife 26:cov. (c,1) F '88
Nat Wildlife 27:60 (c,1) F '89
—Short-eared
Nat Wildlife 25:cov. (c,1) F '87
Trav/Holiday 171:55 (c,4) Ap '89
—Snowy owls
Nat Wildlife 28:54–5 (c,1) D '89
Nat Wildlife 28:8–9 (c,4) Je '90
Natur Hist 100:50–1 (c,1) Jl '91
—Spotted owls
Nat Wildlife 26:9 (c,4) F '88
Life 12:136 (c,4) Ja '89
Nat Geog 178:110–11 (c,1) S '90
Life 14:52–3 (c,1) Ja '91
OXEN
Nat Geog 178:130 (c,4) D '90
Nat Wildlife 29:42–3 (c,1) D '90
—See also
BISON
BRAHMANS
CATTLE
MUSK OXEN
WATER BUFFALOES

YAKS
OXFORD, ENGLAND
—Pitt Rivers Museum
Smithsonian 18:108–17 (c,1) Jl '87
OXFORD UNIVERSITY, ENGLAND
Trav&Leisure 19:112–13, 167 (c,2) My '89
Trav/Holiday 173:68–73 (c,1) Je '90
Nat Geog 179:118–19 (c,1) Je '91
OYSTER CATCHERS (BIRDS)
Natur Hist 96:64–71 (c,1) Mr '87
OYSTER INDUSTRY
—Maryland
Trav/Holiday 172:42 (c,2) Ag '89
OYSTERS
Smithsonian 18:60–71 (c,1) Ja '88
Natur Hist 99:66–7 (painting,c,1) F '90
—See also
PEARLS
OZARK MOUNTAINS, ARKANSAS/
MISSOURI
—Fanciful scenes of mountain life
Gourmet 47:62, 134 (drawing,2) F '87
OZONE
—Map of earth's ozone hole
Nat Wildlife 28:42 (c,4) F '90
Nat Geog 177:42 (c,3) Ap '90
—Research on earth's ozone layer
Smithsonian 18:142–55 (c,2) F '88

- P -

PACA, WILLIAM
Nat Geog 178:102 (painting,c,4) D '90
Life 14:42 (painting,c,4) Fall '91
—Home (Annapolis, Maryland)
Nat Geog 178:103 (c,1) D '90
PACIFIC ISLANDS
—French Polynesia
Trav/Holiday 168:cov., 54–9 (map,c,1)
Ag '87
—See also
ASIAN TRIBES
BELAU ISLANDS
CHRISTMAS ISLAND
EASTER ISLAND
PAPUA NEW GUINEA
PITCAIRN ISLAND
SAIPAN
SOCIETY ISLANDS
TAHITI
WAKE ISLAND
PACIFIC ISLANDS—COSTUME
—1938 Dani tribe (New Guinea)
Natur Hist 97:28–30 (2) Ag '88
—Asmat people (Papua New Guinea)
Trav&Leisure 17:98–9 (c,1) D '87

—Children (Russell Islands)
Nat Geog 173:443 (c,1) Ap '88
—Children in traditional dress (Raiatea)
Trav&Leisure 18:125 (c,1) F '88
—Dayak woman (Borneo)
Nat Geog 175:105 (c,4) Ja '89
—French Polynesia
Trav/Holiday 168:cov., 54–9 (c,1) Ag '87
—Huli clan (Papua New Guinea)
Trav&Leisure 17:cov., 77, 84–5 (c,1) Mr
'87
Nat Geog 176:247 (c,2) Ag '89
Trav&Leisure 21:173 (c,1) O '91
—Mangyan people (Philippines)
Nat Geog 178:20–1 (c,1) S '90
—Tasaday baby nursing (Philippines)
Nat Geog 174:304 (c,2) S '88
—See also
MAORI PEOPLE
PACIFIC ISLANDS—HISTORY
—World War II aircraft and shipwreck re-
mains
Nat Geog 173:cov., 424–67 (c,1) Ap '88
PACIFIC ISLANDS—MAPS
—French Polynesia

Trav&Leisure 18:130 (c,4) Г '88
PACIFIC ISLANDS—RITES AND FESTIVALS
—Kukukuku people funeral rites (New Guinea)
Life 14:76 (c,3) O '91
PACIFIC OCEAN
—California coast
Trav&Leisure 17:118–33 (c,1) S '87
Gourmet 49:110–7 (c,1) D '89
Nat Geog 177:38–9 (c,1) F '90
Natur Hist 99:95 (c,1) My '90
Trav&Leisure 21:84–91 (c,1) Mr '91
Nat Geog 180:34–5 (c,1) O '91
—Fiji coast
Trav&Leisure 21:104–5 (c,1) F '91
—Stormy sea
Smithsonian 21:82–3 (painting,c,3) O '90
—Tide pools (California)
Nat Geog 180:34–5 (c,1) O '91
—See also
BALBOA, VASCO NÚÑEZ DE
BERING SEA
PACIFIC ISLANDS
PADEREWSKI, IGNACE JAN
Smithsonian 19:145 (cartoon,4) N '88
PADUA, ITALY
Gourmet 48:cov., 60–5, 132 (map,c,1) My '88
—16th cent. Bo anatomical theater
Gourmet 48:64–5 (c,1) My '88
PAGODAS
—China
Trav/Holiday 171:45 (c,4) My '89
—Hong Kong
Gourmet 50:114 (c,4) O '90
—Kew Gardens, London, England
Gourmet 49:113 (c,4) O '89
PAIGE, SATCHEL
Sports Illus 70:117 (2) My 8 '89
PAINE, THOMAS
Nat Geog 176:53 (painting,c,4) Jl '89
PAINTED DESERT, ARIZONA
Am Heritage 38:60–1 (c,1) Ap '87
Trav/Holiday 173:46–51 (c,1) Ja '90
—See also
PETRIFIED FOREST NATIONAL PARK
PAINTING
—1886 (New England)
Smithsonian 21:69 (4) D '90
—Artist at work
Life 11:106 (c,3) Jl '88
Sports Illus 73:56 (c,3) S 3 '90
—Artist working inside box for privacy (Maine)
Nat Geog 180:102–3 (1) Jl '91
—Artists painting Independence Hall, Philadelphia, Pa.

Nat Geog 178:107 (c,1) D '90
—Artist painting scenery (Great Britain)
Trav&Leisure 19:118–19 (c,1) My '89
—Artist sketching from New York fire escape (1920)
Am Heritage 40:99 (painting,c,4) D '89
—Artist working outdoors (Maryland)
Nat Geog 174:183 (c,1) Ag '88
—Chicken feet painting (Pennsylvania)
Life 12:88 (c,3) D '89
—Elephant painting picture (Arizona)
Smithsonian 21:41–51 (c,1) D '90
—On silk (Singapore)
Trav/Holiday 168:18 (c,4) Ag '87
—Portrait painting
Smithsonian 19:42–51 (c,1) Jl '88
—Prehistoric artists' materials (France)
Nat Geog 174:487 (c,4) O '88
—Stripes on baseball stadium (Maryland)
Sports Illus 67:30 (c,1) Jl 6 '87
—Surma people painting their bodies (Ethiopia)
Nat Geog 179:82–7 (c,1) F '91
PAINTINGS
—19th cent. (U.S.)
Smithsonian 18:168 (c,4) Ja '88
—19th cent. Hudson River School landscapes
Life 10:56–60 (c,1) O '87
—Early 20th cent. art works
Smithsonian 18:84–97 (c,1) N '87
—Early 20th cent. Fauves works (France)
Smithsonian 21:64–77 (c,1) O '90
—Artists' views of Paris, France (1870–1911)
Smithsonian 22:cov., 42–51 (painting,c,1) Ag '91
—Children studying paintings at museum (Illinois)
Smithsonian 19:32–3, 37 (c,2) Ag '88
—Children's drawings of TV characters
Life 12:76–81 (c,1) Mr '89
—Bev Doolittle's wildlife art
Nat Wildlife 29:34–9 (c,1) O '91
—Famous artists' paintings of their mothers
Am Heritage 39:48–53 (c,1) My '88
—Modern landscapes
Smithsonian 21:104–11 (c,2) Ap '90
—Modern works (U.S.S.R.)
Smithsonian 20:130–43 (c,1) D '89
—Paintings by child prodigy (China)
Smithsonian 20:cov., 70–9 (c,1) S '89
—Paintings by Louisa Matthiasdottir
Trav/Holiday 173:50–3 (c,2) Je '90
—Paintings of American Indians
Am Heritage 41:96–104 (c,2) F '90
—Paintings of birds
Nat Wildlife 28:cov., 50–9 (c,1) O '90

Natur Hist 100:60–5 (c,1) S '91
—Paintings of fish
Nat Wildlife 26:45–51 (c,1) Ag '88
—Paintings of flowers
Smithsonian 19:176 (c,4) F '89
—Paintings of hunting
Nat Wildlife 25:cov., 48–57 (c,1) O '87
—Portraits by Irving Ramsey Wiles
Am Heritage 39:87–93 (c,1) S '88
—Trompe l'oeil staircase painting by Peale
Nat Geog 178:104–5 (c,1) D '90
—Women's wall paintings (West Africa)
Smithsonian 21:128–35 (c,2) My '90
—Works by Roger Brown
Smithsonian 18:148 (c,4) Ag '87
—Works by Frederic Church
Smithsonian 20:88–98 (c,1) O '89
—Works by Childe Hassam
Smithsonian 21:68–79 (c,1) D '90
—Works by Fitz Hugh Lane
Am Heritage 39:39–47 (c,1) Jl '88
—Works by Jacob Lawrence
Smithsonian 18:56–67 (c,2) Je '87
—Works by George Luks
Am Heritage 39:54–63 (c,1) F '88
—Works by Prince Charles
Life 10:82–3 (painting,c,2) Ag '87
—Works by Man Ray
Smithsonian 19:62–7 (c,1) D '88
—Works by Weinold Reiss
Smithsonian 20:172–83 (c,2) N '89
—Works by Sassetta
Smithsonian 22:59, 62 (c,3) Jl '91
—Works by Chaim Soutine
Smithsonian 19:128–39 (c,1) N '88
—Works by Henry Tanner
Am Heritage 42:76–83 (c,1) F '91
—Works by Joseph Wright
Smithsonian 21:50–9 (c,1) S '90
—Works by N. C. Wyeth
Am Heritage 38:106–14 (c,2) My '87
Nat Geog 180:80, 83 (c,1) Jl '91
PAINTS
—Swirling different paint colors together
Smithsonian 18:122–3 (c,4) D '87
PAKISTAN
—K-2 Mountain
Smithsonian 18:177, 192, 196–8 (c,2) O '87
Nat Geog 172:542–3 (c,2) O '87
—Karakoram Highway
Trav&Leisure 19:69–78 (map,c,2) Ja '89
—Ship dismantling industry
Smithsonian 21:30–41 (c,1) Je '90
—See also
INDUS RIVER
KASHMIR
KHYBER PASS
PAMIR RANGE

PAKISTAN—COSTUME
Natur Hist 96:8, 12 (c,4) N '87
Smithsonian 19:44–52 (c,3) D '88
—Fishmonger
Natur Hist 98:89 (2) Ap '89
—Laborers
Smithsonian 21:30–41 (c,1) Je '90
PAKISTAN—POLITICS AND GOV-
ERNMENT
—Political demonstration
Life 10:124–5 (c,1) Ja '87
PAKISTAN—RITES AND FESTIVALS
—Wedding of Benazir Bhutto
Life 11:58–62 (c,1) F '88
PAKISTAN—SOCIAL LIFE AND CUS-
TOMS
—Decorated bus
Smithsonian 20:122 (c,4) Mr '90
PALACES
—18th cent. hilltop palace (Turkey)
Life 11:68–9 (c,1) S '88
—1895 ice palace (Leadville, Colorado)
Nat Geog 175:232 (3) F '89
—Amber Palace, Jaipur, India
Gourmet 51:82–3 (c,1) My '91
—Blenheim Palace, England (18th cent.)
Am Heritage 42:46–7 (painting,c,1) S '91
—Casa Rosada, Buenos Aires, Argentina
Trav&Leisure 18:134–5 (c,1) D '88
—Ceausescu's palace, Bucharest, Romania
Nat Geog 179:4–5 (c,1) Mr '91
—Charlottenburg Palace, Berlin, West
Germany
Trav&Leisure 19:84 (c,4) F '89
—Chimu, Peru (14th cent.)
Life 10:34 (drawing,c,4) Mr '87
—Chinese emperor Qianlong's palace gar-
den (1744)
Smithsonian 21:119 (painting,c,4) S '90
—Diocletian's palace (Split, Yugoslavia)
Trav/Holiday 175:36–42 (c,1) Ja '91
—Fatehpur Sikri, India
Trav&Leisure 20:150–3 (c,1) Ap '90
—Fez, Morocco
Gourmet 50:78, 80 (c,3) S '90
—Grand Palace, Bangkok, Thailand
Trav/Holiday 176:cov., 53 (c,1) N '91
—Grand Palace Grand Cascade, Pet-
rodvorets, U.S.S.R.
Trav/Holiday 167:6 (c,3) F '87
—Hawa Mahal, Jaipur, India
Gourmet 51:82 (c,4) My '91
—Het Loo Palace, Netherlands
Trav&Leisure 18:190–2 (c,3) Je '88
—Iolani Palace, Hawaii
Trav/Holiday 169:54–5 (c,2) Ap '88
—National Palace, Port-au-Prince, Haiti
Nat Geog 172:652 (c,3) N '87
—Palazzo Barberini salon, Rome, Italy

—Panda on bicycle (China)
Trav&Leisure 17:82–3 (4) Ag '87
Trav/Holiday 173:98 (c,4) Ja '90
PANTHEON, PARIS, FRANCE
Gourmet 49:56 (c,1) Jl '89
PANTHEON, ROME, ITALY
Trav&Leisure 19:119 (c,1) F '89
PANTHERS
Natur Hist 97:50–4 (c,1) Ap '88
Nat Wildlife 27:24–8 (c,1) O '89
—Florida panthers
Nat Wildlife 27:24–8 (c,1) O '89
Nat Geog 177:87 (c,2) Ap '90
Nat Wildlife 29:48–9 (painting,c,1) Ap '91
PAPER INDUSTRY
—Otomí Indians pounding bark into paper (Mexico)
Natur Hist 100:8 (c,4) Je '91
—Primitive bark beaters used to make paper
Natur Hist 100:12–14 (c,2) Je '91
—Splitting bamboo for pulp mill (China)
Natur Hist 98:52–3 (c,2) O '89
PAPUA NEW GUINEA
Trav&Leisure 17:cov., 77–87, 132 (map,c,1) Mr '87
—Oil exploration sites
Nat Geog 176:241, 246–51 (c,1) Ag '89
PAPUA NEW GUINEA—COSTUME
Trav&Leisure 17:cov., 77–87 (c,1) Mr '87
—1938
Natur Hist 97:30 (4) Ag '88
Natur Hist 97:2 (4) N '88
—Asmat people in canoes
Trav&Leisure 17:98–9 (c,1) D '87
—Flute players
Natur Hist 99:28 (c,4) Mr '90
—Huli tribesmen
Trav&Leisure 17:cov., 77, 84–5 (c,1) Mr '87
Nat Geog 176:247 (c,2) Ag '89
Trav&Leisure 21:173 (c,1) O '91
PAPUA NEW GUINEA—RITES AND FESTIVALS
—Kukukuku people funeral rites
Life 14:76 (c,3) O '91
PAPYRUS PLANTS
Nat Geog 178:40 (c,1) D '90
PARACHUTING
Sports Illus 71:130, 132, 138 (c,2) O 9 '89
Life 14:68 (2) D '91
—1837 failed parachuting attempt (Great Britain)
Smithsonian 21:60 (painting,c,4) Ag '90
—History of parachuting
Smithsonian 21:60–3 (c,3) Ag '90
—Parasailing (France)

Smithsonian 18:98, 100 (c,4) Je '87
Nat Geog 176:66–7 (c,1) Jl '89
—U.S. soldiers (Italy)
Life 11:36–7 (c,1) Ap '88
PARADES
—1787 Constitution ratification celebration (New York)
Am Heritage 38:14 (drawing,4) S '87
—1865 Civil War victory parade (Washington, D.C.)
Am Heritage 41:98–104 (1) Mr '90
—1916 War Preparedness Parade (Washington, D.C.)
Nat Geog 174:288–9 (1) S '88
—1917 parade of French veterans (New York City)
Am Heritage 39:58–9 (painting,c,1) F '88
—1920 float saluting radio (Atlantic City, New Jersey)
Am Heritage 39:108 (2) Mr '88
—1951 parade for Douglas MacArthur (New York)
Life 10:10–11 (1) Fall '87
—1953 parade for Eisenhower (Abilene, Kansas)
Trav/Holiday 174:72 (4) O '90
—Bastille Day parade (Paris, France)
Nat Geog 176:6 (c,4) Jl '89
—Fiesta (Barcelona, Spain)
Gourmet 47:53 (c,1) Je '87
—Fourth of July (California)
Trav/Holiday 174:48–50 (c,1) Jl '90
—Gulf War victory parade (New York)
Life 14:80–5 (c,1) Ag '91
—Huge heads for Mardi Gras floats (New Orleans, La.)
Life 13:2–3 (c,1) Mr '90
—Macy's Thanksgiving Day Parade, New York City, New York
Trav/Holiday 172:82–7 (c,1) N '89
—May Day parade (Warsaw, Poland)
Nat Geog 173:95 (c,3) Ja '88
—Procession for the Immaculate Conception (Chile)
Nat Geog 174:84 (c,3) Jl '88
—Procession of our Lady of Sorrows (Malta)
Nat Geog 175:703 (c,1) Je '89
—Procession of the Holy Blood (Bruges, Belgium)
Trav/Holiday 171:64–71 (c,3) Mr '89
—Synttende Mai parade (Minnesota)
Trav/Holiday 170:55 (c,4) D '88
PARAGUAY
—Trinidad mission
Trav/Holiday 168:8 (c,3) O '87
PARAKEETS
Trav&Leisure 17:86 (c,4) Mr '87

—Portland, Oregon
Trav&Leisure 21:125 (c,3) Ap '91
—Recreation greenways along old railroads
Nat Wildlife 26:40–3 (map,c,1) Ag '88
Smithsonian 21:132–41 (c,1) Ap '90
Nat Geog 177:76–99 (map,c,1) Je '90
—Rio de Janeiro, Brazil
Smithsonian 21:98–9, 107 (c,3) Jl '90
—Santiago de Compostela, Spain
Trav&Leisure 20:150–1 (c,1) Mr '90
—Summer park activities
Trav&Leisure 18:123 (painting,c,2) Ag '88
—See also
AMUSEMENT PARKS
CENTRAL PARK
GARDENS
PLAYGROUNDS
WILDLIFE REFUGES
list under NATIONAL PARKS
PARKS, ROSA
Life 11:54 (4) Spring '88
PARLORS
—19th cent. home (New York)
Am Heritage 41:6 (c,2) D '90
—1830s mansion (Pennsylvania)
Am Heritage 41:82–3 (c,1) N '90
—1892 castle (New Jersey)
Trav/Holiday 174:54–5 (c,1) D '90
—Antebellum parlor (Natchez, Mississippi)
Am H(c,1) Mr '90
—Lincoln's parlor (Springfield, Illinois)
Am Heritage 40:112 (c,2) Mr '89
Am Heritage 40:74 (c,2) Ap '89
—Salon of French villa
Smithsonian 17:56 (c,4) Ja '87
—Villa's drawing room (Switzerland)
Life 11:137 (c,2) O '88
PARROTS
Nat Wildlife 26:34–6 (c,1) F '88
Smithsonian 19:146 (painting,c,4) My '88
Nat Geog 177:103 (c,4) Je '90
—See also
COCKATOOS
MACAWS
PARAKEETS
PARTHENON, ATHENS, GREECE
Smithsonian 20:98 (painting,c,3) O '89
Sports Illus 73:51 (c,3) Ag 27 '90
—Full-scale model of the Parthenon (Nashville, Tennessee)
Trav&Leisure 19:211 (c,4) N '89
PARTIES
—Late 1950s cocktail party (New York)
Am Heritage 40:102 (painting,c,2) D '89
—Block party (Chicago, Illinois)
Nat Geog 179:51 (c,1) My '91

—Children's slumber party (Virginia)
Life 13:38 (c,4) Spring '90
—Hitting piñata (Mexico)
Sports Illus 68:6 (c,4) F 22 '88
See also
BIRTHDAY PARTIES
DANCES
PASQUEFLOWERS
Nat Wildlife 25:50 (c,4) Je '87
Nat Geog 174:850 (c,4) D '88
PASSPORTS
—1916 Greek passport
Trav&Leisure 20:76 (c,4) S '90
—1924 U.S. residence documents of Chinese man
Smithsonian 21:114 (2) F '91
—Ronald Reagan's passport
Life 11:26 (c,4) Ag '88
PASTERNAK, BORIS
Smithsonian 19:221 (4) N '88
PASTEUR, LOUIS
Am Heritage 40:10 (painting,c,4) Jl '89 supp.
PATENTS
—1794 cotton gin patent
Am Heritage 41:48 (4) S '90
—1846 sewing machine patent by Elias Howe
Am Heritage 41:49 (drawing,4) S '90
—1865 diagram of paper bowties
Smithsonian 19:32 (c,4) F '89
—1880 patent for light bulb
Am Heritage 41:54 (drawing,4) S '90
—1895 Selden's patent for automobile
Am Heritage 38:60 (c,4) D '87
Am Heritage 41:56 (drawing,4) S '90
—1906 patent for airplane by Wright Brothers
Am Heritage 41:58 (drawing,4) S '90
—1942 xerography patent
Am Heritage 41:58 (drawing,4) S '90
—1950 transistor patent
Am Heritage 41:59 (drawing,4) S '90
—Bell's 1876 patent for the telephone
Am Heritage 41:46, 52 (c,4) S '90
—Oliver Evans's automated gristmill diagram (1795)
Am Heritage 39:110 (4) D '88
—Patent drawings of major inventions
Am Heritage 41:48–59 (4) S '90
—Vacuum cleaner patent drawing (1912)
Am Heritage 38:111 (drawing,c,2) Jl '87
PATERSON, WILLIAM
Life 10:52 (painting,c,4) Fall '87
PATTON, GEORGE S., JR.
Smithsonian 22:103 (2) S '91
Am Heritage 42:106 (4) D '91
—Caricature
Am Heritage 41:58–9 (c,1) F '90

—Statue (Luxembourg)
Trav/Holiday 168:39 (c,4) D '87
PEACHES
Gourmet 47:114 (drawing,4) Jl '87
Gourmet 50:110 (c,4) N '90
PEACOCKS
Natur Hist 98:51 (painting,c,2) Jl '89
Natur Hist 99:cov. (c,1) Jl '90
PEALE, CHARLES WILLSON
—Family
Nat Geog 178:101, 105, 113 (paint-
ing,c,2) D '90
—Paintings by him
Nat Geog 178:98–121 (c,1) D '90
—Portrait of James Josiah (1787)
Am Heritage 39:77 (painting,c,4) D '88
—Self-portraits
Nat Geog 178:98–101, 113 (painting,c,1)
D '90
Am Heritage 41:51 (painting,c,1) D '90
PEARL HARBOR, HAWAII
—1941 attack on Pearl Harbor
Am Heritage 40:128 (2) S '89
Trav/Holiday 176:16 (4) Jl '91
Trav/Holiday 176:90 (4) S '91
Am Heritage 42:152 (2) N '91
Trav&Leisure 21:150–3, 195 (c,1) N '91
Nat Geog 180:50–77 (map,c,1) D '91
Am Heritage 42:cov. (1) D '91
Smithsonian 22:72–5 (painting,c,1) D '91
—Sunken ship "Arizona"
Trav/Holiday 173:48 (c,4) Mr '90
Natur Hist 100:64–72 (c,1) N '91
—U.S. after Pearl Harbor bombing (1941)
Am Heritage 40:52–72, 170 (1) N '89
—U.S.S. Arizona Memorial
Natur Hist 100:64–5 (c,1) N '91
Trav&Leisure 21:152–3 (c,1) N '91
Nat Geog 180:54–5 (c,1) D '91
Smithsonian 22:83 (painting,c,2) D '91
PEARL INDUSTRY
—Australia
Nat Geog 180:108–23 (map,c,1) D '91
PEARLS
Nat Geog 180:108–23 (c,1) D '91
PEARS
Gourmet 49:120, 162 (c,4) O '89
Gourmet 50:cov. (c,1) S '90
PEARY, ROBERT E.
Nat Geog 173:43 (3) Ja '88
Nat Geog 174:386–413 (1) S '88
Sports Illus 71:4 (4) O 23 '89
Natur Hist 98:30, 32 (4) N '89
Nat Geog 177:44 (4) Ja '90
Am Heritage 42:38 (4) My '91
—1909 Peary expedition to North Pole
Nat Geog 174:386–413 (1) S '88
Natur Hist 98:28, 34–6 (3) N '89
Nat Geog 177:44–61 (1) Ja '90

—Eskimo descendants (Greenland)
Nat Geog 174:414–21 (c,1) S '88
—Peary's 1909 telegram about reaching
North Pole
Natur Hist 98:28 (4) N '89
—Scientific proof that Peary reached North
Pole
Nat Geog 177:44–61 (c,1) Ja '90
PEAT INDUSTRY
—Cutting peat (Scotland)
Gourmet 49:96 (c,4) D '89
PECK, GREGORY
Life 10:58–9 (c,1) Ap '87
PEDRO II (BRAZIL)
Life 13:43 (painting,c,4) Mr '90
PEKINGESE DOGS
Life 13:88 (4) F '90
PELICANS
Nat Geog 171:340 (c,4) Mr '87
Nat Wildlife 25:45 (c,4) Ag '87
Natur Hist 96:6 (c,3) S '87
Nat Geog 173:136 (c,3) Ja '88
Nat Geog 176:715–16 (c,1) D '89
Nat Wildlife 29:2–3 (c,1) Ag '91
—Brown pelicans
Nat Wildlife 26:2 (c,2) O '88
Nat Wildlife 28:22–3 (c,1) F '90
Nat Wildlife 28:45 (c,2) O '90
PENCILS
—Mid 19th cent. (Massachusetts)
Am Heritage 39:66–7, 71 (c,1) Jl '88
PENGUINS
Nat Geog 171:558–9 (c,2) Ap '87
Trav&Leisure 17:48 (c,4) Ap '87
Life 10:42–52 (c,1) My '87
Life 10:8–9 (c,1) Jl '87
Trav&Leisure 17:97, 99–105 (c,1) Ag '87
Nat Geog 173:136–7 (c,1) Ja '88
Natur Hist 97:80–1 (c,1) Ja '88
Nat Geog 173:420–1 (c,1) Mr '88
Nat Wildlife 26:52–3 (c,1) Ap '88
Natur Hist 97:79–80 (c,1) O '88
Natur Hist 97:60–1 (c,1) N '88
Nat Wildlife 27:56 (c,4) F '89
Nat Geog 175:352–3, 359–63, 368, 373
(c,1) Mr '89
Natur Hist 98:28–37 (c,1) D '89
Nat Geog 177:7–9, 13, 33, 48–9 (c,1) Ap
'90
Life 13:60–3 (c,1) Jl '90
Trav&Leisure 20:26 (c,4) N '90
Trav&Leisure 21:78 (c,4) O '91
—Adélie penguins
Natur Hist 100:cov., 3, 46–55 (c,1) Ja '91
Nat Wildlife 29:6–7 (c,1) Ap '91
—Aerial view of flock
Nat Geog 177:7–9, 33 (c,1) Ap '90
—"Bloom County's" penguin Opus
Life 10:42–52 (c,1) My '87

—Emperor penguins
Nat Geog 177:48–9 (c,1) Ap '90
Nat Wildlife 29:4–5 (c,1) Ap '91
PENN, WILLIAM
—1682 treaty signing between William
Penn and Indians
Smithsonian 20:132 (painting,c,4) Je '89
PENNSYLVANIA
—1682 treaty signing between William
Penn and Indians
Smithsonian 20:132 (painting,c,4) Je '89
—Braddock
Nat Geog 180:135 (c,3) D '91
—Brandywine region
Trav&Leisure 17:cov., 64–75, 109–13
(map,c,1) Ag '87
—Bucks County
Trav/Holiday 168:54–5 (c,2) N '87
Gourmet 50:82–5, 176 (c,1) S '90
—Delaware Canal
Trav/Holiday 168:56–7 (c,2) N '87
—History of the Pennsylvania Turnpike
Am Heritage 41:102–11 (map,c,1) My
'90
Smithsonian 21:96–109 (map,c,1) O '90
—Lancaster County scenes
Gourmet 49:112–17 (c,1) N '89
—Lititz
Trav/Holiday 171:64–7 (c,4) Je '89
—Monongahela
Sports Illus 73:68–9 (c,4) Ag 6 '90
—New Hope railroad station
Trav/Holiday 168:59 (c,3) N '87
—See also
AMISH PEOPLE
GETTYSBURG
PHILADELPHIA
PITTSBURGH
SCRANTON
Pens. See
WATERMAN, LEWIS E.
PENTAGON BUILDING, ARLING-
TON, VIRGINIA
Life 12:61–9 (c,1) D '89
PEONIES
Trav&Leisure 18:144 (painting,c,3) Mr
'88
People and civilizations. See
ABORIGINES
AFRICAN TRIBES
AGED
AMISH PEOPLE
ASIAN TRIBES
ASSYRIAN CIVILIZATION
AZTEC CIVILIZATION
BABIES
BEDOUINS
BERBERS
BLACK AMERICANS

BOY SCOUTS
BUDDHISM
BYZANTINE EMPIRE
CELTIC CIVILIZATION
CHILDREN
COLLEGE LIFE
COMMUTERS
CONVICTS
CROWDS
ESKIMOS
ETRUSCAN CIVILIZATION
FAMILIES
FAMILY LIFE
FARM LIFE
GIRL SCOUTS
GYPSIES
HANDICAPPED PEOPLE
HOBOES
IMMIGRANTS
INCA CIVILIZATION
INDIANS OF LATIN AMERICA
INDIANS OF NORTH AMERICA
INJURED PEOPLE
JUDAISM
KU KLUX KLAN
LAPP PEOPLE
LIFESTYLES
MAN, PREHISTORIC
MAORI PEOPLE
MAYA CIVILIZATION
MENNONITES
MIDDLE AGES
MOORS
MORMONS
MOSLEMS
NOMADS
OBESITY
OTTOMAN EMPIRE
PALESTINIANS
PERSIAN EMPIRE
QUAKERS
REFUGEES
ROMAN EMPIRE
SHAKERS
SPECTATORS
TOURISTS
TWINS
VIKINGS
WITCHCRAFT
YOUTH
People's Republic of China. See
CHINA
PEPPER INDUSTRY—HARVESTING
—New Mexico
Nat Geog 172:618 (c,4) N '87
—Yugoslavia
Life 14:1 (c,2) Ap '91
PEPPERS
—Red chili peppers

—Peter the Great's 17th cent. coat buttons
 Nat Geog 177:89 (c,4) Ja '90
—Winter Palace, Leningrad
 Trav&Leisure 19:128–9 (c,1) F '89
 Trav&Leisure 20:140 (c,4) Ja '90
PETER II (YUGOSLAVIA)
 Life 13:38 (painting,c,4) Mr '90
PETRA, JORDAN
 Trav/Holiday 172:44–51 (c,2) O '89
—Ancient building
 Natur Hist 100:24 (c,3) F '91
—Chronology of Petra history
 Trav/Holiday 172:48–9 (c,4) O '89
PETRELS
 Natur Hist 97:32–3, 38 (c,1) Ag '88
 Nat Geog 175:366–7, 374–5 (c,1) Mr '89
 Natur Hist 98:52 (c,3) Mr '89
 Nat Geog 177:38–9, 50–1 (c,1) Ap '90
 Natur Hist 99:96–7 (c,1) N '90
 Natur Hist 100:58 (c,1) My '91
PETRIFIED FOREST NATIONAL
 PARK, ARIZONA
 Trav/Holiday 173:46–51 (c,1) Ja '90
Petroglyphs. See
 CAVE PAINTINGS
 ROCK CARVINGS
 ROCK PAINTINGS
PHARMACIES
—Hong Kong medicine shop
 Trav/Holiday 176:59 (c,2) O '91
—Wall, South Dakota drugstore
 Trav/Holiday 171:90 (c,4) Je '89
PHEASANTS
 Natur Hist 97:37 (lithograph,c,4) Mr '88
 Nat Geog 174:650 (c,4) N '88
—Ring-necked pheasants
 Natur Hist 97:106–7 (c,1) O '88
 Sports Illus 75:11 (c,4) O 21 '91
PHILADELPHIA, PENNSYLVANIA
 Trav/Holiday 167:cov., 44–53 (c,1) Ap
 '87
 Am Heritage 38:72–81 (c,1) My '87
 Life 10:44–5 (c,1) Fall '87
 Trav&Leisure 21:E1–E4 (map,c,3) Ja '91
—Mid 19th cent. street scene
 Am Heritage 39:44–5 (painting,c,1) S '88
—Academy of Art
 Smithsonian 20:172–3 (c,2) O '89
—Drug culture in North Philadelphia
 Life 13:30–41 (1) Je '90
—Elfreth's Alley
 Trav&Leisure 21:E2 (c,4) Ja '91
—Friends School
 Am Heritage 41:68 (c,4) N '90
—Map of Ben Franklin Parkway
 Trav&Leisure 17:197 (c,4) My '87
—Map of downtown area
 Trav/Holiday 173:25 (c,4) My '90
—Memorial Hall sculpture

Am Heritage 38:10 (c,4) S '87
—Merchants Exchange
 Smithsonian 20:173 (c,4) O '89
—Neighborhood destroyed by 1985 police
 bomb
 Life 12:148 (c,4) Fall '89
—State House (1815)
 Am Heritage 38:cov., 146 (painting,c,1)
 My '87
—Top of City Hall
 Trav&Leisure 19:42 (c,3) F '89
—Waterworks
 Smithsonian 20:172–3 (c,2) O '89
—See also
 INDEPENDENCE HALL
 LIBERTY BELL
PHILIP II (SPAIN)
 Smithsonian 18:153, 156, 163 (c,2) D '87
 Natur Hist 97:54 (painting,c,4) S '88
—Funeral robe
 Smithsonian 18:162 (c,4) D '87
PHILIPPINES
 Nat Geog 178:2–22 (map,c,1) S '90
—1991 volcano damage
 Life 14:6–7 (c,1) S '91
—Mayon volcano
 Natur Hist 96:20–1 (c,3) Jl '87
—See also
 MANILA
PHILIPPINES—COSTUME
 Nat Geog 178:2–4, 10–17, 20–1 (c,1) S
 '90
—Mangyan people
 Nat Geog 178:20–1 (c,1) S '90
—Tasaday baby nursing
 Nat Geog 174:304 (c,2) S '88
PHILIPPINES—HISTORY
—Spanish Mexico-Philippines trade routes
 (1586–1815)
 Nat Geog 178:4–53 (map,c,1) S '90
—U.S. soldiers in the Philippines (1899)
 Smithsonian 20:134–5, 144–50 (1) My '89
—See also
 AGUINALDO, EMILIO
 MARCOS, FERDINAND
PHILIPPINES—MAPS
—Intramuros, Manila (18th cent.)
 Nat Geog 178:22 (c,4) S '90
PHILIPPINES—POLITICS AND GOV-
 ERNMENT
—Aquino addressing crowd
 Life 10:126–7 (c,1) Ja '87
—Political demonstration
 Trav/Holiday 171:20 (c,4) F '89
PHLOX
 Nat Wildlife 25:24, 27 (drawing,c,4) Ap
 '87
 Nat Wildlife 28:56 (c,4) Ap '90
 Nat Geog 179:104–5 (c,1) Mr '91

PILOT WHALES
 Life 11:162–3 (c,1) Fall '88
 Nat Geog 174:895 (c,1) D '88
PINBALL MACHINES
—Playing pinball
 Life 13:76–82 (c,1) S '90
PINCHOT, GIFFORD
 Am Heritage 42:86–92, 98 (4) F '91
PINCKNEY, CHARLES
 Smithsonian 18:41 (drawing,4) Jl '87
 Life 10:58 (painting,c,4) Fall '87
PINE TREES
 Nat Wildlife 25:14–15 (c,1) Ag '87
 Nat Geog 175:481 (c,2) Ap '89
 Trav/Holiday 171:63 (c,1) Ap '89
 Natur Hist 99:29, 31 (c,1) Ag '90
 Natur Hist 100:32 (c,3) N '91
—Pine cones
 Nat Geog 175:270 (c,2) F '89
 Natur Hist 99:29 (c,4) Ag '90
 Life 14:31 (2) Summer '91
—Time rings in pine tree trunk
 Nat Geog 177:117 (c,1) Mr '90
—See also
 BRISTLECONE PINE TREES
 SPRUCE TREES
PINEAPPLE INDUSTRY
—Field of pineapples (Hawaii)
 Gourmet 51:96–7 (c,2) D '91
PINEAPPLE INDUSTRY—HARVEST-
 ING
—Cuba
 Nat Geog 180:112–13 (c,1) Ag '91
PINEAPPLES
 Gourmet 49:49 (c,1) Mr '89
Ping pong. See
 TABLE TENNIS
PINKS (FLOWERS)
 Natur Hist 98:99 (c,4) N '89
PINTAIL DUCKS
 Nat Geog 175:365 (c,4) Mr '89
 Nat Wildlife 27:4–5 (painting,c,1) O '89
—Pintails in flight
 Natur Hist 98:68–9 (c,1) Ja '89
 Nat Wildlife 28:58–9 (painting,c,1) O
 '90
Pioneers. See
 WESTERN FRONTIER LIFE
PIPE SMOKING
—Early 19th cent.
 Am Heritage 39:62 (drawing,4) S '88
—Laotian Hmong people smoking water
 pipe (Minnesota)
 Nat Geog 174:604–5 (c,1) O '88
—Water pipe (Dubai)
 Nat Geog 173:669 (c,3) My '88
—Zaire
 Natur Hist 97:32, 41 (c,1) D '88
 Nat Geog 176:670 (c,4) N '89

PIPEFISH
 Nat Geog 173:448 (c,4) Ap '88
 Nat Geog 178:32–3 (c,1) O '90
Pipelines. See
 ALASKA PIPELINE
PIPES
—Colorful museum heating pipes (Wash-
 ington, D.C.)
 Smithsonian 21:52 (c,4) Mr '91
PIPES, TOBACCO
—1830 clay pipe
 Am Heritage 40:51 (c,4) Jl '89
—Prehistoric pottery pipe (Ohio)
 Smithsonian 20:49 (c,4) O '89
—Franklin Roosevelt's face on wooden
 pipe
 Smithsonian 21:86 (c,4) D '90
PIRATES
—Man in pirate costume (Florida)
 Sports Illus 67:50 (c,3) D 7 '87
—Treasure hunting (Oak Island, Nova
 Scotia)
 Smithsonian 19:52–63 (c,1) Je '88
—See also
 BARBAROSSA
 BLACKBEARD
PISA, ITALY
 Trav&Leisure 17:96–7 (c,1) Ap '87
 Trav&Leisure 21:144–5 (1) O '91
—See also
 LEANING TOWER OF PISA
PITCAIRN ISLAND
 Smithsonian 18:94–102 (c,2) F '88
PITCAIRN ISLAND—COSTUME
—Child swinging from tree
 Natur Hist 96:cov. (c,1) My '87
PITCHER PLANTS
 Nat Geog 171:412 (c,4) Mr '87
 Nat Geog 175:550 (c,4) My '89
 Natur Hist 100:34 (c,1) Jl '91
PITTSBURGH, PENNSYLVANIA
 Smithsonian 21:50–1 (c,4) Ap '90
 Am Heritage 42:132–3 (c,3) Ap '91
 Nat Geog 180:124–45 (map,c,1) D '91
—1890s
 Smithsonian 18:144 (4) S '87
 Am Heritage 42:132 (3) Ap '91
—Pennsylvania Railroad Station
 Am Heritage 41:92–3 (c,2) Jl '90
Plague. See
 BUBONIC PLAGUE
Planets. See
 ASTEROIDS
 EARTH
 JUPITER
 MARS
 NEPTUNE
 SATURN
 URANUS

Am Heritage 42:58 (drawing,4) F '91
—1884 cartoon about Cleveland's ille-
gitimate son
Life 10:75 (4) Ag '87
—1890 census fight between Minneapolis
and St. Paul
Am Heritage 41:106–9 (2) Jl '90
—1896 cartoon depicting England as a
bully
Am Heritage 39:97 (c,2) S '88
—1900 cartoon about U.S. territorial ambi-
tions
Smithsonian 20:142 (painting,c,4) My '89
—1901 cartoon about Teddy Roosevelt's
foreign policy
Smithsonian 21:138 (4) Je '90
—1913 cartoon about ineffectual Wilson
chiding Mexico
Am Heritage 39:40 (drawing,4) N '88
—1930 Smoot-Hawley Tariff cartoon
Am Heritage 39:78 (4) F '88
—1948 Truman civil rights cartoon by Her-
block
Am Heritage 42:55 (4) N '91
—1973 cartoon about devaluation of U.S.
dollar
Am Heritage 42:39 (4) Jl '91
—1973 cartoon about empty gas tanker
Am Heritage 42:40 (2) Jl '91
—1976 cartoon about OPEC consuming
American lifestyle
Am Heritage 42:112 (3) My '91
—1980 cartoon about Carter's presidential
campaign
Am Heritage 42:49 (2) Jl '91
—1988 presidential campaign shown as
cowboy shootout
Smithsonian 19:160 (painting,c,2) O '88
—Cartoon about 1807 Embargo Act
Smithsonian 18:82 (painting,c,4) S '87
—Cartoon about 1892 Exclusion Act
Smithsonian 21:120 (c,4) F '91
—Cartoon about 1939 Hitler-Stalin pact
Am Heritage 40:34 (4) Jl '89
—Cartoon of presidential scandals
Am Heritage 38:38 (drawing,c,1) S '87
—Cartoons about FDR
Am Heritage 39:37, 42, 48 (4) F '88
—Cartoons about vicious U.S. presidential
campaigns
Smithsonian 19:148–60 (drawing,c,1) O
'88
—Editorial cartoons about 1980s America
Life 12:89, 91 (4) Fall '89
—Upton Sinclair's 1934 run for California
governor
Am Heritage 39:36, 39–40 (4) S '88
—U.S.-U.S.S.R. arms reduction cartoon
Life 11:128 (4) Ja '88

Politics and government. See
DEMONSTRATIONS
ELECTIONS
GOVERNMENT—LEGISLATURES
POLITICAL CAMPAIGNS
STATESMEN
U.S.—POLITICS AND GOVERN-
MENT
specific countries—POLITICS AND
GOVERNMENT
POLLEN
Nat Wildlife 25:14–17 (c,1) Ag '87
POLLOCK, JACKSON
Life 13:48 (1) Fall '90
—"Number 2, 1951"
Smithsonian 21:18 (painting,c,4) D '90
—"Number 3, 1949: Tiger"
Smithsonian 21:18 (painting,c,4) D '90
POLLUTION
—Chemical pollution's effect on wildlife
Nat Wildlife 28:20–7 (c,1) F '90
—Digging radon-contaminated soil (New
Jersey)
Nat Wildlife 28:12–13 (c,1) F '90
—Effects of Kuwait's burning oil fields
Nat Geog 180:cov., 2–33 (map,c,1) Ag
'91
—Forecasts of pollution's impact on cli-
mate
Sports Illus 67:78–92 (c,1) N 16 '87
—Pollution in Eastern Europe
Nat Geog 179:36–69 (map,c,1) Je '91
—Protective suits for waste disposal (Geor-
gia)
Nat Wildlife 26:20 (c,4) Ag '88
—See also
ACID RAIN
AIR POLLUTION
WATER POLLUTION
POLLUTION CONTROL EQUIPMENT
—Burner catching coal ash
Nat Geog 171:522 (c,4) Ap '87
POLO
Sports Illus 73:22–3 (c,2) D 24 '90
Gourmet 51:86 (c,3) Ap '91
Gourmet 51:52 (c,3) Jl '91
—1939 polo costume (New York)
Am Heritage 38:109 (2) N '87
—Dominican Republic
Trav&Leisure 18:140 (c,4) Ja '88
—Elephant polo (Nepal)
Sports Illus 75:128, 130 (c,4) D 16 '91
POLO, MARCO
—sites associated with his 13th cent. travels
Life 11:68–73 (map,c,1) S '88
Polynesia. See
PACIFIC ISLANDS
POMPEII, ITALY
—Ruins

Trav&Leisure 18:74–7 (c,1) Ag '88
PONCE, PUERTO RICO
 Am Heritage 42:30 (c,4) N '91
 Trav/Holiday 176:80–1 (c,1) D '91
PONDS
—Building a backyard pond
 Nat Wildlife 25:32–5 (c,1) Je '87
—Costa Rica
 Natur Hist 100:46–7 (c,1) F '91
—Glacier-cut ponds (North Dakota)
 Nat Geog 171:340–1 (c,1) Mr '87
—Pond in autumn (Delaware)
 Life 13:42–3 (c,1) My '90
—Walden Pond, Massachusetts
 Sports Illus 67:6 (c,4) O 19 '87
 Trav&Leisure 19:19 (c,4) Jl '89
PONTIAC (OTTAWA INDIANS)
 Am Heritage 38:52 (painting,4) D '87
PONY EXPRESS
—1900 painting by Remington
 Am Heritage 40:82 (c,4) S '89
—1860 Pony Express stamp
 Am Heritage 39:66 (c,3) Mr '88
POODLES
 Sports Illus 73:164 (c,4) N 5 '90
—Poodles pulling sleds
 Sports Illus 68:5–7 (c,4) Mr 7 '88
Pool playing. See
 BILLIARD PLAYING
Pools. See
 SWIMMING POOLS
POPES
—Clement VII
 Nat Geog 172:563 (painting,c,4) N '87
—Cowboy boots designed for Pope John
 Paul II (Texas)
 Life 10:8 (c,4) S '87
—John XXIII
 Gourmet 47:63 (sculpture,c,3) S '87
—John Paul II
 Life 10:34–5 (c,1) N '87
 Nat Geog 17386–7 (c,1) Ja '88
 Life 11:74 (c,4) Ja '88
 Life 12:34–42 (c,1) D '89
 Life 13:136 (c,2) Ja '90
 Life 14:64 (c,3) D '91
—Pope John Paul II assassination attempt
 (1981)
 Life 12:160 (c,2) Fall '89
POPLAR TREES
 Smithsonian 21:114–15 (c,2) Mr '91
—See also
 ASPEN TREES
 COTTONWOOD TREES
POPPIES
 Nat Geog 173:761 (c,3) Je '88
 Life 11:88–9 (c,1) Fall '88
 Nat Wildlife 27:60 (c,1) Ap '89
 Nat Wildlife 28:58–9 (c,1) Ap '90

Life 14:50–1 (c,1) Summer '91
—Poppy field (Mexico)
 Life 11:80–1 (c,1) Mr '88
PORCHES
—1817 mansion (Connecticut)
 Trav/Holiday 169:48–9 (c,2) Ja '88
—1925 hotel verandah (New Brunswick)
 Am Heritage 42:123 (3) Ap '91
—Hotel porch (Block Island, Rhode Is-
 land)
 Gourmet 49:80–1 (c,1) My '89
—Martha's Vineyard, Massachusetts
 Trav&Leisure 17:96–7 (c,1) My '87
—Porch swing (Missouri)
 Trav/Holiday 176:54–5 (1) Jl '91
—Resort hotel (Michigan)
 Trav&Leisure 18:150 (c,1) My '88
—Resort hotel (North Carolina)
 Gourmet 48:61 (c,1) Mr '88
—Southeast
 Nat Geog 172:496–7 (c,1) O '87
 Trav&Leisure 21:21 (c,4) S '91
PORCUPINES
 Nat Wildlife 29:52 (c,1) Je '91
PORT-AU-PRINCE, HAITI
 Nat Geog 172:644–7, 652–3 (c,1) N '87
—Slum
 Life 10:61 (c,3) Ag '87
 Nat Geog 172:644–5, 652–3 (c,1) N '87
PORTERS
—Bellhop carrying luggage
 Trav&Leisure 20:48 (c,4) S '90
—Children riding on luggage cart (Illinois)
 Nat Geog 175:183 (c,2) F '89
—London hotel concierge, England
 Trav&Leisure 18:20 (c,4) Ja '88
 Trav&Leisure 19:92–3 (c,1) Ag '89
PORTLAND, OREGON
 Nat Wildlife 27:31 (c,1) Ag '89
 Trav&Leisure 21:87 (c,4) Ja '91
 Trav&Leisure 21:123–38 (map,c,1) Ap
 '91
—Keller Fountain
 Smithsonian 19:164–5, 171 (c,1) D '88
—Oak Bottom Wildlife Refuge
 Nat Wildlife 27:30–1 (c,1) Ag '89
Ports. See
 HARBORS
PORTSMOUTH, NEW HAMPSHIRE
 Gourmet 51:128–31, 260–1 (c,1) N '91
PORTUGAL
 Natur Hist 96:52–61 (c,1) F '87
 Trav&Leisure 17:90–3 (c,1) D '87
 Trav&Leisure 18:44–9 (c,3) Je '88
 Trav&Leisure 20:154–63, 202, 208
 (map,c,1) O '90
—Alentejo province
 Trav&Leisure 19:110–17, 170 (map,c,1)
 S '89

POSTAL SERVICE
—1850s Wells Fargo ad
 Am Heritage 40:81 (c,4) S '89
—1860 envelopes
 Am Heritage 40:81 (c,4) S '89
—1919 mail plane
 Am Heritage 40:76–7 (1) S '89
—History of U.S. mail delivery
 Am Heritage 40:6, 76–85 (c,1) S '89
—Package sorting station (Tennessee)
 Am Heritage 40:84 (c,4) S '89
—Path of a letter through the system
 Smithsonian 19:96–107 (c,1) S '88
—Postal service operations
 Smithsonian 19:96–107 (c,1) S '88
—Sorting mail at post office (Texas)
 Sports Illus 72:69 (c,4) Ap 30 '90
—See also
 MAILBOXES
 PONY EXPRESS
 POST OFFICES
 POSTAGE STAMPS
 POSTAL WORKERS
POSTAL WORKERS
 Smithsonian 19:96–107 (c,1) S '88
—1900 railway mail sorters
 Am Heritage 40:82 (4) S '89
—1963 postman (Missouri)
 Nat Geog 175:202–3 (1) F '89
POSTERS
—1883 Davos poster, Switzerland
 Smithsonian 18:140 (c,4) D '87
—1897 movie poster (France)
 Am Heritage 40:18 (c,4) Jl '89 supp.
—1905 vaudeville poster
 Am Heritage 41:109 (4) F '90
—1920s–30s posters of coming indus-
 trialization (U.S.S.R.)
 Am Heritage 39:56, 61, 67 (c,4) D '88
—1927 poster for "The Jazz Singer"
 Am Heritage 40:108 (4) Mr '89
—1934 anti-Sinclair for governor billboards
 (California)
 Am Heritage 39:34–5, 41 (1) S '88
—1939 movie posters
 Life 12:32–46 (c,4) Spring '89
—1939 poster promoting boxer
 Sports Illus 70:104 (c,2) My 8 '89
—1944 U.S. Army recruitment poster
 Am Heritage 40:4 (c,2) Mr '89
—Anti pollution poster (Siberia,
 U.S.S.R.)
 Nat Geog 177:25 (c,4) Mr '90
—Baseball tournament poster (U.S.S.R.)
 Sports Illus 69:39 (c,4) Jl 25 '88
—Billboard art (Los Angeles, California)
 Smithsonian 21:98–111 (c,1) S '90
—Boxing event posters
 Sports Illus 71:90–1 (c,1) O 16 '89

—Civil War black soldier recruitment
 poster
 Life 13:92 (painting,c,4) F '90
—"From Here to Eternity" poster (France)
 Trav/Holiday 173:44 (c,4) Mr '90
—"H.M.S. Pinafore" poster
 Smithsonian 19:61 (c,4) Ap '88
—Kiosk (Warsaw, Poland)
 Trav/Holiday 173:62 (c,2) Mr '90
—Movie poster (India)
 Trav/Holiday 170:108 (4) O '88
—Movie posters pasted on street wall
 Sports Illus 67:80–1 (c,1) D 7 '87
—Poster kiosk (Paris, France)
 Trav&Leisure 17:6 (c,4) Jl '87
—Promoting Sarah Bernhardt's U.S. tours
 (1905–1911)
 Am Heritage 40:56, 60, 65, 114 (c,4) Jl '89
—Russian World War II poster
 Am Heritage 39:114 (c,4) D '88
—World War I poster by Flagg
 Smithsonian 21:160 (c,4) N '90
—World War I posters
 Smithsonian 20:122–7 (c,1) N '89
—World War I recruitment poster (Can-
 ada)
 Smithsonian 18:206 (c,4) N '87
—World War II "Russian friend" poster
 (U.S.)
 Am Heritage 42:120 (2) D '91
POTATO INDUSTRY
—Planting potatoes (Idaho)
 Smithsonian 22:64–5 (c,1) Ag '91
—Potato field (Vietnam)
 Nat Geog 176:580–1 (c,1) N '89
POTATO INDUSTRY—HARVESTING
—Czechoslovakia
 Nat Geog 171:142–3 (c,1) Ja '87
—Digging potatoes (Portugal)
 Natur Hist 96:54–5 (c,1) F '87
—Peru
 Nat Geog 179:96–7 (c,1) Ap '91
 Smithsonian 22:138, 144–5 (c,4) O '91
POTATOES
 Gourmet 50:78 (c,4) Ja '90
 Smithsonian 22:138–49 (c,1) O '91
—Baked potato
 Smithsonian 22:139 (c,2) O '91
—Mid 19th cent. potato famine (Ireland)
 Smithsonian 22:142 (engraving,c,4) O
 '91
POTOMAC RIVER, SOUTHEAST
 Nat Geog 171:cov., 716–53 (map,c,1) Je
 '87
—18th cent. Potomac Canal, Southeast
 Nat Geog 171:cov., 716–53 (map,c,1) Je
 '87
POTOMAC RIVER, WEST VIRGINIA
—Harpers Ferry

Nat Geog 171:226–7 (c,1) F '87
POTOSÍ, BOLIVIA
Nat Geog 171:448–9 (c,1) Ap '87
—17th cent.
Nat Geog 171:448–9 (painting,c,1) Ap '87
POTSDAM, EAST GERMANY
—Sanssouci Palace teahouse
Trav&Leisure 21:113 (c,4) Ja '91
POTTER, BEATRIX
Smithsonian 19:81, 86, 89 (4) Ja '89
Smithsonian 19:17 (4) Mr '89
—Home (Lake District, England)
Gourmet 48:62–3 (c,1) Je '88
—Illustrations from *Peter Rabbit* stories
Gourmet 48:62–5, 96 (c,4) Je '88
Smithsonian 19:80–91 (c,2) Ja '89
—Paintings of animals
Natur Hist 97:48–51 (c,2) My '88
POTTERY
—3500 B.C. Naqada vase (Egypt)
Nat Geog 173:536 (c,4) Ap '88
—14th cent. B.C. (Cyprus)
Nat Geog 172:711 (c,2) D '87
—14th cent. B.C. Mycenaean pottery
Nat Geog 172:714–15 (c,1) D '87
—12th cent. Mimbres bowl (New Mexico)
Am Heritage 42:37 (c,2) N '91
—15th cent. Indian bowl (Tennessee)
Natur Hist 98:55 (c,4) S '89
—Late 19th cent. ornamental tiles by Mer-
cer (Pennsylvania)
Smithsonian 19:113–15, 120 (c,2) O '88
—1870 folk art jug with face
Trav&Leisure 19:56 (c,2) Mr '89
—Early 20th cent. handicrafts
Am Heritage 38:83–9, 114 (c,3) Jl '87
—Early 20th cent. whimsical pieces by Ohr
Smithsonian 20:160 (c,4) Mr '90
—Ancient Etruscan funerary urns (Italy)
Nat Geog 173:725, 740–1 (c,1) Je '88
—Ancient Maya pieces (Honduras)
Nat Geog 176:486–7 (c,1) O '89
—Ancient Moche pottery (Peru)
Nat Geog 174:540–1 (c,2) O '88
Nat Geog 177:16–31 (c,1) Je '90
—Ancient pottery (Hong Kong)
Gourmet 50:110–11 (c,1) O '90
—Ancient Roman (Caesarea)
Nat Geog 171:270–1 (c,1) F '87
—Clay jugs (Egypt)
Nat Geog 180:18 (c,1) D '91
—Stoke-on-Trent, England
Smithsonian 19:130–9 (c,1) Mr '89
POTTERY INDUSTRY—TRANSPOR-
TATION
—Shipping pottery on river (Great Britain)
Smithsonian 19:130 (c,1) Mr '89
POTTERY MAKING
Gourmet 48:74 (c,4) My '88

Gourmet 49:58–9 (c,1) Ag '89
—Austria
Gourmet 47:47 (c,1) Jl '87
—Peru
Nat Geog 177:40–1 (c,1) Je '90
POUND, EZRA
Smithsonian 20:138 (4) Mr '90
—Gaudier sculpture of Pound
Smithsonian 19:66–7 (c,2) Je '88
POUSSIN, NICOLAS
—"Victory of Joshua over the Amalekites"
Trav&Leisure 20:55 (painting,c,4) My
'90
POVERTY
—1877 woman with child (Great Britain)
Life 11:127 (4) Fall '88
—1911 child laborers (Massachusetts)
Am Heritage 39:49 (4) Mr '88
—1930s homeless family (Oklahoma)
Smithsonian 20:cov. (1) Je '89
—1930s homeless people cooking outdoors
(Illinois)
Am Heritage 39:102–3 (painting,c,1) Mr
'88
—Abandoned children (Brazil)
Nat Geog 171:363 (c,2) Mr '87
—Charity home (Calcutta, India)
Life 11:28–32 (c,2) Ap '88
—Drug culture in North Philadelphia,
Pennsylvania
Life 13:30–41 (1) Je '90
—Homeless children (Sudan)
Life 11:72–8 (1) Je '88
—Homeless people
Nat Geog 173:384–5 (c,1) Mr '88
Nat Geog 174:17 (c,3) Jl '88
Life 12:100–1 (1) Fall '89
Life 13:94–101 (1) N '90
—Homeless people (Moscow, U.S.S.R.)
Nat Geog 179:14 (c,4) F '91
—Homeless sleeping in railroad station
(Hungary)
Nat Geog 179:27 (c,4) Mr '91
—Life in Harlem, New York City, New
York
Nat Geog 177:cov., 52–75 (c,1) My '90
—Poor family (Ohio)
Life 12:56–66 (1) S '89
—Poor people collecting cans to redeem
(New York)
Life 12:98–102 (1) Ag '89
—Poor people saying grace (1894)
Am Heritage 42:76–7 (painting,c,1) F '91
—Romania
Life 13:86–7 (c,2) Ap '90
—Taking census of the homeless (Washing-
ton, D.C.)
Life 14:70 (c,3) Ja '91
—Tent shelters for the homeless

Life 11:78 (4) Ja '88
Life 12:7 (c,4) Je '89
—Welfare families
Life 11:78–81 (1) Spring '88
—See also
BEGGARS
DEPRESSION
HOBOES
MALNUTRITION
SLUMS
POWER PLANTS
—1939 hydroelectric plant
Am Heritage 38:90 (painting,c,2) N '87
—Construction of power plant (Turkey)
Smithsonian 21:28–9 (c,1) Ag '90
—Electrical (California)
Smithsonian 17:40–3 (c,2) F '87
—Electrical (Ireland)
Nat Geog 171:419 (c,1) Mr '87
—Electrical (Oregon)
Smithsonian 17:44 (c,3) F '87
—Florida
Nat Wildlife 28:45 (c,1) D '89
Nat Wildlife 28:8–9 (c,1) F '90
—Geothermal (Iceland)
Nat Geog 171:184–5 (c,1) F '87
Trav&Leisure 19:75 (c,3) Ap '89
—Geothermal (New Zealand)
Nat Geog 171:677 (c,4) My '87
—Hydroelectric generators (Quebec)
Nat Geog 180:77 (c,4) Ag '91
—Northport, New York
Nat Geog 180:78 (c,4) Ag '91
—U.S. electric energy sources
Nat Geog 180:60–89 (c,1) Ag '91
—See also
NUCLEAR POWER PLANTS
PRAGUE, CZECHOSLOVAKIA
Trav&Leisure 17:108–17 (c,1) F '87
Trav/Holiday 170:26–8 (c,2) Jl '88
Trav/Holiday 173:cov., 44–51 (map,c,1)
My '90
Trav&Leisure 21:114–15 (c,2) Ja '91
—1968 Russian invasion of Prague
Life 11:40–4 (1) Jl '88
—Old Jewish Cemetery
Trav&Leisure 17:112 (c,4) F '87
Trav/Holiday 170:28 (c,3) Jl '88
Trav/Holiday 173:48 (c,3) My '90
—Wenceslas Square
Trav/Holiday 173:46–7 (c,1) My '90
PRAIRIE
—Midwest
Smithsonian 19:58 (c,4) Jl '88
Trav&Leisure 20:120 (c,4) S '90
—Prairie grass along railroad tracks (Michigan)
Nat Geog 174:833 (c,2) D '88
—Prairie highway (Canada)

Nat Geog 174:336–7 (c,1) S '88
—Prairie potholes (North Dakota)
Natur Hist 98:66–7 (c,1) Ja '89
—Red Cloud, Nebraska
Am Heritage 41:78–9 (c,1) Ap '90
PRAIRIE CHICKENS
Nat Wildlife 27:46 (c,4) Je '89
Trav&Leisure 21:76 (c,4) O '91
PRAIRIE DOGS
Nat Wildlife 27:18–21 (c,1) F '89
Nat Wildlife 28:39 (c,4) D '89
PRAYING
—1880s orphans praying (New York)
Life 13:80–1 (1) Spring '90
—1974 Moslem praying toward Mecca
(Saudi Arabia)
Life 11:73 (4) Mr '88
—Buddhist monks praying at rock (Burma)
Life 13:56–7 (c,1) D '90
—Children at commune dinner (North Dakota)
Nat Geog 171:347 (c,3) Mr '87
—Family prayer (Pennsylvania)
Nat Geog 178:66–7 (1) Ag '90
—Family saying grace
Life 10:26–7 (c,1) Jl '87
—Football players
Sports Illus 66:13 (c,4) Ja 12 '87
Sports Illus 71:82–3 (c,1) N 13 '89
Sports Illus 72:16–17 (1) F 5 '90
—In church (Istanbul, Turkey)
Trav&Leisure 17:132–3 (c,1) N '87
—Moslem (Bangladesh)
Nat Geog 174:710–11 (c,1) N '88
—Moslems (Indonesia)
Nat Geog 175:102–3 (c,1) Ja '89
—Moslems (Paris, France)
Nat Geog 176:124–5 (c,1) Jl '89
—Orphans saying grace (Mexico)
Sports Illus 67:90 (c,2) D 21 '87
—Pope John Paul II praying
Life 12:36–7 (c,1) D '89
—Prayer meeting at roadside cross (Poland)
Nat Geog 173:82–3 (c,1) Ja '88
—Praying for peace in Washington, D.C.
church
Life 14:64–5 (c,1) Mr '91
—Saudi Arabia
Life 11:95 (c,4) Ap '88
—With gas mask on (Saudi Arabia)
Life 14:16 (c,2) Mr '91
PREGNANCY
—Pregnant women (Cuba)
Nat Geog 180:104 (c,3) Ag '91
—Woman listening to fetus heartbeat
Life 14:30–1 (1) Ap '91
—See also
CHILDBIRTH
REPRODUCTION

Prehistoric man. See
MAN, PREHISTORIC
PRENDERGAST, MAURICE
—"Surf, Nantasket"
Trav/Holiday 175:109 (painting,c,3) Mr
'91
Presidents. See
U.S. PRESIDENTS
PRESLEY, ELVIS
Life 10:45 (4) S '87
Life 11:46 (c,4) D '88
Life 12:105 (c,2) Ja '89
Sports Illus 71:149 (4) N 15 '89
Trav&Leisure 19:166–7 (c,1) D '89
Life 13:cov., 96, 104 (c,1) Je '90
Life 13:42–3 (1) Fall '90
Am Heritage 42:32 (4) O '91
—Daughter Lisa
Life 11:46–55 (c,1) D '88
—Graceland home (Memphis, Tennessee)
Life 10:4, 44–57 (c,1) S '87
PRESS CONFERENCES
Sports Illus 66:18 (c,4) Mr 9 '87
—Football locker room
Sports Illus 67:110 (c,3) S 9 '87
—Microphones thrust at baseball manager
Sports Illus 68:2–3 (c,1) My 9 '88
—Tennis media event in tent
Sports Illus 75:34–5 (c,2) Jl 29 '91
PRIBILOF ISLANDS, ALASKA
Trav&Leisure 20:160–9, 223 (map,c,1)
Mr '90
PRICE, LEONTYNE
Nat Geog 176:209 (3) Ag '89
PRICKLY PEARS
Trav/Holiday 167:6 (c,4) Mr '87
Nat Wildlife 26:17 (c,4) Ag '88
Natur Hist 97:24 (c,4) S '88
Natur Hist 97:36 (c,4) O '88
Natur Hist 100:54 (c,1) Ap '91
Life 14:54–5 (c,1) Summer '91
Primates. See
APES
LEMURS
MONKEYS
PRIMROSES
Smithsonian 18:38 (c,4) Ap '87
Nat Wildlife 25:26 (drawing,c,4) Ap '87
Natur Hist 96:71 (c,4) Jl '87
Smithsonian 18:78–9 (c,1) N '87
PRINCETON, NEW JERSEY
Trav&Leisure 21:E1, E8 (map,c,3) S '91
PRINCETON UNIVERSITY, NEW JER-
SEY
—18th cent.
Nat Geog 172:344–5 (painting,c,3) S '87
PRINTING INDUSTRY
—1830s destruction of abolitionist's print-
ing press

Am Heritage 38:10 (drawing,4) N '87
—1841 printing equipment (Hawaii)
Trav/Holiday 169:52 (c,4) Ap '88
—1889 sign-makers (Oklahoma)
Smithsonian 20:200 (4) N '89
—Engraving U.S. currency
Smithsonian 20:39 (c,4) My '89
—Home printing press (Vermont)
Life 10:67 (c,4) O '87
—Linotype machine
Smithsonian 18:27 (c,4) Mr '88
—Printing press
Smithsonian 18:92 (c,4) Jl '87
—Printing press (Poland)
Nat Geog 173:120 (c,1) Ja '88
PRISONS
—18th cent. (Philadelphia, Pennsylvania)
Am Heritage 38:93, 100 (drawing,c,4) Jl
'87
—19th cent.
Am Heritage 38:92–100 (drawing,c,4) Jl
'87
—19th cent. prison fetters and hoods (Aus-
tralia)
Nat Geog 173:237 (c,2) F '88
—1860s Andersonville Prison, Georgia
Am Heritage 41:118 (4) My '90
—1864 escape from Libby Prison, Virginia
Am Heritage 40:36 (drawing,4) F '89
—1878 Sing Sing lifestyle (New York)
Am Heritage 38:94, 100 (drawing,c,4) Jl
'87
—Cell (California)
Life 11:164–5 (c,1) My '88
—Cell (Switzerland)
Life 12:30 (c,4) Je '89
—Convicts in solitary playing chess (Cuba)
Life 11:24–5 (c,1) Ap '88
—Devil's Island, French Guiana
Smithsonian 19:90–8 (c,2) Ag '88
—Hanoi, Vietnam
Nat Geog 176:579 (c,1) N '89
—Local jail (Frederick, South Dakota)
Smithsonian 19:118 (c,4) N '88
—Moscow, U.S.S.R.
Life 10:68 (4) Ag '87
—Prison boot camp (Georgia)
Life 11:82–5 (c,1) Jl '88
—Prison sports
Sports Illus 69:82–96 (c,1) O 17 '88
—Prison tattoo utensils (U.S.S.R.)
Nat Geog 177:48 (c,4) Mr '90
—Soviet Gulag, Siberia, U.S.S.R.
Life 10:73–5 (c,4) S '87
Nat Geog 177:40–9 (c,1) Mr '90
—Spandau, Berlin, West Germany
Life 10:42 (c,2) O '87
—See also
ALCATRAZ

CONCENTRATION CAMPS
CONVICTS
TOWER OF LONDON
PROGRAMS
—1947 Ice Capades program cover
Life 12:8 (painting,c,4) S '89
PROHIBITION
—1900 cartoon of Carry Nation smashing
saloon
Smithsonian 20:148 (drawing,4) Ap '89
—1920s bootlegger police patrol (Alberta)
Smithsonian 19:82 (4) F '89
—See also
NATION, CARRY
PRONGHORNS
Natur Hist 96:57 (c,4) My '87
Sports Illus 67:96, 103 (painting,c,3) N
23 '87
Natur Hist 98:38–49 (c,1) Ap '89
Nat Wildlife 27:2 (c,2) Je '89
Nat Wildlife 29:52 (c,1) Ag '91
Nat Wildlife 29:2–3 (c,1) O '91
PROSPECTING
—Alaska
Nat Geog 177:52–3 (1) F '90
—British Columbia
Nat Geog 180:96–7 (c,1) N '91
—Laos
Nat Geog 171:788–9 (c,1) Je '87
PROSTITUTION
—Ancient concubine (India)
Gourmet 50:93 (painting,c,4) Mr '90
—Brothel bedroom (Ketchikan, Alaska)
Trav/Holiday 169:114 (c,4) My '88
—Haiti
Life 10:60 (c,3) Ag '87
PROUST, MARCEL
Nat Geog 176:172 (4) Jl '89
—Manuscript of *A la Recherche du Temps
Perdu*
Smithsonian 21:119 (c,4) S '90
PROVIDENCE, RHODE ISLAND
Gourmet 50:116–19, 212 (map,c,2) O '90
Psychology. See
FREUD, SIGMUND
THERAPY
PTARMIGANS
Natur Hist 96:62–9 (c,1) F '87
Nat Geog 173:760 (c,3) Je '88
Nat Wildlife 26:52 (c,1) Ag '88
Nat Wildlife 27:cov. (c,1) D '88
Nat Wildlife 28:14–19 (c,1) D '89
PUBLIC SPEAKING
—1919 suffragette making speech
Life 10:8–9 (1) Fall '87
—1988 presidential candidate at baseball
camp (Florida)
Sports Illus 68:2–3 (c,1) Mr 14 '88
—Dale Carnegie class

Smithsonian 18:84–8, 93 (c,3) O '87
—Czech president addressing U.S. Con-
gress
Life 14:85 (c,2) Ja '91
—Pope addressing crowd (Rome, Italy)
Life 12:34–5 (c,1) D '89
Publishing industry. See
BOOKS
CENSORSHIP
MAGAZINES
NEWSPAPER INDUSTRY
PRINTING INDUSTRY
PUCCINI, GIACOMO
—Settings of Puccini's "Tosca" (Rome, It-
aly)
Trav/Holiday 175:68–71 (map,c,1) Je '91
PUEBLO INDIANS (SOUTHWEST)
Sports Illus 68:147–50 (c,4) F 15 '88
—History of Pueblo Indians
Nat Geog 180:6–1'3, 84–99 (map,c,1) O
'91
—Pueblo "origin of man" story
Nat Geog 180:8–9, 12–13 (painting,c,1)
O '91
PUEBLO INDIANS (SOUTHWEST)—
ARCHITECTURE
—Anasazi Indian ruins (Chaco, New Mex-
ico)
Natur Hist 96:74–6 (2) Mr '87
Life 14:40–1 (c,1) Summer '91
Trav/Holiday 176:58–65 (map,c,1) Jl '91
—Ceremonial kiva (New Mexico)
Nat Geog 180:11, 96 (c,4) O '91
PUEBLO INDIANS (SOUTHWEST)—
ART
—15th–16th cent. rock carvings (New Mex-
ico)
Nat Geog 172:621 (c,3) N '87
Nat Geog 180:6, 84, 96 (c,3) O '91
PUEBLO INDIANS (SOUTHWEST)—
COSTUME
—Late 1880s
Smithsonian 21:116–18 (2) My '90
—New Mexico
Trav/Holiday 174:62, 64 (c,3) D '90
PUEBLO INDIANS (SOUTHWEST)—
HOUSING
—11th cent. Taos pueblo (New Mexico)
Trav/Holiday 171:28–9 (c,1) Je '89
Smithsonian 20:144 (c,1) N '89
—13th cent. Pueblo cliff dwelling (Ar-
izona)
Nat Geog 180:85 (c,2) O '91
—Acoma Pueblo mesa (New Mexico)
Nat Geog 172:632–3 (c,1) N '87
Smithsonian 20:40–1 (c,2) Ja '90
Trav/Holiday 174:68 (c,4) N '90
PUEBLO INDIANS (SOUTHWEST)—
RELICS

PUZZLES
—19th–20th cent. jigsaw puzzles
 Smithsonian 21:108, 110 (c,4) My '90
 Am Heritage 41:102–7, 114 (c,2) D '90
—Jigsaw puzzle of wine glass
 Gourmet 51:32 (c,2) Jl '91
—Jigsaw puzzles
 Smithsonian 21:104–13 (c,1) My '90
—Rubik's Cube
 Life 12:63 (c,4) Fall '89
—Three-dimensional puzzle of Rome
 Trav&Leisure 18:56–7 (c,1) My '88
—"Time is money" rebus
 Am Heritage 40:6 (c,2) My '89
—See also
 LABYRINTHS
PYGMIES
—Congo
 Nat Geog 179:32–3 (c,2) My '91
—Efe people (Zaire)
 Nat Geog 176:664–86 (map,c,1) N '89
 Natur Hist 100:54–63 (c,1) O '91
—Zaire
 Natur Hist 97:32–41 (c,1) D '88
PYGMIES—RITES AND FESTIVALS
—Coming of age festival (Zaire)
 Natur Hist 100:54–5, 60–3 (c,1) O '91
PYRAMIDS

—Egypt
 Nat Geog 180:19 (c,3) D '91
—Great Pyramid, Giza, Egypt
 Nat Geog 173:512–13, 548–9 (c,1) Ap '88
—Maya (Calakmul, Mexico)
 Nat Geog 176:428–9 (c,1) O '89
—Maya (Chichén Itzá, Mexico)
 Trav&Leisure 17:80–3 (c,1) F '87
—Maya (Teotihuacán, Mexico)
 Trav/Holiday 167:54 (c,2) F '87
—Maya (Tikal, Guatemala)
 Nat Geog 176:451 (c,2) O '89
—Maya (Uxmal, Mexico)
 Trav&Leisure 17:78–9 (c,1) F '87
—Saqqara, Egypt
 Nat Geog 173:537–9 (c,1) Ap '88
 Nat Geog 179:12–13 (c,2) Ap '91
—Step pyramid, Cairo, Egypt
 Trav&Leisure 21:74 (c,3) Jl '91
PYRAMIDS—CONSTRUCTION
—El Mirador, Guatemala
 Nat Geog 172:316–17 (painting,c,1) S '87
PYTHONS
 Natur Hist 96:59 (c,3) N '87
 Nat Wildlife 27:54–5 (c,1) D '88
 Trav&Leisure 20:137 (c,4) S '90
—Prehistoric python
 Smithsonian 20:136 (drawing,4) Ja '90

- Q -

QUAIL
—Bobwhites
 Nat Wildlife 27:12–13 (c,1) D '88
 Natur Hist 99:70 (drawing,4) F '90
QUAKERS
—19th cent.
 Am Heritage 41:67–8 (painting,c,4) N '90
—Friends School (Philadelphia, Pennsylvania)
 Am Heritage 41:68 (c,4) N '90
QUARTZ
—Quartz crystals
 Smithsonian 19:82–101 (c,1) N '88
 Smithsonian 22:64 (c,4) S '91
QUEBEC
—Maine-Quebec border
 Nat Geog 177:96–9, 118 (c,1) F '90
—Ring lake caused by meteorite
 Smithsonian 20:84 (c,4) S '89
 Natur Hist 100:50–1 (c,1) Je '91
—See also
 MONTREAL
 QUEBEC CITY
 ST. LAWRENCE RIVER

QUEBEC CITY, QUEBEC
 Am Heritage 39:88–90 (c,2) Mr '88
 Trav&Leisure 18:C12 (c,4) My '88 supp.
 Trav/Holiday 169:46–7 (c,1) My '88
 Trav&Leisure 19:82–91 (c,1) Ag '89
 Am Heritage 41:36 (c,4) Ap '90
 Trav&Leisure 21:131, 178 (c,3) My '91
 Gourmet 51:80–5, 162 (map,c,1) Je '91
—1722
 Am Heritage 39:80 (engraving,2) Mr '88
—Château Frontenac
 Gourmet 51:80–1, 85 (c,1) Je '91
—Outdoor art market
 Trav/Holiday 171:24 (c,4) My '89
 Trav&Leisure 19:86 (c,3) Ag '89
QUEEN CHARLOTTE ISLANDS,
 BRITISH COLUMBIA
 Nat Geog 172:102–27 (map,c,1) Jl '87
QUETZALS
 Nat Geog 176:457 (c,4) O '89
 Sports Illus 72:87 (c,2) Ap 9 '90
QUILTING
 Trav/Holiday 167:12 (c,4) Ja '87
 Smithsonian 18:114, 120 (c,4) My '87
 Natur Hist 96:59 (c,1) Jl '87

Trav&Leisure 18:E12 (c,3) D '88
Nat Geog 178:84 (3) Ag '90
Nat Geog 179:88–9 (c,1) Ja '91
—1870s quilting bee (New England)
Smithsonian 18:114 (painting,c,4) My '87
—Pennsylvania Dutch (Pennsylvania)
Trav/Holiday 170:88 (c,4) Jl '88
Gourmet 49:114 (c,4) N '89
QUILTS
Smithsonian 18:cov., 114–25 (c,1) My '87
—19th cent. patriotic quilt

Am Heritage 39:21 (c,2) F '88
—1876 wedding quilt
Am Heritage 38:106 (4) Ap '87
—Early 20th cent. Amish quilts
Trav&Leisure 20:68, 70 (c,4) Jl '90
—AIDS quilt commemorating victims
Life 13:38–9 (c,1) Ja '90
Trav&Leisure 20:203 (c,4) Mr '90
Nat Geog 179:138–9 (c,1) Ja '91
—Flag quilt (Massachusetts)
Trav/Holiday 167:44 (c,2) Ja '87

- R -

RABBITS
—Arctic hares
Nat Geog 173:761, 766–7 (c,1) Je '88
—Bugs Bunny
Natur Hist 100:8 (drawing,c,4) O '91
—Cottontail
Nat Wildlife 26:cov. (c,1) Ap '88
—Dürer painting of hare
Natur Hist 98:78 (c,3) S '89
—Endangered volcano rabbit
Trav&Leisure 21:76 (c,4) O '91
—Fanciful "jackalopes"
Natur Hist 96:50–5 (c,1) Ag '87
—Illustrations from *Peter Rabbit*
Gourmet 48:62–5, 96 (c,4) Je '88
—Snowshoe hares
Nat Wildlife 25:2 (c,2) F '87
Smithsonian 18:80 (c,4) F '88
Nat Wildlife 29:47–51 (c,2) F '91
Natur Hist 100:56 (c,4) D '91
—White Rabbit from "Alice in Wonderland"
Nat Geog 179:104–5, 110–12 (drawing,c,1) Je '91
—Wild hares
Natur Hist 96:46–9 (c,1) F '87
—See also
CONIES
RACCOONS
Nat Wildlife 26:16 (c,4) Ap '88
Nat Wildlife 26:2 (c,2) Ag '88
Nat Wildlife 26:54 (c,3) O '88
Nat Wildlife 28:60 (c,1) D '89
RACE TRACKS
—Arlington Park, Illinois
Sports Illus 71:14 (c,4) Jl 10 '89
—Churchill Downs, Kentucky
Sports Illus 68:24–5 (c,1) My 16 '88
Sports Illus 69:7 (c,3) O 24 '88
Sports Illus 70:20–1 (c,1) My 15 '89
—Del Mar, California
Sports Illus 75:68–9 (c,1) Jl 15 '91

—Equitrack surface
Sports Illus 69:104 (c,4) O 24 '88
—Gulfstream Park, Florida
Sports Illus 70:33 (c,4) Mr 13 '89
—Hialeah, Florida
Sports Illus 68:40–7 (c,1) Ja 11 '88
Sports Illus 74:90–1 (c,1) Ap 22 '91
—Hollywood Park starting gate, California
Sports Illus 67:13 (c,2) N 2 '87
—Indianapolis Motor Speedway
Nat Geog 172:254–5 (c,1) Ag '87
Sports Illus 68:24–5 (c,1) Je 6 '88
—Laurel Race Course, Maryland
Trav/Holiday 167:36 (c,4) Ap '87
—Local auto speedway (New York)
Sports Illus 71:58, 61 (c,3) Ag 14 '89
—Remington Park, Oklahoma
Nat Geog 176:750–1 (c,1) D '89
—Santa Anita, California
Sports Illus 68:100–1 (c,2) My 9 '88
Sports Illus 74:100 (c,3) Ap 22 '91
—Shatin, Hong Kong
Trav&Leisure 18:96–7 (c,1) Ja '88
—Suffolk Downs, Boston, Massachusetts
Sports Illus 70:50 (c,3) Je 26 '89
RACES
—1988 Paris-to-Dakar race
Sports Illus 68:2–3, 20–7 (c,1) F 1 '88
—Camel racing (Dubai)
Life 12:79–80 (c,1) Ap '89
—Celebrating after winning race (Georgia)
Nat Geog 174:22–3 (c,2) Jl '88
—Empire State Building Run-up finish line, New York
Sports Illus 68:150 (c,4) F 15 '88
—Falmouth Road Race, Massachusetts
Life 14:10–11 (c,1) N '91
—Iditarod dog sled race (Alaska)
Sports Illus 66:4–5, 12 (c,1) Mr 30 '87
Sports Illus 68:8 (c,4) F 15 '88
Trav/Holiday 171:60–1 (c,2) Ja '89
Sports Illus 70:40–8 (c,1) Mr 27 '89

Sports Illus 74:190–4 (c,1) F 11 '91
—Omak Suicide horse race (Washington)
Nat Geog 176:800–1 (c,1) D '89
—Pigeon racing
Smithsonian 21:80–93 (painting,c,1) O
'90
—Potato sack race (Pilton, England)
Trav&Leisure 19:139 (c,2) My '89
—Shrove Tuesday Pancake Race, Olney,
England
Gourmet 50:88 (painting,c,2) F '90
—Snowshoe race (Anchorage, Alaska)
Nat Geog 173:366–7 (c,1) Mr '88
—12-K race (Spokane, Washington)
Nat Geog 176:802 (c,1) D '89
—Ultrarunner at finish line (New York)
Sports Illus 69:163 (c,3) D 26 '88
—Wheelchair race
Sports Illus 71:44–6 (c,2) Jl 17 '89
—See also
AUTOMOBILE RACING
BICYCLE RACES
BOAT RACES
CROSS COUNTRY
DOG RACING
HORSE RACING
MARATHONS
MOTORBOAT RACES
MOTORCYCLE RACES
ROWING COMPETITIONS
SAILBOAT RACES
SKIING COMPETITIONS
SWIMMING COMPETITIONS
TRACK
RADAR
—1940s radar set (Great Britain)
Am Heritage 38:8 (4) D '87
—Use of radar during World War II
Smithsonian 21:120–9 (c,3) Jl '90
RADIO BROADCASTING
—1930s radio stars
Smithsonian 17:70–8 (2) Mr '87
—1951
Life 10:10 (4) N '87
—Listening to World War II broadcasts
from homefront
Trav&Leisure 19:106 (3) Ap '89
—People in studio
Sports Illus 69:92 (c,4) N 14 '88
—See also
DISC JOCKEYS
RADIO BROADCASTING—HUMOR
—Radio call-in sports programs
Sports Illus 73:108–21 (painting,c,1) O 8
'90
RADIOS
—1933 Art Deco radio
Am Heritage 39:23 (c,1) Ap '88
—Ghetto boom box

Life 11:44 (4) Spring '88
RAFTING
—Adirondacks, New York
Trav&Leisure 20:214 (c,3) Ap '90
—Colorado River, Southwest
Trav&Leisure 17:40, 44 (c,3) My '87
Trav&Leisure 18:173–4 (c,4) Mr '88
Trav&Leisure 20:108–9 (c,1) F '90
Sports Illus 75:60–72 (c,1) Jl 1 '91
—Costa Rica
Trav/Holiday 169:45 (c,3) F '88
—Hudson River, New York
Trav&Leisure 17:NY2 (painting,3) Ap
'87
—Indonesia
Trav&Leisure 18:82 (c,4) Je '88
—Mexico
Trav&Leisure 20:100 (c,4) O '90
—New River, West Virginia
Trav/Holiday 169:72–5 (c,2) F '88
—Rogue River, Oregon
Trav/Holiday 175:82–3 (painting,c,1) Mr
'91
—Salmon River, Idaho
Trav/Holiday 167:56–7 (c,2) My '87
Gourmet 48:60–5, 102 (c,1) Jl '88
—South Pacific
Trav/Holiday 169:87 (c,1) Ap '88
—White water rafting (Utah)
Sports Illus 71:34–7 (c,1) Jl 10 '89
—Zambezi River, Zambia
Trav/Holiday 171:50–1 (c,4) Ap '89
RAFTS
—Heyerdahl's raft "Kon-Tiki" (Norway)
Trav&Leisure 20:157 (c,4) My '90
—Inflatable
Trav&Leisure 19:cov. (c,1) D '89
—Suspended from dirigible
Nat Geog 178:128–38 (c,1) O '90
RAILROAD CONDUCTORS
—New York City subway conductor
Trav&Leisure 20:193 (c,4) S '90
—San Francisco trolleymen, California
Smithsonian 18:138 (c,2) F '88
Trav&Leisure 18:76 (c,4) Mr '88
RAILROAD STATIONS
—1897 stationmaster's desk (Nebraska)
Am Heritage 41:83 (c,2) Ap '90
—Bangkok, Thailand
Trav/Holiday 168:42–3 (c,1) D '87
—Beijing, China
Nat Geog 173:310 (c,4) Mr '88
—Bern, Switzerland
Trav&Leisure 20:188 (c,4) S '90
—Budapest, Hungary
Gourmet 48:68 (c,4) O '88
Trav&Leisure 19:109 (4) Je '89
—Canaan, Connecticut
Trav/Holiday 168:30 (c,2) S '87

Trav&Leisure 20:128–37 (c,1) Ap '90
—Railroad Museum, Sacramento, California
Trav/Holiday 172:64–70 (c,1) O '89
—Railroad yard (Paris, France)
Nat Geog 176:98–9 (c,1) Jl '89
—Recreation greenways along old railroads
Nat Wildlife 26:40–3 (map,c,1) Ag '88
Smithsonian 21:132–41 (c,1) Ap '90
Nat Geog 177:76–99 (map,c,1) Je '90
—Spain
Trav&Leisure 17:82 (drawing,c,3) Ap '87
—Stylized depictions
Trav/Holiday 173:113–14, 117 (painting,c,4) Mr '90
—Switzerland
Trav&Leisure 17:88–95 (c,1) Ag '87
—Tiger emblem of Malayan Railway System
Trav/Holiday 168:43 (c,4) D '87
—Woman running to catch train
Trav/Holiday 171:32 (drawing,c,3) Mr '89
—See also
GOULD, JAY
LOCOMOTIVES
PULLMAN, GEORGE
RAILROAD STATION
STANFORD, LELAND
TRAINS
VANDERBILT, CORNELIUS
RAILROADS—CONSTRUCTION
—Building Pennsylvania railroad tunnel (1885)
Am Heritage 41:104–5 (3) My '90
—Chinese working on transcontinental railroad (1869)
Smithsonian 21:116 (engraving,3) F '91
—History of railroad construction (Canada)
Sports Illus 68:302, 310, 316 (4) Ja 27 '88
RAILS (BIRDS)
Smithsonian 19:cov., 38–45 (c,1) Ag '88
Nat Wildlife 26:14 (painting,c,3) Ag '88
Smithsonian 22:116 (c,2) O '91
—Guam rails
Smithsonian 22:113, 119 (c,3) Ag '91
RAIN
—1903 downtown Los Angeles scene, California
Am Heritage 39:106 (2) D '88
—Arizona desert
Smithsonian 17:98 (c,3) Mr '87
—Dominica, Windward Islands
Nat Geog 177:120 (c,3) Je '90
—Driving in rain (Oklahoma)
Nat Geog 171:692–3 (c,1) Je '87

—Kentucky Derby fans under plastic sheet in rain
Sports Illus 70:2–3 (c,1) My 15 '89
—Main in rain
Gourmet 48:188 (drawing,4) Ap '88
Trav&Leisure 21:195 (c,1) O '91
—On baseball field
Sports Illus 67:2–3 (c,1) S 21 '87
—Playing football in rain
Sports Illus 71:2–3 (c,1) D 4 '89
Sports Illus 75:54–5 (c,1) S 2 '91
—Rain falling on branch
Trav/Holiday 173:142 (c,4) Ap '90
—See also
MONSOONS
STORMS
RAIN FORESTS
Nat Geog 180:78–107 (map,c,1) D '91
—Australia
Nat Geog 173:204 (c,4) F '88
Trav&Leisure 20:135–9 (map,c,1) S '90
—Brazil
Smithsonian 19:106–16 (c,1) Ap '88
Nat Geog 174:772–817 (map,c,1) D '88
Smithsonian 20:cov., 58–75 (c,1) N '89
Trav&Leisure 20:188 (c,3) Mr '90
Nat Geog 180:104–5 (c,1) D '91
—Clear-cutting forests (Brazil)
Smithsonian 19:107, 109 (c,2) Ap '88
—Costa Rica
Sports Illus 72:84–90, 95–8 (c,1) Ap 9 '90
Trav&Leisure 20:129 (c,4) S '90
Nat Geog 180:78–107 (c,1) D '91
—Destruction of Central American rain forests
Nat Geog 176:438–9 (c,1) O '89
—Dominica, Windward Islands
Nat Geog 177:102–3 (c,1) Je '90
—Ecuador
Nat Geog 178:124–5 (c,1) Ag '90
Smithsonian 22:36–49 (c,1) Je '91
—El Yunque, Puerto Rico
Natur Hist 96:76–8 (map,c,1) F '87
Natur Hist 100:76–8 (map,c,1) O '91
—French Guiana
Nat Geog 178:128–38 (c,1) O '90
—Madagascar
Nat Geog 171:164–9 (map,c,2) F '87
Natur Hist 97:58 (c,2) Jl '88
—Olympic National Park, Washington
Life 14:12–13 (c,1) Summer '91
—Peru
Sports Illus 66:63 (c,2) Ap 13 '87
—Rain forest burning down (Honduras)
Nat Geog 176:438–9 (c,1) O '89
—South America
Trav/Holiday 173:70–2, 76 (c,1) Mr '90
—Space photo of rain forest burning (Brazil)

Nat Geog 178:94 (c,3) O '90
—Stylized depiction of Belize
Trav&Leisure 18:88 (drawing,c,3) Mr
'88
—Tongass National Forest, Alaska
Life 10:92–6 (map,c,1) N '87
—Torched rain forest (Brazil)
Life 12:8–9 (c,1) Ja '89
—Venezuela
Trav&Leisure 20:192 (c,3) Mr '90
—Waikamoi Preserve, Maui, Hawaii
Trav&Leisure 20:121 (map,c,1) S '90
—Zaire
Nat Geog 176:664–86 (c,1) N '89
RAINBOWS
Nat Geog 175:28–9 (c,1) Ja '89
Life 12:146–7 (c,1) Mr '89
—Arizona desert
Smithsonian 20:48 (c,4) Ja '90
—Colombia
Life 10:32–3 (c,1) Mr '87
—Dominica
Trav/Holiday 176:87 (c,1) N '91
—Mountain scene (California)
Nat Geog 175:466 (c,2) Ap '89
—Over Belize reef
Nat Geog 176:432–3 (c,1) O '89
—Over field (Switzerland)
Trav&Leisure 18:31 (c,4) S '88
—Over forest (Brazil)
Smithsonian 20:59 (c,2) N '89
—Over harbor (Ireland)
Trav&Leisure 21:106–7 (c,1) S '91
—Over ocean
Gourmet 49:96–7 (c,1) N '89
—Over river (Suriname)
Smithsonian 19:96–7 (c,3) F '89
—Over Victoria Falls, Zimbabwe
Trav&Leisure 20:116–17 (c,2) S '90
RAINWEAR
—Bicyclists in rain (Vietnam)
Nat Geog 176:603 (c,4) N '89
—Slickers on boating tourists (Quebec)
Nat Geog 179:62–3 (c,1) Mr '91
RAMSES II (EGYPT)
—Mummy of Ramses II
Nat Geog 179:8 (c,2) Ap '91
—Ramses II tomb sculptures (Abu Simbel)
Smithsonian 19:85 (painting,c,3) Je '88
Trav&Leisure 19:cov., 139, 142–3 (c,1) S
'89
Nat Geog 179:6–7, 9 (c,1) Ap '91
—Sculptures (Luxor)
Trav&Leisure 19:138, 140 (c,1) S '89
Nat Geog 179:2–31 (c,1) Ap '91
—Wooden sculpture
Trav&Leisure 18:33 (c,3) Jl '88
RANCHES
—Aerial view of sheep station (Australia)

Nat Geog 173:756 (c,1) My '88
—Dude ranch (Arizona)
Trav&Leisure 20:96–105, 128 (c,1) Jl '90
—Sheep ranch (Falkland Islands)
Nat Geog 173:404–5 (c,1) Mr '88
—Sheep ranch (New Zealand)
Trav/Holiday 170:55 (c,3) Jl '88
RANCHING
Life 10:19 (c,3) Jl '87
Nat Geog 174:206–7 (c,1) Ag '88
Trav/Holiday 170:49 (c,3) D '88
Nat Geog 175:78–9 (c,1) Ja '89
Trav/Holiday 171:68–71 (c,3) F '89
Life 12:88–94 (c,1) Jl '89
Smithsonian 21:42–53 (c,1) N '90
Sports Illus 74:120–3, 131 (c,1) Ap 15 '91
—1910s sheep rancher transporting wool
(Montana)
Smithsonian 21:58–9 (2) N '90
—Argentina
Trav&Leisure 21:118–21 (c,1) N '91
—Branding cattle (South Dakota)
Life 12:92 (c,4) Jl '89
—Branding roundup (Chile)
Nat Geog 174:82 (c,3) Jl '88
—Cattle ranching (Australia)
Nat Geog 179:10–11, 20–1 (c,1) Ja '91
—Cattle ranching (Texas)
Sports Illus 74:64–5 (c,2) F 25 '91
—Cattlemen's 1892 fight against Invaders
(Wyoming)
Am Heritage 40:46, 50–1 (4) Ap '89
—Lassoing steer (Brazil)
Smithsonian 20:72 (c,4) N '89
—Moving cattle to grasslands (Spain)
Nat Geog 179:120–5 (c,1) Ap '91
—Ranchers (Chile)
Natur Hist 96:48–9 (c,2) My '87
—Rounding up cattle (Australia)
Life 11:40–1 (c,1) F '88
—Rounding up cattle (Louisiana)
Nat Geog 178:62–3 (c,1) O '90
—Shearing sheep
Nat Geog 173:552–3, 557 (c,1) My '88
—Shearing sheep (Tibet)
Nat Geog 175:774–5 (c,1) Je '89
—Sheep (Australia)
Nat Geog 173:578–9 (c,1) My '88
Nat Geog 179:18–19 (c,1) Ja '91
—Sheep (New Mexico)
Smithsonian 22:36–47 (c,1) Ap '91
—Sheep (New Zealand)
Nat Geog 171:667, 672–3 (c,1) My '87
—Sorting sheep into pens (Iceland)
Nat Geog 171:196–7 (c,1) F '87
—U.S.S.R.
Nat Geog 171:608–9 (c,1) My '87
—See also
COWBOYS

RANDOLPH, EDMUND
 Am Heritage 38:48 (painting,c,4) My '87
 Smithsonian 18:33 (drawing,4) Jl '87
 Am Heritage 38:79 (drawing,2) S '87
 Life 10:56, 69 (c,4) Fall '87
 Life 14:42 (painting,c,4) Fall '91
RAPHAEL
—"St. John the Baptist"
 Trav/Holiday 174:33 (painting,c,3) N '90
RASPBERRIES
 Gourmet 51:cov. (c,1) Jl '91
RATS
 Nat Geog 174:145 (c,4) Ag '88
 Natur Hist 97:8 (c,4) S '88
 Nat Wildlife 29:16 (c,4) F '91
 Nat Geog 179:98–9 (c,1) Je '91
RATTLESNAKES
 Nat Geog 172:128–38 (c,1) Jl '87
 Natur Hist 96:67 (c,1) N '87
 Natur Hist 98:30–1, 34–5 (c,1) My '89
RAVENS
 Natur Hist 98:44–51 (c,1) F '89
—Seen in silhouette
 Nat Geog 180:31 (c,4) O '91
RAZORS
—Antique razors
 Smithsonian 22:114 (c,4) My '91
READ, GEORGE
 Life 10:55 (painting,c,4) Fall '87
READING
—In resort lounge chair (Caribbean)
 Trav&Leisure 21:72 (c,2) Ag '91
—The Koran (Kashmir)
 Nat Geog 172:533 (c,4) O '87
—Man in office reading newspaper (New
 York)
 Life 11:33 (c,2) D '88
—Man reading at beach
 Trav&Leisure 20:84 (c,2) Jl '90
—Man reading newspaper on corner (New
 York)
 Trav/Holiday 174:55 (c,4) S '90
—Man relaxing in lawn chair (Illinois)
 Life 14:52–3 (c,1) Ag '91
—Mother reading to children
 Life 14:90 (c,4) D '91
—People reading newspapers (Moscow,
 U.S.S.R.)
 Trav/Holiday 174:45, 49 (c,1) Ag '90
—Reading Braille
 Smithsonian 19:166 (c,4) My '88
—Reading newspaper at cafe (Hamburg,
 Germany)
 Trav/Holiday 174:64 (c,3) O '90
—Reading newspaper at coffeehouse (Vi-
 enna, Austria)
 Gourmet 51:85 (c,1) Ja '91
—Reading newspaper in car (New York)
 Life 12:48 (c,3) D '89

—Reading newspaper in garden (Great
 Britain)
 Gourmet 51:79 (c,1) Mr '91
—While floating in water (Virgin Islands)
 Trav&Leisure 21:145 (c,2) My '91
REAGAN, RONALD
 Life 10:60–1 (c,1) Ja '87
 Nat Geog 171:204 (c,3) F '87
 Life 10:29 (2) S '87
 Life 10:25 (c,2) O '87
 Sports Illus 68:2–3 (c,1) Ja 11 '88
 Life 11:26–30 (c,4) Ag '88
 Life 12:128 (c,4) F '89
 Life 12:53–6 (c,1) Fall '89
—1940 wedding to Jane Wyman
 Life 10:71 (4) Ag '87
—1981 assassination attempt
 Life 12:50–1 (c,1) Mr '89
—In World War II training film
 Am Heritage 42:34 (4) My '91
—Letters written by him
 Life 11:201, 20 4(c,4) N '88
—Reagan asleep in hammock (California)
 Trav/Holiday 173:69 (c,4) F '90
—Ronald Reagan's passport
 Life 11:26 (c,4) Ag '88
—With mother (1942)
 Life 12:124 (2) Spring '89
—With Nancy Reagan
 Life 12:12–13 (1) Fall '89
RECORDING STUDIOS
—Home recording studio
 Sports Illus 73:91 (c,4) D 17 '90
—Producing television commercial
 Smithsonian 18:134–7, 142 (c,2) O '87
—Singers recording song
 Life 10:67 (c,2) My '87
RECORDS
—1930s blues record labels
 Am Heritage 42:41–7 (c,4) Jl '91
—Carter family record albums
 Life 14:112 (c,2) D '91
—Folkways records covers
 Smithsonian 18:111 (c,4) Ag '87
—See also
 JUKEBOXES
Recreation. See lists under
 AMUSEMENTS
 SPORTS
RECREATIONAL VEHICLES
 Trav/Holiday 170:22, 24 (c,4) Ag '88
—ATVs
 Life 10:54–5 (c,10 Je '87
 Nat Geog 173:404 (c,3) Mr '88
 Smithsonian 19:91 (c,1) F '89
—Riding off-highway vehicles on sand
 dunes (California)
 Nat Geog 171:44–5, 64–5 (c,1) Ja '87
—See also

ACAPULCO, MEXICO
ATLANTIC CITY, NEW JERSEY
BADEN-BADEN, WEST GERMANY
BEACHES, BATHING
HOT SPRINGS, ARKANSAS
MACKINAC ISLAND, MICHIGAN
MIAMI BEACH, FLORIDA
SKI RESORTS
SPAS
RESORTS—HUMOR
—Decadence of spa life
 Trav&Leisure 20:194 (drawing,c,4) Mr
 '90
RESTAURANTS
—Mid 19th cent. Harvey girls serving fron-
 tier travelers
 Smithsonian 18:130–9 (drawing,c,1) S
 '87
—1890 restaurant bill (Great Britain)
 Gourmet 48:75 (c,3) F '88
—1900 Chinese restaurant (Minnesota)
 Am Heritage 38:102–3 (3) D '87
—Early 20th cent. Italian restaurants
 (U.S.)
 Am Heritage 40:125–31 (4) D '89
—1907 cartoon warning against fast food
 Am Heritage 39:70 (4) Ap '88
—1930s drive-in restaurant (California)
 Am Heritage 39:71 (4) Ap '88
—1930s hamburger fast food place
 Am Heritage 39:6 (4) S '88
—1931 checklist for fast food employee ap-
 pearance
 Am Heritage 39:72 (3) Ap '88
—1961 hamburger counter
 Sports Illus 75:65 (3) O 28 '91
—At Gare de Lyon, Paris, France
 Trav&Leisure 17:116 (c,1) S '87
—Barcelona, Spain
 Trav&Leisure 20:149–53 (c,1) Je '90
—Berlin, West Germany
 Trav&Leisure 17:93 (c,3) S '87
—Bistros
 Trav&Leisure 20:140–1 (c,1) Ap '90
 Gourmet 50:102 (painting,c,4) O '90
 Trav&Leisure 21:130–41, 182 (c,1) N '91
—Blackboard menu (West Indies)
 Gourmet 47:50 (c,4) Mr '87
—Budapest, Hungary
 Gourmet 48:70 (c,4) O '88
 Trav&Leisure 19:83 (c,3) O '89
—Buffet (California)
 Gourmet 47:42 (painting,c,2) D '87
 Gourmet 49:40 (drawing,4) S '89
—Cafe (Burma)
 Trav&Leisure 18:110 (c,4) S '88
—Cafe (Cartagena, Colombia)
 Nat Geog 175:496–7 (c,1) Ap '89
—Cafe (Paris, France)

Gourmet 51:77 (c,1) Ja '91
 Trav/Holiday 175:73 (c,1) Ap '91
—Cafe Opera, Stockholm, Sweden
 Trav&Leisure 20:98–101 (c,1) Ag '90
—Caribbean Islands
 Trav&Leisure 19:148, 169 (c,4) O '89
—Chinese restaurant postcards (1950s)
 Am Heritage 38:98–107 (c,4) D '87
—Chinese restaurants
 Am Heritage 38:98–107 (c,1) D '87
—Delicatessen (New York City, New
 York)
 Trav/Holiday 170:52 (c,2) S '88
—Diners
 Life 10:67–72 (c,2) Jl '87
 Gourmet 48:58 (drawing,c,3) F '88
 Trav&Leisure 18:91 (c,4) N '88
 Smithsonian 19:125 (c,2) D '88
—Eating at restaurant counters
 Gourmet 51:100–5 (c,2) O '91
—Famous old Los Angeles restaurants,
 California
 Gourmet 51:58 (drawing,c,2) Ja '91
—Fast food (Hamburg, West Germany)
 Trav&Leisure 18:133 (c,4) Je '88
—History of fast food restaurants (1907–
 1985)
 Am Heritage 39:68–75 (c,3) Ap '88
—History of Nathan's Famous hot dogs
 (coney Island, N.Y.)
 Trav&Leisure 21:41, 44–5 (3) Jl '91
—Hotel coffee shop (California)
 Trav&Leisure 18:106 (c,4) My '88
—Ladling soup (Texas)
 Trav&Leisure 19:104–5 (c,1) Ag '89
—Leningrad, U.S.S.R.
 Trav&Leisure 20:204 (c,4) Ap '90
—London, England
 Gourmet 48:74–9 (c,1) F '88
—Los Angeles, California
 Trav&Leisure 20:129–35 (c,1) D '90
—Lyon, France
 Trav&Leisure 19:130–7 (c,1) S '89
—Madrid, Spain
 Trav&Leisure 19:83 (c,3) S '89
—McDonald's (Moscow, U.S.S.R.)
 Trav&Leisure 20:137 (c,4) O '90
 Nat Geog 179:9–10 (c,1) F '91
 Am Heritage 42:56 (c,3) My '91
—Munich, West Germany
 Trav&Leisure 18:129 (c,2) My '88
—New Orleans, Louisiana
 Trav&Leisure 19:201 (c,4) My '89
 Trav/Holiday 176:40 (c,4) N '91
—Outdoor (Romania)
 Trav/Holiday 167:62 (c,3) Ap '87
—Outdoor cafe (France)
 Gourmet 47:52 (c,4) Ag '87
 Trav&Leisure 18:112–13 (c,1) Je '88

—Outdoor cafe (Italy)
 Trav&Leisure 20:122–5 (c,1) Ap '90
 Gourmet 51:107 (c,1) O '91
—Outdoor cafe (New York City, New
 York)
 Trav&Leisure 21:cov. (c,1) S '91
—Outdoor cafe (Santa Monica, California)
 Trav&Leisure 21:132–3 (1) Je '91
—Outdoor cafe (Split, Yugoslavia)
 Trav/Holiday 175:34–5, 43 (c,1) Ja '91
—Outdoor cafe (West Germany)
 Trav&Leisure 18:136–7 (c,1) Je '88
 Trav&Leisure 19:217 (c,3) N '89
—Outdoor food stands (Tahiti)
 Gourmet 49:40 (c,4) Ja '89
—Oyster bar (New York)
 Gourmet 50:140 (drawing,4) F '90
—Paris, France
 Gourmet 47:117 (drawing,4) S '87
 Trav/Holiday 172:52, 55, 57 (c,2) Jl '89
 Trav&Leisure 19:98–9 (c,1) Jl '89
 Trav&Leisure 21:130–41, 182 (c,1) N '91
—Pastry shop (Vienna, Austria)
 Trav&Leisure 18:130–1 (c,1) N '88
—Pizza restaurant (Naples, Italy)
 Trav&Leisure 18:101 (c,4) Je '88
—Plastic food in restaurant window (Ja-
 pan)
 Trav&Leisure 20:107 (c,4) Ag '90
—Polo Lounge, Los Angeles, California
 Trav&Leisure 19:64 (c,4) Jl '89
—Pub menu boards (London, England)
 Gourmet 47:56 (c,3) Mr '87
—Quebec
 Gourmet 49:64, 66 (c,4) My '89
 Gourmet 51:83 (c,1) Je '91
 Trav&Leisure 21:130 (c,2) My '91
—Rainbow Room, New York City, New
 York
 Trav&Leisure 18:114–21, 169 (c,1) Ap
 '88
—Restaurant booths (California)
 Gourmet 51:46 (painting,c,2) My '91
—Restaurant sign (West Germany)
 Gourmet 48:58, 63 (c,1) Ap '88
—Romantic dining room (Arizona)
 Trav/Holiday 170:47 (c,3) N '88
—San Francisco, California
 Gourmet 50:40 (drawing,c,2) D '90
 Gourmet 51:25 (painting,c,2) F '91
 Trav&Leisure 21:100–7, 120–1, 189 (c,1)
 Mr '91
 Gourmet 51:58–64 (c,3) D '91
—Sculpture of diner (Michigan)
 Trav/Holiday 172:27 (c,4) S '89
—Snack bar (Bahamas)
 Trav/Holiday 174:44 (c,3) D '90
—Sonoma, California
 Gourmet 48:54 (painting,c,3) S '88

—Sushi bar (Japan)
 Life 11:60 (c,3) D '88
—Switzerland
 Trav&Leisure 19:85–7 (c,1) Jl '89
—Taiwan
 Gourmet 48:42 (painting,c,2) Ja '88
 Gourmet 51:80–3 (c,2) S '91
—Tapas bar (Spain)
 Natur Hist 96:98(c,4) O '87
—Teahouse (Bisley, England)
 Trav/Holiday 175:63 (c,4) Mr '91
—Terrace dining (California)
 Gourmet 49:38 (painting,c,2) S '89
—Toronto, Ontario
 Smithsonian 19:63 (c,4) Ap '88
 Trav&Leisure 18:50 (c,3) S '88
—Truck stop services
 Smithsonian 20:94–105 (c,1) N '89
—Waitresses dancing on diner counter
 (Ohio)
 Trav/Holiday 172:52–3 (c,1) Ag '89
—Waterside restaurant (Venice, Italy)
 Gourmet 51:54–5 (c,2) Ag '91
—See also
 CHEFS
 COFFEEHOUSES
 COOKING
 DINNERS AND DINING
 KITCHENS
 NIGHT CLUBS
 TAVERNS
 WAITERS
 WAITRESSES
 issues of *Gourmet*
RESTORATION OF ART WORKS
—25 B.C. Roman glass vase
 Smithsonian 20:52–63 (c,1) Jl '89
—Cleaning Leonardo painting (Wash-
 ington, D.C.)
 Smithsonian 21:60 (c,4) Mr '91
—Mosaics (Ravenna, Italy)
 Trav/Holiday 172:62–3 (c,3) N '89
—Murals (Cuba)
 Nat Geog 176:293 (c,3) Ag '89
—Restoration of Sistine Chapel frescoes
 (Vatican)
 Life 11:47–51 (painting,c,1) Je '88
 Nat Geog 176:cov., 688–713 (c,1) D '89
—Restoring 16th cent. bookbinding
 (Washington, D.C.)
 Nat Geog 171:250–1 (c,2) F '87
—Restoring Angkor Wat, Cambodia
 Smithsonian 21:40 (c,4) My '90
—Restoring the Great Sphinx, Egypt
 Nat Geog 179:32–9 (c,1) Ap '91
—Restoring Nefertiti's tomb paintings
 (Egypt)
 Life 11:143–7 (c,2) D '88
 Nat Geog 179:24–5 (c,2) Ap '91

RETRIEVERS (DOGS)
—Golden retrievers
 Smithsonian 17:18 (c,4) Ja '87
 Sports Illus 66:4 (c,4) Ja 12 '87
 Life 12:102–3 (c,1) S '89
—See also
 LABRADOR RETRIEVERS
REVERE, PAUL
—Home (Boston, Massachusetts)
 Am Heritage 42:140 (c,4) N '91
REVOLUTIONARY WAR
—1765 anti-Stamp Act woodcut
 Am Heritage 41:35 (4) Mr '90
—1779 battle between "Bonhomme Rich-
 ard" and "Serapis"
 Am Heritage 38:52 (painting,c,4) D '87
—1780 hanging of spy John André
 Am Heritage 38:8 (drawing,4) Jl '87
—1781 Battle of Yorktown
 Am Heritage 38:56–7, 115 (painting,c,1)
 F '87
 Life 10:20–1 (c,1) Fall '87
 Nat Geog 173:808–9 (drawing,c,1) Je '88
—Benedict Arnold's march on Quebec
 (1775)
 Smithsonian 18:cov., 40–9 (painting,c,1)
 D '87
 Am Heritage 41:66 (map,4) S '90
—Battle of Princeton (1777)
 Trav/Holiday 174:70–5 (map,c,1) Jl '90
—Battle of Princeton reenactment
 Am Heritage 38:26 (c,4) D '87
—Events in Virginia
 Am Heritage 38:54–7, 114 (painting,c,1)
 F '87
—Men in British Redcoat costumes (Mas-
 sachusetts)
 Trav/Holiday 170:30 (c,3) Jl '88
—Role of France in the American Revolu-
 tion
 Am Heritage 40:38–40 (painting,c,3) Jl
 '89
—Woman soldier
 Life 14:53 (painting,c,4) My '91
—See also
 ADAMS, SAMUEL
 ALLEN, ETHAN
 ARNOLD, BENEDICT
 BOSTON TEA PARTY
 BUNKER HILL, BATTLE OF
 CORNWALLIS, CHARLES
 FORT TICONDEROGA
 FRANKLIN, BENJAMIN
 HENRY, PATRICK
 JEFFERSON, THOMAS
 JONES, JOHN PAUL
 KOSCIUSZKO, THADDEUS
 LAFAYETTE, MARQUIS DE
 LEE, HENRY

LEE, RICHARD HENRY
LIBERTY BELL
PACA, WILLIAM
PAINE, THOMAS
PULASKI, CASIMIR
REVERE, PAUL
ROONEY, CAESAR
ROSS, BETSY
WASHINGTON, GEORGE
REVOLUTIONARY WAR—HUMOR
—Patriots "cooking up" 1783 peace treaty
 Smithsonian 21:69 (painting,c,4) My '90
REYKJAVIK, ICELAND
 Nat Geog 171:204–5 (c,1) F '87
RHEAS
 Trav/Holiday 171:cov. (c,1) Ap '89
RHINOCERI
 Smithsonian 18:66–9 (c,1) S '87
 Smithsonian 18:182 (c,4) Mr '88
 Smithsonian 19:72 (c,4) S '88
 Trav&Leisure 19:114–19 (c,1) Ja '89
 Nat Geog 177:99 (c,2) Ap '90
 Trav&Leisure 20:107 (c,4) S '90
—Black rhinos
 Sports Illus 66:60–72 (c,1) Mr 2 '87
 Trav&Leisure 17:104 (c,1) N '87
 Life 12:60–1 (c,1) Ap '89
 Trav/Holiday 171:45 (c,3) Ap '89
 Nat Geog 177:93 (c,2) Ap '90
 Nat Wildlife 28:38–9 (c,1) O '90
—Extinct miocene era rhinos
 Natur Hist 96:26–33 (painting,c,1) Ag
 '87
—Horns
 Sports Illus 66:64 (c,3) Mr 2 '87
RHODE ISLAND
—Blithewold manor house
 Trav/Holiday 169:38 (c,4) Mr '88
—Block Island
 Am Heritage 39:114–17 (c,3) S '88
 Gourmet 49:76–81, 166 (map,c,1) My
 '89
—Block Island (late 19th cent.)
 Am Heritage 39:115–16 (3) S '88
—Block Island lighthouse
 Life 10:36–7 (c,1) Ag '87
 Gourmet 49:78–81 (c,1) My '89
—Coastline
 Trav&Leisure 19:NY1–2 (c,4) Ag '89
—Watch Hill
 Trav&Leisure 19:NY1–2 (c,4) Ag '89
—See also
 NEWPORT
 PROVIDENCE
RHODE ISLAND—MAPS
—Narragansett Bay
 Trav&Leisure 17:E4 (c,4) Ag '87
RHODES, GREECE
 Trav/Holiday 170:57, 59 (c,2) S '88

RHODODENDRONS
 Nat Geog 171:224 (c,4) F '87
 Nat Geog 174:650 (c,4) N '88
 Nat Wildlife 27:50–1 (c,1) O '89
 Smithsonian 21:218 (c,4) Ap '90
RICE FIELDS
—Bangladesh
 Nat Geog 172:101 (c,4) Jl '87
—California
 Nat Wildlife 29:5 (c,2) Je '91
—Flooded rice fields (China)
 Nat Geog 175:295 (c,3) Mr '89
—Indonesia
 Trav/Holiday 170:64 (c,4) Jl '88
 Nat Geog 175:100–1 (c,1) Ja '89
 Trav&Leisure 20:128–9 (c,1) Ja '90
 Trav/Holiday 175:38–9 (c,1) Ap '91
 Gourmet 51:cov., 66–7 (c,1) Ap '91
—Nepal
 Nat Geog 172:57 (c,1) Jl '87
—Philippines
 Nat Geog 178:19 (c,1) S '90
—South Korea
 Life 10:26–7 (c,1) S '87
RICE INDUSTRY
—Drying rice (India)
 Nat Geog 173:613 (c,3) My '88
—Haiti
 Nat Geog 172:660–1 (c,2) N '87
RICE INDUSTRY—HARVESTING
—Indians harvesting wild rice (Minnesota)
 Natur Hist 97:86 (c,4) My '88
—Indonesia
 Trav/Holiday 175:40 (c,4) Ap '91
—Laos
 Nat Geog 171:774–5 (c,1) Je '87
—South Korea
 Nat Geog 174:256–7 (c,1) Ag '88
RICE INDUSTRY—TRANSPORTATION
—Trucking rice to mill (Louisiana)
 Nat Geog 178:48–9 (c,1) O '90
RICE PADDIES
—Harvested paddies (China)
 Nat Geog 175:307 (c,1) Mr '89
—Hawaii
 Trav/Holiday 168:45 (c,2) S '87
—India
 Nat Geog 174:700–1 (c,3) N '88
—Japan
 Gourmet 48:73 (c,2) S '88
—Kashmir
 Trav&Leisure 17:104 (c,4) S '87
—Kenya
 Life 12:94–5 (c,1) Ag '89
—Madagascar
 Nat Geog 171:170–1 (c,2) F '87
 Natur Hist 97:53 (c,4) Jl '88

—Water buffalo plowing in rice paddy (China)
 Natur Hist 99:42 (c,4) Je '90
RICHELIEU, CARDINAL
 Smithsonian 21:90 (painting,c,4) Mr '91
RICHMOND, VIRGINIA
—Capitol building
 Life 14:45 (c,2) Fall '91
—Washington Monument
 Am Heritage 38:82–3 (c,2) D '87
RICHTER, CHARLES
 Life 12:48 (4) F '89
RICKSHAWS
—Hong Kong
 Sports Illus 66:50 (c,4) Ap 13 '87
 Smithsonian 20:53 (c,1) Ap '89
 Trav/Holiday 172:54 (c,4) S '89
—India
 Nat Geog 177:121 (c,4) My '90
—Motorized rickshaw (Vietnam)
 Smithsonian 18:64–5 (c,2) Ap '87
—Shanghai, China (1940)
 Trav&Leisure 18:92 (4) Ap '88
RIFLES
—18th cent. long rifle
 Am Heritage 41:70 (c,4) N '90
—19th cent. flintlock (U.S.S.R.)
 Natur Hist 98:55 (c,4) D '89
—AK-47 assault rifle
 Life 12:156–7 (c,1) Fall '89
—Making handmade rifle (New York)
 Nat Geog 178:57 (c,3) N '90
RIGA, LATVIA
 Nat Geog 178:22–3 (c,2) N '90
RIIS, JACOB
 Nat Geog 173:16 (4) Ja '88
—1887 photo of tenement lodgers (New York City, N.Y.)
 Nat Geog 176:544–5 (1) O '89
RINGLING, JOHN
—Bust (Sarasota, Florida)
 Trav/Holiday 172:NE12 (c,4) N '89
—Home (Sarasota, Florida)
 Trav/Holiday 172:NE6 (c,3) N '89
RIO DE JANEIRO, BRAZIL
 Trav/Holiday 167:43 (c,1) F '87
 Nat Geog 171:350–1, 356–7 (c,1) Mr '87
 Smithsonian 21:98–9, 107 (c,3) Jl '90
—Sugarloaf Mountain
 Trav&Leisure 20:74–5 (c,1) Ag '90
RIO GRANDE RIVER, COLORADO
—1881
 Nat Geog 175:249 (3) F '89
RIO NEGRO, BRAZIL
 Trav&Leisure 19:120–1 (c,1) F '89
RIOTS
—1965 Watts riots, Los Angeles, California
 Life 11:22–3 (c,1) Spring '88
 Am Heritage 41:39 (4) Jl '90

—Afghan villagers fighting over blankets
 Life 12:7 (2) Ap '89
—Fatal riot at soccer game (Sheffield, England)
 Sports Illus 70:24–5 (c,1) Ap 24 '89
 Sports Illus 71:8–9 (c,3) S 25 '89
—Haiti
 Nat Geog 172:646–7 (c,1) N '87
—Neofascists attacking students (Poland)
 Nat Geog 179:6–7 (c,1) Mr '91
—Northern Ireland teens attacking armored car (1972)
 Life 12:96–7 (1) S '89
—Police subduing tax protester (Bristol, England)
 Life 13:16 (2) My '90
—Soccer game riot (Dusseldorf, West Germany)
 Sports Illus 68:49–53 (c,3) Je 27 '88
—Student riot (Seoul, South Korea)
 Nat Geog 174:244–7 (c,1) Ag '88
 Smithsonian 19:54 (c,3) Ag '88
Rites and ceremonies. See
 FUNERAL RITES AND CEREMONIES
 HAND SHAKING
 MARRIAGE RITES AND CUSTOMS
 RELIGIOUS RITES AND FESTIVALS
 specific countries—RITES AND FESTIVALS
RIVERA, DIEGO
 Trav&Leisure 20:22 (3) D '90
—"The Grinder"
 Trav/Holiday 174:83 (painting,c,4) S '90
—Mural by him (Mexico)
 Gourmet 49:66 (c,4) F '89
—Mural of Zapata
 Trav/Holiday 174:47 (painting,c,4) O '90
RIVERBOATS
—18th cent. riverboat reproduction (Virginia)
 Nat Geog 171:cov., 716–17 (c,1) Je '87
—Amazon River, Peru
 Natur Hist 96:56–61 (c,1) O '87
—History of the "Delta Queen"
 Trav/Holiday 173:74–9 (c,1) Je '90
—"Mississippi Queen"
 Am Heritage 38:24 (c,4) Ap '87
 Trav&Leisure 19:42–3 (c,3) Jl '89
—Paddle wheeler (Galveston, Texas)
 Trav&Leisure 18:246 (c,3) D '88
—Paddleboat "Natchez"
 Trav/Holiday 168:52 (c,4) Jl '87
—Stern-wheeler (Kentucky)
 Gourmet 48:72 (c,4) My '88
—Stern-wheeler (Lake Tahoe, Nevada/California)
 Sports Illus 72:6–7 (c,3) My 14 '90

—Zaire
 Nat Geog 180:2–25 (c,1) N '91
RIVERS
—Alsek, Alaska
 Natur Hist 97:52–63 (map,c,1) My '88
—Brooks River, Katmai National Park, Alaska
 Trav/Holiday 174:59 (c,2) Jl '90
—Chao Phraya River, Bangkok, Thailand
 Trav/Holiday 176:48–56 (map,c,1) N '91
—Charente River, France
 Trav/Holiday 174:66–7, 70 (c,1) Ag '90
—Charles River, Cambridge, Massachusetts
 Gourmet 49:92–3 (c,1) S '89
 Nat Geog 177:78–9 (c,1) Je '90
—Chicago River, Chicago, Illinois
 Trav&Leisure 20:180 (c,4) O '90
—Cuyahoga River, Cleveland, Ohio
 Trav&Leisure 19:113, 116 (c,1) Ap '89
—Feni, Bangladesh
 Nat Geog 172:92–101 (c,1) Jl '87
—Green River, Vermont
 Trav&Leisure 174:38–9 (c,1) Jl '90
—Green River, Wyoming
 Natur Hist 100:68–71 (map,c,1) Je '91
—Hampton, Virginia
 Trav/Holiday 169:51 (c,2) F '88
—Han River, Seoul, South Korea
 Sports Illus 69:38 (c,3) S 14 '88
—Harlem River, New York City (1890)
 Nat Geog 175:248 (3) F '89
—Hayes, Manitoba
 Nat Geog 172:202–3 (c,1) Ag '87
—Jinshui River, Sichuan province, China
 Life 13:74 (c,3) O '90
—Kalamazoo River, Michigan
 Sports Illus 71:76–90 (painting,c,1) Jl 24 '89
—Kissimmee River, Florida
 Nat Geog 178:96 (c,4) Jl '90
 Nat Wildlife 29:18–20 (map,c,1) Ap '91
—Kongakut, Alaska
 Nat Geog 174:852–3 (c,1) D '88
—McKenzie, Oregon
 Life 10:40–1 (c,1) Jl '87
—Moskva, Moscow, U.S.S.R.
 Trav/Holiday 168:62–3 (c,1) Ag '87
—Narmada River, India
 Smithsonian 21:118–33 (map,c,1) N '90
—Nashua River, Massachusetts
 Nat Wildlife 27:6–7 (c,2) Ag '89
—Neckar, Heidelberg, West Germany
 Gourmet 47:49 (c,1) Ja '87
—New River, West Virginia
 Trav/Holiday 169:72–5 (c,2) F '88
—New River, West Virginia (1906)
 Am Heritage 39:86–7 (1) Jl '88
—Okavango River, Botswana

Nat Geog 178:8, 46–7 (map,c,1) D '90
—Palouse River, Washington
Nat Geog 176:808–9 (c,1) D '89
—Pearl, Canton, China
Gourmet 47:58–9 (c,1) My '87
—Rio Napo, Ecuador
Trav&Leisure 20:186 (c,3) Mr '90
—Russian River, California
Trav&Leisure 18:161 (c,2) D '88
Trav&Leisure 21:82–3, 129 (c,1) Mr '91
—Saigon River, Vietnam
Nat Geog 176:610–13 (c,1) N '89
—Salmon, Idaho
Trav/Holiday 167:56–61 (c,2) My '87
Gourmet 48:60–5, 102 (map,c,1) Jl '88
Trav&Leisure 19:136–9, 177 (c,1) Mr '89
—Salzach River, Salzburg, Austria
Gourmet 50:100 (c,3) D '90
—San Pedro River, Arizona
Smithsonian 20:44–5 (c,3) Ja '90
—Savage River, Maryland
Sports Illus 71:2–3 (c,1) Jl 3 '89
—Sigatoka River, Fiji
Trav&Leisure 21:108–9 (c,1) F '91
—Singapore, Malaysia
Trav/Holiday 168:44–5 (c,2) D '87
—Songhua River, China
Nat Geog 175:281–3 (c,1) Mr '89
—Sundborn, Sweden
Gourmet 47:58 (c,3) Jl '87
—Tatshenshini River, Alaska/Canada
Life 14:72–6 (map,c,1) My '91
—Usumacinta River, Mexico
Trav&Leisure 20:100, 105 (map,c,4) O '90
—Zangbo River, Tibet
Nat Geog 174:674–9, 690–3 (map,c,1) N '88
Natur Hist 100:66 (c,4) Ja '91
—See also
AMAZON
APALACHICOLA
BRAHMAPUTRA
COLORADO
COLUMBIA
CONNECTICUT
CUMBERLAND
DAMS
DANUBE
DELAWARE
DETROIT
GANGES
HUANG HO
HUDSON
INDUS
KENNEBEC
LOIRE
MEKONG
MEUSE

MISSISSIPPI
MISSOURI
NEVA
NIGER
NILE
OHIO
POTOMAC
RIO GRANDE
RIO NEGRO
ST. LAWRENCE
SAVANNAH
SEINE
SHENANDOAH
SNAKE
SUWANNEE
THAMES
WATERFALLS
WILLAMETTE
YUKON
ZAIRE
RIYADH, SAUDI ARABIA
—King's palace
Life 11:90–6 (c,1) Ap '88
ROAD RUNNERS (BIRDS)
Smithsonian 18:84 (c,4) Ag '87
Nat Wildlife 27:16 (c,2) Ap '89
Natur Hist 98:34–41 (c,1) S '89
—Road runner eggs
Natur Hist 98:39 (c,4) S '89
ROADS
—Ancient Roman milestone (Jordan)
Smithsonian 18:106 (c,4) N '87
—Ancient Roman road (Turkey)
Nat Geog 176:356–7 (c,1) S '89
—Bavaria, Germany
Gourmet 50:52–3, (c,2) Ag '90
—Country road (Indiana)
Gourmet 50:113 (c,1) N '90
—Country road (Portugal)
Trav&Leisure 20:202 (c,3) O '90
—Country road (West Virginia)
Trav&Leisure 19:117 (c,3) N '89
—Curving mountain road (French Alps)
Nat Geog 176:135 (c,1) Jl '89
—Dirt road
Life 12:51 (c,3) O '89
—Iowa
Am Heritage 39:66–7 (c,3) Ap '88
—Lonely Montana road
Life 11:68–9 (c,3) Ag '88
—Lonely Texas road
Smithsonian 19:86 (c,1) My '88
—Sites along India's Grand Trunk Road
Nat Geog 177:118–37 (map,c,1) My '90
—See also
HIGHWAYS
ROADS—CONSTRUCTION
—Alaska Highway (1940s)
Nat Geog 180:78–9 (4) N '91

—Atlanta, Georgia
Nat Geog 174:16 (c,1) Jl '88
—Bhutan
Life 11:86–95 (c,1) Mr '88
—Building the Pennsylvania Turnpike
(1930s)
Am Heritage 41:106 (4) My '90
—Ecuadoran forest
Smithsonian 22:48–9 (c,1) Je '91
—Highway 126
Trav/Holiday 174:60 (4) Ag '90
—Kashmir
Nat Geog 172:539 (c,3) O '87
—Road repair (India)
Nat Geog 177:128 (c,4) My '90
ROBESON, PAUL
Am Heritage 40:12 (drawing,4) Ap '89
Smithsonian 20:175 (painting,c,4) N '89
ROBINS
Nat Wildlife 27:23 (c,1) D '88
ROBINSON, EDWARD G.
Life 10:18 (4) Ap '87
ROBINSON, JACKIE
Sports Illus 66:4 (4) Ja 26 '87
Sports Illus 67:57 92) Jl 20 '87
Sports Illus 67:72, 74 (c,3) S 28 '87
Life 11:104 (4) Spring '88
Sports Illus 71:48–9 (1) N 15 '89
Sports Illus 72:28 (4) Ap 16 '90
Life 13:28 (4) Fall '90
ROBOTS
Smithsonian 18:152 (c,4) O '87
—Robot bee used to study bee com-
munications
Nat Geog 177:134–40 (c,1) Ja '90
—Robot jockey on miniature horses (Ala-
bama)
Sports Illus 66:8 (c,4) Ja 26 '87
—Robot sparring partner
Sports Illus 67:18 (c,4) Jl 6 '87
—Robotic dinosaurs
Smithsonian 20:46–57 (c,1) Ag '89
—Robotic suitcase carrier
Smithsonian 21:73 (c,1) S '90
—Robots designed like insects
Smithsonian 22:64–73 (c,1) Je '91
—Robots for reconnaissance work
Life 12:80–1 (c,1) F '89
—"Star Wars" R2D2 (1977)
Sports Illus 71:148 (c,4) N 15 '89
ROCK CARVINGS
—15th–16th cent. Pueblo rock carvings
(New Mexico)
Nat Geog 172:621 (c,3) N '87
Nat Geog 180:6, 84 (c,4) O '91
—18th cent. carving of surfer (Hawaii)
Smithsonian 20:108 (c,4) Je '89
—Ancient Indian carvings in desert (Cali-
fornia)

Nat Geog 171:62–3 (c,1) Ja '87
—Washington
Nat Geog 180:38 (c,4) O '91
—See also
CAVE PAINTINGS
ROCK PAINTINGS
ROCK CLIMBING
—Hotel wall climbing competition (Utah)
Sports Illus 69:117–20 (c,3) O 3 '88
—Indoor climbing wall (North Carolina)
Sports Illus 66:12 (c,4) Ja 19 '87
—New York
Life 12:103–4 (c,1) Ag '89
—Rappelling down cliff (Hawaii)
Nat Wildlife 27:23 (c,4) O '89
—Rock gym (Boston, Massachusetts)
Sports Illus 72:9–10 (c,3) Ap 30 '90
—Santa Barbara, California
Sports Illus 67:64 (c,1) S 7 '87
—Washington
Sports Illus 70:112 (c,4) F 10 '89
Rock of Gibraltar. See
GIBRALTAR
ROCK PAINTINGS
—15th cent. Indian rock paintings (Mani-
toba)
Nat Geog 172:222–3 (c,1) Ag '87
—Aboriginal rock paintings (Australia)
Nat Geog 173:268–71, 278–80, 286–7
(c,1) F '88
—Ancient Pedra Furada rock art (Brazil)
Natur Hist 96:8–10 (c,4) Ag '87
Smithsonian 21:141 (c,4) Mr '91
—Ancient rock paintings (Algeria)
Nat Geog 172:180–91 (c,1) Ag '87
Natur Hist 100:24–5 (c,4) S '91
—Indian pictograph (Idaho)
Gourmet 48:63 (c,4) Jl '88
—Navajo pictograph (Arizona)
Trav/Holiday 176:62 (c,4) Jl '91
—Nazca Indian lines drawn on Peruvian
hillsides
Nat Geog 177:76–7, 90–1 (c,1) Mr '90
—See also
CAVE PAINTINGS
ROCK CARVINGS
ROCKEFELLER, JOHN D.
Am Heritage 38:cov. (painting,c,1) N '87
Nat Geog 173:24 (4) Ja '88
Life 13:61 (4) Fall '90
Life 14:36 (4) Summer '91
—Rockefeller family members
Am Heritage 38:51–2 (4) D '87
ROCKEFELLER, NELSON
—Making rude middle finger sign
Sports Illus 71:143 (4) N 15 '89
ROCKEFELLER CENTER, NEW
YORK CITY, NEW YORK
—Rockefeller Center Christmas tree

Nat Wildlife 28:13 (c,2) D '89
ROCKETS
—China
Smithsonian 21:128–9 (c,1) O '90
—Goddard's first working rocket (1926)
Smithsonian 20:46 (4) N '89
—Russian (Cuba)
Nat Geog 180:90–1 (c,1) Ag '91
—Small weather rocket (India)
Nat Geog 173:599 (c,4) My '88
—See also
GODDARD, ROBERT
ROCKNE, KNUTE
Am Heritage 39:40 (4) N '88
ROCKS
—America's Stonehenge, New Hampshire
Trav/Holiday 168:28 (c,4) Jl '87
—Ancient Wizard Stones, Honolulu, Hawaii
Trav/Holiday 174:78–9 (c,1) O '90
—Arch Rock, Michigan
Gourmet 49:71 (c,1) Je '89
—Ayers Rock, Australia
Trav&Leisure 17:A38 (c,4) O '87 supp.
Trav&Leisure 18:202 (c,4) Je '88
—Beacon Rock, Washington
Am Heritage 39:85 (c,4) Ap '88
—Camel Rock, Shawnee National Forest, Illinois
Natur Hist 96:66–7 (c,1) Je '87
Natur Hist 98:60 (c,3) Ja '89
—Cathedral Rock, Arizona
Trav&Leisure 20:116–17 (c,1) Ja '90
—Chimney Rock, Colorado
Nat Geog 175:246 (c,4) F '89
—Devils Hopyard Canyon, White Mountains, New Hampshire
Natur Hist 96:38–40 (map,c,1) O '87
—El Arco de Finisterra, Baja, Mexico
Gourmet 48:80–1 (c,1) O '88
—Glacial boulders (Nova Scotia)
Natur Hist 99:78 (c,1) F '90
—Grand Menhir Brisé, Brittany, France
Smithsonian 20:148 (c,4) S '89
—Great Sandy Desert, Australia
Nat Geog 179:32–3 (c,1) Ja '91
—Haystack Rock, Oregon
Trav/Holiday 175:80–1 (painting,c,1) Mr '91
Trav&Leisure 21:168 (c,4) S '91
—Huge gilded boulder (Burma)
Life 13:56–7 (c,1) D '90
—In riverbed
Life 10:8–9 (c,1) Je '87
Natur Hist 98:86 (c,1) Mr '89
Trav/Holiday 174:38–9 (c,1) Jl '90
—Lighthouse, Palo Duro Canyon, Texas
Trav/Holiday 170:47 (c,1) D '88
—Moon rocks

Life 12:58–9 (c,1) Jl '89
—Natural Arches, Bermuda
Trav&Leisure 21:120–1 (c,1) F '91
—The Olgas (Australia)
Nat Geog 173:157–9, 200–1 (c,1) F '88
—Paint Rock, North Carolina
Natur Hist 98:64–5 (map,c,1) Ag '89
—Precariously perched rock (Maine)
Trav/Holiday 171:51 (c,4) F '89
—Pyramid Lake, Nevada
Sports Illus 71:4–5 (c,4) N 6 '89
—Remarkable Rocks, Kangaroo Island, Australia
Trav/Holiday 168:26 (c,4) S '87
—Sandstone rock (Louisiana)
Natur Hist 98:32 (c,2) F '89
—Ship Rock, New Mexico
Nat Geog 172:624–5 (c,1) N '87
Smithsonian 21:104–5 (c,1) D '90
—Teapot Rock (Wyoming)
Am Heritage 40:47 (c,2) Ap '89
—Volcanic rocks (Texas)
Trav&Leisure 21:124–5 (c,1) S '91
—See also
GARDEN OF THE GODS
LIMESTONE
MINERALS
ROCKWELL, NORMAN
—1964 Rockwell painting of school desegregation
Smithsonian 20:125 (c,3) Ap '89
—"Blood Brothers"
Life 12:10 (painting,c,4) Ag '89
—"Southern Justice"
Life 12:10 (painting,c,4) Ag '89
ROCKY MOUNTAIN GOATS
Nat Wildlife 29:40–5 (c,1) Ag '91
ROCKY MOUNTAIN NATIONAL PARK, COLORADO
Trav/Holiday 173:78–84, 88 (map,c,1) F '90
Life 14:18–19, 32 (c,1) Summer '91
ROCKY MOUNTAINS, CANADA
Smithsonian 19:70–1 (c,1) D '88
—Alberta
Gourmet 48:54–5 (c,1) Ja '88
Gourmet 50:95–5, 210 (map,c,1) D '90
Trav/Holiday 176:40–6 (c,1) D '91
—British Columbia
Gourmet 50:90–5, 210 (map,c,1) D '90
ROCKY MOUNTAINS, COLORADO
Trav&Leisure 18:197 (c,4) Je '88
Trav&Leisure 18:cov., 132–7 (c,1) N '88
Am Heritage 41:86 (c,4) S '90
Trav/Holiday 175:74–5, 78–9 (c,1) Je '91
—Telluride
Gourmet 47:55–7 (c,1) Ja '87
Trav/Holiday 175:74–5 (c,1) Je '91
—Vail

Sports Illus 70:70–82 (c,1) Ja 30 '89
—See also
PIKES PEAK
ROCKY MOUNTAINS, U.S.
—Northern Rockies region
Trav&Leisure 19:107–77, 182–8
(map,c,1) Mr '89
RODENTS
—Gerbils
Nat Wildlife 29:54 (c,4) O '91
—Maras
Smithsonian 18:182 (c,4) Mr '88
—See also
BATS
BEAVERS
CAPYBARAS
CHIPMUNKS
COYPUS
MARMOTS
MICE
PORCUPINES
PRAIRIE DOGS
SQUIRRELS
WHITE-FOOTED MICE
VOLES
RODEOS
Sports Illus 67:57 (c,4) S 7 '87
Sports Illus 69:68–72 (painting,c,4) S 19
'88
Sports Illus 69:8 (c,3) N 28 '88
Sports Illus 69:2–3, 28–35 (c,1) D 19 '88
Trav&Leisure 19:130–1, 151–3 (c,1) Mr
'89
Trav/Holiday 173:52–7 (c,1) My '90
—Chile
Natur Hist 96:52–3 (c,1) My '87
—Futurity cutting horse event (Texas)
Sports Illus 74:2–3, 62–74 (c,1) F 25 '91
—Mexico
Trav/Holiday 171:53 (c,2) Je '89
—National Finals rodeo (Nevada)
Sports Illus 73:2–3, 48–50 (1) D 24 '90
—National Finals rodeo 1965
Sports Illus 74:160 (4) F 11 '91
—New York City, New York
Sports Illus 69:6 (c,3) Ag 8 '88
—Roping calf (Nebraska)
Smithsonian 21:44 (c,4) N '90
—Twirling lasso (Colorado)
Trav/Holiday 175:77 (c,4) Je '91
RODGERS, RICHARD
Life 13:111 (1) Fall '90
RODIN, AUGUSTE
—"Burghers of Calais"
Smithsonian 21:18 (sculpture,c,4) Ag
'90
—Bust of Balzac
Gourmet 47:48 (c,4) S '87
Smithsonian 19:30 (c,4) Ag '88

—Sculpture by him (Philadelphia, Pennsyl-
vania)
Trav/Holiday 167:49 (c,1) Ap '87
RODNEY, CAESAR
—Statue (Wilmington, Delaware)
Trav/Holiday 170:16 (c,3) S '88
ROEBLING, JOHN A.
Am Heritage 42:46 (4) Ap '91
ROEBLING, WASHINGTON A.
Am Heritage 42:46, 51 (painting,c,4) Ap
'91
ROGERS, GINGER
Life 12:13 (c,4) Spring '89
ROGERS, WILL
Trav/Holiday 168:32 (sculpture,c,4) Jl
'87
Life 13:15 (4) Fall '90
Trav/Holiday 176:5, 74 (2) Jl '91
ROLLER COASTERS
Life 12:34–7 (c,1) Jl '89
Smithsonian 20:82–93 (c,3) Ag '89
Trav&Leisure 21:82 (c,4) Ja '91
—1884 Coney Island roller coaster ride
(Brooklyn, N.Y.)
Smithsonian 20:86 (drawing,c,4) Ag '89
—Bordeaux Carnival, France
Gourmet 48:cov. (c,1) S '88
—New Zealand
Nat Geog 171:678–9 (c,1) My '87
ROLLER SKATING
—Being pulled by sheep dog (California)
Life 11:54–5 (c,1) Je '88
—California
Sports Illus 67:52, 70 (c,2) S 7 '87
—Competition
Sports Illus 69:12–13 (c,4) O 3 '88
—In-line skating
Life 14:96 (c,2) Ja '91
Sports Illus 74:6 (c,4) Je 3 '91
Sports Illus 75:4–5 (c,3) D 16 '91
—Pan American Games 1987 (Indiana)
Sports Illus 67:18–19 (c,2) Ag 24 '87
Sports Illus 67:84–5 (c,1) D 28 '87
—Skating under limbo bar (Texas)
Life 14:16 (c,4) My '91
ROLLING STONES
—Mick Jagger
Life 13:46 (c,3) Ja '90
ROMAN EMPIRE
—61 A.D. Roman attack on Druids
(Wales)
Smithsonian 18:152 (engraving,4) Mr '88
—See also
CAESAR, JULIUS
CLAUDIUS
DIOCLETIAN
EPHESUS
HADRIAN
HERCULANEUM

Life 14:6–7 (c,1) My '91
—Traditional
Trav/Holiday 167:103 (4) Ap '87
ROMANIA—HISTORY
—Nikolae Ceausescu
Sports Illus 71:41 (c,4) D 11 '89
—Deposed royalty
Life 13:34–5 (c,1) Mr '90
—See also
CAROL II
ROMANIA—POLITICS AND GOV-
ERNMENT
—Political rally
Life 13:6–7 (c,1) Jl '90
—Ruins of Ceausescu's palace
Life 13:6–7 (c,1) F '90
—TV picture of murdered Ceausescu
Nat Geog 177:126 (c,4) Ap '90
ROMANIA—SOCIAL LIFE AND CUS-
TOMS
—Scenes of Romanian life
Life 13:6–7, 82–8 (c,1) Ap '90
ROME, ITALY
—18th cent. paintings of Rome
Smithsonian 19:240 (c,4) N '88
—Aventine
Trav&Leisure 18:204–7, 212 (c,2) O '88
—Castel Sant'Angelo
Trav/Holiday 175:70–1 (c,3) Je '91
—Map
Trav/Holiday 176:70–1 (c,2) D '91
—Map of Trastevere
Trav&Leisure 18:213 (c,4) My '88
—Palazzo salons
Trav&Leisure 17:162, 164 (c,3) Je '87
—Piazza Navona
Trav&Leisure 18:157 (c,3) N '88
—Romulus and Remus symbols of Rome
Nat Geog 173:737 (sculpture,c,3) Je '88
—Settings of Puccini's "Tosca"
Trav/Holiday 175:68–71 (map,c,1) Je '91
—Spanish Steps
Trav&Leisure 17:68 (c,2) Ap '87 supp.
Trav&Leisure 17:88 (c,4) D '87
Gourmet 51:89 (c,1) Ja '91
—Three-dimensional puzzle of Rome
Trav&Leisure 18:56–7 (c,1) My '88
—See also
COLOSSEUM
PANTHEON
VATICAN CITY
ROMMEL, ERWIN
Am Heritage 42:106 (4) D '91
ROOSEVELT, ELEANOR
Am Heritage 38:50 (4) Ap '87
Am Heritage 38:109 (4) S '87
Smithsonian 19:185 (4) D '88
Am Heritage 40:57–74 (4) S '89
Smithsonian 20:64 (4) D '89

Life 13:8 (1) Fall '90
ROOSEVELT, FRANKLIN DELANO
Am Heritage 38:41, 50 (3) Ap '87
Am Heritage 38:102 (2) Jl '87
Life 10:71 (4) Ag '87
Am Heritage 38:69 (2) D '87
Am Heritage 39:cov., 34–50 (c,1) F '88
Am Heritage 39:10, 100 (c,4) My '88
Sports Illus 69:82 (4) Ag 22 '88
Am Heritage 39:158 (4) N '88
Am Heritage 40:95 (4) Mr '89
Am Heritage 40:57–74 (4) S '89
Am Heritage 40:66 (4) N '89
Smithsonian 20:59–65 (4) D '89
Life 13:68 (1) Fall '90
Am Heritage 42:70, 72 (4) D '91
—Caricatures of FDR
Am Heritage 39:cov., 3 (c,1) F '88
—Cartoons about FDR
Am Heritage 39:37, 42, 48 (4) F '88
—FDR fishing (Georgia)
Trav/Holiday 173:66–7 (2) F '90
—FDR's face on wooden pipe
Smithsonian 21:86 (c,4) D '90
—FDR's political campaign memorabilia
Smithsonian 20:66, 69 (c,2) D '89
—Home (Hyde Park, New York)
Am Heritage 38:41–50 (c,2) Ap '87
Smithsonian 20:59–69 (c,2) D '89
Trav/Holiday 172:68, 70–2 (map,c,1) D
'89
—Items belonging to him
Smithsonian 20:59–69 (c,2) D '89
—Metal sculpture of FDR
Smithsonian 21:86 (c,4) D '90
—Young FDR (1909)
Life 10:36 (4) Mr '87
ROOSEVELT, THEODORE
Am Heritage 38:111 (4) S '87
Am Heritage 39:93 (painting,c,2) S '88
Smithsonian 20:154 (4) My '89
Natur Hist 98:32 (3) N '89
Life 13:69 (4) Fall '90
Am Heritage 41:120 (4) N '90
—1901 cartoon about Roosevelt's foreign
policy
Smithsonian 21:138 (4) Je '90
—Caricature
Am Heritage 39:114 (c,1) Jl '88
—Daughter Alice Roosevelt Longworth
Am Heritage 39:14 (drawing,4) My '88
—In western garb
Am Heritage 40:8 (4) N '89
Natur Hist 100:64, 67 (4) F '91
—Mount Rushmore sculpture, South Da-
kota
Life 13:2–3, 50–2 (c,1) F '90
—Rough Riders charging up San Juan Hill
Nat Geog 174:214–15 (painting,

RUGS
—5th cent. B.C. rug (Siberia)
 Nat Geog 173:558 (c,2) My '88
—18th cent. Gördes prayer rug (Turkey)
 Smithsonian 17:112 (c,4) Mr '87
—Afghan rug depicting weapons
 Life 12:8 (c,4) Mr '89
—Indian carpet
 Gourmet 47:68–9 (c,4) S '87
—Rug merchant (Morocco)
 Trav&Leisure 18:97 (c,1) Jl '88
—Rug merchant (Turkey)
 Gourmet 48:95 (c,3) D '88
—Textile Museum, Washington, D.C.
 Smithsonian 17:108–17 (c,1) Mr '87
RULERS AND MONARCHS
—16th cent. rulers
 Nat Geog 172:562–3 (painting,c,4) N '87
—1990 coronation of Empress Michiko (Japan)
 Life 14:10–11 (c,1) Ja '91
—Contemporary royals in exile
 Life 13:34–45 (c,1) Mr '90
—Emperor Alexius Comnenus (Turkey)
 Nat Geog 176:349 (painting,c,4) S '89
—Ngo Dinh Diem (Vietnam)
 Am Heritage 39:42 (4) N '88
—German rulers (955–1945)
 Smithsonian 21:82–95 (c,1) Mr '91
—Václav Havel (Czechoslovakia)
 Nat Geog 179:22–3 (c,1) Mr '91
—Iraqi president Saddam Hussein
 Nat Geog 173:654 (painting,c,4) My '88
 Life 13:6–7 (c,1) O '90
 Life 14:37, 113 (c,3) Ja '91
 Life 14:49 (c,4) Mr '91
—Jordan's King Hussein
 Life 13:6–7 (c,1) O '90
—Kim II Sung (North Korea)
 Life 11:87, 92 (painting,c,3) S '88
—King Jigme Singye Wangchuck (Bhutan)
 Nat Geog 179:80–1 (c,1) My '91
—King Kamehameha I (Hawaii)
 Trav/Holiday 174:80 (c,4) O '90
—Czar Alesky Mikhailovich (Russia)
 Smithsonian 21:140 (painting,c,4) Ja '91
—Mohawk chief Hendrick (1710)
 Nat Geog 172:372 (painting,c,4) S '87
—Daniel Ortega (Nicaragua)
 Life 11:14–15 (c,1) Ja '88
—Palestinian leader Yassir Arafat
 Life 11:160 (c,4) Fall '88
—Pictorial history of Russia
 Nat Geog 179:5–8 (c,1) F '91
—President Pinochet (Chile)
 Nat Geog 174:60 (c,4) Jl '88
—Sweden
 Trav&Leisure 18:37 (c,4) Ap '88
—*Time*'s men of the year (1957–63)

 Smithsonian 17:18 (c,4) Mr '87
—See also
 ALEXANDER III
 ANNE
 ASSURBANIPAL
 BORIS III
 CAESAR, JULIUS
 CAROL II
 CASTRO, FIDEL
 CATHERINE II, THE GREAT
 CHARLES V
 CHIANG KAI-SHEK
 CHOU EN-LAI
 CHRISTOPHE, HENRI
 CLAUDIUS
 CROWNS
 DE GAULLE, CHARLES
 EDWARD VII
 EDWARD VIII
 ELIZABETH I
 ELIZABETH II
 FAISAL I
 FERDINAND V
 FRANCO, FRANCISCO
 FRANCOIS I
 FREDERICK THE GREAT
 FREDERICK III
 GEORGE V
 GEORGE VI
 GORBACHEV, MIKHAIL
 GUSTAV III
 HADRIAN
 HAMMURABI
 HENRI IV
 HENRY VIII
 HITLER, ADOLF
 HO CHI MINH
 ISABELLA I
 IVAN IV
 JUSTINIAN
 KARL X GUSTAV
 KHRUSHCHEV, NIKITA
 KHUFU
 KRISTINA
 KUBLAI KHAN
 LENIN, NIKOLAI
 LOUIS XIII
 LOUIS XIV
 LOUIS XVI
 MAO ZEDONG
 MARCOS, FERDINAND
 MARIA THERESA
 MARIE ANTOINETTE
 MARY, QUEEN OF SCOTS
 MARY OF TECK
 NAPOLEON
 NAPOLEON III
 NEFERTITI
 OTTO I

- S -

SABER-TOOTHED CATS
Natur Hist 99:74–5 (painting,c,4) Ja '90
SACRAMENTO, CALIFORNIA
—Railroad Museum
Trav/Holiday 172:64–70 (c,1) O '89
SADNESS
—Family watching departing sailor father
Life 14:24 (2) D '91
SAFES
—1900 interior of safe
Am Heritage 42:6 (painting,c,2) F '91
SAFFRON
Smithsonian 19:104–11 (c,1) Ag '88
SAFFRON INDUSTRY—HARVESTING
—Spain
Gourmet 50:124–5 (c,4) O '90
SAGE
Gourmet 50:130 (painting,c,4) N '90
SAGEBRUSH
Natur Hist 97:60 (c,4) O '88
Nat Geog 175:52–3, 63 (c,1) Ja '89
SAGUARO NATIONAL MONUMENT,
ARIZONA
Trav&Leisure 17:191–2 (map,c,4) D '87
Trav&Leisure 21:60, 62 (c,4) Je '91
SAHARA DESERT, EGYPT
Trav&Leisure 21:146–7 (c,1) O '91
Saigon, Vietnam. See
HO CHI MINH CITY
SAILBOAT RACES
Nat Geog 174:184–5 (c,1) Ag '88
Sports Illus 74:42–5 (c,1) My 20 '91
—America's Cup competition 1983
Sports Illus 71:176 (c,4) N 15 '89
—America's Cup competition 1987
Sports Illus 66:cov., 2–3, 10–19 (c,1) F 16
'87
Sports Illus 71:200–1 (c,1) N 15 '89
—America's Cup contenders
Sports Illus 66:46–62 (c,1) Ja 5 '87
Sports Illus 66:86–7 (c,3) Ja 12 '87
Sports Illus 66:2–3, 10–15 (c,1) Ja 26 '87
Sports Illus 66:66–71 (c,1) F 9 '87
Sports Illus 68:44–6, 51–2 (c,1) Je 13 '88
Life 11:82–5 (c,1) S '88
Sports Illus 69:24–5 (c,1) S 19 '88
—BOC challenge 1987
Sports Illus 66:74–5 (c,3) My 18 '87
—Party for New Zealand boat (Auckland)
Nat Geog 171:660–1 (c,1) My '87
SAILBOATS
Trav&Leisure 17:E2 (c,3) Je '87
Trav&Leisure 17:E2 (c,3) Ag '87
Trav/Holiday 171:36 (c,4) Ja '89
—Mid 19th cent. sailing ship (Massa-
chusetts)

Am Heritage 38:73 (painting,c,3) Ap '87
—America's Cup contenders
Sports Illus 68:44–6, 51–2 (c,1) Je 13 '88
—Catamaran
Nat Geog 175:584–5, 600–1 (c,1) My '89
—Dhows (Kenya)
Trav/Holiday 170:46–7 (c,1) Ag '88
Trav/Holiday 175:64–5, 68–9 (c,1) Mr '91
—Feluccas (Egypt)
Trav&Leisure 17:112–13 (c,1) O '87
Trav&Leisure 19:146 (c,4) S '89
—Gulets (Turkey)
Trav/Holiday 174:36–9 (c,1) Ag '90
—Italy
Gourmet 51:52–3 (c,1) Ag '91
—Sails
Life 10:8–9 (c,1) Mr '87
—Schooner
Trav/Holiday 174:50–2 (c,1) N '90
—Supermaxi racing boat designs
Sports Illus 67:28–30 (c,3) D 7 '87
—See also
JUNKS
YAWLS
SAILING
—Antarctic Islands
Nat Geog 175:340–8 (c,1) Mr '89
—Sailing class (Maryland)
Trav/Holiday 172:86 (c,2) Ag '89
—San Diego, California
Nat Geog 176:188–9 (c,1) Ag '89
—Virgin Islands
Trav/Holiday 169:cov., 44–9 (c,1) Ap '88
—Yachting (Turkey)
Trav&Leisure 18:cov. (c,1) D '88
SAILORS
—1915 (U.S.)
Am Heritage 38:38–9 (1) My '87
—France
Nat Geog 176:83 (c,4) Jl '89
—"Popeye" costume
Life 11:25 (c,2) F '88
—Steamboat workers
Nat Geog 22:42–5 (2) O '91
—U.S.S.R.
Nat Geog 175:602–3, 610–11 (c,1) My '89
—See also
BLIGH, WILLIAM
ST. AUGUSTINE, FLORIDA
—1586 attack by Francis Drake
Nat Geog 173:358–9 (drawing,1) Mr '88
—Castillo de San Marcos
Am Heritage 39:84 (c,3) Mr '88
Life 14:76 (c,4) Summer '91
—Ponce de Leon hotel (1930s)
Am Heritage 39:30 (4) F '88

ST. BERNARD DOGS
 Smithsonian 20:70–81 (c,1) Mr '90
 Trav/Holiday 173:21 (drawing,4) My '90
 Trav&Leisure 21:146 (c,4) Jl '91
—Monument to St. Bernard rescue dog
 (France)
 Smithsonian 20:73 (c,4) Mr '90
—St. Bernard aiding snowbound man
 (1820)
 Smithsonian 20:70–1 (painting,c,1) Mr
 '90
ST. ELIAS RANGE, ALASKA/YUKON
 Trav&Leisure 17:116–17 (c,1) D '87
 Trav/Holiday 176:38–9 (c,1) Jl '91
ST. GAUDENS, AUGUSTUS
—Bronze medallion of R. L. Stevenson
 Am Heritage 39:85 (c,4) D '88
—"Diana"
 Trav&Leisure 21:E14 (sculpture,c,4) Ap
 '91
 Trav&Leisure 21:103 (sculpture,c,1) Jc
 '91
—Home (New Hampshire)
 Trav&Leisure 21:E10, E14 (c,3) Ap '91
 Life 14:45 (c,1) Summer '91
ST. LAWRENCE RIVER, NORTH-
 EAST
 Trav/Holiday 169:48–51 (map,c,1) My
 '88
 Trav/Holiday 173:17 (map,c,3) Je '90
ST. LAWRENCE RIVER, QUEBEC
—Lachine Rapids, Montreal
 Nat Geog 179:62–3 (c,1) Mr '91
—St. Lambert locks, Montreal
 Trav/Holiday 169:50 (c,3) My '88
ST. LOUIS, MISSOURI
—Missouri Botanical Garden
 Nat Geog 178:132–40 (c,1) Ag '90
—Scene of 1904 Olympics
 Am Heritage 39:41 (2) My '88
St. Martin. See
 LEEWARD ISLANDS
ST. MORITZ, SWITZERLAND
 Trav&Leisure 18:90 (c,4) N '88
 Trav/Holiday 175:66–73 (map,c,1) Ja '91
—1948
 Sports Illus 75:58–9 (painting,c,4) D 16
 '91
ST. PAUL, MINNESOTA
—19th–20th cent. winter carnivals
 Smithsonian 17:62–5 (c,1) Ja '87
—1887
 Am Heritage 41:107 (4) Jl '90
—1890 census fight between Minneapolis
 and St. Paul
 Am Heritage 41:106–9 (2) Jl '90
ST. PAUL'S CATHEDRAL, LONDON,
 ENGLAND
 Trav&Leisure 20:160–1 (c,1) N '90

 Nat Geog 180:60–1 (1) Jl '91
—Chapel dedicated to American fighters
 Am Heritage 38:78 (c,4) Ap '87
ST. PETER'S BASILICA, VATICAN
 CITY
—Model at Popes' Museum, New Brun-
 swick
 Trav/Holiday 171:46 (c,4) F '89
ST. SOPHIA CATHEDRAL, IS-
 TANBUL, TURKEY
 Trav&Leisure 20:136–9, 195 (c,1) My '90
SAINTS
—5th cent. mass baptism by St. Patrick
 (Ireland)
 Smithsonian 18:162 (etching,3) Mr '88
—15th cent. fresco of St. Peter (Italy)
 Smithsonian 20:96, 102 (painting,c,4) F
 '90
—15th cent. St. Roch, patron saint of
 plague
 Nat Geog 173:678 (painting,c,4) My '88
—1502 painting of St. Nicholas (U.S.S.R.)
 Smithsonian 20:138 (c,4) Ap '89
—1554 John of the Ladder icon (U.S.S.R.)
 Nat Geog 177:86 (c,4) Ja '90
—"Martyrdom of St. Lawrence" by Titian
 (1547)
 Smithsonian 21:74–6 (painting,c,1) N '90
—St. Benedict
 Smithsonian 18:130, 148 (c,4) Ap '87
—St. Dominic
 Smithsonian 22:43 (painting,c,4) My '91
—St. Francis of Assisi
 Trav&Leisure 19:158 (painting,c,4) N
 '89
 Smithsonian 21:126–7 (painting,c,1) F
 '91
SAIPAN, MARIANA ISLANDS
 Nat Geog 178:46–7 (c,1) S '90
SALAMANDERS
 Natur Hist 96:82 (c,4) S '87
 Natur Hist 99:82 (c,3) Mr '90
 Nat Wildlife 28:12–16 (c,1) Ap '90
SALEM, MASSACHUSETTS
—1668 "House of the Seven Gables"
 Am Heritage 42:140 (c,4) N '91
SALISBURY, ENGLAND
—Salisbury Cathedral
 Trav&Leisure 20:161 (c,3) Ap '90
SALK, JONAS
 Life 13:36–40 (c,1) Ap '90
 Life 13:98 (1) Fall '90
SALMON
 Sports Illus 67:78 (c,4) O 26 '87
 Nat Geog 178:2–37 (c,1) Jl '90
 Nat Geog 179:90–1 (c,1) Je '91
—Life cycle of salmon
 Nat Geog 178:26–7 (painting,c,2) Jl '90
—Roe

Nat Geog 177:53 (4) F '90
—Salmon fry
Nat Geog 177:38 (c,2) Ja '90
Nat Geog 178:5 (c,4) Jl '90
—Salmon species
Nat Geog 178:19 (painting,c,4) Jl '90
—Sockeye
Sports Illus 68:85 (c,4) Mr 14 '88
Life 14:85 (c,1) Summer '91
Saloons. See
TAVERNS
SALT
—Desalination plant (Arizona)
Nat Geog 179:33 (c,4) Je '91
—Lake Assal salt flats, Djibouti
Nat Geog 177:6–7, 18–19 (c,1) My '90
—Salt deposits from evaporated water
(California)
Nat Geog 179:59 (c,4) F '91
SALT INDUSTRY
—Djibouti
Nat Geog 177:18–19 (c,1) My '90
—Salt hill (Vietnam)
Life 10:61 (c,4) D '87
Salt Lake City, Utah. See
GREAT SALT LAKE
SALT MINES
—Romania
Life 12:8 (c,4) F '89
SALTON SEA, CALIFORNIA
Nat Geog 171:74–5 (c,1) Ja '87
SALVADOR, BRAZIL
Trav&Leisure 20:80–2 (c,1) Ag '90
SALZBURG, AUSTRIA
Trav&Leisure 17:cov., 28–30, 92–103,
146–50 (c,1) Je '87
Gourmet 50:96, 100, 144, 146 (c,3) D '90
Trav&Leisure 21:190 (c,4) Je '91
SAMPANS
—Vietnam
Nat Geog 176:592–3, 612–13 (c,1) N '89
SAN ANTONIO, TEXAS
Trav&Leisure 19:102–14 (c,1) Ag '89
Trav/Holiday 173:27 (map,c,4) Mr '90
—Christmas decorations
Am Heritage 40:2a (c,4) S '89
—See also
ALAMO
SAN DIEGO, CALIFORNIA
Nat Geog 176:176–205 (map,c,1) Ag '89
Gourmet 50:cov., 66–71 (c,1) Ap '90
—Horton Plaza
Nat Geog 176:186 (c,4) Ag '89
—Hotel del Coronado
Trav&Leisure 18:56 (c,4) F '88
Nat Geog 176:204–5 (c,1) Ag '89
SAN FRANCISCO, CALIFORNIA
Am Heritage 38:92–8 (c,2) Ap '87
Gourmet 47:60–5 (c,1) Je '87

Trav&Leisure 18:28 (c,4) Ap '88
Trav&Leisure 20:84–6 (c,4) My '90
Gourmet 51:82–3 (c,1) Ja '91
Trav&Leisure 21:81–186 (map,c,1) Mr
'91
—1850s
Am Heritage 38:92–5 (2) Ap '87
—1853 fire on gunpowder ship
Am Heritage 41:86–7 (painting,c,1) D '90
—1878
Trav&Leisure 21:22 (4) Ja '91
—1906 San Francisco earthquake
Life 12:44 (4) F '89
—1939 Golden Gate International Expo
Am Heritage 40:42–53, 122 (c,1) My '89
—1989 earthquake damage
Sports Illus 71:6–7, 22–9 (c,1) O 30 '89
Sports Illus 71:213 (c,4) N 15 '89
Life 13:26–32 (c,1) Ja '90
Nat Geog 177:76–91, 96–105 (c,1) My '90
—Cable cars
Gourmet 47:62 (c,4) Je '87
Smithsonian 18:136–8 (c,2) F '88
—Embarcadero Plaza
Smithsonian 19:163 (c,2) D '88
—Fairmont Hotel
Trav&Leisure 17:79 (4) Je '87
Trav&Leisure 17:60–2 (c,4) O '87
—Hotels
Trav&Leisure 17:102–5 (c,2) D '87
Trav/Holiday 169:78 (c,4) F '88
Trav&Leisure 21:95–9 (c,1) Mr '91
—North Beach
Trav/Holiday 173:33 (map,c,4) Ap '90
Trav&Leisure 21:114–21, 196 (map,1)
Mr '91
—Ridge Trail
Nat Geog 177:99 (c,1) Je '90
—South of Market area map
Trav&Leisure 20:E22 (c,4) Ap '90
—See also
ALCATRAZ
GOLDEN GATE BRIDGE
SAN FRANCISCO-OAKLAND BAY
BRIDGE
SAN FRANCISCO-OAKLAND BAY
BRIDGE, CALIFORNIA
Gourmet 47:60–1 (c,1) Je '87
Trav/Holiday 169:82 (c,4) My '88
Gourmet 51:82–3 (c,1) Ja '91
—1989 earthquake damage
Sports Illus 71:23, 26 (c,4) O 30 '89
Nat Geog 177:86 (c,4) My '90
SAN JOSE, CALIFORNIA
—Night scene
Nat Geog 180:60–1 (c,1) Ag '91
SAN JUAN, PUERTO RICO
Trav/Holiday 173:cov., 48–57 (map,c,1)
F '90

SAPSUCKERS
—Red-naped sapsucker
 Smithsonian 20:38 (c,4) S '89
SARASOTA, FLORIDA
—John Ringling's home
 Trav/Holiday 172:NE6 (c,3) N '89
SARATOGA, NEW YORK
—19th–20th cents.
 Sports Illus 69:76–89 (c,1) Ag 22 '88
—Saratoga Springs
 Gourmet 51:48–53, 103 (c,1) Jl '91
SARDINE INDUSTRY
—1930s (Monterey, California)
 Nat Geog 177:8 (4) F '90
—Monterey, California
 Nat Geog 177:9 (c,1) F '90
SARDINIA, ITALY
 Trav&Leisure 18:134–54 (map,c,1) Ap
 '88
 Natur Hist 100:63 (c,1) Jl '91
SARGENT, JOHN SINGER
—"Madame X" (1884)
 Smithsonian 19:45 (painting,c,4) Jl '88
—Portrait of Robert Louis Stevenson
 Am Heritage 39:81, 90 (painting,c,4) D
 '88
SARTRE, JEAN-PAUL
 Life 10:120 (4) Ja '87
SASKATCHEWAN
—Countryside
 Sports Illus 68:308 (c,3) Ja 27 '88
 Nat Geog 174:336–7 (c,1) S '88
—Drought's effect on Saskatchewan lake
 Natur Hist 98:48–9 (c,3) Ja '89
SATELLITES
 Smithsonian 19:73, 78–80 (c,4) D '88
—Galileo
 Life 12:39 (c,2) O '89
—Home satellite dishes
 Smithsonian 20:156–68 (c,1) O '89
—LDEF satellite rescue
 Nat Geog 180:106–9, 114–18 (c,1) N '91
—Satellite launch (Japan)
 Smithsonian 21:134–5 (c,1) O '90
—Satellite rescue network for crash victims
 Smithsonian 17:136–46 (c,1) Mr '87
SATURN (PLANET)
 Life 12:134 (c,4) My '89
 Life 12:108–9 (c,1) N '89
 Nat Geog 178:48–9, 58–62, 65 (c,1) Ag
 '90
—Rings
 Smithsonian 19:46–7 (c,2) S '88
 Natur Hist 98:24 (c,4) D '89
SAUDI ARABIA
 Nat Geog 172:cov., 422–52 (c,1) O '87
—Qatif oasis
 Nat Geog 172:438–9 (c,1) O '87
—Tarut Island citadel

 Nat Geog 172:424–5 (c,1) O '87
—See also
 BEDOUINS
 JIDDAH
 MECCA
 RED SEA
SAUDI ARABIA—ART
—Large iron fist sculpture
 Nat Geog 172:432–3 (c,1) O '87
SAUDI ARABIA—COSTUME
 Life 11:90–6 (c,1) Ap '88
—Beaded headcloths
 Natur Hist 98:68 (c,3) Ag '89
—Bridal couple
 Nat Geog 172:426–7 (c,1) O '87
—Hands decorated with henna
 Nat Geog 172:445 (c,4) O '87
—King Fahd
 Life 11:90–5 (c,1) Ap '88
—Women in veils
 Nat Geog 172:cov., 422–52 (c,1) O '87
SAUDI ARABIA—HISTORY
—Mecca worshipers dead in airless tunnel
 Life 13:10–11 (c,1) S '90
—Ibn Saud
 Smithsonian 22:146 (4) My '91
—See also
 GULF WAR
SAUNAS
—Austria
 Sports Illus 68:52 (c,4) Ja 27 '88
—Football players in sauna (U.S.S.R.)
 Life 13:44–5 (c,1) Jl '90
—Toddlers in sauna (East Germany)
 Life 11:150–1 (c,1) N '88
SAVANNAH, GEORGIA
 Am Heritage 40:32 (c,4) F '89
 Gourmet 50:78–83, 144 (c,1) Je '90
SAVANNAH RIVER, SAVANNAH,
 GEORGIA
 Gourmet 50:80–3 (c,2) Je '90
SAVONAROLA, GIROLAMO
—1498 execution (Florence, Italy)
 Smithsonian 22:35 (painting,c,2) D '91
SAWMILLS
—Alaska
 Trav/Holiday 167:45 (c,4) Je '87
—Moving logs at sawmill (China)
 Nat Geog 173:305 (c,4) Mr '88
—Sutter's Mill, California
 Am Heritage 40:30 (c,4) My '89
SAXIFRAGE PLANTS
 Natur Hist 99:58–9 (c,1) Jl '90
SAXOPHONE PLAYING
 Sports Illus 67:64 (c,3) S 9 '87
 Sports Illus 71:112–13 (c,1) O 9 '89
 Smithsonian 20:176–8 (c,2) O '89
 Sports Illus 72:39 (c,3) Ja 8 '90
 Sports Illus 74:69 (c,2) Ap 22 '91

—In Central Park, New York City, New York
Sports Illus 69:10 (c,4) N 21 '88
—Playing sax to cows (Great Britain)
Life 14:92 (c,2) My '91
—See also
PARKER, CHARLIE
SCALES
—Baby scale (Laos)
Nat Geog 171:792 (c,4) Je '87
—Doctor's scale
Life 10:24–5, 34 (c,1) F '87
—Doctor's scale (U.S.S.R.)
Nat Geog 171:620 (c,4) My '87
—Weighing baboons
Natur Hist 98:60–3 (c,1) My '89
—Weighing caught fish (Alaska)
Trav/Holiday 172:64 (c,4) Ag '89
—Weighing cheese wheels (Italy)
Gourmet 47:77 (c,3) O '87
—Weighing dehydrated child (Mali)
Life 11:131 (2) Fall '88
—Weighing produce (Ecuador)
Natur Hist 100:79 (4) Jl '91
—Weighing tortoise (Arizona)
Nat Wildlife 27:14 (c,4) Ap '89
SCALLOPS
Natur Hist 97:50–1 (c,1) O '88
SCARECROWS
Nat Wildlife 26:18–21 (c,1) O '88
Gourmet 50:84 (drawing,3) Ap '90
—Battery-powered scarecrow (Mississippi)
Smithsonian 22:46 (c,4) Jl '91
SCHOLARS
—Confucian scholar (South Korea)
Smithsonian 19:56 (c,4) Ag '88
SCHOOLS
—1839 one-room schoolhouses
Am Heritage 41:68 (drawing,4) F '90
—1888 sod schoolhouse (Nebraska)
Smithsonian 18:72–3 (4) Mr '88
—Children eating school lunches
Life 13:106–7 (c,1) Spring '90
—Cincinnati Academy of Physical Education (CAPE), Ohio
Sports Illus 67:84–8 (c,4) O 26 '87
—Edinburgh Royal High School, Scotland
Nat Geog 174:360 (c,4) S '88
—High school (Brooklyn, New York)
Sports Illus 70:55 (c,3) My 15 '89
—One-room schoolhouse (Nebraska)
Smithsonian 21:48 (c,4) N '90
—One-room schoolhouse (New Zealand)
Nat Geog 171:673 (c,3) My '87
—School programs encouraging creativity (Indiana)
Life 13:56–61 (c,1) Spring '90
—Vocational high school program (Ohio)
Smithsonian 19:132–43 (1) My '88

—See also
CLASSROOMS
COLLEGES AND UNIVERSITIES
EDUCATION
MANN, HORACE
TEACHERS
SCHWAB, CHARLES
Am Heritage 42:16 (engraving,4) Jl '91
SCIENCE
—City of Science and Industry, Paris, France
Smithsonian 18:148–57 (c,1) O '87
—French technological accomplishments (19th–20th cents.)
Am Heritage 40:1–24 (c,1) Jl '89 supp.
—Model of superconductor
Nat Geog 176:760 (c,4) D '89
—Periodic Table
Nat Geog 176:757–9 (c,1) D '89
—See also
ANATOMY
ASTRONOMY
EVOLUTION
GENETICS
LABORATORIES
MEDICAL RESEARCH
MEDICINE—PRACTICE
SCIENTIFIC EXPERIMENTS
SCIENTIFIC INSTRUMENTS
SPACE PROGRAM
SCIENCE—HUMOR
—Announcing breakthrough discoveries
Smithsonian 22:72–80 (painting,c,2) My '91
SCIENCE EDUCATION
—Body parts drawn by children
Life 14:39 (c,3) S '91
—High school teacher demonstrating combustion (Wisconsin)
Life 13:60–1 (c,1) O '90
—School science fair projects
Smithsonian 21:62–73 (c,1) S '90
SCIENCE FICTION
—Film depictions of space creatures
Life 12:48–57 (c,1) Jl '89
—Hugo Gernsback's science fiction magazines
Smithsonian 21:44–5 (c,2) Ag '90
—History of science fiction
Am Heritage 40:cov., 42–54 (c,1) S '89
—Video simulation of artificial environments
Smithsonian 21:36–45 (c,1) Ja '91
—See also
UNIDENTIFIED FLYING OBJECTS
SCIENTIFIC EXPERIMENTS
—Analyzing garbage (Arizona)
Nat Wildlife 26:22 (c,4) Ag '88
—Animal specimens used in scientific study

—Kilts
 Life 11:37 (c,4) Mr '88
 Trav&Leisure 19:cov., 74 (c,1) Jl '89
—Prince Charles in kilt
 Trav&Leisure 19:47 (c,4) N '89
—Scottish expatriates (Hong Kong)
 Nat Geog 179:122–3 (c,1) F '91
SCOTLAND—SOCIAL LIFE AND CUS-
 TOMS
—New Year's Eve traditions
 Gourmet 48:64, 104 (painting,c,2) Ja '88
SCOTTS BLUFF NATIONAL MONU-
 MENT, NEBRASKA
 Trav&Leisure 20:109 (c,3) Mr '90
SCRANTON, PENNSYLVANIA
—Railroad station (1964)
 Am Heritage 39:110 (4) Jl '88
Scuba diving. See
 SKIN DIVING
SCULPINS
 Nat Geog 177:22 (c,3) F '90
SCULPTING
—Creating metal sculpture (Illinois)
 Smithsonian 21:60–1 (c,1) Jl '90
—Italy
 Smithsonian 19:106–15 (c,1) F '89
—Making doll from dough (China)
 Trav&Leisure 17:82 (4) Ag '87
—Sculpting Mount Rushmore, South Da-
 kota
 Trav/Holiday 175:74–5 (c,1) F '91
—Sculpting wood (West Germany)
 Smithsonian 20:118 (c,3) My '89
—Sculpting wood with chain-saw (British
 Columbia)
 Trav/Holiday 170:65 (c,3) Ag '88
SCULPTURE
—15th cent. wooden horse (Padua, Italy)
 Gourmet 48:63 (c,1) My '88
—1850 carved wooden folk art giraffe
 Am Heritage 40:113 (c,4) S '89
—1865 sculpture of freed female slave
 (Georgia)
 Am Heritage 42:4 (c,2) Jl '91
—1888 folk sculpture of newsboy
 Smithsonian 20:21 (c,4) Mr '90
—Animal sculptures
 Nat Wildlife 26:20–3 (c,1) Je '88
 Am Heritage 41:6, 66–73 (c,1) My '90
—Anti nuclear sculpture made from atomic
 weapon scraps
 Life 12:146–8 (c,1) Mr '89
—Auto-kinetic sculptures by George
 Rhoads
 Smithsonian 19:134–45 (c,1) O '88
—Botero sculptures (Monaco)
 Gourmet 48:69 (c,1) My '88
—By Dubuffet (France)
 Trav&Leisure 18:106–7 (c,1) Jl '88

—Caricature sculptures of famous athletes
 Sports Illus 72:58–70 (c,1) Ja 8 '90
—Clay images of goddess Kali (India)
 Smithsonian 22:32–3 (c,1) Jl '91
—Coconut sculpture of Harry Truman
 Smithsonian 21:cov. (c,1) D '90
—Dinosaur sculptures made from old auto
 parts (New Jersey)
 Smithsonian 21:164 (c,4) My '90
—Djénné bronze sculptures (Mali)
 Trav&Leisure 17:116 (c,4) Ja '87
—Eskimo sculpture depicting violent
 crimes (Northwest Terr.)
 Natur Hist 99:cov., 32–41 (c,1) Ja '90
—Folk art chicken
 Trav&Leisure 17:39 (c,4) N '87
—Gargoyle (Washington National Cathe-
 dral, D.C.)
 Smithsonian 21:14 (4) Ag '90
—Gaudier sculptures
 Smithsonian 19:66–77 (c,1) Je '88
—Huge garden sculptures (Thailand)
 Smithsonian 21:120–7 (c,1) Mr '91
—Ice sculpture (Alberta)
 Trav/Holiday 176:cov. (c,1) D '91
—Jade sculpture
 Nat Geog 172:288–315 (c,1) S '87
—Kalabari sculptures (Nigeria)
 Smithsonian 19:220 (c,4) D '88
—Land sculptures on midwestern farm-
 lands
 Nat Wildlife 27:30–3 (c,1) Je '89
—Large iron fist sculpture (Saudi Arabia)
 Nat Geog 172:432–3 (c,1) O '87
—Lighted ice sculptures (China)
 Nat Geog 173:308–9 (c,1) Mr '88
—Made from exploded metals
 Smithsonian 18:166–73 (c,1) D '87
—Made from tumbleweed (Texas)
 Smithsonian 19:87–8 (c,4) My '88
—Maori stone heads (Easter Island)
 Trav/Holiday 167:62 (c,4) Ja '87
 Trav&Leisure 21:178–9 (c,1) O '91
—Modern (Austria)
 Gourmet 47:44–5 (c,1) Jl '87
—Modern (Italy)
 Trav/Holiday 168:56 (c,1) S '87
—Modern outdoor work (Fort Wayne, In-
 diana)
 Gourmet 50:107 (c,3) N '90
—Modern works
 Trav&Leisure 17:10, 12, NY2–4 (c,3) My
 '87
—Modern works by Richard Hunt
 Smithsonian 21:62–3, 68–71 (c,1) Jl '90
—Modern works by Magdalena Jetelová
 (West Germany)
 Smithsonian 20:106–19 (c,1) My '89
—Modern works by Brett Whiteley

Nat Geog 173:226–7 (c,1) F '88
—Olympic sprinter (Vancouver, British Columbia)
Trav&Leisure 21:76 (c,3) Ag '91
—Rauschenberg's "1/4 Mile or 2 Furlong Piece"
Smithsonian 18:54 (c,4) My '87
—Sculpture in subway stations (Boston, Massachusetts)
Smithsonian 18:114–27 (c,1) Ap '87
—Sculpture of diner (Michigan)
Trav/Holiday 172:27 (c,4) S '89
—Show sculpture at North Pole
Life 12:7 (c,3) S '89
—Unusual works depicting 20th cent. presidents
Smithsonian 21:cov., 82–9 (c,1) D '90
—Wooden sculpture of shepherd (Lithuania)
Nat Geog 178:32 (c,4) N '90
—Wooden sculptures of insects
Smithsonian 19:117–19 (c,3) D '88
—Works by Elie Nadelman
Am Heritage 40:cov., 80–91 (c,1) Mr '89
—Works by Gustav Vigeland (Norway)
Trav&Leisure 20:152–3 (c,1) My '90
—Works by Gloria Vanderbilt Whitney
Am Heritage 40:106–7 (2) S '89
—See also
 BERNINI, GIOVANNI LORENZO
 CARPEAUX, JEAN-BAPTISTE
 DEGAS, EDGAR
 FRENCH, DANIEL CHESTER
 GAUGUIN, PAUL
 GHIBERTI, LORENZO
 GIACOMETTI, ALBERTO
 HOUDON, JEAN ANTOINE
 LIBERTY, STATUE OF
 MANSHIP, PAUL
 MICHELANGEO
 MIRO, JOAN
 MONUMENTS
 MOORE, HENRY
 NOGUCHI, ISAMU
 REMINGTON, FREDERIC
 RODIN, AUGUSTE
 ST. GAUDENS, AUGUSTUS
 SNOW SCULPTURES
 WOOD CARVINGS
SCULPTURE—ANCIENT
—1400 B.C. bronze horse (Denmark)
Nat Geog 171:414–15 (c,2) Mr '87
—14th cent. B.C. Egyptian sculpture
Smithsonian 19:84 (c,4) Je '88
—5th cent. B.C. "Charioteer" (Greece)
Trav&Leisure 20:251 (c,4) O '90
—5th cent. B.C. Greek sculpture
Trav&Leisure 18:42 (c,4) Ja '88
Gourmet 48:78 (c,4) O '88

—1st cent. silver Roman shepherd
Nat Geog 173:569 (c,4) My '88
—Ancient Olmec jade sculpture (Mexico)
Natur Hist 100:4, 10 (c,4) Ag '91
—Ancient Roman bronze Jupiter
Nat Geog 171:269 (c,1) F '87
—Angkor, Cambodia
Natur Hist 99:52–9 (c,1) Ja '90
Smithsonian 21:cov., 36–51 (c,1) My '90
—Effects of pollution on Greek frieze
Nat Geog 171:535 (c,4) Ap '87
—Egyptian works
Nat Geog 179:2–31 (c,1) Ap '91
—Ephesus, Turkey
Trav&Leisure 17:104, 109 (c,4) Mr '87
—Etruscan sculpture (Italy)
Nat Geog 173:698–734 (c,1) Je '88
—Fat lady sculpture (Malta)
Nat Geog 175:713 (c,4) Je '89
—Greek Gigantomachy frieze (Pergamon, Turkey)
Smithsonian 22:76–84 (c,1) O '91
—Kushite works (Sudan)
Nat Geog 178:98–119 (c,1) N '90
—Kyongju, Korea
Trav/Holiday 167:24 (c,3) Ja '87
—Maya sculpture
Smithsonian 20:104, 110–13 (c,1) D '89
Natur Hist 100:7 (c,1) Je '91
Trav/Holiday 175:49 (c,1) Je '91
Nat Geog 180:95, 102–5 (c,1) S '91
Natur Hist 100:10 (sculpture,c,4) N '91
—Moche people (Peru)
Nat Geog 177:16–31 (c,1) Je '90
—Phoenician sculptures
Smithsonian 19:70–1, 74–5 (c,1) Ag '88
—Prehistoric representations of humans
Nat Geog 174:449, 458–9, 478–81 (c,4) O '88
—Roman works (Petra, Jordan)
Trav/Holiday 172:44–5 (c,4) O '89
—Winged griffin (Phoenicia)
Smithsonian 19:66 (c,4) Ag '88
—See also
 SPHINX
SEA ANEMONES
Nat Wildlife 25:22–5 (c,1) O '87
Nat Geog 174:714 (c,4) N '88
Smithsonian 20:94–5 (c,2) Ag '89
Natur Hist 98:33 (c,2) Ag '89
Natur Hist 98:cov., 42–7 (c,1) S '89
Nat Geog 176:515 (c,4) O '89
Nat Wildlife 28:52–3 (c,1) D '89
Nat Geog 177:32, 37 (c,3) F '90
Nat Geog 178:28–9 (c,1) O '90
Nat Wildlife 29:50 (c,4) Je '91
Natur Hist 100:69 (c,1) N '91
SEA COWS
Natur Hist 96:64 (drawing,c,3) Ap '87

Smithsonian 18:48 (painting,c,4) Ja '88
SEURAT, GEORGES
Smithsonian 22:102 (4) O '91
—"Afternoon on the Island of La Grand
Jatte"
Smithsonian 19:32–3 (painting,c,2) Ag
'88
Natur Hist 100:41 (painting,c,4) My '91
Smithsonian 22:106–9 (painting,c,1) O
'91
—"Le Cirque"
Trav&Leisure 21:27 (painting,c,4) Ap
'91
Smithsonian 22:111 (painting,c,2) O '91
—Paintings by him
Smithsonian 22:100–11 (c,1) O '91
—"Young Woman Powdering Herself"
Trav&Leisure 17:30 (painting,c,4) Ja '87
SEUSS, DR.
Life 12:104–7 (c,1) Jl '89
SEVILLE, SPAIN
Trav&Leisure 20:cov., 124–37, 186, 235
(map,c,1) N '90
—Maestranza Theater
Trav/Holiday 176:93 (c,4) S '91
SEWARD, WILLIAM HENRY
Am Heritage 39:116 (4) N '88
SEWERS
—Early manhole (New York City, New
York)
Smithsonian 18:40 (drawing,4) Ag '87
—Manhole covers
Sports Illus 73:40–1 (c,1) O 1 '90
—Tunnels and tubes beneath New York
City streets
Smithsonian 18:38–47 (c,1) Ag '87
SEWING
—Sewing U.S. flag
Life 12:96–7 (1) Fall '89
—See also
GARMENT INDUSTRY
NEEDLEWORK
QUILTING
SEWING MACHINES
—1846 sewing machine patent by Elias
Howe
Life 41:49 (drawing,4) S '90
—1899 sewing machine used by the Wright
Brothers
Life 14:61 (c,4) Summer '91
—Industrial sewing machine
Life 12:96–7 (1) Fall '89
SEYCHELLES ISLANDS
Trav&Leisure 17:110–19 (map,c,1) Mr
'87
SEYCHELLES ISLANDS—COSTUME
Trav&Leisure 17:118 (c,4) Mr '87
SHAKERS
Nat Geog 176:302–25 (c,1) S '89

—19th cent. Shaker sewing desk
Am Heritage 38:102 (c,4) My '87
—Mid 19th cent. lifestyle
Natur Hist 96:54–7 (drawing,c,1) S '87
—Hancock Shaker Village, Massachusetts
Trav&Leisure 21:E1–4 (map,c,3) My '91
—History
Nat Geog 176:302–25 (c,1) S '89
—Maps of Shaker villages
Natur Hist 96:48–57 (c,1) S '87
Nat Geog 176:312–13 (c,2) S '89
—Shakertown, Pleasant Hill, Kentucky
Gourmet 48:73–6 (c,1) My '88
Nat Geog 176:302–3, 306–7, 322–3 (c,1)
S '89
SHAKESPEARE, WILLIAM
Nat Geog 171:252 (drawing,c,4) F '87
Smithsonian 18:155–60 (c,3) S '87
Trav&Leisure 19:129, 132 (c,4) My '89
—Artifacts from Folger Library, Washing-
ton, D.C.
Nat Geog 171:245–59 (c,1) F '87
—Birthplace (Stratford-on-Avon, En-
gland)
Smithsonian 18:168 (c,4) S '87
Natur Hist 97:37 (c,4) Ap '88
—Drawing of Falstaff
Smithsonian 18:173 (4) S '87
—Drawing of Puck
Natur Hist 100:4 (c,4) O '91
—Anne Hathaway's cottage (Shottery, En-
gland)
Trav&Leisure 19:131 (c,2) My '89
—Sculpture of him (Ontario)
Trav/Holiday 167:57 (c,2) Je '87
—Stratford sites associated with him, En-
gland
Smithsonian 18:155–75 (c,3) S '87
SHAMANS
—19th cent. Haida shaman's rattle
(Alaska)
Natur Hist 98:49 (c,4) D '89
—Ancient Marajoara woman (Brazil)
Natur Hist 98:79 (painting,c,1) F '89
—Curer using herbs for healing (Peru)
Nat Geog 177:46–7 (c,1) Je '90
—Maya (Guatemala)
Nat Geog 177:94 (c,4) Mr '90
—Sculpture of shaman's ritual (Alaska)
Smithsonian 20:54–5 (c,1) O '89
—Suriname
Smithsonian 19:95–101 (c,4) F '89
—Tlingit shaman's masks and artifacts
(Alaska)
Smithsonian 19:cov., 49, 51 (c,1) O '88
Smithsonian 20:46 (c,4) O '89
SHANGHAI, CHINA
Trav&Leisure 17:76–87 (map,1) Ag '87
Trav&Leisure 19:184 (c,3) F '89

Life 12:78–86 (c,1) Je '89
—1949 scenes
Life 12:79–86 (4) Je '89
—Xujiahui Catholic Cathedral
Nat Geog 173:326–7 (c,2) Mr '88
SHARKS
Nat Geog 171:312–13 (c,3) Mr '87
Natur Hist 97:54–5 (c,4) Mr '88
Nat Geog 174:730–1 (c,1) N '88
Sports Illus 71:97–9 (c,4) D 4 '89
Nat Geog 177:36–7 (c,2) F '90
Nat Geog 179:44–5 (c,1) F '91
Natur Hist 100:61 (c,2) My '91
Life 14:cov., 22–30 (c,1) Ag '91
—Blue shark caught in net
Life 14:27 (c,2) Ag '91
—Great white
Nat Geog 171:290–3 (c,1) Mr '87
Nat Wildlife 27:14–17 (c,1) O '89
—Lemon shark
Natur Hist 97:50–9 (c,1) Mr '88
—White shark
Nat Geog 179:5–7 (c,1) Ja '91
SHASTA DAM, CALIFORNIA
Nat Wildlife 29:6 (c,4) Je '91
SHAW, GEORGE BERNARD
Trav&Leisure 18:34 (3) Jl '88
Life 13:90 (4) S '90
Smithsonian 21:155–6, 165–8 (3) N '90
—Wife Charlotte
Smithsonian 21:160 (4) N '90
SHAY'S REBELLION (1787)
—Memorial (Massachusetts)
Nat Geog 172:346 (c,4) S '87
—Daniel Shays and Job Shattuck
Life 10:24 (drawing,4) Fall '87
SHEARWATERS (BIRDS)
Natur Hist 97:38–9 (c,1) Ag '88
SHEELER, CHARLES
Am Heritage 38:88 (4) N '87
—Industrial paintings by him
Am Heritage 38:86–91 (c,1) N '87
SHEEP
Trav/Holiday 167:9 (c,4) Mr '87
Gourmet 47:56 (c,3) Ap '87
Trav&Leisure 17:102–3, 110 (c,1) Jl '87
Nat Geog 172:616–17 (c,1) N '87
Trav&Leisure 18:98 (c,2) O '88
Life 13:10 (c,3) O '90
Nat Wildlife 29:47 (c,4) D '90
Smithsonian 22:36–7, 46–7 (c,1) Ap '91
Nat Geog 180:4–5 (c,1) S '91
—Annual sheep herding ritual (Cévennes, France)
Life 11:11 (c,4) Ap '88
—Dall's sheep
Nat Wildlife 27:58–9 (c,1) Ap '89
Nat Wildlife 27:52 (c,4) O '89
Nat Wildlife 28:13 (c,4) Je '90

Life 14:79 (c,1) Summer '91
—Lambs
Life 11:68–9 (c,1) Mr '88
—Merino sheep
Nat Geog 173:552–3, 578–9 (c,1) My '88
Trav&Leisure 18:201 (c,4) Je '88
—Ram's head
Natur Hist 97:50–1 (painting,c,2) My '88
—Shearing sheep
Nat Geog 173:552–3, 557 (c,1) My '88
—Shearing sheep (Tibet)
Nat Geog 175:774–5 (c,1) Je '89
—Sheep mural (Quebec)
Nat Geog 179:75 (c,3) Mr '91
—Spray-painted sheep (Ireland)
Trav&Leisure 20:106–7 (c,1) Je '90
—Varieties of wool-producing sheep
Nat Geog 173:570–1 (painting,c,1) My '88
—See also
RANCHING
SHEEP DOGS
Trav/Holiday 169:58 (c,3) Ap '88
Life 11:54–5 (c,1) Je '88
—See also
COLLIES
GERMAN SHEPHERDS
SHELLS
Trav/Holiday 167:42 (c,4) F '87
Trav&Leisure 17:33 (c,4) S '87
Nat Geog 174:724 (c,4) N '88
Gourmet 49:94 (c,4) O '89
Trav&Leisure 20:146, 149, 151–2 (drawing,4) O '90
—Flowers made of shells
Smithsonian 17:106–10 (c,1) Ja '87
—Hunting for sea shells (Florida)
Trav&Leisure 19:170–1, 174 (c,1) D '89
—Nautilus shell
Nat Wildlife 27:52–3 (c,1) Ap '89
—Snail shells
Natur Hist 100:6, 8 (c,4) S '91
—See also
COWRIES
SHENANDOAH NATIONAL PARK, VIRGINIA
Life 14:72 (c,4) Summer '91
SHENANDOAH RIVER, VIRGINIA
Trav&Leisure 19:61 (c,3) Je '89
SHEPHERDS
—1st cent. Roman sculpture
Nat Geog 173:569 (c,4) My '88
—Bulgaria
Trav&Leisure 21:142–3 (c,1) O '91
—Camel herder (China)
Life 11:72–3 (c,1) S '88
—Ethiopia
Nat Geog 177:2–3 (c,1) My '90
—Germany

Nat Geog 180:4–5 (c,1) S '91
—Hungary
Nat Geog 173:cov. (c,2) My '88
—India
Trav&Leisure 20:156–7 (1) D '90
—Italy
Trav&Leisure 17:135 (c,4) Ap '87
—Jordan
Trav/Holiday 172:47 (c,4) O '89
—Mexico
Trav&Leisure 21:104–5 (c,1) Ap '91
—New Mexico
Smithsonian 22:41 (c,3) Ap '91
—New Zealand
Trav&Leisure 17:129 (c,1) Je '87
—Romania
Life 13:84–5 (c,1) Ap '90
Nat Geog 179:64–5 (c,1) Je '91
—South Africa
Life 11:70–1 (c,1) D '88
—Tibet
Nat Geog 174:690–1 (c,1) N '88
—Tunisia
Nat Geog 172:596–7 (c,1) N '87
—Turkey
Natur Hist 96:92 (c,4) Mr '87
Nat Geog 173:584–5 (c,1) My '88
SHERMAN, ROGER
Smithsonian 18:33, 39 (drawing,4) Jl '87
Life 10:52 (painting,c,4) Fall '87
SHERMAN, WILLIAM TECUMSEH
Am Heritage 38:144 (4) My '87
Am Heritage 38:cov., 3, 25–41 (c,3) Jl
'87
Am Heritage 41:102 (4) Mr '90
Am Heritage 42:78 (4) Jl '91
Smithsonian 22:12 (painting,4) O '91
—Caricature
Am Heritage 41:14 (4) N '90
—Letter written by him (1862)
Am Heritage 38:26 (3) Jl '87
—Statue (New York City, New York)
Trav&Leisure 18:109 (c,4) Mr '88
SHINTOISM—COSTUME
—Priest (Japan)
Nat Geog 180:46–7 (c,1) N '91
Life 14:62–3 (c,1) D '91
SHINTOISM—RITES AND FESTIVALS
—Parading mikoshi at Tokyo shrine (Ja-
pan)
Nat Geog 177:54–5 (c,1) Ap '90
—Priest blessing new car (Japan)
Nat Geog 180:45– (c,1) N '91
SHIPBUILDING INDUSTRY
—Building cruise ship (Italy)
Trav&Leisure 174:74–9 (c,1) S '90
—Building dhows (India)
Nat Geog 180:34 (c,4) D '91
—Oregon

Am Heritage 39:80 (c,4) Ap '88
—Recreations of Columbus ships
Life 12:26–30 (c,1) Ap '89
—Refurbishing oil tanker (Bahrain)
Nat Geog 173:664–5 (c,1) My '88
—Ship breaking industry (Bangladesh)
Life 12:64–8 (1) Ag '89
—Ship dismantling industry (Pakistan)
Smithsonian 21:30–41 (c,1) Je '90
—South Korea
Life 10:23 (c,4) S '87
Nat Geog 174:236–7 (c,1) Ag '88
—Turkey
Trav/Holiday 168:59 (c,4) O '87
—See also
BOATS—CONSTRUCTION
SHIPS
—14th cent. B.C. merchantman
Nat Geog 172:694–5 (painting,c,1) D '87
—Late 15th cent. Spanish ships of Co-
lumbus
Life 10:34 (engraving,4) Mr '87
—1519 ships of Magellan
Smithsonian 22:84, 88, 92 (painting,c,3)
Ap '91
—1592 Korean "turtle ships"
Smithsonian 19:50 (painting,c,4) Ag '88
—1674 warship (Sweden)
Nat Geog 175:440–1 (painting,c,1) Ap '89
—Late 18th cent. British ship
Nat Geog 173:804–5 (painting,c,1) Je '88
—1789 "Mutiny on the Bounty"
Smithsonian 18:92–8 (painting,c,1) F '88
—Early 19th cent. steamships
Am Heritage 39:28 (painting,4) Ap '88
Am Heritage 39:39 (painting,c,3) Jl '88
—1838 brigantine
Natur Hist 97:94 (painting,c,4) O '88
—Mid 19th cent. ship paintings
Am Heritage 39:39–45 (c,1) Jl '88
—1853 fire on gunpowder ship (San Fran-
cisco, California)
Am Heritage 41:86–7 (painting,c,1) D
'90
—Late 19th cent. square-riggers
Am Heritage 38:112 (3) F '87
Am Heritage 39:76–7 (painting,c,1) D
'88
Smithsonian 20:150 (4) My '89
—1930s lake steamers (Great Lakes)
Am Heritage 38:104–5 (3) F '87
—1940s U.S. aircraft carriers
Am Heritage 38:105–7 (3) F '87
Am Heritage 38:111 (4) D '87
—1968 Navy monitor boat
Natur Hist 99:36 (4) N '90
—Aircraft carriers
Trav/Holiday 169:48–9 (c,2) F '88
Life 14:52–3 (c,1) Mr '91

—Container ship (Scotland)
Smithsonian 20:126–7 (c,3) O '89
—Depictions of Columbus's ships
Am Heritage 42:43, 50 (drawing,4) O '91
—"Greenpeace" ship
Trav/Holiday 176:79 (c,4) O '91
—Ice-breakers (Canada)
Nat Geog 178:6–7, 11, (c,1) Ag '90
Nat Geog 180:11 (c,3) Jl '91
—Ice-breakers (Finland)
Nat Geog 175:614–15 (c,1) My '89
—Ice-breakers freeing trapped gray whales
Sports Illus 69:126–30 (c,3) N 28 '88
—Model of 17th cent. Venetian ship
Trav/Holiday 169:46–7 (c,1) F '88
—Model of Viking ship (Minnesota)
Sports Illus 69:72–3 (c,1) D 5 '88
—The "Normandie"
Trav&Leisure 17:72 (painting,c,4) O '87
—"QE2"
Trav/Holiday 173:60–3 (c,1) Ap '90
—Recreations of Columbus ships
Life 12:26–30 (c,1) Ap '89
Trav&Leisure 21:24 (c,4) S '91
—Schooners
Natur Hist 96:4 (3) Ja '87
Nat Geog 179:47 (c,4) Ja '91
—Spanish Mexico-Philippines trade routes
(1586–1815)
Nat Geog 178:4–53 (map,c,1) S '90
—Tall ships
Nat Geog 173:234 (c,4) F '88
—Viking ships
Trav/Holiday 167:66 (c,3) Je '87
Trav/Holiday 176:93 (drawing,4) S '91
—See also
list under BOATS
SHIPWRECKS
—1638 Spanish galleon (Saipan)
Nat Geog 178:8–9, 38–51 (map,c,1) S '90
—1708 sinking of Spanish ship "San Jose"
Life 10:30–1 (painting,c,2) Mr '87
—1781 British wreck (Yorktown, Virginia)
Nat Geog 173:804–23 (c,1) Je '88
—Early 19th cent. horse ferry (Lake Cham-
plain, NY/Vermont)
Nat Geog 176:548–56 (c,1) O '89
—1941 wreck of the "Bismarck"
Nat Geog 176:622–37 (c,1) N '89
—1942 "Coolidge" wreck (Pacific Islands)
Nat Geog 173:458–67 (c,1) Ap '88
—1976 sunken freighter (Caribbean)
Nat Geog 174:726–7 (c,2) N '88
—Andrea Doria sinking (1956)
Sports Illus 70:10 (c,4) Je 19 '89
—Argentine ship aground (Antarctica)
Nat Geog 177:22–3 (c,1) Ap '90
—Depiction of 1676 Swedish warship ship-
wreck

Nat Geog 175:452–3 (painting,c,1) Ap
'89
—Exxon Valdez after oil spill
Nat Wildlife 27:6–7 (c,2) Je '89
Life 13:16–17 (c,1) Ja '90
—Hunting for treasure
Smithsonian 17:96–105 (c,1) Ja '87
—Japanese ship (Ecuador)
Nat Geog 173:150 (c,4) Ja '88
—Sites of unclaimed treasures
Life 10:30–4 (c,1) Mr '87
—Sonar scanner for ocean floor
Nat Geog 172:470–1 (c,2) O '87
—Sunken Russian nuclear submarine
(Norway)
Nat Geog 179:42–3 (c,1) F '91
—World War II shipwrecks (South Pacific)
Nat Geog 173:cov., 424–67 (c,1) Ap '88
SHIPWRECKS—RELICS
—1676 Swedish warship "Kronan"
Nat Geog 175:438–65 (c,1) Ap '89
—18th cent. British artifacts (Virginia)
Nat Geog 173:807–23 (c,1) Je '88
—Artifacts from 1588 Spanish Armada
shipwreck
Natur Hist 97:52–3 (c,1) S '88
—Bronze Age ship (Turkey)
Nat Geog 172:cov., 692–733 (c,1) D '87
—Treasure from 1622 Spanish shipwreck
Life 10:cov., 28–9 (c,1) Mr '87
SHOEMAKING
—Italy
Gourmet 47:89 (c,3) N '87
Shoes. See
FOOTWEAR
SHOESHINE STAND
—Virginia
Life 12:66 (c,4) D '89
SHOOTING
—1936 photo of bullet coming out of gun
Life 11:20–1 (1) Fall '88
—Biathlon
Sports Illus 66:54–5 (c,3) F 23 '87
Sports Illus 66:74–5 (c,1) Mr 9 '87
Sports Illus 68:220 (c,4) Ja 27 '88
Life 11:80–1 (c,1) F '88
Sports Illus 68:58, 60 (c,3) F 29 '88
—Jordan's King Hussein at shooting range
(Iraq)
Life 13:6–7 (c,1) O '90
—Marksmen's practice
Sports Illus 66:84–6 (c,4) Mr 30 '87
—Matchlock gun (Tibet)
Nat Geog 175:770 (c,3) Je '89
—Movie cowboy
Trav/Holiday 168:10 (c,4) Ag '87
—NCAA Championships 1990
Sports Illus 72:108, 110 (c,4) Ap 9 '90
—Olympic competition

Natur Hist 98:51 (c,4) D '89
—1855 wooden bald eagle as U.S. symbol
 Am Heritage 38:98–100 (c,1) F '87
—1962 baseball player thumbing nose at
 crowd
 Sports Illus 74:54 (4) Je 3 '91
—Baseball player mooning
 Sports Illus 73:58–9 (drawing,c,1) Ag 13
 '90
—George Bush doing victory sign (1988)
 Life 11:14–15 (c,1) D '88
—Celebrities raising middle fingers
 Sports Illus 71:138, 143, 146, 163, 184 (4)
 N 15 '89
—Father Time
 Gourmet 48:44 (drawing,c,2) D '88
—Fingers making devil's horns sign over
 man's head
 Life 10:160 (2) N '87
—Football fans doing The Wave (Berlin,
 Germany)
 Sports Illus 73:39 (c,3) Ag 20 '90
—Football players doing high five
 Sports Illus 72:cov. (c,1) F 5 '90
—History of U.S. flag
 Life 12:106–10 (c,1) Ag '89
—Korean yin and yang symbol
 Smithsonian 19:47 (c,4) Ag '88
—Meaning of hand gestures around the
 world
 Trav/Holiday 174:10 (drawing,c,4) N
 '90
—Olympic rings in skywriting
 Trav&Leisure 21:34 (c,4) O '91
—Peace symbol
 Nat Geog 171:187 (c,4) F '87
—"Recycled materials" seals
 Natur Hist 99:86–9 (c,4) My '90
—Romulus and Remus symbols of Rome
 Nat Geog 173:737 (sculpture,c,3) Je '88
—Skull and crossbones poison warning
 Nat Wildlife 27:4 (c,4) F '89
—"Thumbs up" sign
 Sports Illus 74:cov. (c,1) F 25 '91
—Victory finger sign (Czechoslovakia)
 Life 13:26–7 (1) F '90
—See also
 CHRISTMAS TREES
 FLAGS
 HAND SHAKING
 LIBERTY, STATUE OF
 LIBERTY BELL
 MASCOTS
 MEDALS
 SEALS AND EMBLEMS
 UNCLE SAM
 U.S.—SIGNS AND SYMBOLS
SIGNS AND SYMBOLS—HUMOR
—Giving baseball signals

Sports Illus 74:74–80 (painting,c,1) Ap
 15 '91
SILHOUETTES
—Early 19th cent. women
 Am Heritage 38:58–9 (3) S '87
—Silhouettes of famous world monuments
 Trav/Holiday 174:76 (c,4) Jl '90
—Silhouettes of hands
 Gourmet 48:84 (painting,c,4) Je '88
SILK INDUSTRY
—Turkey
 Nat Geog 172:580 (c,3) N '87
SILVERWARE
—1900 Gorham silverware
 Am Heritage 40:27 (c,1) N '89
—Morning coffee service (Indiana)
 Gourmet 50:105 (c,4) D '90
SINATRA, FRANK
 Life 13:117 (c,2) D '90
SINCLAIR, UPTON
 Am Heritage 39:37 (3) S '88
—1934 campaign for governor of California
 Am Heritage 39:34–41, 130 (1) S '88
SINGAPORE
 Trav/Holiday 168:cov., 12, 14 (c,1) O '87
 Trav&Leisure 19:65 (c,3) S '89
—1930s
 Gourmet 49:100 (3) My '89
—"Little India"
 Trav&Leisure 19:194, 200, 208 (c,2) Mr
 '89
SINGERS
—1906 carol singers (Great Britain)
 Natur Hist 99:58–9 (1) D '90
—Baptist church choir (New York)
 Life 13:73 (3) D '90
—Beach Boys
 Smithsonian 20:110 (4) Je '89
—Caricature of 1938 radio stars
 Smithsonian 17:74 (painting,c,3) Mr '87
—Carter family
 Life 14:102–14 (c,1) D '91
—Chinese rock singer
 Nat Geog 180:110–11 (c,1) Jl '91
—Contemporary singers
 Life 13:117–26 (c,1) D '90
—Country music shrines (Nashville, Ten-
 nessee)
 Smithsonian 18:84–94 (c,1) Mr '88
—Female country music singer
 Life 11:115–16 (c,2) O '88
—Female singer at microphone
 Life 13:80 (c,4) O '90
—Folk singers
 Smithsonian 18:114–20 (3) Ag '87
—Heavy metal bands
 Life 11:98–9 (c,1) Ap '88
 Sports Illus 73:74 (c,4) O 1 '90
—Johnny Mathis

—World Championships 1988 (Budapest, Hungary)
Sports Illus 68:34–41 (c,2) Ap 4 '88
—World Championships 1990 (Halifax, Nova Scotia)
Sports Illus 72:24–9 (c,2) Mr 19 '90
—World Championships 1991 (Germany)
Sports Illus 74:34–7 (c,1) Mr 25 '91
—See also
HENIE, SONJA
SKATING, SPEED
Sports Illus 66:166 (c,4) F 9 '87
Sports Illus 68:236–55, 281 (c,1) Ja 27 '88
Life 11:cov., 76–7, 86 (c,1) F '88
Sports Illus 70:32–3 (c,2) Mr 6 '89
Sports Illus 72:92 (c,4) Ja 15 '90
—1924 Olympics (Chamonix)
Sports Illus 67:59 (4) D 14 '87
—1980 Olympics (Lake Placid)
Sports Illus 67:51–3 (c,2) D 14 '87
—1988 Olympics (Calgary)
Sports Illus 68:24–6, 47 (c,1) F 22 '88
Sports Illus 68:48, 57 (c,3) F 29 '88
Sports Illus 68:50–2, 57 (c,3) Mr 7 '88
Life 11:74–5 (c,2) Ap '88
—China
Sports Illus 68:259–60 (c,3) Ja 27 '88
SKELETONS
—365 A.D. earthquake victims (Cyprus)
Nat Geog 174:31, 35, 40, 50–1 (c,1) Jl '88
—Ancient Greece
Natur Hist 99:78 (c,4) O '90
—Ancient human sacrifice victims (Denmark)
Nat Geog 171:408–10 (c,1) Mr '87
—Ancient Indian woman (Missouri)
Life 12:12 (4) Jl '89
—Bronze Age human skeletons
Smithsonian 21:38 (c,4) Ag '90
Life 14:91–101 (c,1) N '91
—Human bones in Paris Catacombs, France
Nat Geog 176:86–7 (c,1) Jl '89
—Human skeleton
Life 13:96 (2) S '90
—Ichthyosaur fossils
Nat Geog 175:662–3 (c,1) Je '89
—Reptile and amphibian skeletons used for research
Nat Wildlife 26:4–5 (c,4) Ap '88
—Sled dog's skeleton
Nat Geog 177:21 (c,3) Ap '90
—Tyrannosaurus rex skeleton
Trav&Leisure 18:87 (c,1) Jl '88
Life 11:155 (4) D '88
—Used in medical education
Sports Illus 71:54–5 (c,1) Ag 28 '89
SKI JUMPING
Sports Illus 67:122 (c,2) D 28 '87

Sports Illus 68:204–11, 269 (c,1) Ja 27 '88
Sports Illus 68:18 (c,4) F 1 '88
—1988 Olympics (Calgary)
Sports Illus 68:20–2 (c,1) F 22 '88
Sports Illus 68:82–3 (c,1) Mr 7 '88
Sports Illus 68:38 (c,4) Mr 14 '88
—Olympic ski jump (Calgary, Alberta)
Sports Illus 66:72–3 (c,1) Mr 9 '87
—Rear view (Alaska)
Nat Geog 173:364–5 (c,1) Mr '88
—Summer practice on tile track (New York)
Life 12:8 (c,4) S '89
SKI LIFTS
Sports Illus 68:23 (c,4) F 22 '88
Sports Illus 70:80 (c,4) Ja 30 '89
Trav&Leisure 19:168–9 (c,1) N '89
Gourmet 50:74–5 (c,1) F '90
—Chairlift (Stratton, Vermont)
Trav&Leisure 17:195 (c,4) D '87
—Chairlift (Switzerland)
Trav/Holiday 168:42 (c,4) O '87
—Gondolas (Killington, Vermont)
Trav&Leisure 20:E8 (c,3) Ja '90
—Hi-tech subway lift (France)
Trav&Leisure 21:84 (c,4) N '91
SKI RESORTS
—Cortina d'Ampezzo, Italy
Trav&Leisure 17:78–85 (c,1) Ja '87
—Crans-Montana, Switzerland
Sports Illus 68:44 (c,3) Ja 27 '88
—Killington, Vermont
Trav&Leisure 20:E8 (c,3) Ja '90
—Steamboat, Colorado
Sports Illus 71:50–1 (c,1) Ag 21 '89
—Stratton, Vermont
Trav&Leisure 17:E4, 195 (c,4) D '87
—Sun Valley, Idaho
Gourmet 50:74–7 (c,1) F '90
—Telluride, Colorado
Gourmet 47:55–7 (c,1) Ja '87
—Vail, Colorado
Sports Illus 70:70–82 (c,1) Ja 30 '89
—Whistler, British Columbia
Trav&Leisure 21:106–9, 141 (map,c,1) Ja '91
SKIERS
Sports Illus 75:47–90 (c,1) N 18 '91
SKIING
Sports Illus 68:cov., 36–73 (c,1) Ja 27 '88
Trav&Leisure 18:35, 75 (painting,c,4) D '88
Trav&Leisure 21:1–21 (c,1) N '91 supp.
Sports Illus 75:78–9 (c,1) D 30 '91
—Alberta
Gourmet 50:90–5 (c,1) D '90
—British Columbia
Gourmet 50:90–5 (c,1) D '90
Trav&Leisure 21:104–9 (c,1) Ja '91

—California
Trav/Holiday 169:72 (c,3) Ja '88
—Colorado
Trav&Leisure 18:88, 132–3 (c,1) N '88
—Elephant on skis
Trav&Leisure 20:E1 (painting,c,2) Ja
'90
—Falling in snow
Sports Illus 66:29 (c,3) F 16 '87
—France
Trav&Leisure 21:F1–F6 (c,1) S '91 supp.
—Freestyle stunts
Life 10:2–3, 97–8 (c,1) D '87
Sports Illus 68:226–7, 231 (c,1) Ja 27 '88
—Helicopter skiing (British Columbia)
Sports Illus 74:84–96 (c,1) Ja 14 '91
—Himalayas (Kashmir)
Life 12:126–7 (c,1) F '89
—Inept skier about to fall
Trav/Holiday 175:94 (4) Ja '91
—Making skis (Yugoslavia)
Nat Geog 178:118 (c,4) Ag '90
—Montana
Trav/Holiday 168:26–8 (c,4) N '87
—Nevada
Trav/Holiday 171:91 (c,1) Mr '89
—New Zealand
Nat Geog 171:656–7 (c,1) My '87
Trav/Holiday 170:54 (c,4) Jl '88
—Olympic skiing history
Sports Illus 67:41–57 (c,2) N 23 '87
—On grass (California)
Sports Illus 67:62–3 (c,1) S 7 '87
—On steep slope
Trav&Leisure 21:E10 (painting,c,3) Ja
'91
—One-legged woman skiing
Sports Illus 73:7–8 (c,4) D 31 '90
—Sand skiing (Abu Dhabi)
Life 10:6–7 (c,2) S '87
—Ski hut (Austria)
Gourmet 48:84 (c,3) D '88
—Slalom
Sports Illus 68:30–1 (c,1) Ja 25 '88
Sports Illus 72:2–3, 44–8 (c,1) Mr 5 '90
—Snowboarding (Colorado)
Sports Illus 70:78 (c,4) Ja 30 '89
Sports Illus 72:2–3 (c,1) Ja 8 '90
—Sun Valley, Idaho
Trav/Holiday 176:76–9 (c,3) N '91
—Utah
Trav/Holiday 169:48 (c,2) Je '88
Trav&Leisure 21:142–9 (map,c,1) N '91
—Vermont
Trav&Leisure 17:E2 (c,3) F '87
Trav&Leisure 20:E2 (c,4) N '90
—Wyoming
Trav&Leisure 17:116–17, 122–3, 179
(c,1) N '87

SKIING—CROSS-COUNTRY
—1988 Olympics (Calgary)
Sports Illus 68:64–5 (c,1) F 29 '88
—Alaska
Trav/Holiday 171:54 (c,2) Ja '89
—Alberta
Trav&Leisure 20:145–7 (c,1) D '90
—Antarctica
Nat Geog 178:94–5 (c,1) N '90
—California
Nat Geog 175:481–3 (c,1) Ap '89
—Finland
Trav&Leisure 17:68 (painting,c,4) N '87
—Minnesota
Nat Geog 177:96–7 (c,1) Je '90
—Switzerland
Trav&Leisure 20:128–9 (c,4) S '90
—Vermont
Trav&Leisure 19:E16 (c,3) N '89
—Wyoming
Trav/Holiday 170:65 (c,1) N '88
SKIING—HUMOR
—Skier surveying snowless mountain
Trav&Leisure 20:104–5 (drawing,c,1) D
'90
SKIING COMPETITIONS
Sports Illus 67:66–70 (c,4) D 21 '87
Sports Illus 67:24–5 (c,1) D 28 '87
—1988 Olympics (Calgary)
Sports Illus 68:41–7 (c,1) F 29 '88
Sports Illus 68:46–9 (c,1) Mr 7 '88
Life 11:76–7 (c,1) Ap '88
—Alpine World Championships 1987
Sports Illus 66:26–30 (c,1) F 16 '87
—Alpine World Ski Championships 1991
(Austria)
Sports Illus 74:38–43 (c,1) F 11 '91
—Colorado
Sports Illus 70:14–21 (c,1) F 13 '89
Sports Illus 70:2–3, 32–5 (c,1) F 20 '89
—U.S. Alpine Championships 1990 (Colo-
rado)
Sports Illus 72:2–3, 44–8 (c,1) Mr 5 '90
—World Cup Championships 1987 (Al-
berta)
Sports Illus 66:42–3 (c,3) Mr 23 '87
—World Cup Championships 1988 (Swit-
zerland)
Sports Illus 68:16–19 (c,2) F 1 '88
SKIMMERS (BIRDS)
Nat Wildlife 26:48–51 (c,1) F '88
Nat Wildlife 28:56 (painting,c,4) O '90
SKIN
—Cross-section of skin from hand
Smithsonian 19:164 (drawing,c,3) My '88
—Dead skin cells
Smithsonian 19:168, 180 (c,4) My '88
—Freckles
Smithsonian 19:159 (c,3) My '88

—Research on human skin
Smithsonian 19:159–80 (c,3) My '88
SKIN DIVING
Trav&Leisure 18:114–15, 118–19 (c,1) O
'88
Trav/Holiday 172:18, 20, 79–81 (c,1) Jl
'89
—Australia
Nat Geog 173:166–7 (c,1) F '88
Nat Geog 180:120 (c,1) D '91
—Caribbean
Trav/Holiday 171:10 (c,3) Ap '89
Trav&Leisure 21:118–23, 160 (c,2) D '91
—Diving bell
Nat Geog 175:462–3 (c,1) Ap '89
—Exploring shipwrecks
Smithsonian 17:105 (c,1) Ja '87
Nat Geog 172:cov., 692–733 (c,1) D '87
—Florida
Sports Illus 67:7 (c,3) O 26 '87
—New Zealand
Nat Geog 176:512, 517–26 (c,1) O '89
—Scuba diving
Life 10:46–51 (c,1) Je '87
—Scuba diving (Cayman Islands)
Trav/Holiday 167:40–1 (c,1) F '87
Trav/Holiday 169:cov., 8, 52–7 (c,1) Ja
'88
—Scuba lesson (Jamaica)
Trav&Leisure 19:201 (c,4) O '89
—Snorkeling (Australia)
Trav&Leisure 17:cov. (c,1) D '87
—Snorkeling (French Polynesia)
Trav/Holiday 168:56–9 (c,2) Ag '87
SKUAS (BIRDS)
Nat Geog 173:420–1 (c,1) Mr '88
SKULLS
—4,000 year old skull (Florida)
Natur Hist 96:10 (4) Jl '87
—African buffalo skull
Natur Hist 97:14 (c,3) N '88
—Cro-Magnon skull
Smithsonian 22:114 (c,4) D '91
—"Heidelberg man" jawbone
Gourmet 47:52 (c,4) Ja '87
—Neanderthal skull and bones
Nat Geog 174:464–5 (c,4) O '88
Smithsonian 22:115–16, 126–7 (c,2) D '91
—Skulls of extinct lemurs
Nat Geog 174:141 (c,4) Ag '88
—Tribal skull trophies (Indonesia)
Nat Geog 175:122 (c,4) Ja '89
—Victims of civil strife (Uganda)
Nat Geog 173:480–1 (c,1) Ap '88
SKY DIVING
Sports Illus 71:92–3 (c,1) D 25 '89
Smithsonian 21:cov., 58–71 (c,1) Ag '90
Sports Illus 74:14 (c,4) My 27 '91
—1988 Olympics (Seoul)

Smithsonian 21:58–9 (c,1) Ag '90
—Brazil
Life 10:96 (c,2) My '87
—55-person diving group (Washington)
Life 14:14 (2) N '91
—Sky surfing
Life 13:3 (c,2) Je '90
Sports Illus 73:2–3 (c,1) D 31 '90
—Surfing while suspended from plane
Life 11:16 (c,3) N '88
—With dog (Great Britain)
Life 11:7 (c,3) Mr '88
SLAVERY
—3rd cent. B.C. Carthaginian slaves
Natur Hist 96:58–9 (c,1) D '87
—16th cent. slaves (West Indies)
Smithsonian 18:98 (painting,c,2) Ja '88
—16th cent. Spanish enslavement of Indi-
ans
Smithsonian 22:41 (painting,c,2) D '91
—18th cent. torture of slaves (Haiti)
Smithsonian 18:164 (painting,c,4) O '87
—1787 slaves dancing
Life 10:33 (painting,c,4) Fall '87
—1798 slave women farming (Virginia)
Nat Geog 172:354 (painting,c,4) S '87
Smithsonian 18:84 (painting,c,4) S '87
—1839 uprising on slave ship
Am Heritage 38:142 (drawing,4) My '87
—1852 ad for *Uncle Tom's Cabin*
Am Heritage 38:50 (4) D '87
—1861 slaves (South Carolina)
Am Heritage 39:66 (3) F '88
—1863 allegorical print of Emancipation
Am Heritage 39:28 (4) F '88
—1865 sculpture of freed female slave
(Georgia)
Am Heritage 42:4 (c,2) Jl '91
—Ancient Kushite prisoner (Egypt)
Nat Geog 178:103 (painting,c,4) N '90
—Jamaica
Natur Hist 100:26 (painting,c,4) D '91
—Dred Scott
Life 10:85 (4) Fall '87
—Slave cabin home of Booker T. Washing-
ton (Virginia)
Life 14:72 (c,4) Summer '91
—Unloading slave ship (early 18th cent.)
Am Heritage 40:34 (engraving,4) S '89
—See also
ABOLITIONISTS
DOUGLASS, FREDERICK
TUBMAN, HARRIET
SLEDS
—17th cent. sleigh races (France)
Smithsonian 18:140–1 (painting,c,2) D
'87
—1900 child's sled (Maine)
Smithsonian 18:138 (c,1) D '87

—Child on sled (Moscow, U.S.S.R.)
 Nat Geog 177:104–5 (c,1) Ja '90
—Child pulling man on sled
 Sports Illus 66:38 (c,4) F 2 '87
—History of sledding
 Smithsonian 18:138–49 (c,1) D '87
—Horse-drawn sleigh (Wyoming)
 Trav&Leisure 17:118–19 (c,1) N '87
—Parents pulling children on sled (Colorado)
 Life 12:72–3 (c,1) Ap '89
—Sledding down Washington glacier (1926)
 Life 14:33 (2) Summer '91
—Sleigh carrying Christmas tree home (New England)
 Nat Wildlife 27:4–5 (c,1) D '88
—Sleigh ride (Alberta)
 Trav/Holiday 176:42 (c,1) D '91
—See also
 BOBSLEDDING
 DOG SLEDS
 LUGE
 TOBOGGANING
SLEEPING
—1941 soldier asleep in hammock (Louisiana)
 Smithsonian 22:98 (4) S '91
—Counting sheep
 Nat Geog 172:820–1 (c,1) D '87
—Couple at resort hotel (Caribbean)
 Trav&Leisure 17:89 (c,1) S '87
 Trav&Leisure 19:182–3 (c,1) O '89
—Exhausted doctors napping
 Nat Geog 180:74–5 (c,1) S '91
—Leopard yawning
 Natur Hist 99:cov. (c,1) F '90
—Man in bed hugging pillow
 Sports Illus 66:36 (c,4) Mr 9 '87
—Man napping on Yellowstone Park bench, Wyoming
 Trav&Leisure 19:109 (c,4) Mr '89
—Man on couch
 Sports Illus 66:88 (c,3) Je 8 '87
—Paintings of people having nightmares
 Smithsonian 19:73–83 (c,1) Mr '89
—Passengers napping on plane
 Life 13:70–1 (c,1) Ag '90
—People dreaming of leftovers
 Gourmet 50:126 (drawing,3) N '90
—People sleeping on the street (Bombay, India)
 Nat Geog 172:801 (c,4) D '87
—Poor child sleeping on cardboard (Haiti)
 Nat Geog 172:644–5 (c,1) N '87
—Racing car driver taking nap
 Sports Illus 67:35 (c,3) S 7 '87
—Sleep research
 Nat Geog 172:786–821 (c,1) D '87

—Walruses sleeping
 Trav&Leisure 21:28 (c,4) N '91
—Yawning
 Sports Illus 66:42–3 (c,1) F 2 '87
 Life 12:118 (c,2) O '89
SLEEPING BEAR DUNES NATIONAL LAKESHORE, MICHIGAN
 Trav/Holiday 171:10 (c,2) My '89
SLIME MOLD
 Smithsonian 22:98–103 (c,3) Jl '91
SLINGSHOTS
—Laos
 Nat Geog 171:785 (c,1) Je '87
SLOAN, ALFRED
 Smithsonian 19:129 (4) Jl '88
 Life 13:63 (1) Fall '90
SLOAN, JOHN
 Smithsonian 19:77, 81 (4) Ap '88
—Paintings by him
 Smithsonian 19:74–84 (c,1) Ap '88
 Am Heritage 39:44–54 (c,1) N '88
—Portrait of Juliana Force (1916)
 Am Heritage 40:108 (painting,c,2) S '89
SLOTHS
 Nat Geog 171:392 (c,4) Mr '87
 Smithsonian 18:88–99 (c,2) Ap '87
 Natur Hist 98:92–3 (c,1) Je '89
 Nat Geog 180:97 (c,4) D '91
SLUGS
 Natur Hist 96:cov., 50–3 (c,1) O '87
 Smithsonian 19:134–41 (c,1) F '89
 Nat Geog 175:794 (c,4) Je '89
 Natur Hist 98:80–1 (c,1) Ag '89
 Smithsonian 20:94–101 (c,2) Ag '89
 Nat Geog 176:512, 523 (c,4) O '89
 Nat Geog 177:22 (c,4) F '90
 Natur Hist 100:46–7 (c,1) Ap '91
 Nat Wildlife 29:49 (c,4) Je '91
 Nat Geog 180:15 (c,4) Jl '91
 Nat Geog 180:140–1 (c,1) O '91
—Slug eggs
 Smithsonian 19:140 (c,4) F '89
 Nat Geog 180:140 (c,4) O '91
SLUMS
—Late 19th cent. (New York)
 Life 11:128 (3) Fall '88
 Nat Geog 176:544–5 (1) O '89
—Guatemala
 Nat Geog 173:784–5 (c,1) Je '88
—Harlem, New York City, New York
 Nat Geog 177:52–75 (c,1) My '90
—Homes with no water supply (El Paso, Texas)
 Life 10:152–6 (1) N '87
—Indianapolis, Indiana
 Nat Geog 172:244–5 (c,1) Ag '87
—Jakarta, Indonesia
 Nat Geog 175:119 (c,4) Ja '89
—New York City, New York

Nat Geog 178:82–3 (c,1) S '90
—Port-au-Prince, Haiti
　Life 10:61 (c,3) Ag '87
　Nat Geog 172:562–3, 644–5 (c,1) N '87
—Rocinha, Brazil
　Nat Geog 171:359 (c,1) Mr '87
—Sydney, Australia
　Nat Geog 173:252–3 (1) F '88
SMETANA, BEDRICH
　Trav/Holiday 167:84 (sculpture,4) Ja '87
SMITH, JOHN
　Am Heritage 38:54 (painting,c,4) F '87
SMITH, JOSEPH
—Angel Moroni giving gift to Mormon
　Smith
　Life 14:38 (painting,c,4) Jl '91
SMITH, KATE
　Life 10:120 (4) Ja '87
SMITHSONIAN INSTITUTION, WASH-
　INGTON, D.C.
　Smithsonian 18:120–7 (c,1) Jl '87
　Trav&Leisure 17:120–1 (c,1) D '87
—1865 fire at the Smithsonian
　Smithsonian 18:24 (drawing,4) D '87
—Hirschhorn Museum facade as screen for
　light show
　Smithsonian 19:24 (c,3) Ja '89
—National Air and Space Museum
　Trav&Leisure 18:120, 160 (c,3) S '88
—National Museum of African Art
　Smithsonian 18:cov., 44–63 (c,1) S '87
　Trav&Leisure 17:118–21 (c,1) D '87
—Arthur M. Sackler Gallery
　Smithsonian 18:cov., 45–63 (c,1) S '87
　Trav&Leisure 17:118–21 (c,1) D '87
SMOG
—Los Angeles, California
　Nat Wildlife 25:34–5 (c,1) O '87
—San Francisco, California
　Nat Geog 178:72–3 (c,2) O '90
—Smog over Washington, D.C.
　Nat Wildlife 28:4–5 (c,1) F '90
SMOKE
—Factory smoke (Romania)
　Life 13:85 (c,4) Ap '90
—From Colorado power plant
　Nat Wildlife 28:8–9 (c,1) F '90
—Smoke from burning oil fields (Kuwait)
　Nat Geog 180:2–3, 18–20 (c,1) Ag '91
—Smokestacks spewing smoke (Arizona)
　Nat Geog 171:502–3 (c,1) Ap '87
—Space photo of rain forest burning (Bra-
　zil)
　Nat Geog 178:94 (c,3) O '90
—Steam from train engine (China)
　Nat Geog 173:296–7, 304–5 (c,1) Mr '88
—See also
　CHIMNEYS
　FIRES

SMOG
Smoking. See
　CIGAR SMOKING
　CIGARETTE SMOKING
　PIPE SMOKING
SNAILS
　Smithsonian 18:112 (c,4) Je '87
　Natur Hist 97:cov., 43 (c,1) Ja '88
　Natur Hist 98:6 (c,3) Mr '89
　Nat Geog 177:22 (c,4) F '90
　Nat Geog 178:86 (c,4) Jl '90
　Natur Hist 100:64–5 (c,1) My '91
　Nat Wildlife 29:51 (c,2) Ag '91
—See also
　SLUGS
SNAKE RIVER, IDAHO
　Smithsonian 21:101 (c,1) Ap '90
SNAKE RIVER, WYOMING
　Trav&Leisure 21:91 (c,4) Ap '91
SNAKEROOT
—White snakeroot
　Natur Hist 99:8 (c,3) Jl '90
SNAKES
　Natur Hist 96:cov., 58–67 (c,1) N '87
　Nat Wildlife 26:59 (c,1) D '87
　Smithsonian 18:158–65 (c,1) F '88
　Natur Hist 99:44–5 (c,1) Ja '90
　Natur Hist 99:64 (c,4) My '90
—Eastern indigo snake
　Nat Geog 180:116–17 (c,1) S '91
—Eating habits of snakes
　Smithsonian 18:158–65 (c,1) F '88
—People handling snake (Belize)
　Smithsonian 22:96 (c,3) N '91
—Snake eating mouse
　Nat Wildlife 26:22–3 (c,1) O '88
—Tree snakes
　Nat Wildlife 26:12–13 (painting,c,1) Ag
　'88
　Smithsonian 22:112, 118 (c,4) Ag '91
—Water snake
　Natur Hist 99:50–1 (c,1) Jl '90
—See also
　BOA CONSTRICTORS
　COPPERHEADS
　FER-DE-LANCE
　GARTER SNAKES
　PYTHONS
　RATTLESNAKES
　VIPERS
SNEAD, SAM
　Sports Illus 71:5 (c,3) S 11 '89
SNEEZING
　Trav/Holiday 169:32 (drawing,4) F '88
SNIPES (BIRDS)
　Nat Wildlife 27:12–15 (c,1) Ag '89
SNOW SCENES
　Nat Wildlife 30:4–9 (c,1) D '91
—1888 blizzard (New York City)

Sports Illus 71:22–3 (c,1) S 25 '89
Sports Illus 71:22–3 (c,2) N 27 '89
—World Cup Championships 1990
Sports Illus 72:40–5 (c,1) Je 18 '90
Sports Illus 72:46–8 (c,2) Je 25 '90
Sports Illus 73:26–8 (c,1) Jl 2 '90
Sports Illus 73:2–3 (c,1) Jl 9 '90
Sports Illus 73:26–8, 33 (c,1) Jl 16 '90
SOCCER—PROFESSIONAL—HUMOR
—Italian passion for soccer
Sports Illus 72:72–84 (painting,c,1) Je 11 '90
SOCIAL SECURITY ADMINISTRA-
TION
—First Social Security check (1940)
Am Heritage 41:41 (4) F '90
SOCIETY ISLANDS, POLYNESIA
Trav&Leisure 18:122–35 (map,c,1) F '88
Gourmet 49:58–63, 100 (map,c,1) F '89
—Bora Bora
Trav&Leisure 18:122–3, 130–2 (c,1) F '88
Gourmet 49:58–62, 100 (map,c,1) F '89
—Moorea
Gourmet 49:cov., 36–41, 110, 113
(map,c,1) Ja '89
—See also
TAHITI
SOCIETY ISLANDS, POLYNESIA—
COSTUME
—People dressed for church (Raiatea)
Gourmet 49:61 (c,3) F '89
SOD HOUSES
—1886 (Nebraska)
Trav&Leisure 21:182 (4) O '91
—Norway
Trav/Holiday 167:64 (c,3) Je '87
SOFAS
—18th cent. Empire sofa (Massachusetts)
Am Heritage 40:72 (c,1) My '89
—1929 art deco sofa
Trav&Leisure 17:26 (c,4) Mr '87
SOFTBALL
—Boys at summer camp
Smithsonian 21:93 (c,4) Ag '90
—Indoor softball (Missouri)
Sports Illus 74:63 (c,4) Mr 11 '91
SOFTBALL—AMATEUR
—Pitching
Sports Illus 66:2–3 (c,1) Ja 5 '87
—U.S.-U.S.S.R. game
Sports Illus 70:46–53 (c,1) Je 19 '89
SOFTBALL—COLLEGE
Sports Illus 72:2–3 (c,1) Je 4 '90
Solar eclipses. See
ECLIPSES
SOLAR ENERGY
—Computer-controlled mirrors (Mojave
Desert, California)
Life 12:8 (c,3) Mr '89

—Heliostat (New Mexico)
Nat Geog 176:751 (c,4) D '89
—Hot water heater (Nepal)
Nat Geog 176:401 (c,4) S '89
—Mirror panels
Smithsonian 21:64–5 (c,2) Ap '90
—Solar collectors (New Mexico)
Natur Hist 99:90–1 (c,1) My '90
—Solar panels (California)
Nat Geog 178:70–1 (c,1) O '90
—Solar-powered car
Nat Geog 178:93 (c,4) O '90
—Solar-powered car race (Australia)
Smithsonian 18:cov., 48–59 (c,1) F '88
—Solar-powered electric fence (North Da-
kota)
Nat Wildlife 26:14 (c,4) Ap '88
—Solar-thermal complex (Mojave Desert,
California)
Nat Geog 180:84–5 (c,1) Ag '91
—Tower boiler for steam (California)
Nat Geog 171:70–1 (c,2) Ja '87
—Used at wildlife refuge (New Mexico)
Smithsonian 18:148 (c,4) My '87
Soldiers. See
MILITARY COSTUME
U.S. ARMY
WARFARE
SOLOMON
—Depiction of famous maternity decision
Smithsonian 18:122–3 (drawing,c,1) O '87
SOMALIA—COSTUME
Sports Illus 68:74 (c,4) My 30 '88
SORGHUM INDUSTRY—HARVEST-
ING
—Botswana
Nat Geog 178:84 (c,4) D '90
SOUTH AFRICA
Nat Geog 174:556–85 (c,1) O '88
—Border Cave
Nat Geog 174:438–9 (c,1) O '88
—See also
JOHANNESBURG
SOUTH AFRICA—COSTUME
Life 11:70–5 (c,1) D '88
—Afrikaners
Nat Geog 174:556–85 (c,1) O '88
—Archbishop Tutu
Life 13:22 (c,4) Ap '90
SOUTH AFRICA—HISTORY
—1830s Zulus attacking Boers
Nat Geog 174:564 (painting,c,4) O '88
—Afrikaner history
Nat Geog 174:556–85 (map,c,1) O '88
—Anglo-Boer War guerrillas (1902)
Nat Geog 174:566 (4) O '88
SOUTH AFRICA—HOUSING
—Ndebele house design
Nat Geog 174:346–7 (c,1) S '88

SOUTH AFRICA—POLITICS AND
GOVERNMENT
—Nelson Mandela
Life 13:22–6 (c,1) Ap '90
Life 14:78–9, 86 (c,1) Ja '91
—Stoning gunman's mother
Life 14:12 (c,2) Ap '91
—Women begging for end to tribal warfare
Life 13:16 (c,2) N '90
SOUTH AMERICA
—Sights along the eastern coast
Trav&Leisure 20:74–83, 126 (map,c,1)
Ag '90
—See also
AMAZON RIVER
ANDES MOUNTAINS
IGUAÇU FALLS
LAKE TITICACA
SOUTH CAROLINA
—Hilton Head
Trav/Holiday 168:24 (c,3) Ag '87
Trav&Leisure 20:96 (c,4) Mr '90
—Little Wambaw Swamp
Natur Hist 96:68–70 (map,c,1) Ag '87
—Sea Islands
Nat Geog 172:734–63 (map,c,1) D '87
—See also
BEAUFORT
CHARLESTON
SOUTH CAROLINA—MAPS
—Coastline
Trav&Leisure 20:80 (c,4) Ja '90
SOUTH DAKOTA
—Corn Palace, Mitchell
Smithsonian 19:115 (c,3) N '88
—Countryside
Life 13:48–9 (c,1) D '90
—Countryside (1940)
Am Heritage 40:94–5 (1) F '89
—Sturgis
Life 13:11 (c,3) O '90
—Wall drugstore
Trav/Holiday 171:90 (c,4) Je '89
—See also
BADLANDS
BADLANDS NATIONAL PARK
MOUNT RUSHMORE
South Korea. See
KOREA, SOUTH
South Pacific. See
PACIFIC ISLANDS
SOUTH POLE
Nat Geog 171:556–8 (c,1) Ap '87
Trav&Leisure 18:103, 106 (c,3) N '88
Life 12:10 (c,4) Ap '89
—South Geomagnetic Pole
Nat Geog 178:85 (c,3) N '90
—See also
AMUNDSEN, ROALD

SOUTHERN U.S.
—19th cent. stylized depiction of the South
Am Heritage 40:150 (engraving,4) N '89
—1930s scenes of black American life
Life 12:58–64 (1) N '89
—Cartoon spoofing life in the South
Smithsonian 20:180 (c,2) S '89
—Famous Southern gardens
Trav/Holiday 167:44–9 (c,1) Mr '87
—Gracious 19th cent. homes (Beaufort,
South Carolina)
Trav/Holiday 175:58–65 (c,1) My '91
—Plantation houses (Louisiana)
Trav&Leisure 19:cov., 96–105, 146–8
(map,c,1) F '89
—Small town life (Mississippi)
Nat Geog 175:312–39 (c,1) Mr '89
—See also
MISSISSIPPI RIVER
PLANTATIONS
SOUTHWESTERN U.S.
—Late 19th cent. scenes
Smithsonian 21:116–19 (2) My '90
—Landscape
Am Heritage 38:52–61 (c,1) Ap '87
—Retracing Coronado's 1540 Southwest-
ern expedition
Smithsonian 20:40–53 (map,c,1) Ja '90
SOUTHWESTERN U.S.—MAPS
—The Four Corners
Trav&Leisure 20:NY12 (c,4) D '90
SOUVENIRS
—20th cent. scenic luggage stickers
Am Heritage 38:cov., 29–37, 114 (c,4)
Ap '87
—1939 San Francisco World's Fair
Am Heritage 40:42–53, 122 (c,4) My '89
—Baseball memorabilia
Smithsonian 18:cov., 102–13 (c,1) Ap '87
Sports Illus 70:94–5 (c,4) Je 12 '89
Am Heritage 40:116–19, 130 (c,4) S '89
—Souvenir Eiffel Towers (France)
Trav&Leisure 19:148 (c,4) Ap '89
—Souvenir shop (Great Britain)
Trav&Leisure 19:123 (c,3) My '89
—Statue of Liberty souvenir hat
Trav/Holiday 172:NE4 (c,4) N '89
—Zoo souvenir stand (New York)
Trav/Holiday 171:75 (c,4) My '89
SOYBEAN INDUSTRY
Nat Geog 172:68–87 (c,1) Jl '87
—Soybean farm
Nat Wildlife 28:22–3 (c,1) Ap '90
Smithsonian 21:116–17 (c,2) Ap '90
—Use in American products
Nat Geog 172:70–1 (painting,c,1) Jl '87
SOYBEAN INDUSTRY—HARVEST-
ING
—Illinois

Nat Geog 176:196–7 (c,1) Ag '89
—Mud bath (California)
Life 10:26–7 (c,1) F '87
—Piest'any, Czechoslovakia
Nat Geog 171:146 (c,4) Ja '87
—Snowbird, Utah
Trav/Holiday 171:27–31 (c,4) Ja '89
—Thermal spa (Romerbad, Austria)
Gourmet 48:84 (c,4) D '88
—See also
BADEN-BADEN
SPAS—HUMOR
—Decadence of spa life
Trav&Leisure 20:194 (drawing,c,4) Mr
'90
SPEARS
—Aborigine stone spearpoint (Australia)
Nat Geog 174:474 (c,4) O '88
—Prehistoric Clovis spearpoints (Washington)
Nat Geog 174:501–3 (c,1) O '88
—Prehistoric spears
Nat Geog 174:450–1 (c,4) O '88
SPECTATORS
—1917 football fans
Am Heritage 39:103 (painting,c,4) S '88
—America's Cup race (Australia)
Sports Illus 66:10–11 (c,1) F 16 '87
—Angry fans throwing cushions at matadors (Spain)
Life 13:10–11 (c,1) Ag '90
—Baseball
Sports Illus 67:40–1, 60–1, 70–1 (c,1) Jl 6
'87
Sports Illus 69:26–7 (c,1) S 26 '88
Nat Geog 179:64–5 (c,1) My '91
—Baseball (Japan)
Sports Illus 66:74–5 (c,2) Mr 23 '87
Sports Illus 71:60–1 (c,2) Ag 21 '89
—Baseball fans begging for autographs
Sports Illus 73:cov., 34–9 (c,1) Ag 13 '90
—Baseball fans catching ball
Sports Illus 67:2–3 (c,1) Jl 6 '87
Sports Illus 69:2–3 (c,1) S 12 '88
Sports Illus 69:2–3 (c,1) O 17 '88
—Baseball fans doing the Wave
Sports Illus 75:2–3 (c,1) O 21 '91
—Basketball
Sports Illus 66:2–3 (c,1) Mr 16 '87
Sports Illus 69:6–7 (c,1) N 28 '88
—Basketball fans waiting on ticket line
(Georgia)
Sports Illus 72:43 (c,4) Ja 22 '90
—Boxing fans (1953)
Am Heritage 40:96 (3) F '89
—Bullfight (Spain)
Trav&Leisure 20:134–5 (c,1) N '90
—Fatal riot at soccer game (Sheffield, England)

Sports Illus 70:24–5 (c,1) Ap 24 '89
Sports Illus 71:8–9 (c,3) S 25 '89
—Football
Sports Illus 67:98–9 (c,1) D 28 '87
—Football (Great Britain)
Sports Illus 74:49–50 (c,4) Je 17 '91
—Football fans doing The Wave (Berlin, Germany)
Sports Illus 73:39 (c,3) Ag 20 '90
—Football fans pulling down goalposts
Sports Illus 69:63 (c,3) N 28 '88
—Golf
Sports Illus 66:128 (c,2) Ap 6 '87
Sports Illus 67:2–3 (c,1) Jl 27 '87
Sports Illus 68:20–1 (c,2) Je 27 '88
Sports Illus 75:2–3 (c,1) Jl 22 '91
—High school basketball game
Sports Illus 66:79 (c,4) F 16 '87
—Hockey
Sports Illus 69:41 (c,2) O 31 '88
—Horse races
Sports Illus 75:70–1 (c,4) Jl 15 '91
—Kentucky Derby fans under plastic sheet
in rain
Sports Illus 70:2–3 (c,1) My 15 '89
—Pelting basketball court with toilet paper
Sports Illus 68:52 (c,3) Ja 11 '88
—Soccer (Ireland)
Trav&Leisure 18:109 (4) Ap '88
—Soccer game riot (Dusseldorf, West Germany)
Sports Illus 68:49–53 (c,3) Je 27 '88
—Sports fan looking through binoculars
Sports Illus 69:70–1 (c,2) N 14 '88
—Tennis
Sports Illus 66:27 (c,4) Ja 5 '87
Sports Illus 67:2–3 (c,1) Jl 13 '87
Sports Illus 67:72–3 (c,1) D 28 '87
Sports Illus 68:45–6 (c,4) Ap 11 '88
Sports Illus 70:78–9 (c,1) Je 26 '89
—Watching 1952 World Series in Chicago
bar
Life 12:66–7 (1) Mr '89
—Watching World Cup soccer events on
TV worldwide
Life 13:92–3 (c,1) Ag '90
SPECTATORS—HUMOR
—Baseball fans
Sports Illus 71:40–1 (painting,c,4) O 23
'89
—Hockey fans at game
Sports Illus 70:64–6, 71–4 (painting,c,1)
Ap 3 '89
—Rotisserie League for baseball fans
Smithsonian 21:100–13 (painting,c,1) Je
'90
SPERM WHALES
Nat Geog 174:908–9 (c,1) D '88
Natur Hist 100:65–7 (c,1) Mr '91

SPHINX, EGYPT
 Smithsonian 21:106 (sculpture,c,4) Ag
 '90
 Trav&Leisure 21:52 (c,4) Ag '91
 —Great Sphinx under scaffolding (Giza,
 Egypt)
 Life 13:11 (c,3) Ap '90
 Nat Geog 179:32–9 (c,1) Ap '91
SPICE INDUSTRY
 —Bags of spices (Egypt)
 Trav&Leisure 21:100 (c,4) D '91
 —Frankincense
 Nat Wildlife 30:36 (c,4) D '91
 —Grenada, Windward Islands
 Gourmet 50:72 (c,4) Ja '90
 —Grinding turmeric (Great Britain)
 Nat Geog 180:40–1 (c,2) Jl '91
 —Saffron (Spain)
 Smithsonian 19:104–11 (c,1) Ag '88
 —See also
 NUTMEG
 PEPPERS
 SAFFRON
SPIDERS
 Smithsonian 18:94–104 (c,1) O '87
 Nat Wildlife 26:8 (c,4) F '88
 Natur Hist 98:116–17 (c,1) N '89
 Natur Hist 99:8 (c,3) Mr '90
 Natur Hist 99:36–7 (c,1) Je '90
 Nat Geog 178:70, 78, 86 (c,1) Jl '90
 Nat Wildlife 29:52–9 (c,1) F '91
 Natur Hist 100:44–9 (c,1) D '91
 —Community spider nest
 Natur Hist 99:6–7, 10 (c,1) Mr '90
 —Insects caught in spider webs
 Smithsonian 18:94–8 (c,1) O '87
 —Jumping spiders
 Natur Hist 98:76–7 (c,1) Jl '89
 Nat Geog 180:42–63 (c,1) S '91
 —Sea spiders
 Natur Hist 99:cov., 74–5 (c,1) S '90
 —Sexual organs of male spiders
 Natur Hist 96:8 (4) D '87
 —Webs
 Smithsonian 18:104–5 (c,1) O '87
 Nat Wildlife 27:57 (c,1) Ap '89
 Nat Wildlife 29:56–7 (c,1) D '90
 Nat Wildlife 29:54–7, 60 (c,1) F '91
 —See also
 TARANTULAS
SPIDERWORTS
 Nat Wildlife 26:17 (c,4) Ag '88
SPIES
 —1780 hanging of spy John André
 Am Heritage 38:8 (painting,4) Jl '87
 —Spy cameras
 Smithsonian 18:cov., 118–19 (c,1) O '87
SPINNING WHEELS
 —Massachusetts

 Trav/Holiday 167:47 (c,4) Ja '87
SPLIT, YUGOSLAVIA
 Nat Geog 178:96–7 (c,1) Ag '90
 Trav/Holiday 175:34–43 (map,c,1) Ja '91
 —Diocletian's palace
 Trav/Holiday 175:36–42 (c,1) Ja '91
 Trav&Leisure 21:190 (c,4) Ap '91
SPOCK, BENJAMIN
 Life 13:84 (2) Fall '90
SPOKANE, WASHINGTON
 —Lilac Bloomsday Run
 Nat Geog 176:802 (c,1) D '89
SPONGES
 Nat Wildlife 25:56–7 (c,1) F '87
 Trav/Holiday 169:52–3 (c,1) Ja '88
 Natur Hist 97:54–5 (c,1) O '88
 Natur Hist 100:66–7, 69 (c,1) N '91
 —Elephant-ear sponges
 Nat Geog 174:722–3 (c,2) N '88
 —Giant barrel sponge
 Life 10:51 (c,1) Je '87
 —Tube sponge
 Nat Geog 174:724 (c,4) N '88
 Natur Hist 98:73 (c,3) O '89
 Natur Hist 100:84–5 (c,1) F '91
SPOONBILLS
 —Roseate
 Life 10:55 (c,3) Jl '87
 Gourmet 49:91 (c,3) O '89
 —Royal
 Nat Geog 171:280–4 (c,1) F '87
SPORTS
 —1880s scenes
 Nat Geog 173:28–9 (c,1) Ja '88
 —1954–1989 events
 Sports Illus 71:22–216 (c,1) N 15 '89
 —1987 events
 Sports Illus 67:entire issue (c,1) D 28 '87
 —1988 events
 Sports Illus 69:cov., 54–138 (c,1) D 26 '88
 —1989 events
 Sports Illus 71:52–115 (c,1) D 25 '89
 —1990 events
 Sports Illus 73:47–131 (c,1) D 31 '90
 —1991 events
 Sports Illus 75:48–91 (c,1) D 30 '91
 —Aztec hip soccer game (Mexico)
 Nat Geog 177:96–7 (c,1) Mr '90
 —Basque handball "pala"
 Sports Illus 69:124 (c,4) N 7 '88
 —Baton twirling
 Sports Illus 69:99–102 (painting,c,3) D
 12 '88
 —Biathlon (New York)
 Sports Illus 66:54–5 (c,2) F 23 '87
 —Bungee jumping off bridge (New Zeal-
 and)
 Sports Illus 70:12 (c,4) Je 5 '89
 —China

JAVELIN THROWING
JOGGING
JUDO
JUMPING
KARATE
LACROSSE
LOCKER ROOMS
LUGE
MARATHONS
MARTIAL ARTS
MOTORBOAT RACES
MOTORCYCLE RACES
MOTORCYCLE RIDING
MOUNTAIN CLIMBING
OLYMPICS
PARACHUTING
POLE VAULTING
POLO
RACE TRACKS
RACES
RAFTING
ROCK CLIMBING
RODEOS
ROLLER SKATING
ROPE JUMPING
ROWING
RUGBY
RUNNING
SAILBOAT RACES
SAILING
SCOREBOARDS
SHOOTING
SHOT-PUTTING
SKATEBOARDING
SKATING
SKATING, FIGURE
SKATING, SPEED
SKIING
SKIING—CROSS-COUNTRY
SKIN DIVING
SKY DIVING
SNOWMOBILING
SOAP BOX DERBIES
SOCCER
SOFTBALL
SPECTATORS
SPORTS ARENAS
SQUASH
STADIUMS
SURFING
SWIMMING
TABLE TENNIS
TENNIS
TOBOGGANING
TRACK
TRACK AND FIELD—MEETS
TREE CLIMBING
TROPHIES
VOLLEYBALL

WALKING
WATER POLO
WATER SKIING
WEIGHT LIFTING
WINDSURFING
WRESTLING
YOGA
SPORTS—HUMOR
—Life on the sports team bus
 Sports Illus 71:58–68 (drawing,c,1) Jl 3
 '89
—Radio call-in sports programs
 Sports Illus 73:108–21 (painting,c,1) O 8
 '90
SPORTS ANNOUNCERS
 Sports Illus 69:105–8 (painting,c,4) N 28
 '88
—Baseball
 Sports Illus 67:80 (c,4) Jl 6 '87
SPORTS ARENAS
—Boston Gardcn, Massachusctts
 Sports Illus 68:53, 62 (c,2) Mr 21 '88
—Civic Arena, Pittsburgh, Pennsylvania
 Sports Illus 66:18 (c,4) Je 29 '87
—McNichols, Denver, Colorado
 Sports Illus 67:22–3 (c,2) Jl 20 '87
—Natatorium pool (Indianapolis, Indiana)
 Nat Geog 172:258 (c,3) Ag '87
—Oakland Coliseum, California
 Sports Illus 67:38–9 (c,1) O 12 '87
—Skating dome (Calgary, Alberta)
 Sports Illus 68:234–5 (c,1) Ja 27 '88
—Zamboni machine used to clean stadium
 ice
 Sports Illus 66:38–40, 45 (c,2) Mr 30 '87
 Sports Illus 66:8 (c,4) Ap 27 '87
—See also
 STADIUMS
SPORTS EQUIPMENT
—Humorous ideas for new sports equip-
 ment
 Sports Illus 68:198–201 (painting,c,4) Ja
 27 '88
—See also
 BASEBALL BATS
 BASEBALL GLOVES
 BASKETBALLS
 FISHING EQUIPMENT
 GOLF BALLS
 GOLF CARTS
 GOLF CLUBS
 HUNTING EQUIPMENT
 SKATES
 SPORTSWEAR
 TENNIS RACQUETS
Sports fans. See
 SPECTATORS
SPORTSWEAR
—19th cent. women's golf attire

Sports Illus 69:70–1 (c,1) D 26 '88
Life 12:112–13 (c,1) Ja '89
—See also
SPORTS ARENAS
TENNIS COURTS
STAGECOACHES
—1871
Am Heritage 40:80 (painting,c,4) S '89
—1901 painting by Remington
Nat Geog 174:231 (painting,c,1) Ag '88
Am Heritage 40:6 (c,2) S '89
STAINED GLASS
—16th cent. depictions of wool production
(France)
Nat Geog 173:568 (c,4) My '88
—1900 stained glass screen by Tiffany
Am Heritage 39:21 (c,1) S '88
—1905 Wright stained glass window
Am Heritage 38:84 (c,4) Jl '87
—1915 bathhouse skylight (Arkansas)
Am Heritage 42:138 (c,4) Ap '91
—By Matisse (Vence, France)
Trav&Leisure 19:56, 61 (c,3) Jl '89
—Chagall window (New York)
Trav&Leisure 17:NY2 (c,4) S '87
—Chartres cathedral, France
Nat Geog 176:114 (c,4) Jl '89
—Matisse rose window (New York)
Trav&Leisure 17:NY2 (c,4) S '87
—Notre Dame Cathedral, Paris, France
Trav&Leisure 17:49 (c,4) D '87
—St. Louis Catholic Cathedral, Missouri
Life 11:16 (c,4) My '88
—Sainte-Chapelle, Paris, France
Nat Geog 176:116–17 (c,1) Jl '89
—Washington National Cathedral, Wash-
ington, D.C.
Smithsonian 21:126 (c,3) Je '90
—Works by John La Farge
Smithsonian 18:cov., 52–7 (c,1) Jl '87
STAIRCASES
—1683 home (Massachusetts)
Am Heritage 42:136 (c,4) N '91
—18th cent. Federal style home (Mas-
sachusetts)
Am Heritage 40:71 (c,1) My '89
—18th cent. home (Virginia)
Life 10:69, 73 (c,2) Fall '87
—1790 home (South Carolina)
Trav/Holiday 175:64 (c,1) My '91
—1890s mansion (North Carolina)
Trav/Holiday 175:59 (c,1) Ap '91
—Ancient Maya temple (Guatemala)
Trav&Leisure 18:162, 167 (c,1) N '88
—British Embassy, Washington, D.C.
Am Heritage 38:91 (c,1) My '87
—Cat Street, Hong Kong
Gourmet 48:65 (c,4) Mr '88
—Circular hotel staircase (Germany)

Trav&Leisure 21:96–7 (c,1) S '91
—Circular staircase (New Mexico)
Trav/Holiday 174:64 (c,3) D '90
—Climbing steps of Maya ruins (Belize)
Trav/Holiday 175:cov. (c,1) Je '91
—Great Skellig stone steps, Ireland
Trav/Holiday 176:80–1 (c,1) O '91
—Hermitage Museum, Leningrad,
U.S.S.R.
Life 11:58–9 (c,1) My '88
—Hong Kong hotel
Trav&Leisure 17:30 (c,2) Ap '87 supp.
—Ladder Street, Hong Kong
Trav&Leisure 18:133 (c,4) Ja '88
—Louvre entrance circular staircase (Paris,
France)
Nat Geog 176:106 (c,1) Jl '89
—Mall's circular staircase (Glasgow, Scot-
land)
Trav/Holiday 174:44 (c,4) N '90
—Mansion (Mauritius)
Gourmet 49:99 (c,3) N '89
—Mansion's spiral staircase (Indiana)
Gourmet 50:107 (c,1) D '90
—Marble library staircase (Chicago, Illi-
nois)
Smithsonian 18:125 (c,3) Mr '88
—Smithsonian Institution, Washington,
D.C.
Smithsonian 18:51 (c,3) S '87
—Spiral staircase at college (Montreal,
Quebec)
Nat Geog 179:83 (c,1) Mr '91
—Stadium steps
Sports Illus 68:196 (c,4) Ja 27 '88
Sports Illus 73:2–3 (c,1) Ag 27 '90
—Steps leading up to front door (Portugal)
Trav/Holiday 174:56 (c,2) N '90
—Supreme Court Building, Washington,
D.C.
Life 10:112 (c,2) Fall '87
—Trompe l'oeil staircase painting by Peale
Nat Geog 178:104–5 (c,1) D '90
—Vienna State Opera House, Austria
Gourmet 50:68 (c,3) Ja '90
—See also
ESCALATORS
STALIN, JOSEF
Life 11:56–62 (1) Je '88
Am Heritage 39:57 (drawing,1) D '88
—Bust (Poland)
Nat Geog 179:2–3 (c,1) Mr '91
—Sweeping fallen Stalin statue (Lithuania)
Nat Geog 178:cov., 15 (c,1) N '90
Stalingrad. See
VOLGOGRAD
STAMPS
—Duck stamps
Nat Wildlife 25:56 (painting,c,4) O '87

—State wildlife stamps
 Nat Wildlife 27:34–40 (painting,c,2) D '88
—See also
 POSTAGE STAMPS
STANFORD, LELAND
 Am Heritage 38:91 (2) D '87
STANFORD UNIVERSITY, CALIFOR-
 NIA
 Am Heritage 41:79 (c,4) N '90
STANLEY AND LIVINGSTONE
 Smithsonian 17:158 (drawing,4) Mr '87
—Their historic 1871 meeting in Africa
 Nat Geog 173:15 (4) Ja '88
STANTON, EDWIN M.
 Am Heritage 42:11 (4) Ap '91
STARFISH
 Nat Geog 171:300 (c,4) Mr '87
 Trav&Leisure 18:117 (c,4) O '88
 Smithsonian 20:96–8 (c,4) Ag '89
 Natur Hist 98:cov., 72–6 (c,1) O '89
 Nat Geog 177:18–19, 32–3 (c,1) F '90
 Natur Hist 99:cov., 70–1 (c,1) S '90
 Natur Hist 100:31 (c,4) F '91
 Natur Hist 100:44–5 (c,1) Ap '91
—Starfish eating jellyfish
 Smithsonian 21:104 (c,4) F '91
STARLINGS
 Nat Wildlife 29:54 (c,4) D '90
 Nat Wildlife 30:18–19 (c,1) D '91
—Oxpeckers
 Natur Hist 97:92–3 (c,1) F '88
 Nat Geog 178:62 (c,1) D '90
STARLINGS—HUMOR
—Starlings' rowdy behavior
 Nat Wildlife 28:24–7 (painting,c,1) Ap
 '90
STARS
—Beta Pictoris
 Life 12:51 (c,2) Jl '89
—Exploded star
 Smithsonian 17:36 (c,4) Mr '87
 Smithsonian 19:46–57 (c,1) Ap '88
—Night sky
 Life 11:2–3 (c,1) Jl '88
 Life 13:cov. (c,1) D '90
—Supernovas
 Smithsonian 19:46–57 (c,1) Ap '88
 Nat Geog 173:618–47 (c,1) My '88
—Supernova 1987A
 Life 10:123 (c,2) D '87
 Life 14:55 (c,4) Ja '91
—Time exposure of star movement
 Nat Geog 171:459 (c,3) Ap '87
 Smithsonian 19:54 (c,4) Ap '88
—See also
 CONSTELLATIONS
 NEBULAE
STATESMEN
—Congressmen Smoot and Hawley (1930)

 Am Heritage 39:77 (2) F '88
—Contemporary U.S. political figures
 Life 10:96–101 (c,1) Fall '87
—Framers of the U.S. Constitution
 Am Heritage 38:46–51, 82–5 (paint-
 ing,c,1) My '87
 Smithsonian 18:32–43 (drawing,1) Jl '87
 Life 10:51–8 (painting,c,4) Fall '87
—Members of first U.S. Congress (1789)
 Smithsonian 19:196 (painting,c,4) Mr '89
—See also
 ADAMS, CHARLES FRANCIS
 ADAMS, SAMUEL
 BACON, FRANCIS
 BALDWIN, ABRAHAM
 BASSETT, RICHARD
 BEDFORD, GUNNING
 BISMARCK, OTTO VON
 BLAIR, JOHN
 BLOUNT, WILLIAM
 BOONE, DANIEL
 BREARLY, DAVID
 BRYAN, WILLIAM JENNINGS
 BUTLER, PIERCE
 CARROLL, CHARLES
 CARROLL, DANIEL
 CHAMBERLAIN, NEVILLE
 CHOATE, RUFUS
 CHURCHILL, WINSTON
 CLAY, HENRY
 CLINTON, GEORGE
 CLYMER, GEORGE
 DAYTON, JONATHAN
 DEMOSTHENES
 DICKINSON, JOHN
 DULLES, JOHN FOSTER
 FEW, WILLIAM
 FRANKLIN, BENJAMIN
 GERRY, ELBRIDGE
 GILMAN, NICHOLAS
 GOLDWATER, BARRY
 GORHAM, NATHANIEL
 HAMILTON, ALEXANDER
 HANCOCK, JOHN
 HAY, JOHN MILTON
 HENRY, PATRICK
 HUGHES, CHARLES EVANS
 INGERSOLL, JARED
 JENIFER, DANIEL OF ST. THOMAS
 JOHNSON, WILLIAM SAMUEL
 KENNEDY, ROBERT
 KING, RUFUS
 KISSINGER, HENRY
 LAGUARDIA, FIORELLO
 LANDON, ALFRED M.
 LANGDON, JOHN
 LEE, RICHARD HENRY
 LEE, ROBERT E.
 LIVINGSTON, WILLIAM

Stoats. See
ERMINE
STOCK EXCHANGES
—Early 18th cent. stock scandal (Great
 Britain)
 Smithsonian 20:155–74 (painting,c,3) D
 '89
—1904 wool exchange (Bradford, En-
 gland)
 Nat Geog 173:572–3 (2) My '88
—1911 cartoon about businessmen doing
 "real" work
 Am Heritage 42:130–1 (1) Ap '91
—1987 Wall Street crash headline
 Sports Illus 71:198 (c,4) N 15 '89
—Cartoons about 1929 stock market crash
 and Depression
 Am Heritage 39:105–9 (3) Jl '88
—Examining stock ticker (1929)
 Am Heritage 39:4 (painting,c,2) Jl '88
—Hong Kong
 Trav&Leisure 18:71 (c,4) Ja '88
 Smithsonian 20:50 (c,4) Ap '89
 Trav/Holiday 176:54–5 (c,2) O '91
—Milwaukee Grain Exchange, Wisconsin
 Am Heritage 42:106–7 (c,2) Jl '91
—New York Stock Exchange trading floor
 Am Heritage 38:51 (c,4) N '87
—Tokyo, Japan
 Trav&Leisure 19:56 (c,4) Ja '89
STOCKHOLM, SWEDEN
 Trav&Leisure 17:94–5 (c,1) O '87
—Cafe Opera
 Trav&Leisure 20:98–101 (c,1) Ag '90
—Djurgården map
 Trav&Leisure 17:58–60 (c,3) My '87
STOKOWSKI, LEOPOLD
 Smithsonian 21:72 (4) F '91
STONEHENGE, ENGLAND
 Trav&Leisure 18:53 (c,3) F '88
 Nat Geog 177:110 (c,4) Mr '90
 Trav&Leisure 20:132 (c,3) S '90
—Summer solstice ritual at Stonehenge,
 England
 Smithsonian 18:166 (c,4) Mr '88
STORES
—19th cent. general store (Staten Island,
 New York)
 Am Heritage 42:105 (c,4) My '91
—Mid 19th cent. (New York City, New
 York)
 Trav&Leisure 19:221 (4) Ap '89
—1865 bookstore (Boston, Massachusetts)
 Am Heritage 40:60 (4) Ap '89
—1873 shoppers in elevator (New York)
 Smithsonian 20:216 (engraving,3) N '89
—Late 19th cent. general store (New Mex-
 ico)
 Am Heritage 42:72–3 (c,3) Ap '91

—1886 Bloomingdale's grand opening an-
 nouncement (New York)
 Am Heritage 38:13 (4) Ap '87
—1880s millinery shop (New York)
 Am Heritage 40:116 (painting,c,3) D '89
—1901 candy shop (New York)
 Am Heritage 41:128 (3) N '90
—1920s antique shop (Vienna, Austria)
 Smithsonian 21:105 (3) Ag '90
—1920s Christmas shoppers
 Am Heritage 39:cov. (painting,c,2) D '88
—1920s Shakespeare & Company book-
 store (Paris, France)
 Nat Geog 176:173 (3) Jl '89
—1934 (Texas)
 Am Heritage 38:44–7 (1) Jl '87
—1936 general store (Alabama)
 Life 11:41 (4) Fall '88
—1955 small town shopping street (Rolla,
 Missouri)
 Nat Geog 175:187 (2) F '89
—1957 used furniture store (Missouri)
 Nat Geog 175:192–3 (1) F '89
—Antique prints gallery (Pennsylvania)
 Smithsonian 20:86–7, 90–1 (c,1) D '89
—Antique shop (Louisiana)
 Natur Hist 99:80–1 (c,2) Je '90
—Bargain store (Toronto, Ontario)
 Smithsonian 19:64–71 (c,2) Ap '88
—Barren store window (Moscow,
 U.S.S.R.)
 Trav/Holiday 174:47 (c,2) Ag '90
—Basket store (Singapore)
 Trav/Holiday 169:35 (c,4) F '88
—Bookstores
 Smithsonian 18:83 (c,3) Jl '87
 Trav&Leisure 18:110 (2) Ap '88
—Bookstores (Hay-on-Wye, Wales)
 Gourmet 50:78–9 (c,3) F '90
—Children playing in toy store (Mas-
 sachusetts)
 Smithsonian 20:80–1 (c,1) D '89
—Country store (Montana)
 Nat Geog 171:813 (c,4) Je '87
—Country store (Vermont)
 Gourmet 50:62–3 (c,1) Ja '90
—Department store (Moscow, U.S.S.R.)
 Trav/Holiday 168:64 (c,4) Ag '87
 Trav&Leisure 17:96–7 (c,1) D '87
—Department store saleswomen (Japan)
 Nat Geog 177:56–7 (c,1) Ap '90
—Hong Kong
 Trav&Leisure 18:74–85 (c,1) Ja '88
 Gourmet 48:63–7 (c,4) Mr '88
—Ice cream stand shaped like windmill
 (California)
 Smithsonian 19:116 (c,4) N '88
—Local store (Kashmir)
 Nat Geog 172:536 (c,4) O '87

—Los Angeles, California
 Gourmet 51:74–9 (c,2) Ap '91
—Madrid, Spain
 Gourmet 50:84–9 (c,1) Je '90
 Gourmet 50:50–5 (c,2) Jl '90
—Le Marais area, Paris, France
 Gourmet 50:68–73 (c,2) F '90
—Marks & Spencer (London, England)
 Smithsonian 18:142–53 (c,1) N '87
—Milan, Italy
 Gourmet 47:86–91 (c,3) N '87
—Pewter shop (West Germany)
 Trav/Holiday 169:107 (c,4) Mr '88
—Recreation of 19th cent. country store
 (New York)
 Trav&Leisure 20:E1 (c,3) Je '90
—Shoplifting
 Life 11:32–8 (c,1) Ag '88
—Soho, New York City, New York
 Trav&Leisure 17:64–6 (c,4) Je '87
—Souvenir shop (Great Britain)
 Trav&Leisure 19:123 (c,3) My '89
—Tiffany's history (New York City, New
 York)
 Smithsonian 18:52–65 (c,1) D '87
—Tiffany's storefront, New York City,
 New York
 Gourmet 47:54, 60 (painting,c,2) D '87
—Tinsmith's shop (Hong Kong)
 Natur Hist 98:108 (c,4) F '89
—Violin store (Paris, France)
 Gourmet 50:72 (c,4) F '90
—See also
 BAKERIES
 BUTCHERS
 CASH REGISTERS
 FIELD, MARSHALL
 FLEA MARKETS
 FOOD MARKETS
 MARKETS
 PHARMACIES
 RESTAURANTS
 SHOPPING MALLS
 STREET VENDORS
 SUPERMARKETS
STORKS
 Natur Hist 97:36 (lithograph,c,1) Mr
 '88
 Trav/Holiday 171:45 (c,4) Ap '89
 Am Heritage 41:68 (sculpture,c,4) My
 '90
 Nat Geog 178:111 (c,3) Jl '90
 Natur Hist 100:34 (c,4) S '91
STORMS
—1641 storm at sea
 Smithsonian 17:102 (painting,c,3) Ja '87
—1930s Dust Bowl scenes (Oklahoma)
 Smithsonian 20:cov., 44–57 (1) Je '89
—1981 dust storm (Somalia)

 Natur Hist 96:28 (c,4) F '87
—Dust storm (India)
 Trav&Leisure 19:140 (c,1) Ap '89
—Dust storm (Mali)
 Nat Geog 172:140–1 (c,1) Ag '87
—Ocean storm (North Carolina)
 Nat Geog 172:504–5 (c,1) O '87
—Ocean storm around lighthouse (France)
 Life 13:6–7 (c,1) My '90
—Sandstorm (Khartoum, Sudan)
 Life 13:4–5 (c,1) S '90
—Storm clouds (Kansas)
 Smithsonian 21:46–7 (1) Mr '91
—Storm clouds over sea (Australia)
 Nat Geog 179:28–9 (c,1) Ja '91
—Thunderstorm (Oklahoma)
 Nat Geog 171:710–11 (c,1) Je '87
—See also
 BLIZZARDS
 HURRICANES
 MONSOONS
 RAIN
 SNOW STORMS
STORMS—DAMAGE
—Damage from hailstorms
 Nat Geog 171:90 (c,3) Ja '87
—Hailstorm damage to farm (North Da-
 kota)
 Nat Geog 171:331 (c,4) Mr '87
—Uprooted tree blown into car (Michigan)
 Life 13:10 (c,2) Ap '90
STORY, JOSEPH
 Am Heritage 42:97 (painting,4) O '91
STOVES
—1833 cast-iron cookstove
 Am Heritage 40:110 (4) D '89
—1888 coal stove (Mississippi)
 Am Heritage 40:106–7 (1) D '89
—1920s
 Am Heritage 42:31, 114 (c,1) My '91
—Woodburning stove (Costa Rica)
 Smithsonian 17:59 (c,4) Mr '87
—Woodburning stoves
 Trav&Leisure 18:138 (c,4) N '88
 Trav/Holiday 170:58 (c,1) N '88
STOWE, HARRIET BEECHER
—1852 ad for *Uncle Tom's Cabin*
 Am Heritage 38:50 (4) D '87
STRASBOURG, FRANCE
 Trav/Holiday 171:48–9 (c,1) Ja '89
STRATFORD-ON-AVON, ENGLAND
—Sites related to Shakespeare
 Smithsonian 18:155–75 (c,3) S '87
STRAUS, NATHAN
 Am Heritage 41:14 (drawing,4) Jl '90
STRAUSS, JOHANN
—Johann Strauss monument (Vienna,
 Austria)
 Trav&Leisure 18:127 (c,4) N '88

SULFUR MINING
—Chile
　Nat Geog 171:455 (c,4) Ap '87
SULLIVAN, JOHN L.
　Nat Geog 173:29 (4) Ja '88
　Am Heritage 39:12 (drawing,4) S '88
　Sports Illus 71:70–2 (4) Jl 3 '89
SUMAC
　Nat Wildlife 29:56–60 (c,1) O '91
SUMMER
—Summer of 1988 drought scenes (U.S.)
　Natur Hist 98:42–71 (c,1) Ja '89
　Life 12:12–13 (c,1) Ja '89
—Summer park activities
　Trav&Leisure 18:123 (painting,c,2) Ag
　　'88
—Summer solstice ritual at Stonehenge,
　England
　Smithsonian 18:166 (c,4) Mr '88
SUN
　Trav/Holiday 167:10 (c,4) Mr '87
　Trav&Leisure 19:110 (drawing,4) Je '89
　Nat Wildlife 28:43 (c,1) Ap '90
　Nat Geog 178:66–7 (c,1) O '90
—Refraction display
　Natur Hist 100:70 (c,3) F '91
—Solar flares
　Natur Hist 97:74 (c,3) N '88
　Smithsonian 20:32–41 (c,1) Mr '90
　Nat Geog 178:96 (c,4) O '90
—Sunspots
　Natur Hist 96:88 (4) N '87
　Natur Hist 97:74 (c,3) N '88
　Smithsonian 20:32–41 (c,1) Mr '90
—Time-lapse photos of Alaskan winter sun
　Nat Wildlife 29:4–5 (c,1) D '90
—See also
　ECLIPSES
SUNBATHING
—Aboard cruise ship
　Trav/Holiday 171:32 (c,4) Ja '89
—Applying suntan lotion (Caribbean)
　Trav&Leisure 19:199 (c,3) O '89
—Brazil
　Smithsonian 19:162 (c,4) My '88
—By hotel pool (California)
　Trav&Leisure 18:104–5 (c,1) My '88
—By hotel pool (Hawaii)
　Trav&Leisure 19:87 (c,2) Ja '89
—Florida
　Trav&Leisure 20:178–9 (c,1) N '90
—Italy
　Trav&Leisure 17:102 (c,4) F '87
　Trav&Leisure 18:140–1 (c,1) Ap '88
　Gourmet 50:74–5 (c,1) Je '90
—Lincoln Park, Chicago, Illinois
　Nat Geog 179:56 (c,3) My '91
—North Carolina college campus
　Sports Illus 69:74–5 (c,2) O 17 '88

—On roof
　Nat Wildlife 28:25 (drawing,c,4) Ag '90
—Sunburned woman (Virginia)
　Nat Geog 178:89 (c,4) O '90
—Thailand
　Trav&Leisure 19:146 (c,4) N '89
—West Indies
　Trav&Leisure 17:cov., 68–9 (c,1) Ja '87
　Trav/Holiday 167:38–9 (c,1) Mr '87
　Trav/Holiday 168:67 (c,1) Ag '87
SUNDAY, BILLY
　Smithsonian 19:139 (4) Ja '89
SUNDEW PLANTS
　Nat Geog 171:412 (c,4) Mr '87
　Nat Geog 175:548–9 (c,2) My '89
SUNDIALS
—1939
　Smithsonian 20:168 (4) My '89
SUNFLOWERS
　Nat Geog 171:cov., 330–1 (c,1) Mr '87
　Nat Wildlife 25:26 (drawing,c,4) Ap '87
　Nat Wildlife 27:52 (c,4) O '89
　Smithsonian 20:104–5 (c,1) Ja '90
　Gourmet 50:101 (c,4) Mr '90
　Trav/Holiday 174:68–9 (c,1) N '90
　Gourmet 51:77 (c,4) Je '91
　Natur Hist 100:19 (c,2) D '91
—Field of sunflowers
　Nat Wildlife 26:18–19 (c,1) O '88
　Nat Wildlife 27:32–3 (c,1) Je '89
—O'Keeffe painting
　Am Heritage 38:cov. (c,1) S '87
—Spiral design of seeds
　Nat Wildlife 27:54–5 (c,1) Ap '89
SUNRISES
—Australian sea
　Nat Geog 171:310–11 (c,1) Mr '87
—Chianti countryside, Italy
　Trav&Leisure 21:cov. (c,1) Ja '91
—Dawn over New Mexican countryside
　Nat Geog 172:630–1 (c,1) N '87
—Florida Bay
　Life 10:48–9 (c,1) Jl '87
—Long Island coast, New York
　Trav&Leisure 18:97 (c,3) S '88
—Over fishing boats (Virginia)
　Trav/Holiday 169:50 (c,4) F '88
—Over mountains (Texas)
　Trav&Leisure 21:126 (c,3) S '91
—Over water (Mexico)
　Gourmet 48:83 (c,3) O '88
—Seen from mountain top (California)
　Life 11:10–11 (c,1) Ja '88
—Silhouetting fisherman (Indonesia)
　Trav&Leisure 20:191 (c,4) F '90
—Time-lapse photos of Alaskan winter sun
　Nat Wildlife 29:4–5 (c,1) D '90
SUNSETS
　Trav/Holiday 18:52 (c,4) Mr '88

- T -

Smithsonian 19:120 (4) My '88
TAFT, WILLIAM HOWARD
Nat Geog 173:39 (4) Ja '88
Am Heritage 39:35 (4) Mr '88
Sports Illus 72:118 (painting,c,4) Ap 16 '90
Life 13:70 (4) Fall '90
Trav/Holiday 176:52 (4) D '91
TAHITI
Trav&Leisure 18:134–5 (c,1) F '88
Life 11:46–52 (c,2) Jl '88
—Paintings by Gauguin
Life 11:46–52 (c,2) Jl '88
TAHITI—COSTUME
Trav/Holiday 168:cov. (c,1) Ag '87
Life 11:46–52 (c,2) Jl '88
TAILORS
—Hong Kong
Trav&Leisure 21:54 (c,4) Ap '91
TAIPEI, TAIWAN
Gourmet 49:cov., 80–5, 188, 196–8 (map,c,1) Ap '89
—Chiang Kai-shek Memorial
Trav/Holiday 167:78 (c,4) F '87
—Lung Shan temple
Gourmet 51:cov. (c,1) S '91
—Restaurants
Gourmet 51:80–3 (c,2) S '91
TAIWAN
—Sun Moon Lake
Trav&Leisure 17:138 (c,4) Mr '87
—Taroko Gorge
Trav/Holiday 167:79 (c,4) F '87
—See also
CHIANG KAI-SHEK
TAIPEI
TAIWAN—MAPS
Gourmet 51:156 (4) S '91
TAJ MAHAL, AGRA, INDIA
Trav&Leisure 20:118–21 (c,1) F '90
TAMPA, FLORIDA
Am Heritage 40:115 (c,3) My '89
—1925
Am Heritage 40:114 (3) My '89
TANAGERS
—Scarlet tanagers
Nat Wildlife 27:27 (c,1) D '88
TANKERS
Smithsonian 19:59 (c,1) F '89
—Computer simulation of driving tanker
Life 12:8 (c,4) Je '89
—Exxon Valdez
Life 13:78 (c,4) F '90
—Exxon Valdez after oil spill
Nat Wildlife 27:6–7 (c,2) Je '89
Life 13:16–17 (c,1) Ja '90
—Tankers on fire
Nat Geog 173:649–50 (c,1) My '88
Life 14:10–11 (c,1) Jl '91

TANKS, ARMORED
—1940s (U.S.)
Am Heritage 38:136–8 (3) My '87
Trav/Holiday 172:62–3 (c,1) S '89
—1940s British concrete anti-tank barriers (Pakistan)
Smithsonian 19:49 (c,4) D '88
—Australia
Trav/Holiday 169:59 (c,3) Ap '88
—British (Saudi Arabia)
Life 14:6–7 (c,1) Ap '91
—China
Life 12:2–3, 38 (c,1) Jl '89
Life 12:32–3 (c,1) Fall '89
—Russian tank factory (1943)
Am Heritage 39:69 (4) D '88
—Sherman tank buried in sand (France)
Life 13:18 (c,2) My '90
—South Africa
Nat Geog 174:585 (c,1) O '88
TANZANIA
Trav&Leisure 17:94–109, 173–4 (map,c,1) N '87
—Carbonatite volcano
Nat Geog 177:28 (c,3) My '90
—Lake Manyara National Park
Trav/Holiday 168:22–7 (c,3) Jl '87
—Ngorongoro crater
Nat Geog 177:32–5 (c,1) My '90
—Serengeti National Park
Smithsonian 17:50–61 (c,1) F '87
—Zanzibar
Trav/Holiday 171:86–7 (c,3) Ja '89
TANZANIA—COSTUME
—Masai people
Trav&Leisure 17:cov., 96–7, 106–7 (c,1) N '87
TAOS, NEW MEXICO
Trav/Holiday 171:cov., 28–33 (c,1) Je '89
TAPESTRIES
—14th cent. Angers tapestry (France)
Trav&Leisure 18:206 (c,4) D '88
—Spanish-colonial Peru
Smithsonian 17:108, 117 (c,1) Mr '87
TAPIRS
Nat Geog 176:459 (c,4) O '89
Trav&Leisure 21:76 (c,4) O '91
TARANTULAS
Nat Wildlife 29:58–9 (c,1) F '91
TARZAN
Sports Illus 69:45 (4) Ag 1 '88
—Scenes from Tarzan movies
Sports Illus 67:82–3 (2) D 7 '87
TASMANIA, AUSTRALIA
—Countryside
Trav/Holiday 171:63 (c,1) Ap '89
—Last Tasmanian man (1866)
Natur Hist 97:10 (drawing,4) O '88
—Mount Field National Park

Sports Illus 74:30–3 (c,4) F 4 '91
—Watching 1952 World Series in Chicago
 bar
 Life 12:66–7 (1) Mr '89
—Watching 1991 Gulf War news reports
 (U.S.)
 Life 14:26–38 (c,1) Mr '91
—Watching World Cup soccer events on
 TV worldwide
 Life 13:92–3 (c,1) Ag '90
TELEVISIONS
—Australia
 Nat Geog 173:246–7 (1) F '88
—1927 television receiver
 Life 12:96 (4) Mr '89
—1939 RCA television
 Life 12:96 (c,4) Mr '89
—1939–1950s sets
 Smithsonian 20:82–5 (c,1) Je '89
—1949 3-inch screen
 Life 12:96 (c,4) Mr '89
—1953
 Am Heritage 39:77 (4) Mr '88
—1954 color set
 Life 12:96 (4) Mr '89
—1959 portable television
 Life 12:96 (c,4) Mr '89
—TV assembly plant (Mexico)
 Nat Geog 176:193 (c,3) Ag '89
—TV at 1939 World's Fair (New York)
 Smithsonian 20:85 (c,1) Je '89
—TV monitors on Boston Commons, Mas-
 sachusetts (1948)
 Am Heritage 39:78 (3) Mr '88
TEMPLE, SHIRLEY
 Life 10:91 (4) Ap '87
 Am Heritage 40:12 (drawing,4) Mr '89
 Trav&Leisure 19:115 (4) Je '89
TEMPLES
—18th cent. Ahilya Bai temple (India)
 Smithsonian 21:133 (c,3) N '90
—Bali, Indonesia
 Trav&Leisure 17:74–7 (c,1) Jl '87
 Trav/Holiday 175:43 (c,1) Ap '91
—Bangkok, Thailand
 Trav&Leisure 17:6 (c,4) Jl '87 supp.
 Trav&Leisure 19:179 (c,4) S '89
 Trav/Holiday 176:58 (c,4) N '91
—Chengdu, Sichuan, China
 Trav/Holiday 171:12, 16 (c,3) Ja '89
—Chiang Mai, Thailand
 Trav&Leisure 20:142 (c,3) F '90
—Hindu (Guwahati, India)
 Nat Geog 174:703 (c,1) N '88
—Hsi Lai Buddhist temple, Hacienda
 Heights, California
 Life 11:8 (c,4) O '88
—Kailasa Temple, Ellora, India
 Trav&Leisure 21:60 (c,4) D '91

—Kyoto, Japan
 Trav&Leisure 18:35 (c,4) Je '88
 Trav&Leisure 20:181, 183 (c,4) Je '90
—Minakshi temple, India
 Smithsonian 21:124 (c,4) Ag '90
—Monkey temple, Kathmandu, Nepal
 Trav&Leisure 21:140–1 (c,1) O '91
—Sensoji, Asakusa, Tokyo, Japan
 Trav&Leisure 17:72 (c,3) F '87
—Suzhou, China
 Trav&Leisure 18:186 (c,4) N '88
—Swayambhunath, Nepal
 Trav/Holiday 167:46 (c,4) My '87
—Taipei, Taiwan
 Gourmet 49:82–4 (c,2) Ap '89
 Gourmet 51:cov. (c,1) S '91
—See also
 CHURCHES
 MOSQUES
TEMPLES—ANCIENT
—Ancient temple ruins (Malta)
 Nat Geog 175:713 (c,3) Je '89
—Angkor Wat, Cambodia
 Smithsonian 21:cov., 36–51 (c,1) My '90
—Egypt
 Trav&Leisure 19:cov., 138–45 (c,1) S '89
—Great Temple of Amun, Karnak, Egypt
 Trav&Leisure 19:144 (c,1) S '89
 Nat Geog 179:20–1 (c,1) Ap '91
—Great Temple of Ramses II, Abu Sim-
 bel, Egypt
 Trav&Leisure 19:cov., 139, 142–3 (c,1) S
 '89
—Hadrian's Temple, Ephesus, Turkey
 Trav&Leisure 17:105 (c,2) Mr '87
—Maya (Chichén Itzá, Mexico)
 Trav/Holiday 167:52–3 (c,1) F '87
—Maya (Tikal, Guatemala)
 Trav/Holiday 18:162–7 (c,1) N '88
 Trav/Holiday 175:44, 49, 53 (c,1) Je '91
—Temple of Aphrodite, Aphrodisias, Tur-
 key
 Smithsonian 19:145 (c,3) Mr '89
—Temple of Neptune, Paestum, Italy
 Trav&Leisure 18:81 (c,3) Ag '88
—Temple of Poseidon, Cape Sounion,
 Greece
 Natur Hist 96:25 (c,3) D '87
 Trav&Leisure 20:70 (c,3) Mr '90
—See also
 PARTHENON
TENNESSEE
—Roan Mountain
 Nat Geog 171:224–5 (c,2) F '87
—See also
 CHATTANOOGA
 CUMBERLAND RIVER
 MEMPHIS
 NASHVILLE

—"The Contrast" (1787)
Life 10:30 (drawing,4) Fall '87
—Girls auditioning for "Annie" role
Life 12:42–9 (c,1) N '89
—Hamlet played by famous actors
Life 14:40–1 (4) F '91
—"H.M.S. Pinafore" poster
Smithsonian 19:61 (c,4) Ap '88
—Japanese kabuki (Florida)
Trav&Leisure 18:E20 (c,4) F '88
—Javanese shadow puppet show (Indonesia)
Natur Hist 96:68–76 (c,1) N '87
—"Jerome Robbins' Broadway"
Life 12:122–8 (c,1) Mr '89
Nat Geog 178:58–9 (c,1) S '90
—"Julius Caesar" (1864)
Am Heritage 40:36 (4) N '89
—"The King and I"
Life 12:126–7 (c,3) Mr '89
—Lighting design for theater sets
Smithsonian 22:104–15 (c,1) S '91
—"A Midsummer Night's Dream"
Nat Geog 171:256–7 (c,1) F '87
Trav/Holiday 167:61 (c,3) Je '87
—"Les Miserables"
Smithsonian 18:76–7 (c,3) Ap '87
—"Othello" (Washington, D.C.)
Nat Geog 171:254 (c,4) F '87
—"Phantom of the Opera"
Life 11:89–92 (c,1) F '88
—Settings of Puccini's "Tosca" (Rome, Italy)
Trav/Holiday 175:68–71 (map,c,1) Je '91
—"Smile"
Smithsonian 17:92, 98–9 (c,1) F '87
—"South Pacific"
Life 14:104 (2) Ja '91
—"Tony 'n Tina's Wedding"
Life 11:16 (c,4) My '88
—See also
PROGRAMS
THEATER—COSTUME
—17th cent. costumes (France)
Trav/Holiday 172:69 (c,2) Jl '89
—Cat from "Cats"
Nat Geog 178:72 (c,4) S '90
—China
Life 11:109 (c,2) D '88
Nat Geog 180:42–3 (c,1) D '91
—Chinese opera performers
Trav&Leisure 17:110 (c,1) O '87
Trav&Leisure 18:cov., 100 (c,1) Ja '88
—"Nutcracker" toy soldiers
Gourmet 51:100 (c,4) D '91
—Opera costumes
Life 10:8–9 (c,1) My '87
THEATER—EDUCATION
—Drama class (New York)

Smithsonian 19:56–67 (c,2) S '88
—Teaching Shakespearean acting (Massachusetts)
Smithsonian 22:135–45 (c,1) N '91
THEATERS
—1910 nickelodeon (Nebraska)
Am Heritage 38:110 (4) F '87
—1920s mobile movie house (U.S.S.R.)
Trav&Leisure 20:41 (c,3) Jl '90
—1920s movie palaces
Am Heritage 39:92–3 (c,1) N '88
Am Heritage 41:114–21, 126 (c,1) S '90
—Apollo Theater, Harlem, New York City, New York
Trav/Holiday 169:24 (c,4) Ja '88
—Avalon Theater, Catalina, California
Smithsonian 22:164 (c,4) O '91
—Broadway theaters, New York City, New York
Life 10:84–92 (c,1) D '87
—Alice Busch Opera Theater, Cooperstown, New York
Gourmet 49:106 (c,2) O '89
—Bastille Opéra, Paris, France
Trav&Leisure 20:49 (c,4) Mr '90
—Carnegie Hall, New York City, New York
Trav/Holiday 167:30 (4) Mr '87
Trav&Leisure 17:E2–4 (c,3) S '87
Trav&Leisure 20:84–9, 95 (c,1) Ag '90
Smithsonian 21:68–80 (c,1) F '91
Gourmet 51:44 (painting,c,2) Mr '91
—Concertgebouw, Amsterdam, Netherlands
Trav&Leisure 18:38–9 (c,4) Ap '88
—"Dive-In" movie theater in pool (California)
Life 11:8 (c,4) O '88
—Festival Centre, Adelaide, Australia
Trav&Leisure 17:A30 (c,4) O '87 supp.
—Folger Shakespeare Library stage, Washington, D.C.
Nat Geog 171:256–7 (c,1) F '87
—Grand Ole Opry, Nashville, Tennessee
Trav/Holiday 170:58–9, 61 (c,1) O '88
—Hollywood Bowl, California
Trav/Holiday 168:44 (c,4) Ag '87
—Maestranza Theater, Seville, Spain
Trav/Holiday 176:93 (c,4) S '91
—Naples Opera House, Italy
Trav&Leisure 19:90 (c,2) Ap '89
—Niagara-on-the-Lake, Ontario
Gourmet 51:111 (c,4) N '91
—Oberammergau's Passion play stage, Germany
Gourmet 50:48–9 (c,3) Ag '90
—Old movie theater (Oregon)
Smithsonian 19:120 (c,4) N '88
—Outdoor movie theater (Australia)

Nat Geog 179:14–15 (c,2) Ja '91
—Palais Garnier, Paris, France
 Trav&Leisure 19:135 (c,3) O '89
—Palau de la Musica, Barcelona, Spain
 Trav&Leisure 19:162–3 (c,1) N '89
—Piper's Opera House, Virginia City, Nevada
 Trav/Holiday 176:78 (c,40 Jl '91
—Radio City Music Hall, New York City, New York
 Trav&Leisure 18:13, 148–55, 219–20 (c,1) N '88
 Gourmet 51:66 (painting,c,2) D '91
—Royal Opera, Versailles, France
 Nat Geog 176:22–3 (c,1) Jl '89
—Small theater interior (London, England)
 Trav&Leisure 20:226 (painting,c,3) N '90
—Stratford, Ontario
 Trav/Holiday 167:58–9 (c,1) Je '87
—Sydney Opera House, Australia
 Trav&Leisure 17:cov., A11 (c,1) O '87 supp.
 Smithsonian 18:128–9, 136 (c,1) Ja '88
 Trav/Holiday 170:8–9 (c,2) Ag '88
 Trav/Holiday 175:17 (c,4) Je '91
—Teatro Amazonas, Manaus, Brazil
 Trav/Holiday 168:63 (c,4) Jl '87
 Trav&Leisure 17:LA6 (c,4) N '87 supp.
 Trav&Leisure 19:124 (c,4) F '89
—Teatro Colón, Buenos Aires, Argentina
 Trav&Leisure 19:45 (c,2) My '89
—Toronto, Ontario
 Smithsonian 19:68 (c,3) Ap '88
 Trav&Leisure 21:E12 (c,3) Mr '91
—Vienna State Opera House staircase, Austria
 Gourmet 50:68 (c,3) Ja '90
—Wortham Theater Center interior, Houston, Texas
 Gourmet 47:69 (c,1) O '87
—See also
 LINCOLN CENTER
THEATERS—ANCIENT
—Aphrodisias, Turkey
 Smithsonian 19:146–7 (c,1) Mr '89
—Beit Shean amphitheater, Israel
 Trav/Holiday 174:85 (c,4) N '90
—Ephesus, Turkey
 Trav&Leisure 17:102–3 (c,1) Mr '87
—Epidaurus, Greece
 Nat Geog 172:816–17 (c,1) D '87
—Green amphitheater (Knidos, Turkey)
 Trav/Holiday 174:37 (c,3) Ag '90
—Roman (Amman, Jordan)
 Smithsonian 18:109 (c,2) N '87
—Roman (Gadara, Jordan)
 Smithsonian 18:113 (c,2) N '87

—Roman (Petra, Jordan)
 Trav/Holiday 172:50 (c,3) O '89
—Roman (Syracuse, Sicily, Italy)
 Gourmet 51:86 (c,4) Je '91
—Roman amphitheater (Arles, France)
 Gourmet 49:47 (c,3) Jl '89
—Roman amphitheater (Lecce, Italy)
 Trav/Holiday 167:50 (c,4) Je '87
—See also
 COLOSSEUM
THERAPY
—Acupuncture (Japan)
 Sports Illus 66:80 (c,3) Mr 23 '87
—Alcohol abuse counseling (Iceland)
 Nat Geog 171:207 (c,4) F '87
—Cancer support group
 Life 11:74–8 (c,1) Mr '88
—Drug rehabilitation therapy for teens (Massachusetts)
 Nat Geog 175:48–51 (c,1) Ja '89
—Laugh therapy for AIDS victims
 Life 11:46 (c,4) Ja '88
—Men butting shoulders at retreat (Texas)
 Life 14:12–13 (c,1) S '91
—New Age medicine circle (Sedona, Arizona)
 Trav&Leisure 20:120 (c,4) Ja '90
—Physical therapy on patient's hand
 Smithsonian 20:67 (2) S '89
—Rolfing
 Sports Illus 70:114 (c,3) Ja 9 '89
—Strategies to aid human conception
 Life 10:24–6 (c,4) Je '87
—Stress reduction "mind gym" (Japan)
 Nat Geog 180:39 (c,4) N '91
—Synchro-Energizer treatment of stress (New York)
 Life 12:10 (c,4) Je '89
—Wilderness training for addicted teens (Montana)
 Nat Geog 171:814–15 (c,2) Je '87
—See also
 FREUD, SIGMUND
 MENNINGER, KARL A.
THERMOMETERS
—1941 Coca-Cola weather thermometer
 Trav/Holiday 174:83 (c,4) S '90
—Ski conditions thermometer
 Gourmet 50:95 (c,4) D '90
THIMPHU, BHUTAN
 Nat Geog 179:82, 86–7 (c,1) My '91
THIRTY YEARS' WAR
—1618 Defenestration of Prague
 Smithsonian 21:85 (painting,c,4) Mr '91
THISTLES
—Texas thistle heads
 Smithsonian 18:40 (c,4) Ap '87
THOMAS, GEORGE HENRY
 Am Heritage 41:81 (4) Mr '90

THOMPSON, DOROTHY
—Caricature
 Am Heritage 41:16 (drawing,4) My '90
THOMSON, VIRGIL
 Life 13:116 (4) Ja '90
THOREAU, HENRY DAVID
 Am Heritage 39:65, 72 (4) Jl '88
—Items belonging to him
 Am Heritage 39:66–74 (c,1) Jl '88
—Replica of Thoreau's cabin (Concord,
 Massachusetts)
 Am Heritage 39:68–9 (c,2) Jl '88
—Tombstone (Concord, Massachusetts)
 Am Heritage 39:75 (c,2) Jl '88
—Walden Pond, Massachusetts
 Sports Illus 67:6 (c,4) O 19 '87
 Trav&Leisure 19:19 (c,4) Jl '89
THORPE, JIM
 Sports Illus 75:10 (4) N 18 '91
THRONES
—Denmark
 Natur Hist 98:47 (c,1) Je '89
THRUSHES
—Wood thrushes
 Smithsonian 20:32 (c,4) F '90
THUMB, TOM
 Am Heritage 39:28 (4) F '88
TIBET
 Natur Hist 96:42–9 (c,1) Mr '87
 Nat Geog 174:632–7, 674–93 (map,c,1) N
 '88
—Anye Machin range
 Natur Hist 100:64–5 (c,1) Ja '91
—Chang Tang
 Nat Geog 175:752–81 (map,c,1) Je '89
—Destroyed monasteries
 Nat Geog 174:637, 674–5 (c,1) N '88
 Natur Hist 98:42–3 (c,2) Mr '89
—Monasteries
 Natur Hist 98:40–5 (c,1) Mr '89
—Mt. Kailas
 Nat Geog 172:768–9 (c,1) D '87
 Nat Geog 174:676 (c,1) N '88
—Zangbo River
 Nat Geog 174:674–9, 690–3 (map,c,1) N
 '88
 Natur Hist 100:66 (c,4) Ja '91
—See also
 BRAHMAPUTRA RIVER
 HIMALAYA MOUNTAINS
 LHASA
TIBET—COSTUME
 Nat Geog 174:632–6, 685–93 (c,1) N '88
—Buddhist nuns
 Natur Hist 98:40–3, 46–7 (c,1) Mr '89
—Children
 Life 11:72 (c,4) S '88
—Dalai Lama
 Nat Geog 172:767 (4) D '87

Life 11:21, 24 (c,3) Je '88
 Smithsonian 22:92 (c,4) Je '91
 Life 14:61 (c,3) D '91
—Hindu people
 Natur Hist 96:cov., 38–49 (c,1) Mr '87
—Nomads
 Nat Geog 172:764–84 (c,1) D '87
 Nat Geog 175:752–81 (c,1) Je '89
 Natur Hist 100:66 (c,4) Ja '91
TIBET—RITES AND FESTIVALS
—Hindu bride marrying five brothers
 Natur Hist 96:cov., 38–49 (c,1) Mr '87
TICKETS
—1925 World Series ticket stub
 Am Heritage 40:117 (c,4) S '89
—1964 World Series ticket
 Sports Illus 71:83 (c,4) S 25 '89
—Football season ticket
 Sports Illus 67:10 (drawing,c,4) S 9 '87
 Sports Illus 69:28 (c,4) Ag 22 '88
—Train ticket (Switzerland)
 Trav&Leisure 17:88 (c,4) Ag '87
TICKS
 Smithsonian 17:24 (c,4) Ja '87
 Sports Illus 68:38–9 (c,2) Je 20 '88
—Deer ticks
 Trav/Holiday 171:88 (c,4) Je '89
 Natur Hist 98:4, 8 (painting,c,4) Jl '89
TIERRA DEL FUEGO, ARGENTINA
 Trav&Leisure 17:LA21 (c,4) N '87 supp.
TIFFANY, LOUIS COMFORT
—1900 stained glass screen by Tiffany
 Am Heritage 39:21 (c,1) S '88
—Art works by him
 Smithsonian 20:236 (c,4) O '89
—Jewelry by him
 Smithsonian 18:60 (c,4) D '87
—Tiffany lamps
 Trav&Leisure 17:26 (c,4) Mr '87
 Smithsonian 18:97 (c,1) N '87
 Trav&Leisure 19:66–7 (c,3) S '89
 Trav/Holiday 172:19 (c,4) D '89
 Trav&Leisure 21:56 (c,4) Je '91
TIGERS
 Smithsonian 18:52–65 (c,1) N '87
 Natur Hist 97:cov., 72–5 (c,10) Jl '88
 Trav&Leisure 20:cov., 146–9, 170, 174
 (c,1) S '90
 Nat Wildlife 29:13 (c,4) F '91
—Head scar from tiger attack (India)
 Smithsonian 18:55 (c,4) N '87
—Siberian tiger
 Nat Wildlife 29:30–1 (c,1) Je '91
 Trav&Leisure 21:E10 (c,3) Jl '91
—Stuffed tiger
 Nat Wildlife 26:8–9 (c,1) Ap '88
—White tigers
 Smithsonian 18:30 (c,4) S '87
 Smithsonian 20:32 (c,4) Jl '89

TILDEN, WILLIAM
 Sports Illus 66:10 (4) My 25 '87
TIMBUKTU, MALI
 Nat Geog 172:166–7 (c,1) Ag '87
TIN MINES
—Brazil
 Nat Geog 174:778–9 (c,1) D '88
TIN MINING
—Bolivia
 Nat Geog 171:447 (c,1) Ap '87
TIRE INDUSTRY
—Michelin man
 Trav&Leisure 18:39 (c,4) Mr '88
 Am Heritage 40:12 (4) Jl '89 supp.
TIRES
—Tire junkyard
 Natur Hist 100:56–7 (c,1) Jl '91
—Tire junkyard on fire (Colorado)
 Life 11:13 (c,3) Jl '88
TITANIC (SHIP)
—Remains on sea floor
 Life 10:67 (c,4) Ja '87
 Nat Geog 172:454–63 (c,1) O '87
TITANIUM
 Smithsonian 18:86–95 (c,1) My '87
TITIAN
—"La Bella"
 Trav&Leisure 20:70 (painting,c,4) Ja
 '90
—Paintings by him
 Smithsonian 21:65–81 (c,1) N '90
—Self-portrait
 Smithsonian 21:73 (painting,c,4) N '90
TITMICE
 Natur Hist 97:76–7 (c,1) D '88
 Natur Hist 99:74–5 (drawing,4) F '90
—See also
 CHICKADEES
TITO (YUGOSLAVIA)
 Nat Geog 178:119 (4) Ag '90
TITTLE, Y. A.
 Sports Illus 66:43 (3) Ja 26 '87
 Sports Illus 71:12 (4) N 27 '89
TLINGIT INDIANS (ALASKA)
—Carving totem pole
 Trav/Holiday 167:42 (c,4) Je '87
—Tlingit Indian gillnetting salmon
 Natur Hist 99:32 (c,4) S '90
TLINGIT INDIANS (ALASKA)—COS-
 TUME
—1818 warrior
 Natur Hist 98:52 (painting,c,1) D '89
TLINGIT INDIANS (ALASKA)—REL-
 ICS
—19th cent. Tlingit Indians gambling sticks
 Natur Hist 98:55 (c,4) D '89
—Tlingit shaman's masks and artifacts
 Smithsonian 19:cov., 49, 51 (c,1) O '88
 Smithsonian 20:46 (c,4) O '89

TOADS
 Nat Wildlife 25:18–19 (c,1) F '87
 Nat Geog 175:544 (c,4) My '89
 Natur Hist 99:48 (c,4) Ja '90
 Nat Wildlife 29:4 (c,3) F '91
—Cane toads
 Smithsonian 21:139–45 (c,1) O '90
—Desert toads
 Smithsonian 17:99–105 (c,2) Mr '87
—Tadpoles
 Nat Wildlife 25:19 (c,4) F '87
 Smithsonian 17:102–4 (c,4) Mr '87
TOASTERS
—1920s
 Trav&Leisure 19:221 (4) Ap '89
 Am Heritage 41:36 (c,4) D '90
TOBACCO INDUSTRY
—Sorting tobacco leaves (1943)
 Smithsonian 20:98–9 (painting,c,2) Ap
 '89
TOBACCO PLANTS
 Smithsonian 20:108 (drawing,c,4) Jl '89
—Tobacco plant glowing with firefly gene
 Smithsonian 18:126 (c,4) Ag '87
TOBAGO
—Tobago Cays
 Trav&Leisure 17:82–3 (c,1) O '87
 Trav/Holiday 171:16 (c,4) Ap '89
TOBOGGANING
—19th cent.
 Smithsonian 18:142–4 (drawing,4) D '87
TOKYO, JAPAN
 Trav&Leisure 20:103–7 (c,1) Ag '90
 Nat Geog 180:36–9 (c,1) N '91
—Asakusa temple
 Trav&Leisure 17:72 (c,3) F '87
—Big Egg domed stadium
 Smithsonian 18:125 (c,1) Ja '88
—City hall
 Trav&Leisure 21:21 (c,4) Ag '91
—Demboin garden
 Trav&Leisure 19:99–100 (map,c,3) N '89
TOLSTOY, LEO
 Natur Hist 97:14 (4) Jl '88
TOMATO INDUSTRY
—Sorting tomatoes at cannery (California)
 Nat Geog 179:54–5 (c,1) F '91
—Tomatoes hanging to dry (Italy)
 Gourmet 50:47 (c,1) Jl '90
—Tomatoes spoiled by freeze (Florida)
 Nat Geog 179:74–5 (c,1) Ap '91
TOMATO INDUSTRY—HARVEST-
 ING
 Natur Hist 98:70–1 (c,3) Jl '89
TOMATOES
 Gourmet 49:66 (c,4) Ag '89
 Gourmet 50:47 (c,4) Jl '90
TOMATOES—HUMOR
—History of tomatoes

Smithsonian 21:110–17 (painting,c,3) Ag
'90
TOMBAUGH, CLYDE
Smithsonian 22:32 (c,4) My '91
TOMBS
—5th cent. B.C. Lycian tombs (Turkey)
Trav/Holiday 174:41 (c,3) Ag '90
—8th cent. (Kyongju, Korea)
Nat Geog 174:262–3, 268 (c,3) Ag '88
—14th cent. ossuary decoration (Rouen,
France)
Nat Geog 173:673 (c,4) My '88
—16th cent. Tellem burial caves (Mali)
Nat Geog 178:106–7 (c,1) O '90
—1989 memorial to escaping East German
(Berlin)
Nat Geog 177:119 (c,4) Ap '90
—Ancient Bactria
Nat Geog 177:51, 62–5, 73 (c,2) Mr '90
—Ancient burial mounds (Bahrain)
Smithsonian 18:134–5 (c,1) My '87
—Ancient Egyptian tombs (Saqqara)
Nat Geog 179:14–15 (c,1) Ap '91
—Ancient Etruscan tombs (Italy)
Nat Geog 173:698–739 (c,1) Je '88
—Ancient Indian woman (Missouri)
Life 12:12 (4) Jl '89
—Ancient Kushite tombs (Sudan)
Nat Geog 178:100–1, 112–19 (c,1) N '90
—Ancient Moche tomb contents (Peru)
Nat Geog 174:510–55 (c,1) O '88
Nat Geog 177:2–15 (c,1) Je '90
—Ancient tomb mounds (Korea)
Trav/Holiday 167:26 (c,3) Ja '87
—Artifacts from King Tut's tomb (Egypt)
Nat Geog 173:540–1 (c,1) Ap '88
—Athlete's gravesite (Pennsylvania)
Sports Illus 74:76 (c,4) Mr 4 '91
—Backyard grave (Uganda)
Nat Geog 173:471 (c,4) Ap '88
—Cairn (New Zealand)
Trav/Holiday 175:80 (c,1) F '91
—Cairn for dead mountain climber
(Nepal)
Life 14:54 (c,4) S '91
—Grave of race horse Alydar (Kentucky)
Sports Illus 75:139 (c,4) S 2 '91
—Hyderabad, India
Gourmet 50:97 (c,1) Mr '90
—Andrew Jackson's grave (Nashville, Ten-
nessee)
Trav&Leisure 19:214 (c,4) N '89
—John F. Kennedy's grave (Arlington,
Virginia)
Smithsonian 19:110–11 (c,4) My '88
—Khai Dinh's tomb, Hue, Vietnam
Nat Geog 176:596–9 (c,1) N '89
—Martin Luther King, Jr. (Georgia)
Life 11:30 (c,4) Spring '88

—Robert E. Lee (Lexington, Virginia)
Am Heritage 42:72 (c,3) My '91
—Pierre Charles L'Enfant's tomb (Vir-
ginia)
Nat Geog 180:134 (c,3) Ag '91
—Lenin shrine (Moscow, U.S.S.R.)
Trav/Holiday 168:65 (c,2) Ag '87
Nat Geog 177:98–9 (c,1) Ja '90
—Madagascar
Nat Geog 171:178 (c,3) F '87
Natur Hist 98:24–6 (c,2) Ap '89
—Maya (Belize)
Smithsonian 20:101–2 (c,4) D '89
—Maya (Copán, Honduras)
Nat Geog 176:480–7 (c,1) O '89
—Maya ruler Pacal's tomb (Palenque,
Mexico)
Trav&Leisure 20:102 (c,4) O '90
—Ming Dynasty's Yung-lo (China)
Nat Geog 175:310 (c,3) Mr '89
—Marilyn Monroe's crypt (California)
Life 12:97 (4) O '89
—Nefertiti (Thebes, Egypt)
Nat Geog 179:24–5 (c,2) Ap '91
—Pocahontas (London, England)
Am Heritage 38:82 (c,4) Ap '87
—Prehistoric burial site (Czechoslovakia)
Nat Geog 174:466 (c,2) O '88
—Prehistoric passage graves (Brittany,
France)
Smithsonian 20:146–7, 154 (c,1) S '89
—Puerto Rico
Trav/Holiday 173:56 (c,4) F '90
—Ramses II (Egypt)
Smithsonian 19:85 (painting,c,3) Je '88
Nat Geog 179:6–7, 9 (c,1) Ap '91
—Salzburg, Austria
Trav&Leisure 17:103 (c,1) Je '87
—Shrine to Mexican bandit
Life 11:83 (c,4) Mr '88
—Tomb of the Unknowns, Arlington, Vir-
ginia
Smithsonian 19:109, 111 (c,4) My '88
—See also
CEMETERIES
MUMMIES
TAJ MAHAL
TOMBSTONES
TOMBSTONES
—16th cent. memorial to wool merchant
(Great Britain)
Nat Geog 173:573 (c,4) My '88
—1778 footstone for dead children (Massa-
chusetts)
Natur Hist 99:18 (c,4) D '90
—Billy the Kid (New Mexico)
Am Heritage 42:78 (c,4) Ap '91
—Floyd Collins' grave (Kentucky)
Smithsonian 21:150 (c,4) My '90

—Sir Arthur Conan Doyle (Minstead, England)
Trav&Leisure 20:160 (c,4) Ap '90
—Dian Fossey's grave (Rwanda)
Life 13:57 (c,4) F '90
—Gunshot victim (Arizona)
Gourmet 49:50 (c,4) Ja '89
—Sonny Liston's grave (Nevada)
Sports Illus 74:80 (4) F 4 '91
—Plane crash victims (Pennsylvania)
Life 11:72 (c,3) Ap '88
—Edgar Allen Poe's grave (Maryland)
Life 13:57–8 (c,4) Jl '90
—Secretariat's grave (Kentucky)
Sports Illus 71:25 (c,4) O 16 '89
—Slain students (South Korea)
Life 12:98 (c,4) My '89
—Henry David Thoreau (Concord, Massachusetts)
Am Heritage 39:75 (c,2) Jl '88
TONGUES
—Chameleon's long tongue outstretched
Nat Wildlife 29:6–7 (c,1) F '91
TOOLS
—14th cent. B.C.
Nat Geog 172:703, 712–13 (c,1) D '87
—19th cent. coopering tools (Pennsylvania)
Smithsonian 19:121 (c,1) O '88
—1867 silver trowel
Am Heritage 40:34 (4) My '89
—Antique blacksmith's tools
Smithsonian 21:59 (c,4) F '91
—Antique tool collections
Smithsonian 21:cov., 52–65 (c,1) F '91
—Chain saws
Sports Illus 67:57 (c,4) Ag 10 '87
—Piano maker's tool kit
Smithsonian 21:56–7 (c,1) F '91
—Prehistoric stone tools (Asia)
Natur Hist 98:50 (c,4) O '89
—Primitive bark beaters used to make paper
Natur Hist 100:12–14 (c,2) Je '91
—See also
KNIVES
TOPAZ
—6.9 inch long golden topaz
Smithsonian 19:16 (c,4) Ag '88
TOPEKA, KANSAS
—Judicial Center lobby
Trav/Holiday 169:29 (c,4) Mr '88
TORNADOES
Nat Geog 171:690–714 (c,1) Je '87
—1978 (North Dakota)
Nat Geog 171:690–1 (c,1) Je '87
—Tornado shelter
Nat Geog 171:707 (c,2) Je '87

TORNADOES—DAMAGE
—Oklahoma (1986)
Nat Geog 171:703 (c,3) Je '87
—Saragosa, Texas (1987)
Life 11:74 (c,4) Ja '88
TORNADOES—MAPS
—U.S. tornado activity
Nat Geog 171:705 (c,1) Je '87
TORONTO, ONTARIO
Smithsonian 19:62 (c,4) Ap '88
Trav&Leisure 20:E1 (c,2) Mr '90
Life 13:6–7 (c,1) N '90
—Bargain store
Smithsonian 19:64–71 (c,2) Ap '88
—Mirvish Village
Smithsonian 19:64–5 (c,2) Ap '88
—Museums
Trav/Holiday 168:44–9 (c,1) O '87
—Sky Dome
Sports Illus 70:48–53 (c,1) Je 12 '89
Sports Illus 71:4 (c,4) Jl 31 '89
Sports Illus 74:86 (c,4) My 13 '91
Sports Illus 75:36–9 (c,1) Jl 8 '91
—Theater interior
Smithsonian 19:68 (c,3) Ap '88
Trav&Leisure 21:E12 (c,3) Mr '91
TORPEDOES
—1941 Japanese torpedo
Nat Geog 180:71 (c,4) D '91
TORTOISES
Nat Geog 171:177 (c,3) F '87
Trav&Leisure 17:112 (c,4) Mr '87
Nat Geog 174:831 (c,4) D '88
Trav/Holiday 172:16 (c,4) S '89
Trav&Leisure 20:143 (c,3) S '90
—Desert tortoises
Life 12:5 (c,4) N '89
Smithsonian 20:147 (drawing,4) Mr '90
Smithsonian 21:34 (c,4) S '90
Smithsonian 22:115 (c,2) O '91
—Giant tortoises
Nat Geog 173:126–7, 134–5 (c,1) Ja '88
TOTEM POLES
—1900 (British Columbia)
Nat Geog 172:110–11 (1) Jl '87
—Alaska
Trav/Holiday 167:42 (c,4) Je '87
Trav/Holiday 172:58 (c,4) Ag '89
—British Columbia
Trav/Holiday 172:82, 87 (c,2) D '89
—Oregon
Trav/Holiday 167:cov., 82 (c,1) Je '87
—Pu'uhonua o Honaunau, Hawaii
Am Heritage 39:28 (c,4) Mr '88
TOUCANS
Trav&Leisure 17:85 (c,4) F '87
Nat Geog 176:458 (c,4) O '89
TOULOUSE-LAUTREC, HENRI DE
—"Jane Avril"

—Train crash wreckage (Maryland)
Life 10:10–11 (c,1) Mr '87
Life 11:29 (c,4) Ja '88
Life 12:145 (c,4) Fall '89
—Train passengers (Europe)
Trav&Leisure 19:104–9 (c,2) Je '89
—Train prepared to help in nuclear emergency (France)
Nat Geog 175:421 (c,4) Ap '89
—Western U.S.
Trav&Leisure 20:128–9, 136–7 (c,1) Ap '90
—See also
LOCOMOTIVES
RAILROADS
SUBWAYS
TRANSPORTATION
—19th cent. coach-building business (Australia)
Nat Geog 173:242–3 (2) F '88
—19th cent. rail-riding steam horse
Smithsonian 18:132 (drawing,4) F '88
—London Transport Museum, England
Gourmet 47:74 (c,2) D '87
—Monorail (Brisbane, Australia)
Trav/Holiday 169:43 (c,3) Ja '88
—People movers (O'Hare Airport, Chicago, Illinois)
Trav&Leisure 17:144 (c,4) D '87
—Tunnel monorail (France/Switzerland)
Smithsonian 19:109 (c,4) Mr '89
—See also
AIRPLANES
AIRSHIPS
AMBULANCES
AUTOMOBILE RACING CARS
AUTOMOBILES
BABY STROLLERS
BALLOONING
BICYCLING
BOATS
BUSES
CABLE CARS
CARAVANS
CARRIAGES AND CARTS
CARRIAGES AND CARTS—
HORSE-DRAWN
COVERED WAGONS
DOG SLEDS
ELEVATORS
ESCALATORS
FIRETRUCKS
GOLF CARTS
HELICOPTERS
HORSEBACK RIDING
JEEPS
LOCOMOTIVES
MASS TRANSIT
MERRY-GO-ROUNDS

MOTORCYCLES
RAILROADS
RECREATIONAL VEHICLES
RICKSHAWS
ROADS
SLEDS
SNOWMOBILES
SPACECRAFT
STAGECOACHES
SUBMARINES
SUBWAYS
TANKS, ARMORED
TAXICABS
TRAILERS
TRAINS
TROLLEY CARS
TRUCKS
WAGONS
TRANSPORTATION—HUMOR
—Combination air-bus-ship
Trav&Leisure 17:122 (drawing,c,1) D '87
TRASH
—Animals harmed by plastic debris in oceans
Smithsonian 18:58–67 (c,1) Mr '88
—15-year-old trash in landfill
Nat Geog 179:120–1, 130–1 (c,4) My '91
—Garbage archaeology (California)
Natur Hist 99:55 (c,1) My '90
—Garbage barges
Life 10:8 (c,4) Ag '87
Life 11:78 (c,4) Ja '88
Nat Wildlife 26:18–19, 23 (c,1) Ag '88
Natur Hist 99:6 (c,4) My '90
—Garbage piled on highway (California)
Nat Geog 171:60 (c,4) Ja '87
—Generating energy by burning garbage (Connecticut)
Nat Geog 180:82–3 (c,2) Ag '91
—Incinerator ash (Pennsylvania)
Nat Wildlife 26:21 (c,1) Ag '88
—Leaf composting site (Massachusetts)
Nat Wildlife 27:19 (c,4) O '89
—Protective suits for waste disposal (Georgia)
Nat Wildlife 26:20 (c,4) Ag '88
—Recycling landfill contents (Florida)
Natur Hist 99:58–9, 62–3 (c,1) My '90
—Trash at landfill (Seattle, Washington)
Life 11:158–9, 162 (c,1) D '88
—U.S. trash disposal problem
Life 11:158–62 (c,1) D '88
Nat Geog 179:116–34 (c,1) My '91
TRASH—HUMOR
—Landfill sights
Smithsonian 21:146–55 (painting,c,1) Ap '90
TRAWLERS
—Poland

TURNER, J. M. W.
—"Dogana San Giorgio"
Trav&Leisure 19:160 (painting,c,4) Mr
'89
—"The Lake, Petworth: Sunset" (1828)
Natur Hist 100:34–5 (painting,c,1) O '91
—Painting of Venice
Trav&Leisure 17:47 (c,4) O '87
—Paintings by him
Smithsonian 18:50–63 (c,1) Ag '87
—Self-portrait (1798)
Smithsonian 18:52 (painting,c,4) Ag '87
TURNIPS
Gourmet 51:78 (c,4) F '91
TURTLES
Nat Geog 173:281 (c,2) F '88
Natur Hist 98:8–10 (c,3) Ag '89
Nat Geog 176:459 (c,4) O '89
Nat Geog 177:100 (c,2) Ap '90
—Box turtles
Nat Wildlife 26:57 (c,4) F '88
Nat Wildlife 27:14–16 (c,1) Je '89
Nat Wildlife 29:12 (c,4) D '90
—Heron on turtle's back
Nat Wildlife 30:56 (c,2) D '91
—Leatherback turtles
Nat Wildlife 26:4–11 (c,1) Je '88
—Loggerheads
Smithsonian 20:45 (c,3) D '89
Trav&Leisure 21:80–4 (c,4) My '91
Nat Geog 179:74–6 (c,1) Je '91
—River cooter
Natur Hist 99:68–9 (painting,c,1) F '90
—Sea turtles
Natur Hist 96:4 (c,4) My '87
Trav/Holiday 169:56–7 (c,2) Ja '88
Smithsonian 20:45, 51–3 (c,2) D '89
Trav/Holiday 175:39 (c,3) My '91
Nat Wildlife 29:24–8 (c,1) O '91
Nat Wildlife 30:cov. (c,1) D '91
—Sideneck turtles
Natur Hist 98:104–5 (c,1) Mr '89
—Turtle hatching from egg
Natur Hist 97:70 (c,2) Ap '88
—See also
TERRAPINS
TORTOISES

TUTANKHAMUN (EGYPT)
—Artifacts from his tomb
Nat Geog 173:540–1 (c,1) Ap '88
TWAIN, MARK
Am Heritage 39:48 (1) D '88
Smithsonian 20:172 (4) Ap '89
Am Heritage 41:14 (drawing,4) S '90
Trav/Holiday 176:49, 53 (4) Jl '91
—*A Connecticut Yankee in King Arthur's Court* (1889)
Am Heritage 40:97–104 (drawing,4) N '89
—Home (Hannibal, Missouri)
Trav/Holiday 176:49 (4) Jl '91
—"The Jumping Frog" illustration (1874)
Am Heritage 41:43 (4) N '90
—Tom Sawyer's fence (Hannibal, Missouri)
Trav/Holiday 176:50 (4) Jl '91
TWILIGHT
—Dusk over fishing boats (Louisiana)
Nat Geog 178:54–5 (c,1) O '90
—Dusk over Marigot harbor, St. Martin
Gourmet 47:46–7 (c,2) Ja '87
—Dusk over Saudi Arabian desert
Life 14:6–7 (c,1) Ap '91
—Mexico's Pacific coast
Trav/Holiday 172:42–3 (c,2) N '89
TWINS
Life 11:70–1 (c,4) Ag '88
—Twin babies
Smithsonian 19:123 (c,3) D '88
Life 12:104–5 (1) Fall '89
TYPEWRITERS
—19th cent.
Smithsonian 21:54–62 (c,2) D '90
—1865 typewriter for the blind
Smithsonian 21:60 (c,4) D '90
—1970s Chinese manual typewriter
Smithsonian 21:60 (c,4) D '90
—Antique Smith-Corona upright
Natur Hist 96:16 (4) Ja '87
—Modern electronic typewriter
Smithsonian 21:65 (c,1) D '90
TYPING
—Playwright at typewriter (Vermont)
Life 10:68 (c,3) O '87

- U -

UFO's. See
UNIDENTIFIED FLYING OBJECTS
UGANDA
Nat Geog 173:468–91 (map,c,1) Ap '88
—See also

KAMPALA
UGANDA—COSTUME
Nat Geog 173:468–91 (c,1) Ap '88
UGANDA—POLITICS AND GOVERNMENT
—Victims of civil strife

UKRAINE, U.S.S.R.
Nat Geog 171:594–631 (map,c,1) My '87
—Russian-Ukraine reunification statue,
Kiev
Nat Geog 171:630 (c,1) My '87
—See also
KIEV
LVOV
ODESSA
YALTA
UKRAINE (U.S.S.R.)—COSTUME
Nat Geog 171:594–631, 652–3 (c,1) My
'87
Life 11:110–13 (c,1) Jl '88
UMBRELLAS
—1903 (California)
Am Heritage 39:106 (2) D '88
—Beach umbrella
Trav/Holiday 171:89 (c,1) Mr '89
—Beach umbrellas (Italy)
Trav&Leisure 17:88–9, 92–3 (c,1) Jl '87
—Golf umbrella
Sports Illus 68:61 (c,4) Ap 11 '88
Sports Illus 70:22 (c,2) Je 26 '89
—Painting umbrellas (Thailand)
Trav&Leisure 18:126–7 (c,2) D '88
—Parasols (Thailand)
Trav/Holiday 167:80 (c,4) F '87
Trav&Leisure 17:12 (c,4) Jl '87 supp.
—Scotland
Sports Illus 67:2–3 (c,1) Jl 27 '87
—Sun umbrella (Mexico)
Trav&Leisure 17:81 (c,1) S '87
—Thailand
Natur Hist 98:54–5 (c,1) O '89
—Wooden chair with umbrella attached
Trav/Holiday 174:81 (c,2) Ag '90
UMBRELLAS—HUMOR
—History of the umbrella
Smithsonian 20:130–41 (painting,c,1) N
'89
UNCLE SAM
Am Heritage 39:48 (drawing,c,2) Jl '88
Gourmet 49:40 (painting,c,4) Ag '89
Gourmet 51:39 (drawing,c,4) Jl '91
—Late 19th cent. Uncle Sam toy bank
Am Heritage 42:cov. (c,4) F '91
—1900 cartoon about U.S. territorial ambi-
tions
Smithsonian 20:142 (painting,c,4) My '89
—1977 cartoon of fat Uncle Sam
Am Heritage 39:101 (2) S '88
—Man dressed as Uncle Sam
Life 11:76 (c,2) Ag '88
Trav/Holiday 174:48 (c,1) Jl '90
—Uncle Sam depicted as Old West sheriff
Am Heritage 41:26 (drawing,4) D '90
—Uncle Sam wearing gas mask
Nat Wildlife 25:33 (drawing,c,2) F '87

—Wearing British flag on hat
Am Heritage 41:59 (painting,c,2) N '90
UNIDENTIFIED FLYING OBJECTS
(UFOs)
—Aliens in flying saucer
Trav/Holiday 171:104 (drawing,c,4) My
'89
—Film depictions of space creatures
Life 12:48–57 (c,1) Jl '89
UNIFORMS
—U.S. military clothing store mannequins
(Virginia)
Life 12:64–5 (c,1) D '89
U.S.S.R.
—1986 Chernobyl nuclear disaster
Life 10:10–11, 23, 43, 68 (c,1) Ja '87
Nat Geog 171:632–53 (c,1) My '87
Nat Geog 175:416 (c,4) Ap '89
—Aral Sea region
Nat Geog 177:70–93 (map,c,1) F '90
—Arkhangel'sk church
Smithsonian 20:143 (c,2) Ap '89
—Baltic nations
Nat Geog 178:cov., 3–37 (map,c,1) N
'90
—Breadlines (Sverdlovsk)
Life 14:76–81 (c,1) Je '91
—Bukhara's Tower of Death minaret
Trav&Leisure 20:38 (c,3) Jl '90
—Chukchi charm string (Siberia)
Smithsonian 19:50 (c,3) O '88
—European region
Nat Geog 179:3–37 (map,c,1) F '91
—Koryak people artifacts (Siberia)
Smithsonian 19:45–51 (c,2) O '88
—Kraternaya Bay
Natur Hist 98:28–31 (map,c,1) Ag '89
—Petropavlovsk, Kamchata peninsula
Smithsonian 22:30–9 (c,1) Ag '91
—Ushishir Islands
Natur Hist 98:28–31 (map,c,1) Ag '89
—See also
ARAL SEA
ARMENIA
KIEV
LAKE BAYKAL
LENINGRAD
LVOV
MOSCOW
ODESSA
SIBERIA
UKRAINE
VOLGOGRAD
YALTA
U.S.S.R.—ARCHITECTURE
—1920s mobile movie house
Trav&Leisure 20:41 (c,3) Jl '90
—Monasteries
Smithsonian 20:131–40 (c,1) Ap '89

U.S.—HISTORY—COLONIAL PE-
RIOD
—16th cent. history of La Florida
Nat Geog 173:330–63 (map,c,1) Mr '88
—1638 map of Fort Christina, New Swe-
den, Delaware
Am Heritage 39:32 (4) My '88
—1682 treaty signing between William
Penn and Indians
Smithsonian 20:132 (painting,c,4) Je
'89
—Late 18th cent. Acadian deportation
from Nova Scotia
Nat Geog 178:45 (map,c,2) O '90
—1754 Franklin "Join or die" cartoon
against French
Am Heritage 38:14 (4) My '87
—1765 anti-Stamp Act woodcut
Am Heritage 41:35 (4) Mr '90
—Map of British immigration to U.S.
Am Heritage 41:60–1 (c,1) N '90
—Early history of Virginia
Am Heritage 38:49–57, 114 (paint-
ing,c,1) F '87
—Philadelphians protecting Indians from
Paxton mob (1763)
Am Heritage 39:30 (engraving,4) D '88
—Recreation of 17th cent. St. Mary's City,
Maryland
Trav&Leisure 19:E10–E14 (c,3) Mr '89
—Reenactment of 18th cent. life (Wil-
liamsburg, Virginia)
Trav&Leisure 19:100–14 (c,1) Jl '89
—Reenactment of Pilgrim life (Mas-
sachusetts)
Trav/Holiday 170:38–9 (c,3) N '88
—Site of 1607 Jamestown settlement, Vir-
ginia
Life 14:74 (c,4) Summer '91
—Small artifacts from the era (Maryland)
Nat Geog 174:167 (c,1) Ag '88
—See also
FRENCH AND INDIAN WAR
PENN, WILLIAM
POCAHONTAS
REVOLUTIONARY WAR
SMITH, JOHN
U.S.—HISTORY—1783–1861
—1784 treaty between U.S. and Iroquois
nations
Nat Geog 172:370–3 (c,1) S '87
—1787 artifacts of American life
Life 10:28–34 (c,4) Fall '87
—1787 pro-Federalist cartoon
Life 10:22–3 (c,1) Fall '87
—1830s lifestyle reenactment (Sturbridge,
Massachusetts)
Trav/Holiday 168:60–3 (c,1) O '87
—1840s life on the Mississippi

Smithsonian 20:42–3, 54–5 (painting,c,1)
Mr '90
—Cartoon about 1807 Embargo Act
Smithsonian 18:82 (painting,c,4) S '87
—Andrew Jackson's 1818 invasion of Flor-
ida
Smithsonian 19:140–54 (painting,c,4) Ap
'88
—Run on bank during Panic of 1857
Am Heritage 38:56 (painting,4) D '87
—Scenes along the Santa Fe Trail
Nat Geog 179:98–123 (map,c,1) Mr '91
—See also
CIVIL WAR
GOLD RUSH
NORTHWEST ORDINANCE
SHAY'S REBELLION (1787)
SLAVERY
U.S. CONSTITUTION
WAR OF 1812
WESTERN FRONTIER LIFE
U.S.—HISTORY—1865–1898
—1880s events
Nat Geog 173:5–35 (c,1) Ja '88
—1889 homesteading movement (Okla-
homa)
Am Heritage 40:32 (4) Ap '89
Smithsonian 20:192–206 (2) N '89
—1894 Coxeyites
Smithsonian 20:116–17 (3) Ap '89
—Cattlemen's 1892 fight against Invaders
(Wyoming)
Am Heritage 40:46, 50–1 (4) Ap '89
—Famous personalities of the 1880s
Nat Geog 173:5–35 (c,1) Ja '88
—Time capsule of 1889 artifacts
Nat Geog 176:366–9 (c,1) S '89
—See also
GOLD RUSH
INDIAN WARS
SPANISH-AMERICAN WAR
WESTERN FRONTIER LIFE
U.S.—HISTORY—1898–1919
—1900 cartoon about U.S. territorial ambi-
tions
Smithsonian 20:142 (painting,c,4) My '89
—1918 influenza epidemic
Smithsonian 19:130–45 (1) Ja '89
—History of Ellis Island immigration
Smithsonian 21:88–97 (c,1) Je '90
Nat Geog 178:88–101 (1) S '90
Trav&Leisure 20:73–80 (c,2) S '90
Trav/Holiday 174:cov., 39–50 (c,1) S '90
Life 13:cov., 26–38 (c,1) S '90
—See also
IMMIGRANTS
SPANISH-AMERICAN WAR
WOMEN'S SUFFRAGE MOVEMENT
WORLD WAR I

Life 10:cov., 12–17 (c,1) Ag '87
Life 11:34–7 (c,1) Ja '88
Life 12:22–6 (c,1) F '89
Life 12:28–9 (c,1) Fall '89
—FDR signing bill into law
Am Heritage 39:44 (4) F '88
—See also
CAPITOL BUILDINGS
ELECTIONS
GOVERNMENT—LEGISLATURES
GOVERNMENT BUILDINGS
POLITICAL CAMPAIGNS
SOCIAL SECURITY ADMINISTRA-
TION
U.S. CONSTITUTION
U.S. PRESIDENTS
U.S.—RITES AND CEREMONIES
—1954 classroom pledge of allegiance (Vir-
ginia)
Am Heritage 42:34 (4) Ap '91
—Children reciting pledge of allegiance
(1942)
Life 12:108 (4) Ag '89
—Men reciting pledge of allegiance (Texas)
Life 12:25 (c,3) F '89
—Pledging allegiance to flag at club meet-
ing (Wyoming)
Nat Geog 173:54–5 (c,1) Ja '88
U.S.—SIGNS AND SYMBOLS
—1855 wooden bald eagle as U.S. symbol
Am Heritage 38:98–100 (c,1) F '87
—Great Seal of the U.S.
Natur Hist 100:4 (drawing,4) Mr '91
—History of U.S. flag
Life 12:106–10 (c,1) Ag '89
—U.S. pop symbols on T-shirts (Ontario)
Nat Geog 177:110–11 (c,1) F '90
—See also
LIBERTY, STATUE OF
LIBERTY BELL
UNCLE SAM
U.S.—SOCIAL LIFE AND CUSTOMS
—Early 20th cent. cartoons by H. T. Web-
ster
Am Heritage 42:101–7 (1) S '91
—1922 illustrations of proper manners
Am Heritage 42:73–82 (drawing,4) S '91
—American items endangered by "pro-
gress"
Life 12:cov., 50–4, 65, 68 (c,2) O '89
—America's love affair with cars (1900–
1990)
Trav/Holiday 174:cov., 51–65 (c,1) Ag
'90
—Baseball's role in American life
Sports Illus 74:52–63 (c,1) Ap 15 '91
Smithsonian 22:98–107 (c,1) Ap '91
—"Daddy" Browning and 15-year-old
"Peaches" (1927)

Smithsonian 21:152 (4) My '90
—Cartoon spoofing life in the South
Smithsonian 20:180 (c,2) S '89
—Dating couples on Saturday night
Life 13:64–8 (c,1) Ap '90
—Important moments in a girl's life (1911)
Am Heritage 38:34–5 (painting,c,4) F '87
—Scenes of contemporary American life
Nat Geog 173:44–79 (c,1) Ja '88
—See also
HAND SHAKING
LIFESTYLES
U.S. AIR FORCE
—1940s flyer
Sports Illus 71:60 (3) Ag 7 '89
Smithsonian 21:20 (4) Mr '91
—Griffiss Air Force Base, Rome, New
York
Nat Geog 178:56 (c,3) N '90
—Sites of 1940s American air bases (East
Anglia, England)
Am Heritage 41:100–9 (map,c,1) Ap '90
—Survival training
Nat Wildlife 25:20–3 (c,1) F '87
U.S. ARMY
—1915 West Point graduates
Am Heritage 39:46 (3) Ap '88
—1944 U.S. Army recruitment poster
Am Heritage 40:4 (c,2) Mr '89
—Current worldwide U.S. military activi-
ties
Life 11:36–43 (c,1) Ap '88
—Desert tracks of 1940s tank maneuvers
(California)
Nat Geog 171:62 (c,3) Ja '87
—Female brigadier general
Nat Geog 176:215 (2) Ag '89
—History of women in the U.S. military
Life 14:52–62 (c,1) My '91
—Pentagon War Room, Arlington, Vir-
ginia
Life 12:62–3 (c,1) D '89
—Soldier being sworn in
Life 13:30–1 (c,1) O '90
—World War II deserter Eddie Slovick
Am Heritage 38:97–103 (4) S '87
—See also
MILITARY COSTUME
PENTAGON BUILDING
list under MILITARY LEADERS
U.S. COAST GUARD
—Lifeboat skipper training (Washington)
Smithsonian 18:98–111 (c,1) My '87
U.S. CONSTITUTION
Nat Geog 172:342–3, 368–9 (c,1) S '87
Life 10:2–3, 62–3 (c,1) Fall '87
—1787 Constitution ratification celebration
(New York)
Am Heritage 38:14 (drawing,4) S '87

VAN BUREN, MARTIN
WASHINGTON, GEORGE
WHITE HOUSE
WILSON, WOODROW
UNIVERSE
—Evidence of meteorite impact on Earth
 Smithsonian 20:80–93 (map,c,1) S '89
—Pre-Columbian theories of the universe
 Nat Gcog 177:81–3 (painting,c,1) Mr
 '90
—Pueblo "origin of man" story
 Nat Geog 180:8–9, 12–13 (painting,c,1)
 O '91
—Research collider detector (Illinois)
 Smithsonian 20:34 (c,4) Ja '90
—Research on earth's ozone layer
 Smithsonian 18:142–55 (c,2) F '88
—Solar system
 Nat Geog 178:48–65 (c,1) Ag '90
—Theory of how the moon was created
 Natur Hist 98:cov., 68–77 (c,1) N '89
—See also
 ASTEROIDS
 ASTRONOMY
 CONSTELLATIONS
 EARTH
 ECLIPSES
 GALAXIES
 HALLEY'S COMET
 JUPITER
 MARS
 METEORITES
 METEORS
 MILKY WAY
 MOON
 NEBULAE
 NEPTUNE
 OBSERVATORIES
 SATURN
 SCIENCE FICTION
 SPACE PROGRAM
 SPACECRAFT
 STARS
 SUN
 URANUS
URANIUM
 Life 10:32 (c,2) N '87
—Radioactive sand from uranium mill
 (New Mexico)
 Nat Geog 175:428–9 (c,1) Ap '89
URANUS (PLANET)
 Smithsonian 19:46 (c,4) S '88
 Life 12:110–11 (c,1) N '89
 Nat Geog 178:51, 58 (c,4) Ag '90
—Moon Miranda
 Nat Geog 178:63 (c,4) Ag '90
URBAN SCENES
—1880s
 Nat Geog 173:16 (c,1) Ja '88

—City spots invaded by vegetation
 Smithsonian 17:72–9 (c,1) Ja '87
—Independence, Missouri (1951)
 Am Heritage 38:36–7 (1) My '87
—Neon signs at night (Guatemala)
 Nat Geog 173:780–1 (c,2) Je '88
—New York City, New York
 Smithsonian 19:119–31 (c,1) F '89
—Orville Simpson's future Victory City de-
 signs
 Life 10:15–18 (drawing,c,3) S '87
—Trichur, India
 Nat Geog 173:598–9 (c,1) My '88
—Tunnels and tubes beneath New York
 City streets
 Smithsonian 18:38–47 (c,1) Ag '87
—See also
 AUTOMOBILES—TRAFFIC
 COMMUTERS
 CROWDS
 SLUMS
 SUBURBAN SCENES
UTAH
—Arch Canyon
 Natur Hist 97:26–8 (map,c,1) Je '88
—Bonneville Salt Flats
 Natur Hist 98:70 (c,4) D '89
—Brain Head
 Natur Hist 99:82–4 (map,c,1) N '90
—Brumley Ridge
 Natur Hist 98:69–71 (map,c,2) S '89
—Canyons
 Trav&Leisure 21:66–70 (c,1) Ag '91
—Cedar Breaks
 Natur Hist 99:82–4 (map,c,1) N '90
—Countryside
 Life 10:94–5 (c,1) Ja '87
—Dead Horse Point State Park
 Nat Geog 175:70 (c,2) Ja '89
—Deer Valley
 Trav&Leisure 21:142–9 (map,c,1) N '91
—Escalante Canyon
 Smithsonian 21:38 (c,3) S '90
—Monument Valley
 Trav&Leisure 18:131 (c,2) D '88
 Trav/Holiday 176:80 (c,4) Jl '91
—Mt. Tukuhnikivatz
 Natur Hist 98:69 (c,4) S '89
—Paria Canyon
 Life 11:125–7 (c,1) N '88
—Park City
 Trav/Holiday 169:52 (c,4) Je '88
 Trav&Leisure 21:142 (c,4) N '91
—Park City (1930)
 Trav/Holiday 169:52 (4) Je '88
—Red Canyon
 Natur Hist 97:18–21 (map,c,1) D '88
—See also
 ARCHES NATIONAL PARK

BRYCE CANYON NATIONAL
 PARK
CANYONLANDS NATIONAL PARK
CAPITOL REEF NATIONAL PARK
GREAT SALT LAKE

NATURAL BRIDGES NATIONAL
 MONUMENT
ZION NATIONAL PARK
UTRECHT, NETHERLANDS
Trav&Leisure 20:17 (c,2) F '90 supp.

- V -

VACCINATIONS
—Inoculating children against polio (1955)
 Life 13:38–9 (4) Ap '90
—Vaccinating child against measles (Min-
 nesota)
 Life 13:22 (c,4) Spring '90
VACUUM CLEANERS
—1910
 Am Heritage 38:68 (3) S '87
—1912 patent drawing
 Am Heritage 38:111 (drawing,c,2) Jl '87
VACUUMING
—Vacuuming bugs from crops
 Life 12:10 (c,4) My '89
VAMPIRES
—Art works depicting vampires
 Natur Hist 99:74–82 (1) O '90
VAN BUREN, MARTIN
 Am Heritage 39:152 (painting,2) N '88
—1840 anti-Van Buren cartoons
 Am Heritage 41:40 (4) Ap '90
—Home (Kinderhook, New York)
 Trav&Leisure 20:E16–E18 (c,3) O '90
—Nasty caricature of him
 Smithsonian 19:151 (painting,c,4) O '88
VANCOUVER, BRITISH COLUMBIA
 Sports Illus 68:318 (c,3) Ja 27 '88
 Trav&Leisure 18:C14 (c,4) My '88 supp.
 Nat Geog 178:114–17 (c,1) S '90
 Trav&Leisure 21:76–7, 103 (c,3) Ag '91
—Canada Place
 Trav&Leisure 18:62–3 (c,4) O '88
VANDERBILT, CORNELIUS
 Am Heritage 38:20 (drawing,4) N '87
 Am Heritage 40:16 (drawing,4) Mr '89
VAN EYCK, JAN
—"Ghent Altarpiece," Belgium
 Trav&Leisure 17:51 (painting,c,4) Jl '87
VAN GOGH, VINCENT
 Trav&Leisure 20:166–7 (c,1) Ap '90
—"La Berceuse"
 Trav&Leisure 21:23 (painting,c,4) My
 '91
—"Irises"
 Trav&Leisure 20:5 (painting,c,4) F '90
 supp.
—Paintings by him
 Trav&Leisure 20:1–11 (c,2) F '90 supp.

—"The Potato Eaters"
 Trav&Leisure 20:8 (painting,c,4) F '90
 supp.
—Self-portraits
 Trav&Leisure 20:1 (painting,c,4) F '90
 supp.
 Trav&Leisure 20:168, 170 (painting,c,4)
 Ap '90
 Life 14:70 (painting,c,4) My '91
—"Skull with a Burning Cigarette"
 Smithsonian 20:18 (painting,c,4) S '89
—"Starry Night"
 Trav&Leisure 20:4 (painting,c,2) F '90
 supp.
VATICAN CITY
—Piazza di San Pietro (1908)
 Trav&Leisure 18:130 (c,4) My '88
—Restoration of Sistine Chapel frescoes
 Nat Geog 176:cov., 688–713 (c,1) D '89
 Life 14:cov., 28–40, 45 (painting,c,1) N
 '91
—See also
 POPES
 ST. PETER'S BASILICA
VEGETABLES
—Autumn harvest vegetables
 Gourmet 47:cov., 83 (c,1) N '87
—Fennel
 Gourmet 50:125 (c,1) N '90
—Rutabagas
 Gourmet 51:78 (c,4) F '91
—See also
 ARTICHOKES
 ASPARAGUS
 BROCCOLI
 CORN
 LETTUCE
 PEPPERS
 POTATOES
 PUMPKINS
 SQUASH
 TURNIPS
VELÁZQUEZ, DIEGO
—"The Mirror of Venus"
 Smithsonian 18:244 (painting,c,4) N '87
—Portrait of Maria Theresa
 Trav&Leisure 19:69 (painting,c,4) O
 '89

Smithsonian 19:112–13 (c,1) My '88
VETERINARIANS
—Dog blood drive
 Life 12:8 (c,4) Je '89
—Giving injection to horse
 Sports Illus 67:41 (c,4) Ag 10 '87
—Great Britain
 Life 11:68–9 (c,1) Mr '88
—Treating panther (Florida)
 Natur Hist 97:50–1 (1) Ap '88
VICKSBURG, MISSISSIPPI
 Trav/Holiday 171:67–71 (c,2) Ja '89
—1863 Union siege of Vicksburg
 Am Heritage 39:32 (4) Jl '88
VICTORIA (GREAT BRITAIN)
 Trav&Leisure 17:37 (4) Ag '87
 Life 10:36 (4) S '87
 Smithsonian 18:222 (painting,c,4) O '87
 Life 10:45 (painting,4) O '87
—Statue (Mauritius)
 Gourmet 49:100 (c,3) N '89
VICTORIA, BRITISH COLUMBIA
 Trav/Holiday 168:68–9 (c,3) N '87
 Trav/Holiday 172:82–7 (c,1) D '89
—Butchart Gardens
 Trav/Holiday 173:62–3 (c,1) Ja '90
VICTORIA FALLS, ZIMBABWE
 Trav&Leisure 20:116–17 (c,2) S '90
Video games. See
 GAME PLAYING
VIENNA, AUSTRIA
 Gourmet 47:64–9, 90 (c,1) Mr '87
 Trav&Leisure 18:120–31 (c,1) N '88
 Trav&Leisure 19:87–90 (c,2) Mr '89
—16th cent. map
 Nat Geog 172:590 (c,1) N '87
—Aunt Dorothy's auction house
 Smithsonian 21:110–20 (c,2) D '90
—Coffeehouse
 Trav&Leisure 18:34, 36 (c,4) F '88
 Trav&Leisure 20:218 (c,4) N '90
 Gourmet 51:85 (c,1) Ja '91
—Historic hotels
 Gourmet 47:64–9 (c,1) Mr '87
—Rathaus
 Trav&Leisure 18:120–1 (c,1) N '88
—St. Stephen's Cathedral
 Gourmet 50:67 (c,2) Ja '90
—Schönbrunn Palace
 Trav&Leisure 18:126–7 (c,1) N '88
—Stadtpark
 Gourmet 51:84 (c,3) Ja '91
—Vienna State Opera House staircase
 Gourmet 50:68 (c,3) Ja '90
VIETNAM
 Smithsonian 18:62–71 (c,1) Ap '87
 Life 10:58–69 (c,1) D '87
 Nat Geog 176:cov., 558–621 (map,c,1) N '89

—See also
 HANOI
 HO CHI MINH CITY
 HUE
VIETNAM—COSTUME
 Smithsonian 18:62–71 (c,1) Ap '87
 Life 10:59–69 (c,1) D '87
 Nat Geog 176:cov., 558–621 (c,1) N '89
 Trav&Leisure 21:120, 122–3, 174 (c,1) Je '91
—Amerasian children
 Life 10:10 (c,3) D '87
 Life 11:38–9 (c,1) Jl '88
—Boat people refugees (Hong Kong)
 Nat Geog 179:132–8 (c,1) F '91
—Traditional ao dai (Hue)
 Nat Geog 176:603 (c,2) N '89
VIETNAM—HISTORY
—Bao-Dai
 Life 13:45 (c,4) Mr '90
—Ngo Dinh Dicm
 Am Heritage 39:42 (4) N '88
—Khai-Dinh
 Life 13:45 (4) Mr '90
—See also
 HO CHI MINH
 VIETNAM WAR
VIETNAM—HOUSING
—Stilt huts
 Am Heritage 42:106–7 (painting,c,1) F '91
VIETNAM—RITES AND FESTIVALS
—Vietnamese funeral (Australia)
 Nat Geog 173:260–1 (1) F '88
VIETNAM—SOCIAL LIFE AND CUS-
 TOMS
—Sipping communal drink
 Natur Hist 100:62 (c,3) N '91
VIETNAM WAR
—1955 cartoon about U.S. involvement in
 Vietnam
 Am Heritage 38:53 (4) D '87
—1975 flight of refugees from Da Nang
 Am Heritage 42:97–105 (c,4) Jl '91
—Americans involved in 1968 My Lai mas-
 sacre
 Am Heritage 41:44–53 (c,1) F '90
—Artist Linzee Prescott's portrayal of the
 war
 Am Heritage 42:100–13 (painting,c,1) F '91
—Damage to U.S.S. Maddox by North Vi-
 etnam (1964)
 Am Heritage 40:34 (4) Jl '89
—Impact on the environment
 Natur Hist 99:34–41 (map,c,1) N '90
—Injured U.S. soldiers (1966)
 Life 11:80–1 (c,1) Fall '88
—MIAs

Life 10:110–19 (c,4) N '87
—My Lai massacre memorial (Vietnam)
Life 11:6 (c,4) Mr '88
—Red River bridge damaged in Vietnam
War (Hanoi)
Nat Geog 176:575 (c,4) N '89
—Remains of U.S. soldiers in Vietnam
(1988)
Nat Geog 176:576–7 (c,1) N '89
—Spraying Agent Orange
Natur Hist 99:34–8 (c,1) N '90
—U.S. troops in Vietnam
Am Heritage 38:12 (4) Ap '87
Life 10:32–4 (c,1) My '87
Am Heritage 39:8 (4) Jl '88
Am Heritage 41:112 (painting,c,2) D
'90
—Vietcong prisoner being shot
Life 11:50 (4) Fall '88
—Vietcong tunnels (Saigon)
Nat Geog 176:616–17 (c,1) N '89
—Vietnam Veterans Memorial, Washing-
ton, D.C.
Smithsonian 17:149 (4) F '87
Am Heritage 39:112 (c,4) Ap '88
Trav/Holiday 169:11, 14 (c,4) Ap '88
Trav&Leisure 18:122–3 (c,1) S '88
Life 12:18–19 (c,1) Fall '89
Life 14:46–7 (c,1) Summer '91
VIGNY, ALFRED DE
—Caricature
Smithsonian 20:157 (c,3) Ja '90
VIKINGS—HOUSING
—Viking longhouse (Denmark)
Trav/Holiday 176:71 (c,4) S '91
VIKINGS—RELICS
—Model of Viking ship (Minnesota)
Sports Illus 69:72–3 (c,1) D 5 '88
—Viking ship
Trav/Holiday 167:66 (c,3) Je '87
Trav/Holiday 176:93 (drawing,4) S '91
VILLA, PANCHO
Smithsonian 21:56 (drawing,c,4) Ja '91
VILLAGES
—Aerial view of small town
Gourmet 51:102 (painting,c,2) S '91
—Basilicata, Italy
Gourmet 48:76 (c,3) O '88
—Dogon village (Mali)
Nat Geog 178:119 (c,4) O '90
—Ecuador
Trav&Leisure 21:20 (c,4) Mr '91
—England
Gourmet 47:56 (c,2) S '87
Trav/Holiday 173:cov., 52 (c,1) Ap '90
—Guangdong Province, China
Nat Geog 175:292–3 (c,1) Mr '89
—Kenya
Natur Hist 98:46–7 (c,2) My '89

—Loire Valley village, France
Gourmet 51:34 (painting,c,3) Jl '91
—Majorca, Spain
Trav&Leisure 18:22 (c,4) My '88
—Maps of Shaker villages
Natur Hist 96:48–57 (c,1) S '87
—Marvao, Portugal
Trav/Holiday 174:60 (c,3) N '90
—Pre-Columbia Indian villages
Nat Geog 180:42–94 (painting,c,1) O
'91
—Safranbolu, Turkey
Nat Geog 172:572–3 (c,2) N '87
—Switzerland
Gourmet 49:49 (c,1) Ag '89
Trav/Holiday 175:66–7 (c,1) Ja '91
—Trevejo, Spain
Nat Geog 179:126–7 (c,1) Ap '91
—West Germany
Trav/Holiday 169:27 (c,4) Mr '88
VINEYARDS
Gourmet 49:57, 60 (drawing,4) D '89
—Australia
Gourmet 48:52–3 (c,1) Ap '88
—California
Gourmet 48:44, 92 (painting,c,2) Mr
'88
Trav/Holiday 169:76–7 (c,2) Mr '88
Am Heritage 39:24 (c,4) Ap '88
Trav&Leisure 18:156–7, 160 (c,1) D '88
Gourmet 49:86–7, 90 (c,1) S '89
Gourmet 50:98 (drawing,4) Ja '90
Gourmet 50:42 (painting,c,2) Mr '90
Nat Geog 179:48–9 (c,1) F '91
Trav&Leisure 21:124–5 (c,1) Mr '91
Gourmet 51:64 (painting,c,2) My '91
—France
Trav/Holiday 169:58–9 (c,1) Mr '88
Gourmet 48:58, 65–6 (c,4) S '88
Trav/Holiday 171:50–1 (c,2) Ja '89
Trav&Leisure 21:116–17, 166 (c,1) F
'91
Gourmet 51:77 (painting,c,2) N '91
—Italy
Trav/Holiday 169:66 (c,4) F '88
Trav/Holiday 174:61–3 (c,1) S '90
Gourmet 51:38 (painting,c,2) Mr '91
Trav&Leisure 21:107 (c,4) Jl '91
—Oregon
Gourmet 48:43 (c,2) Ag '88
—Switzerland
Gourmet 49:53 (c,1) Ag '89
—West Germany
Gourmet 49:65 (c,1) Je '89
—See also
GRAPE INDUSTRY
WINE INDUSTRY
VIOLIN PLAYING
—Brazil

Trav/Holiday 173:18 (c,4) Ja '90
Life 14:18 (c,2) Ap '91
Life 14:105 (c,2) Summer '91
—Kilauea lava flow (Hawaii)
Nat Geog 178:71, 74 (c,4) Jl '90
Natur Hist 100:cov., 50–3, 60–1 (c,1) Ap
'91
—Mt. St. Helens, Washington (1980)
Life 12:14–15 (c,1) Fall '89
—Réunion
Natur Hist 100:58–9 (c,1) Ap '91
—Zaire
Nat Geog 177:4–5 (c,1) My '90
VOLCANOES
—Andes Mountains, South America
Nat Geog 171:422–3 (c,1) Ap '87
—Carbonatite volcano (Tanzania)
Nat Geog 177:28 (c,3) My '90
—Djibouti
Nat Geog 177:15 (c,1) My '90
—Fuego, Guatemala
Nat Geog 173:794–7 (c,1) Je '88
—Haleakala Volcano, Maui, Hawaii
Natur Hist 98:50–1 (c,1) Mr '89
Trav&Leisure 20:27 (c,4) D '90
—Hotel's mock volcano (Las Vegas, Nevada)
Nat Geog 179:3 (c,4) Je '91
—Life growing on volcanic lava (Hawaii)
Nat Geog 178:70–87 (c,1) Jl '90
—Mayon, Philippines
Natur Hist 96:20–1 (c,3) Jl '87
—Mt. Semeru, Indonesia
Nat Geog 175:112–13 (c,1) Ja '89
—Osorno volcano, Chile
Natur Hist 96:42–3 (c,1) S '87
—Poás volcano, Costa Rica
Trav&Leisure 18:134–5 (c,1) O '88
—Sangay, Ecuador
Nat Geog 171:434–5 (c,1) Ap '87
—Tambora, Indonesia
Natur Hist 97:66–73 (map,c,1) Je '88
—Volcanic rocks (Texas)
Trav&Leisure 21:124–5 (c,1) S '91
—See also
ACONCAGUA
COTOPAXI
EL MISTI
KILAUEA
MOUNT ETNA
MOUNT HOOD
MOUNT ST. HELENS
VOLCANOES—DAMAGE
—1985 victim of volcano (Columbia)
Life 12:122–3 (c,1) Fall '89
—Bay created by volcano (Ecuador)
Nat Geog 173:132–3 (c,1) Ja '88
—Cars buried in lava (Hawaii)
Nat Geog 178:72–3 (c,1) Jl '90

—Lava-covered housing (Hawaii)
Life 12:10 (c,4) Ag '89
—Lava river crossing highway (Hawaii)
Life 13:10–11 (c,1) Je '90
Trav/Holiday 174:22 (c,4) O '90
—Philippines (1991)
Life 14:6–7 (c,1) S '91
VOLES
Smithsonian 19:79 (c,4) O '88
Natur Hist 98:80 (c,4) N '89
Natur Hist 98:38, 42 (c,1) D '89
Nat Geog 178:111 (c,4) S '90
VOLGOGRAD, U.S.S.R.
Nat Geog 179:34–5 (c,1) F '91
—"Mother Russia" statue
Nat Geog 179:34–5 (c,1) F '91
VOLLEYBALL
—1988 Olympics (Seoul)
Sports Illus 69:104–5 (c,2) O 10 '88
—Beach volleyball
Sports Illus 67:50–1 (c,1) S 7 '87
Sports Illus 69:54–8 (c,1) Ag 1 '88
—Pan American Games 1987 (Indiana)
Sports Illus 67:19 (c,2) Ag 24 '87
—President Hoover playing medicine ball
Sports Illus 67:6 (4) N 9 '87
—U.S.-U.S.S.R. game
Sports Illus 71:24–5 (c,2) Jl 10 '89
—USA Cup championships 1988
Sports Illus 69:40–3 (c,1) Jl 4 '88
—Women
Sports Illus 66:2–3, 46–7 (c,2) Je 29 '87
VOLLEYBALL—COLLEGE
Sports Illus 66:87, 90 (c,3) My 11 '87
Sports Illus 72:84, 89 (c,3) My 14 '90
Sports Illus 74:54–5 (c,2) Mr 4 '91
—NCAA championships
Sports Illus 73:79–80 (c,3) D 24 '90
VOLLEYBALL—PROFESSIONAL
—Women
Sports Illus 66:6 (c,4) My 25 '87
VOLTAIRE
Smithsonian 20:192 (drawing,4) S '89
—Home (Ferney, France)
Nat Geog 176:28 (c,3) Jl '89
VON BRAUN, WERNHER
Life 13:50 (4) Fall '90
VOODOO
—Altar (Pennsylvania)
Nat Geog 178:74–5 (1) Ag '90
—Haiti
Nat Geog 172:668 (c,4) N '87
—Voodoo artifacts (Brazil)
Trav/Holiday 167:100 (c,4) Mr '87
VULTURES
Smithsonian 17:59 (c,4) F '87
Nat Wildlife 25:16–21 (c,1) Je '87
Nat Wildlife 26:59 (c,1) F '88
Trav&Leisure 18:132 (c,4) O '88

- W -

—See also
PERRY, OLIVER HAZARD
WARBLERS
.Nat Wildlife 25:47 (c,4) Ap '87
Nat Wildlife 27:20, 26 (c,3) D '88
Natur Hist 98:52–3 (c,2) Ap '89
Natur Hist 98:cov., 50–9 (c,1) My '89
Natur Hist 98:90–1, 94–5 (c,1) O '89
Smithsonian 20:34 (c,4) F '90
Natur Hist 99:24 (c,4) O '90
Natur Hist 100:10 (c,3) Ap '91
Trav&Leisure 21:80 (c,4) O '91
—See also
CHATS
REDSTARTS
YELLOWTHROATS
WAREHOUSES
—Food warehouse (Virginia)
Smithsonian 19:44–5 (c,3) N '88
WARFARE
—15th cent. attack on castle
Smithsonian 22:33 (painting,c,4) D '91
—1526 Battle of Mohács (Hungary)
Nat Geog 172:578–9 (c,2) N '87
—1543 naval attack on Nice, France
Nat Geog 172:595 (painting,c,1) N '87
—1571 naval battle of Lepanto (Greece)
Smithsonian 18:160 (painting,c,3) D '87
—1590s invasion of Korea by Japanese
Smithsonian 19:50–1 (painting,c,3) Ag '88
—1676 Swedish naval attack on Denmark
Nat Geog 175:444–5 (painting,c,2) Ap '89
—1813 Battle of Leipzig
Smithsonian 21:87 (painting,c,3) Mr '91
—1830s War of the Castes (Mexico)
Nat Geog 176:462 (painting,c,3) O '89
—1830s Zulus attacking Boers (South Africa)
Nat Geog 174:564 (painting,c,4) O '88
—1840s Anglo-Afghan War battle (Kabul)
Smithsonian 19:50 (painting,c,3) D '88
—1846 battle of Sobraon, India
Smithsonian 18:50–1 (painting,c,1) Ja '88
—1980s violent worldwide events
Life 12:118–25 (c,1) Fall '89
—Afghanistan-U.S.S.R. conflict
Life 10:6–7 (c,1) Je '87
Life 11:100–6 (c,1) F '88
—Ancient Egypt
Nat Geog 179:5, 16–19 (painting,c,1) Ap '91
—Ancient Moche warriors (Peru)
Nat Geog 174:550–5 (c,1) O '88
—Film reenactment of 3rd cent. B.C. battle (China)
Natur Hist 98:68–9 (c,1) Jl '89
—Iran-Iraq War (1980–1989)
Life 11:26–34 (c,1) O '88
—Libya-Chad conflict waged in pickup trucks
Life 10:6 (c,4) O '87
—Persian Gulf naval attacks
Life 11:122–5 (map,c,1) Ja '88
—Robots for reconnaissance work
Life 12:80–1 (c,1) F '89
—Science fiction space wars (1930s–1940s)
Am Heritage 40:cov., 46, 50 (painting,c,1) S '89
—See also
ARMS
BUNKER HILL, BATTLE OF
DUELS
MILITARY COSTUME
SPIES
WARS
WARHOL, ANDY
Life 11:113 (c,2) Ja '88
Sports Illus 70:40 (4) F 10 '89
Smithsonian 19:65 (4) F '89
Life 12:90 (c,4) D '89
Life 13:49 (4) Fall '90
—Art works by him
Smithsonian 19:62–75 (c,1) F '89
—Portrait of Sioux chief (1976)
Natur Hist 99:88 (painting,c,3) N '90
—Screen-print of Pete Rose
Smithsonian 19:184 (c,4) S '88
—Self-portrait
Smithsonian 19:62 (c,1) F '89
—Warhol painting of Siberian tiger
Nat Wildlife 29:30–1 (c,1) Je '91
—Warhol's family
Life 12:84–92 (c,1) D '89
WARREN, ROBERT PENN
Life 10:39 (c,1) Ja '87
Life 13:114 (4) Ja '90
WARS
—1840 Opium War naval battle (China)
Smithsonian 20:47 (painting,c,3) Ap '89
—See also
ARMS
CIVIL WAR
CRIMEAN WAR
FRANCO-PRUSSIAN WAR
FRENCH AND INDIAN WAR
GULF WAR
INDIAN WARS
KOREAN WAR
MILITARY COSTUME
MILITARY LEADERS
REVOLUTIONARY WAR
SPANISH-AMERICAN WAR
THIRTY YEARS' WAR
VIETNAM WAR
WAR OF 1812
WARFARE

—Clouds reflected in puddle (Colorado)
 Smithsonian 21:38 (c,4) S '90
—Drake Passage, Antarctica
 Nat Geog 175:128–38 (map,c,1) Ja '89
—Homes with no water supply (El Paso,
 Texas)
 Life 10:152–6 (1) N '87
—Household water conservation measures
 Nat Wildlife 27:18–23 (c,3) Je '89
—South Florida's water problems
 Nat Geog 178:88–113 (map,c,1) Jl '90
—Strait of Messina, Italy
 Trav&Leisure 21:91 (c,3) Je '91
—Tide pools (California)
 Trav&Leisure 18:190, 193 (c,4) N '88
—Tunnels and tubes beneath New York
 City streets
 Smithsonian 18:38–47 (c,1) Ag '87
—Water dripping from faucet
 Smithsonian 18:134–5 (c,1) D '87
—See also
 CANTEENS
 DAMS
 DIKES
 DROUGHT
 FLOODS
 FOUNTAINS
 IRRIGATION
 WELLS
 list under WATER FORMATIONS
WATER BUFFALOES
 Nat Geog 171:376 (c,3) Mr '87
Water formations. See
 AQUEDUCTS
 ATLANTIC OCEAN
 BALTIC SEA
 BAYS
 BERING SEA
 CANALS
 CARIBBEAN SEA
 CHESAPEAKE BAY
 CREEKS
 DAMS
 DEAD SEA
 ENGLISH CHANNEL
 FJORDS
 FLOODS
 FOUNTAINS
 GIBRALTAR, STRAIT OF
 GREAT LAKES
 GULF OF CALIFORNIA
 GULF STREAM
 HARBORS
 INDIAN OCEAN
 IRRIGATION
 LAKES
 MARINAS
 NORTH SEA
 OCEANS

PACIFIC OCEAN
PONDS
PUGET SOUND
RED SEA
RESERVOIRS
RIVERS
SEAS
STREAMS
WATERFALLS
WAVES
WELLS
list under LAKES; RIVERS
WATER HYACINTHS
 Gourmet 50:89 (c,4) Mr '90
WATER LILIES
 Smithsonian 18:49 (painting,c,4) Jl '87
 Trav/Holiday 168:60 (c,2) Jl '87
 Trav&Leisure 17:108 (c,4) Jl '87
 Trav&Leisure 17:101, 106–7 (c,1) S '87
 Natur Hist 96:26 (c,3) D '87
 Gourmet 48:44 (c,4) Ja '88
 Nat Geog 173:173 (c,4) F '88
 Trav&Leisure 18:117 (c,3) My '88
 Smithsonian 19:176 (painting,c,4) F '89
 Natur Hist 98:10 (c,3) Mr '89
 Nat Wildlife 28:58–9 (c,1) D '89
 Smithsonian 21:97, 104 (c,2) Jl '90
 Nat Geog 178:42 (c,4) D '90
WATER POLLUTION
—Animals harmed by plastic debris in
 oceans
 Smithsonian 18:58–67 (c,1) Mr '88
—Anti pollution poster (Siberia, U.S.S.R.)
 Nat Geog 177:25 (c,4) Mr '90
—Cleanup of toxic spill (Loire River,
 France)
 Life 11:9 (c,4) S '88
—Great Lakes
 Nat Geog 172:16–17, 22–3 (c,1) Jl '87
—Industrial waste in harbor water (China)
 Nat Geog 175:291 (c,3) Mr '89
—Sewage contamination sign on beach
 (California)
 Nat Geog 176:192 (c,2) Ag '89
—Unsafe beach (Estonia)
 Nat Geog 175:624–5 (c,2) My '89
—See also
 ACID RAIN
 OIL SPILLS
WATER POLO
 Sports Illus 69:2–3, 36–7 (c,1) Jl 18 '88
 Sports Illus 69:174 (c,3) S 14 '88
—1988 Olympics (Seoul)
 Sports Illus 69:108 (c,3) O 10 '88
WATER PUMPS
—Mali
 Nat Geog 172:158–9 (c,2) Ag '87
WATER SKIING
 Trav/Holiday 168:46–7 (c,2) Jl '87

—Cattlemen's 1892 fight against Invaders (Wyoming)
Am Heritage 40:46, 50–1 (4) Ap '89
—Depicted in paintings
Natur Hist 96:36–41 (c,1) My '87
Am Heritage 41:96–104 (c,2) F '90
—Fight between Indian and frontiersman (1845)
Natur Hist 96:36 (painting,c,1) My '87
—Film sets of Old West (Tucson, Arizona)
Trav/Holiday 168:10–12 (c,4) Ag '87
—History of western barbed wire
Smithsonian 22:72–83 (c,1) Jl '91
—Hole-in-the-Wall outlaw hideout (Wyoming)
Am Heritage 40:48–9 (c,1) Ap '89
—Lifestyles of the rural West
Nat Geog 175:52–71, 76–83 (c,1) Ja '89
—Marshal riding into town
Smithsonian 20:115 (painting,c,3) Ap '89
—Movie westerns
Am Heritage 40:64–5 (c,4) Mr '89
—Outlaw Ned Christie
Smithsonian 20:120 (3) Ap '89
—Pioneer Monument, San Francisco, California
Am Heritage 38:94 (c,3) Ap '87
—Scenes along the Santa Fe Trail
Nat Geog 179:98–123 (map,c,1) Mr '91
—Sheriff Pat Garrett
Smithsonian 21:142–3 (4) F '91
—Sites associated with Billy the Kid (New Mexico)
Am Heritage 42:65–78 (map,c,4) Ap '91
—Uncle Sam depicted as Old West sheriff
Am Heritage 41:26 (drawing,4) D '90
—See also
BILLY THE KID
BOONE, DANIEL
CARSON, KIT
CODY, BUFFALO BILL
COVERED WAGONS
COWBOYS
EARP, WYATT
GHOST TOWNS
INDIAN WARS
JAMES, JESSE
JAMES, WILLIAM
OAKLEY, ANNIE
RANCHING
REMINGTON, FREDERIC
RODEOS
STAGECOACHES
VIRGINIA CITY
WESTERN FRONTIER LIFE—HUMOR
—Fights over location of county seats
Smithsonian 20:100–11 (painting,c,1) Mr '90

WESTERN U.S.
—Early 20th cent.
Nat Geog 175:216–49 (c,1) F '89
—See also
ROCKY MOUNTAINS
WESTERN U.S.—MAPS
—Land use map of western U.S.
Nat Geog 175:62 (c,1) Ja '89
WESTMINSTER ABBEY, LONDON, ENGLAND
—Interior
Life 13:54 (4) D '90
WHALES
Nat Geog 174:872–909 (c,1) D '88
Natur Hist 100:cov., 36–41, 65–74 (c,1) Mr '91
—Blue whale
Nat Geog 174:888–9 (c,1) D '88
—Bowhead whales
Natur Hist 100:39–41 (c,1) Mr '91
Nat Geog 180:18–23 (c,1) Jl '91
—Evolutionary path of whales
Nat Geog 174:883–5 (painting,c,1) D '88
—Fin whale
Nat Geog 174:878–9 (c,1) D '88
—Gray
Nat Geog 171:754–71 (c,1) Je '87
Nat Wildlife 29:34–5 (painting,c,1) Je '91
—Humpback
Nat Wildlife 26:23 (sculpture,c,4) Je '88
Nat Wildlife 26:48 (painting,c,3) Ag '88
Nat Geog 174:872–3, 898–903 (c,1) D '88
Sports Illus 70:66–83 (c,1) My 29 '89
Nat Wildlife 28:48–9 (c,1) Je '90
Natur Hist 100:36–7, 42–5 (c,1) Mr '91
—Model of whale
Trav&Leisure 18:88–9 (c,1) Jl '88
—Rescue of gray whales trapped in ice (Alaska)
Sports Illus 69:126–30 (c,3) N 28 '88
Life 11:42–5 (c,1) D '88
Life 12:116–17 (c,1) Ja '89
—Right whales
Nat Wildlife 26:46–7 (painting,c,1) Ag '88
Nat Geog 174:874–5, 886–7, 896–7 (c,1) D '88
—Whale watching (British Columbia)
Nat Geog 174:892 (c,3) D '88
—Whale watching (California)
Trav/Holiday 170:22–3 (c,3) Jl '88
—Whale watching (Massachusetts)
Sports Illus 71:44–6 (c,4) Ag 21 '89
—See also
BELUGAS
KILLER WHALES
NARWHALS
PILOT WHALES
SPERM WHALES
WHALING

WHALING
—15th cent. Makah Indians (Northwest)
Smithsonian 22:41–2 (painting,c,1) N '91
—1848 (Japan)
Natur Hist 98:76–7 (painting,c,2) Mr '89
—1880 (Iceland)
Natur Hist 98:78 (painting,c,4) Mr '89
—Bringing bowhead to land (Canada)
Nat Geog 178:24–9 (c,1) Ag '90
—Catching minke whales (Antarctica)
Nat Geog 177:46–7 (c,1) Ap '90
—Eskimos (U.S.S.R.)
Natur Hist 100:32–3 (c,1) Ja '91
—Hunting narwhals (Canada)
Nat Geog 178:12–19 (c,1) Ag '90
—Makah Indians (Northwest)
Nat Geog 180:44–7 (painting,c,1) O '91
—Whale destroying boat (19th cent.)
Natur Hist 98:81 (painting,c,4) Mr '89
WHARTON, EDITH
—Home (Lenox, Massachusetts)
Trav/Holiday 168:114 (drawing,c,4) O
'87
Smithsonian 22:136–7 (c,3) N '91
WHEAT
Nat Geog 179:84–5 (drawing,c,4) Ap '91
WHEAT FIELDS
Nat Wildlife 28:18 (c,1) Ap '90
—Aerial view
Nat Geog 175:281–3 (c,1) Mr '89
Natur Hist 100:89 (c,3) S '91
—Brazil
Nat Geog 171:353 (c,1) Mr '87
—Guatemala
Nat Geog 176:472–3 (c,1) O '89
—Italy
Trav/Holiday 172:60–1 (c,1) N '89
—North Dakota
Nat Geog 171:330–1 (c,1) Mr '87
—Quebec
Trav&Leisure 19:122 (c,4) Ag '89
—Washington
Nat Geog 176:784–5 (c,1) D '89
—Wheat field transplanted to central Paris,
France
Life 13:96 (c,2) Ag '90
—Winter wheat (Washington)
Natur Hist 99:40–1 (c,1) My '90
WHEAT INDUSTRY
—Miller (Maryland)
Trav/Holiday 172:48 (c,2) Ag '89
—Winnowing wheat (Peru)
Nat Geog 179:88–9 (c,1) Ap '91
WHEAT INDUSTRY—HARVESTING
—China
Natur Hist 99:72–3 (c,1) My '90
—Early 20th cent. wheat threshing (Mid-
west)
Smithsonian 21:54–5 (1) N '90

Smithsonian 22:56–7 (3) Ag '91
WHEELCHAIRS
Life 10:13 (c,3) My '87
Sports Illus 68:4 (c,4) Ja 25 '88
Life 11:28–9 (c,1) O '88
Sports Illus 73:14, 17, 82 (c,3) S 10 '90
Sports Illus 73:94–5 (c,1) S 24 '90
Life 14:62, 67 (c,3) F '91
—Cross-country roll by wheelchair
Trav/Holiday 172:24 (c,4) Jl '89
—Girl in mobile life-support wheelchair
Life 12:10 (c,4) S '89
—People in wheelchairs
Nat Geog 180:76 (c,2) S '91
Nat Wildlife 29:46 (c,3) O '91
—Franklin Roosevelt's wheelchair
Am Heritage 38:48 (c,4) Ap '87
—Wheelchair race
Sports Illus 71:44–6 (c,2) Jl 17 '89
WHISTLER, JAMES MCNEILL
—"Whistler's Mother" (1871)
Trav&Leisure 17:95 (painting,c,2) Ja '87
Life 10:90 (painting,c,4) Fall '87
Am Heritage 39:48–9 (painting,c,1) My
'88
WHITE, STANFORD
Am Heritage 41:108 (4) F '90
WHITE-FOOTED MICE
Nat Geog 172:134–5 (c,1) Jl '87
Nat Wildlife 26:7 (c,4) F '88
Nat Wildlife 26:58 (c,4) O '88
Smithsonian 19:79 (c,4) O '88
Nat Geog 175:796 (c,3) Je '89
Nat Wildlife 29:2 (c,2) Je '91
WHITE HOUSE, WASHINGTON, D.C.
Trav/Holiday 169:81 (c,4) My '88
Trav&Leisure 18:119 (c,4) S '88
Life 13:38–40 (c,1) Ja '90
—1941
Am Heritage 40:68 (4) N '89
—Blue Room
Trav&Leisure 17:25 (c,3) Jl '87
—LBJ in Oval Office (1967)
Am Heritage 41:50–1 (1) My '90
—Oval Office
Life 12:36 (c,2) My '89
Life 12:56 (4) Fall '89
WHITE MOUNTAINS, NEW HAMP-
SHIRE
Trav/Holiday 169:61–5 (c,1) Ap '88
—Devils Hopyard Canyon
Natur Hist 96:38–40 (map,c,1) O '87
—See also
MOUNT WASHINGTON
WHITE SANDS NATIONAL MONU-
MENT, NEW MEXICO
Trav&Leisure 21:214 (c,4) Mr '91
Life 14:99 (c,1) Summer '91
Nat Geog 180:46–7 (c,2) Ag '91

Trav&Leisure 21:164–5 (c,1) O '91
WHITEFIELD, GEORGE
 Am Heritage 39:32 (painting,4) My '88
WHITEHORSE, YUKON
 Nat Geog 180:92 (c,4) N '91
WHITNEY, ELI
—1794 cotton gin patent
 Am Heritage 41:48 (4) S '90
WHOOPING CRANES
 Nat Wildlife 25:38–43 (c,1) Je '87
 Life 10:52 (c,2) Jl '87
 Nat Wildlife 26:20–1 (sculpture,c,1) Je
 '88
 Trav&Leisure 21:78 (c,4) O '91
WIGS
—History of wigs
 Smithsonian 22:124–35 (c,1) O '91
—Judge's wig (Bermuda)
 Trav&Leisure 21:129 (c,3) F '91
WILDCATS
 Smithsonian 20:111 (c,4) F '90
WILDEBEESTS
 Smithsonian 17:50–61 (c,1) F '87
 Smithsonian 18:62 (c,4) My '87
 Natur Hist 96:60 (c,4) My '87
 Natur Hist 96:74–5 (c,3) Jl '87
 Trav&Leisure 17:102–3 (c,1) N '87
 Natur Hist 98:62–3 (c,1) Mr '89
—Lion attacking wildebeest
 Nat Geog 174:342–3 (c,1) S '88
WILDLIFE REFUGES
—Arctic National Wildlife Refuge area,
 Alaska
 Nat Geog 174:858–67 (map,c,1) D '88
 Trav&Leisure 21:67, 70, 75 (map,c,4) F
 '91
 Nat Wildlife 30:38–9, 44–5 (c,1) D '91
—Backyard habitats
 Nat Wildlife 27:22–7 (c,1) Ap '89
—Bosque del Apache, New Mexico
 Nat Geog 172:630–1 (c,1) N '87
—Canyon Colorado Equid Sanctuary, New
 Mexico
 Smithsonian 18:138–51 (c,1) My '87
—Central Valley, California
 Nat Wildlife 29:8 (c,4) Je '91
—Jamaica Bay, New York
 Nat Wildlife 27:32–3 (c,1) Ag '89
—Merritt Island National Wildlife Refuge,
 Florida
 Trav/Holiday 175:91 (c,2) Je '91
—Montezuma National Wildlife Refuge,
 New York
 Nat Geog 178:60–1 (c,1) N '90
—Oak Bottom, Portland, Oregon
 Nat Wildlife 27:30–1 (c,1) Ag '89
—Wildlife reserve of Bible animals (Israel)
 Smithsonian 20:106–15 (c,2) F '90
—Yukon Delta, Alaska

Nat Wildlife 28:18–19, 23 (c,1) Je '90
WILHELM II (GERMANY)
 Life 13:37 (4) Mr '90
 Smithsonian 21:92 (4) Mr '91
WILLAMETTE RIVER, OREGON
 Trav&Leisure 21:129 (c,2) Ap '91
WILLIAM III, OF ORANGE (GREAT
 BRITAIN)
 Nat Geog 174:170 (painting,c,3) Ag '88
 Smithsonian 20:156 (painting,c,4) D '89
 Smithsonian 20:16 (painting,c,4) F '90
WILLIAMS, TED
 Sports Illus 69:16 (c,4) N 21 '88
 Sports Illus 72:cov. (c,1) Ap 16 '90
 Sports Illus 75:43 (4) Ag 19 '91
WILLIAMS, TENNESSEE
 Life 13:79 (1) Fall '90
WILLIAMSBURG, VIRGINIA
—Reenactment of 18th cent. Christmas
 Trav&Leisure 19:100–14 (c,1) Jl '89
WILLIAMSON, HUGH
 Life 10:58 (painting,c,4) Fall '87
Willow trees. See
 PUSSY WILLOWS
WILLS, HELEN
 Sports Illus 69:150 (4) S 14 '88
WILMINGTON, DELAWARE
 Trav/Holiday 170:16, 18 (c,3) S '88
WILSON, JAMES
 Am Heritage 38:82–5 (drawing,c,1) My
 '87
 Smithsonian 18:36 (drawing,4) Jl '87
 Life 10:55 (painting,c,4) Fall '87
WILSON, WOODROW
 Am Heritage 39:35, 45 (4) Mr '88
 Am Heritage 39:112 (4) My '88
 Life 13:39 (4) Fall '90
—1913 cartoon about ineffectual Wilson
 chiding Mexico
 Am Heritage 39:40 (drawing,4) N '88
—Edith Galt Wilson
 Am Heritage 41:46 (painting,4) D '90
WINCHELL, WALTER
 Life 13:56 (4) Fall '90
WINCHESTER, ENGLAND
—Winchester Cathedral
 Trav&Leisure 20:121, 124 (c,4) O '90
WIND
—Studying wind patterns on a model of
 Chicago
 Smithsonian 19:129 (c,2) My '88
—Walking against winter wind (Chicago,
 Illinois)
 Nat Geog 179:58–9 (c,1) My '91
—Wind damage to Hancock Tower win-
 dows, Boston, Mass.
 Smithsonian 19:122 (c,4) My '88
—Wind turbines (California)
 Nat Geog 171:48–9 (c,1) Ja '87

Nat Geog 178:92–3 (c,1) O '90
Nat Geog 180:80–1 (c,1) Ag '91
—See also
MONSOONS
STORMS
WINDMILLS
WINDMILLS
—Aruba
Trav/Holiday 168:24 (c,4) D '87
—East Hampton, New York
Trav&Leisure 18:96 (c,3) S '88
—Ice cream stand shaped like windmill
(California)
Smithsonian 19:116 (c,4) N '88
—Nantucket, Massachusetts
Trav/Holiday 169:38 (c,4) My '88
—Netherlands
Trav/Holiday 168:48–9 (c,1) Ag '87
Trav&Leisure 20:12, 21 (c,4) F '90 supp.
Trav/Holiday 173:98 (c,4) Mr '90
Trav&Leisure 21:20, 23–4 (c,3) F '91
supp.
—Portugal
Trav/Holiday 168:cov., 50 (c,1) N '87
Gourmet 50:73 (c,4) S '90
—Refurbished windmill hotel (St. Kitts)
Trav/Holiday 175:68–9 (c,1) F '91
—Romania
Trav/Holiday 169:71 (c,4) Mr '88
—Spain
Gourmet 48:52 (c,3) Mr '88
Trav&Leisure 18:140–1 (c,1) My '88
Trav/Holiday 170:52–3 (c,1) Ag '88
Gourmet 50:125 (c,4) O '90
—Texas
Trav/Holiday 170:45 (c,1) D '88
WINDOWS
—1905 Wright stained glass window
Am Heritage 38:84 (c,4) Jl '87
—Palladian style windows (New England)
Am Heritage 40:75 (c,4) My '89
—See also
STAINED GLASS
WINDSOR CASTLE, ENGLAND
Gourmet 47:60–1 (c,1) Ap '87
WINDSURFING
Trav&Leisure 18:62 (c,4) Ja '88
—Australia
Nat Geog 173:178–80 (c,1) F '88
—France
Nat Geog 176:94–5 (c,1) Jl '89
—Hawaii
Trav/Holiday 168:44 (c,4) S '87
Sports Illus 170:20 (c,3) D '88
—West Indies
Gourmet 47:51 (c,1) Mr '87
Trav&Leisure 17:147 (c,4) N '87
—Windsurfing among icebergs (Alaska)
Nat Geog 173:cov. (c,1) Mr '88

WINDWARD ISLANDS
—1983 U.S. invasion of Grenada
Trav/Holiday 172:84–8 (c,4) Jl '89
—Dominica
Nat Geog 177:100–21 (map,c,1) Je '90
Trav/Holiday 176:81–9 (map,c,1) N '91
—Grenada
Trav&Leisure 17:53–4 (drawing,c,4) Ap
'87
Trav&Leisure 17:80–1 (c,1) O '87
Trav/Holiday 172:84–90 (map,c,1) Jl '89
Gourmet 50:70–3, 112 (map,c,1) Ja '90
Trav&Leisure 20:87 (c,4) F '90
—St. Lucia
Trav/Holiday 167:14–16 (c,2) Je '87
Trav&Leisure 19:52 (c,4) Ja '89
Trav/Holiday 171:56–61 (c,1) F '89
Gourmet 51:80–5, 122 (map,c,1) Mr '91
WINE
—Bottle cork
Trav&Leisure 19:149 (c,4) O '89
—Bottles covered with dust (Spain)
Trav/Holiday 167:18 (c,4) F '87
—Dutch wine bottles
Trav/Holiday 171:22 (c,3) Ja '89
—Old Wine bottles in cellar (France)
Nat Geog 176:73 (c,4) Jl '89
—Popping champagne cork
Trav/Holiday 172:26 (c,4) Jl '89
—Wine bottles
Trav/Holiday 168:73–4 (c,4) Jl '87
Gourmet 49:38 (painting,c,2) Jl '89
Gourmet 49:74 (painting,c,2) O '89
Gourmet 50:34 (painting,c,2) F '90
Gourmet 50:42 (painting,c,2) Ap '90
Gourmet 50:42 (painting,c,2) S '90
—See also
DRINKING CUSTOMS
WINE INDUSTRY
—17th cent. vineyard scenes (Bordeaux,
France)
Gourmet 47:32 (drawing,2) F '87
—Crushing grapes (Portugal)
Gourmet 51:115 (c,1) D '91
—Great wine barrel (Heidelberg, West
Germany)
Gourmet 47:53 (c,1) Ja '87
—Kiwifruit wine bottles (New Zealand)
Nat Geog 171:688 (c,3) My '87
—Map of Clarksburg viticultural area, Cal-
ifornia
Gourmet 50:28 (painting,c,3) Ag '90
—Wine barrels (Australia)
Trav/Holiday 167:24 (c,3) F '87
—Wine cellars (Austria)
Gourmet 47:48 (c,4) Jl '87
—Wine master tasting wine (California)
Trav&Leisure 18:162 (c,4) D '88
—Wine tasting (Australia)

—Mabel Dodge
Smithsonian 22:123–36 (c,2) Je '91
—Fat woman on beach (California)
Life 13:156 (c,2) D '90
—History of the bra
Life 12:cov., 88–98 (c,1) Je '89
—History of women in the U.S. military
Life 14:52–62 (c,1) My '91
—Italian men leering at woman on street
(1951)
Life 11:14–15 (1) Fall '88
—Journalist Polly Pry
Smithsonian 21:49–57 (drawing,c,1) Ja
'91
—Life of working mother (Missouri)
Life 12:100–8 (1) My '89
—Nancy Hanks Lincoln
Natur Hist 99:4 (painting,c,4) Jl '90
—Mother Teresa (India)
Life 11:30–1 (c,2) Ap '88
—Nancy Drew author Harriet Stratemeyer
Adams
Smithsonian 22:60 (4) O '91
—Prehistoric sculptures of female figures
Nat Geog 174:458–9 (c,1) O '88
—Prominent contemporary black women
Nat Geog 176:206–25 (1) Ag '89
—Prominent women in the American civil
rights movement
Life 11:54–63 (1) Spring '88
—Role of women in Japanese life
Nat Geog 177:52–83 (c,1) Ap '90
—U.S. First Ladies (1789–1988)
Life 11:2–3 (painting,c,4) O '88
—Women in World War II
Life 14:58–9 (2) My '91
—See also
ABBOTT, BERENICE
ADDAMS, JANE
ALCOTT, LOUISA MAY
ANDERSON, MARIAN
ANNE
ANTHONY, SUSAN B.
ASTOR, MARY
BAKER, JOSEPHINE
BALL, LUCILLE
BARRYMORE, ETHEL
BARTON, CLARA
BEAUVOIR, SIMONE DE
BERGMAN, INGRID
BERNHARDT, SARAH
BLOOMER, AMELIA
BLY, NELLIE
BRICE, FANNY
BUCK, PEARL S.
CARSON, RACHEL
CASSATT, MARY
CATHER, WILLA
CATHERINE II, THE GREAT

CHILDBIRTH
CHRISTIE, AGATHA
COLBERT, CLAUDETTE
COLETTE
CONNOLLY, MAUREEN
CURIE, MARIE
DAVIS, BETTE
DIETRICH, MARLENE
EARHART, AMELIA
EDDY, MARY BAKER
EDERLE, GERTRUDE
ELIZABETH I
ELIZABETH II
FITZGERALD, ELLA
FRIEDAN, BETTY
GARBO, GRETA
GARLAND, JUDY
GARSON, GREER
GIBSON, ALTHEA
GISH, LILLIAN
GOLDMAN, EMMA
GRABLE, BETTY
GRAHAM, MARTHA
GREEN, "HETTY" HENRIETTA
HARLOW, JEAN
HENIE, SONJA
HEPBURN, KATHARINE
HOLIDAY, BILLIE
ISABELLA I
JOSEPHINE
KAHLO, FRIDA
KELLER, HELEN
LANGTRY, LILY
LOMBARD, CAROLE
LOW, JULIETTE
LUCE, CLARE BOOTH
MADISON, DOLLEY
MARIA THERESA
MARIE ANTOINETTE
MARLOWE, JULIA
MARY, QUEEN OF SCOTS
MARY OF TECK
MEAD, MARGARET
MONROE, MARILYN
NATION, CARRY
NEFERTITI
OAKLEY, ANNIE
O'KEEFFE, GEORGIA
PARKS, ROSA
PICKFORD, MARY
POST, EMILY
POTTER, BEATRIX
PREGNANCY
PRICE, LEONTYNE
ROGERS, GINGER
ROOSEVELT, ELEANOR
ROSS, BETSY
RUDOLPH, WILMA
RUSSELL, LILLIAN

SANGER, MARGARET
SMITH, KATE
STEIN, GERTRUDE
STEINEM, GLORIA
STOWE, HARRIET BEECHER
TAYLOR, ELIZABETH
TEMPLE, SHIRLEY
TERRY, ELLEN
THOMPSON, DOROTHY
TRUTH, SOJOURNER
TUBMAN, HARRIET
VICTORIA
WELTY, EUDORA
WHARTON, EDITH
WILLS, HELEN
WOMEN'S LIBERATION MOVE-
 MENT
WOMEN'S SUFFRAGE MOVEMENT
WOOLF, VIRGINIA
WOMEN'S LIBERATION MOVEMENT
—1969 poster
 Am Heritage 38:59 (c,4) D '87
—See also
 FRIEDAN, BETTY
 STEINEM, GLORIA
WOMEN'S SUFFRAGE MOVEMENT
—1919 suffragette making speech
 Life 10:8–9 (1) Fall '87
—See also
 ANTHONY, SUSAN B.
 BLOOMER, AMELIA
WOOD
—Petrified wood
 Natur Hist 97:12 (4) D '88
—See also
 LUMBERING
WOOD, GRANT
—"American Gothic"
 Smithsonian 19:37 (painting,c,2) Ag '88
—Dog spoof of "American Gothic"
 Life 11:104 (c,3) Ja '88
—"Woman with Plants" (1929)
 Am Heritage 39:53 (painting,c,4) My '88
WOOD CARVING
—Carving animals (Mexico)
 Smithsonian 22:118–21 (c,1) My '91
—Hand carving wooden dolls (Italy)
 Life 13:111–12 (c,1) D '90
—Italy
 Gourmet 47:53 (c,4) Jl '87
—Jamaica
 Trav/Holiday 167:51 (c,4) Ja '87
—Kenya
 Trav/Holiday 170:50 (c,4) Ag '88
—Making duck decoys (Maryland)
 Trav/Holiday 172:49 (c,4) Ag '89
—Making walking sticks (Pennsylvania)
 Nat Geog 178:85 (4) Ag '90
—Whittling (North Dakota)

Nat Geog 171:343 (c,3) Mr '87
WOOD CARVINGS
—Carved nymphs on golf course (Connect-
 icut)
 Sports Illus 68:6 (c,4) Je 6 '88
—Duck decoys (Louisiana)
 Nat Geog 178:56 (c,4) O '90
—Jamaica
 Trav/Holiday 167:48 (c,4) Ja '87
—Rooster carvings (Puerto Rico)
 Nat Geog 179:101 (c,3) Ja '91
—Switzerland
 Trav/Holiday 167:18–19 (c,4) Ja '87
WOOD DUCKS
 Nat Wildlife 26:24–8 (c,1) O '88
 Natur Hist 98:72 (c,3) Je '89
 Nat Wildlife 29:50 (c,3) Ag '91
WOOD WORKING
—Sawing wood
 Sports Illus 75:61 (c,4) Jl 15 '91
WOODCOCKS
 Sports Illus 68:164–9 (painting,c,3) F 15
 '88
WOODPECKERS
 Nat Wildlife 25:48–9 (c,1) Ag '87
 Natur Hist 97:81 (c,4) Ap '88
 Nat Wildlife 27:20 (c,2) Ap '89
 Nat Geog 176:456 (c,4) O '89
 Natur Hist 99:68 (c,4) Je '90
 Natur Hist 99:28 (c,1) Ag '90
 Nat Wildlife 28:26, 40 (c,4) O '90
—Acorn woodpecker's storage tree
 Nat Geog 176:456–7 (c,3) O '89
—Woodpeckers attacking utility poles
 Nat Wildlife 27:22 (painting,c,2) F '89
WOOL INDUSTRY
 Nat Geog 173:cov., 552–91 (c,1) My '88
—16th cent. wool processing (France)
 Nat Geog 173:568 (stained glass,c,4) My
 '88
—New Mexico
 Smithsonian 22:38–9 (c,4) Ap '91
—Thickening Harris tweed (Scotland)
 Nat Geog 173:574 (c,4) My '88
—See also
 GARMENT INDUSTRY
 YARN INDUSTRY
WOOLF, VIRGINIA
 Life 10:77 (4) Mr '87
 Trav&Leisure 18:95, 101 (c,1) Ag '88
—Bust of Woolf
 Gourmet 51:60–1 (c,4) Ag '91
—Home (Sussex, England)
 Trav&Leisure 18:96–7 (c,1) Ag '88
WOOLLCOTT, ALEXANDER
 Am Heritage 41:42 (4) Ap '90
WORLD TRADE CENTER, NEW
 YORK CITY, NEW YORK
 Trav/Holiday 174:57 (c,3) S '90

Am Heritage 42:91 (c,4) D '91
—Headlines about 1945 bombing of Hiroshima (Washington)
Natur Hist 99:16 (2) S '90
—Hitler crossing into Czechoslovakia (1938)
Smithsonian 19:198 (2) O '88
—Iwo Jima memorial (Washington, D.C.)
Life 14:78–9 (c,1) Ag '91
—Japanese bomb-carrying balloons
Smithsonian 19:182 (4) D '88
—Listening to radio reports from homefront
Trav&Leisure 19:106 (3) Ap '89
—Londoners digging trenches in war preparation (1939)
Smithsonian 19:166 (4) O '88
—Memorial to U.S. dead (Philippines)
Trav/Holiday 172:60–1 (c,1) S '89
—Men at U.S. Navy recruiting station (Massachusetts)
Am Heritage 40:70 (4) N '89
—Monuments to Americans (Luxembourg)
Trav/Holiday 168:34–41 (c,1) D '87
—"Overlord Embroidery" tribute to D-Day (Great Britain)
Am Heritage 40:108–13 (c,2) My '89
—Raising U.S. flag at Iwo Jima (1945)
Life 11:48 (4) Fall '88
Life 12:108 (4) Ag '89
—Raising U.S. flag at Midway
Am Heritage 42:88 (4) D '91
—Roosevelt asking Congress for declaration of war (1941)
Am Heritage 38:69 (2) D '87
—Roosevelt signing declaration of war on Japan (1941)
Am Heritage 40:66 (4) N '89
Smithsonian 20:59 (4) D '89
—Roosevelt's war plans on newspaper front page (1941)
Am Heritage 38:64 (c,2) D '87
—Russian World War II poster
Am Heritage 39:114 (c,4) D '88
—U.S. after Pearl Harbor bombing (1941)
Am Heritage 40:52–72, 170 (1) N '89
—U.S. air bases (East Anglia, England)
Am Heritage 41:100–4 (map,c,1) Ap '90
—U.S. bomber crew (1945)
Am Heritage 40:155 (4) N '89
—U.S. civil defense activities
Smithsonian 19:174–204 (1) D '88
—U.S. soldiers in Paris (1944)
Trav&Leisure 19:103 (2) Ap '89
—U.S. soldiers returning home after war (1945)
Life 13:68–78 (1) N '90
—Use of radar during World War II

Smithsonian 21:120–9 (c,3) Jl '90
—"USS Franklin" under attack (1945)
Smithsonian 22:22, 24 (3) N '91
—Victims of Nazi death squad (Crimea)
Life 11:78–9 (1) Fall '88
—War in the Pacific
Nat Geog 173:432–3 (map,c,1) Ap '88
Am Heritage 40:39 (3) Mr '89
Trav/Holiday 172:60–71 (c,1) S '89
Am Heritage 42:80–91 (map,c,1) D '91
—War ordnance and materiel (Great Britain)
Am Heritage 39:83 (3) Jl '88
—Watch stopped during 1945 Hiroshima bombing (Japan)
Nat Geog 177:112 (c,4) Mr '90
—Women in World War II
Life 14:58–9 (2) My '91
—World War II deserter Eddie Slovick
Am Heritage 38:97–103 (4) S '87
—World War II memorial (Gdansk, Poland)
Trav/Holiday 170:52–3 (c,1) O '88
—World War II memorial (Leningrad, U.S.S.R.)
Trav&Leisure 19:130 (c,4) F '89
—World War II memorial (Warsaw, Poland)
Nat Geog 173:118–19 (c,1) Ja '88
—World War II pinup photo of Betty Grable
Life 11:73 (4) Fall '88
—World War II "Russian friend" poster (U.S.)
Am Heritage 42:120 (2) D '91
—See also
ATOMIC BOMBS
CHURCHILL, WINSTON
CONCENTRATION CAMPS
EISENHOWER, DWIGHT DAVID
HALSEY, WILLIAM FREDERICK, JR.
HITLER, ADOLF
MONTGOMERY, BERNARD
MUSSOLINI, BENITO
NAZISM
NIMITZ, CHESTER
PATTON, GEORGE
PEARL HARBOR
ROMMEL, ERWIN
ROOSEVELT, FRANKLIN DELANO
WORMS
—Christmas tree worm
Natur Hist 97:50 (c,4) O '88
Nat Wildlife 27:58 (c,4) Ap '89
—Feather duster worms
Nat Wildlife 29:20–1 (c,1) F '91
Natur Hist 100:66–7 (c,1) N '91
—Ice worm

Nat Geog 171:100 (c,4) Ja '87
—See also
LEECHES
WRANGELL-ST. ELIAS NATIONAL
PARK, ALASKA
Life 14:104 (c,2) Summer '91
WRENS
Nat Wildlife 25:49 (c,4) Ag '87
Smithsonian 18:210 (painting,c,4) F '88
Life 11:166–7 (c,1) Fall '88
—House wrens living in glove on clothes-
line (Maryland)
Nat Wildlife 26:2 (c,2) Je '88
WRESTLERS
Sports Illus 74:67 (c,1) My 13 '91
—Sumo wrestlers
Sports Illus 68:2–3 (c,1) Mr 28 '88
Trav&Leisure 19:105 (c,3) D '89
Sports Illus 71:30 (4) D 11 '89
Sports Illus 72:16–18 (c,3) F 12 '90
Sports Illus 75:70–1 (c,1) D 30 '91
—Sumo wrestlers in tutus (Japan)
Sports Illus 74:88 (c,4) Je 24 '91
Life 14:16 (c,2) Ag '91
WRESTLING
Sports Illus 70:102 (4) Ja 9 '89
—17th cent. self-defense diagrams (Nether-
lands)
Sports Illus 71:5–6 (4) S 11 '89
—18th cent. (Korea)
Smithsonian 19:46 (painting,c,2) Ag '88
—1988 Olympics (Seoul)
Sports Illus 69:102 (c,4) O 10 '88
Life 11:162–3 (c,1) N '88
—Arm wrestling
Sports Illus 74:4 (painting,c,4) My 6 '91
Nat Geog 180:88 (c,2) N '91
—El Salvador
Sports Illus 75:73 (3) D 9 '91
—Goodwill Games 1990 (Seattle, Washing-
ton)
Sports Illus 73:25–6 (c,3) Ag 6 '90
—Grade school children
Sports Illus 70:46 (c,4) Ja 16 '89
—Poking wrestler in eye
Sports Illus 73:110–11 (c,1) D 31 '90
WRESTLING—AMATEUR
Sports Illus 70:71–3 (c,4) Ap 10 '89
WRESTLING—COLLEGE
Sports Illus 66:20–1 (c,2) Mr 2 '87
Sports Illus 66:36–7 (c,4) Mr 30 '87
Sports Illus 68:81–2 (c,4) Ja 18 '88
Sports Illus 68:52, 57, 60 (c,4) Mr 14 '88
Sports Illus 68:58–9 (c,3) Mr 28 '88
Sports Illus 70:2–3, 72–3 (c,1) F 13 '89
Sports Illus 70:132–3 (c,4) Mr 20 '89
Sports Illus 70:70 (c,3) Mr 27 '89
—NCAA Championships 1987
Sports Illus 66:4 (c,4) Ap 20 '87

—NCAA Championships 1990
Sports Illus 72:42–3 (c,1) Ap 2 '90
—NCAA Championships 1991
Sports Illus 74:62, 65 (c,3) Mr 25 '91
WRESTLING—HIGH SCHOOL
Sports Illus 66:64 (c,4) F 9 '87
Sports Illus 70:45 (c,3) Ja 16 '89
WRESTLING—PROFESSIONAL
—Mexico
Sports Illus 67:88–9, 96 (c,1) D 21 '87
—Sumo wrestling
Sports Illus 71:83 (c,3) Ag 28 '89
Life 13:18 (c,2) F '90
WRIGHT, FRANK LLOYD
Trav&Leisure 17:46 (4) D '87
Life 13:105 (4) Fall '90
Am Heritage 42:63 (4) Jl '91
—1905 Wright stained glass window
Am Heritage 38:84 (c,4) Jl '87
—Adobe Pottery House, Santa Fe, New
Mexico
Smithsonian 20:145 (c,4) N '89
—Caricature
Am Heritage 41:59 (c,3) F '90
—Chairs designed by Wright
Am Heritage 38:83 (c,3) Jl '87
Trav&Leisure 17:46 (c,4) D '87
Smithsonian 19:130 (c,4) Ag '88
Am Heritage 42:68 (c,4) Jl '91
—Falling water house designed by Wright
(Pennsylvania)
Trav&Leisure 20:E1 (c,3) Ap '90
—Homes designed by him (Illinois)
Am Heritage 42:62–9 (c,1) Jl '91
—Taliesin home (Spring Green, Wis-
consin)
Gourmet 51:70–3, 95 (c,1) F '91
—Taliesin West home (Scottsdale, Ari-
zona)
Gourmet 51:86–9 (c,1) Mr '91
—Usonian home by Wright (Manchester,
New Hampshire)
Trav&Leisure 21:18 (c,4) Jl '91
—Wright-designed silver bowl
Am Heritage 39:29 (c,1) N '88
—Wright office building (Oklahoma)
Smithsonian 22:116 (c,4) Ap '91
—Wright's Hollyhock House (Los Ange-
les, California)
Trav&Leisure 20:84 (c,4) S '90
WRIGHT, WILBUR AND ORVILLE
Am Heritage 40:153 (4) N '89
Life 13:50 (4) Fall '90
Trav/Holiday 176:48–53 (1) D '91
—1899 sewing machine used by the Wright
Brothers
Life 14:61 (c,4) Summer '91
—1900 camp (Kitty Hawk, North Carolina)
Am Heritage 39:94–5 (1) Ap '88

—1903 Wright Brothers plane
 Am Heritage 39:4 (replica,c,2) Ap '88
 Gourmet 51:103 (c,4) D '91
—1906 patent for airplane
 Am Heritage 41:58 (drawing,4) S '90
—Early Wright Brothers flights
 Trav/Holiday 176:84 (4) Jl '91
 Trav/Holiday 176:48–53 (1) D '91
—Home (Dayton, Ohio)
 Am Heritage 39:105 (c,4) Ap '88
 Trav/Holiday 176:51 (4) D '91
WRITERS
—18th cent. French philosophers
 Smithsonian 20:192 (drawing,4) S '89
—1960s Greenwich Village writers, New
 York
 Am Heritage 38:80 (painting,c,4) D '87
—Mabel Dodge
 Smithsonian 22:123–36 (c,2) Je '91
—Famous French writers
 Smithsonian 20:144–57 (c,4) Ja '90
—Louis L'Amour
 Smithsonian 18:154–70 (c,2) My '87
—Nancy Drew author Harriet Stratemeyer
 Adams
 Smithsonian 22:60 (4) O '91
—Playwright at typewriter (Vermont)
 Life 10:68 (c,3) O '87
—Edward Stratemeyer
 Smithsonian 22:50 (4) O '91
—Writer at typewriter (Great Britain)
 Life 11:68 (c,4) Mr '88
—Writer sitting beside pond
 Sports Illus 66:72–3 (c,2) Ja 19 '87
—See also
 ADAMS, HENRY BROOKS
 ALCOTT, LOUISA MAY
 ALLEN, FRED
 ANDERSEN, HANS CHRISTIAN
 ASCH, SHOLEM
 ASIMOV, ISAAC
 ASTOR, MARY
 BACON, FRANCIS
 BALDWIN, JAMES
 BALZAC, HONORE DE
 BANCROFT, GEORGE
 BARTLETT, JOHN
 BEAUVOIR, SIMONE DE
 BEERBOHM, MAX
 BELLOW, SAUL
 BOCCACCIO, GIOVANNI
 BOSWELL, JAMES
 BUCK, PEARL S.
 BURTON, SIR RICHARD FRANCIS
 BYRON, LORD
 CARROLL, LEWIS
 CARSON, RACHEL
 CATHER, WILLA
 CATTON, BRUCE

CHRISTIE, AGATHA
CLAUDEL, PAUL
COCTEAU, JEAN
COLETTE
CONRAD, JOSEPH
CRANE, STEPHEN
DEMOSTHENES
DICKENS, CHARLES
DOYLE, SIR ARTHUR CONAN
DREISER, THEODORE
DUMAS, ALEXANDRE PERE
DUNBAR, PAUL LAURENCE
ELIOT, T. S.
EMERSON, RALPH WALDO
ENGELS, FRIEDRICH
FAULKNER, WILLIAM
FITZGERALD, F. SCOTT
FORD, FORD MADOX
FRIEDAN, BETTY
GEORGE, HENRY
GIBBON, EDWARD
GIDE, ANDRE
GOETHE, JOHANN
GOLDMAN, EMMA
GRAHAME, KENNETH
GRIMM BROTHERS
HALE, EDWARD EVERETT
HARDY, THOMAS
HAWTHORNE, NATHANIEL
HEMINGWAY, ERNEST
HENRY, O.
HEYERDAHL, THOR
HUGHES, LANGSTON
HUGO, VICTOR
IRVING, WASHINGTON
JAMES, WILL
JOYCE, JAMES
KEROUAC, JACK
KIPLING, RUDYARD
LARDNER, RING
LAWRENCE, D. H.
LONDON, JACK
LONGFELLOW, HENRY WADS-
 WORTH
LUCE, CLARE BOOTH
MARX, KARL
MATHER, COTTON
MAUGHAM, W. SOMERSET
MELVILLE, HERMAN
MENCKEN, HENRY LOUIS
MILLER, ARTHUR
MILLER, HENRY
MONTESQUIEU
MORE, SIR THOMAS
NABOKOV, VLADIMIR
O'NEILL, EUGENE
PAINE, THOMAS
PARKMAN, FRANCIS
PASTERNAK, BORIS

Trav&Leisure 19:116–17 (c,1) Mr '89
Life 14:16–17 (c,1) Summer '91
—Grizzly bear warning signs
Nat Wildlife 26:21 (c,4) F '88
—Grotto Geyser
Life 12:42 (c,4) Je '89
—Lower Falls
Nat Geog 175:235 (c,3) F '89
—Mammoth Hot Springs
Life 12:32–3 (c,1) Je '89
Smithsonian 21:41 (4) Ap '90
Trav&Leisure 21:66–7 (c,1) Jl '91
—Old Faithful
Trav&Leisure 17:E1 (c,3) N '87
Nat Geog 175:252–3 (c,1) F '89
Life 12:2–3 (c,1) Je '89
Life 14:110 (c,2) Summer '91
—Old Faithful (1872)
Nat Geog 175:228 (4) F '89
—Tower Falls
Trav&Leisure 21:90 (c,2) Ap '91
—Tower Falls (1860s)
Smithsonian 21:40 (painting,c,4) Ap '90
YELLOWSTONE RIVER, WYOMING
Trav/Holiday 174:55 (c,3) Jl '90
YELLOWTAILS (FISH)
Life 10:49 (c,4) Je '87
YELLOWTHROATS
Natur Hist 98:54–5 (c,1) My '89
YEMEN—COSTUME
—Woman with baby
Life 14:16 (c,2) O '91
YOGA
Nat Geog 175:177 (c,4) F '89
YORK, ENGLAND
—York Minster
Trav&Leisure 19:45 (c,4) F '89
YORKSHIRE TERRIERS
Sports Illus 66:10 (c,4) F 23 '87
YORKTOWN, VIRGINIA
—1781 map
Nat Geog 173:808–9 (c,1) Je '88
YOSEMITE NATIONAL PARK, CALI-
FORNIA
Trav/Holiday 170:41 (c,4) Jl '88
Trav/Holiday 170:45 (c,2) N '88
Nat Geog 175:466, 470 (c,2) Ap '89
Life 12:10 (c,4) O '89
Trav/Holiday 173:30 (c,2) Ja '90
Trav/Holiday 173:89 (map,c,2) F '90
Life 14:20–1 (c,1) Summer '91
—1944 photograph by Ansel Adams
Trav&Leisure 17:107 (2) F '87
—Auto on edge of Yosemite cliff (1923)
Nat Geog 174:308 (3) S '88
—Lower Yosemite Falls (1880s)
Nat Geog 175:220–1 (1) F '89
YOUNG, CY
Sports Illus 74:47 (c,3) Ap 15 '91

YOUTH
—Clashing with police (South Korea)
Sports Illus 66:38 (c,4) Je 8 '87
—Drug culture in North Philadelphia,
Pennsylvania
Life 13:30–41 (1) Je '90
—Harvard student swallowing goldfish
(1939)
Am Heritage 40:33 (4) Mr '89
—High school prom attire (Texas)
Nat Geog 177:58–9 (c,1) Je '90
—Lifestyles of Chinese youth
Nat Geog 180:110–36 (c,1) Jl '91
—Missouri teenagers dancing (1953)
Nat Geog 175:207 (4) F '89
—Navy recruits (California)
Nat Geog 176:180–1 (c,1) Ag '89
—Riding on top of speeding trains (Brazil)
Life 14:52 (c,2) O '91
—Summer camp (Ontario)
Sports Illus 75:52–63 (c,1) Jl 8 '91
—Teenage boy's bedroom (Connecticut)
Sports Illus 71:2–3 (c,1) D 25 '89
—Teenage sexuality
Life 12:24–30 (1) Jl '89
—Teens at vocational high school (Ohio)
Smithsonian 19:132–43 (1) My '88
—Teens cruising in car (North Dakota)
Nat Geog 171:323 (c,2) Mr '87
—Worldwide coming of age rituals
Life 14:30–52 (c,1) O '91
—See also
BOY SCOUTS
CHILDREN
COLLEGE LIFE
GIRL SCOUTS
YPRES, BELGIUM
—13th cent. Cloth Hall
Nat Geog 173:572 (c,4) My '88
YUCCA PLANTS
Natur Hist 100:72–5 (c,1) F '91
Life 14:55 (c,4) Summer '91
—See also
JOSHUA TREES
YUGOSLAVIA
Nat Geog 178:92–123 (map,c,1) Ag '90
—Adriatic coast
Trav&Leisure 21:188–94 (map,c,4) Ap
'91
—Brioni
Trav&Leisure 18:52–4 (map,c,3) Je '88
—Dalmatian Islands
Trav/Holiday 175:74–81 (map,c,1) My
'91
—Dubrovnik
Trav/Holiday 167:46–51 (c,1) Je '87
Nat Geog 178:114–15 (c,1) Ag '90
Trav&Leisure 21:194 (c,4) Ap '91
—Korcula

- Z -

Trav&Leisure 17:100, 103 (c,4) N '87
Life 11:104–5 (4) Je '88
Trav&Leisure 18:111 (c,4) N '88
Trav/Holiday 171:46–7 (c,1) Ap '89
Trav&Leisure 20:107 (c,4) S '90
Sports Illus 73:105 (c,4) D 17 '90
Nat Geog 178:16–17, 59 (c,1) D '90
—Attacked by lion
Life 11:164–5 (c,1) Fall '88
—Grévy's zebras
Smithsonian 18:138, 141, 151 (c,1) My '87
—Lego model of zebra
Smithsonian 19:129 (c,1) Je '88
Zebu oxen. See
BRAHMANS
ZEPPELIN, FERDINAND VON
Life 11:66 (4) N '88
ZIMBABWE
—Hwange National Park
Natur Hist 96:28–9 (c,1) Je '87
Trav&Leisure 20:106–11 (c,1) S '90
—Kariba Lake
Trav&Leisure 20:110 (c,4) S '90
—National parks
Trav&Leisure 20:104–17, 158 (map,c,1) S '90
—See also
VICTORIA FALLS
ZIMBABWE—COSTUME
Trav&Leisure 20:114–17 (c,1) S '90
ZIMBABWE—HOUSING
—Safari camp cottage
Trav&Leisure 176:39 (c,3) N '91
ZION NATIONAL PARK, UTAH
Life 14:14–15 (c,1) Summer '91

—Road entering narrow tunnel
Trav&Leisure 19:211–12 (map,c,4) S '89
ZOLA, EMILE
—Caricature
Smithsonian 20:150 (drawing,4) Ja '90
—Nasty cartoon about him
Smithsonian 20:120 (c,4) Ag '89
ZOOS
—Bronx Zoo, New York
Smithsonian 17:106 (c,1) F '87
Trav&Leisure 20:NY8 (c,3) O '90
—Central Park Zoo, New York City, New York
Smithsonian 17:108–15 (c,1) F '87
Trav&Leisure 19:NY2–4 (c,3) F '89
Trav/Holiday 171:73–5 (c,4) My '89
—Construction of zoo habitats (Arizona)
Smithsonian 17:108–15 (c,1) F '87
—National Zoo, Washington, D.C.
Smithsonian 19:27 (c,4) S '88
Smithsonian 20:cov., 26–35 (c,1) Jl '89
—National Zoo, Washington, D.C. (19th–20th cents.)
Smithsonian 20:26–35 (c,1) Jl '89
ZULU PEOPLE (AFRICA)
—1830s Zulus attacking Boers (South Africa)
Nat Geog 174:564 (painting,c,4) O '88
—Zulu couple (1896)
Nat Geog 174:290 (4) S '88
ZURICH, SWITZERLAND
—1860s
Trav&Leisure 17:32 (painting,c,3) Ap '87 supp.
—Baur au Lac Hotel
Trav&Leisure 17:32–5 (c,2) Ap '87 supp.

ABOUT THE AUTHOR

Marsha C. Appel has a B.A. from the State University of New York at Albany, and an MLS from Syracuse University. She is Vice President, Manager of the Member Information Service at the American Association of Advertising Agencies in New York City. An active member of Special Libraries Association, she has served as editor of *What's New in Advertising and Marketing,* and as chair of the association's Advertising & Marketing Division. In addition to this volume, she has produced three previous volumes of the *Illustration Index,* together covering the years 1972–1986.